MW01492994

AN ILLUSTRATED DICTIONARY OF
HISTORIC COSTUME

RICHARD II.

From the Painting in Westminster Abbey.

AN ILLUSTRATED DICTIONARY OF
HISTORIC COSTUME

FROM THE FIRST CENTURY B.C. TO C. 1760

JAMES ROBINSON PLANCHÉ

DOVER PUBLICATIONS, INC.
Mineola, New York

Bibliographical Note

An Illustrated Dictionary of Historic Costume: From the First Century B.C. *to c. 1760*, first published in 2003, is an unabridged republication of Volume I (i.e., THE DICTIONARY) of the two-volume work originally published in 1876 by Chatto and Windus, Piccadilly, London, under the title *A Cyclopædia of Costume or Dictionary of Dress, including Notices of Contemporaneous Fashions on the Continent; and A General Chronological History of the Principal Countries of Europe, from the Commencement of the Christian Era to the Accession of George the Third*. The running heads in the current volume reflect the work's original title.

All of the color plates have been reproduced in black and white in their original size and positions, and in color on the inside and back covers of this reprint in somewhat reduced form. Please note that some of the plates have been moved slightly — usually no more than two pages from their original positions — so that all the plates fall on recto pages; the reader should compensate accordingly when following page references to the plates in the text. Finally, the original edition contained an error in numbering plate numbers XVII–XIX, which has been corrected herein.

DOVER *Pictorial Archive* SERIES

Library of Congress Cataloging-in-Publication Data

Planché, J. R. (James Robinson), 1796–1880.
 [Cyclopaedia of costume]
 An illustrated dictionary of historic costume : from the first century B. C. to c. 1760 / James Robinson Planché.
 p. cm. — (Dover pictorial archive series)
 "An unabridged republication of volume I (i.e., The dictionary) of the two-volume work originally published in 1876 by Chatto and Windus, Piccadilly, London, under the title A cyclopaedia of costume, or, Dictionary of dress" — T.p. verso.
 ISBN 0-486-42323-9 (pbk.)
 1. Costume — History. 2. Costume — Europe — History. I. Title. II. Series.

GT510 .P48 2002
391'.009 — dc21

2002031507

Manufactured in the United States of America
Dover Publications, Inc., 31 East 2nd Street, Mineola, N.Y. 11501

ADVERTISEMENT.

N collecting materials for a History of Costume of more import-
ance than the little Handbook which has met with so much
favour as an elementary work, I was not only made aware of
my own deficiencies, but surprised to find how much more vague
are the explanations and contradictory the statements of our
best authorities than they appeared to me when, in the plenitude
of my ignorance, I rushed upon almost untrodden ground, and
felt bewildered by the mass of unsifted evidence and unhesitating assertion which met
my eyes at every turn.

During the forty years which have elapsed since the publication of the first edition
of my 'History of British Costume' in 'The Library of Entertaining Knowledge,'
archæological investigation has received such an impetus by the establishment of
metropolitan and provincial peripatetic antiquarian societies, that a flood of light has
been poured upon us by which we are enabled to re-examine our opinions, and discover
reasons to doubt, if we cannot find facts to authenticate.

That the former greatly preponderate is a grievous acknowledgment to make after
assiduously devoting the leisure of half my life to the pursuit of information on this, to
me, most fascinating subject. It is some consolation, however, to feel that, where I
cannot instruct, I shall certainly not mislead, and that the reader will find, under each
head, all that is known to or suggested by the most competent writers I am acquainted
with, either here or on the Continent.

That a portion of this work appears in a glossarial form arises from the desire of
many artists who have expressed to me the difficulty they constantly meet in their

endeavours to ascertain the complete form of a garment, or the exact mode of fastening a piece of armour, or the buckling of a belt, from their study of a sepulchral effigy or a figure in an illumination; the attitude of the personages represented, or the disposition of other portions of their attire, effectually preventing the requisite examination.

The books supplying any such information are very few, and the best confined to armour or ecclesiastical costume. The only English publication of the kind required, that I am aware of, is the late Mr. Fairholt's 'Costume in England,' the last two hundred pages of which contain a glossary; the most valuable portion thereof being the quotations from old plays, mediæval romances, and satirical ballads containing allusions to various articles of attire in fashion at the time of their composition. Many years have expired since the last edition of that book appeared, and it has been thought that a more comprehensive work on the subject than has yet issued from the English press, combining the pith of the information of many costly foreign publications, and in its illustrations keeping in view the special requirements of the artist to which I have alluded, would be, in these days of educational progress and critical inquiry, a welcome addition to the library of an English gentleman.

J. R. PLANCHÉ.

COLLEGE OF ARMS,
July 1876.

List of Colour Illustrations*

*For this edition, all nine of the color plates have been reproduced in black and white in their original size and in or near their original positions, and in color on the inside and back covers in somewhat reduced form.

CYCLOPÆDIA OF COSTUME.

A BACOT, ABOCOCKE, ABOCOCKED, ABOCOCKET, BYCOCKET. (French, *bicoque*.) A cap worn during the fourteenth, fifteenth, and commencement of the sixteenth century by royal and noble personages.

Spelman has, "Abacot. Pileus augustalis Regum Anglorum duabus coroniis insignatus. Vide Chronica, ann. 1463, Edw. IV. pag. 666, col. ii. lib. 27." He has been followed literally by Ducange, and without further explanation by the recent editors of the latter. Abacot is also inserted in Bailey's and other English dictionaries, the former erroneously describing it as "a royal cap of state *made in the shape of two crowns*, anciently worn by the kings of England." *Insignatus* signifies ensigned or distinguished, and in Hall's Chronicle we find the cap mentioned thus : "King Henry was this day the beste horseman of his company, for he fled so faste that no man could overtake hym, and he was so nere pursued that certain of his henxmen or followers were taken, their horses being trapped in blew velvet, whereof one of them had on his hed the said Kyng Henries healmet, some say his high cap of state, called Abococked, garnished with twoo riche crownes, which was presented to Kyng Edward at Yorke the fourth daie of May." (Union, *sub reg.* Edward IV. f. 2.)

Grafton and Holinshed have the same account, but the former spells the word Abococket, and the latter Abacot and Abococke. At the coronation of Elizabeth of York, daughter of Edward IV. and queen of Henry VII., A.D. 1487, we read that "the Earl of Derby, Constable of England, entered Westminster Hall, mounted on a courser richly trapped and enamed—that is to say, quarterly golde, in the first quarter a lion gowles, having a man's hede in a bycocket of silver, and in the ij^de a lyon of sable. This trapper was right curiously wrought with the needell, for the mannes visage in the bycockett shewed veryly well favoured." (Leland's 'Collectanea,' vol. iv. p. 225.)

Why the trappings of the Earl of Derby's horse should have been emblazoned with these charges or badges, was a question difficult to answer ; such a device as a lion with a man's head in a bycocket not appearing to have been borne by the Stanleys. It is to be seen, however, in the standard of John Ratcliff, Baron Fitzwalter (Book of Standards, Coll. Arms ; *vide* Plate I. fig. 11) ; and on referring to the notice of that nobleman in Dugdale, we find that on the 3rd of Henry VII. he was associated with Jasper, Duke of Bedford, and others, for exercising the office of High Steward of England at the coronation of the said Queen Elizabeth. It is therefore clear that it was Lord Fitzwalter as High Steward, and not the Earl of Derby as Constable, who rode the courser so "trapped and enamed."

That the abacock or bycocket was not peculiarly "a *royal* cap of state" appears from an entry in a MS. of the close of the fifteenth century, in the College of Arms, marked L. 8, fol. 54^b, entitled 'The Apparel for the Field of a Baron in his Sovereign's Company.' "Item, another pe. of hostynge harness [to] ryde daily with all, with a *bycocket* and alle other apparell longynge thereto."

It is, I think, evident that the abocock or bycocket was the cap so frequently seen in illuminations of the fifteenth century, turned up behind, coming to a peak in front, varying and gradually decreasing in height, encircled with a crown when worn by regal personages (*vide* Plate I. fig. 4), and similar to, if not identical with, what is now called the knight's chapeau, first appearing in the reign of Edward III., and on which the crest is placed (Plate I. figs. 1, 3, and 8); as we may fairly conclude from the badge of Robert Fitzwalter, Earl of Sussex (*temp.* Queen Elizabeth), the descendant of John, Lord Fitzwalter, before mentioned, in which it is depicted with the two peaks worn behind as in achievements of the present day. (MS. College of Arms, Vincent, No. 172. *Vide* Plate I. fig. 12.)

In the list of articles ordered for the coronation of Richard III. "two hats of estate" are directed to be prepared, and worn "with the round rolls behind and the beeks before." (Book of Piers Courtenay, the King's Wardrober.) As these hats were provided for the two persons representing the Dukes of Normandy and Aquitaine, I take it that they were ordered to be so worn in accordance with some ancient fashion, as at this period and subsequently the knight's chapeau is always represented with the peaks or beaks behind. The two crowns that are said to have garnished the cap of Henry VI. might have betokened the kingdoms of France and England. M. Viollet le Duc, on the authority of an anonymous writer, gives examples of a closed helmet as a bicocquet. That it was not a helmet is perfectly clear from the contemporary documents I have quoted, with which M. Viollet le Duc was evidently not acquainted. The name, however, might have been capriciously applied to a steel head-piece, as it is at the present day to small dwelling-houses. (See BYCOCKET.)

ACTON, AKETON, HACKETON. (French, *aqueton, haucton, hoqueton.*) A tunic or cassock made of buckram or buckskin, stuffed with cotton, and sometimes covered with silk and quilted with gold thread, worn under the hauberk or coat-of-mail, used occasionally as a defensive military garment without the hauberk. "Qui non habuerit actonem et basinetum habeat unum bonum haburgellium et unum capitium de ferro." (Statute of Robert I. of Scotland, cap. 27.) In a wardrobe account, dated 1212, twelve pence is entered as the price of a pound of cotton required for stuffing an aketon belonging to King John. (Harleian MS. 4573.)

Aketon. From Roy. MS. xiv. E. 5.

"Si tu veuil un auqueton
Ne l'empli une de côton
Mais d'œuvres de miséricorde
Afin que diables ne te morde."
Roman du Riche et du Ladre.

"Le hacuton fut fort qui fut de bonquerant."
Chron. Bertrand du Guesclin.

"Sur l'auqueton qui d'or fu pointurez
Veste l'auberc qui fut fort et serrez."
Roman de Gaydon.

Chaucer, describing the dress of a knight, says:

"Next his sherte a haketon,
And over that a habergeon
For peircing of his heart,
And over that a fine hauberk
Was all ywrought of Jewe's work.
Full strong it was of plate."
Rhyme of Sir Topaz.

This passage has been a sad puzzle to commentators, but it is curiously illustrated by a miniature in a fine copy of Boccaccio's 'Livre des nobles Femmes' in the Royal Library, Paris. (See under HAUBERGEON.)

That the colour of the aketon was generally white appears from the old French proverb, "Plus

From the Great Seal of Edward III.

2

From the Seal of Richard Duke of York.

3

From the Seal of Edward the Black Prince.

4

From a Tapestry of the 15th Century

5

From Royal MSS. 14 E. 4. f. 50.

6

From Royal MSS. 14 E. 4. f. 245.

7

From Harl. MS. 437.

8

From the brass of Sir Hugh Hastings
at Elsyng, Norfolk.

9

From grant to John de Kingston by Richard II.
Harl. MS. 5804.

10

From a MS. in the College of Arms.

11

Badge of John Baron Fitzwalter. Temp. Hen. VII.
From Book of Standards at the College of Arms.

12

Robert Lord Fitzwalter, Earl of Sussex.
Temp. Eliz. From MS. in College of Arms.

blanc qu'un auketon." "But this was not invariably the case," remarks Sir S. R. Meyrick, "for Matthew de Couci in his 'History of Charles VII.' says, 'Portoient auctons *rouges* recoupez dessous sans croix.'" (Archæologia, vol. xix.); and in the 'Romance of Sir Carline' we have, "His acton it was all of black." (Halliwell's 'Dictionary of Archaic Words,' *in voce*.) I infer, therefore, it was usually coloured when intended to be worn, as in these instances, without or in lieu of the hauberk. In an inventory of John Fitz Marmaduke, Lord of Horden, we find mention of an aketon covered with green samite, and a red aketon with sleeves of whalebone, "cum manicis de balyn." (*Vide* Glossary to Meyrick's 'Critical Inquiry' under "Gaynepayne," vol. iii. 2nd ed.) Camden describes it, however, as "a jacket without sleeves, called a haketon." (Remaines, p. 196, ed. 1657.) In process of time the word was applied to a defence of plate. In a letter of the year 1478, quoted by Sir S. R. Meyrick, we read of a *silver* aketon, "Lequel Perrin bailla à celui mace ung coup de la fourche en la poitrine, dont il le navra, et l'eust tué n'eust este son hauqueton d'argent." (Archæologia, *ut supra*.) And a writer of the reign of Elizabeth says, "Haketon is a sleeveless jackett of plate for the warre covered with any other stuffe; at *this day also called a jackett of plate*." (Animadversions on Chaucer, by Francis Thynne, 1598. His note is only valuable as an authority for his own time.) The "haketon" of Chaucer was *not* of plate. M. le Duc actually represents the heraldic tabard as a hoqueton!

The etymology of the word is much disputed. Perizonius derives the French word *hoqueton* from the Greek ὁ χισῶν; Sir S. R. Meyrick from the German *hauen*, to hew, and *Quittung*, a quittance. "Hence," he observes, "it would imply an obstacle to wounds." This, I think, is rather far-fetched. After all, it may be simply a corruption of the French *à coton* or *au coton* the material with which the garment was stuffed, or of the original Arabic word *alkoton*, from which the Italians derived their *cotone*, the French *coton*, the English "cotton," and the Spaniards, retaining the article, *algodon*. The "auqueton qui d'or fu pointurez" is well displayed in the figure on p. 2, from Royal MS. xiv. E. 5, where a knight is depicted as being wounded while he is putting on or taking off the hauberk which was worn over it.

AGGRAPES. (French, *agrafe*.) A clasp or buckle. Also, hooks and eyes.

AGLET, ANGLET, AIGLET, AIGUILLETTE. (French, *aiguillette*.) The metal tag to a lace, or point, as it was called; sometimes used to signify the lace or point itself, as in the military costume of the present day. Also the ornament of a cap or bonnet of the sixteenth century.

"A doblet of white tylsent cut upon cloth of gold embraudered, with hose to the same and clasps and anglets of golde, delivered to the Duke of Buckingham." (Harleian MS. No. 2284: Wardrobe Inventory, 8th Henry VIII. 1517.) "Item, a millen bonnet dressed with agletts, 11s." (Roll of Provisions for the Marriage of the daughter of Sir John Nevil, temp. Henry VIII.: Archæol. vol. xxvii. p. 87.) "*Aglet* of a lace or point *fer*." (Palsgrave, 'Eclaircissements.') "*Aglet, Aygulet:* a little plate of any metal was called an aglet."—Halliwell *in voce*. "A spangle: the gold or silver tinsel ornamenting the dress of a showman or rope dancer." (Hartshorne, Salop. Antiq., p. 300.)

Aygulet.
"Which all above besprinkled was throughout
With golden aygulets that glistend bright."
Spenser's *Faery Queen*, ii. 3, 16.

Aglottes.
"Two dozen poyntys of cheverelle
The aglottes of sylver fyne."
Council of the Jews—Coventry Mysteries, p. 241.

The aglets or tags were sometimes cut into the shape of little images, whence the term "aglet-baby" is applied to a very diminutive person by Shakespeare: 'Taming of the Shrew,' act i. s. 2.

Aiguillette. A lace, strap, thong, or point, used during the Middle Ages for fastening pieces of plate armour, and also for connecting various portions of the civil dress, such as sleeves, hose, doublets, &c. "Pour six livres de soye de plusieurs couleurs pour faire les tissus et *aiguillettes* ausdits harnois." (Account of Etienne de la Fontaine, Argentier du Roi, fait en 1352.) "Item. Store of dozen

of armynge poyntes, sum w^t. gylt naighletts," i.e. aglets or tags. (The Apparel for the Field, MS. Coll. Arms, L. 8, p. 86^b.)

In the 'History of Charles VI.,' by Jean le Fevre, Seigneur de St. Remy, the English men-at-arms are described preparing for the battle of Agincourt by replacing their "aiguillettes"; and in a note on that passage by Sir S. R. Meyrick, he says, "In the time of Henry V. the fronts of the shoulders, a wound received in which renders a man *hors de combat*, were protected by circular plates called

Points with Aglets, drawing together a slashed sleeve. From a print of 1650.

'palettes,' and these were attached by straps or points as they were called, with tags or aiguillettes at the end. The word here implies the whole fastening. The elbows were sometimes similarly protected. An illumination in Lydgate's 'Pilgrim' (Harleian MS., Brit. Mus., No. 4826) exhibits the Earl of Salisbury with palettes in which the aiguillettes are very conspicuous." (Nicolas, 'Hist. of the Battle of Agincourt,' notes, p. 114. See Plate II. fig. 4 of this work for the example alluded to, and fig. 3 for a specimen of the fastening of the elbow-pieces, from a curious painting of the fifteenth century at Hampton Court; see also under AILETTES.) The accompanying woodcut, from a print, 1650, exhibits their application in the civil costume of that period. The term *aiguillette* is also applied to a shoulder-knot worn during the last two centuries by soldiers and livery servants. In the English army an aiguillette is the distinction of field-marshals, aides-de-camp to the sovereign, and the officers of the Life Guards and Royal Horse Guards, Blue. It is of gold and worn on the right shoulder under the epaulette. Non-commissioned officers of the Household Brigade of Cavalry wear an aiguillette on the left shoulder, not by regulation order, but by permission of Gold Stick.

AILETTES, ALETES. (French, *ailettes*.) Defensive ornaments of various shapes and materials, worn by armed knights on their shoulders (whence their names, *ailettes*, little wings), and introduced towards the close of the thirteenth century. They continued in fashion till about the middle of the reign of Edward III. They were generally emblazoned with the armorial bearings of the wearer, or simply with the cross of St. George, and therefore sometimes called *gonfanons*, from their resemblance to a small flag or banner. They are to be seen square, round, pentagonal, and shield shaped, and in one instance they appear as small crosses patée. (See Plate II. fig. 8.) Their use appears to have been the protection of the neck, like the later pass-guard; and in the specimens presented to us in paintings and sculptures, "We see them," remarks Sir S. R. Meyrick, " placed sometimes in front of the shoulders, sometimes behind, and others on the sides ; whether, therefore, they were fixed in these positions or made to traverse I cannot pretend to determine, though from one appearing in front while the other is worn behind, in the pair worn by the knight in the 'Liber Astronomiæ,' a MS. in the Sloane Library, marked No. 3983, I am inclined to the latter opinion. (Archæologia, vol. xix.)

"Autre divers garnementz des armes le dit pieres avesc les *alettes* garniz et freitez de perles."— (Inventory of the effects of Piers de Gaveston, taken A.D. 1313: Rymer's Fœdera, vol. ii. p. 31.) " iii paire de Alettes des armes le Comte de Hereford." (Inventory of the Effects of Humphrey de Bohun, Earl of Hereford, A.D. 1319 : Duchy of Lancaster Office.)

In a roll of purchases made for a tournament at Windsor, 6th of Edward I., A.D. 1278, we find " I. par Alett," and " XXXVIII. par Alettañ." (Archæologia, vol. xvii. p. 217.) These were formed of leather lined and covered with cloth, called *carda*, and attached to the shoulders by laces of silk. Mr. T. H. Turner, who alludes to this in the eighth number of the 'Archæological Journal of the Institute,' seems to have overlooked the fact that the whole of the armour for this tournament was made of gilt leather, being a mere May game, and, therefore, no authority for the ailettes worn with real armour. It is unfortunate that the Inventory of the Earl of Hereford's effects, quoted above, has not supplied us with the desired information. While left to conjecture, it appears to me most probable that the ailettes worn in battle were made either of steel plates, the intermixture of which with mail was then commencing, or of *cuir bouilli*, that celebrated preparation of leather so variously used in the composition of defensive armour. An effigy of one of the Pembridge family, in Clehongre Church, Herefordshire, presents us with ailettes fastened by arming points. (See Plate II. figs. 1 and 2.) The

AIGUILLETTE.

1

2

3

4

From the Effigy of a Knight of the Pembridge family in Clehongre Church, Herefordshire. Temp. Ed. II.

From a figure of St George in a painting at Hampton Court. Ann. 1482.

From an Illumination in Lydgate's Pilgrim, Harl. MS. 4826.

AILETTE.

5

6

7

From Sloane MSS. 3983. 13th cent.

Sir Geoffrey Louterell. From the Louterell Psalter. Temp. Ed. III.

From Royal MSS. 16 G. 6.

8

9

10

From Royal MSS. 2 A. 22.

From an Ivory Carving.

From the brass of a Septvans, Chartham, Kent.

means by which they were generally affixed to the shoulders cannot be ascertained from the other examples.

ALAMODE. (French, *à la mode.*) A silk resembling lutestring, mentioned in the fourth year of the reign of Philip and Mary. (Act for the Better Encouragement of the Silk Trade in England. Ruffhead, vol. ii. p. 567.)

ALBE, AWBE. (Latin, *alba.*) A shirt or white linen garment reaching to the heels (whence its names, alba, telaris, &c.), and folded round the loins by a girdle, formerly the common dress of the Roman Catholic clergy ; but now used only in sacred functions. The second vestment put on by the priest when preparing for the celebration of mass. (See AMICE.) The choristers were called "albæ infantes," from their wearing this dress, "quorum vestes propriæ alba est." (Ducange *in voce.*)

"The Albe," says Mr. Pugin, "is the origin of all surplices, and even rochets, as worn by the bishops, the use of which is by no means so ancient as that of the former." It was sometimes richly embroidered, and even jewelled round the bottom edge and the wrists, from the tenth to the sixteenth century. Another mode of decoration is observed, consisting of oblong or quadrangular pieces of embroidery, varying from twenty inches by nine to nine inches by six from the bottom of the Albe, and from six inches by four to three inches for the wrist. These pieces were called the "apparel" or "parure" of the albe, and were taken off when it required washing. "For washing of an awbe and an amyce parteying [appertaining] to the vestments of the garters and flour de lice, and in sewing on the 'parells of the same, v^d." (St. Peter's Church, Sandwich : Boy's 'Collection,' p. 364.) The albe used by St. Thomas à Becket, when an exile from England, is still preserved, with his mitre and other portions of his episcopal robes, in the cathedral church of Sens. It is ornamented with purple and gold apparels of a quadrangular form.

Albe. From Pugin's 'Ecclesiastica Costume.'

In the English Church albes of various colours were introduced, although the vestment still retained its original name. Silk albes were also worn in the Middle Ages. In Gunton's 'History of the Church of St. John the Baptist, Peterborough,' there is a list of albes in which mention is made of twenty-seven red albes for Passion Week, forty blue albes of different sorts, fourteen green albes with counterfeit cloth of gold, four albes called "yerial white," seven albes called "yerial black." Mr. Pugin observes, "This is the most curious list of albes I have met with, and is one of the many proofs of coloured albes in the English Church, but I have not found any document which mentions the practice on the Continent." (Glossary of Ecclesiastical Costume and Ornament, p. 3.) In Picart's 'Cérémonies Religeuses,' vol. ii., plate of the 'Processions des Rameaux,' the clergy are represented in apparelled albes and the acolytes in plain ; and in his following plate, 'Procession of the Fête Dieu,' is shown the fashion introduced about that period, 1723, of edging the albe with narrow lace. (*Vide* Pugin, *ut supra,* for an elaborate article on the albe ; Ducange *in* Alba, Alba parata, &c. See also APPAREL.)

ALCATO. A collar or gorget, mentioned by Matthew Paris as worn by the Crusaders in the thirteenth century. (See GORGET.)

ALENÇON. See LACE (POINT).

ALLECRET, HALECRET, HALLECRET. A name given to a particular sort of plate armour worn by the French light cavalry and the German and Swiss infantry, *circa* 1535. Sir S. R. Meyrick says the term signified "all strength," and he applies it to a particular breast and backplate in the armoury at Goodrich Court with the Nuremberg stamp on it, and engraved in Skelton's 'Illustrations,' vol. i. p. xxv. For this opinion there is, however, no foundation, and it is apparently

contradicted by the allusions to it in contemporary documents. Père Daniel gives a different description of it : " Le *halecret* étoit une espèce de corselet de deux pièces, une devant et une derrière. Il étoit *plus leger* que la cuirasse." And in the ' Ordonnances ' of Francis I., the French chevaux legers are required to be "armez de hausecou, de *hallecret* avec les tassettes jusque au dessous du genoul," &c. (Histoire de la Milice Françoise, tome v. p. 397, ed. 1721 ; Guillaume de Bellay, Discipline Militaire, liv. i. f. 29.) I consider Daniel's description to be most correct, and that it was a species of gorget with a back-piece (see GORGET), deriving its name from the German word "Hals," the neck or throat, which it specially protected. Mr. Hewitt (' Ancient Armour and Weapons in Europe,' vol. iii. p. 599) simply calls it a corslet without further observation. Demmin, ' History of Arms and Armour,' calls it decidedly a gorget, but gives also *Halberkrebs* as the German name for the *lower* part of plate armour with the long cuisses of the end of the sixteenth and beginning of the seventeenth century, which appears to answer to the " Hallecret avec les tassettes jusque au dessous du genoul " of the time of Francis I. " Hallecret" is suspiciously like a French corruption of " Halberkrebs."

ALLEJAH. In an advertisement of clothes for sale in 1712 appears, amongst other articles of ladies' dress, an " Allejah petticoat, striped with green, gold, and white." No conjecture can be indulged in as to the origin of the name, which, as I have not met with it in any other document, may be a typographical error. Another unexplained name is given in the same advertisement to both gowns and petticoats of very costly materials. (See ATLAS.)

ALMAIN RIVETS. Sliding or movable rivets, invented about the middle of the fifteenth century by the Germans, and giving their name to the complete suits of armour, " so called because they be rivetted or buckled after the old Alman fashion." (Minshew.)

Grose quotes an indenture between Master Thomas Wooley and John Dance, Gent., in the fourth

Almain Rivets. From the Meyrick Collection.

year of Henry VIII., on the one part, and Guido Portavarii, merchant of Florence, on the other part, whereby he covenants to furnish two thousand complete harnesses, " called Alemain Rivetts, accounting always among them a salet, a gorget, a breastplate, a back-plate, and a payre of splints, for every complete harness." (Military Antiquities, vol. ii. p. 51.)

" Almane *belett*," evidently a mistake of the copyist or the printer, is mentioned as armour in an account of Norham Castle, temp. Henry VIII. (Archæologia, vol. xvii. p. 204.)

Almond (for Almaine) rivett. In an inventory taken in 1603, at Hargrave Hall, Suffolk : " Item, one odd back for an *almond* rivett."

ALNER. See AULMONIERE.

AMESS, AMMIS, AUMUSES. (Latin, *almecia, almucium ;* German, *Mutze,* a cap; old French, *musser ;* Provençal and Catal., *almuser :* Ducange, edit. 1840.) A canonical vestment lined with fur, that served to cover the head and shoulders, perfectly distinct from the *amice.* (Way, in Prompt. Parv.) Also a cowl or capuchon worn by the laity of both sexes.

" Ammys for a Channon, Aumusse." (Palsgrave.) " Grey fur was generally used." (Halliwell.)

> " Those words his grace did say
> Of an *ammus gray.*"
>
> Skelton's Works, vol. xi. p. 84.

So also Milton has :

> " Morning fair
> Came forth with pilgrim steps in *amice grey.*"
>
> *Paradise Regained*, book iv. line 426.

It was worn by the monks "ut almutiis de panno nigro vel pelibus caputiorum loco uterentur" (Clemens V. P. P. in Concilio Viennensi statuit) and formed a portion of the Royal, Imperial, and Pontifical habit. "Or issirent-ils de Paris et encontra le Roy, l'Empereur son oncle assez pres de la Chapelle. A leur assemblée l'Empereur osta *l'aumusse* et chaperon tout juz." (Chron. Hand., cap. 103.) "Ubi Imperator sedens deposita *almucia*." (Ceremon. Romanum, lib. i. sec. 5.) "Pour 24 dos de Gris a fourrer *aumuces pour le Roy*." (Comptes d'Etienne de la Fontaine, Argentier du Roi. Anno 1351. Cap des Pennes.) Little aumuses, *almucelles*, are mentioned in the will of Ramirez, King of Aragon, A.D. 1099.

Aumuse. From an old brass.

The aumuse was likewise worn by females, as in the accounts of Etienne de la Fontaine before quoted there is the entry following : "Pour fourrer une bracerole et une *aumuse* pour la dite Madame Ysabel." In Bonnard's 'Collection of Costumes,' Pope Sixtus IV. is represented wearing a scarlet "aumusse doublée de hermines que les Papes portent encore de nos jours." (Plate I. vol. i. p. 10.) Plate 83 in the same volume presents us with a canon wearing the Aumuse, from an effigy of the date 1368. It is of black cloth, lined with fur, and so coloured on the authority of Père Bonami, corresponding with the "almutiis de panno nigro," mentioned above. (See wood-cut). Though peculiarly a canonical vestment, it is evident therefore from the above quotations that it was worn by both sexes and all classes.

Mr. Pugin defines it as " a hood of fur worn by canons, intended as a defence against the cold whilst reciting the divine office," and adds, " it is found in brasses, the points coming down in front, something like a stole. In this respect it was worn somewhat differently from the present mode of wearing it on the Continent. The usual colour was grey ; but for the cathedral chapter, white ermine ; in some few cases, where the bishop was a temporal prince, spotted, the tails of the ermine being sewn round the edge." (Glossary of Ecclesiastical Costume.)

Canon with Aumuse. 1368.

I believe the points that are seen hanging in front, like a stole, are portions of a distinct article of attire, called the tippet, and worn under the aumuse.

AMICE, AMYCE, AMYTE. (Latin, *amictus*.) The first of the sacerdotal vestments. "Primum ex sex indumentis Episcopo et Presbyteris communibus sunt autem illa *Amictus*, Alba, Cingulum, Stola, Manipulus, et Planeta." (Ducange, Innoc. III. P. P. lib. i. de Myster. : Missæ, cap. 10.)

" A fine piece of linen of an oblong-square form, which was formerly worn on the head until the priest arrived before the altar, and then thrown back upon the shoulders." (Way, in Prompt. Parv. p. 11.) It was sometimes richly ornamented as well as the Albe, "and in ancient representations appears," says Mr. Way, "like a standing collar round the neck of the priest." "Une aube et une amit parés de vi ymages en champagne d'or." (Invent. MS. Reliquar. etc. Eccles. Camerac. *sub anno* 1371.

"Upon his hede the amyte first he laieth."
Lydgate, MS. Lambeth Lib.—*Vide* Halliwell *in voce*.

Embroidered or apparelled amices were generally used in the English Church previous to the reign of Edward VI. The apparels were sewed on to the amices, and, when there, were fastened round the neck ; they formed the collar which is invariably represented on the effigies of ecclesiastics. When the amice was pulled up over the head, the apparel appeared like a phylactery. (Pugin's ' Glossary of Ecclesastical Costume.')

In the plate representing the Procession of Palms, in Picart's 'Cérémonies Religieuses,' vol. ii., the officiating clergy are figured wearing apparelled amices on their heads.

Amice. From Pugin's 'Glossary of Ecclesiastical Costume,' and Picard, Cérém. Rel.

ANADEME. A diadem or fillet, wreath, chaplet, or garland.

"Upon his head
An *anademe* of laurel fronted well
The sign Aquarius."
Ben Jonson's *Masque of Beauty.*

"And for their nymphals, building amorous bowers,
Oft dressed this tree with *Anademes* of flowers."
Drayton's *Owl.*

"A band to tie up wounds" is called by Minshew an "anadesm."

ANAPES, FUSTIAN ANAPES. "Mock velvet, or fustian anapes." (Cotgrave.) A species of fine fustian, probably made at Naples, *à Naples,* as we have now a silk called "gros de Naples." Fustian anapes is mentioned in 'The strange Man telling Fortunes to Englishmen,' 1662. "This," remarks Mr. Halliwell, "is, of course, the proper reading in Middleton's Works, iv. 425 : 'Set a fire my fustian an ape's breeches.'"

ANDREA FERRARA. See SWORD.

ANELACE. (Also in French, *alenas, alinlaz, analasse, anlace.*) A broad knife or dagger worn at the girdle. "Genus cultelli quod vulgariter Anelacius dicitur." (Matthew Paris, p. 274, and in many other passages.)

"An anelace and a gipeciere all of silke
Hung at his girdle white as morwe milke."
Chaucer, *Canterbury Tales.*

"Or alnilaz and god long knif."
Havelock the Dane, line 2554.

Brass to a Merchant, name unknown, in Northleach Church (showing Anelace). 14th century.

The termination *laz* is said to signify *latus,* a side, the waist. "Germanis laz olim latus significabat ; hinc Anelacius, Schiltero, est telum ad laterale : Seitengunches. Adel. (Ducange, ed. 1840.) Sir S. R. Meyrick says, "An anelace or anelacio, probably so called from having originally been worn in a ring ;" or rather, appended to one at the girdle, as the form of the blade would not admit its being worn *in* a ring.

In Skelton's 'Engraved Specimens,' Plate LXII., are

Anelaces. 15th century.

five anelaces, the earliest in point of date being of the time of Edward IV. Its mention by Matthew Paris, however, shows that it was a well-known weapon in the thirteenth century, and we have examples in monumental brasses and sculpture of the thirteenth and fourteenth centuries of what are supposed to be anelaces, though differing in form from those of later

date. Our examples are from a brass in Northleach Church, of the fourteenth century, and specimens from Demmin and Skelton, *temp.* Edward IV. and Henry VII.

ANGLETERRE, POINT OF. See LACE.

ANLET. "An annulet or small ring." (Yorkshire : Halliwell, *in voce.*)

In 'The Device for the Coronation of Henry VII.,' published by the Camden Society, in the volume of 'Rutland Papers,' the queen is directed to wear "a kirtell of white damask daie (raie ?) cloth of gold, furred with mynever, pure, garnished with *anletts* of gold," which the editor considers to mean agletts or tags. (See under AGLET.)

APPAREL. This word is used not only for general dress, but to specify the embroidered borders of ecclesiastical vestments. (See under ALBE and AMICE.)

APRON, APORNE, NAPRON. (From *nappe*, cloth, French ; or, according to some, from Saxon æponæn.) The barm-rægl or barm-cloth of the Anglo-Saxons, from barm, the lap or bosom.

Apparel. From a brass, temp. Edward III., in Wensley Church, Yorkshire.

The leathern apron worn by smiths, &c., is seen in an illumination of the time of Edward II., Sloane MS. 3983. It is called barm-*skin* in Northumberland, and in Lincolnshire they have a proverb, "As dirty and greasy as a barm-skin." The term barm-feleys for the same article occurs in a curious poem in 'Reliq. Antiq.' i. 240 ; Halliwell.

> "A barm cloth as white as morrow milke
> Upon her lendes, full of many a gore."
> Chaucer, *Canterbury Tales.*

Waiters, from wearing an apron, were called apron-men and aperners.

> "It was our pleasure, as we answered the apron-man."
> Rowley's *Search for Money*, 1609.

> "Where's this aperner ?"
> Chapman's *May Day*, 1611.

From the useful garment of the housewife, domestic, and artisan, the apron became, towards the end of the sixteenth century, a portion of the dress of a fashionable lady.

> "These aprons white of finest thrid,
> So choicely tide, so dearly bought,
> So finely fringed, so nicely spred,
> So quaintlie cut, so richlie wrought ;
> Were they in worke to save their cotes,
> They need not cost so many grotes."
> Stephen Gosson's *Pleasant Quippes for upstart new-fangled Gentlewomen*, 1596.

Leathern Apron. From Sloane MS. 3983. 13th century.

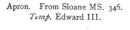

Apron. From Sloane MS. 346. *Temp.* Edward III.

In Massinger's 'City Madam,' 1659, we hear of young ladies wearing "*green* aprons," which they are ordered to "tear off," being no longer fashionable.

In 1753 the lady is directed to "pull off" her "lawn apron with flounces in rows." ('Receipt for Modern Dress.')

In 1744 aprons were worn so long that they almost touched the ground. They were next shortened, and lengthened again before 1752, as a lady is made to exclaim, in the 'Gray's Inn Journal' of that date (No. 7), that "Short aprons are coming into fashion again." (See 'General History.')

ARBALEST, ARBLAST, ALBLAST. (*Arcubalista,* Latin ; *arbaleste, ballestre,* French ; *Armbrust, Hebelarmbrust,* German). A cross-bow.

> "Shoot to them with arblast,
> The tailed dogs for to aghast."
> *Richard Cœur de Lion,* l. 1867.

> "Both alblast and many a bow
> War redy railed upon a row."
> Minot's *Poems,* p. 16.

"The cross-bow," says Sir S. R. Meyrick, "was an invention of the Roman Empire in the East, suggested by the more ancient military engines used in besieging fortresses : hence its name Arcubalist or Arbalist, compounded of Latin and Greek words. It was introduced into England at the Norman Conquest, but Richard Cœur de Lion is said first to have brought it into general fashion." (Skelton's 'Engraved Specimens,' vol. ii.)

Guiart says the French received them from Richard I., about the year 1191, and remarks :

> "Nul ne savoit riens d'arbalaste,
> Et temps dont je faiz remembrance
> En tout le Royaume de France."
> *Branches des Royaux.*—Chron. Nat. vii. 49, l. 616.

Guillaume le Breton supports this assertion by stating, that in the early part of the reign of Philip Augustus there was not a person in the French army who knew how to use an arblast :

> "Francigenis nostris illis ignota diebus
> Res erat omnino quid ballistarius arcus,
> Quid ballista foret, nec habebat in agmine toto
> Rex, quemquam sciret armis qui talibus uti."—*Philip,* l. 2.

And, speaking of the death of Richard Cœur de Lion, who was mortally wounded by a shot from a cross-bow, he says :

> "Hac volo non alia Richardum morte perire,
> Ut qui Francigenis ballistæ primitus usum,
> Tradidit ipse sui rem primitus experiatur,
> Quamque alios docuit, in se visu sentiat artis."

The Sieur de Caseneuve and Père Daniel have shown, however, that Richard and Philip Augustus only revived the use of the arblast, which had been prohibited by the Twenty-ninth Canon of the Second Council of Lateran, held in 1139, during the reign of Louis le Jeune in France and Stephen in England. "Artem illam mortiferam et Deo odibilem Ballistariorum et Sagittariorum adversus Christianos et Catholicos exerceri de cætero *sub anathemate prohibemus*"—a curious fact in the history of arms, and which caused the death of Richard by the weapon he had re-introduced in defiance of the injunction to be considered as an especial judgment of God.* That the cross-bow was used for the chase in Normandy and England in the eleventh century has been stated on the authority of Wace, who tells us that William (the Conqueror) was in his park at Rouen when he received the news of the death of Edward the Confessor, and that he had just strung his bow and charged it, and given it to a varlet to hold for him. But Wace uses the word *arc,* and not arbalète or arblast :

> "Entre ses mainz teneit un arc
> Encordé l'aveit é tendu
> Et entésé é desentu."

and it is open to the doubt whether this was a long-bow. Certainly no cross-bow is seen in the Bayeux Tapestry. Also, on the day William Rufus was slain in the New Forest, his brother Henry, who was hunting in a different part of it, found the string of his bow broken, and, taking it to a "vilain" to be mended, met with an old woman there, who told him he would soon be king. Wace, who relates this anecdote, says :

> "Mais de son arc quant fu tenduz
> Fu un cordon de l'arc rompu"—

* *Vide* 'Histoire de la Milice Françoise,' tome i. liv. iv. p. 425.

"But when his bow was bent, *a* string of it was broken," which would imply that the bow had more than one string, and, therefore, prove it to be a cross-bow, of the kind used for hunting, and called prodd, which had two.

In Domesday Book mention is made of Odo the Arbalister, as a tenant in capite of the king of land in Yorkshire; and the manor of Worstead, Norfolk, was, at the time of the Survey, held of the Abbot of St. Benet at Holme by Robert the Cross-bowman. The arblast had

Arbalestiers. From Roy. MS. 14, E. iv.

Arbalest, with Moulinet or Windlass, bending it.

what is called a "stirrup" at the end of the stock, into which the foot was put in the act of stretching it. "Balista duplici tensa pede missa sagitta."—Guillaume le Breton. (Balista grossa ad Stephani Twini Balasterii or Arbalete à tour.) It was wound up by a portable apparatus called a *moulinet, cranequin,* or windlass ("balista grossa de molinelles") carried at the girdle. This form of arblast was used in battle to the middle of the fifteenth century, by the Genoese especially. In our illustration from a MS. of the reign of Edward IV., the two first archers are represented winding the bow. The third is drawing an arrow from his quiver, his foot being still in the stirrup, and the fourth is shooting. The smaller cross-bow was bent by means of an instrument called a "goat's-foot" lever (*Geisfuss,* German). (See also under LATCH and PRODD.)

ARGENTAN. Vide LACE (POINT).

ARISAD, AIRISARD. A long robe or tunic girdled round the waist, worn by females in Scotland as late as 1740. ('Poems,' by Alexander McDonald.) Martin describes it as a white plaid, having a few small stripes of black, blue, and red, plaited all round, and fastened beneath the breast with a belt of leather and silver mixed like a chain.

ARMESIN TAFFETA. "A kind of taffeta mentioned by Howel in his 25th section." (Halliwell, *in voce.*) "Armoisin ou armosin: sorte de taffetas faible et peu lustre." (Landais, Dict. Générale. See TAFFETA.)

ARMET. A form of helmet worn in the latter half of the fifteenth century. In the 'Mémoires de J. Duclercq,' it is stated that, at the entry of Charles VII. of France into Rouen, the Count de St. Pol had a page, "qui portoit un *armet* en sa teste de fin or richement ouvré." (Tome i. p. 349; Bruxelles, 1823.)

Claude Fauchet and La Colombierre use the terms armet and salade indifferently; but Guillaume de Bellay, or, at least, the author of the work attributed to him, makes a remarkable distinction between them in his description of the men-at-arms, who, according to the 'Ordonnances' of Francis I., he says, should wear the "armet avec ses bavières," whilst the chevaux legers should be armed "d'une salade forte et bien coupée à vue coupée."—(Discipl. Militaire, l. 1, fol. 29. *Vide* also Père Daniel, Hist. de la Milice Franç. vol. i. p. 397, edit. 1721; and Allou, 'Études sur les Casques du

Moyen Age,' p. 48.) Palsgrave has merely, "Armet, a head pese of harnesse," (f. 18.) In Sir S. R. Meyrick's Collection was a helmet, dated 1558, brought from the Château de Brie, which belonged to the Dukes of Longueville. It is thus described in Skelton's 'Engraved Specimens,' Plate XXIX. : "Fig. 1.—The armet grand et petit, so called from being capable of assuming either character, seen in profile. The wire which appears above the umbril is to hold the triple-barred face-guard." "Fig. 2. —The same viewed in front with the oreillettes closed ; but the beaver removed so as to render it an 'armet petit.' "

Armet. From the Meyrick Collection.

I give these figures here, as I am by no means prepared to deny that this helmet may be of the kind included in the word "armet," though others are of opinion that the distinguishing feature of the armet was its opening at the back.

Demmin calls it the most complete form of helmet, and classes it with the casque. It is almost impossible to decide from mere description, but I believe the term "armet" to have been given to the earliest kind of close helmet which began to be adopted towards the end of the fifteenth century ; indeed, to be the French and Italian word for helmet itself, which is but the diminutive of helm, and is not met with before that period. The ponderous helm (heaume) had been for some time past only used for the tournament, and the visored bascinet, only worn in battle. The next improvement was a combination of these, and the production of a complete head-piece, which received from the Italians the name of *elmetto* or *armetto*, the little helm ; *Anglicè*, helmet, or armet ; "Armet, petit heaume," French. The word eventually was applied generally to any head-piece. One armet in the Meyrick Collection had a round plate at the back ; and in the curious painting by Uccello in the National Gallery, said (but incorrectly, as I believe,) to represent the battle of St. Egidio, in 1417, several of the knights are depicted with head-pieces exhibiting

Armets. From battle piece by Uccello : National Gallery.

this peculiarity. Another painting, at Hampton Court, ' The meeting of Francis I. and Henry VIII. of England in the Vale of Ardres,' presents us with several instances, but none that illustrates its use. It is presumed, however, its object was to prevent the point of a lance entering where the helmet opened behind.

ARMILAUSA, ARMIL, ARMYLL. "A body garment, the prototype of the surcoat." (Meyrick.) The Emperor Maurice in his 'Strategies' calls the short military tunics which reached only to the knees, 'Αρμελαύσια, and tells us they were put on over the armour. Isidorus derives the word from *armiclausa* : "Armelausa vulgo vocata quod ante et retro divisa, atque aperta est ; in armos tantum clausa quasi armiclausa." (Origin. liber xix. cap. 22.) Wachter and other German authorities derive it from words expressive of a tunic without sleeves : " Non manicata, absque manicis, a *los*, destitutus ;" "Tunica serica sine manicis ;" "Armel-laus significare potuit sine brachiis ;" while, on the other hand, Schiller suggests, "Aermellatz : ein latz mit aermeln,"—a waistcoat *with* sleeves !

In 'The Device of the Coronacion of King Henry VII.,' we read : "The King then, gird with his sword and standing, shall take the *armyll* of the Cardinall, saying these words : 'Accipe armillam' [' Accipite armulam' in the MS.] ; and it is to wete that armyll is made in maner of a stole, wovyn with

gold and set with stones, to be putt by the Cardinall aboute the Kinges necke, and commyng from both shudres to the Kinges both elbowes, wher it shall be fastened by the said Abbot with laces of silke on evry elbowe, in twoo places, that is to saye, above the elbowes and bynath." ('Rutland Papers,' Camden Society, page 18.) Camden says, quoting the 'Book of Worcester,' that in 1372 they first began "to wanton it in a new round curtall weed, which they called a cloak, and in Latin, armilausa, as only covering the shoulders." (Remaines, p. 195.) This description corresponds with that of the armyll which came "from both shoulders to the king's both elbows," and a cloak so formed may be seen in illuminations about that date; but it certainly cannot be said to be made "in manner of a stole." (See STOLE.) Nor could it be conveniently fastened with laces of silk both above and beneath the elbows. It is very probable that in this, as in many other instances, the same name has been at various periods bestowed on widely differing garments. Mr. Taylor, in his 'Glory of Regality,' p. 81, uses some very ingenious arguments to prove that the armyll in our coronation ceremony is an error arising from a confusion of the stole with the bracelets—*armillæ*. The word, at all events, occurs in English costume as early as the time of the Anglo-Saxons. In a deed of Ethelbert we find, "Armilasia oloserica camisiames ornatam prædicto Monasterio garanter obtuli." (Dugdale, 'Monasticon.') And as it is expressly said to have been put on after the king has been girt with the sword, it must have been open at each side, and resembled, not the stole, but the dalmatic or the tabard, the latter of which, particularly, might be described as having and not

Armilausa. From Roy MS. 20, A 2. 14th century.

having sleeves in the usual acceptation of the word. The accompanying figure, from an illumination in a MS. in the Royal Collection, is supposed to represent one form of the armilausa as described by Camden, but not "ante et retro divisa," according to Isidorus.

ARMILLA. See BRACELET.

ARMING DOUBLET. A loose doublet with sleeves, worn over the armour in the fifteenth and sixteenth centuries. Sir John Paston, 3rd June, 1473, 13th of Edward IV., writes: "Item, I pray you to sende me a new vestment off wyght damaske for a dekyn (deacon), which is among myn other geer at Norwich. I will make an armyng doublet of it." (Paston Letters.) In explanation of this curious message, it is to be observed, that *white* was the field of the Paston arms, and that the word "arming" was used in the sense of coat armour is apparent from the lines of Drayton:

> "When the Lord Beaumont, who their *armings* knew,
> Their present peril to brave Suffolk shewe."
>
> *Poems*, p. 63.

"First. 2 Armynge Doublets." (Th' Apparell for the Feld, &c., MS. L. 8, Coll. of Arms, fol. 85.) "An Armyng Doublet of crimson and yellow satin, embroidered with scallop shells, and formed down with threads of Venice gold." (Inventory, 33rd of Henry VIII. 1542; Harleian MS. No. 1419.) "Item, That every man have an Arming Doublette of fustian or chanvas." (Order of the Duke of Norfolk, 36th Henry VIII.; MS. Coll. Arms, W. S.)

ARMING GIRDLE. The belt which carried the arming sword or estoc. (*Vide* ARMING SWORD.) Cotgrave renders "Ceinture à crouppière: a belt, *arming girdle*, or sword girdle of the old fashion." (*Vide* also Florio *in* Balteo.)

ARMING HOSE. In the Inventory of Henry VIII.'s Wardrobe, taken in 1542, before quoted, we find, "a paire of arming hoze of purple and white satten, formed down with threads of Venice silver." (Harleian MS. No. 1419.) I presume these to have been trunk hose, worn only under tassets which would not entirely conceal them. (See ARMOUR.)

ARMING POINTS. See under AIGUILLETTE and AILETTES.

ARMING SPURS. "Item, 2 pere of Armyng Spores." ('Th' Apparell for the Feld.')

ARMING SWORD. A small sword, called in French *estoc*. It was worn naked, passed through a ring suspended from the belt on the left side, when a man was armed to fight on foot ; but when on horseback the weapon hung on the left side of the saddle-bow. (S. R. Meyrick, 'Archæologia,' vol. xx.) "Item, an armynge sword." (Th' Apparell for the Feld, *ut supra*.) "Some had their armynge swordes freshly burnished." (Hall's 'Chronicles,' Henry IV. f. 11.) Sir John Paston, under date, 30th April, 1466, writes to his brother : "Sir John of Parr is your friend and mine, and I gave him a fine *arming sword* within this three days." "Armynge swordes with vellet (velvet) skaberdes, xi." (Brander's MS. 'Inventory of Royal Stores,' 1st Edward VI., 1546.)

ARMINS. Cloth or velvet coverings of the staves of halberds, pikes, &c., sometimes ornamented with fringes and gilt-headed nails. "You had then armins for your pikes, which have a graceful shew, for many of them were of velvet embroidered with gold, and served for fastness when the hand sweat : now I see none, and some inconveniences are found by them." (Art of Training, 12mo. 1622.)

ARMOUR. This familiar word is generally associated with the idea of metal ; but there were many varieties of defensive military equipment with which metal had little or nothing to do, the principal, and perhaps the earliest, being formed of leather, and surviving the abandonment of plate armour shortly after the commencement of the eighteenth century. These varieties, as well as the particular portions of the metal armour of the Middle Ages, will be found separately noticed under their several heads in the 'Dictionary,' and comprehensively in the 'General History' preceding it. I shall, therefore, in this place speak only of armour as popularly understood, and the principal features which distinguished it from the eleventh to the eighteenth century.

The metal armour of the Normans and Anglo-Saxons consisted of a tunic of what is commonly called "mail," composed in the earlier instances of iron rings firmly sewn flat upon a strong foundation of cloth or leather, and subsequently interlinked one with the other, so as to form a garment of themselves, known by the name of "chain mail." Coexistent with these were several sorts of mail to which Sir S. R. Meyrick gave the names of "tegulated," "trellised," "mascled," "banded," &c., scale mail being

Cotton. MS. B. IV.

already recognised by antiquaries in the "lorica squamata" of the Romans. Cavillers have objected to these designations, and maintained that the differences visible in representations of the armour of that day were only attributable to the manner in which the several artists indicated ring or chain armour. Subsequent study and experience have established the truth of Meyrick's observations, and no better nomenclature has yet been proposed for their definition. Their peculiarities will be minutely illustrated under the head of MAIL.

The Anglo-Saxon MSS. furnish us with numerous examples of the ring mail. Here is one from the Cottonian MS., marked B. IV., Brit. Mus., of the close of the tenth or beginning of the eleventh century. The subject is Abraham rescuing his nephew Lot ; and the Anglo-

Norman Armour. From the Bayeux Tapestry.

Saxon illuminator, as customary, has represented the Hebrew patriarch in the military habit of his

William, Duke of Normandy. From the Bayeux Tapestry.

own period. The Bayeux Tapestry presents us with specimens of nearly every other variety. Our cut, taken from that valuable relic, shows the ringed, the mascled, the tegulated, and the trellised varieties. The legs were undefended, save by bandages of cloth or leather crossing each other over the chausses or hose, and reminding us of the pattern of the Scotch stockings of the present day, which we might fancy perpetuated the fashion. The helmet was sharply conical, with a nose-guard, to which the collar of the mail hood was occasionally hooked up the better to protect the face. The shield of the Saxons was ordinarily round, with a boss or spike in the centre, but in the Bayeux Tapestry some of the chiefs are represented with long kite-shaped shields like those of the Normans, which the latter appear to have imported from Italy. The weapons in use were the sword, the lance, the javelin or dart, the bow, the war-club, and a long-handled axe peculiar to the Saxons, which is in their language called a *byl* (bill), and by Norman writers a *guisarme*, though bearing no resemblance whatever to the weapons known by those names.

At a later period additions were gradually made to the mail armour of the twelfth century till the whole body, from head to heel, and the very tips of the fingers, were encased with iron in some form or other. We have here a knight in complete mail of the kind denominated "mascled," from a psalter in the Doucean Collection now in the Bodleian Museum at Oxford; the mail protecting the legs, occasionally differing from that of the hauberk, the improvement of interlinked rings ultimately superseding all other varieties, and presenting to us the knight in a complete suit of chain, over which descended, in graceful folds, the silken cyclas or surcoat, at first plain or embroidered with gold or silver, and subsequently with his armorial bearings, and confined round the waist by a richly ornamented belt, from which depended his trusty sword. The effigies in the Temple Church, London, and the numerous sepulchral monuments, happily preserved to us in our cathedrals and parish churches, illustrate the military costume of the thirteenth century with great fidelity of detail and ornament.

From a Psalter of the 11th century.

We give two of the earliest examples ; the first from an effigy in Walkern Church, Hertfordshire,

and the other, a little later, from the Temple. The beautiful effigy of Brian Lord Fitzalan, in Bedale Church, Yorkshire (A.D. 1302), affords us a fine specimen of the sword belt above mentioned, and of

From Walkern Church.　　　From Temple Church.　　　Brian Lord Fitzalan. 1302.　　　Figure of a Despenser. Tewkesbury.

the next advance in armour, which was the addition of knee-caps, either of steel or of a preparation of leather called "cuir bouillie." The armpits were also protected by palettes or gussets of similar materials, the neck by plates of various forms affixed to the shoulders, and called, from their position, "ailettes" (little wings), and the fronts of the legs by shin-guards (bainbergs), also of steel or leather, sometimes highly ornamented. Steel skull-caps of divers shapes and names were worn over the mail hood, and the haume or helm, with or without a crest, makes its appearance. The reproduction of elbow-pieces and brassarts rapidly followed; and from the middle of the reign of Henry III. to nearly the close of that of Edward III. the period is known to antiquaries as that of "mixed armour." (See Plate II., Ailettes, and the accompanying group of knights on horseback and the figures of the De Clares, Despensers, and others in the windows of the Abbey Church of Tewkesbury, painted in the reign of Edward II.).

With the reign of Richard II. commences the third great change in the military equipment, the period of complete plate, which, varying only in the shape of particular portions, lasted till its gradual abandonment, piece by piece, during the seventeenth century. The invention of firearms in the reign of Edward IV., and the improvement of field artillery (the exact date of the introduction of which is still a contested point), led, no doubt, to the disuse of a cumbrous, complicated, and costly equipment, which no longer ensured them an adequate advantage in its defensive quality. The buff coat offered nearly as fair a resistance to the thrust of the pike or the cut of the sabre. The cuirass, though pistol-proof, was sent "into store." A gorget (not the gilt toy some of us can still remember) was worn for a few years by officers, and with that departed the last remnant of the body armour of our ancestors.

Group of Knights on Horseback. 1300–1327.

In illustration of the first half of this third period, comprising about a hundred and fifty years, the reader is referred to the engraving from a miniature in the curious MS. containing a metrical history of Richard II., in the Harleian Collection, British Museum, No. 1379, representing that unfortunate sovereign conferring the honour of knighthood on Henry of Monmouth, afterwards Henry V., the son of the man who was so soon to defeat him. The basinet with the beaked vizor, which is the marked characteristic of the reign of Richard II. and Henry IV., the ample gorget of chain, and the surcoat, are faithfully depicted.

From Harleian MS. No. 1379.

The brasses and sculptured effigies of knights of the reign of Henry V., are noticeable for the absence of any appearance of chain. The camail is superseded by a gorget of plate overlapping the upper edge of the breast-plate, to the lower part of which is appended a skirt, composed of what are called "tassets," lateral bands or plates of steel, protecting the wearer from the waist to

the mid-thigh, over which the military belt is, in some examples, seen fastened as previously over the jupon.

In the reign of Henry VI. the number of these bands is diminished, and to the lowest we find two broad plates called "tuilles," attached by straps and buckles, defending the front of the thighs. The toes of the sollerets, or steel shoes, are extravagantly long and pointed, and the shanks of the spurs are equally elongated.

The vizored basinet gives place to a head-piece called a "salade," the lower part of the face being protected by a chin-piece called a "hausse col." The jupon and military belt have also disappeared, and a loose tabard with short open sleeves, embroidered with the armorial bearings of the wearer, takes the place of the former. The breast-plate is composed of two pieces, the lower one lapping over the other, to which it is secured by a strap and buckle, and the back-plate is articulated and moulded to the form of the body with anatomical precision and exquisite taste. The coudes, or coudieres (elbow-pieces), are extremely large, some being fan-shaped, of elegant design; and the art of the armourer may fairly be said to have culminated at the close of the fifteenth century. A marked change took place during the reign of Henry VII. The armet, or close helmet, displaced the salade. Pass-guards, plates of steel rising perpendicularly upon the shoulders to ward off the thrust or blow of a weapon from the side of the neck, were introduced, a similar service having been formerly rendered by the long discarded ailettes. The breast-plate was again formed of one piece; but the lower portion was globose, and frequently fluted, as well as the whole suit; some portions being elaborately engraved. This recently invented art became thenceforth greatly resorted to for the ornamentation of every portion of armour, and to it was shortly added that of embossing, and what

Temp. Henry IV.
Brass of Robert Albyn, Hemel-
Hempstead, Herts.

Temp. Henry V.
Brass of Sir Robert Suckling,
Barsham, Suffolk.

Temp. Henry VI.
Brass of the Son of
Alderman Feld.

Temp. Edward IV.
One of the Erdington Family.
From Aston Church, Warwickshire.

is known by the name of *repoussé* work. Magnificent examples of such suits are to be seen in the Louvre and Musée d'Artillerie at Paris, the Ambrass Collection at Vienna, and the armouries of Dresden, Berlin, Florence, Madrid, and the principal cities of Europe, as well as in the cabinets of private collectors. Our own noble, but sadly neglected, armoury at the Tower is also rich in suits of this description, one of the most interesting being a present from the Emperor Maximilian to King Henry VIII., on his marriage with Catherine of Aragon. It is furnished with ample steel skirts, called "lamboys," in conformity with the fashion of the civil costumes of the period, elaborately engraved with the martyrdom of St. Catherine and other similar subjects. Armour was also made in imitation of the puffed and slashed dresses that were in vogue about the same time. The sollerets were round-toed, and in the reign of Henry VIII. became as extravagantly broad and square as they had previously been long and pointed.

Temp. Henry VII.
Sir John Crocker, Yealmpton, Devon.

Richly embossed casques of a classical form, with cheek-pieces, marked the revival of the arts, and a close helmet, called a "burgonet," was added to the head-pieces already adopted.

The breast-plate assumed various shapes during the reign of Henry VIII., which will be described under the separate head of BREAST-PLATE, and the introduction of trunk hose led to that of long tassets reaching from the waist to the knees, and rounded at the extremities. During the remainder of the sixteenth century the principal characteristic is the form of the breast-plate, which gradually assumed that of the "peasecod bellied doublet," so remarkable in the male costume of the reign of Elizabeth, and still worn during that of James I. A head-piece called the "morion" was introduced from Spain, and was generally worn by the infantry.

Armour for the legs and feet was discarded, and in its place we find leathern boots reaching above the knees, where they were met by the lengthened tassets, now terminating in steel caps firmly secured by straps and buckles. Even the latter were frequently dispensed with by officers when not actually in the field, and gradually by the cavalry.

The armour of royal and distinguished personages in the sixteenth century was of the most

Suit of Henry VIII. Presented by the Emperor Maximilian. Tower of London.

Puffed and Ribbed Armour. *Temp.* Henry VIII. Meyrick Collection.

sumptuous description. Embossing, chasing, engraving, and gilding were lavishly employed; but during the seventeenth, as I have already stated, its glory departed, and its use was gradually dispensed with. Backs and breasts and iron pots were generally worn by the infantry. Cromwell's

Demi-lancer, 1555. Meyrick Collection.

Henry Prince of Wales.

Ironsides fought in cuirasses and tassets, vambraces and pauldrons, gorgets, and triple-barred helmets, called "lobster-tailed," from the articulated flap which protected the back of the neck; the gallant

Officer of Pikemen. *Temp.* James and Charles I.

Cavaliers opposed to them frequently wearing only a gorget over the buff coat and a casque or triple-barred helmet.

I have just briefly sketched the rise and progress of armour in England from the tenth to the eighteenth century, in the early part of which it was completely abandoned; and endeavoured to point out the distinguishing features of the three great epochs into which it may be divided, viz.: 1. Mail armour. 2. Mixed mail and plate. 3. Complete plate. The first extending to the reign of Edward I.; the second to that of Richard II.; and the third to its ultimate abolition. I have spoken only of armour for the field. That for the tiltyards will be treated under its separate headings, as no distinction seems to have been made in the form of the various pieces worn in war from those used for the jousts of peace previous to the reign of Edward IV., when additional defences of the most complicated description appear to have been invented, and continued in use to the end of the reign of Elizabeth, as will be fully set forth in the 'General History,' as well as under their separate heads in the 'Dictionary.'

ARQUEBUS. See HARQUEBUSS.

ARROW. The arrows used by the early inhabitants of the British Islands were formed of reeds headed with flint or bone. The Welsh Triads celebrate Gurneth the Sharp-shooter as shooting with reed arrows ; and Abaris, the Hyperborean priest, is said by Herodotus to have carried a reed arrow with him : and though the Triads are not of the age to which they have been attributed, and the story of Abaris is apocryphal, these allusions show that reed arrows had been used in very ancient times by the Britons. The arrows of the Saxons and the Danes were headed with iron ; but both these nations appear to have used the bow for hunting or for pastime, more than for battle. (See under Bow.) Henry of Huntingdon reports William, Duke of Normandy, to have spoken of the Anglo-Saxons as a nation not having even arrows. With the Northmen archery was considered " an essential part of the education of a young man who wished to make a figure in life " (Strutt), and the shafts used by them are distinguished by the various names of arrows, bolts, bosons, piles, quarrels, standards, and vires. The arrow was the shaft of the long-bow, although occasionally shot from the arblast, or cross-bow ; but the other descriptions were appropriated to the latter alone. (See under the separate heads.)

Various Arrows for Cross-bows. From the Meyrick Collection.

Arrow-heads, from various sources.
Figs. 1 and 2, Flint; the rest Iron.

The old English arrow, "the cloth-yard shaft," or standard arrow, made famous by our gallant yeomanry of the Middle Ages, was formed of ash, asp, oak, hardbeam, or birch, headed with burnished steel, and winged with the feathers of the grey goose or the peacock, and sometimes of the swan, as well as other birds.

Roger Ascham tells us there are three essential points in the composition of an arrow : " A shaft hath three principal parts—the stell (or wand), the fethers, and the head. Stells be made of divers woodes, as brasell, Turkie woode, fustiche, sugarcheste, hardbeame, byrche, asshe, dake, servis tree, hulder, blackthorne, beeche, elder, aspe, salowe. Birche, hardbeame, dake, and ash are best, though this depends on the shooter. Sheaffe arrowes should be of ashe, and not of aspe, as they be now adayes."

The length of the arrow depended on the height of the archer. " In the true proportion of the human figure," remarks Sir S. R. Meyrick, " it is found that the distance from the tip of the middle finger of one hand to that of the other, when at the utmost extension, equals that from the crown of the head to the soles of the feet. Now, if such be the length of the bow-string, and the shaft half that size, a man of six feet high would use a cloth-yard arrow. Probably this rule was seldom, if ever, attended to ; yet, as the arrow was drawn to the ear, leaving as much beyond the bow as would reach the middle finger end, if not clasped, and the ear was brought over the centre of the chest, the result was precisely the same."

Ascham says it is better to have them "a little too short than over long; no one fashion of steele can be fit for every shooter." English arrows had forked heads and broad heads; but Ascham accounted those with round pointed heads resembling a bodkin as the best. Sheaf arrows had flat heads for short lengths, and he recommends they should have a shoulder to warn the archer when he has drawn them far enough. "The nocke of the shaft is diversely made, for some be great and full, some hansome and litle, some wyde, some rounde, some longe, some with double nockæ, whereof every one hath his propertye."

In the old ballad of 'Robin Hood' the nockes of the arrows are said to have been bound with white silk:

> "An hundred shefe of arrowes good,
> With hedes burnished full bryght,
> And every arrowe an ell longe,
> With peacocke well ydight;
> And nocked they were with white silk.
> It was a semely sight."
>
> *Geste of Robyn Hode.*

Chaucer's Squire's yeoman bore

> "A shefe of peacocke arwes bryght and kene."
>
> *Prologue to Canterbury Tales.*

In the ancient ballad of 'Chevy Chase,' we read:

> "The swan's feathers that were thereon;"

which in the more modern version is altered to

> "The grey-goose winge that was thereon."

There appears to have been some difference between "the *flight*" or "*roving* arrow," and "the *sheaf* arrow;" but in what particular is not quite clear. "A sheaf" consisted of twenty-four arrows. "Pro duodecim flecchis cum pennis de pavonæ emptis pro rege, de 12 den." (Lib. Comput. Garderobæ, *sub an.* 4 Ed. II. A.D. 1311. MS. Cott. Nero, G. viii.) An English bowman was, therefore, vauntingly said to bear four-and-twenty Scots in his girdle.

Matthew Paris mentions arrows headed with combustible matter, which were shot from bows into towns and castles, and also arrows headed with phials full of quicklime: "Missimus igitur cum spicula ignita" (p. 1090). "Et phialas plenas calce, arcubus per parva hostilia sagittarum super hostes jaculandas" (p. 1091). Mr. Demmin has given us a specimen of these, at a later period, from a drawing in the Hauslaub Library, Vienna. Arrows with wild fire and arrows for fireworks are mentioned amongst the stores at Newhaven and Berwick in the 1st of Edward VI. (Grose, Mil. Antiq. vol. ii. p. 270.) A curious particular respecting arrow-heads occurs in Swinden's 'History of Great Yarmouth,' where the sheriff of Edward III., being ordered to provide a certain number of garbs (sheaves) of arrows headed with steel for the king's use, is directed to seize, for the heading of them, all the flukes of anchors ("omnes alas ancarum") necessary for that purpose. (*Ibid.* vol. ii. p. 269, note i.). In the 7th of Henry IV. (A.D. 1406) it was enacted that every arrow-head, or quarrel, should have the mark of the maker, under penalty of fine and imprisonment of the offending workman (*ibid.*), the making of arrow-heads constituting formerly a separate trade:

> "Lanterners, stryngers, grynders,
> *Arow-heders*, maltemen, and corne-mongers."
>
> *Cocke Lorell's Boat*, p. 10.

Throughout the fifteenth century the orders for making and providing arrows are numerous, the sheaf still consisting of twenty-four. In 1543 the King's letter to the mayor and sheriffs of Norwich orders them to provide forty able footmen, "whereoff viii to be archers, evry oon to be furnyshed with a gode bowe and a case to carye it inne, w^t *xxiiii. goode arrowes.*" In 1559 the price of a sheaf of arrows was twenty-two pence.

In the reign of Elizabeth, when fire-arms were beginning to supersede the bow, arrows were made for shooting out of cannon and muskets. " Item, for a dozen arow heds for musketts." "To William Fforde, ffletcher, for a dozen arrowes feathered, and heds for musketts, and a case for them, xxᵈ." ('Accounts of Robert Goldman, Chamberlayne of the Citie of Norwich,' 1587.)

In 1595 there were in the Tower of London "Musket arrowes, 892 shefe," and "one case full for a demi-culvering"; and at Rochester, "Musket arrowes with fier works, 109 shefe." These were for use at sea, and are called by Lord Verulam "sprights." (See also under BOW, BOLT, and QUARRELL.)

ARRIÈRE-BRAS. See REREBRACE.

ASSASSIN, or *VENGEMOY,* "signifies a breast-knot, or may serve for the two leading strings that hang down before, to pull a lady to her sweet-heart." (Ladies' Dictionary. London, 1694.)

ATLAS. A name given to gowns and petticoats in the reign of Queen Anne—derivation uncertain. In 1712 was advertised for sale—"a purple and gold *atlas* gown," "a scarlet and gold *atlas* petticoat edged with silver," and "a blue and gold *atlas* gown and petticoat." (Malcolm's 'Anecdotes,' vol. ii. p. 319.)

AURILLIAC. See LACE.

AVANT-BRAS. See VAMBRACE.

AVENTAILE. (*Aventaille,* French.) The movable front to a helmet, or to the hood of the hauberk, through which the wearer breathed, and which, succeeding the nasal of the eleventh, preceded the visor of the fourteenth century. It was applied to all defences of the face, whether a continuation of the mail-hood, or a plate attached to the front of the helmet. One sort of aventaile may be seen in an illumination of a Latin Psalter of the thirteenth century, marked A. xxii. Royal MS., British

Helmet of
Richard I.

Helmet of Baldwin, Count
of Flanders, 1192,
showing Aventailes.

Helmet. 1203.

Aventail of Mail, from Roy. MS. 2 A. xxii. Brit. Mus. It could be
pulled up from the chin to cover the face as high as the eyes.

Museum. It is tied to the mail-hood, and forms a kind of chin-piece, thereby illustrating the following passages in the 'Romance of Lancelot de Lac,' quoted by Strutt, 'Dress and Habits,' vol. ii. p. 64, edit. 1842 : "Le abat l'avantaille sur les espaules." "Ote son escu et son hiaume, et si li abat l'aventaille tant ke la tieste remest toute nue." "Ostes nos hiaumes et nos ventailles abatues."

AULMONIÈRE. The Norman name for the bag, pouch, or purse appended to the girdle

of noble persons, and derived from the same root as "alms" and "almoner." It was more or less orna-mented, and hung from long laces of silk or gold. It was sometimes called alner :

Aulmonière, or Purse.
From a painting by Holbein, in the Louvre, Paris.

> "I will give thee an *alner*
> Made of silk and gold clear."
> *Lay of Sir Launfal.*

AUREATE SATIN. A rich stuff thus mentioned by Hall, 'Union of Honour,' fol. 83, *temp.* Henry VIII. : "Their hosen being of riche gold satten called *aureate satten*, overauled to the knees with scarlet."

Aulmonière.
From Viollet-le-Duc.

AVOWYRE. Cognizance, badge, or distinction. "Also a pensel to bere in his hand of his avowyre." (Lansdowne MS., British Museum, printed in 'Archæologia,' vol. xvii. p. 295.)

AXE, BATTLE. (Acꞃe, Saxon; *Akizi*, Goth.; *Accetta*, Ital.) That the axe was a weapon used by the original inhabitants of the British Isles, is a fact which I am surprised to find questioned by any antiquary of the present day. Ammianus Marcellinus tells us that the Gauls had battle-axes and swords (lib. xix. c. vi.), and for what possible reason should we doubt that axe-heads of flint or bronze, which have been found in such numbers throughout the British Islands, were used for the sole purpose of felling timber, or in other peaceful employments, and have never been wielded in defence of their sacred groves, never hewn down the Roman invader ? That the smaller implements of the same form, all absurdly called "celts" (see under CELT), were used as chisels, or similar carpenters' tools, is highly probable, though Mr. Syer Cuming has pointed out to us a striking similarity between these well-known relics, and the *ferulæ* of the spears of the soldiers in the Assyrian sculptures in the British Museum ; but it is contrary to all analogy, to all known practice in ancient or modern times, that the woodman should abandon his hatchet on the approach of the foe—that the axe which is used by the carpenter in the time of peace should hang idly on the wall when "the blast of war blows in his ears," its value as a weapon of offence increased by its readiness to the hand as well as the familiarity of that hand with its grasp. Unless the use of the battle-axe be absolutely proved to have been unknown to the ancient Britons (and what authority can be produced for that purpose I have yet to learn), it is surely probable that some specimens of that weapon would be found with the numberless swords, spear-heads, arrow-heads, shields, and personal ornaments, acknowledged to be of that period ; and yet if we deny the claim of the larger "celts" to be so considered, a British battle-axe has still to be discovered. I cannot, therefore, for a moment hesitate to designate the articles of flint and mixed metal as British axe-heads. Although I am not aware of any peculiarity which should distinguish the war-hatchet from its peaceful prototype, I am inclined to believe the more orna-

Saxon Battle-axes. From
Cott. MS. Claudius, B. iv.

mented specimens best entitled to the appellation. The Saxon battle-axe had a long handle, and was called *byl* (in modern orthography, "bill"). It was used to a very late period in England. (See BILL.) Wace, in his description of the Battle of Hastings, continually alludes to it as "lunge emaunchie." The Danes were celebrated for their use of the battle-axe, which was generally double-bladed, and called in Latin *bipennis*. "At Scarpa Skeria," says the dying king, Ragner Lodbroch, "cruelly hacked the trenchant battle-axe." Mr. Hewitt, in his 'Ancient Arms and Weapons in Europe,' quotes a charter of Canute to the monks of Christ Church, Canterbury, in which mention is made of a "taper axe," and such, he considers, is the one found in the grave of Chilperic. The Irish in the time of Henry II. appear to have been equally well

skilled in the use of this terrible weapon. Giraldus tells us they had "broad axes excellently well steeled, the use of which they borrowed from the Norwegians and the Ostmen." He also describes their peculiar mode of wielding them: "They make use of but one hand to the axe when they

Battle-axes. From the
Bayeux Tapestry.

Battle-axes. 1 & 2 *temp*. Henry VIII. 3 & 4, Elizabeth. 5, James I. 6, Dutch, A.D. 1685.

strike,* and extend their thumb along the handle to guide the blow from which neither the crested helmet can defend the head, nor the iron folds of the armour the body: whence it has happened in our time that the whole thigh of a soldier, though cased in well-tempered armour, hath been lopped off by a single blow of the axe, the whole limb falling on one side of the horse, and the expiring body on the other."

The Irish name for the battle-axe was *tuagh-catha*, and in the county of Galway is a hill called "Knock-Tuagh"—"the hill of axes," from the circumstance of the Irish having gained a victory over the English there, by means of their axes. In the museum of the Royal Irish Academy, Dublin, is a most interesting collection of axe-blades of all sizes, some very elaborately ornamented.

Ornamented Irish Axe-blade. From
T. Crofton Croker's Collection.

Irishman with Bat-
tle-axe. From
an illuminated
copy of Giraldus
Cambrensis.

The Scotch also fought with axes, for the introduction of which they were, like the Irish, probably indebted to the Danes and Norwegians. Two celebrated sorts have descended to the present day. (See JEDBURGH and LOCHABER.) Axes are carried also by the town guards of Edinburgh and Aberdeen. In the reign of William, King of Scotland, A.D. 1165–1214, mention is made of the hand-axe, which is said to be identical with the *gysarm*. (See under GUISARM.) The "hand ex" is also named with the "Jedburgh staif" in a mandate of the Provost of Edinburgh, in 1552. (Wilson's 'Memorials of Edinburgh.') The Normans naturally numbered the battle-axe among their offensive weapons.

Hoveden describes King Stephen at the battle of Lincoln, A.D. 1141, as performing prodigies of valour with his enormous battle-axe, till at length it broke, and he was compelled to use his sword.

* This is in singular contradiction of Wace, who objects to this weapon, because it required both hands to wield it:

> "Hoem ki od hache volt ferir,
> *Od sez dous mainz l'estuet tenir*,
> Ne pot entendre à sei covrir
> S'il velt ferir de grant air."

It is probable, however, that Wace is speaking of the long-handled *byl* used by the Saxons, and not of the broad Danish axe.

The double axe (*bipennis*) is also named amongst the weapons in vogue during the reign of Richard I., and the following lines have been often quoted :

> "This King Richard, I understonde,
> Yer he went out of Englonde,
> Let make an axe for the nones
> Wherewith to cleave the Saracens bones.
> The head in sooth was wrought full weele,
> Thereon were twenty pounds of steele ;
> And when he came to Cyprus lond
> This ilkon axe he took in hond."
>
> Matthias Prideaux.

The battle-axe appears to have fallen into disuse about the middle of the fifteenth century.

"Item, Four battle-axes partely guilt, with long small staves of brasell garnished with velvet, white and greene, and silk, in the armory at Westminster." (Brandon MS., 1st of Edward VI., 1546.)

AXE, JEDBURGH. A battle-axe so called from the place of its manufacture, the chief town of Roxburghshire, and one of the most noted on the Scottish border. It was sometimes called a "Jeddart staff" (*vide ante*, p. 8) ; all weapons attached to long handles, or poles, being classed as "staves."

Jedburgh Axe. From Lochaber Axe. From Pole Axes of the 15th century.
Skelton, Pl. lxxiii. 6. Skelton, Pl. lxiii. 7. From Skelton, Pl. lxxiii. 1, 3.

AXE, LOCHABER. The Lochaber axe appears to have differed in form from the Jedburgh and resembled more the bill than the battle-axe.

AXE, POLE. The Pole-axe, or pollax, as it is sometimes written, was known to the Anglo-Saxons, and in the Bayeux Tapestry it is represented exactly of the same form as a Polish one in the collection formerly at Goodrich Court. According to Sir Samuel Meyrick, it was as early as the Saxon times the peculiar weapon of a leader of infantry, and so continued to the sixteenth century, at which period they are frequently found combined with a fire-arm.

> "Pole axes with gonnes in the endes, xxvii.
> Pole axes without gonnes, ii.
> Short pole axes playne, c.
> Two hand pole axes, iv.
> Hand poll axes with a gonne and a case for the same oone.
> Poliaxes gilte, the staves covered with crimsyne velvet fringed with silke of golde, iv."

These were in the Tower in 1546 (Brandon MS.), and we learn from this document that there were varieties of the pole-axe distinguished as "short" or "hand," which could have differed but little from the abandoned battle-axe, if they were not that identical weapon so re-christened. The long-handled axe was called in Germany, *Fuss Streitaxt ;* and the short-handled, used by knights on horseback, *Reiteraxt.* (Demmin's 'Weapons of War.' See also HATCHET.)

BACK AND BREAST. The usual form of expression employed in official documents, orders, inventories, &c., of the seventeenth century, to designate the body armour of that period, which consisted chiefly of a back and breast plate, and some sort of defence for the head. In the 'Militarie Instructions for the Cavalrie,' dated 1632, the harquebusier, "by the late orders rendered by the Council of War," is directed to wear, besides a good buff coat, "a back and breast like the cuirassier, more than pistol-proof," &c. (See under BREAST-PLATE and CUIRASS.) "The arms, offensive and defensive," says the Statute of the 13th and 14th of Charles II., "are to be as follows : the defensive arms (of the cavalry), a back, breast, and pot, and the breast and pot to be pistol-proof." Pikemen are to be armed, in addition to the pike, "with a back, breast, head-piece, and sword."

BACK-SWORD. See SWORD.

BACYN. See BASINET.

BADGE. The earliest personal distinction of the Middle Ages, and the origin of armorial insignia. Wace tells us that at the Battle of Hastings all the Normans had made or adopted cognizances, that one Norman might know another by, and that none others bore ; but we fail to distinguish any such signs in the Bayeux Tapestry. Upon the general adoption of regular and hereditary armorial bearings, the badge was transferred from the chief to his retainer, and from the banner to the standard. It was likewise used for the decoration of tents, caparisons of horses, and household furniture. Modern writers have frequently confounded it with the crest and the device, but it was perfectly distinct from both. It was never borne on a wreath, like the former, and it differed from the latter by becoming hereditary with the arms, while the device, properly so called, was only assumed on some particular occasion, to which it usually bore a special reference. (See CREST and DEVICE.) The etymology of the word "badge" is uncertain. Johnson derives it from the Italian *bajulo*, to carry. Mr. Albert Way more probably suggests from the Anglo-Saxon *beag*, a bracelet. (Note to 'Prompt. Parvulorum,' tom. i. p. 21.) The Norman term *cognoissance*, anglicised *cognizance*, is more explicit, and was the one in use during the twelfth, thirteenth, and fourteenth centuries. In the fifteenth the word "badge" appears incorporated with the English language, and one of the earliest lists of badges is of the reign of Edward IV. The badge was at that period embroidered on the breast, back, or sleeve

Portion of Robe of Anne of Bohemia. From her effigy in Westminster Abbey.

of the soldier or servant, and in the sixteenth century engraved or embossed on a metal plate affixed to the sleeve, such as we still see on the jackets of watermen, postillions, &c., although they now

improperly display the crest or entire coat of arms of the person or company employing them. When worn by the sovereign, noble, or knight himself, it was not on the sleeve or any particular part of his attire, but introduced as a portion of the ornamental pattern with which his robe, tunic, or other vestment was embroidered. The effigies of Richard II. and his queen, Anne of Bohemia, in Westminster

Badges of Richard II.

Abbey, afford us a fine example of this fashion. The king's tunic is covered with his badges of the white hart, crowned and chained, the sun issuing from a cloud, and the open broom-pod ; the

Badge of Anne of Bohemia.

queen displays her family badge of the ostrich with a nail in his beak, amidst a profusion of knots, crowned initials, &c.

The Duke of Bedford, *temp.* Henry VI., is represented in a robe embroidered with his badge, a tree root (called by the French *le racine du Bedfort*), in the Bedford Missal, a MS. of the fifteenth century, and the examples might be multiplied *ad infinitum.*

In the Orders of the Duke of Norfolk, 36th of Henry VIII., we find "no gentleman or yeoman to were [wear] any manner of badge." (MS. Coll. Arm., marked W. S.)

Badge of Anne of Bohemia, indicating the letter a.

The portraits of Richard II., at Wilton House and in the Jerusalem Chamber at Westminster,* furnish us with other interesting proofs of this gorgeous style of decoration, and in the Metrical History of his deposition (Harleian MS. No. 1319) the caparisons of his horse are powdered with golden ostrich feathers.† The shields worn at the girdles by inferior officers of arms, and the small metal escutcheons occasionally found, and which appear to have been ornaments of horse furniture, are not badges, as they have been incorrectly termed by some antiquaries, except in the modern and general sense of the word, a mark or sign, as it is now applied to the plate carried by the cabmen, or when employed metaphorically, as in the well-known line of Shylock :

 " Sufferance is the badge of all our tribe."

(See under LIVERY.)

BADGER. See GREY.

BAG. See WIG.

* See coloured plate in ' General History.' † See wood-cut, page 17, *ante.*

BAGGE. Badge, which see. " His bagges are sabylle." (MS. Lincoln, A. E.)

BAINBERGS. (German, *Bein-bergen.*) Shin-guards of leather or iron, strapped over the chausses of mail, as an additional defence to the front of the leg; the precursors of the steel greaves or jambs of the fourteenth century. It is probable that the term was used by the Teutonic races to designate any sort of protection for the legs.

"Bainborgas bonas vi. sol tribuat." (Lex Ripuar. cap. 36, s. 11.)

"Bembergas 2." (Testamentum Everardi Ducis Förojül.)

BAIZE, BAYS. A well-knôwn woollen manufacture, first made in England at Sandwich, Colchester, and Norwich, in the reign of Queen Elizabeth.

It was still considered a novelty in the following reign; for in Hilary Term, 2nd of James I., there was a question, whether certain woollen cloths were subject to the duty of alnage, referred to the judges, who made a certificate, which is set

Bainbergs. 14th century. From statue at Naples, dated 1335.

Bainbergs. From brass of Sir J. de Creke, in West-ley - Waterless Church, Cambs.

out verbatim by Lord Coke in his 4th Institute, p. 31. They say, "We are resolved that all *new-made drapery,* made wholly of wool, as frizadors, *bays,* northern dozens, northern cottons, cloth wash, and other like drapery, of what *new* name soever, for the use of man's body, are to yield subsidy and alnage." (Certificate, dated 24th June, 1605.)

> " Hops, reformation, bays, and beer,
> Came into England all in a year."
> *Old English Rhymes.*

Those of the Walloon "strangers" who came over to England, and were workers in serges, baize, and flannel, fixed themselves at Sandwich at the mouth of a haven, where they could have an easy communication with the metropolis and other parts of the kingdom. The queen, in her third year, 1561, caused letters to be passed under her great seal, directed to the mayor, &c., of Sandwich, to give liberty to certain of them to inhabit that town, for the purpose of exercising their manufactures, which had not been used before in England. (Hasted's Kent, iv. p. 252.)

"The strangers" of Sandwich were the most ancient, for from them proceeded those of Norwich and Colchester; and the English which dwelt at Coxhall, Braintree, Hastings, and other places, that make baizes now in great abundance, did learn the same of the strangers. (Cotton MS. Titus, B v.)

BALANDRANA. (French, *balandrus, balandran.*) A mantle or cloak, similar, if not identical, with the supertotus, or surtout, worn by travellers in the thirteenth century. (See SUPERTOTUS.) In the statutes of the Order of St. Benedict, A.D. 1226, it is thus mentioned: " Illas quidem vestes quæ vulgo Balandrava et Supertoti vocantur, et sellas rubeas et fræna penitus amputamus." It was prohibited to the clergy with other laical garments. " Prohibemus quoque districtim ut nulli regulares cum Balandranis seu Garmasiis vel aliis vestibus laicorum equitent vel incedant." (Concil. Albiense, *anno* 1254.)

BALAS. (*Baleis,* Latin ; *balais,* French.) A species of ruby of a rosy colour. When engraved or incised, called " balais of entail," " balay d'entail."

" Cum rubetis et balesiis." (Rymer's Fœd. i. 370.)

In what was called " the Harry crown," broken up and distributed amongst several people by Henry V., was " a great fleur de lys, garnished with one great *balays,* and one other *baleys,* one ruby

three great saphires, and two great pearls," and a pinnacle of the aforesaid crown, "was garnished with two saphires, one *square balays*, and six pearls."

BALDEKIN. Cloth of Baldekins. (French, *baudekin*.) A costly stuff of silk and gold, so called from being originally manufactured at Baldech, or Baldach, one of the names of Babylon or Bagdad. (Ducange, *in voce*.) Baldekinus. "Pallas preciosus quos Baldekinus vocant." (Mathew of Paris, 1254.) Wachter derives the word "a cambrico, *pali*, sericum, et German, *Dach*, tectum;" and the authors of the 'Glossarii Bremensis' from "*boll*, caput, and *dech*, tegumentum." It was used for robes of state curtains, canopies, &c. Mathew Paris speaks of it under the date of 1247, as forming a portion of the royal vestments of Henry III., when he conferred the honour of knighthood on William de Valence: "Dominus Rex vesta deaurata facta de preciocissimo Baldekino sedens." (Mathew Paris, 1247.)

There is a town called Boldeck in Lower Germany, but I do not consider it has any connection with this subject.

It is constantly mentioned in mediæval romances:

> "She took a rich baudekine
> That her lord brought from Constantine
> And lapped the little maiden therein.
> *Lay le Freine.*

> "All the city was by-hong
> Of rich baudekyns."
> *Romance of King Alexander.*

> "With samites and baudekyns
> Were curtained the gardens."
> *Ibid.*

In the inventory of the wardrobe of Henry V. occur "a piece of baudekyn of purple silk, valued at 33 shillings," "a piece of white baudekyn of gold at 20 shillings the yard." In another, of Edward IV., we read of "baudekyns of silk," and in that of Henry VIII. (Harleian MS. 2284) are entries of "green baudekins of Venice gold," and "blue, white, green, and crimson baudekyns with flowers of gold."

The term "baldaquin" is still in use to signify the state canopy borne over the head of the Pope, and other similar canopies suspended in churches, from the rich material of which they were generally composed.

BALDRICK. (*Baudroie*, French; *baudrinus*, Latin, infini.) A broad belt worn over the right or left shoulder, either simply as an ornament, or to carry a weapon or a horn. (See effigy of JOHN CORPE, from his brass in Stone-Fleming Church, Devon.) Some were magnificently decorated and garnished with bells (see figure of nobleman, from Royal MS. 15 D 3, of the close of the fourteenth century,) and also with precious stones:

> "Un baudréot a grandes bandes d'or fin,
> A chieres pierres sont attachés et mis."
> *Le Roman de Garin.*

Effigy of John Corpe, Stone-Fleming Church, Devon.

Royal MS. Brit. Mus. 15 D 3.

Spenser seems almost to have copied these lines:

"Athwart his breast a baldrick brave he bare,
That shined like twinkling stars with stones most precious rare."

(See group of Huntsmen from the 'Livre de Chasse' of Gaston Phœbus, MS., fifteenth century, in the National Library at Paris.) The yeoman in Chaucer's 'Canterbury Tales' is described as having his horn slung in a green baldrick, and the ploughman in the same work upbraids the clergy for wearing baldricks with keen basilards or daggers. The fashion appears to have reached its height in the fifteenth century.

Huntsmen with Baldricks. From the 'Livre de Chasse' of Gaston Phœbus.

That the baldrick was a shoulder-belt is clearly evident from the "device for the coronation of King Henry VII.," in which William Newton and Davy Philipp, esquires of the king's body, selected to represent the Dukes of Guyen and Normandy, are instructed to wear their mantles "in bawderick-wise," which can only mean diagonally, i.e. over one shoulder and passing under the other arm, a fashion of which examples will be found under the word CLOAK.

In the sixteenth and seventeenth centuries the term was used by the poets to signify a shoulder belt generally; but it still was applied to certain belts worn by surgeons in the army to distinguish them in the field. In Ralph Smith's MSS., *temp.* Elizabeth, we are told "suche surgeons must wear their baldricke, whereby they may be known in the time of slaughter: it is their charter (i.e. protection, safeguard,) in the field." Grose, quoting this MS. in his 'Military Antiquities,' vol. i. p. 241, says, "from this passage it would seem that surgeons wore a distinguishing belt over their shoulder like that now used by the itinerant farriers vulgarly styled 'sow-gelders.'" He might have added "and ratcatchers," who are probably the last illustrators of this custom. The broad shoulder-belt worn by gentlemen in the reign of Charles II. and James II., by the *suisses* in Continental churches and the Pope's Guards, are properly baldricks. Monsieur Viollet-le-Duc applies the word "baudrier" to the military belt and girdle "ceinture." (See under BELT, MILITARY, and SWORD.)

BALISTA. Occasionally an abbreviation of *arcubalista*, as in Guillaume le Breton : " Nec tamen interea cessat balista vel arcus ;" but it was more properly the name of an engine of war, from which the arcubalista, or arbalest, derived its appellations. (See ARBALESTA.)

BALLOK-KNIFE. A knife, hung from the girdle, mentioned as worn by priests in the fourteenth century.

> "Sir John and Sir Geoffrey
> Hath a girdle of silver,
> A baselard or a ballok-knyf,
> With buttons overgilt."
> *Piers Plowman's Vision.*

BAND. The collar which in the seventeenth century supplanted the ruff. It was first a stiff stand-up collar of cambric, lawn, or linen, starched, wired, and sometimes edged with lace. It was

Stand-up Band, from portrait of John George, Duke of Saxony.

Falling Band, from a portrait by William Marshall, *temp*. Charles I.

Falling Band, from portrait of John Scott, carpenter and carriage-maker to the Office of Ordnance, *temp.* Charles II., in Carpenters' Hall.

worn by persons of consideration abroad, as late as the middle of the century, as appears from a portrait of John George, Duke of Saxony, who died 1656. Yellow starch was used for the stiffening, as in the case of the ruff. (See under RUFF). In the play of 'Albumazzar,' published A.D. 1614, Armelina asks Trincalo, "What price bears wheat and saffron that your band is so stiff and so yellow?" This fashion as regards collars appears to have been peculiarly English, for in 'Notes from Black Fryers,' a satirical poem by Henry Fitzgeffery, 1617, it is said, "Hee is of England, by his *yellow* band." Contemporary with it was the falling band, also occasionally edged with lace more or less costly, and sometimes embroidered, or made of Italian cut work, ornamented with pearls. Ben Jonson, in 'Every Man in his Humour,' speaks of some as costing "three pounds on the exchange." Falling bands are mentioned as early as 1604, and are sometimes called "French falls." Very narrow bands were worn by the Roundheads, in contradistinction to the broad bands of the Cavaliers :

> "What creature's this with his short hairs,
> His *little band*, and huge long ears,
> That this new faith has founded?
> The Puritans were never such,
> The saints themselves had ne'er so much.
> Oh! such a knave 's a Roundhead!"
> *Character of a Roundhead.* 1641.

Geneva bands, were so called from their adoption by the ministers and members of the Protestant church there.

In the female costume the breadth of the band varied with the usual inconstancy of fashion. A lady, we are told, one day,

> "Commends a shallow band, so small
> That it may scarce seem any bande at all ;
> But soon to a new fancy doth she reele,
> And calls for one as big as a coach-wheele."
> *Rhodon and Iris.* 1631.

"Hungerland bands" are mentioned by Massinger in his play of 'The City Madam,' 1659. After the introduction of the cravat, or neck-cloth, the bands were confined to the learned profes-sions. They appear in the early part of the eighteenth century as merely the elongated ends of the shirt-collar, but they soon became independent of it, and assumed the shape they bear in the present day—

Merchant's Wife of London.
From Hollar, 1640.

Stand-up Band.
From portrait of Anne, Queen of James I.

English Lady with plain Falling.Band.
From Hollar, 1640.

two meaningless strips of lawn or fine French cambric, hemmed down the sides and at the bottom, and fastened by a tape round the neck—one of the many instances I shall have to produce of the ridiculous practice of tampering with ancient fashions, which, if worth preserving, should be retained in their integrity, or, if not, discarded altogether. Our examples of the bands worn by females are taken from the portrait of Anne of Denmark, Queen of James I., and engravings by Hollar.

The term "band-box" has descended to us from those days, when similar boxes were used expressly for keeping bands and ruffs in.

BAND-STRINGS. Laces used, as the expression implies, to fasten the neck bands. "Snakebone band-strings" are mentioned in the reign of Charles I., and in 1652 John Owen, Dean of Christchurch and Vice-Chancellor of Oxford, is said to have appeared "in querpo, like a young scholar, with powdered hair, snake-bone band-strings, a lawn band," &c. "Band-strings or handkerchief-buttons" was one of the cries of London at that period, and the figure of a woman employed in selling them is to be found among a set of "the cries" published in the reign of Charles II., and preserved at the British Museum.

BANDELET. Under the word *Ciarpa* in Florio's Italian Dictionary we find, "any sort of scarf or bandelet."

BANDEROLLE, BANNEROLL. A little streamer attached to the head of a lance, as even to this day may be seen fluttering in any regiment of lancers, English or foreign.

Band-strings. From the portrait of
Sir John Scarborough, M.D.

Band-strings. From portrait of the
Speaker Lenthal.

BANDILEER. (*Bandolier*, French.) A broad leather belt or baldrick, to which were attached twelve pipes or cases of metal or wood, with caps or covers to them, for containing charges of gun-powder. It was worn by musketeers, over the left shoulder, and the fashion is presumed to have been imported from the Netherlands. Davies, in his 'Art of War,' describes the Walloons as having hung about their necks, upon a baldrick or border, or at their girdles, "certain pipes which they call charges, of copper and tin, made with covers." Introduced about the middle of the sixteenth century, they were completely superseded before the close of the seventeenth by the cartridge-box. They do not appear to have been long in favour, for in 1670 Sir James Turner says

Musqueteer with Bandileer, Matchlock and Rest. From the work of Jacob de Gheyn. 1607.

they had been gradually growing into disesteem "for the last seventy years."

"For a new bandelier, with twelve charges, a primer a priming wire, a bullet bag, and a strap or belt of two inches in breadth, 2s. 6d." (Order of Council of War, 7th, Charles I.) "To a musketeer belongs also a bandelier of leather, at which he should have hanging eleven or twelve shot of powder, a bag for his ball, a primer, and a cleanser." (Turner's 'Pallas Armata,' p. 176.)

BARBE. A piece of linen, generally plaited, and worn over or under the chin, according to the rank of the lady. It was only worn in mourning or by widows. It is seen in monumental effigies and brasses of the fifteenth century, and is specially mentioned by Margaret, Countess of Richmond, mother of Henry VII., in her 'Ordinance for the Reformation of Apparell for great Estates of Women in the tyme of Mourning.' (Harleian MS. 6064.) The queen, and all ladies down to the degree of a baroness, are therein licensed to wear the barbe above the chin.

*Bandileer.
Tower Armoury.*

Baronesses, lords' daughters, and knights' wives, are ordered to wear the barbe beneath it, and all chamberers and other persons, "below the throat *goyll*," or gullet, that is, the lowest part of the throat.

In Chaucer's 'Troilus and Cresseide,' the poet makes Pandarus bid Cresseide, who is in widow's attire, to do away her *barbe* and show her face bare. (Book 2, l. 110.) In 1694 the barbe is described as "a mask or vizard." (Ladies' Dictionary.)

BARBUTE. See BASINET.

BARME CLOTH. See APRON.

*Mourning Habit of the 16th century.
From Harleian MS. 6064.*

BARRAD, or *BARRAID.* The name of a conical cap worn by the Irish as late as the seventeenth century, and apparently of very ancient origin. O'More, a turbulent Irish chieftain, is represented wearing one, in a delineation of the taking of the Earl of Ormond in 1600. It is of the most primitive form, resembling the *cappan* of the ancient Britons. (See CAP.)

BARRED. Striped. The girdle of the carpenter's wife in Chaucer's 'Canterbury Pilgrims,' is

said to have been " barred all of silk." The word is of constant occurrence in works of that age, and signified also the metal ornaments of a girdle, which were frequently of the richest description. (See BELT and GIRDLE.) " Barre of a gyrdylle or other harneys." (Prompt. Parvulorum.) These ornaments, were called *cloux* by the French, and were perforated, to allow the tongue of the buckle to pass through them. Sometimes they were simple bars, attached transversely to the stuff of which the girdle was made, but more frequently they were round or square, or fashioned like the heads of lions or other devices, the name of *barre* being still retained, though improperly. (See BELT, Plate IV.) A citizen of Bristol bequeathed in 1430 " Zonam haringatam cum *barris* argente *rotundis.*" Chaucer, in his 'Romaunt of the Rose,' describing the girdle of Richesse, says :

Emperor Maximilian I. 15th century.
From a sketch by Holbein.

" The barres were of gold full fine,
Upon a tissue of sattin,
Full hevie, grete, and nothing light,
In everiche was a besaunt wight."

In the original 'Roman de la Rose,' the first line reads—

" Les cloux furent d'or epuré."

Spur leathers, similarly ornamented, are spoken of in 'Gawayn and the Green Knight' :

" chasse spurs under
Of bryst golde upon silke bordes
Barred ful ryche."

BASES. The plaited skirts appended to the doublet and reaching from the waist to the knee, which are so noticeable in the male costume of the time of Henry VII. and in the early part of that of Henry VIII., and were imitated in the armour of that period. (See ARMOUR and LAMBOYS.) They were made of cloth, velvet, or rich brocaded stuffs, and worn with armour, as well as without. They appear to have been a German or Italian fashion, as examples abound in paintings and engravings of the Maximilian era. " Coats with bases or skirts " are mentioned in an inventory of the apparel of King Henry VIII. (Harleian MS. 2884.) The accompanying example is from a sketch of the Emperor Maximilian I., by Holbein.

BASILARD. (*Basilaire, baze,* French ; also *badelaire, badilardus,* Latin.) " Ensis brevis species. Coutellas olim Badelaire." (Du Cange.) A weapon of the Middle Ages, worn by civilians, and sometimes by the priesthood. It was a species of short sword or long dagger, like the anelace ; but longer and narrower than that weapon. " Le dit de Lestre aiant une grant baze . . . et le dit Guillaume son cousin une autre grant baze." (Lit. remiss. *anno* 1339.)

" En ce debat sacherent tous deux leurs bases ou baselaires, l'un contre l'autre." (Rursum, chap. 252, *apud* Duschesne *sub.* Basalaria.)

Hence the verb *besiller* in old French—to wound, mutilate, or maim. In a satirical song of the reign of Henry V. (Sloane MS. 2593) we are told that

" There is no man worth a leke,
Be he sturdy, be he meke,
But he bere a baselard."

And the writer describes his own as having " a shethe of red," " a clean loket of lead," " a wreathen haft," or twisted hilt, and " a sylver chape." Henry Gildeny, merchant, sheriff of Bristol, 1423, leaves to John Basset his basilard with

From the effigy of Walter Frampton at Bristol.

From a brass of the 15th century.

the ivory hilt ("baslardum meum cum le ivery hafte") garnished with silver. (Additional MS. notes by Dallaway to Barret's History of Bristol in the College of Arms.) The Ploughman, in 'Chaucer's Canterbury Tales,' upbraids the clergy for being armed like men of war, with broad bucklers and long swords and baldricks, with keen basilards or daggers, and in 'Pier's Plowman's Vision' we read it would be more decorous

> "if many a preest bare,
> For their baselards and their broaches,
> A pair of beads in their hands,
> And a book under their arm."

And in a poem of the fifteenth century by John Audeley, a parish priest is said to have "his girdle garnished with silver his basilard hangs by." Our cuts are copied from the effigy in St. John's Church, Bristol, of Walter Frampton, three times mayor of Bristol, and M.P. for that city, 1362, 36th of Edward III., and a brass, fifteenth century. (See also the effigy of John Corpe, under BALDRIC, and further under DAGGER.)

BASINET, BASCINET, BASNET. (*Bacyn,* French.) A steel head-piece, so called from its original basin-like form in the early part of the thirteenth century. It is mentioned in 1214, by Guillaume Guiart: "Li yaumes (heaumes) et bascinez reluire;" after which it became gradually more conical and lengthened behind, so as to defend the nape of the neck. To it was appended, in the fourteenth and fifteenth centuries, a neck-piece of chain, called the "camail" (see CAMAIL), which, leaving an opening for the upper part of the face, fell like a tippet over the shoulders and protected the wearer's chin, throat, and chest. (Plate III. figs. 1, 4, 5.) "En ce temps la coustume des hommes estoit qu'ils s'armoient a bacinez a camail a une pointe aigue a une grosse orfray sur les epaules." (MS. Chron. France, *temp.* Charles V. of France, quoted by Ducange.) The camail was fastened to the basinet by a silken cord, which ran through rings or staples set at equal distances round the outer edge of the basinet, and connected through small holes with the links of the chain inside. (Plate III. figs. 3, 6.) The cord and staples were, in some instances, covered with a metal band or fillet, richly gilt, and occasionally ornamented with jewels, forming a splendid border to the steel head-piece. Over the basinet was placed the ponderous heaume or helm when in battle or in the lists ; but the great weight and inconvenience of the heaume led to the adoption of a vizor for the basinet, which could be removed when the heaume was indispensable. This appears as early as 1270, from the line of Guillaume Guiart: "Et clers bacinez a visieres." From the reign of Richard II. the use of the vizored basinet became more and more general, and the heaume was scarcely ever worn but in the tilt-yard. The various forms of the vizor will be best understood from our engravings. (See VIZOR.) Its singular appearance in the reigns of Richard II. and IV. is illustrated, not only from illuminations of the period, but fine existing specimens in the National and the Meyrick Collections. In addition to the band or fillet which covered the cord sustaining the camail the basinet was sometimes encircled by a band or wreath of metal magnificently ornamented and jewelled. (Plate III. figs. 7, 8.) In the accounts of Etienne de la Fontaine, silversmith to the king of France, under the date of 1352, we have a minute description of a magnificently ornamented basinet: "Poure faire et forger la garnison d'un bacinet c'est a savoir 35 vervelles (rings, or *vertivelles,* staples) 12 bocettes (bosses) pour le fronteau tout d'or de touche et un ecouronne d'or pour mettre sur icelui bacinet, dont les fleurons sont des feuilles d'espines, et le circle diapré de fleurs de lys. Et pour forger la couroye a fermer le dit bascinet dont les clous sont de bousseaux et de croissettes esmaillées de France."

In the reign of Henry V. the basinet had sometimes a hollow knob or pipe on its apex, to receive a plume of feathers (Plate III. fig. 10), and one of its latest forms was evidently a copy of the ancient Greek helmet, ordinarily seen on the head of Minerva (Plate III. fig. 11.)

Lydgate, writing in the reign of Henry VI., has,

> "Strokys felle, that men might herden ring
> On bassenets, the fieldes round about."
> *Troy,* book xi. l. 18.

1.
Effigy of a Knight of the Pembridge family in Clehongre
Church, Herefordshire.

2.
Side view of No. 1.

3.
Mode of attaching Camail.

4.
Effigy of Humphrey de Bohun, Earl of Hereford, in
Hereford Cathedral.

5.
Effigy of Sir Richard Pembridge, in Hereford Cathedral.

6.
Mode of attaching Camail.

9.
Ornamental Border, covering the fastenings of the
Camail (Figs. 7 and 8.)

8.
Side view of Fig. 7

7.
Sir H. Stafford, from Bromsgrove Church,
Worcestershire.

10. 10 and 11. Latest forms. 15th Century, from
the Meyrick Collection. 11.

Towards the close of that reign the basinet seems to have given place to the salade. (See that word.) M. Viollet-le-Duc, under the head of "Barbute," describes nothing more than the basinet, both with and without the camail. He is either mistaken as to the particular head-piece, or "barbute" must have been merely another name for the basinet, in Italy. "Barbute," or "barbuce," is rendered by Ducange, "Salade a baviere : barbuce ou armet de gorgent, &c."

> "Si posa in capo una barbuta nuova."—*Orlando Furioso.*

"Barbute" was also the name for a monk's hood : *caputium magnum sine cauda.*

BASTARD. The name of a cloth manufactured in England in the reign of Richard III.

BASTARD-MUSQUET. See Musquet.

BASTON. (French, *baton.*) A truncheon carried by leaders, and now the peculiar distinction of a field-marshal. In the Meyrick Collection, formerly at Goodrich Court, there was a most interesting specimen of the sixteenth century, supposed by Sir Samuel Meyrick to have belonged to the great Duke of Alva. It was of steel, and hollow, so that it might contain a muster roll or any other important paper, and the exterior is engraved all over with Arabic numerals in gold, with divisions of silver on a russet ground, the results of calculations according to the system of warfare of that period, by which the general ascertained what number of men would occupy any given space. The modern baton is of wood, with ornamental gilt or gold mountings. The baton carried by the Hereditary Earl Marshal of England was ordered by Richard II. to be of gold, ornamented with black at each end, having the king's arms engraved on the top and his own arms on the bottom of the baton.

The term "baston" or "baton" was, however, anciently used to designate a club, sometimes headed with iron (baton-ferée), continually alluded to in descriptions of battles and tournaments, from the time of the Conquest to the sixteenth century.

In the battle of Hastings, Odo, bishop of Bayeux, is said by Wace to have been armed with such a weapon : "Un baston tenoit en son poing ;" and in the Bayeux Tapestry he is represented grasping a bludgeon, the inscription over him being, "Hic Odo, baculum tenens confortat pueros."

Duke William, in the same work, is depicted similarly armed. (See ARMOUR.)·

The baton was the weapon of light-armed troops.

It was also used in tournaments previously to the year 1290, about which time a tournament statute was promulgated, in which it is expressly interdicted, in company with other weapons : "Qe nul chivaler ne esquier qe sert al tourney ne porte espeie a point, ne cotel a point, ne *bastoun,* ne mace, fors epee large pur turner." (Statutes of the Realm.)

From a miscellaneous Roll of the reign of Henry III.

In trials by battle the combatants of inferior degree were armed with a weapon called "baston cornue" (Britton 'De Jure Anglie'), which, from a drawing of the time of Henry III., appears to have been a sort of pick, having a double beak.

The greatest length of the baston allowable on such occasions is exactly stated in a statute of Philip Augustus, A.D. 1215: "Statuimus quod campiones non pugnent de caetero cum baculis qui excedant longitudinem trium pedum."

Baston is also generally used for any staff or club. (See HALBERT and GODENDAC.)

BAVARETTE. "A bib, mocket, or mocketer, to put before the bosome of a child." (Cotgrave.)

BAVIERRE. A term occasionally applied to the avantaille or ventail. (See BEAVER.) "Bassinet à bavierre."

BAYONET. This well-known weapon derives its name from Bayonne in Spain, where it was originally made, about 1580. Its earliest form was that of a dagger with a guard and a

wooden hilt or handle, which was screwed or merely stuck into the muzzle of the firelock. The blade was sometimes three-edged, sometimes flat. (See figures 1, 2, 3, and 6.) In the reign of James II. a ring was added to the guard, at first for defence; but it gave rise to an improvement by the French in the reign of our William III., which consisted of fixing the bayonet by the ring passing over the muzzle of the musket, instead of the hilt being screwed into it, so that the gun could be discharged without removing the bayonet. (Figs. 6 and 7.) This led to the invention of the modern socket bayonet, which very shortly afterwards entirely superseded the pike in infantry regiments.

Figs. 1, 2, 4, 6, are from specimens formerly in the Meyrick Collection. Figs. 3 and 7, Grose's 'Military Antiquities' (Plate XL.) Fig. 5, a combination of the bayonet with the musket-rest, *ibid.*

BAYS. See BAIZE.

BAZANE. "Sheep's leather dressed like Spanish leather." (Cotgrave.) "Red bazan" is mentioned in wardrobe accounts of Henry VIII. ('Archæologia,' vol. xxxi.)

BEAD. Beads of various materials have been used for personal decoration, by nearly all nations, from their earliest savage state to the period of their highest civilisation. Beads of glass, jet, and amber, appear to have been much worn by the Belgic and Southern Britons, as necklaces and ornaments for the hair. Amber beads are constantly found in the graves of the Anglo-Saxons, and coloured beads are presumed to have been attached as ornaments to their swords. Mr. Neville, in his 'Saxon Obsequies,' Plate xxi., has figured two beads discovered with swords at Wilbraham, and says, "An immense blue and white perforated bead accompanied three out of the four swords, probably as an appendage to the hilt, or some point of the scabbard." The Anglo-Normans do not appear to have affected them, at least we do not discover it, either in their paintings or writings, and it is not until the sixteenth century that the fashion seems to have raged again. Since that period, beads have ever been more or less used for necklaces, bracelets, trimming of dresses, and decoration of the hair; and the varieties of material in which they are made at the present day require no description.

BEAD-CUFFS. Small ruffles. (See RUFFLE.)

BEARERS. Randle Holmes, in his 'Academy of Armoury,' 1688, classes "bearers" amongst other "things made purposely to put under the skirts of gowns at their setting on at the bodies, which raise up the skirt at that place to what breadth the wearer pleaseth, and as the fashion is." The "bustle," therefore, so constantly the object of satire some few years ago, may claim descent from the bearer of the seventeenth century.

BEAVER. (*Bavierre,* French.) The lower portion of the face-guard of a helmet, when worn

with a vizor, but occasionally serving the purposes of both. In the fourteenth century, the term "bavierre" was applied to the movable face-guard of the basinet, otherwise called "viziere" and "ventaile," or "avant-taile." In the early part of the succeeding century the beaver appears formed of overlapping plates, which can be raised or depressed to any degree desired by the wearer. In the sixteenth century it again became confounded with the vizor, and could be pushed up entirely over the top of the helmet, and drawn down at pleasure. We therefore find Shakespeare making Hamlet say, "He wore his beaver *up*," by which is meant that the face of the wearer was disclosed by the beaver being thrown up over the head, and not hidden by its being drawn up from the chin. While in Henry IV. he shows us that the beaver was also a vizor, for he says,

From the effigy of Thomas, Duke of Clarence. 1421.

"Their beavers *down*,
Their eyes of fire sparkling *through sights of steel;*"

and consequently they must have been drawn down over the forehead and eyes, so as to guard the face, not pushed up to reveal it. (See HELMET and VIZOR.) One of the earliest examples of a movable beaver is seen in the effigy of Thomas, Duke of Clarence, slain 1421, engraved above.

BEAVER-HAT. See HAT.

BECKS or *BEAKS.* Beaks or peaks of the knight's chapeau (see ABACOT), and of the mourning head-dresses of the sixteenth century; but it is by no means clear to what description of head-dress the beak or peak belonged. "The ordinance for the reformation of apparell for great estates of women in the tyme of mourning," issued in the eighth year of the reign of Henry VII. by his mother, Margaret, Countess of Richmond, simply commands that "*bekes* be no more used in any manner of wyse, because of the deformitye of the same." In all MSS. of an earlier period than the date of this ordinance that I have examined the mourners are represented in long black cloaks and cowls, but nothing like a beak or peak is visible. The examples referred to by Mr. Fairholt under this head, in his 'Costume of England,' are not mourning dresses.

BELT, MILITARY, or *OF KNIGHTHOOD.* (*Balteus,* Latin.) This distinguishing feature of the military costume of the fourteenth and fifteenth centuries has been so called by modern antiquaries; not that it is more military or more indicative of knighthood than the common sword-belt with which every knight on his creation was girt from the earliest days of chivalry (see below, under BELT, SWORD); for it was equally worn over the coat-hardie in hall and at banquet, or over the jupon in the lists or the field of battle. Its excessive magnificence, however, when compared with the waist or shoulder belts which had preceded it, and the marked character it imparts to the costume of a particular period, ranging from about the middle of the reign of Edward III. to the end of that of Henry VI., have obtained for it the designation *par excellence* of the "military belt" or "belt of knighthood," as it does not indeed appear to have been worn by any one under the rank of a knight. M. Viollet-le-Duc describes it under the head of "Baudrier," which would lead an English reader to confound it with the baldrick, from which it essentially differed, the latter being worn by all classes and invariably over the shoulder. That *baudrier* in French may be synony-

Military Belt, worn with civil dress. From the monument of Edward III.

mous with *ceinture* I do not dispute, but, except by poetic licence, it has a distinct signification in English. He describes it more appropriately as "*le ceinture noble.*" I am not aware that any portion of one of these belts has been preserved to the present day, and we are therefore left to conjecture respecting the materials of which they were composed. From the admirable representations of them in the monumental sculptures of the time, it would appear that some were wholly formed of square plates of metal linked together, while others had a foundation of leather or

velvet on which similar metal plates were fastened more or less close to each other, the said plates being in either case richly gilt, elaborately ornamented with roses and other objects, and frequently enamelled or set with precious stones. (See Plate IV. fig. 6.) They were not worn round the waist but encircled the hips, and were occasionally furnished like ordinary belts with a buckle and chape, fastening in front in the peculiar fashion of the Garter worn by knights of that most noble Order. They must have been sustained in such a position by some means which are not visible in the generality of instances, and never in the civil dress, to which it is probable they were sown or attached by loops and hooks. In some examples of armed knights they appear to be connected with other belts, but supporting as they seem to do both the sword and dagger of the knight, they must inevitably have slipped down if not very strongly fixed to the jupon, hauberk, or skirt of steel plates, over which we behold them. A small statue of St. George, at Dijon, affords us the rare opportunity of observing the mode by which they were secured in some instances, and we borrow from M. le-Duc another illustration. (See Plate IV. fig. 7.)

Figure of St. George at Dijon.

St. George at Dijon. Back view of Belt.

BELT, SWORD. The mode in which the belt was worn wherein the sword was suspended, has alternated between the two most convenient fashions, according to the form of habit prevailing at the time; now passing over the shoulder, and now girdling the waist. We have no distinct authority for the British period; but the Anglo-Saxons, the Danes, and the Normans, all seem to have preferred the latter. In one of the most ancient Kentish barrows, opened by Douglas, in the Chatham Lines, A.D. 1779, the skeleton of a Saxon warrior was discovered entire, with a leathern strap still unperished encircling the waist, from which, on the left side hung a sword, and on the right a knife or dagger; the brass buckle which had fastened the strap in front being found near the last bone of the vertebræ, where it would naturally have dropped from its original position. In the Anglo-Saxon illuminations the sword appears to be simply stuck into the waist-belt, and not appended to it, and so it is likewise seen in the Bayeux Tapestry, and other pictorial authorities of the eleventh century. In the Cotton MS., Nero C. 4, some drawings, at one time supposed to be of the tenth, but now acknowledged to be of the close of the eleventh or beginning of the twelfth century, present us with the figures of soldiers, one of whom has the sword stuck in the girdle on the left side, while another, whose sword is in his hand, exhibits the scabbard on the right side, worn under the mail hauberk, and passing through a hole in it at the waist; but towards the close of the twelfth century the sword-belt begins to be a very important feature in the military costume, and in the thirteenth affords great scope for the ingenuity and taste of the sculptor. A remarkable instance may be seen in Exeter Cathedral, where the end of the sword-belt of a cross-legged effigy, in the south aisle of the choir, is naturally and gracefully made to protect itself and other portions of the figure from accidental injury. Towards the close of the fourteenth century, when the jupon has superseded the surcoat, they decrease in breadth, and are sometimes altogether dispensed with, the sword being suspended

1.
A Septvans. Chartham Church, Kent.

2.
Brian Lord Fitzalan of Bedale. From Bedale Church, Oxford.

3.
Brass of Sir John de St Quentin, Bransburton Church, Yorkshire.

4.
Sir Walter Arden, Aston Church, Warwickshire.

5.
Detail of Belt in fig. 4.

6.
Brass of a Knight in Laughton Church, Lincolnshire.

7.
Mode of fastening Sword-Belt, 15th cent, from Viollet-le-Duc

8.
Brass of John Cray at Chinnor, Oxfordshire. Ann. 1390.

9.
Sword-Belt. Temp. Q. Elizabeth

from the military hip-belt on the left, and the dagger on the right side. In the fifteenth century it is concealed beneath the tabard, and where the tabard is not worn it is seen to be connected with a waist-belt (see Plate IV. fig. 9), some examples resembling those of our modern cavalry. In the sixteenth, the extreme length of the rapier gave rise to an apparatus for carrying it, known by the name of CARRIAGES or HANGERS. (See under those words.)

In the seventeenth century the sword was again worn in a broad shoulder-belt, emulating the baldric in ornament and amplitude; after which, it disappeared from sight in civil costume, and became in the military much what it is to the present day.

BERGER. (*Shepherd.*) A name given to a curl of hair as worn by ladies, *temp.* Charles II. (J. Evelyn.) A little lock, plain, with a puff turning up like the ancient fashion used by shepherdesses. ('Ladies' Dictionary,' 1694.)

BERIDEL. An article of Irish dress, mentioned in an Act of the reign of Henry VIII., amongst other linen apparel, which was not to be worn coloured or dyed with saffron.

BERYL, BERALLE. A precious stone of a pale sea-green colour; or a species of emerald. (Pliny.) There are varieties pale blue, yellow, and white.

> "The ȝatys [gates] were of fine crystalle,
> And as bryghte as any beralle."
> MS. Cantab. F. f. 11, 38, f. 49.

BESAGNES. This word occurs in Rous's 'Life of Richard Beauchamp, Earl of Warwick.' (Cotton, Julius, E. 4, written in the time of Edward IV.) : "The Erle smote up his vizor thrice and brake his besagnes and other harneys."

Sir Samuel Meyrick considered they were the two small circular plates, about the size of a shilling, which covered the pins on which the vizor turned, and received their name from their resemblance to the coins called "bezants," current during the Middle Ages. Some confirmation is, however, required of this opinion. See HARNESS.

BESAGUE. See BISAGUE.

BIB. The upper portion of the apron, covering the breast; also a cloth worn on the breast by infants. "A stomacher bib" is mentioned as a fashionable article of female attire in 1753. (See BAVARETTE.)

BICE. (*Bis*, old French; *bisus*, Latin.) A term for the colour blue.

> "Mainte eccu bis et rouge."—*Roman de la Rose.*

> "Lescu au col qui fu fet a Paris,
> Et milieu et un grand Lioncel bis."
> *Roman de Garin.*

Also used for

BICHE, BISCHE. The skin of the female deer. By statute 4th Henry IV. furs of biche were prohibited to clergymen below the dignity of resident canon. Thirteen "furres de biches" were valued at 60 shillings. (Rot. Parliament, 2nd Henry VI.)

BIDAG. See DAGGER.

BIGGON, BIGGIN. (*Beguin*, French). A sort of cap or quoif, with ears, formerly worn by men, but in later times only by children. "Upon his head he wore a filthy coarse biggin, and next it a garnish of nightcaps, with a sage button cap." ('Pierce Pennilesse's Supplication to the Devil,' 1592.)

In a masque acted at Whitehall in 1639, and entitled 'Salmacida Spolia,' the fourth entry is "a nurse and three children in long coats, with bibs, biggins, and muckenders."

It was a portion of the official costume of legal personages. In Jasper Mayne's comedy of the 'City Match,' 1639, we read :

> "One whom the good
> Old man, his uncle, kept to the Inns of Court,
> And would in time ha' made him barrister,
> And raised him to his sattin cap and biggon."

From a passage in Chaucer's 'Romaunt of the Rose,' it has been suggested that the word was derived from the head-dress of the order of nuns called Bigins or Beguines. In that poem, Abstinence is described as attiring herself "as a Bigine."

> "A large coverchief of thread
> She wrapped all about her head."

But this does not convey to me the idea of the eared quoif worn under a cap, so often met with in paintings and engravings of the sixteenth century. (See COIF.)

BILL. (Saxon, *byl.*) One of the earliest weapons mentioned in mediæval warfare, and especially used by the Anglo-Saxons. It was with this weapon, which consisted of a sort of axe-blade of iron, sometimes hooked or curved, at the end of a long staff, that the Anglo-Saxon infantry made such havoc in the ranks of the invading Normans in the battle of Hastings. Wace calls them *gisarmes*, but he evidently uses a Norman name for the Saxon weapon, between a variety of which and the Norman *guisarme* there was much resemblance. (See GUISARME.) The bill-hook used by our English rustics to the present day retains the latest form of the ancient offensive weapon in its blade, but with a short handle. The term *byl,* in fact, appears to have been applied by the Saxons to all kinds of axes, as that of *seax* was to every sort of knife or dagger. The *bipennis*, or double-bladed axe, was, for instance, called by them *twy-byl.* "Black " or "brown bills," as they were called, were carried by civic guards in England to the end of the seventeenth century, and the cry of "Bills and bows! Bills and bows!" was the first in every tumult previous to the general use of fire-arms. The bill was gradually superseded in the regular infantry by the pike, which was introduced about the close of the fifteenth century. That the bill was the weapon of watchmen in the times of Elizabeth and James we have abundance of evidence in the dramatists of that period. Dogberry warns his men to take care their bills are not stolen ('Much Ado about Nothing'), and May, in his comedy of 'The Heire,' 1620, makes the constable compare a watchman to a vintner, a tailor, or the like, "for they have *long bills.*" Dekker, in his 'O per se O,' 1612, has given an engraving of a watchman bearing his bill.

Bill.
Temp. Henry VI.

Bill.
Temp. Edward IV.

Bill.
Temp. Henry VII.

Bill
Temp. Elizabeth.

Bill.
17th century.

Sir Roger Williams, in his 'Brief Discourse of War,' A.D. 1590, tells us that the bills of musqueteers "must be of good stuffe, not like our common browne bills, which are for the most part all yron, with a little steele or none at all; but they ought to be made of good yron and steele, with strong pikes at least of twelve inches long, armed with yron to the midds of the staffe, like the holberts." Silver, in his 'Paradoxes of Defence,' 1599, says, "the black bill ought to be five or six feet long, and may not be well used much longer."

BILLIMENT. An abbreviation of *abilliment*, from the French, *habiller*, to dress or attire. The word is generally applied to head-dresses or trimmings of dresses. In the 'History of Jack of Newbury' (*temp.* Henry VIII.) the bride is said to have had her head attired with "a billiment of gold."

BINNOGUE. A head-dress worn in Ireland by the female peasantry of Connaught, mentioned in a letter by Mr. Richard Geoghegan of that county to Mr. Walker, in his 'History of the Irish Bards': "awkward binnogues or kerchiefs on their heads, generally spotted with soot."

BIRNIE. See BYRN.

BIRRUS, BURREAU, BURELLUS. A coarse woollen cloth worn by the lower orders in the thirteenth century.

> "Car aussi bien sont amourettes
> Sou lez bureaux que sous brunettes."
> *Roman de la Rose.*

"Item, legamus c. libras ad burellos emendos pro pauperibus vestiendis." (Will of St. Louis.) A richer sort appears to have been manufactured in the twelfth century, according to the Statutes of the Order of Cluny, in which "pretiosos burrellos" are, with other stuffs, forbidden to be worn by the monks. M. le-Duc says that table-covers were made of it, whence the word *bureau.*

BISAGUE, BESAGUE. (Old French, *besog;* Latin, *besogium.*) A military weapon used by knights to the close of the fourteenth century. In the romance of 'Parthonopex', King Fornegur is described as armed with a long and strong sword, while

> "Another hung at his saddle-bow
> With a besague at his side."

It has been described as a cornuted staff or club, and Mr. Fairholt has given an engraving of a knight so armed from a MS. of the fourteenth century ('Costume in England,' p. 434); but I demur to this opinion. The word *bis-ague,* evidently derived from *bisacuta,* distinctly indicates a two-edged or double pointed or bladed weapon, of which many varieties existed at that period. Under the word *besogium,* in the last edition of Ducange, 1840, we find "Securis duplicem habens aciem. Gall. bêche, pioche, houé, serpe." And this is followed by a crowd of quotations, showing clearly that the term was applied indifferently to a double-bladed axe, an iron-headed staff, a spade, a pickaxe, a hoe or dibble, and a hedging-bill or knife for dressing vines. "L'un des varlets du suppliant eust feru ledit Cayphas d'un cop de besog." (Lit. Remiss. *anno* 1398.) "Unum instrumentum ferreum vulgariter vocatum *besog.*" (*Anno* 1411.) The bisague which concerns us was, I believe, the military pick of the thirteenth and fourteenth centuries, or the "baston cornue" with its two beaks. (See *ante* under BASTON.)

Père Daniel quotes, from an old French poem written *circa* 1376, the two lines following, which I think, decide the question as regards the form of the weapon at that period:

> "Trop bien feroit la besague
> Qui est par les *deux becs* ague."—*Mil. Franc.* i. 433.

BLIAUS. (French, *bliaut.*) A loose upper garment, or surcoat, worn by both sexes of all classes in the twelfth century, and familiarised to us by the modern blouse, which has so nearly

preserved the name. It was worn by knights over their armour, and is frequently mentioned as lined with fur for the winter. In a close roll of the reign of King John, there is an order for a bliaus lined with fur for the use of the queen. For the lower orders the bliaus was made of canvas and fustian. (*Vide* Ducange *in voce* for quotations.) M. Viollet-le-Duc has a long article, profusely illustrated, respecting the bliaus, which he represents as resembling in form almost every sort of surcoat, robe, or gown, of which we possess an example in sculpture or painting.

BLONDE. See LACE.

BLUE-COAT. A blue-coat was the usual habit of a serving-man in the sixteenth, and early part of the seventeenth, century. The dramatists of those periods constantly allude to it.

> "Where's your blue-coat, your sword and buckler, sir?
> Get you such like habit for a serving-man?"
> *Two Angry Wives of Abingdon*, 1599.

> "A country blue-coat serving-man."—Rowland's *Knave of Clubs*, 1611.

> "Blue-coats and badges to follow at her heels."—*Patient Guzzle.*

It is unnecessary to multiply quotations.

The blue-coat appears also to have been the dress of a beadle as early as the days of Shakespeare. Doll Tearsheet calls the beadle a "blue-bottle rogue" in the 'Second Part of King Henry IV.'; also in Nabbes's 'Microcosmos,' 1637: "The whips of furies are not half so terrible as a blue-coat;" and the custom has continued to this day. The blue-coat laced with gold, and sometimes with a red cape, are additions of the last century. The form of the blue-coat worn in the time of Edward VI. has been preserved in the dress of the scholars of Christchurch School, London, founded by him. "Blue-coat school" and "blue-coat boys" are appellations familiar to all Englishmen. Howe, the continuator of Stowe's 'Annals,' tells us that many years before the reign of Queen Mary (and therefore as early as that of Henry VIII., at least), all the apprentices in London wore blue cloaks in the summer and blue gowns in the winter.

BLUNDERBUSS. A short fire-arm with a wide bore, and sometimes bell-mouthed, now rarely seen, but carried by mail-guards as late as 1840. One of that date is in the Tower Armoury. Sir J. Turner, writing in the time of Charles I., says, " I do believe the word is corrupted,

for I guess it is a German term, and should be '*Donderbucks*;' and that is, 'thundering gun,' *Donder* signifying thunder and *Bucks* a gun." This was shortly after its introduction, and if we read "Dutch" for "German," the derivation may possibly be correct. The barrel was commonly of brass. It does not appear to have been much used as a military weapon in

Blunderbuss. 17th century. From the Meyrick Collection.

England, but as a defence against housebreakers and highwaymen, and for the latter purpose carried by the guards of the royal mail coaches within my recollection. Our example is an early one, formerly in the Meyrick Collection, and which bears a strong family likeness to the bell-mouthed harquebuss, probably its prototype. (See HARQUEBUSS.)

BOB. (See WIG.) In the reign of William III.

BOB-TAIL was the name given to "a kind of short arrow-head." The steel of a shaft or arrow that is small breasted, and big towards the head." (Halliwell *apud* Kersey.)

BOBBIN. "A cord or twist of cotton, used to fasten portions of female attire." ('Ladies' Dictionary.')

BODICE. "A pair of bodies" is mentioned in the fifteenth century, and the modern word "bodice" is evidently derived from it. It occurs in the latter form in a list of the articles of a lady's wardrobe in a play called 'Lingua; or, the Combat of the Tongue and the Five Senses for Superiority,' published in 1607. A "buttoned bodice skirted doublewise" is mentioned in Goddard's 'Mastiff Whelp,' a collection of satires of the time of Elizabeth, as forming part of a lady's riding-habit. The coxcombs of the seventeenth century wore bodices, as the dandies now wear stays:

> "He'll have an attractive lace,
> And whalebone bodies, for the better grace."
>
> *Notes from Black Fryers*, 1617.

BODKIN. A hair-pin. This well-known article of a ladies hair-dress has been used from the earliest times in England. Bodkins of bone and bronze have been found in early interments, and were used also for fastening the mantles of the Britons; but it is principally as an ornament for the hair that we find it in the catalogue of female attire. By the Saxons it was called a hair-needle : hæp-næðl.

A bronze pin, supposed to be used for the hair, was discovered some thirty years ago in a Saxon barrow on Breach Downs, near Canterbury. We subjoin an engraving the size of the original.

Bodkins for the Hair.
1. Bronze Bodkin. From a Saxon barrow on Breach Downs, near Canterbury.
2 and 3. Saxon. British Museum.

"He pulls her bodkin, that is tied in a piece of black bobbin." ('Parson's Wedding,' 1663.)

"A sapphire bodkin for the hair." (J. Evelyn, 'Mundus Muliebris; or, the Ladies' Dressing-room unlocked and her Toilet spread,' 1690.)

> "A silver bodkin in my head,
> And a dainty plume of feather."
>
> D'Urfey's *Song of the Poor Man's Portion.*

The name was also given to a small dagger.

BODKIN-WORK. "A sort of trimming anciently used for women's gowns, made of tinsel or gold thread." (Bailey.)

BOLT. An arrow.

> "To a quequer [quiver] Robin went,
> A good bolt out he toke."—*Robin Hood.*

Bolt, as a general name for an arrow, occurs in many old proverbs: "Wide, quoth Bolton, when his bolt flew backwards." "A fool's bolt is soon shot," &c. Small bolts were used for shooting birds with, and called "bird-bolts." "The bird-bolt is a short, thick arrow without point, and spreading at the extremity so much as to leave a broad flat surface about the breadth of a shilling." (Stevens' note to 'Much ado about Nothing,' act i. s. 1.)

Bird-bolt. From the 'Livre de Chasse' of Gaston Phœbus, 15th century, and Douce's 'Illustrations of Shakespeare.'

BOMBACE, BOMBASE, or *BOMBIX.* Under which name it appears to have been known as early as the thirteenth century. Cotton from Bombay.

> "Here shrubs of Malta for my meaner use,
> The fine white ball of bombace to produce."
>
> Halliwell, *apud* Du Bartas, p. 27.

BOMBARDS. See BREECHES.

BOMBAST. Stuffing for clothes, made of wool, flax, or hair, much used in the reign of Elizabeth and James.

> "Thy bodies bolstered out
> With bombast and with bagges."
>
> Gascoigne's *Fable of Jeronimo.*

See BREECHES, DOUBLET, and HOSE.

BOMBAZINE. A stuff composed of silk and cotton, so-called from "bombax" or "bombix," the ancient name for cotton. (See BOMBACE.) Bombazine was first manufactured in this country in the reign of Elizabeth. "In 1575, the Dutch elders presented in court (at Norwich) a specimen of a novel work, called 'bombazines,' for the manufacturing of which elegant stuff this city has ever since been famed." (Burns's 'History of the Protestant Refugees in England.')

BONE-LACE. See LACE.

BONGRACE. (French.) This article of female attire is described by Mr. Fairholt in his 'Costume of England,' p. 441, as "a frontlet attached to the hood, and standing up round the forehead, as worn by Anne Bullen" in the engraving of her at page 243 of his work; and he quotes in support of this opinion,

> "Here is of our lady a relic full good :
> Her bongrace, which she wore with her French hood,"

from Heywood's 'Merry Play between the Pardoner and the Frere,' 1538 ; also from John Heywood's 'Dialogue of Proverbs':

> "For a bongrace,
> Some well-favored vizor on her ill-favored race."

The word "vizor" in the latter quotation is certainly in favour of his opinion, otherwise there is nothing positively to identify the bongrace with the stand-up border of the well-known head-dress which antiquaries have, for want of reliable information, described as "the diamond-shaped head-dress." It is at any rate clear from the first quotation, that whatever the bongrace was it was worn with the French hood, under which article we shall further inquire into the subject. In 1694 it is described as "a certain cover which children used to wear on their heads to keep them from sun-burning, so called because it preserves their *good grace* and beauty." ('Ladies' Dictionary.' See CORNETTE.)

BONNET. (See CAP.) The word, from the French, *bonnet,* is now, except in Scotland, applied by us only to the well-known article of female attire, the introduction of which is of too recent a date to demand further notice in this work, beyond the record of the fact, that it was first made of straw, and succeeded the flat Gipsy hat towards the close of the last century. Straw bonnets were in full fashion in the year 1798.

BOOT. (French, *botte.*) Under the latinized form of *bota, botarum,* we find these familiar articles of costume mentioned in early Anglo-Norman documents, but from pictorial illustrations it would appear that, whether worn by men or women, the boots of the first century after the Conquest were simply varieties of what we should now call half-boots, bottines, or even high-lows, such as we see indeed in the Anglo-Saxon illuminations, but cannot identify with any term we meet.

with in these MSS. *Scin-hose* and *pad-hose* may probably designate them, but I would not venture to assert it. The Latin words *ocrea, æstivales, sotulares,* etc., afford us no assistance, as they are applied to greaves, buskins, and other protections or coverings for the legs, or any portion of the legs, and have been rendered into French or English according to the fancy of the translator. (See under BUSKIN, HOSE, SHOE, and START-UP.) In a window of the thirteenth century, engraved in M. Paul la Croix's beautiful work, we are startled by the appearance of something like a pair of Hessian boots in a boot-maker's shop, from their immense size probably the sign of his trade, an apprentice being at

work at one of reasonable dimensions. But it is not till we have advanced far into the fifteenth century that we discover any other example approaching to the full or high-boot of later days. In the illuminations of MSS. of that period they are frequently depicted— the toes in some instances preposterously long, gene- rally painted black, with a turn-over top of brown leather, reminding us of the modern top-boot. The boots which are entered in the wardrobe accounts of Edward IV. are of two kinds, one sort reaching only to the knees and the other above them. They are also described as lined and single. Boots of Spanish

Bootmaker. From a painted window. 13th century.

tawny leather reaching to the knee are charged sixteen-pence the pair; black leather of the same length at three shillings each, being single, i.e. without lining. Boots of red Spanish leather extending above the knees without lining, at six shillings. The same black, six-and-eightpence; when lined, as high as eight shillings the pair. Towards the end of this reign the points were abandoned, and the fashion ran to the opposite extreme, at first taking something of the form of the foot and then becoming so excessively square-toed that the law, which had formerly limited the length, was now called on to abridge the breadth of these pedal terminations. We give examples of these fashions below; the first being from Royal MSS., 15 E. 2, dated 1482. The toes of the boots during the reign

Temp. Edward IV. *Temp.* Henry VII. to Henry VIII. *Temp.* Henry VIII. *Temp.* Elizabeth.

of Henry VII. and Henry VIII. varied continually in breadth, but the absurdly long-pointed toe never again made its appearance. The boots worn in the reign of Edward VI., Mary, and Elizabeth, were wider at the top, and could be pulled up over the knee and half-way up the thigh, meeting the trunk hose of that period. In the time of James I. we learn that a lady "admires the good wrinkle" of a gallant's boot ('Return from Parnassus,' 1606,) and during this reign it had become fashionable for gentlemen to walk in boots, they having previously been only worn when riding: "He's a gentleman, I can assure you, sir, for he always walks in boots." ('Cupid's Whirligig,' 1616.)

This is curiously corroborated by Fabian Phillips, in a work published in 1663, at which time, he says, "boots are not so frequently worn as they were in the latter end of King James's reign, when the Spanish ambassador, the Conde de Gondomar, could pleasantly relate when he went home into Spain that all the citizens of London were booted, and ready, as he thought, to go out of town."

In the diary of expenses of a foreign gentleman, preserved in the museum of Saffron Walden, containing entries from 1628 to 1630, there is an entry under the latter date of payment "to a boot-

maker for one pair of boots, white and red, 14s." This probably means a pair of white boots with red tops, which are often seen in paintings of that period. The tops increased in size amazingly in the time of the Commonwealth and in the reign of the second Charles, when, after the fashions of the court of Versailles, the gallants of Whitehall had the upper portion of their boot-hose trimmed with a profusion of costly lace, which formed as it were a lining to the expanded boot-top, and edged it all round. In the time of James II. what is commonly known by the name of "jack-boot" (being, like the drinking vessel called a "black jack," made of "jacked" leather,) first makes its appearance. These excessively ugly, cumbersome, stiff inventions gradually diminished in size and rigidity during the reigns of the first two Georges. In that of George III. the Hessian boot was added to the catalogue, and the top-boot, so called from its brown leather tops, was generally worn by civilians in England and by the officers in the French Republican army. In England they were not only worn for riding but were fashionable amongst "the bucks and bloods" of the day as a portion of their walking dress. Their length was regulated by that of the buckskin or drab kerseymere knee breeches, which at one time descended nearly half-way down the leg.

Charles I. Charles I. Commonwealth. Commonwealth.

Charles II. James II. William III. Jack-boot. Latest form. 1702-14.

Malcolm, writing at the beginning of the present century, says, "Half and whole boots are, I believe, everything but slept in." ('Anecdotes,' 187.)

Boots for women are mentioned as early as the twelfth century. In a tiring roll of the 2nd of King John, A.D. 1200, there is an order for four pair of women's boots: 'Quatuor parium *botarum ad fœmina,"* and one pair of them to be ornamented with circles. Strutt quotes an old French author, who speaks of the *cortes botes* worn by women, and also tells us that the nuns of Montmartre were permitted to use boots lined with fur; but these short or half boots will be further illustrated under the head of BUSKIN.

BOOT-HOSE. See HOSE.

BOSON. A name given to the peculiar sort of bolt or arrow, described by Randal Holmes as "an arrow with a round knob at the end of it, and a sharp point proceeding therefrom." The Norman family of Boson bore three bosons.

Arms of Bozun or Boson.

BOSS. (*Bose*, French.) The central projection of a buckler or shield, in Latin called *umbo ;* also for a small buckler itself. (See under those heads.)

BOSSES. Certain projections of the head-dress of ladies of the fourteenth century. (See HEAD-DRESS.)

BOTTINE. See BUSKIN.

BOUCHE. (French.) An indentation in the upper portion of the shield to admit the passage of the lance. It is first seen in England at the commencement of the fifteenth century, *temp.* Henry IV. (See SHIELD.)

BOUCHETTE. "The large buckle used for fastening the lower part of the breast-plate (the placard or demi-placate) to the upper one." (Fairholt, 'Art in England.' See PLACARD.)

BOUFFETTE. An ear-bow of ribbon.

BOUFFON, BUFFONT. A neckerchief of cambric or gauze, worn by ladies in 1786, and so called from the French *bouffir*, to puff or swell. (See cut, from caricature of that date, entitled 'Modern Elegance.' Above them is drawn the figure of a Pouter pigeon.)

Bouffons. From a caricature of the period.

BOUGE. See VOULGE.

BOURDON. (French.) A walking or pilgrim's staff, from whence

BOURDONASS. A lance or javelin, the handle of which was hollow. The Count de Comines, in his description of the battle of Fornoue, says: "Nous feismes descendre les varlets et amasser des lances par le camp dont il y avoit assez, par especial des bourdonasses, qui ne valoit gueres et etoient creuses et legeres, ne pesant point une javeline, mais bien peinctes." Mr. Hewitt, who quotes the above passage, refers to the Beauchamp Accounts, 15 Henry VI., as given in Dugdale's 'Warwick-shire,' for an illustration of the painting alluded to ; but it may be questioned whether the "one grete burdon peynted with reed" [red], and the "i nother burdon wyrithyn with my lords colours, reed [red],

white, and russet," were the military weapons called "bourdonasses," or simply bourdons—walking or processional staves. The pilgrim's bourdon described by Piers Plowman is said to have been

> "a burdon y-bounde
> With a broad liste in a witherwynde wyse,
> Y-wounden aboute."

Pilgrim with Bourdon. 13th century. Sir John Mandeville as a Pilgrim. Pilgrim with Bourdon. 15th century.

(We append also a fac-simile drawing of Sir John Mandeville in a pilgrim's dress, from a MS. copy of his 'Travels,' in the British Museum. Spear shafts, banner staves, and all sorts of wooden handles, were painted in this "wyse," as familiarly exemplified in the now almost extinct barber's pole, and the still common pole turn-pikes in Germany. The family of Bourdon bear three pilgrims' staves in their arms.

BOURGOIGNE. Mentioned by Evelyn as a portion of a lady's head-dress, *temp.* Charles II. (*Vide* 'Book of Costume,' p. 136.) In the 'Ladies Dictionary,' 1694, it is described as "the part of a head-dress that covers the hair, being the first part of the dress."

Arms of the Family of Bourdon.

BOW. (Celtic, *bwa.*) This once formidable weapon of the English infantry is one of the oldest in the world. That it was known to the Britons is evident from the constant discovery of arrow-heads of flint and bronze, independently of the fact that the word itself is of Celtic origin ; but it is possible that they used it for the chase more than for warfare, as it is not recorded among their military weapons by Cæsar, or any of the Greek or Roman writers who have touched upon the subject. The Romans themselves were not famous for their archery, the *sagitarii* in their armies being generally auxiliary troops of Asiatic origin. The Saxons also do not appear to have distinguished themselves in the use of the bow as a military weapon, for according to Henry of Huntingdon, William the Conqueror actually reproached them with their want of it altogether. This, if true, however, must have been an exaggeration, as in the Anglo-Saxon illuminated manuscripts we find

the bow frequently represented, and arrow-heads are constantly found in their graves ; while in the most ancient pictorial representation existing of the battle of Hastings, viz. the Bayeux Tapestry, the Saxon archers in the van of Harold's forces are depicted exchanging shots with their Norman antagonists. With the Danes and Northmen generally the bow was a most favourite weapon, and the expert use of it was indispensable to the list of qualifications of a warrior. Olaff Treggvason is said to have been so famous a bowman that none could equal him ; and Kali, Earl of the Orkneys, boasts that he excels in shooting with the bow. From the time of the Conquest until long after the invention of fire-arms, the long-bow maintained its prominent place in our armies. In a military treatise of the time of Queen Elizabeth it is said, " None other weapon can compare with this noble weapon ;" and King Charles I. twice granted special commissions under the great seal for enforcing the use of the long-bow. In early Saxon illuminations the bow is sometimes represented of the classical form, such as we see it in the hands of Apollo and Cupid, composed of two arches, connected in the middle by a straight piece ; but in the eleventh century it is the ordinary bow of one uniform curve, but shorter, it would seem, than

Archer. From Bayeux Tapestry.

Bow.
From Anglo-Saxon MS.,
Harleian, 503.

the bow emphatically called "the long-bow," the stave of which measured ordinarily six feet, and sometimes more. They were chiefly made of yew ; but ash, elm, and witch-hazel were also used. The strings were made of hemp, flax, and silk. In the reign of Edward III. the price of a painted bow was one shilling and sixpence, and that of a white bow one shilling. In the reign of Elizabeth bows of foreign yew were directed to be sold for six and eightpence, the second sort at three and fourpence, and the coarse sort, called "living bows," at a price not exceeding two shillings each, and the same for bows

Bow and Arrow. From Anglo-Saxon MS., Tiberius, C. vi.

of English yew. The bow was commonly carried in a case, to keep it dry and prevent its warping. In Shakespeare's play of Henry IV. Sir John Falstaff is made to call the Prince of Wales "a bow-case," in allusion to his slender make. Two long bows recovered from the wreck of *The Mary Rose* are to be seen in the Tower Armoury, undoubted relics of the reign of Henry VIII.

BOW, CROSS. See ARBALEST, LATCH, and PRODD.

BRACELET. This well known ornament was commonly worn by the better classes of both sexes, and of all the earlier races inhabiting the British Isles, Britons, Romanized-Britons, Saxons, and Danes, but by the Normans more sparingly. Bracelets were never entirely banished from the catalogue of ladies' ornaments, but from the fifteenth century they became more general, and since that period have been always more or less in fashion. In the early interments bracelets have been found of bone or ivory, bronze, silver, and gold. Dion Cassius describes Boadicea as wearing bracelets on her arms and wrists. William of Malmesbury tells us that the Saxons at the time of the Conquest were in the habit of loading their arms with them: *brachia onerati ;* a fashion which the monkish writers assert was borrowed from the Normans, whose customs at that period they greatly affected. In the will of Brithric and his wife Elfswythe an arm-bracelet is mentioned weighing 180 mancuses of gold, nearly twenty ounces troy weight ; and another bequeathed to the queen, weighing 30 mancuses of gold, or three ounces and a half. (Hickesii Dissert. p. 51.) Ethelstan is called in the Saxon Chronicle, " the child of the bracelet givers," *sub. anno* 938.

All the Northmen seem to have been fond of these particular ornaments. The Sagas are full of allusions to them.

"She, the queen, circled with bracelets."—Poem of *Beowulf.*

The golden bracelets (two on each arm) worn by the soldiers on board the vessel presented by Earl Godwin to Hardicanute, weighed each sixteen ounces. A silver chain, each link of which

Chain of Bracelets of Silver. From Queen's County, Ireland.

opens and appears as if intended to form a series of bracelets or armlets, was found in 1817 in an old ditch on the borders of Queen's County, Ireland. The weight of the whole chain was eleven ounces and three-quarters. Bracelets (*armillæ*) formed part of the coronation paraphernalia of our English sovereigns to a very late date.

But though it is quite possible that bracelets were worn during the thirteenth, fourteenth, and fifteenth centuries by ladies, we do not find them mentioned amongst the various personal decora-

British Bracelet or Armlet of Gold.

tions of the female sex so constantly to be met with in the romances and fabliaux of the Middle Ages. In the sixteenth century they had evidently recovered their popularity, possibly from the shortening of the sleeve and consequent display of the arm to the elbow.

British Bracelets of Gold.

"I would put amber bracelets on thy wrists,
Crownets of pearl about thy naked armes."
Barnfield's *Affectionate Shepherd,* 1594.

Stubbs, the great *censor morum* of the reign of Elizabeth, says, "their fingers must be decked with gold, silver, or precious stones, their wrists with bracelets and armlets of gold and costly jewels." From this time the allusions to them are constant, and it is needless to multiply quotations or descriptions of so familiar an object.

BRACER. The guard for the left arm worn by archers, to protect it from the action of the string of the long-bow. In the Prologue to the 'Canterbury Tales' the yeoman is described as having "upon his arm a gay bracer." "A bracer serveth for two causes: one to save his arme from the strype of the stringe and his doublet from wearing, and the other is that the stringe, gliding sharply and quickly off the bracer, may make the sharper shot." (Roger Ascham.) In the Meyrick

Ivory Bracer. Meyrick Collection.

Collection was an ivory one of the reign of Elizabeth, which we engrave.

BRANC. A linen vestment similar to a rochet, worn by women over their other clothing. Strutt *apud* Charpentier.

BRAND. (*Branc, brans,* French.) In the old French romances this term is applied to a species of sword, which was hung on the right-hand side of the saddle.

"Li quens voit le bauchant devant lui aresté
Et li dois branc pendoient a l'archon noielé."—*Fierabras.*

"Richart gete la lance, trait le branc d'acier et air."—*Ibid.*

It appears to have been similar to, if not identical with, the ESTOC, which see. Brand in English poetry signifies simply a sword.

"With this brand burnyshed so bright."—Townley Mysteries.

BRANDEBOURG. See CASSOCK.

BRANDEUM. A costly manufacture of silk or cloth. Du Cange imagines the former; but the numerous quotations only show that it was a rich material used for various purposes: palls, mitres, girdles, &c. I consider it to have been embroidered, as "brandata" is written for "braudata," *acupictus*, and may be the derivation of the word.

BRAQUEMART. See SWORD.

BRASSART, BRASSARD, BRASER. (*Bras*, the arm, French.) That portion of plate armour which protected the upper part of the arm from the shoulder to the elbow, and thence to the wrist;

Brassarts formed of strips of Metal. Effigy of Schwein-furt, 1369.

Brassart of Cuir bouilly. Effigy at Naples, 1335.

Brassarts of Plate. Brass of Wm. de Aldeburgh, 1300, in Alde-borough Church, Yorkshire.

Brassarts of Plate. Connecting with Elbow-pieces. Sloane MS. 346, *circa* 1330.

Brassarts.
From effigy in marble of Charles Comte D'Alençon, 1345, in the Church of St. Denis. M. Viollet-le-Duc.

Brassarts. Brass of Ralph de Knevynton, 1370, Aveley Church, Essex.

the former being distinguished as the "rere-brace" and the latter as the "vant-brace" (or, as it is sometimes written, "vambrace") from the French *arrière-bras* and *avant-bras*. Arm defences, called

Brassarts. From effigy of Louis de Sancerre, 1432. Church of St. Denis.

in French *brachierres*, are mentioned as early as the 6th of Edward I., 1278, but the armour ordered for the equipment of the knights in that tournament was all made of leather, pasteboard, buckram, &c., being a mere pageant, a jest instead of a joust, and affords us no further information than the fact of the existence of brassarts at that period. Shortly afterwards they are seen of one piece of plate or cuir bouilly, or leather studded with steel and other varieties of protective materials, simply strapped round the arm and only covering the outside of it.

Brassarts. 1535. Meyrick Collection.

Later in the fourteenth century they are all of plate and encompass the whole arm. In the fifteenth century they were occasionally formed of three or more pieces, and in the sixteenth and seventeenth invariably so.

BREAST-KNOT of purple ribbon, fashionable in 1731. ('Weekly Register,' July 10.) A
'French embroidered knot and *bosom*-knot" are valued, in 1719, at *2l. 2s.*

BREAST-PLATE. Under this head I shall only describe the especial piece of defensive
armour, properly so called, and not the variously named plates of iron or steel which were worn
under the hauberk of mail previous to the middle of the fourteenth century. The Florentine annals

Fig. 1.—Breast-plate. *Temp*. Henry VI. 2.—Back-plate. Meyrick Collection. 3.—Breast-plate. *Temp*. Henry VII.
Meyrick Collection.
From Skelton, Plate XV.

give the year 1315 as the date of a new regulation on armour, by which every horseman who went to
battle was to have his helmet, breast-plate, gauntlets, cuirass, and jambes, all of iron : a precaution
taken on account of the disadvantage which their country had suffered from their light armour at the
battle of Catina. Shortly after this period we begin to read in wills, accounts, inventories, and

4.—*Temp.* Henry VII. Meyrick Collection.

other documents, of "steel plates" (*plates d'acier*), "a pair
of plates," "a pair of plates large," and also of "a breast-
plate." Sufficient evidence has not yet been adduced as
to the absolute signification of those terms. They may
have been plates worn under the hauberk, and similar to
if not identical with the pectoral, the plastron, the steel-
piece (*pièce d'acier*), &c., which will be treated of under
their separate heads ; but the fact that they are named
occasionally in company with the *pièce d'acier*, and that
the "plates" appear to have been always covered with
velvet, silk, cloth of gold, or other rich material, certainly
favours the presumption that they were worn over the
coat of mail. Still there remains the probability that,
even in that case, they were only such plates as are seen
in the figures from Bamberg Cathedral engraved in the
second volume of Mr. Hewitt's 'Ancient Armour' (pp. 138, 139). In one of the illuminations in
the curious MS., 'The Metrical History of the Deposition of Richard II.' (Harleian MSS.), Boling-
brook is represented with a breast-plate over his black tunic ; and in a MS. of the reign of
Henry IV., formerly in the library of H.R.H. the late Duke of Sussex, a figure kneeling and
holding a sword has a globular breast-plate, unmistakably without a back-plate, fastened over the

body of his gown, the long scolloped edge sleeves of which are so characteristic of the end of the fourteenth and beginning of the fifteenth centuries. I shall therefore, under this head, speak only

5, 6, 7.—Breast-plates. Reign of Henry VIII. From 1520 to 1530.

8.—Long-waisted Breast-plate.

9.—Breast-plate of Demi-Lancer. 1555.
Meyrick Collection.
Skelton, Plate XXVI.

10.—Back-plate of Demi-Lancer. 1555.
Meyrick Collection.

11.—Breast-plate. *Temp*. Elizabeth.

12.—Breast-plate. Pikeman's Armour, 1635.
Meyrick Collection.

13.—Breast-plate of blue Steel.
Cuirassier's Armour, 1645. Meyrick Collection.

of the breast-plate when it appears in all its brightness at the latter period, and connected with a back-plate, of which we then for the first time find distinct mention, viz. "the era of complete

plate," as it has been justly called, and of the reign in England of one of its most chivalric sovereigns, Henry V. An illumination in the Bedford Missal represents the king being armed by his esquires or pages, and the breast-plate appears extremely globose and the waist short. The multitude of fine effigies and brasses of this date, presents us a series of examples, from which we learn that the globular short-waisted breast-plate was not general, or did not remain long in fashion, as its form in the majority of instances is more graceful and in accordance with the natural shape of the body. (See ARMOUR.) In the following reign, of Henry VI., both the breast-plate and back-plate are composed of two pieces, the lower one overlapping the other, and attached to the upper by a strap, fastened by a buckle, or by a bolt and staple. (See PLACARD.) In some instances the lower portion is articulated, that is, composed of two or three pieces sliding on rivets, so as to facilitate the movements of the wearer, the edges being elegantly indented (figs. 1 and 2). This fashion lasted, with some variations, to nearly the close of the fifteenth century. The reign of Henry VII. presents us again with the globose and short-waisted breast-plate, which is frequently fluted, as is the whole suit, and sometimes the upper half of it plain or engraved (figs. 3 and 4). It continued globose during the early portion of the reign of Henry VIII., being occasionally puffed and ribbed, raised, or engraved, in accordance with the rest of the suit. (See ARMOUR.) Towards the middle of this reign, the breast-plate rose to an edge down the centre, which was called the "tapul," gradually becoming more decided, till at length it presented a salient angle in the centre (figs. 5, 6, and 7). A fashion also arose of a very ugly description, called the "long-waisted," or "long-breasted"

14.—The Back-plate of blue Steel, with Culette or Garde de Rein attached. 1645. Meyrick Collection.

armour, of which the breast-plate, of course, was the principal feature (fig. 8). It was, however, speedily discarded, and during the rest of the century the breast-plate took the form of the body, or rather of the civil doublet of the day, preserving the raised edge or tapul, the salient point descending gradually till it disappeared altogether (figs. 9 and 10); in the latest examples forming a beak at the bottom of the breast-plate, projecting downwards in conformity with what was called the "peasecod-bellied" doublet of the day (fig. 11). The breast- and back-plate continued to be worn over the buff coat long after armour for the limbs had been relinquished (figs. 12, 13, and 14), and after a century's disuse were re-introduced in the English army subsequently to the battle of Waterloo. (See BACK AND BREAST, CORSLET and CUIRASS.)

BREECHES. (*Breac*, Celtic; *braccæ*, Latin). The word "breeches," in its present acceptation, describes a portion of male attire, to which it was first applied towards the end of the sixteenth century. The braccæ of the Gaulish Britons and other Celtic nations were trowsers, full and gathered at the ankle, the prototypes of the Highland *truis* of the present day. (See TROWSERS.) In the Museum of the Royal Irish Academy, Dublin, some most interesting relics of the old Irish dress are preserved, and among them a pair of chequered trowsers, the precise age of which I will not presume to determine, but undoubtedly of the form and pattern worn by the earliest Celtic inhabitants of that island. The word, during the Middle Ages, signified what we now term "drawers" (see that word). It is not until the reign of Queen Elizabeth that we find the word "breeches" applied to

that outer garment, which had been previously called HOSE, UPPER-STOCKS and SLOP. (See those words.) In an inventory taken at Barmston, 28th February, 1581, of "the goods & chattels of Sir Thos. Boynton, Knight, deceased," I find, "Item 6 pare of velvet brytches with thre pare of lether brytches." In an old ballad, quoted by Mr. Douce, entitled, 'A lamentable Complaint

Bombasted Breeches. *Temp.* Elizabeth.

of the Countrymen for the loss of their Cattelles Tails,' (Harleian MS., British Museum), it is asserted that these caudal appendages were used by gallants who delighted

> " With woole, with flaxe, with hair also,
> To make their breeches wyde."

Peirce Penniless, A.D. 1592, says, "They are bombasted like beer barrels." They were so wide about the middle of the reign of Elizabeth that a gallery or scaffold was erected to accommodate members of Parliament who wore them.

Dalzel, a contemporary of King James, informs us in his 'Fragments of Scottish History' that that monarch had "his breeches in great plaits and full stuffed;" and in an old play of that reign we read, "his breeches must be pleated as if he had thirty pockets." ('Ram Alley,' 1611, act iv. s. 1.) In 'A Jewel for Gentry,' printed in 1614, is an engraving of James I. and his attendants hawking. The king is represented in stuffed breeches tapering to the knee, profusely slashed and striped with lace. In the reign of Charles I. the bombasting or stuffing of the breeches was discontinued, and they took the form of short trowsers, loose to the knee, ending with a fringe or row of ribbons. On the restoration of Charles II. the petticoat-breeches were introduced from the court of Versailles. Randal Holmes says, "at the latter end of 1658 were introduced short-waisted doublets and petticoat-breeches, the lining lower than the breeches, tied above the

James I. From 'A Jewel for Gentry.' 1614.

knee, ribbons up to pocket-holes half the breadth of the breeches, then ribbons all about the waistband, and shirt hanging out." This fashion went out before the end of the reign; and with William III. came in the tight knee-breeehes, which during the last century were worn by all classes, and still form a portion of English costume. At first they did not cover the knee, the stockings

Temp. Charles II.

Temp. Charles II.

being brought up over them, nearly to the middle of the thigh; but afterwards they were buttoned beneath the knee, and fastened additionally by gold, silver, steel, diamond, or paste buckles. Towards the close of the last century knee-buckles went out of fashion, except for court dress, and strings were introduced. In 1703, an advertisement, quoted by Malcolm, describes the breeches of a youth of the middle rank of life, as being made of " red shag, striped with black stripes"; but at this period, the long flaps of the waistcoat nearly meeting the stockings, the breeches were scarcely to be seen. In the reign of George II. black velvet was extremely fashionable for these nether garments. In 'Mist's Journal,' 1727, we have the description of the dress of a beau, who is advised

" In black velvet breeches let him put all his riches;"

and in another satire of the same date, occurs the line,

" Without black velvet breeches, what is man?"

Petticoat-Breeches.
Temp. Charles II.

In 1753, the breeches were again worn short, for the beau is described

" With breeches in winter would cause one to freeze,
To add to his height must not cover his knees."
Receipt for Modern Dress.

Nine years afterwards we find fashion, as usual, running into the opposite extreme, for in 1762 we learn from the *London Chronicle*, that " The mode makers of the age have taken an antipathy to the leg, for by their high-topped shoes and long trowser-like breeches, with a broad knee-band like a compress for the rotula, a leg in high taste is not longer than a common councilman's tobacco stopper." Doe or buckskin breeches were much worn by gentlemen in the latter half of the last century, even for walking dress, and it was the fashion to have them made so tight that the most extraordinary and absurd means were resorted to for putting them on. A gentleman is said to have told his tailor when ordering a pair, " If I can get into them, I won't have them."

BRENE. See BROIGNE.

BRICHETTES. Armour protecting the loins and hips, composed of culettes and tassets, appended to the back and breast-plates, was collectively so called.

BRIDGWATER. A sort of broad cloth manufactured in the town of that name, and mentioned in an Act of the 6th Edward VI., A.D. 1553. (Ruffhead, vol. ii.)

BRIGANDINE, BRIGANTAYLE, BRIGANDYRON. Body armour composed of iron rings or small thin iron plates, sewed upon canvas, linen, or leather, and covered over with similar materials, deriving its name from troops called *brigans*, an irregular sort of infantry of the thirteenth

century, by whom they were first worn. When covered with white linen, cloth, or fustian, they were called "miller's coats"; but persons of condition had them covered with silk velvet and cloth of gold. Archers and cross-bowmen are generally represented in these quilted coats or jackets. (Specimens are to be seen in the Tower and other collections.)

"Lequel l'Estourmey vestit icelles *brigandines* en disant que cestoit une belle jaquette." (Lit. Remiss. A.D. 1456.)

Meyrick describes the one in his collection "as composed of a great number of rudely-shaped pieces of flat iron, quilted between two pieces of canvas, the exterior being of a sky blue colour, and the small cords which perform this operation are seen in straight and diagonal lines knotted together at their intersections outside." Skelton has engraved a portion of it, showing the holes in the edge for lacing it down the front.

Grose observes that it is frequently confounded with the JACK, and sometimes with the HABERGEON; but see those words, and also JAZERANT. In Brander's MS. ('Inventory of Armour in the Royal Arsenals,' 1546), were mentioned a variety of brigandines, some styled "complete," having sleeves covered with crimson, or cloth of gold, others with blue satin, and some with long taces or skirts.

Brigandine Jacket. In the Tower Armoury.

> "Of armis and of brigantayle,
> Stood nothing thanne upon batayle."
> Gower MS., Soc. Arch.

BROCADE. (*Brocat, brocard,* French; from *brocher,* to work with the needle, to stitch, to knit.) A rich stuff of silk and gold or silver: "Aurum vel argentum serico intexere." (Ducange *in voce* Brocare.) "Casulam panni rubii brocato di auro." ('Charta Antiqua,' A.D. 1382.) At this period the word was probably applied to stuffs embroidered by the hand. In the inventory of the wardrobe of Edward IV., 1481, we read of "cloth of gold broched upon satin ground," and "blue cloth of silver broched upon satin ground." And as late as the reign Henry VIII., Hall, the chronicler, tells us that the French king, Francis I., at the celebrated meeting of those two sovereigns in the Vale of Ardres, wore a cloak of "broched satin" with gold and purple colours, wrapped about his body traverse. In an inventory of the wardrobe of King Charles II., dated 1679, we meet with "white and gold brocade," at 2*l.* 3*s.* 6*d.* per yard, and "colour du prince brocade," at 2*l.* 3*s.* per yard, and after that period the mention of this still fashionable material becomes common. In 1719, "a mantua and petticoat of French brocade" is prized at 70*l.* "Flowered brocades" are named as fashionable in 1766, and several advertisements of lost female apparel at nearly the same date, quoted by Malcolm, corroborate the popularity of brocades and brocaded dresses at the commencement of the reign of George III., whose queen, the same author tells us, landed in England in 1761, "habited in a gold brocade with a white ground, a diamond stomacher, and a fly cap with richly laced lappets"; such, he adds, "was the then female British dress, which her majesty adopted in compliment to her royal consort's subjects." ('Anecdotes,' vol. ii. 337.)

BROELLA. (*Brouelle,* French.) A coarse sort of cloth. "Pro Religiosis dicti monasterii frocos et circulas de broella." ('Orders of the Parliament of Paris,' 1377.) Most probably identical with BURELLUS or BIRRUS, which see.

BROIGNE, BRENE, BRUNY, BYRNIE, BYRNE. (*Byrn,* Anglo-Saxon; *brynin,* Danish.) These, and other corruptions of the same word, Latinized, *brumam, bruyna* and *bruna,* are applied to some species of body armour, similar to the hauberk. The military tunic, covered with iron rings, was called by the Anglo-Saxons *gehrynged byrn;* by the Normans, *broigne.* That

some difference existed between the broigne and the hauberk is apparent from a line in Wace's 'Roman de Rou' (*temp.* Henry I.):

"Des haubers et des broignes maintes mal feussée;"

and in the 'Roman de Ronceveaux,' we read,

"La vast-on tanta broigne saffrée."

"Omnis homo de duodecim mansis, bruniam (al bruniam) habeat." ('Capitula Caroli Magni,' *anno* 805, cap. 7.)

"In bruny of steel and rich weeds."—*Romance of Alexander.*

"His brene and his basnet was busket full bene."
The Adventures of Arthur at the Tamewathstan:
Romance of the fourteenth century.

"En son dos vist une broigne trellice."—*Roman de Garin.*

The derivation of the word is exceedingly doubtful. Its root, if of Teutonic origin, may be the same with that of *brunus* and *brunitus* (German, *braun;* French, *brun*), from which our words, "brown," "bronze," and even "brownish" (Ducange *in voce*); but the recent editors have, under "Bronia," the note, "*Bron* Britannis est mamma pectus, unde fortassis *bronia* vel *brunea* quod pectus tegat." The latter derivation is analogous to that of "hauberk" from *Hals-beorg;* and *wambais* and *gambezon*, from *panzer:* but against this we have to observe that *bryn*, in the old Norse dialect appears to designate defence for any part of the person, and even weapons; and we find in the 'Speculum Regale,' *bryn hosa* and *bryn knif;* and in King Sverru's saga *bryn kollu* (mail hood?); so that I incline to the belief that the coat of mail obtained this name from either its colour or its material.

BROOCH. A word derived from the French, *broche*, which is applied to several pointed instruments, and from which we have also the verb "to broche," i.e. "to pierce." This well-known ornament has been popular in the British Isles from the earliest periods. Fine examples of ancient Irish and Scotch brooches have been engraved and described in the 'Archæologia,' and other similar publications, and they were worn by all the Celtic tribes for the fastening of the mantle on the breast,

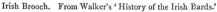

Irish Brooch. From Walker's 'History of the Irish Bards.' Scotch Brooch. From Wilson's 'Prehistoric Annals of Scotland.'

when the bodkin or the ring alone were not employed, the brooch being a combination of the two. The Anglo-Saxon brooches were very magnificent. Specimens have been found displaying a very advanced state of art workmanship. They were made of gold and silver and set with pearls or coloured glass. The Normans appear to have preferred the ring and pin form of the Celtic brooch, but in the fourteenth century we find them occasionally made in the shape of letters. They were worn by both sexes for closing the tunic where it opened at the throat, and fastened

the mantle on the breast. The clergy also indulged in them as well as in other ornaments forbidden by the sumptuary laws and the rules of their orders. "Piers Ploughman" upbraids them for riding "in glittering gold of grete arraie, on a courser like a knight, with hawkes and with hounds, eke with *brooch* or ouches on his hood."
And Chaucer, in the 'Canterbury Tales,' describes the Prioress as wearing

Brooch. 14th century. Formerly in possession of T. Crofton Croker, Esq.

> "A broche of gold full shene,
> On which was first ywretten a crowned A,
> And after, 'Amor vincit omnia.'"

The brooch worn by "the carpenter's wife" in 'The Miller's Tale,' is said to have been "as broad as the boss of a buckler." This was all in despite of the sumptuary laws which, from the reign of Edward III. to that of Henry VIII. inclusive, forbade the wearing of nouches (ouches or brooches) of gold, or silver, or gilt, to all persons under the degree of a knight, or knight's wife, and all clergymen under that of a bishop.

Brooch. 14th century. In the possession of Mr. Warne, of Dorsetshire.

James I., writing to the Duke of Buckingham at Madrid in 1623, says, "If my Babie (Prince Charles) will not spaire the anker from his mistresse, he may well lend thee his rounde brooche to weare, and yett he shall have jewels to weare in his hatt for three great dayes."

Anglo-Saxon Fibula. From Gilston, Kent.

In the sixteenth and seventeenth centuries, brooches were worn in caps and hats. Leather brooches for hats are mentioned by Dekker in his 'Satyromastix,' 1602; and "saffron-gilt brooches," as worn in children's caps in 1605. ('Eastward Hoe.')

BRUNNETTE. See BURNET.

BRUNSWICKS. "Close out-of-door habits for ladies, introduced from Germany about 1750." (Fairholt's 'Costume in England.')

BRUNY. See BROIGNE.

BUCKLE. (*Boucle*, French.) This familiar article for fastening belts and other portions of attire, has existed in so many forms from so early a period that, as Mr. Fairholt has stated in his 'Costume in England,' "It is obviously impossible to enumerate or engrave their many varieties." The buckles used for securing pieces of armour, or to fasten girdles or sword-belts, will be found described or engraved in the notices or illustrations of those articles. The shoe-buckle dates only from the close of the seventeenth century, and the knee-buckle much later. (See BREECHES.) In Piers Ploughman's 'Creed,' a poem of the fourteenth century, the Austin friar, denouncing the pride of the Franciscans, says, "Now have they buckled shoes," in lieu of walking barefoot; and half-boots with straps and buckles are found in

Anglo-Saxon Buckle. From Guilton, Kent.

illustrations of the middle of the fifteenth century. (See BUSKIN.) That a shoe appears buckled above the instep on the brass of Robert Attelath at Lynn, who died in 1376, there is no doubt; but there

is nothing in the buckle itself to distinguish it as what we now call a shoe-buckle, nor does it appear to have been a general fashion. The shoe-buckle proper was first worn about the reign of William III., 1688, when it generally replaced the rosette. Small buckles had been previously worn in conjunction with shoe-ties in the reign of Charles II., and Evelyn, who mentions the fact, under the date 1666, also alludes, in his poetical description of a lady's dress about that period, to diamond buckles " for garters, and as rich for shoes." (See SHOE and figures illustrating it.)

BUCKLER. (*Bouclier*, French.) A small shield similar to the targe or target. As early as the reign of Edward I. there were schools in England for teaching the use of it : " eskirmye de

Sword and Buckler Play.
13th century. Royal MS. 14 E. 3.

bokyler ;" and in the thirteenth year of his reign (1285), they were ordered to be closed in consequence of some disturbances and bloodshed that had taken place in the City, and no one was allowed to be in the streets after curfew had rung from St. Martin's-le-Grand, armed with sword or buckler—" a espey ne a bokuyler "—or any other weapon ; and any person teaching the " eskirmye de bokyler " within the City would be imprisoned for forty days. In the following century we find Chaucer describing the hat of the Wife of Bath, as " broad as is a buckler or a targe." They were ordinarily about a foot and a half in diameter, had a boss or spike in the centre, and were held at arm's length by a bar crossing the

Sword and Buckler Play.
13th century. Royal MS. 14 E. 3.

hollow of the boss. Some, however, were much smaller, and are called by Monsieur Viollet-le-Duc *boces* and *rondelles ;* by others, *rondelles a poing ;* in English, " roundel." Mr. Fairholt has engraved

Square Steel Buckler, with Grating to catch the point of an adversary's sword. Meyrick Collection.

two from the romance of 'The Four Sons of Aymon,' in the Royal Library of Paris, No. 7182. They are very diminutive, and are probably the *rondelles a poing* or *boces* just mentioned. One has a spike, the other, showing the interior, has a handle of wood or a leathern strap, which extends to the edges, and Sir Samuel Meyrick (I think erroneously) considered this form of handle to constitute the only difference between the buckler and the target. (See TARGET.) Some were all of metal, others of wood covered with leather and strengthened with broad-headed nails or studs. Square bucklers, apparently of German origin, are met with in the

Interior of Square Buckler.

fifteenth century. One of steel, with a hook to catch the point of an adversary's sword, was in the Meyrick Collection. It is engraved here with its interior, from Skelton's specimens, also a round one with a similar contrivance.

Circular Steel Bucklers. *Temp.* Henry VII.
Meyrick Collection.

In the fifteenth and sixteenth centuries, sword and buckler play was enjoined by the authorities, and Stow records that the apprentices and youths of London were permitted, on holidays and after evening prayers on Sundays, to practise this exercise before their masters' doors. The buckler was hung at the girdle over the sword, and the bullies and " fire-eaters " of that period were frequently called " swash bucklers," from the noise made

Interior of Buckler.

by the clashing of the sword against the buckler. The buckler was superseded by the introduction of the new fashion of fencing with rapier and dagger, which Stow tells us was in the year 1578; and in 'The Two angry Women of Abbington,' a comedy by Henry Porter, printed in 1599, it is said, "Sword and buckler fight begins to grow out of use. I am sorry for it; I shall never see good manhood again; if it be once gone, this poking fight of rapier and dagger will come up; then a tall man [that is, a courageous man], and a good sword and buckler man, will be spitted like a cat or a rabbit."

The small buckler, called a "roundel" (*rondelle a poing*), was occasionally, however, still used in lieu of the dagger, and swords and bucklers were carried by serving-men in attendance on their masters during the first half of the seventeenth century.

> "Had I a sword and buckler here,
> You should aby these questions dere."
> *Downfall of Robert, Duke of Huntingdon.* 1601.

BUCKRAM. It is uncertain whether the well-known material now called "buckram" is the same which we find mentioned in the Middle Ages, under the names of *bougran* and *bouquerant*, old French; from the mediæval Latin, *bougran* and *bouguerannus*. Ducange has "Bougran, vox Gallica, quæ significat genus telæ subtilis;" and under "Bouguerannus" the following quotations from various authorities: "Item, un bougheran blanc bordé de noir cendal. (Inventar. MS. Eccles. Cameræ, *anno*, 1371. Una casula, tunica, dalmatica de panno serico nigro duplicata de bouguieranno asurea Item tres infulæ quarum una est de serico, aliæ de bougueranno." The word is sometimes spelt "bucaranum," "buchiranum," and "bucherame," and occurs certainly in conjunction with those of stuffs of fine and precious quality:

> "Tyres et pailes bouquerans et cendez."—*Le Roman de Jordaris.*

> "Una coltre de bucherame cypriana blanchissima."—Bocacius.

At the same time we find it used for an aketon: "L'auqueton fut fort qui fut de bouquerant." (Cuvelier, Chron. de Duguesclin.)

M. le-Duc derives the word from Boukhara (Bokhara) in Tartary, whence the manufacture travelled, in the fourteenth century, into Armenia and the Island of Cyprus, and later into Spain. (Dict. Raison., vol. iii. p. 370.)

BUDGE, BUGGE. Lamb skin with the wool dressed outwards, with which garments were edged and lined. The hood of the Bachelor of Arts is still so ornamented. The word is sometimes written *boggy*. (Inventory of the Wardrobe of Edward IV.)

BUFF COAT. (*Buffle*, French.) A military garment of the sixteenth and seventeenth centuries, formed of the hide of the buffalo, whence its name. As plate-armour gradually fell into disuse, the buff coat, which was first worn under the breast and back-plate, became at length the sole protection of the cavalier's body, the neck being alone defended by the gorget of metal. The buff coat is to be met with in the reign of Elizabeth; but its general use dates from that of Charles I. and the Civil War. Many specimens of that period are still in existence. Two from Balborough Hall, Derbyshire, the seat of the Rhodes family, were exhibited at Manchester, in the Collection of Art Treasures, 1857. Those worn by commanders were sometimes richly embroidered with gold and silver upon the sleeves, or trimmed and edged with gold and silver lace, and gold and silver buttons and loops. The "buffe jerkin" is mentioned by Sir Richard Hawkins, in 1593. "The cuirassier is to be armed at all points and accoated with a buffe coat under his arms like the launce" (lancer). ('Militarie Instructions for the Cavallerie,' by Captain Cruso. 1632.) According to the same writer, "The harquebusier, besides a good buffe coat, is to have the back and breast of the cuirassier's arming." "The armes defensive of the dragoons are an open head-piece with cheeks, and a good

buffe coat with deep skirts." (Gervase Markham, 'Souldier's Accidence,' 1625.) A writer, describing the dress and accoutrements of the Life Guards at the coronation of James II., 1685, says, "They are accustomed to have each of them a good buff coat and a large pair of gauntlet gloves of the

Buff Coat. *Temp.* Charles I. Meyrick Collection. Buff Coat. *Circa* 1700. Balborough Hall.

same." (Cannon's 'Historical Records,' p. 74.) In 1714, on the entry of George I., "a detachment of the Artillery Company in buff coats," formed part of the royal escort. They appear to have been abandoned before the following reign.

BUFFIN GOWN. Buffin appears to have been a coarse stuff used for gowns of the middle classes of females in the time of James I., and during the earlier half of the seventeenth century. Whether so called from its material or its colour, I have met with nothing to inform me. In 'Eastward Hoe,' 1605, it is mentioned as being worn with a taffety cape and velvet lace. "My young ladies in buffin gowns and green aprons! Tear them off!" (Massinger's 'City Madam.' 1669.)

BUFFON. See BOUFFONT.

BUGLES. Glass beads, still much used for the decoration of female dress, and in high fashion as early as the reign of Elizabeth, when they were principally worn in the hair. "At their haire thus wreathed and crested are hanged bugles, ouches, rings, gold, silver, glasses, and such other childish gewgawes." (Philip Stubbes' 'Anatomie of Abuses.' 1583.)

BULLET-BAG. A leathern pouch carried by musqueteers in the sixteenth and seventeenth centuries, as the name implies, to hold their bullets. Under the date 1589 we read, "Item, for iiii bullet-bags of the best." ('Norfolk Archæology,' vol. i. 19.) The bag was attached to the girdle beside the powder-flask, but when bandileers were worn, suspended from the baldrick, as shown in our engravings from Jacob de Gheyn's work, translated into English in 1607. (*Vide* also cut to BANDILEER.) Rendered useless by the invention of ball-cartridges.

BUREL. Probably the same as "broella," a coarse cloth, mentioned by writers of the thirteenth and fourteenth centuries. "A curtele of burel," is spoken of in a ballad of the reign of Edward II. (Ritson's 'Ancient Songs.' Piers Ploughman's 'Vision.')

BURGONET, BURGINOT. A species of close helmet invented, or at least first worn by the Burgundians (whence probably its name) in the fifteenth century. Its peculiarity consisted in the

adaptation of the lower rim of the helmet to the upper one of the gorget, by hollowing it out so as to receive the bead of the latter, by which contrivance the head could be freely turned to the right or the left without exposing the throat of the wearer to the point of the lance or the sword.

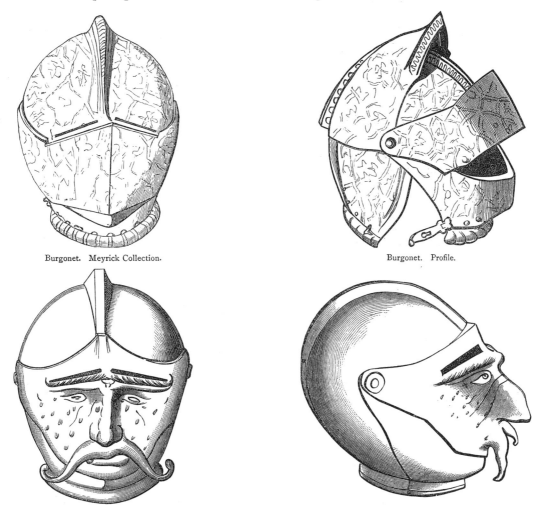

Burgonet. Meyrick Collection.

Burgonet. Profile.

Masked Burgonet. *Temp.* Henry VIII. Meyrick Collection.

Masked Burgonet. Profile.

M. Demmin I think wholly misrepresents the burgonet, which he confounds with the casque, contradicting the President Fauchet, who, writing in the sixteenth century, when they were still worn, must surely speak with some authority, while M. Demmin cites none whatever in support of his opinion, and accuses Fauchet of confounding the burgonet with the armet: a much more natural error, if indeed it be one, for they are represented nearly similar in shape; and as I have already ventured to suggest, "armet" was only a general name for the close helmet, of which class of head-piece the burgonet was one of the earliest.

BURLET. (*Bourrelet*, French.) "A coif." ('Ladies' Dictionary,' 1694.) Rather, the stuffed roll round the coif, or cap, worn still by children in France to protect their heads should they fall. (See also HEAD-DRESS.) The roundelet of a hood, any sort of roll. "A standing or stuffed neck for a gown." (Jamieson.) The ornamental wreath round a bascinet is called by French writers a *bourrelet*.

BURNET, BURNETTE. (*Brunette*, French.) A fine cloth of a dark colour, mentioned in the thirteenth century, not necessarily brown, as the name would suggest. "Brunettam *nigram*, gayzatum et alium quamcunque pannum *notabiliter delicatum*, interdicimus universi." (Concil.

Rudense, *anno* 1279, cap. 61.) In the 'Ladies' Dictionary,' 1694, burnet is described as "woollen," and the name is applied to a hood.

BURRE. A broad ring of iron behind the place made for the hand on the tilting spear.

BUSK. An article of female attire still in use, and apparently first introduced in the sixteenth century, as William Warner in his 'Albion's England,' asks,

> "But heard you named,
> *Till now of late*, busks, perriwigs,
> Masks, plumes of feathers framed," &c.

Minshieu describes it as "made of wood or whalebone, a plaited or quilted thing to keep the body straight." It is now usually of whalebone or steel. Mr. Fairholt suggests that the name may have been derived from its having been originally made of wood; but "to busk" is "to dress." In Lowland Scotch, the song commencing,

> "Come busk ye, busk ye, my bonny bride,
> Come busk ye, busk ye, my winsome marrow,"

is familiar to our ears, and I consider it more probable that the busk obtained its name as being an aid and assistance to dress. Thus, in 'The Adventures of Arthur at the Tamewathlen' (Romance of the fourteenth century), we have, "His brene and his basnet was busket full bene," i.e. "full well or securely put on." (See under BROIGNE.)

BUSKE. This word also occurs at the close of the fifteenth century as the name of some material. Richard III., amongst other articles of apparel he sends for when at York in 1483, mentions "doublets of purple and tawney satin lined with galand cloth, and outlined with buske." (Harleian MS.)

BUSKIN. A species of boot, the name probably derived from the mediæval Latin, "Busa, *corium bovis*" (Ducange in *voce*), leather made of the skin of the ox having been the original material

Anglo-Saxon. From Harleian MS. 2908. Anglo-Norman. 11th century. From a psalter in the Diocesan Collection. From an Anglo-Norman painting in the crypt of St. Paul's Cathedral. *Circa* 1100. From Arundel MS. No 83. *Circa* 1339. Brass of Nicholas Canteys, in Margate Church. 1431.

Examples of Half-boots, buckled and laced. From various authorities. 15th century.

Temp. Edward IV. From original in the collection of Roach Smith, Esq.

used in their manufacture; the *scin-hose*, in fact, of the Anglo-Saxons. Bailey says, probably from *borzacchino*, Italian; *brosken*, Dutch; or *brodequin*, French; the latter being itself derived from the name of the leather of which it was made, according to Casseneuve, who quotes Froissart in support of his opinion. But leather was not the only material of which they were made; the buskins of princes, prelates, and other persons of distinction, were made of gold or embroidered stuffs. A pair found on the legs of Abbot Ingon, when his sarcophagus

was opened in the Abbey of St. Germain des Prés, are described by Mr. Lenoir, who has engraved them, in his 'Musée des Monuments français,' as being "made of dark violet-coloured silk, ornamented with a variety of elegant designs in polygonal shapes, upon which were worked greyhounds and birds in gold. They were fastened at top and bottom by a silk running twist of the same colour, made like the laces of the present day." In this specimen the buskin appears more like a long stocking than a boot, ascending above the knee, and being, as it were, gartered beneath it. The word "buskin" seems to be confined to the English language, the French using the term *housseaux* and *brodequin*, and the Germans, *Halbstiefel*, literally, *half-boot*—the *cothurnus* of the Romans. Henry V. of England was so partial to the wearing of short boots or buskins, that Monstrelet recounts that Messire Sarazin D'Arly, having been told by a relative that he had seen the body of the King lying in state at Abbeville without buskins on his legs, exclaimed, "Then, by my faith, I will not believe he is dead, if he have not left them behind him in France"—Picardy being, at that period, an English province. The application of the term "sock and buskin" to the performance of comedy and tragedy indicates a distinction between short and long stockings, rather than between shoes and boots, and so far justifies Monsieur Lenoir in giving the name of "buskin" to the leggings of Abbot Ingon ; but we are without any positive authority for the ordinary shape or size of the buskin, or the peculiarity which distinguished it from the boot.

> "My hose strayte tyde,
> My buskyn wyde,
> Riche to behold,
> Glitteringe in golde."—Skelton's Interlude of *Magnificence.*

I have already, under BOOT, spoken of those worn by females in the thirteenth century ; but we have no pictorial illustration to enlighten us as to their form or mode of fastening. The shoes of the Carpenter's Wife, Chaucer describes as being "laced high up her legs"; whether they were ankle boots or high shoes we cannot determine.

BUSK-POINTS. The name given to the tag of the lace, not as Mr. Fairholt states, "which secured the end of the busk" alone, but for lacing dresses generally.

> "Clog the wrists with busk-points."—Fitzjeffery's *Satires,* 1617.

BUSSARD. In Rowland's 'Look to it, or I'll Stab you,' 1604, occurs the line, "The bodkin and the bussard in your haire." (See HEAD-DRESS.)

BUTTON. (*Bouton,* French.) I do not find any mention of buttons previous to the Norman Conquest, nor does the Anglo-Saxon dress seem to have required them. The earliest appearance, as well as allusion to them, that I have met with is in the reign of Edward I., when the introduction of tighter fitting garments rendered them as useful as they were ornamental. In a MS. poem (Cotton, Julius), not later than 1300, are the following lines :

> "Botones azur'd [azure, blue] wor ilke ane
> From his elboth to his hand."

And in illustration of this description, we find in the illuminations and effigies of that period numerous examples of the tight sleeve with a row of buttons thickly set from the wrist to the elbow. The servants then, as now, followed the fashion of their masters :

> "Now our horse-clawers [grooms], clothed in pride,
> They busk them with buttons as it were a bride,"
> Wright's *Political Songs. Temp.* Edward I. ;

and buttons appear about the same time in front of the super tunic, and also of the buskins or boots and shoes. The use and fashion of buttons increased during the fourteenth century to such an extent that in 'The Romance of Sir Degrevant,' the writer, describing the dress of an earl's daughter, says, "To tell her botennes was toore," i.e. *dure,* hard : To count her buttons would be too much trouble.

They were set closely down the front of both the gown and the cote-hardie of the time of Edward III., but were less in vogue during the following century, when laces and points appear for a while to have superseded them. They recovered their ascendancy in the sixteenth century, and are to be seen in great variety on the dresses of both sexes, sometimes of metal and sometimes covered with silk. Buttons of diamonds and other precious stones are frequently mentioned. They varied in size, shape, and material so constantly from that period, that it would require a volume of itself to describe them, and the numerous representations of articles of costume in this work wherein buttons form a prominent feature, render it unnecessary here to give engravings of them. They were made, as now, of gold, silver, brass, and other metals, horn, mother-of-pearl, ivory, bone, jet, glass, and wood, covered with silk or velvet, according to the purse of the wearer or the caprice of fashion. In the 12th of Charles II., they are included among the wares imported, and were subject to a very heavy fine. They are specified as follows : buttons of brass, steel, copper, or latten, crystal, glass, silk, fine damask work, bugles and buttons "for handkerchiefs." "Handkerchief buttons" was one of the cries of London in the time of Charles I.

In the reign of William and Mary it was represented to Parliament that thousands of men, women, and children within this kingdom, depended on the making of silk, mohair, gimp, and thread buttons, and that the makers of such needle-work buttons were injured by the wearing of buttons made of threads of cloth, serge, drugget, frieze, camlet, and other stuff and materials. Hutton, in his 'History of Birmingham,' speaks of the cloaks of our grandmothers ornamented with a horn button "nearly the size of a crown piece." Paste buttons of the most magnificent description, rivaling in brilliancy the finest precious stones, were much used in the last century. In 1777 the buttons of the coat were worn of an enormous size, and a beau with steel buttons dazzling a lady, is the subject of a caricature of the same date.

BY. (Anglo-Saxon, *beah.*) A bracelet or collar. ('Dextrotirium,' Reliq. Ant.)

"A by of gold adornyng the righte arm."

BYCOCKET. (*Biquoque, bicoquet,* French.) I have given, under ABACOT, my opinion respecting the "bycocket," and adverted to that of M. le-Duc, who considers it the name for a particular sort of helmet. The authority he quotes for his definition is an anonymous work of the thirteenth century, in which it is said, " Et premierement les biquoques sont de faczon à que sur la teste, en telle forme et maniere come ancienement les bacinez a camail souloient estre, et d'autre part vers les aureilles viennent joindre aval en telle forme et faczon comme souloient etre les derniers." This very hazy description he illustrates by engravings of the egg-shaped close helmet herewith given. Whether this can be the bycocket a nobleman is instructed to "ride daily withal," I leave to the judgment of my readers. *Bicoque,* as I have previously observed, is a term implying in French "une maison très-simple et très-petite," also, "une petite place *mal fortifiée et sans defense.*" "Nous n'avons perdu qu'une bicocque." (Landais.) Also in Italian, "*Biccoca,* a hamlet, a cottage, a little village." (Florio.) How is this applicable to an

Egg-shaped Helmet, called "bicoquet" by Viollet-le-Duc.

almost impenetrable helmet ? In a useful little book, 'Traité des marques nationales,' by M. Beneton de Morange de Peyrins (12mo. Paris, 1739), the bicoquet is described as a "species of morion, pot en tête, or salade," "*plus leger* que le gros casque de battaile." And subsequently, quoting from the same book, 'L'Histoire de Louis XI.,' commonly known as 'La Cronique scandaleuse,' he describes an archer of the guard of the Duke de Berri as " armé d'un brigandine couvert de velours noir à clous doré, croissé de blanc, et qui en tete avoit un bicoquet *garni de bouillons d'argent doré.*" Now, *bouillons* may be translated either "studs" or "puffs of silk or ribbon;" if the latter, the bicoquet could not have been of steel ; but as they are said to have been silver gilt, it might have been either of metal or of black velvet, like the covering of his brigandine, which was similarly ornamented with

gilt nails. In either case it could not have resembled the egg-shaped helmet, imagined by M. le-Duc, as such a head-piece was never worn by archers in the fifteenth century. It is very significant also, that having at page 83 classed the bicoquet with the cramignol, with the morion and the salade, at page 127 he quotes from the same contemporary chronicle the description of the men-at-arms of a Captain de Sallazart: "coiffés de leurs cramignolles *de velour noir à grosses houpes de fil d'or de Chypre.*" What is still more to the purpose, is the fact that *bicoq* is the name of a carpenter's tool, otherwise called *pied-de-chèvre*. Here we have the cloven foot—the two beaks or peaks of the bycocket. Everything tends to show that the steel bycocket, if there was such a head-piece, was so called from its resemblance to the form of the civil cap when worn with its peak behind—a variety of the salade, in fact, if not the salade itself by another name. In 1522, the French, under Lautrec, lost a battle with the Imperialists, under Prospero Colonna, at Biccoca, a small *château de plaisance*, near Milan, on the road to Lodi; and Zedler, in his 'Lexicon,' informs us that the result of this battle, which is famous as that of La Bicoque, gave rise to the saying I have quoted above; but the term "bycocket" had existed in France and England nearly a hundred years before that event, and therefore could not have been derived from it.

BYSSINE. (*Byssus*, Latin.) A fine cloth. "Pannis de bisso seu cimeti viridi." (Ducange.)

CADDIS, CADDAS. A name given to a manufacture of worsted, probably mixed with woollen, and sometimes called "cruel :" "caddas, or cruel ribbon." ('Book of Rates,' 1675, p. 293.) "Caddas, or cruel sayette." (Palsgrave.) It was used for stuffing dresses. In the third year of the reign of Edward IV. a sumptuary act was promulgated, by which no yeoman, or person under the degree of a yeoman, was allowed bolsters, or stuffing of wool, cotton, or cadis, in his pourpoint or doublet, under a penalty of six and eightpence fine, and forfeiture awarded.

CALABRERE. A fur, so called from Calabria, whence imported. "Pelles ex Calabria." (Ducange *in voce*.)

"His collar splayed and furred with ermyn, calabrere, or satin. (25, 'Coventry Mystery.')

Piers Ploughman describes a physician as clad in a furred hood and cloak of calabrere ; which Strutt explains as a costly sort of fur. Mr. Fairholt, without giving his authority, calls it a cloth ; but the word *pelles*, used by Ducange, in allusion to a quotation from Rymer, "Indumentum foderatur cum Calabria," certainly implies skins or fur.

CALASH. (*Calèche*, French.) A hood, made like that of the carriage called in France *calèche*, to pull over the head, whence its name. It is said to have been introduced in England in 1765, if not invented by, the Duchess of Bedford. A similar article of apparel, however, appears to have existed long previously, examples of which are to be seen in the recumbent effigies of the sixteenth and seventeenth centuries. The calash may, therefore, have been, like many other things, an old fashion revived, with improvements, and a new name. (See Hood and Cloak.)

Calash.
From a print, dated 1780.

Calash.
From print after Bunbury.

CALICO. A stuff made of cotton, and originally manufactured at Calicut, in India, whence its name. "I can fit you, gentlemen, with fine calicoes too, for your doublets ; the only sweet fashion now, most delicate and courtly ; a meek, gentle calico, cut upon two double, affable tafatas." (Dekker, 'Honest Whore,' 1604.) "Sir Martin Noel told us the dispute between him, as farmer of the additional duty, and the East India Company, whether callico be linnen or no, which he says it is, having been ever esteemed so. They say it is made of cotton woole, and grows upon trees, not like flax or hemp : but it was carried against the Company, though they stand out against the verdict." (Pepys' 'Diary,' *sub.* February 27, 166¾.)

CALIMANCO. A glazed woollen stuff, called by Lilly, in his 'Midas,' "calamance." But see CAMAIL.

CALIVER. (*Calibre*, French.) A harquebuss, so called from the calibre or width of the bore, introduced in the reign of Elizabeth. "Put me a caliver into Wart's hands, Bardolph." (Shakespeare's 'Henry IV.,' Part II. act iii.) Edmund Yorke, a writer of that period, says, "Before the battel of Mounguntur [Monconteur] in 1569, the Princes of the Religion caused seven thousand harquebuzes to be made, all of one calibre, which was called 'Harquebuse de calibre de Monsieur Prince'; so I think some man, not understanding French, brought hither the name of the height of the piece, which word 'calibre' is yet continued with our good cannoniers." (Maitland's 'History of London.')

The caliver in the Tower Armoury, brought from Penshurst, is four feet ten inches in length. It was lighter and shorter than the musket, and had the advantage of the latter in being fired without a rest, and much more rapidly. As the width of the bore gave its name to the piece, the piece in its turn gave its name to the troops armed with it, who were called "calivers." Mr. Hewitt observes that the caliver seems to have gone out of fashion soon after 1630, for Hexham, in 1637, says, "forasmuch as of late yeares there are noe callivers in a foot companie," &c.

CALLOT. (*Calotte*, French.) A small coif or cap. The little black cap worn by the Roman Catholic clergy is so called. Canons were prohibited from wearing them of linen in the streets, A.D. 1259. (Statuta Eccl. Aquens, *sub anno*.)

Caliver-man. From the roll of the funeral of
Sir Philip Sidney. 1586.

CAMACA. See CAMMAKA.

CAMAIL (French; *camallus*, Latin; *cameglio*, Italian.) The derivation of this word is very uncertain; but the probabilities are in favour of its having the same source as "camlet," "calimanco," and other stuffs which were imitated from a finer material made of camel's hair. (*Vide* Ducange *in voce* Camelaucum.) It was originally a sort of cape worn by ecclesiastics of the highest order: "Camelaucus, vestimentum Papæ"; and sometimes ornamented with precious stones: "Occidit Totilam et vestimenta ejus cruentata cum camilaucio lapidibus preciosis ornato misit Constantinopolim." (Anastatius, in Hist. Eccles.) The term was afterwards applied to the protection for the neck and shoulders of chain mail attached to the basinet, when that head-piece was introduced in the fourteenth century (see under BASINET); and it has therefore been suggested that "camail" was simply a corruption of "cap-mail." The undoubted fact, however, of a similarly shaped vestment having been previously worn by the clergy, and made of camel's hair, I think justifies me in pointing out this as one of the many instances in which the name of one article of apparel becomes transferred to another, very often entirely differing from it in shape and texture. In the accounts of Etienne de la Fontaine, the French king's silversmith, 1349, there is the following entry: "Pour six onces de soie de divers couleurs, a faire les las a mettre les camaux aussdits bacinets." Towards the end of the fourteenth century these silken cords were covered with metal borders, richly engraved and sometimes jewelled. (*Vide* Plate III. fig. 9.) The effigy of Sir Henry FitzRoger, in Newton-Mendip Church, Somersetshire, affords us an example of the ornamentation of the camail itself. A shield

Camail.
From effigy of Sir Henry FitzRoger.

charged with a St. George's cross is fixed on it immediately under the chin. If made of steel, it would be an additional defence to the throat.

CAMBRIC, CAMERICK. This well-known material appears from Stow to have been first introduced into England in the reign of Queen Elizabeth ; and Philip Stubbs, in his 'Anatomie of Abuses,' printed at London, A.D. 1595, tells us that it was chiefly used for the great ruffs then in fashion with both sexes, and was so fine that "the greatest thread was not so big as the smallest hair that is." Bands, cuffs, handkerchiefs, and shirts, were also made of it.

> "His shirt had bands and ruff of pure cambrick."—Thynne's *Debate between Pride and Lowliness.*

> "You velvet, cambricke, silken-feathered toy !"—S. Rowland's *Look to it, for I'll Stabbe ye.* 1604.

CAMELINE. A stuff made of camel's hair. (Halliwell, *in voce.*) But the derivation of this and similar names of several other sorts of material requires confirmation. Cameline is mentioned as early as the thirteenth century :

> "The cloth was ryche and rygt fyn,
> The champe [field] it was of red camelyn."
> *Roman de la Rose*, l. 7367.

It is quite possible it may have been a manufacture similar to what we now call "cashmere," and imported from the East. (See under CAMAIL, CAMLET.) M. le-Duc, however, contends that cameline was an inferior species of manufacture, of Phenician origin, and quotes Joinville, who says "the king [Louis IX.] sent him to Tortosa, and commissioned him to purchase for him one hundred camelins of divers colours, to give to the Cordeliers when they returned to France." He asserts also, that it was always spoken of as a very common stuff, "une étoffe très-ordinaire," in which he is certainly contradicted by the above quotation, wherein it is described as "rich and right fine." He admits, however, that in the thirteenth century camelines were made at St. Quentin, and in the fourteenth at Amiens, Cambrai, Mechlin, Brussels, and Commercy, that they were of various qualities as well as colours, and that their prices differed accordingly, some costing only eleven or twelve sous the ell, and others twenty-four and twenty-eight sous.

CAMISADO. A light, loose dress or robe, of silk or other material.

CAMISE, CAMISIA. (French, *chemise.*) A shirt. (See SHIRT.)

CAMLET, CAMELOTT. A mixed stuff of wool and silk, used for gowns in the reign of Elizabeth. The derivation of the word is uncertain, some etymologists deducing it from "camel," presuming, for there is no proof, that it was originally manufactured from the hair of that animal ; others, from the river Camlet, in Montgomeryshire, where its manufacture in this country, they assert, first began. "After dinner, I put on my new camelott suit, the best that ever I wore in my life, the suit costing me above 24*l.*" (Pepys' 'Diary,' June 1st, 1664.) As early, however, as the seventeenth century, camelots of various colours were highly esteemed, and were paid for by the piece as much as cendal. In the fifteenth century, we read of "Une piece de camelot violet de soye brochee d'or." (Inventory of Charles the Bold, Duke of Burgundy.) That it was in higher esteem formerly than camlet is now, is evident from the suit worn by Pepys costing him twenty-four pounds of the money of the time of Charles II.

CAMMAKA, CAMACA. A fine cloth or silk, used in the fourteenth century for royal and ecclesiastical garments.

> "In kyrtle of cammaka kynge am I clad."—17 *Coventry Mystery.*

"Pour 3 kamokaus azurez brodez dessus des armes de France pour faire une cote et 1 mantel a la Rayne." ('Comptes de Geffroy de Fleury,' 1316.)

CAMPAIGNE. "A kind of narrow lace, picked or scallop'd." ('Ladies' Dictionary.')

CANE. This word, applied generally to a walking-stick, it need scarcely be said, strictly appertains to such sticks as are actually formed of cane. Canes are mentioned as early as the reign of Henry VIII., but became generally fashionable in that of Charles II. (See under WALKING-STICK.)

CANIONS, CANNONS. (*Canons*, French.) This is another of those instances in which the application of the same term to different portions of attire perplex the artist. The word is derived from the same root as " cannon," the gun so-called, viz. *kanna*, Greek ; *canna*, Latin ; and signified a tube, a pipe, or a roll ; anything, in fact, hollowed out, whatever might be the material. In apparel, it was the name given to the rolls of silk or other stuff which terminated the breeches at the knee, as well as to those which ornamented the tops of the long stockings in the reign of Henry III. of France and of Queen Elizabeth in England, *circa* 1574. Therefore we find, " En termes de Bonnetier, le haut d'un grand bas fort large ; en termes de Tailleur, ornament d'étoffe attaché au bas de la culotte, et froncé, faisant comme la haut d'un bas fort large. Cette sorte de parure a été dans le dix-septième siècle fort à la mode en France." (Napoléon Landais' Dict. Général.) " Canons, ornament qu'on portait autrefois au-dessous du genou. Cannions, an old ornament for the legs." (Boyer.) " Subligar, a paire of breeches without cannions." (Welle's 'Janua Linguarum,' 1615.) Cotgrave has only " cannions of breeches, canons de chausses." The tops of the stockings meeting the breeches at the knees, it is difficult to decide, from the examination of drawings or prints of the sixteenth century, to which article of apparel the canions belong.

In the seventeenth century we still hear of these puzzling adjuncts to the nether garments of gentlemen. Just one hundred years after we first make their acquaintance, Pepys tells us, under the date of May 24th, 1660, " Up and make myself as fine as I could, with the linning stockings on and wide canons that I bought the other day at Hague." And on the 29th of November, 1663, he speaks of his black knit silk canons, which he bought a month ago, and which he has previously described (30th October) as " silk tops for my legs." The " wide canons " he speaks of, as belonging to the linen stockings he bought at the Hague, militate against the idea that they were the rows of ribbons and tags worn with the petticoat breeches of that period, and leave us hopelessly in the dark as respects the canions of the reign of Charles II. I subjoin the best illustrations I can find of those of the time of Elizabeth, from engravings by a contemporary artist, Caspar Rutz.

Canions (?) From an engraving of Dutch and Flemish Costumes, by Caspar Rutz, A.D. 1588.

CANIPLE. (*Canif,* French.) A small knife or dagger. "Canipulus. Ensis brevior." (Ducange, *in voce.*) Rad. de Diceto, *sub anno* 1275, has *cnipulum:* "Ne quis viator cnipulum deferet vel arcum."

CANVAS. (*Canevas,* French.) A coarse cloth, familiar to us at the present day. "Striped canvas for doublets," is mentioned by Dekker in 1611.

CAP. This familiar term for a covering for the heads of both sexes (in French, *bonnet*), is in all its varieties so distinct from its congener the HAT, that I prefer treating it separately, as I shall also do the HOOD, to including them all under the general article of HEAD-DRESS.

The Belgic Britons appear to have worn some such head-covering, as we find they had in their language the term *cappan,* and the Welsh children in our own days make conical caps of rushes, which they call *cappan cyrnicyll,* the pointed or horn-like cap, curiously resembling the ancient huts of the Irish and other Keltic inhabitants of these islands, which were formed of wattles tied together at the top, and called *cab* and *cabban,* whence our modern word "cabin."

Bayeux Tapestry.

The Anglo-Saxons are principally depicted in caps identical in form with those of the ancient Phrygians. (See 'General History.') They were probably made of various materials, according to the station of the wearers, and those of the higher classes appear to have been ornamented with metal or embroidery. In some instances they seem from their stiffness to have been of leather, as their helmets of similar form are described to be (see HELM), in others of cloth or woollen stuff. It is a curious fact, that what is known at the present day as a "Welsh wig," if not pulled down tightly upon the head, will take of itself so completely the shape of the Phrygian cap, that it is by no means

Harold. From the Bayeux Tapestry.

improbable the manufacture of it has been continued without variation of pattern from the times of the Keltic and Kimbric colonisation of Britain. The primitive character of the inhabitants of the

I. 2. 3. 4. 5. 6.
Anglo-Saxon Caps. From MSS. of the 9th, 10th, and 11th centuries.

Principality, and the Oriental tenacity with which they cling to their national customs and language, strongly favour this supposition, which is also supported by the fact previously mentioned of the making the *cappan cyrnicyll* by the Welsh children of

this day. Amongst the specimens here given from various Anglo-Saxon MSS., fig. 4 is the cap of Enoch, in a drawing representing his translation in Cædmon's metrical paraphrase of Scripture History, in the Bodleian Library, Oxford; and fig. 2, from a portrait of Wulfstan, Archbishop of York, 1002–1023. Figs. 1 and 3 are seen on the heads of rustics as well as military personages, differing, it may be, only in the material. The others, more highly ornamented, would probably be worn by the nobility.

Two Normans addressing Duke William. From the Bayeux Tapestry.

The Danes and the Normans appear to have worn caps of a similar shape, but in the Bayeux Tapestry we meet with a variety resembling more a coif than a cap, and not covering the back of the head, which is close shaven. About the close of the twelfth century, however, we find them depicted in hats and bonnets of various descriptions, some resembling the *petasus* of the ancient Greeks, and others the blue bonnet still worn in Scotland, or the smoking cap of the present day.

Amongst the examples here given, fig. 4 is the cap of a physician (*temp.* Henry I.), and fig. 5 that of a nobleman (*temp.* Edward I.) sitting in his chair of state.

Caps of various shapes and materials were in common use, even after the introduction of the chaperon, or hood, which came into fashion in the fourteenth century. Here are a few of the many forms met with in illuminations of the reigns of Edward III., Richard II., and Henry IV.

I. 2. 3. 4 5.
Anglo-Norman Caps. From MSS. of the 11th, 12th, and 13th centuries.

According to the Book of Worcester, it was in the year of our Lord 1369 they began to use caps of divers colours, especially red, with costly linings. During the reigns of Henry V., Henry VI., and Edward IV. the varieties increase in number and eccentricity of form, and the latter period is specially remarkable for the prevalence of a high black bonnet, which is seen on the heads of all

Caps from MSS. and paintings. 1327–1399.

persons pretending to gentility, and is alluded to in the following lines :

"Ye proud gallants heartless,
With your high caps witless,
And your short coats graceless,
Have brought this land to heaviness.

Of the "high caps," alluded to, a specimen is seen in the fourth figure in the second row of the subjoined varieties.

Caps and Bonnets. *Temp.* Henry V., Henry VI., and Edward IV.

In the reigns of Richard III., Henry VII., and Henry VIII., caps and bonnets were in great vogue, their form more picturesque, and ornamented with a profusion of feathers. The materials in the latter reign were of the richest description. Hall, in his 'Union,' folio 7, tells us that Henry VIII., at a banquet at Westminster, wore "a bonnet of damaske silver, flat woven in the stole, and thereupon wrought with gold, with rich feathers in it." What were called "Milan bonnets," so named from the duchy in which they were first made, whence also the modern name of "milliner" (Milainer), applied to ladies' cap and bonnet makers in England, were greatly in fashion at this period, and worn by both sexes. They were composed of the

I. 2. 3.
Caps. *Temp.* Henry VII.
Figs. 1 and 2. From tapestry of the period.
Fig. 3. From portrait of Henry VII.

costliest stuffs, cloth of gold and silver, velvet and satin, slashed and puffed like the dresses, and decorated with a profusion of jewels, spangles, aylets, and other pendent ornaments. Their appearance will be better understood by the subjoined engravings from a piece of tapestry of this period, formerly

in the possession of the late Mr. Adey Repton, F.S.A., whose essays on head-dresses generally will be found in vols. xxiv. and xxvii. of the 'Archæologia.'

"Item, paid for ij Myllan caps for Mr. Hammond Lestrange." (Household accounts of the Lestranges.)

Bonnets of fashionable gallants. Close of 15th century.

Sir Thomas Elyot observes, "it would be ridiculous to see an apprentice to the law or pleader to come to the bar with a Millayne or French bonnet on his head set full of aiglettes." The flat cap

Milan and other Bonnets. From tapestry. End of 15th century.

with turned up narrow brim, jewelled and bordered with feathers, in which Henry VIII. has been usually depicted, is of the latter portion of his reign, and rendered so familiar to us by innumerable

prints from the portraits by Holbein, that "bluff King Hal" would hardly be recognised in any other head-gear. It is necessary, however, that the artist or actor who may have to represent him in his earlier days, should not be misled by that circumstance. (See portrait of Henry when young, under COLLAR.)

| Henry VIII. Close of his reign. | Lord Seymour of Sudley. 1549. | Brandon, Duke of Suffolk. | John, Earl of Bedford. 1555. |

During the brief reigns of his son Edward and his daughter Mary, caps and bonnets diminished in size, very small flat caps were worn, jauntily placed on the side of the head, those of the highest orders being distinguished by gold or silver bands or cords, with a jewel or brooch securing a single feather or a tuft of feathers, according to the taste of the wearer, the extravagantly long plumes of the fifteenth century having entirely disappeared. What was subsequently known as the "City flat cap," such as, till lately, were worn by the boys of Christ's Hospital, founded by Edward VI., and designated in our days as the "muffin cap," dates, of course, from this period.

| Sir Anthony Browne. 1544. | Earl of Surrey. 1547. | Sir Christopher Hatton. *Temp.* Elizabeth. | Earl of Oxford. 1578. |

The caps and bonnets of the latter half of the sixteenth century were higher in the crown, and occasionally conical in form, with broader brims. We no longer hear of bonnets of cloth of gold or silver. Velvet and cloth were the principal materials used for the bonnets of the nobility and gentry; and in 1571 an Act of Parliament was passed, by which it was ordained that all above six years of age, except the nobility and persons of degree, should, on Sabbath days and holidays, wear caps of wool manufactured in England, and such caps were consequently called "statute caps." Thus Rosalind, in 'As you Like It,' says, "Well, better wits have worn plain statute caps." This act was repealed in 1597; but the flat cap still distinguished the citizen, the apprentice, and the artisan.

In 1607 (4th of James I.) Thomas Dekker, the dramatist, speaks of a person at bowling-alleys "in a flat cap like a shopkeeper" (Knight's 'Conjuring: a Satire on the Times'); and some three and twenty years later the same writer eulogizes it as

adding, that

> "Light for summer, and in cold it sits
> Close to the skull, a warm house for the wits;"

> "Flat caps as proper are to city gowns
> As to armour, helmets, or to kings their crowns."
> *Honest Whore*, 1630.

Other caps and bonnets were also worn during the reign of James I., but from the commencement of the seventeenth century hats began to predominate in male costume, and caps of particular forms were confined to ecclesiastical and professional persons. The peculiarities by which they were distinguished are amusingly described by Durfey in 'A Ballad on Caps,' which has for its burden

> "Any cap, whatever it be,
> Is still the sign of some degree."

In this rhyming catalogue we find mention of "the Monmouth cap," which is "the soldier's"; and "the sailor's thrumb cap," "the physic cap," "the cap divine," i.e. the square cap, still a portion of academical costume—"square, like scholars and their books;" "the furred and quilted cap of age;" and caps of velvet, satin, silk, cruel, worsted, and fustian, worn by invalids and various classes of men, clerical or laical. This ballad, originally written in the reign of Elizabeth, was reprinted by Durfey in his 'Pills to purge Melancholy.'

In 1680, an advertisement quoted by Malcolm describes a missing boy as wearing "a grey cloth monteer [*montero*] cap, lined and edged with green;" and in 1681, a youth aged fifteen is advertised for, who wore "a sad coloured cloth cap, turned up with sables, and laced down the seams with gold breed" (braid). The caps worn by the running footmen and those we still see on the heads of our huntsmen, jockeys, postillions, state footmen, trumpeters and kettle-drummers of the Life Guards, bargemen and others, in state dress, all had their rise during the last years of the seventeenth century. One of the earliest examples is afforded us in the effigy of John Clobery, in Winchester Cathedral, who died in 1687. The cap contrasts most ludicrously with the gravity of the rest of the costume. (See COAT.) Military caps of various descriptions began to supersede hats in some English regiments during the reign

Grenadier Caps.
Temp. Queen Anne.
Meyrick Collection.

Side view.

of Charles II. In 1678, grenadiers were first brought into our service, and Evelyn tells us that "they had furred caps, with coped crowns, like Janizaries, which made them look very fierce; and some had long hoods, hanging down behind, as we picture fools."

The caps of our infantry, in the days of Queen Anne and the two first Georges, may be seen in numberless paintings and prints of those times, notably in Hogarth's picture of 'The March to Finchley.' Adjoined is an engraving from a specimen of the reign of Queen Anne, in the Meyrick Collection. For the peculiar caps distinguishing certain professions, crafts, and dignities, some of which, like the trencher cap, for instance, have descended to the present day, we must refer the reader to the 'General History.'

From Viollet-le-Duc.

It is rather difficult to say when caps or bonnets were first worn by females in this country. Something like a flat-topped bonnet appears in the thirteenth century. M. Viollet-le-Duc presents us with two examples from sculpture in Notre Dame de Chartres and St. Nazaire de Carcassonne, which correspond with the figures in Harleian MS. No. 1527, written in the latter half of the thirteenth century. (See under CLOAK.) But until the fifteenth century nothing that can decidedly be pronounced a cap or bonnet is either mentioned or depicted. In the illuminated MSS. of that period we occasionally meet with head coverings which may be so denominated. Subjoined are a few examples from

From Viollet-le-Duc.

MSS. of the latter half of the fifteenth century, and representing some of the fashions of the reigns of Edward IV., Richard III., and Henry VII.

In the reign of Henry VIII. the Milan bonnet was worn by ladies as well as gentlemen, and some adorned with feathers were worn over cauls of gold network, which confined the hair. Hall, in his 'Union,' tells us "The Lady Mary, daughter to the king, and with her seven ladies, all appeared after the Romayne fashion in riche cloth of gold tissue, and crimosin tinsel bendy and there heres [hair] wrapped in calles of gold, with bonets of crimosin velvet on their heddes, set full of pearles and stones." And again, on another occasion : "Ten ladies had on their heds square bonnets of damask gold, with loose gold that did hang downe at their backes. Ten other ladies had Myllan bonnetts of crimosyn satten drawn through with cloths of gold."

Ladies' Bonnets. *Temp.* Henry VIII. From tapestry of the period. Anne, Queen of Hungary.

Anne of Cleves is described by the same writer as having on her head "a kalle [caul], and over it a round bonet or cappe set full of orient pearle, of a very proper fashyon, and before that she had a cornet of black velvet." Her portrait by Holbein, however, does not correspond with that description. The portrait long popularly known as that of Anne Boleyn, but latterly shown by Mr. Scharf to be that of Anne, Queen of Hungary and Bohemia, affords a good example of the Milan bonnet worn over the caul, and we add some others from Mr. Adey Repton's paper in vol. xxvii. of the 'Archæologia.' Whether the diamond-shaped head-dress in which Catherine of Aragon, Jane Seymour, Catherine Howard, and Catherine Parr are represented is strictly a cap or but a variety of the French hood will be considered under that name. The head-dress called the "Mary Queen of Scots' cap," composed sometimes of velvet and at others of lighter materials, has a better claim to the designation of "cap" than it has to its being specially assigned to the unfortunate Mary Stuart, as it was not introduced by her. It is seen on the head of Queen Elizabeth, when the daughter of James V. was in her nonage, and is simply a variety of an earlier head-dress fashionable both in France and England in the middle of the sixteenth century, which ought fairly to be classed among the hoods. (See HOOD.) Towards the close of the reign of Henry VIII., we hear of white caps being worn by women of the middle classes, but no hint as to their form or material. The widow of John of Winchcomb, the celebrated Jack of Newbury, after she left off her weeds, is described as coming out of the kitchen "in a fair train gown stuck full of silver pins, having a white cap on her head with cuts of curious needlework under the same." And in the thirty-second year of Henry's reign it was ordered by the Mayor and Corporation of Chester that, to distinguish the head-dresses of married from unmarried women, no unmarried woman should wear white or other coloured caps.

Queen Elizabeth. From an early portrait.

Our information is extremely meagre respecting the female fashions during the reigns of Edward VI. and Mary; but in that of Elizabeth, we have the voluminous accounts of the satirical Philip Stubbs to enlighten us, as far as verbal description can do so, though we still find considerable difficulty in identifying articles of dress unaccompanied by pictorial illustration. Most indignantly he rails at the merchants' wives for wearing French hoods, hats, and kerchiefs, every day, "with close caps beneath, of gold and silver tissue." Howe, the continuator of Stowe's 'Annals,' tells us that, "about the tenth or twelfth year of Queen Elizabeth, and for four or five years afterwards, all the

citizen's wives in general were constrained to wear white knit caps of woollen yarn, unless their husbands were of good value in the Queen's book, or could prove themselves to be gentlemen by descent; and then ceased the wearing of miniver caps, otherwise called "three-cornered caps," which formerly were the usual wearing of all grave matrons. These miniver caps," he adds, "were white and three-square, and the peaks thereof were full three or four inches from the head; but the aldermen's wives, and such like, made them bonnets of velvet after the miniver cap fashion, but larger, which made a great show upon their heads, all which are already quite forgotten." Howe's continuation was published in 1615, and we find some forty years after that date, Philip Massinger, in his play of the 'City Madam,' printed in 1659, makes Luke remind the rich merchant's wife that she wore "sattin on solemn days, a chain of gold, a velvet hood, rich borders, and sometimes a dainty miniver cap." Unfortunately, we have no pictorial illustration of this often-named cap attached to any description of it, and we are left to guess which of the various female head-dresses to be found in the paintings and engravings of the latter half of the fifteenth century represents the one in question. Was the fur called "miniver" used in its fabrication? Do the expressions "three-square" and "three-cornered," the peaks projecting "full three or four inches from the head," designate the "diamond-shaped head-dress," as we term it, from ignorance of its real name, already alluded to, and which first appears in the reign of Henry VIII., or the cap popularly identified with Mary Stuart, which may also be said to have three peaks? In an ordinance for the reformation of gentlewomen's head-dress, written in the middle of Elizabeth's reign, it is said that "none shall wear an ermine or lattice bonnet, unless she be a gentlewoman born, having arms" (i.e. entitled by birth to armorial bearings). (Harleian MS. No. 1776.) And Stubbs describes these lattice caps as having "three horns or corners, like the forked caps of popish priests," apparently identifying, at least in shape, the lattice bonnet with the miniver cap; and I am inclined to believe them to have been the same, as lattice or lettice, in Italian, *latizzi*, was the fur of "a beast of a whitish grey colour" (Cotgrave), somewhat resembling ermine; and miniver [*menu-vair*] was composed of "the fure of ermine mixed or spotted with the fure of the wessell, called 'gris.'" (*Ibid.*) Still no cap or bonnet that I have ever seen sculptured or depicted, resembles in the slightest degree "the forked caps," as Stubbs calls them, of popish priests, which had *four* corners, and although three only were visible in front, it would require a great effort of the imagination to perceive a likeness in them to any of the female head-

Costume of Queen Mary. From prints of the time.

Cap (Beretta) worn by the Roman Catholic Clergy. 16th century.

English Servant. *Temp.* Charles I.

dresses of the sixteenth century. (See HOOD and HEAD-DRESS.) Neither have I been able to discover one of that date of which fur of any description forms a visible portion, and must unwillingly, therefore, wait for some solution of a mystery which no writer on the subject of costume I am acquainted with has even attempted to elucidate.

Hollar has given us a graceful engraving of a female servant of the time of Charles I., in a close white cap; but coifs, hats, and hoods were more generally worn than caps by women of all classes during the seventeenth century, and in our modern sense of the word they do not appear as a portion of female attire previous to the reign of William and Mary, when the head-dress composed of tiers of lace and ribbons, known as "the tower," and less appropriately as "the commode," became the rage, and must, I suppose, be ranked as a cap, although it is never so designated in works of the period when it was in fashion. (See COMMODE.) The earliest women's caps, according to our modern notions, were very small, low-crowned, and bound with a ribbon, much like what are still worn by girls in charity schools, and sometimes with a

narrow frill or edging of lace. As late as 1753, in 'A Receipt for Modern Dress,' a lady is recommended to

"Hang a small bugle cap on, as big as a crown,
Smart it off with a flower, *vulgo dict.* a pompone."

From Moore's 'Fables.' 1744. From Richardson's 'Pamela.' 1745.

My task in this Cyclopædia terminates at the accession of George III., 1760. With the constant changes of fashion in this article of attire since that period I have therefore nothing to do. So innumerable are its varieties, so fantastic, so preposterous, in the majority of instances, its forms, that the monstrosities of the Middle Ages, which provoked the censure and satire of the poets and annalists of their time, appear graceful by comparison. Verbal description would utterly fail to convey a correct idea of them. Fortunately for those who may require accurate information on the subject there is no lack of pictorial illustrations in the annual pocket-books, monthly magazines, and contemporary paintings and caricatures of the last hundred years.

CAP, BLUE. A name given to the Scotch bonnet by Englishmen. In a publication of the time of George I. we read of "a parcel of brawny fellows with mantles about their shoulders, and blue caps upon their heads." ('A Second Tale of a Tub,' London, 1715.)

"Yif ever I have a man, bleu cap for me."—Evans's *Old Ballads.*

The flat cloth bonnet now worn in Scotland, and seen on the head of Prince Charles Edward, in

Prince Charles Edward.

Scotch Bonnets.

his portrait, formerly in the possession of G. A. Williams, Esq., Cheltenham, of which we give a reduced copy, is not very unlike a cap worn in England in the time of Edward I., and that called the Glengary resembles the cap worn by the Danes, and may have been introduced by them in the tenth century.

Blue caps appear to have been worn in England by rustics in the sixteenth century; as in Green's 'Ciceronis Amor,' 1597, a shepherd is described as attired in a grey cloak, a russet jacket with red sleeves, and a blue bonnet on his head. Blue plush caps were also mentioned by Malcolm as worn in London in 1681.

CAP OF ESTATE, or *MAINTENANCE.* See ABACOT.

CAP, FOOL'S. "For William Somar, the king's fool, a cappe of grene clothe fringed with red crule and lined with fryze." (Wardrobe Account, Henry VIII. See HOOD.)

CAP, NIGHT. Nightcaps are first mentioned in the times of the Tudors. In an inventory of the Wardrobe of Henry VIII. we find: "A nightcappe of blacke velvett embroidered." They were worn in the day-time by elderly men and invalids.

"When Zoilus was sick he knew not where,
Save his wrought nightcap and lawn pillow-bear."—Davies's *Epigrams.*

Fox, describing the dress of Bishop Latimer when he attended the commissioners appointed by Queen Mary at his last examination, says, "he held his hat in his hand, having a handkerchief on his head, and upon it a nightcap or two, and a great cap such as the townsmen use, with broad flaps to button under the chin." ('Book of Martyrs.')

In 1547, the cost of "two nyghtcaps of velvet" was eight shillings. ('Archæologia,' vol. xxi.) They are frequent in portraits of the seventeenth century, some of velvet or silk, occasionally richly

From portrait of Earl of Nottingham.

From portrait of Spelman.

Pope. From a mezzotint by T. Smith.

Hogarth. From portrait by himself.

embroidered and edged with lace (see woodcut of the portrait of Spelman from the frontispiece to his 'Glossary'), and were generally worn in the morning at the beginning of last century by gentlemen

Lady's Night-cap. From Hogarth. 1734.

in the absence of their wigs. The portraits of Pope, Hogarth, and Cowper are familiar examples. In Hogarth's works we also find specimens of the nightcap worn by various classes of females, and in 1762 the French nightcap was worn by women of fashion in the day time. It set close to the ears and cheeks, leaving but little of the face to be seen. A writer in the *London Chronicle* of that year says: "Each lady when dressed in this mode can only peep under the lace border." (See also under HEAD-RAIL.)

CAPA. (*Chape*, French.) A hooded mantle or cloak, worn by both sexes, whether lay or clerical, in the twelfth and thirteenth centuries. "*Capa, cappa :* vestis species qua viri laici, mulieres laicæ, monachi, et clerici, induebantur." (Ducange *in voce*.) The "capa pluvialis" was so called from its being worn in rainy weather: "Une chape a pluie afaubla." ('Le Roman des Vacces,' MS.) In France, as late as 1374, the officer subsequently styled *porte-manteau du roy*, was called *porte chappe.* (See CLOAK.)

CAPE. This familiar appendage to a coat or cloak was, in the sixteenth century, a separate article of apparel. In an inventory of the wardrobe of Henry VIII. (Harleian MS. 2284), "half

a yard of purple cloth of gold bandkin, to make a cape to a gown of bandkin for the king;" also, "a Spanish cape of crimson satin, embroidered all over with Venice gold tissue, and lined with crimson velvet, having five pair of large aglets of gold,"·said to have been the gift of the queen.

Capes were exceedingly fashionable with gentlemen in 1735, as may be seen in prints of that period, when loose overcoats of coloured cloth (called "wrap-rascals" by the editor of the *London Evening Post* in 1738, who accuses them of imitating stage-coachmen,) were worn with black velvet capes, and towards the close of the century, coats with double and treble capes were sported by the bucks and beaux of London and Paris. From that date they appear to have been confined to the great coats of coachmen, livery servants, and parish beadles, or similar officials, and to the cloaks of the cavalry.

CAPEDHURSTS, CAPEDEHUSTES. See VOLUPERE.

CAPELINE, CHAPPELINE. An iron or steel cap, worn by archers and light troops during the Middle Ages. In a document of the date 1294, cited by Ducange, occurs, "ij capelinæ ferri"; and in another, A.D. 1377: "Armé de jaques, de cotes et de capelines de fer." Simply a COIF DE FER, which see.

CAPUCHIN. A hood worn by ladies in 1752, resembling that of a Capuchin friar, whence its name. "Mrs. Needlework, bid John come round with the coach to the door, and bring me my fan, gloves, and capuchin, in an instant." ('Gray's Inn Journal.') In the eighth number of the same work is an advertisement of the sale by auction of the whole stock of a coquette leaving off trade, in which mention is made of "a transparent capuchin." It was succeeded by the caleche in 1765.

Transparent Capuchin.

CAPUTIUM. See CHAPERON.

CARBINE, CARABINE, CARABEN. A fire-arm, first introduced in England in the reign of Queen Elizabeth. The origin of the name is disputed; one derivation is from the vessel called 'Carabs,' on board of which it has been presumed they were first used; but troops called "Carabins," a sort of light cavalry from Spain, are first mentioned A.D. 1559 (1st of Elizabeth), and this favours another derivation, signifying, in Arabic, a weapon, and the Spaniards most probably adopted this particular weapon from the Moors, who were celebrated marksmen on horseback.

Wheel-lock Carbine of the time of Queen Elizabeth. Meyrick Collection.

CARCANET. (*Carcan*, a collar, French; *carcannum*, Latin, from καρκίνος, Greek: genus *vinculi.*) Ordinarily, a necklace, but the word is also used occasionally to describe a cluster of jewels or pendent ornaments for the hair.

"Curled hairs hung full of sparkling carcanets."—Marston's *Antonio and Thellida.*

"Your carcanets
That did adorn your neck of equal value."—Massinger, *City Madam.*

"I'll clasp thy neck where should be set
A rich and orient carcanet."—Randolph.

"About thy neck a carkanet is bound,
Made of the rubie, pearl, and diamond."—Herrick.

Cotgrave, who was a contemporary of the fashion, says plainly " a collar of gold ;" but Mr. Fairholt, in his ' Costume in England,' refers the reader to a woodcut, in which a lady's head-dress is ornamented with two strings of pearls ; and in the portrait of Queen Elizabeth, by Elstrack, we see what might have been a necklace hung upon her hair, and the pendent jewel resting upon her forehead. (See HEAD-DRESS.) In 1694, it is clearly described as " a rich chain to wear about the neck." (' Ladies' Dictionary.')

CARDA. A sort of cloth used in the making of surcoats in the fourteenth century, probably for the lining, as in the roll of purchases made for a tournament at Windsor, 9th of July, 1278, sixth of Edward I., one hundred and nineteen ells at fourpence an ell, being furnished for thirty-four surcoats : " Item, p. xxxiiij cooptor̃ [coopertorum] cxix ulñ card." (See also CUIRASS.)

CARDINAL. A cloak with a hood to it of scarlet cloth, and, like the mozetta or crocea, worn by the cardinals. It was much worn by the ladies at commencement of the eighteenth century. Strutt says, " It is a winter vestment worn in the country, I believe, to the present day ; but in my memory it had the hood annexed to it, and its colour was usually bright scarlet." It is still worn in many parts of England. Malcolm, writing in 1807, says the cardinal " was almost always of *black* silk, richly laced ;" but that it was originally scarlet the name alone, without the personal testimony of Strutt in 1796, is sufficient to convince us.

CARGAN. (See CARCANET for derivation.) Apparently a collar or gorget of chain mail worn by foot soldiers in the first half of the thirteenth century. " Peditem armatum intelligimus armatum scuto et propuncto seu conspergato et coifa seu capello ferreo et cargan, vel sine cargan." (' Statutes of Frejus,' A.D. 1233. See GORGET.)

Cardinal. From a print after Hogarth. 1734.

CARRIAGES. An appendage to the sword-belt, of the latter half of the sixteenth century, originally necessitated by the length of the rapier, but generally adopted, *temp.* 2 Elizabeth, for the sword of the period. (*Vide* Plate IV. fig. 9.) It was also called "hangers." The following passage in the tragedy of ' Hamlet ' will be familiar to many of our readers :

" OSRIC. Six French rapiers and poniards, with their assigns, as girdle, hangers, and so. Three of the carriages in faith, are very dear to fancy, very responsive to the hilts, most delicate carriages, and of very liberal conceit.
" HAMLET. What call you the carriages ?
" OSRIC. The carriages, sir, are the hangers."—Act v. scene 2.

CARTRIDGE. (*Cartouche*, French.) According to Sir James Turner (' Pallas Armata,' 1671), cartridges were first used for charging muskets in Germany *circa* 1630, on the abandonment of the bandileers. The

CARTRIDGE BOX was in use before 1677, as Lord Orrery at that date says, " I am also, on long experience, an enemy to the use of bandileers, but a great approver of boxes of cartridges ;" and adds, " I would have these cartridge boxes of tin, as the carabines use them, because they are not so apt to break as the wooden ones are, and do not in wet weather or lying in the tents relax." (' Treatise on the Art of War.')

CASQUE. (French ; *caschetto*, Italian, from *cassis* and its corruption, *cascus*, Latin.) Helmets of every description, from those of classical times to the present, have been called casques by the poets ; but the headpiece specially so designated is first seen in English armour in the reign of Henry VIII. It was generally without a vizor, and worn more for parade, apparently, than serious warfare ; the

specimens in European armories are elaborately ornamented and embossed, and furnished with cheek pieces and oreillets. Mons. Auguste Demmin justifiably applies the term to every species of head-

Casques. Meyrick Collection.

piece which has not a distinctive appellation, as we generally do that of "helmet," with less propriety; but his derivation of the word from the Keltic *cas* (box or sheath), and *ked* from *cead* (head), is exceedingly problematical. It is clear to me that the headpiece of the sixteenth century, which is specially distinguished by the name of "casque," was so called from its classical form being modelled obviously from the antique, in accordance with the taste at that period pervading all western Europe, characterised as the Renaissance, or revival of art. In addition to existing examples, we give engravings from some curious tapestry of the close of the fifteenth century, formerly in the Painted Chamber in the old Palace at Westminster, of casques with vizors and feathers, richly ornamented and studded with jewels.

From the tapestry in Painted Chamber.

The head-pieces worn by the Cavaliers and Roundheads in the seventeenth century, commonly called "lobster-tailed helmets," were casques, with the addition of bars, or simply a nose-guard.

Temp. Charles I. and II.

Temp. Charles I. and II.

Casquetel.
Meyrick Collection.

CASQUETEL. A similar open headpiece of simpler and more business-like appearance, flatter in the crown, with a peak in front, and a protection for the neck.

CASSOCK. (*Casaque*, French ; *casaca*, Latin.) A long loose coat or vest. "Vestis species, lacerna, chlamys." (Ducange *in voce*.) "Foleraturas tamen sindonis, vel casacam in ipsis mantellis vel vestibus liceat eis (mulieribus) portare." ('Litteræ Patentes Caroli V. Regis Franc.' *anno* 1367.) In the Wardrobe Accounts of the reign of Henry VIII. some very rich cassock and cassock coats are described (see COAT) ; but the term is most capriciously used and applied at different periods to widely dissimilar garments. "Mourning cassocks" for ladies and gentlemen are mentioned as early as the 8th of Henry VII. (see SLOP) ; but the word in the reign of Elizabeth signified, according to Stevens, "a horseman's loose coat," the garment having gone out of fashion probably among the higher classes. In Nash's 'Pierce Pennyless,' 1592, we read of "an old straddling usurer, clad in a damask cassock edged with fox-furr." In the old comedy of 'Lingua,' 1607, Mr. Fairholt ('Costume in England,' p. 475) remarks, that Communis Sensus is described "as a grave man in a black velvet cassock, like a counsellor," while Memory is "an old decript man in a black velvet cassock also ;" and he gives as an illustration a woodcut of a figure of a hackney-coachman, from a broadside of the time of Charles I., in the British Museum, dressed as he states, in a cassock, which is certainly nothing more nor less than a loose coat, with buttons all down the front, and large cuffs, the prototype of the coats of our great grandfathers. Subjoined is the figure of a French gentleman of the reign of Louis XIV., from a print of the period, by N. Bonnart, entitled 'Cassaque d'Hyuer à la Brandebourg.' The buttons, with lace loops and frogs, were called Brandebourgs within my recollection. Beneath the figure are these lines :

French Gentleman of the reign of Louis XIV.

Hackney Coachman.
About 1680.

" Cette casaque paroist gauffe
 Mais en hiver à mon aduis,
 Outre que le corps elle echauffe,
 Elle conserve les habits."

Here it is undoubtedly an overcoat.

The clergy, however, had a garment equally called a "cassock," which Randal Holme describes as resembling what he calls the tunic of the laity (see VEST). Bishop Earle, in his 'Microcosmography,' A.D. 1628, characterises a vulgar-spirited man as "one who thinks the gravest cassock the best scholar ;" and Killigrew, in his 'Parson's Wedding,' A.D. 1663, makes the Captain say, "He" (the Parson) "was so poor and despicable when I relieved him, he could not avow his calling for want of a cassock." This is definitive as respects its being a clerical and an academical garment, and as we find it allowed to be worn by women as early as the fourteenth century, it was no doubt originally a long loose *gown*, and like many other articles of attire, as will be shown in these pages, transmitted its name to a garment of a very different description. In the 'Traité des Marques Nationales,' the *casaque* is said to have been introduced into the military costume of France in the reign of Charles VI., after the fatal battle of Nicopolis, 28th September, 1396, and called indifferently "casaque" and "hongreline," from

its being worn by the Cossacks and Hungarians, under Sigismund, to whose assistance against the Turks Charles had despatched a considerable army. The writer, who cites no authority for this statement, describes the garment as a sort of light cloak fastened by a clasp on the breast, and which could be thrown open to display the armour in fine weather and protect it in foul. He proceeds to trace the various alterations of fashion in the cassock, long, short, with hanging sleeves, &c., down to the time of Louis XIV., when it was only worn as a cloak for cold or rainy weather, under the name of "roquelaure."

Mr. Fairholt, at page 276 of his work, tells us that the cassock was an under-garment, commonly worn beneath the academical gown by clergymen until the reign of George II., as a distinctive dress in ordinary life. It was then shortened to the knee. It is not peculiarly clerical, as it is worn in many instances by the undergraduate students in Spanish universities; and he gives us an engraving of a bishop, in which the smallest possible portion of it is to be seen under the rochet. He does not appear to have been struck by the utter dissimilarity of such a vestment to that worn by the hackney coachman he has figured at page 475, or to the vest of the time of Charles II., also called a cassock by Pepys (see VEST), or the magnificent cassock coats of Henry VIII. (See COAT.) One of the principal objects of this work is to clear up as far as I am able the confusion occasioned by verbal descriptions so irreconcilable, apparently, as the foregoing, and enable the artist at once to distinguish amongst several articles of apparel, bearing the same name, the precise object he is in search of.

The cassock appears in the reign of James I. as a portion of female attire, and is alluded to as an old fashioned garment:

"Her apparell was after the elder beere,
Her cassock aged some fifty year.
Grey it was an long beforne;
The wool from the threads was worne."
Cobbler of Canterbury, 1608.

Fifty years would take us back to the early days of Elizabeth. It is now known only as a close under-vestment of black silk, worn by bishops, or of stuff, by the priesthood.

CASTOR. This name for a beaver hat occurs in an advertisement for a missing youth of fifteen, in 1688: "A black castor, with a silver twisted hat-band."

CAUL. During the Middle Ages this word was used to describe the gold net which confined the hair of ladies of distinction. (See CRESPINE.) In a romance of the fourteenth century, entitled 'The King of Tars,' the soldan's daughter is described as attired

"In cloth of rich purple palle,
And on her head a comely calle;"

which of course would not have been worn by "the soldan's daughter;" but this is only one of the numberless instances of the value of these mediæval romances, which furnish us with information respecting the habits and manners of their own times and nations, while purporting to depict those of others of which they were entirely ignorant.

CELDAL. In accounts of the thirteenth century, quoted by Ducange, edit. 1842, *sub voce*, we find under the date 1202: "Pro uno furura de celdal ad robam viridem," xl. 5, and "Pro roba de viridi forato de celdal octo dies magdalenam," lx. 8; and under Cindalum, "Unum supertunicale forratum de cindalo." (Test. Garini. A.D. 1314.) These quotations would appear to indicate that there was a fur called "celdal" or "cindal," as well as the silken stuff known by the name of CENDAL, which see below.

CELT. (*Celtis*, Latin; *cisel*, French. A chisel.) A name given by antiquaries to a bronze implement or weapon, numbers of which are found in England, Ireland, and nearly all over Europe. "Malleolo et celte, literatus silex." (Ducange *in voce*.) Not only the implements themselves, but the

moulds which they were cast in, have been discovered with them, and their use has been the subject of an unending controversy. I have stated my opinion under the word AXE, and will here only give a few specimens of these curious relics from the national and other collections.

1. 2. 3. 4. 5. 6.

1. Archæologia, vol. v., Plate ix. fig. 7.
2. Archæologia, vol. v., Plate x. fig. 2.
3. From collections in Lincolnshire.

4. From Herculaneum. Archæologia, vol. v. Plate viii. fig. 21.
5. Meyrick Collection.
6. Meyrick Collection.

CENDAL. A silken stuff, much valued in the thirteenth and fourteenth centuries. "Tela subserica vel pannus sericus." (Ducange, *in voce* Cendalum.) It was used not only for articles of attire, but for flags, the trappings of horses, curtains, &c.

> " La ont mainte riche garnement,
> Borde sur cendeaus et samis."
> *Siege of Caerlaverock*, A.D. 1300.

"Pour 2 botes de cendal de graine, 120 escus. Pour une bote de cendal jaune, 52 escus." (Comp. Steph. de la Fontaine, 1351.)

The celebrated auriflamme, or banner of St. Denis, is stated to have been made of "cendal pur."

> "L'enseigne tinst, qui fut de cendal pur."—*Roman D'Aubrey*, MS.

Yet *cendalium* and *cindalium* are, in several instances, cited by Ducange, where the names are obviously applied to a fur. (See CELDAL.) A careful consideration of the context is therefore indispensable to the student who would avoid confounding two thoroughly distinct materials in use at the same period.

CERTYL. See KIRTLE.

CERVELLIERE. (*Cervellerium, cerebrarium*, Latin.) A skull-cap of steel or iron. "Quum comperisset se moriturum excogitativit novam armaturam quæ vulgo cerebrerium sive cerebotarium appellatur qua jugitor caput munitium habebat." ('Chronicon Francisi Pepina,' lib. ii. cap. 50.) "Haubergeons et cervelieres." (Guisart 'Chronique Metrique,' *anno* 1298.) "Capelleto di ferro per defera del capo," Ital. (Ducange *in voce*.) In the 'Chronicon Nanantubanam,' *temp.* Frederick II., Emperor of Germany, the introduction of this head-piece is attributed to the astrologer, Michael Scott. "Per hoc tempore Michael Scotus astrologus Frederici Imperatoris familaris agnoscitur, qui invenit usum armatura capitis quæ dicitur cervellerium." Having foreseen that he should be killed by the fall of a stone, weighing two ounces, upon his head, he contrived a cap of plate iron. One day being at mass, upon the elevation of the host, he reverently raised his cap, when a little stone fell on his head and slightly wounded it. Finding it weighed exactly two ounces, he felt his doom was sealed, arranged his worldly affairs and died.

Mr. Strutt says the cervelliere does not appear to have been known in England at any period.

Possibly not under that name, but surely it was the same head-piece as the coif de fer, an iron skull-cap, worn either under or over the coif de mailles. (See COIF DE FER.)

CHAISEL, CHAINSEL. (Old French.) Fine linen. "De chainsel blanc."

> "Une chemise de chaisel
> De fil et d'œuvre mult scrotel."—*Romance of Atis.*

> "In a chaysel smock she lay."—*Romance of Alexander.*

In the tale of 'The Old Wise Man and his Wife,' in 'The Seven Sages,' the wife is said to have had on "a pilche of pris" [*i.e.* a costly furred cloak], "and a chaisel *thereon*, I wis;" the stuff having apparently given its name to some article of apparel which was worn on or over the cloak.

CHAPE. (*Chapa*, Spanish, a thin plate of any metal.) A metal tip or case, that strengthens the end of the scabbard of a sword or dagger, or the termination of a belt or girdle. "Chape of a shethe." (Bouterolle de Gayne.) "To chape a sword or dagger." (Palsgrave.)

The chape of the sword-sheath of John, King of France, is a badge of the Earl Delawarr, assumed by his ancestor Sir Roger de la Warr, in commemoration of his being one of the knights who took that sovereign prisoner at the battle of Poictiers, 1356. It is called a "crampet" in heraldry. Numerous examples are furnished us by the sepulchral effigies of the Middle Ages. The subjoined are from those of Sir John de Lyons, Warkworth Church, Northamptonshire, 1346–84, and Sir Gerrard de Lisle, in Stowe Church, in the same county, 1259, engraved from Albert Hartshorne's 'Recumbent Effigies.'

Chapes of Scabbards. 13th and 14th centuries.

In the sixteenth century some specimens exhibiting much tasteful and elaborate workmanship are met with. See the chapes of a sword and dagger of the reign of Henry VIII., for which we are indebted to Mr. Shaw's 'Dresses and Decorations.'

Chape of Sheath of a Dagger. *Temp.* Henry VIII.

Chape of Sheath of a Sword. *Temp.* Henry VIII.

Chape of Sword-belt. From effigy in Hereford Cathedral. 1321.

CHAPEAU-BRAS. (French.) A small three-cornered flat silk hat, carried under the arm by gentlemen at court, or in full dress, in the latter half of the last century.

CHAPEAU, KNIGHT'S. See ABACOT.

CHAPEAU MONTAUBAN, MONTAUBYN. An anonymous writer of the fifteenth century, quoted by M. Viollet-le-Duc, describes the "chapeau de Montauban" as a steel head-piece. (See CHAPEL DE FER.) Froissart, in the fourth book of his 'Chronicles,' tells us that a page in attendance on Charles VI. of France, the day that monarch was seized with madness, while on his way from Mans to Angers, had on his head "un chapel de Montauban, fin, cler et net, *tout d'acier*, qui

resplendissoit au soleil." It is not clear that this was the king's head-piece which the page had charge of, as it has been suggested, and I cannot adopt that opinion : firstly, because in all instances, and there are many, in which a page or an esquire is represented so occupied, he carries his lord's helmet in his hand ; and that of a sovereign, assuredly distinguished by some regal ornament, it would be unreasonable to suppose he would place on his own head : secondly, on such occasions the prince or noble is always depicted or described as armed *à toutes pièces*, except his head, and in this case the king was in civil attire, wearing a black velvet doublet with a crimson hood, and a chaplet of large pearls, which the queen had presented to him on his departure.

That which most concerns us however is, that we have here evidence of a " chapel de Montauban," of steel, at the close of the fourteenth century. But it was also the name for a hat or cap worn in the sixteenth century. Hall, in his 'Chronicle,' tells us that Henry VIII. wore " a chapeau Montaubyn, with a rich coronal," the folds of the chapeau lined with crimson satin, and on that " a brooch with the image of St. George." Of its shape we have no idea, or whence it derived its name ; it is clear however that, as in the case of the bycocket, there was an article of civil as well as of military costume so called in the fifteenth century,—whether from the city of Montauban, in France, or from a member of one of the families of that name, is at present unknown to us.

CHAPEL, or *CHAPPELLE*, *DE FER*. (French.) A cap or hat of steel, as the name imports, frequently alluded to in English documents as an " iron hat," worn by knights previous to the introduction of the bascinet and generally by men-at-arms during the Middle Ages. Many varieties are to be seen in illuminations and effigies of the thirteenth century, and in the paintings formerly in the old Palace of Westminster, coloured engravings from which were published by the Society of Antiquaries in the 'Archæologia.' (See under FALCHION, also the group of knights at page 17, *ante*.) M. Viollet-le-Duc presents us with two from MSS. in the Bibiliothèque Nationale, Paris ; the

Chapel de Fer.

Chapel de Fer.
13th century.

distinguishing feature of the chapel de fer, or steel hat, from the coif de fer, or skull cap, being the brim to it, which gradually increased in breadth, and received the name of " aventaille " in common with all protections of the face. Towards the close of the thirteenth century the chapel, as well as the coif de fer or de mailles, over which it was worn, took the form of the head, and was occasionally strengthened by a comb or crest, as seen in our woodcut, from Add. MSS., British Museum, No. 11,639, written in the reign of Edward I.

In the fourteenth century the brims became much broader and the crown more conical ; but a curious variety is presented to us by the effigy of a knight of the commencement of it, in Ashington Church, in the county of Somerset, who wears a wide and peculiarly pointed chapel de fer over a coif or cervelliere of metal, as well as a hood of mail. How such a hat could be secured upon the head is a mystery. M. Viollet-le-Duc says, " Ces chapels de fer étaient attachés par-dessus le camail au moyen d'une curroie sous le menton," but quotes as his authority the following line :

Chapel de Fer.
Temp. Edward I.

From a sepulchral slab
in Ashington Church,
co. Somerset.

" Et Robastre deslache son capel qui fu bon."—*Gaufrey*, v. 10161 ;

but certainly that line does not acquaint us with the *modus operandi*. There are indications in the present example that the skull-cap, whatever it may be, is secured to the hood in the same way that the bascinet was to the camail, but there is no visible proof of the security of the iron hat in this representation.

We borrow from M. Viollet-le-Duc's work the six following varieties :—The first, taken from a MS. copy in the Bibliothèque Nationale, Paris, of 'Launcelot du Lac,' date *circa* 1310, exhibits a considerable extension of the brim, with a low crown, rising to a point in the centre, which accords with

the characters of the effigies of the reign of Henry III., and inclines one to assign it to some forty years earlier than the assumed date of the manuscript. The mode in which it was attached to the mail hood is distinctly visible, but the thong does not pass under the chin. It does, however, in the second, taken from an illuminated copy of the *roman* 'Tristan et Iseult,' in the same collection. It is higher in the crown, which has a slight comb to it. The brim is bent down and affords more protection to the face. The date is fairly attributed to the middle of the fourteenth century.

The third, from a MS. copy of Titus Livius, in the library at Troyes, has an extremely broad brim, the front of which, still more depressed, has two slits in it, to enable the wearer, by bending his

Fig. 1.—Chapel de Fer. Close of 13th or commencement of 14th century.

Fig. 2.—Chapel de Fer. *Circa* 1340.

Fig. 3.—Chapel de Fer. From a MS. in the Library at Troyes, 1403.

head, to look through, as he would through a movable vizor. This head-piece, which M. Viollet-le-Duc assigns to the commencement of the fifteenth century, he pronounces to be a chapel or chapeau de Montauban, but upon what authority he has omitted to mention. His words are, " Ces chapels prennent alors le nom de chapels de Montauban. Ils sont de diverses sortes, bien que l'auteur anonyme du 'Costume militaire des Français en 1448' les décrive ainsi : 'Les chappeaulx de Montaulban sont rondes en testes a une creste au meillau, qui vait tout du long, de la haulteur de deux doiz, et tout autour y a ung avantal de quatre ou cinq doiz de large en forme de maniere de chapeau.'" With all deference to M. Viollet-le-Duc, I do not consider that the description of the anonymous writer, whose weight as an authority I have no opportunity of ascertaining, enables us to come to so

Fig. 4.—Chapel de Fer. From MS. 15th century.

Fig. 5.—Chapel de Fer. From MS. 15th century.

Fig. 6.—Chapel de Fer. From a French MS. of Boccaccio, 15th century.

positive a conclusion. I have shown above that there was an article of civil costume at the same period, called a "chapeau de Montauban," which was no doubt round, in some sense of the word, and had probably a brim four or five inches broad ; but surely, no one can look at fig. 3, here engraved, and believe that it resembled in shape the cap worn by Henry VIII., the fold of which was lined with crimson satin, on which was fastened a brooch of St. George ; still less fig. 4, which M. Viollet-le-Duc classes with the head-pieces called Montauban. Fig. 5, from the same MS. ('Miroir Historical,' Bibliothèque Nationale, Paris), presents a form to which some parallel might be found in the caps and bonnets of the fifteenth century. In the MS. it is assigned to King Porus, and has better claims in my opinion than any other to the designation of "chapeau de Montauban ;" but until some contemporary delineation

of that particular head-piece is discovered, which will enable us to recognise it among the mass of civil and military head-gear depicted in our illuminated chronicles and romances, I abstain from any attempt to identify it. Fig. 6, from a French copy of Boccaccio, written *circa* 1420, exhibits the more familiar form of the chapel de fer, which was the immediate precursor of the salade, and was subsequently revived in the morion.

CHAPERON. See Hood.

CHAPLET. This familiar term for a wreath of flowers was in the Middle Ages applied also to a circlet of gold, often set with jewels, in the form of flowers, to bandeaux of pearls and precious stones, and garlands of goldsmith's work more or less elaborate. Chaplets of real flowers were worn by ladies over coifs or cauls of gold embroidery. In the 'Roman de la Rose' Idleness is so represented:

> " D'orphray eut ung chapel mignon ;
> Ung chappel de roses tout frais
> Eut dessus le chapel d'orfrayes."

Thus translated by Chaucer :

> " Of fine orfrays had she a chapelet,
> And fayre above that chapelet
> A rose garland had she set."

Chaplets of jewels and of real flowers were worn by men as well as by women. Edward III. presented his own chaplet of fine pearls to Eustace de Ribeaumont, with whom he had fought beneath the walls of Calais (31st December, 1348), in token of his admiration of the prowess of his antagonist (Froissart, chap. cli.) ; and in the following century, when Charles VIII. of France made his triumphant entry into Naples, the ladies of the city placed upon his head a chaplet of violets. The effigy of Charles Comte d'Estampes (1300–36), in the royal catacombs at St. Denis, represents him in complete mail, but with a chaplet of roses round his head : an indication of his rank, and which would therefore be of goldsmith's work and probably jewelled. Another example is afforded us by the Register of the Benefactors of the Abbey of St. Albans

Head of Effigy of Charles Comte d'Estampes.

Cotton. MS. Nero, D.
15th century.

(Cotton. MSS., British Museum, Nero, D vii.). It was the custom of young girls to make garlands of flowers for themselves and also to give to their lovers.

> " Et sa mie lui fit chapeau
> De roses, gracieux et beau."—*Roman de la Rose.*

Sloane MSS., No. 398.

Royal MSS., 2 B vii. 14th century.

Royal MSS., 15 D ii. 15th century.

Some rude drawings in MSS. of the thirteenth and fourteenth centuries, in the British Museum, exhibit females engaged in this romantic occupation, and from another of the fifteenth century we give the head of a lady so decorated.

CHASTONS. According to Mr. Fairholt, who does not quote his authority, chastons were "breeches of mail used by knights in the thirteenth century, and occasionally worn until the sixteenth." ('Costume in England,' *sub voce.*) The word occurs in the order of provision for the Windsor tournament, in 1278: "It. p. quolibet cresta j par̃ chaston et j clavon." Mr. Hewitt ('Ancient Armour in Europe,' vol. i. p. 347) considers chastones to be a kind of socket or cavity (French, *chaton*), in or by which the crest was affixed to the helm by nails (*clavones*). The word "pair," however, in the line above quoted militates against that interpretation, as "one *pair*" of sockets or cavities would be an unwonted expression. *Chasto* is undoubtedly the mediæval Latin for the modern French *chaton*, the socket in which the gem of a seal or ring is set. It is unfortunate that Mr. Fairholt has not informed us where he met with the word as signifying breeches. Chastons might possibly be a corruption of chaussons, but in the 'Roman de la Rose' chastons are mentioned as ornaments of a lady's head-dress: "Et beaux chastons a quatre esquierres" (l. 21,890), which I take to be four square or diamond-shaped ornaments, probably containing jewels. (See under CRESPINE.)

CHASUBLE. (*Casula*, Latin.) A portion of ancient ecclesiastical costume common to all the Roman Catholic clergy, from the priest and deacon to the archbishop: "Presbyteri vel diaconi non sagas laicorum more vel casulis utantur rito servorum Dei." ('Synodus Liplinensis,' can. 7.)

Stigant, Archbishop of Canterbury.
From Bayeux Tapestry.

Odo, Bishop of Bayeux.
From his seal.

Bishop, 12th century.
Cotton. MS. Nero, C iv.

It was at first perfectly circular, with a round opening in the centre, through which the head was passed, covering nearly all the rest of the person, except when lifted up by the arms, and the uppermost vestment of the clergy. "Casula quæ super omnia vestimenta positur." (Alcuin, Liber de Officio.) But

in the eleventh century we find a variety introduced, the front being much shorter than the hinder portion, and terminating in a peak. Witness that of Odo, Bishop of Bayeux, from his seal, and of Stigant, Archbishop of Canterbury, from the Bayeux Tapestry. Later we perceive another change,

Chasuble of Thomas à Becket.

Front of Chasuble.

Back of Chasuble.

in the chasuble of the celebrated Thomas à Becket, Archbishop of Canterbury, still preserved in the cathedral of Sens. Another, assigned to St. Dominic, is in the church of St. Sermin at Toulouse. It appears almost restored to its old form, but exceedingly ample, and descending before and behind

John de Sheppy,
Bishop of Rochester. 1360.

Richard Thaseburgh, a Priest,
Heylesdon Church, Norfolk. 1387.

Latest form of Chasuble.
From a painting by Rubens of Ignatius Loyola.

ENAMELLED PLATE WITH EFFIGY OF ULGER, BISHOP OF ANGERS, 1149.

to the mid-leg. From that time to the sixteenth century little alteration appears to have been made in its form, and the numerous magnificent effigies of the higher orders of the clergy, still existing in this country, are within the reach of all, and render it necessary to multiply examples. For the bishops and archbishops, the chasuble was made originally of silk, and richly embroidered. "Panus sericus pro cauda facienda;" "Cauda colorisæ theria phrygio palmam habente;" "Casulam preciosa." (*Vide* Ducange *in voce*.) Finally, the sides were still further reduced in consequence of the change of material from silk to thickly embroidered cloth of gold, and became oval, hanging no longer in graceful folds, but flat and stiffly before and behind, and as M. Viollet-le-Duc truly observes : "D'un très-beau vêtement on vint ainsi faire un ornement difforme, qui donne à celui qui le porte l'apparence d'un énorme coléoptère."

CHAUSSES, CHAUCES, CHAUCHES. (French.) The close-fitting coverings for the legs generally worn by men of nearly all classes, from a very early period to the sixteenth century, not only in England, but in the principal nations of Europe. They were what we should now call "tight pantaloons" with feet to them. They seem to have had an Oriental origin, as they appear in Phrygian costume, which, in all its portions, from cap to shoe, so closely resembles the Anglo-Saxon that it indicates unmistakably the course of one of the streams of migration from Asia Minor, so ably traced by Dr. Nicholas in his 'Pedigree of the English People.' The Amazons are depicted in the tight leg coverings, as affecting male attire. They are found on Etruscan vases, and especially distinguished the Venetian costume of the Middle Ages, whence they derived their name of pantaloon. Further information will be found under the word Hose, their Saxon application. The name of "chauces," "chauces de fer" ('Roman de la Rose,' l. 12,818), was also applied by the Anglo-Normans to the leggings of mail or defensive armour of any description, which took the form of the civil articles of attire so denominated. In the Norse language they are called *bryn-hosur* ('Speculum Regale,' an Icelandic chronicle of the twelfth century). Examples will be found in the article on Armour, pp. 15–17, and in the General History. Breeches of leather or quilted stuff were worn with the latter towards the termination of the thirteenth century. "The purpose of which," Mr. Hewitt observes (vol. i. p. 242), "was probably to obviate the inconvenience of the long chausses of metal in riding." Many instances occur of them, but one of the most instructive is seen in the effigy in the Temple Church, London, supposed to be that of William Mareschal

Effigy in the Temple Church, London.

the younger, Earl of Pembroke, as it exhibits the mode of fastening them below the knee. Mr. Hewitt applies to them the name of *chausons*, but I have not met with the word in that sense.

CHECKERATUS. "Capa cum nodulis chekeratis subtilis operis facta de casula Episcopi Fulconis." (Visit. Thesauri S. Pauli, London, A.D. 1295.) Mr. Strutt considers it to be a cloth of chequer-work, curiously wrought, and chiefly used by the clergy, and the same as

CHECLATOUN. A costly silk of the Middle Ages of which robes were made. Chaucer, in his 'Rhyme of Sir Thopas,' speaks of him as clad "in a robe of checklatoun," which Tyrwhitt, in a note, suggests is identical with cyclas, and I think justly so, as it is obviously a corruption of ciclatoun or syglaton, names derived from the same source. (See Cyclas.) Checkeratus appears to me to have been the name of the pattern, and not of the stuff of which the vestment was composed. The capa described above was curiously embroidered or ornamented with little knots in squares or chequers, or little chequered knots ; such fanciful devices were common in those days, but the word "chekeratus" occurs only in the passage quoted by Strutt, and in Ducange, who simply derives it from the English "checker," and offers no opinion respecting its application to the capa itself. "Chekeratus Tesselatus, a voce Anglica *checker*, tessella." Checlatoun was certainly "well known in England at that period," but not chekeratus, so far as I can discover.

CHEVERILL. (From *chèvre*, a goat, French.) Kid leather. "Cheverell lether; cheverotin."
(Palsgrave.)

> "To-day in pumps and cheverill gloves to walk she will be bold."
> *The Cobbler's Prophesie*, Old Play, 1594.

"Two dozen points of cheverelle" are mentioned in No. 25 of the Coventry Mysteries. In Sloane's
MS. 73, fol. 20, is a curious direction "for to make cheverel lether of parchemyne" [parchment]
by means of a solution of alum mixed with yolks of eggs with flour, and also to make "whit [white]
cheverell, reed [red] cheverell," the colour being imparted to it by a compound of brazil. (Promp-
torium Parvulorum, p. 73.)

In an inventory of the wardrobe of Henry VIII., taken in the eighth year of his reign, however,
I find entries of black and blue "cloth of gold cheverall" and green "cloth of silver cheverall," which
could scarcely be any description of leather, and no hint is afforded us of the nature of its composition.
I can only call attention to the fact.

CHEVESAILE. (*Chevessellia*, Latin; *chevessaille*, French.) "Pars vestis qua caput immititur
et quæ collum circumamicit." (Ducange *in voce*.)

> "Et pour tenir la chevesaille
> Deux fermaulx d'or au col lui taille."
> *Roman de la Rose*, l. 21,897.

These lines are rendered by Chaucer in his translation—

> "About her neck of gentle entaill
> Was set the rich chevesaile,
> In which there were full great plenty
> Of stones fair and clear to see."

The French glossarists explain chevessaille differently, some describing it as a "couvrechef," a
"coiffure," and others "tresse de cheveux," while the English call it "a necklace." From the quota-
tions in Ducange it would appear to have been the collar of a gown. "Le quel varlet, dit Cotele . . .
print la dite Heloys *par la chevesaille de sa cote* pour la mener par force hors du dit hostel." (Lit.
Remis., *anno* 1375.) "Lequel Prieur empoigna le suppliant à la chevessaille *ou collet* de sa robe."
(Ibid., *anno* 1450; also under CHEVECEILLIA.) "Ac cum *per cheveceilliam seu coletum vestis* suæ subito
arripuit et ad terram subtus se projecit." (Ibid., *anno* 1380.) We are still left in ignorance of the
exact shape of this article of attire, but the above citations from contemporary official documents
leave no doubt that it was worn by both sexes, and though encompassing the neck was not a necklace
in our modern acceptance of the word. Nothing but a pictorial illustration can decide the question
satisfactorily, and in no illumination contemporary with the composition of 'Le Roman de la Rose'
can I detect any article of apparel that such descriptions could possibly apply to.

CHIMERE. (*Zimara*, Italian.) "Vesta talare de sacerdoti et chierici." ('Ortografia,' Encyclo-
pedia Italiana; Venezia, 1826.) A loose gown with sleeves, worn over the rochet by bishops in the
reign of Edward VI., and then of a scarlet colour, like that of a doctor at Oxford. In Elizabeth's
time it was changed to the black satin gown worn at present. ('History of Convocations,' p. 141.)

CHIN-CLOTH. (See MUFFLER.)

CHISAMUS, CICIMUS, SISMUSILIS. A valuable species of fur mentioned by the his-
torians and poets of the Middle Ages. "Vestis preciossimus, quas robas vulgariter appellamus,
de escarleto præelecto cum penulis et furariis variis cisimorum," &c. (Matthew Paris, Hist. Major,
sub anno 1248.) "Mantel d'escarlate, a penne de chisamus." ('Roman de Lancelot de Lac,'
Royal MS., 20 D iv.) "Roccum sismusilum optimam 10 solid." (Rhenanus, Rerum Germ. lib. ii. p. 95.)
It was the skin, probably, of the Pontic mouse—"pellis muris Pontici"—to which some writers assert
we are indebted for the fur called vair. (See VAIR.)

CHOPA. (*Chopa*, French ; *cioppa*, Italian ; *chupa*, Spanish.) A loose upper garment similar to the PELLARD and the HOUPELAND (which see). The chopa appears to have been a night-gown for women in the thirteenth century. Henry III. ordered "Duas chopas ad surgendum de nocte" for his sisters, A.D. 1235. (MS. Harleian, 4573.) "Una chopa de grosso burella." (Ducange *in voce*.) The chopa was worn over armour in the fourteenth century, "et un vallet avec lui armé de haubere-geon de bacinet a camail, de gorgerette, de gantelle *et chope par dessus le haubergeon*." (Ordinat. reg. Franc., tom. 4, *sub anno* 1351.)

CHOPINE, CHAPINEY. A sort of stilt, clog, or false heel, imported from Turkey into Italy, and from Venice into England. In the plates to the Travels of George Sandys, the Turkish women in the sixteenth century are represented wearing them.

Thomas Coryate in his 'Crudities,' 1611, says, they were so common in Venice "that no woman whatsoever goeth without, either in her house or abroad. It is a thing made of wood and covered with leather of sundry colours, some with white, some red, some yellow ; it is called a chapiney, which they wear under their shoes. Many of them are curiously painted, some also of them I have seen fairly gilt. There are many of these chapineys of a great height, even half a yard high ; and by how much the nobler a woman is, so much higher are her chapineys. All their gentlewomen and most of their wives and widows that are of any wealth are assisted or supported either by men or women when they walk abroad, to the end that they may not fall. They are borne up most commonly by the arm." Evelyn calls them "wooden scaffolds." Shakespeare makes Hamlet allude to them when addressing one of the Players : "Your ladyship is nearer heaven than when I saw you last, by the altitude of a chopine"

Chopines.

(act ii. scene 2). They were in use in Venice until 1670, and Bulwer in his 'Artificial Changeling,' p. 536, complains of Englishwomen adopting the fashion, which he brands as a monstrous affec-tation wherein they imitated the Venetian and Persian ladies. Our examples are taken from Pietro Bertelli's 'Diversarum Nationum Habitus' (Padua, 1591), and Douce's 'Illustrations of Shakspere.'

CICLATOUN, SYGLATON. See CYCLAS.

CLASP. (From *cleopan*, Saxon, to buckle or embrace ; or *gaspe*, Dutch, a buckle.) Of this useful adjunct to costume, known to the Normans as *fermail* and *agrafe*, the most elaborately orna-mented examples are to be found in national and private collections. Sometimes, under the name of ouche or nouche, it is confounded with the brooch or fibula, its use being the same, and differing only from the latter by hooking garments together in lieu of pinning them. *Fermail* has been trans-lated "chain" by more than one English antiquary, but no contemporary description of it justifies such an interpretation. Jean de Meun, in the 'Roman de la Rose,' describes Pygmalion decorating his statue with, amongst other ornaments, a chevesail (see p. 96, *ante*), secured about its neck by "deux fermaulx d'or." The extreme variety of their form, observes M. Viollet-le-Duc, sufficiently indicates the fertility of invention of the workmen to whom the production of these popular objects was due. In the Middle Ages they were amongst the presents most generally made to ladies, and were also important items of bequests in wills.

John of Gaunt leaves to his son Henry, afterwards King Henry IV., "un fermaile d'or del viele mannere et escripte les nons [noms] de Dieu en chacun part d'ycelle fermaile." His much-honoured and beloved lady and mother, the Queen (Philippa), had given it him to keep with her blessing, and he leaves it in like manner to his son.

Philippa, Countess of March, A.D. 1378, leaves to her son Esmond [Edmond] "un fermayl bleu avec deux mangs [mains] tenang un diamant."

Richard, Earl of Arundel, 1392, gives to his daughter Elizabeth a nouche with lions and crowns, and another made like a rose enriched with pearls.

As fastenings for cloaks or mantles they were found much more convenient than the brooch, which had to be entirely removed if the wearer desired to open or throw back the garment on his shoulders, while the clasp had only to be unhooked on one side and remained attached to the other; and, as concerned belts, it was far less trouble to unhook than to unbuckle them.

Numberless examples of the most ornamental description are to be seen in the paintings and sculptured effigies of the Middle Ages both here and on the Continent, in addition to fine specimens preserved in museums and private cabinets, those worn by the clergy being very large and distinguished by the name of MORSE, which see.

As clasps of various descriptions will of necessity appear in many of our illustrations of costume, I shall here introduce only two representations: 1, the celebrated clasp of the Emperor Charles V., engraved by the late Mr. Shaw from the original in the Debruge Collection in Paris; and 2, another from a portrait of Arthur, Prince of Wales, eldest son of King Henry VII., in Her Majesty's possession, for the identification of which we are indebted to the intelligent researches of Mr. G. Scharf.

It will be observed that there is a ring to this clasp through which a ribbon or chain

1. Clasp of the Emperor Charles V.　　　　　2. Portrait of Arthur, Prince of Wales.

may be passed, apparently for the purpose of suspending it, therefore rendering unnecessary any other fastening, and depriving it of the character of a clasp; but the annexed portrait of Prince Arthur throws the clearest light upon the subject. The clasp is suspended by a ribbon round the neck, but the unseen hooks at the same time connect the two edges of the cloak or mantle, and on their being disengaged the clasp would still hang on the breast like a locket or medallion.

CLAYMORE. (*Claidemmore*, Gaelic.) The long cut-and-thrust sword of the ancient Scotch Highlanders, which had originally a simple cross-guard. The basket hilt, as it is now called, was not added before the eighteenth century. (See SWORD.)

CLOAK. (*Klocke*, Flemish; *cloca*, Latin.) Under one name or another this familiar garment has existed time out of mind in nearly all countries. The word "cloak" in English is derived, according

to Skinner, from the Saxon *lach*, but the usual term for the garment in Saxon is *mentil*, as in French it is *manteau*, from whence our word "mantle," more especially appropriated by us to a robe of state, under which head the mantles worn by sovereigns and the nobility on occasions of ceremony will be considered separately. Here, whether a cloak or mantle, I shall speak only of that article of attire, worn by all classes and both sexes, ordinarily known by such appellation. In the earliest glimpses we obtain, through the Greek and Roman writers, of the inhabitants of these islands, we find a mantle formed a portion of their costume ; in Ireland and Scotland, indeed, nearly the whole of it. The Britons, like the Belgic Gauls, wore over their tunic a short cloak, called by the Romans *sagum*, from the Keltic word *saic*, which, Varro informs us, signified a skin or hide, such having been the materials which the cloth manufactured in Gaul had superseded on our southern coasts, but still composed the garments of "those within the country." (Cæsar, de Bell. Gall.) The British sagum was of one uniform colour, generally either blue or black, according to Diodorus Siculus (lib. v. c. 33), but both he and Pliny (Nat. Hist. lib. viii. c. 48) tell us that of the several kinds of cloth manufactured in Gaul, one was composed of fine wool dyed of several different colours, which, being spun into yarn, was woven either in stripes or chequers, and of this the Gauls and Britons made their lighter or summer garments. Surely here we have the origin of the *breacan-foile*, the true Gaelic name for what we call the Highland plaid, and which means literally, "the chequered, striped, or spotted covering." (See PLAID.)

We have no authority for the shape or mode of wearing these cloaks further than we may consider it is afforded us by the sculptures and coins of the Romans, in which are representations of Gaulish and other prisoners, which will be examined in the General History. We must advance several centuries before we can obtain from the Saxon and Frankish illuminated MSS. a pictorial illustration of the habits of our forefathers.

The earliest of these invaluable records shows us that the cloak (mentel), or whatever we may call it, was worn by all conditions of men and women in the eighth century. It was fastened on their shoulders or their breasts by fibulæ, the commoner people using thorns for that purpose, or by the ends being drawn through a ring, or simply knotted together. A few specimens will suffice here, as examples will be continually met with throughout this work, incidentally illustrating other portions of costume.

Anglo-Saxon Mantles. From Cotton. MS. Claudius, B iv.

The cloak could be thrown off without unfastening it by simply slipping it over the head. In a miniature representing Daniel encountering a lion, he is represented as having cast his cloak upon the ground, where it is lying in the above very instructive form. No material alteration appears to have taken place in its shape during the three or four centuries affording us authorities for our guidance. Indeed, we find them in the eighth century reproached for wearing their garments in the manner of their Pagan ancestors. (Council of Chelcyth, co. Northumberland, A.D. 787.) The rank of the wearers was indicated by the richness of the material and not the peculiarity of form. "Uno regium pallium auro textam" occurs in a charter of King Ethelstan. Silk, known in England as early

as the eighth century, but extremely rare from its cost at that period, was much worn in the tenth by the higher orders, and Englishwomen were celebrated for their skill in embroidery. The Venerable Bede mentions silken palls of incomparable workmanship; and Adhelm, Bishop of Sherborne, who wrote in the seventh century, extols the art exhibited by the women of this country in weaving and embroidery even at that early period ('De Virginitate'), their reputation increasing to such a degree as to cause the name of *Anglicum opus* to be given on the Continent to all rare work of that description. Red, blue, and green appear by the illuminations to have been the favourite colours of the Anglo-Saxons in the ninth and tenth centuries.

The exact shape of the mantles worn by females is not so clearly depicted as we have seen that of the cloaks of the men. The veil (*heafodes rægel*, head rail, or *wæfels*, from the verb *wæfan*, to cover) which forms their invariable head-dress, descends so low upon the neck and shoulders that the mode of putting on or fastening the mantle is not visible. It has much the appearance of the chasuble of the priesthood, and could not, I think, have been widely different in formation, in which case the head was probably passed through a circular opening in the centre. In the accompanying example it appears to have been occasionally made with a hood, which could be thrown back at pleasure, or over which the head-rail could be worn for additional warmth or protection. In the splendid benedictional of the tenth century belonging to his Grace the Duke of Devonshire, the illuminations in which were engraved for the twenty-seventh volume of the 'Archæologia,' Etheldrytha, Princess of East Anglia, though represented as a sainted abbess, wears an embroidered scarlet mantle over a tunic of cloth of gold; the dress of the royal Anglo-Saxon nuns being, according to Bishop Adhelm, of the most sumptuous description, even in his time.

Anglo-Saxon Lady. Cotton. MS. Claudius, B iv. Etheldrytha. From a Benedictional of the 10th century.

Little difference, if any, is to be discerned in the cloaks or mantles of the Danes or Normans of the eleventh century. In the Register of Hyde Abbey, written in the reign of Canute, there are rude representations of the king and his wife Alfgive. The mantles of both are fastened by cords or laces with tassels, and in the Bayeux Tapestry the cloak of William, Duke of Normandy, is similarly secured. He is also described by Wace in the 'Roman de la Rose' as

evincing his irritation on hearing the news of Harold's assumption of the crown of England, by impatiently untying and tying the cords of his mantle :—

> " Sovant a sun mantel lacée
> Et sovant l'a detachée."—v. 1103.

Nevertheless, the fibula or the fermail continued in use for the same purpose.

Queen Alfgive. From Register of Hyde Abbey. King Canute.

Henry II. is said to have introduced the cloak of Anjou, which, being shorter than those worn at that period in England, obtained for him the name of "court-manteau." Various cloaks and mantles are mentioned by writers of the twelfth and thirteenth centuries, under as many different names,—the capa, the caputium, the rheno, the supertotus, the balandrana, *cum multis aliis*, which, to avoid repetition and confusion, I have treated separately under their several appellations, without attempting to identify the particular garments amongst the many represented in the miniatures of the time. The subjoined cuts may probably illustrate the capa, the balandrana, and the supertotus, or capa pluvialis ; at all events they are cloaks worn during the above-mentioned periods. The cloca mentioned by Matthew Paris, 'Vit. Abbat.,' fol. 252, has of right a notice here. It was a cloak probably with a hood to it, like to, if not identical with the capa, and allowed to the clergy when they travelled on horseback : "In equitando cloca rotundâ competentis longitudine utentur." Most of such garments were lined with furs, more or less costly, for winter wear, or with silk, taffata, or cendal for summer, and those of the nobility were made of the richest materials profusely embroidered.

Sloane MS. No. 2435. 15th century.

"Pallium aurum paratum" is frequently met with in Latin historians, and in the romances of the thirteenth and fourteenth centuries mantles of Alexandrine work, with embroidery and borders of gold, are as often alluded to.

"Et le mantel à son cal le bandi
Riche d'Arfrois de paillé Alexandrie."
 Roman de Gurm.

"Et par dessus d'un paille Alexandrin
A bandes d'or moult bellement le fist."—*Ibid.*

Anglo-Norman Capa. Cotton. MS. Nero, C iv. Harleian MS. No. 1526-7. 13th century.
12th century.

In the fourteenth century the English word "cloak" constantly occurs. Piers Ploughman says, "Shall no sergeant (at law) for his service weare no silke hoode nor pelure on his cloke for pleadynge at the barre?" and also describes a physician as clad "in a cloak of Calabrere." Chaucer, also, in his 'Testament of Cressyd,' makes Pandarus say to Troilus, "Do on this furred cloak upon thy sherte and follow me."

Serjeant-at-law (?).
From Royal MS.
16, G 6.

The cloak of a physician of the thirteenth century is depicted in a MS. of the early part of it in the Sloane Collection, No. 1975, and differs in no respect from those worn by the Anglo-Normans generally. The cloak of the serjeant-at-law is probably represented in the accompanying figure of a legal personage in Royal MS. 16, G 6, written in the fourteenth century, but it is what we should now consider rather a robe than a mantle or a cloak. The figures of the two females on the next page are fac-similes of drawings in No. 1527 of the Harleian MS., written towards the end of the thirteenth century, *temp.* Edward I. No attempt has been made to improve them as Mr. Strutt has done in the 41st plate of his 'Dress and Habits,' as well as in too many other instances; but that the costume might be made as graceful as it is simple is proved by several engravings in M. Viollet-le-Duc's 'Dictionnaire Raisonné,' vol. iv., from authorities of the same period in France, and from which we have borrowed two cuts at page 78 (*ante*).

The Book of Worcester records that "in 1372 they first began to wanton it in a new curtall weed which they called a cloak, and in Latin *armilausa*, as only covering the shoulders." Under the latter word will be found an engraving of what is considered to be the garment alluded to, none other, in any way according with the description, having been as yet to my knowledge discovered in any drawing or sculpture of that period. (*Vide* page 13, *ante.*) The above passage is, however, important; inasmuch as it supports the opinion I have formed from the facts just stated, that the English word "cloak" was first generally used in the fourteenth century in contradistinction to mantle, which is never employed subsequently in this country except to designate a robe of state.

Lady of the 13th century. From Harleian MS. 1527.

Lady of the 13th century. From Harleian MS. 1527.

A large wrapping cloak was worn by the military at the end of the twelfth century, and called in Latin *birrus*, being made of the coarse woollen stuff so named, much used in the thirteenth century for the garments of the middle and lower classes of both sexes (*vide* page 43). Our example is taken from a MS., written apparently *circa* 1272, in the Bodleian Library, Oxford. In the reign of Henry V. it became a portion of the military costume. In the drawing representing Lydgate presenting his book called 'The Pilgrim' to Thomas de Montacute, Earl of Salisbury (MS. Harleian, No. 4826), the edges of the earl's cloak, escalloped according to the fashion of the day, are clearly discernible.

That the hyke, the pilche, and the pelisse we read of in the fourteenth century, were cloaks, there can be little doubt; but it is not till we come to the reign of Henry VI. that we meet with pictorial illustrations of the cloaks which, in one form or another, became a distinguishing feature of costume, as necessary as it was ornamental in those days, and still remains an important article of apparel in this kingdom. Two examples are given on the next page. One, an illuminated copy of Froissart in the Harleian Collection (No. 4379), written about the middle of the fifteenth century, exhibits a short cloak recalling to mind "the curtall weed" introduced, according to the Book of Worcester, about one hundred years previously, and the other a richly embroidered cloak without sleeves, from Lydgate's 'Life of St. Edmund,' in the same Collection (No. 2278), and of about the same date.

Soldier with Cloak. *Temp.* Edward 1.
From MS. Bodleian Library, Oxford.

Thomas de Montacute, Earl of Salisbury. 1426.
From Harleian MS. No. 4826.

Froissart's Chronicles, Harleian MS. 4379. 15th century.

Harleian MS. 2278. *Temp.* Henry VI.

The subjoined figure is from a copy of the 'Roman de la Rose,' in the Doucean Collection, in the Bodleian Library, Oxford, illuminated, it would appear, *circa* 1400, and affords us a specimen of a
very comfortable cloak worn by ladies of the reigns of Richard II. and Henry IV. It has a high collar, and buttons closely round the neck, according to the fashion of the garments worn by the men at that period.

There can be no doubt that cloaks were occasionally worn by women of all classes during the fifteenth and sixteenth centuries. *Heukes* of scarlet cloth, camlet, and other materials, mentioned in wardrobe accounts and satires of those times, were certainly cloaks of some kind, but of which we cannot, without contemporary graphic illustration, form any decided conception. The *pilche* was also a furred cloak worn by both sexes, but its shape and size are left entirely to conjecture. (See under HEUK and PILCHE.) It is remarkable, however, that in the illuminations and paintings from 1400 to 1600 no writer on this subject appears to have been more fortunate than I in detecting an example of such an outer garment worn by women of the higher classes in England, distinguishable from the mantle, which was a robe of state and full dress, during the above period. Numerous examples may be found in the costume of foreign countries,

Lady. 15th century. From 'Roman de la Rose' of that date.

as will be shown in the General History; but previous to the seventeenth century, no work on the subject with which I am acquainted presents us with an Englishwoman of any class in a cloak.

The next examples are from the splendid copy of the 'Roman de la Rose' in the Harleian Library, No. 4425, written about the year 1490, 7th of Henry VII., and a Royal MS. marked 19 C viii.,

Harleian MS. 4425. *Circa* 1490; *temp.* Henry VII.

Harleian MS. 4425. *Circa* 1490.

Royal MS. 19 C viii. 1496.

dated 1496 ; the former affording front and back views of a cloak with sleeves having openings in the middle, through which the arms could be passed at pleasure, and the latter more fitted for travelling or rough weather.

The two following are a few years later in date : the first from a copy of Monstrelet's 'Chroniques de France,' Royal MS. 20 D viii. (*circa* 1500), and the other from an Harleian MS. (No. 4939),

From Monstrelet's 'Chroniques de France.' *Circa* 1500.

Harleian MS. 4939. *Circa* 1515.

dedicated to Francis I. of France, and therefore not earlier than 1515, or about the seventh or eighth year of the reign of Henry VIII. in England.

In the reign of Henry VIII., the cloaks of royal and noble personages both here and on the Continent were richly laced or embroidered with gold or silver. Hall mentions "Turkey cloaks ribbanded with nettes of silver, and between the knittynges or the meshes flowers of golde." ('Union,' p. 95.) Double cloaks (*i.e.* lined ; *doublé,* French) are frequently mentioned in the inventories of apparel of Henry VIII. : "Thirteen yards of black tylsent damask cloth of gold, to make a double cloak for the king." Francis I., at the memorable meeting with Henry in the Vale of Ardres, is described by Hall as "wearing a cloak of broched satin, with gold of purple colour, wrapped about his body traverse, beded from the shoulders to waist, and fastened in the loop of the first fold, and richly set with pearls and precious stones." ('Union,' p. 77.) Wearing cloaks "traversed," or *en sautoir,* was a fashion of that period, and also of a much earlier one. They were thrown over one shoulder, brought under the arm on the other side, and thrown again over the shoulder, crossing the breast diagonally, or tucked into the girdle. The figure above, from Monstrelet's Chronicles, exhibits the back view of a cloak worn in the former fashion. Another mode was to roll the cloak up and pass it over the right shoulder, and round the body, as Scotchmen at the present day wear their "mauds." "The two squires of honour" who represented the dukes of Guienne and Normandy, in the procession of Queen Mary (Tudor) from the Tower to Westminster, September 30, 1553, the day before her coronation, are described "with their robes of estate rolled and borne *baldrick-wise* about their waists." In the bas-relief at Rouen, representing the meeting of Francis and Henry, the former appears to be carrying his cloak over his left arm.

Henry on the same occasion is represented, in the contemporary painting at Hampton Court, in an ample cloak of cloth of gold, of the same fashion as that in which he is painted in the better-known portrait by Holbein. The portrait of the Earl of Surrey, also by Holbein, affords us another excellent example of a cloak of this period.

King Henry VIII. From a portrait by Holbein.

Henry Howard, Earl of Surrey. From a portrait by Holbein.

The splendid portrait of Anthony Browne, Viscount Montague, probably by Sir Antonio More, in the possession of the Marquis of Exeter, enlightens us respecting the make of the arm-holes of some

Arm-hole of Cloak, with Loop-band to secure Sleeve. From portrait of Viscount Montague.

Wolsey surrendering the Great Seal.

of these cloaks, through which the sleeves of the under-garments were passed. In a curious drawing illustrating Cavendish's Life of Wolsey, formerly in the possession of the late Francis Douce, Esq., and representing the Cardinal surrendering the Great Seal to the dukes of Norfolk and Suffolk,

the more familiar form of cloak is depicted; and another portrait of Henry Howard, Earl of Surrey, by Titian, affords us an example of it.

Earl of Surrey.
From portrait by Titian.

We next hear of "Genoa cloaks, French, Spanish, and Dutch cloaks, some of cloth, silk, velvet, taffata, and such like; some short, reaching to the girdle-stead or waiste, some to the knee, and others trailing upon the ground, resembling gowns rather than cloaks. Then are they guarded with velvet guards, or else faced with costly lace, either of gold or silver, or at least of silk three or four fingers broad, down the back, about the skirts, and everywhere else." (Philip Stubbes, 'Anatomie of Abuses,' London.) "Some have sleeves," he tells us, "and some have hoods to pull up over the head." Subjoined are examples of Spanish, German, Dutch, French, Italian, and Burgundian cloaks of that period, which, by turn, became the fashion in England during the reign of Elizabeth, all copied from prints of the period, published by Cesare Vecellio, in his 'Habiti Antichi et Moderni,' Venetia, 1589.

The plays of the seventeenth century abound in allusions to the various fashions of cloaks, and the wearing of them distinguished the gentleman. One of the characters in an old play called 'The Knave of Hearts,' 1613, says:—

"Because we walk in jerkins and in hose,
Without an upper garment, cloak, or gown,"

people mistake them for "tapsters."

Spanish. 1589. German. Dutch.

French. Italian. Burgundian.

Short cloaks were fashionable in the reign of Charles I.

"I learn to dance already and wear short cloaks."—Jasper Mayne's *City Match*, 1639.

They are alluded to as "elbow cloaks" in Samuel Roland's 'Pair of Spy Knaves.' Towards the end of his reign they lengthened again and continued so till the Restoration.

From an engraving by William Marshall. Puritan. From a print dated 1649. From Ogilby's 'Procession of Charles II.
Temp. Charles I. to his Coronation.'

On p. 109 is an example of the cloaks worn by the gentry and middle classes towards the end of the reign of Charles I., from an engraving by William Marshall, 1635, and one of a Puritan, from a print dated 1649. The latter is a perfect illustration of the passage in the poem 'The Way to Woo a Zealous Lady,' in which the metamorphosed Cavalier describes the attire he has assumed:

> " My 'parel plain, my cloak was void of pride."
> *Songs of the Rump.*

The cloaks of the reign of Charles II. at the time of his restoration are faithfully depicted in the prints accompanying Ogilby's description of the coronation of "the merry monarch." (See sixth figure on previous page.) A significant anecdote is contained in a letter from the poet Waller to St. Evremond, in which the writer relates the king's arriving one night at the Earl of Rochester's, and exclaiming, "How the devil got I here? The knaves have sold every cloak in the wardrobe!" (It was the only way they could obtain their wages.) The witty Earl replied, " Those knaves are fools: that is a part of dress which, for their own sakes, your Majesty should never be without."

Pepys, in his Diary, under the date of 29th October, 1663, says, "This morning was brought

home my new velvet cloak—that is, lined with velvet, a good cloth outside—the first that ever I had in my life." This is noteworthy, as showing that garments were designated occasionally by the material they were lined with, and not, as might naturally be supposed, by their exterior. In the following year he speaks of " a cloak lined with silk moyre," and on the 30th October he writes, " Put on my new fine coloured cloth suit, with my cloak lined with plush, which is a dear and noble suit, costing me about £17." He also mentions his " fine camelot cloak with gold buttons." (July 1, 1660.) " To Whitehall on foot, calling at my father's to change my long black cloake for a short one, long cloakes being now quite out." (October 7, 1660.) Trencher cloaks and blue cloaks were worn by apprentices and serving-men in the seventeenth century.

The general adoption of coats towards the end of the reign of Charles II. rendered the cloak unnecessary, except as an outer garment in cold or wet weather.

The annexed examples of the cloaks worn in the reigns of James II. and William III., and

A Gentleman in Winter Dress. 1688.

A Gentleman in Winter Dress. 1725.

during the first half of the eighteenth century, complete our series of illustrations of this article of clothing from the days of Edgar to those of George III. It is scarcely necessary to say that it has continued in use by both sexes and all classes to the present day.

CLOCK. This is one of the words the derivation of which is uncertain and the application arbitrary. Randal Holmes, writing in the reign of Charles II., says that clocks are " the gores of a ruff, the laying in of the cloth to make it round—the plaites." What are we to understand by such a description? The term, however, was applied to an ornament on the hoods of ladies of the fifteenth century, and subsequently to that of the stockings, which is familiar to us at present, and called in French "le coin du bas," which unfortunately does not assist us as to the derivation of the word. Palsgrave has "clocke of a hose" without the corresponding French. Cotgrave has not the word in that sense, and Halliwell only quotes Palsgrave.

In the 'Ordinances for the Reformation of Apparell for great estates of Women in the time of Marriage,' issued by Margaret, Countess of Richmond, 8th of Henry VII., the queen and all ladies to the rank of a baroness inclusive, are ordered to wear plain hoods "without clockes;" and the inferior gentry, chamberers, and other persons, "hoods with clockes." This is the earliest occurrence of the word in English I have yet lighted on, and examples may, perhaps, be afforded us in MSS. of that period. (See HOOD.) Clocks to stockings are nearly coeval with the stockings themselves. The Beau in 'Mist's Journal,' 1727, is described with gold clocks to his stockings, and the ornament in silk, precisely of the same pattern, has been retained to the present day.

CLOG. This equally familiar word is also without a derivation, but probably owes its origin to the material of which it was principally composed, as we have "clog almanac" for a wooden stick with notches on it, used anciently in Sweden and Denmark, and still amongst the peasantry in Staffordshire. (Clog for Log.)

Fig. 1.　　　　　Fig. 2.　　　　　Fig. 3.

Fig. 4.　　　　　Fig. 5.　　　　　Fig. 6.

Clogs, as worn by men, first appear in illuminations of the reign of Henry VI., but of ladies' clogs the examples are much later, and would seem, like the chopine, to have travelled through Italy from the East. Our engravings will convey the best idea of the varieties. Figs. 1, 2, and 3 above are examples of the latter half of the fifteenth century, when extravagantly long-toed shoes were in fashion. The first two are from Cotton. MS. Julius, E iv., *temp.* Henry VI.; fig. 1 showing the clog, and fig. 2, the clog with the shoe in it. Fig. 3 is from a French painting copied by M. Viollet-le-Duc. The figure presumed to represent Richard, Duke of Gloucester, in the chromolithograph issued with this part affords an example of the time of Edward IV., just previous to the change from the long to the broad toed shoe. (See SHOE.) Fig. 4 is a lady's shoe with a fixed clog, of the time of Charles II.; it was "made of white kid leather calashed with black velvet" (Hone's 'Every Day Book,' vol. ii. p. 1635), and was formerly in the Leverian Museum. Figs. 5 and 6 are copied from the clog and shoe of Dorothy, wife of Abraham Tucker, Esq., of Betchworth Castle (author of 'The Light of Nature pursued'), and daughter of Edward Barker, Cursitor Baron of the Exchequer. She died in 1754, and was celebrated for her small feet. The originals are now in the possession of Stephen J. Tucker, Esq., Rouge Croix Pursuivant of Arms. (See also under GALLOCHES and PATTENS.)

CLOUT. A corruption of CLOTH. A napkin, also a kerchief.

> "With homely clouts yknit upon their head,
> Simple and white as thing so coarse might be."
> Thynne, *Debate between Pride and Lowliness.*

> " ——a clout upon that head
> Where late the diadem stood."
> Shakespeare, *Hamlet*, act ii. sc. 2.

(See COVERCHIEF.)

CLUB. This very primitive weapon was known to the most barbarous tribes in North Britain, one of which, the Catini, is said to have received its name from their general use of it, *cat* being in their language a club with four spikes, or a quadrangular head with sharp edges. (Cambrian Regist., vol. ii. Meyrick, 'Costume of the Orig. Inhab. of Ancient Britain.') Under the name of *baston* it is frequently met with in Norman documents, and it appears wielded by Duke William and Odo, Bishop of Bayeux, in the Bayeux Tapestry. (See woodcut of William, p. 15, *ante; also under BASTON.) Odo may have used it in evasion of the edict of the Council of Rheims, A.D. 1049: but the war club was a common weapon at that period. In the Tapestry it is depicted as a formidable bludgeon, and may have been the prototype of the ragged staff, the badge of the Beauchamps, Earls of Warwick, and Dudley, Earl of Leicester. In the Middle Ages the porter or warder of a castle was furnished with a club, banded with iron. (Rouse's 'Hist. of Richard, Earl of Warwick,' Cotton. MS. Julius, E iv.) In the sixteenth and seventeenth centuries clubs were in great favour with the youths in the City of London, and the cry of "'Prentices! 'prentices! clubs! clubs!" was as familiar to the ears of its inhabitants, in cases of local commotions, as that of "Bills and bows!" in more serious disturbances. Clubs were used in defending breaches as late as the reign of Elizabeth. Sir Henry de Vere, in his 'Commentaries,' describing the siege of Ostend in 1601, says, "We [the defenders] had clubs which we called Hercules clubs, with heavy heads of wood, and nails driven into the squares of them." (Hewitt, vol. iii. p. 615. See also BASTON and CROC.)

COAT. (*Cote*, Saxon; *cotte*, French; *cotta*, Ital.) The garment so called at present is in its original shape not seen previous to the second half of the seventeenth century, but the word applied to articles of costume for both sexes was common both here and on the Continent as early as the thirteenth. From a passage in Joinville ('Hist. de St. Louis') it is clear that at that period the *cote* was a close body-garment, over which, as its name imports, the "*sur*cote" was worn at pleasure, in or out of doors. The king (Louis IX.) is described by his biographer as usually walking in the palace gardens at Paris clad in "une cote de camelot ove un surcote de Tyrtaine sanz manches; un mantel de cendal noir autour son col, mont bien figuiez et sans coife, et un chapel de paon blanc sur la teste." The coat then was identical with the tunic, for which classical vestment it was but the French and Norman name, and, consequently, the habit of all classes, distinguished only by its length and material.

In the poem called 'Piers Ploughman' the pilgrims are said to be habited in "poure cotes," *i.e.* coats of coarse stuff, by way of penance, which Chaucer renders "kirtles." The serjeant-at-law in the 'Canterbury Tales' is described as wearing "a medley cote," *i.e.* of mixed or party colours, and the miller a "whyte cote." Ladies, also, at the same period wore "cotes" of various colours, principally green and white, and "cotes de corde," which Mr. Strutt translates "hemp." These coats, however, bore no similitude to their successors of that name, but were, in fact, what we now call gowns. In the 'Roman de la Rose,' by Guillaume de Lorris and Jean de Meung, 1316—1346, the word "cotte" is of frequent occurrence. Avarice is described as wearing a "cotte vielle et derompue" (l. 215), which Chaucer in his translation renders "an olde torne court pye," which, as its name imports, was a short garment. (See COURT-PIE.) There were coats, however, made with

trains called long coats, some of which contained seven ells and a half. A Belgian bishop, writing *circa* 1230, says :—

> "Et forefaire les longues cotes
> On a sept aunes et demie."—Philippe Mouskes in *Vit. Patrum.*

From Sloane MS. No. 3983.

The rage for long trains had been the subject of satire a century before. Their great extravagance was caricatured in the reign of Henry I., and in that of Edward I. a poet compares the ladies of his day to peacocks and magpies. "The pies," says he, "have long tails that trail in the dirt, so that the ladies make their tails a thousand times longer than those of peacocks and pies."

Here is an example of the long trailing garment, robe, or cote of that period, from a MS. in the Sloane Collection, British Museum, No. 3983, and many others will be found in our illustrations of the dresses of ladies of the fifteenth century under the head of GOWN. Geoffrey de la Tour Landry, in his advice to his daughters, written at the close of the fourteenth century, says that the use of "great purfiles" [borders] and "slitte cotes" was first introduced by wanton women, and afterwards adopted by the "princesses and ladyes of Inglond," who, he adds, "may well holde it yef hem liste." (MS. Harleian, No. 1764.) It is not clear what he means by "slitte cotes," but he probably alludes to the fashion, so popular at that period, of cutting the edges of garments into fantastical designs, which, though forbidden by statute as early as 1188, prevailed to nearly the middle of the fifteenth century. Chaucer uses the word "slittered" in this sense :—

> "Wrought was his robe in strange guise,
> And all to slyttered for quientise."
> *Romaunt of the Rose.*

From MS. 15th century. Bib. Nat., Paris.

Mr. Fairholt has given us a figure from a MS. of the fifteenth century in the Bibliothèque Nationale at Paris, No. 6829, representing a lady undressing herself, "in illustration," he says, "of the passage 'I have taken off my cote.'" He does not favour us with the original French text, but we may be sure that the garment the lady is divesting herself of is what she is stated to have called her "cote," and that is the important point, as this is the only example, I believe, yet discovered of a contemporary representation identifying the "cote" of a lady of the fifteenth century. The colour, he informs us, is red, and clearly distinguished from the under-garment, which is white. The round-toed shoes beside her indicate a late portion of the fifteenth century in England, which is also interesting, as the word "cote" is rarely applied to an article of female attire in this country after the reign of Henry V., when we find amongst the materials of dress remaining in his wardrobe after his decease, "Fifteen furs of gross miniver for womens cotes," which are estimated at five pounds six and eightpence each,—a heavy price for those days.

The cote, gradually assuming the name of gown in the inventories of female apparel, retained its Norman appellation in those of male attire, though still far from resembling in form the coat of the eighteenth century ; but that they were distinct garments to the end of the fourteenth century seems clear from the work of Geoffrey de la Tour Landry above quoted, in which he tells a story of an extravagant woman whose soul after death was weighed in a balance, with St. Michael on one side and the Devil on the other. The latter, addressing St. Michael, said, "This woman had ten diverse gowns, and *as many cotes*," and observes that with one of these gowns or cotes fifty poor men might

have been clothed and kept from the cold. In the 'Booke of Curtasye,' a MS. of the end of the fifteenth century, the chamberlain is commanded to provide against his master's uprising, amongst other articles, "a long cotte," but it would be difficult to discover in any illuminations of the reign of Henry VII. the particular garment indicated, unless, as in the case of the ladies, we are to consider it identical with the long gown generally worn at that period, and which might have been occasionally so called.

In an inventory of apparel belonging to Henry VIII., in MS. Harleian, 2284, there are entries of long coats, demi-coats, short coats, riding coats, coats with bases [skirts], stalking coats, tenice coats, and coats of leather, some with strait or tight sleeves, some with loose sleeves, and some without any. Mr. Strutt truly observes that "with respect to the form of the coats, their colours, or the materials with which they were composed, it is impossible to speak determinately," ('Dress and Habits,' vol. ii. p. 243, edit. 1842,) except, of course, in occasional instances, where the colour and materials are specially mentioned, and then the form is left wholly to speculation. Thus we have "five yards and a half of white cloth of gold tissue, and damask silver striped with purple velvet

Henry VIII.
From his portrait in St. Bartholomew's Hospital.

purled, for *half a coat.*" "Three yards and a half of white satin for a stalking coat "—a gay dress if for stalking deer. "Three yards and a quarter of black velvet for a tenice coat ;" and we are informed that nine yards and a half of green sarcenet were required to line a full coat, and six yards and a half of purple satin for the half coat. But in which of the numerous portraits of the king and the nobles of his court can we find a representation which we can identify as a *coat,* answering any one of the above descriptions? They must surely refer to that well-known upper garment which has always been considered a *cloak*—sometimes having large sleeves slashed down the middle, sometimes hanging sleeves, and sometimes no sleeves at all—as these coats are described, and of which the annexed portrait of Henry VIII. affords us a remarkable variety whether it be a cloak or a coat : but in that case we meet with this difficulty. Hall, in his 'Union of the Houses of York and Lancaster,' tells us that when Henry met Anne of Cleves he was habited " in a coat of velvet *somewhat made like a frocke,* embroidered all over with flatted gold of damaske, with small lace mixed between of the same gold,

and other laces of the same going traverse-wise ; that the ground little appeared, and about this garment was a rich guard or border very curiously embroidered : the sleeves and *the breast* were cut and lined with cloth of gold, and tied together with great buttons of diamonds, rubies, and oriente pearles." Now, a coat made like a frock with *a breast* to it does not correspond with the cloaks I have alluded to, and the whole description seems to agree with the close-fitting vest or body-garment *over* which such cloaks were worn. I confess myself unable to solve the question, which is complicated by the mention of cloaks, cassocks, frocks, doublets, waistcoats, and other portions of dress, as articles distinct from the coat in the same inventories. I have already, under the word CASSOCK, pointed out a similar confusion, and can only refer the reader to the other words above mentioned, and the numerous illustrations throughout this work, for the formation of their own opinion, having stated my reasons for hesitating to express a decided one myself. "To coat" is "to cover ;" "a coating" is "a covering :" and it would in that sense be not improperly applied to any upper garment, whatever its shape or the particular name fashion might give to it. Numerous instances will be found in these pages of similar appropriations of general names to individual articles of attire, and of the capricious appellations of certain varieties of them, effectually misleading us in our idea of their use or appearance. M. Viollet-le-Duc may, therefore, be justified in including almost every body-garment, from the time of Charlemagne to the seventeenth century, under the head of "cotte;" but such generalization would not suit the purpose of this Dictionary, which is to identify, as far as

possible, the various articles of apparel we find depicted with those named or described in the writings of contemporary authors.

In the reign of Charles II. we get the first sight of what in these days would be popularly termed

Charles II. and a Courtier. From a print by Faithorne.

Figures from the Funeral of General Monk. 1670.

a coat. Mr. Fairholt observes ('Costume in England,' p. 479) that the modern gentleman's coat may be said to take its origin from the vest, or long outer garment, worn toward the end of the reign of Charles II., but the vest was not an *outer* garment, and was distinct from the coat, as is clearly shown in the following passage from Pepys' Diary, which Mr. Fairholt himself had quoted at page 319 of his work. Under the date of October 15, 1666, we read, "This day the king begun to put on his vest, and I did see several persons of the House of Lords, and Commons too, great courtiers, who are in it, being a long cassock, close to the body, of long cloth, pinked with white silk under it, and *a coat over it*." What *that* coat was we have ocular demonstration in the paintings and prints of the time, conveying at a glance much more information than pages of verbal description. Above is "the merry monarch" with one of his lieges, from the frontispiece of a book entitled 'The Courtier's Calling,' a scarce print by Faithorne, and next to them are the figures of gentlemen from the series of engravings of the funeral of General Monk, 1670. The coat is a loose strait garment reaching to the knee, with a profusion of buttons down the front, sleeves terminating above or just below the elbows and turned back like a cuff, or ornamented with lace, and having a pocket very low down on either side.

In an inventory of apparel provided for the king in 1679, the entry occurs of a complete suit of one material under the familiar designation of "coat, waistcoat, and breeches." One of the latest representations of Charles II. in ordinary attire is in the painting in which he is depicted receiving the first pine-apple grown in England from the gardener at Chudleigh House. A copy is here given from the engraving. During the reigns of James II. and William III. the coat underwent

Charles II. At Chudleigh House.

little alteration except in the sleeves, which gradually became looser and longer with heavy cuffs. The square-cut stiff skirts were retained till the commencement of the reign of George III., the body being rendered a little more shapely. What is called court dress was then introduced from France, where it is still specially distinguished as "l'habit Français."

Gentleman of the reign of William III.
From a print of that period.

John Law, the " Projector."
From a rare print by Schenk. 1720.

Gentleman in Sporting Dress
From a portrait by Highmore 1733

English Admiral.
From an engraving by Christopher Weigel. 1703.

In the army, the cloth coat which succeeded the buff coat followed the fashion of the times, but the large skirts were first doubled back to a button in the centre, a fashion preserved in the jacket that succeeded it, when the necessity no longer existed. To the navy the same remarks may apply, as it was distinguished by no particular costume from that of the army till the time of George II. (See UNIFORM.)

COAT-ARMOUR. This term was applied to every variety of military garment embroidered with the armorial ensigns of the wearer, whether the surcoat of the thirteenth, the jupon of the fourteenth, or the tabard of the fifteenth century. (See under each of those words.)

Chaucer, in his 'Rhyme of Sir Topas' (Canterbury Tales), describes a knight putting on his hauberk :—

"And over that his cote-armur
As white as is the lily flowre."

An instance of the term being applied to a jupon of plain white silk, or other material.

COAT-HARDY. (*Cote-hardie*, French.) Presumed to be a close-fitting body-garment, buttoned all down the front, worn by both sexes in the fourteenth and fifteenth centuries in France and England, and generally on the Continent. It has never been positively identified, but there is every probability that the habit we so constantly see represented in painting and sculpture at that period is the one which was so designated. The coat-hardy of the men but just covered the hips, round which was buckled by all persons of knightly rank the military belt, as worn with the jupon. (See BELT, MILITARY, and woodcut, p. 39.) That of the ladies varied in length, some reaching to the ground, others but just below the mid-leg : but in all cases fitting the body as tightly as possible.

Ladies in the "Cote-hardie." 14th century.

Geoffrey de la Tour Landry, the knight whose advice to his daughters has been already quoted, relates a story about two sisters, the eldest and handsomest of whom had been promised in marriage by her father to a young knight of good estate, but who had never seen her. A day being appointed for his visit, and the damsel apprised of his coming, she was desirous of displaying her symmetrical figure and slender waist to the greatest possible advantage, and, therefore, clothed herself in a

cote-hardie, without any lining or facing of fur, which sat very strait and close upon her: but it being winter, and the weather exceedingly severe, she appeared pale and sickly, like one perishing with cold, while her sister, with less beauty but more prudence, having put on garments lined with fur, and befitting the season, looked warm and healthy, with a colour like a rose, and so charmed their guest that he neglected his intended bride, and, having obtained the father's consent, married her sister. The same writer tells another story of an esquire of good family and fortune, who, being young and inclined to dress fashionably, came to a festival where a large company of noble persons was assembled, "clothed in a cote-hardie, after the guyse of Almayne," and, having saluted the guests, he sat down to dinner, when Sir Pierre de Loge, a knight well acquainted with his family, called to him before all the guests, and asked him where was "his fydyll or his ribible, or such instrument as belongeth to a mynstrell?" Being answered that he was totally unacquainted with any instrument, the knight said, "Sir, I cannot believe what you say, for you counterfeit the dress of a minstrel. I have known your ancestors, and the knights and squires of your line, who were all worthy men, but I never saw one of them who clothed himself in such array." The young squire, we are told, took the rebuke in good part, retired, and gave the cote-hardie to a pursuivant, and returned, apparelled "in another gowne," amidst the applause of the company.

By this, it would seem, the coat-hardy was a dress in fashion in Germany, and that it bore sufficient resemblance to the habit of a minstrel, to justify the ironical question of the old knight, —an opinion supported by the declaration of a contemporary writer.

Lady and Knight in "Cote-hardie." From Viollet-le-Duc. Minstrel of the 15th century. From Viollet-le-Duc.

Having no description of the coat-hardy more detailed than the slight account of it in the above anecdotes, I can only point out, in the costume of the time, the garment which appears most nearly to correspond with it, and is, therefore, generally considered by antiquaries to be the one in question. There are numerous representations of it, both in sculpture and painting, of the fourteenth century, some of which have long pieces of stuff called tippets, generally painted white, depending from the elbows, and M. Viollet-le-Duc has, in his 'Dictionnaire Raisonné,' under the word MANCHE, engraved the figure of a "vielleux" (violinist), from a MS. of the fifteenth century (copied above), attired in what he calls a *corset*, with hanging sleeves, which is not unlike the garment presumed to be the coat-hardy of the previous period, but he does not appear to be acquainted with the anecdote it illustrates.

COCKADE, COCKARD. (*Cockarde,* French.) Formerly a bow or knot of ribbon worn on one side of the hat or cap, either for ornament or as a national or party distinction. Landais derives the word from *coquearde,* the old French word for a tuft of cock's feathers, worn in the caps or heads of the Hungarian, Croatian, and Polish soldiers. The word does not occur in even the 2nd edit. of Baily's 'English Dictionary,' 1736, shortly after which period "the white cockade" of the adherents to the house of Stuart attained a fatal notoriety. Its colour was, however, not the national one of Scotland nor the family one of the Stuarts, but of the King of France, who had espoused the cause of James II. The black cockade, which first appears about the same period, was probably assumed in direct opposition to it, for that also was not the national colour previously, nor that of the house of Hanover. Nevertheless, it has ever since remained the colour of the cockade of England, unaffected by the change of the reigning families of Brunswick and Saxe-Coburg.

COCKERS, COKERS, COCURS. Boots or high shoes so called were worn by countrymen and labourers in the Middle Ages. Piers Ploughman in his 'Vision' (l. 3915) speaks of his "cockeres," and our illustration is taken from a fine MS. copy of that curious poem in Trinity College, Cambridge,

Ploughman. From MS. in Trinity College, Cambridge.

written about the end of the reign of Edward III. "*Peronatus,* he that weareth raw leather shoen, boteux, or cockers, like a ploughman." (Elyot, 1542.)

> "And his patch'd cockers now despised been."
> Bishop Hall's *Satires.*

The term is still applied in the north of England to leggings and gaiters, and even to old stockings without feet. The rims of iron, also, round wooden shoes are called cockers in Cumberland. (Halliwell.)

COGNIZANCE, COGNOISSANCE. (*Connaissance,* French.) This name, signifying strictly the badge of a gentleman entitled to arms, is occasionally given to the surcoat, jupon, or tabard, embroidered with the whole armorial bearings of the wearer.

> "Knights in their conisance
> Clad for the nonce."—Piers Ploughman's *Creed.*

But the earliest appearance of the word is in the eleventh century, when, previously to the existence of coats-of-arms, the Norman invaders of England, according to Wace, had all made or adopted cognizances by which one Norman might know another, and which none others bore, so that no Norman might perish by the hand of another, or one Frenchman kill another.

> "Et tuit orent fet cognoissances
> Ke Normant altre coneust
> Et k'entreposture n'eust
> Ke Normant altre ne ferist
> Ne Francais altre n'occist."—*Roman de Rou,* line 12,816.

Duchesne's MS. reads "*covenances*," perhaps for "convenances,"—"signes de convention," as M. Pluquet suggests in a note on the passage in his edition of the poem, 8vo, Rouen, 1837; but "cognoissances" is the word that survives, and is still recognised in armoury.

COGWARE. A coarse kind of worsted cloth, worn by the commonalty in the sixteenth century, but mentioned in statutes as early as the eighth year of Edward II.

COIF, QUOIF. (*Coiffe*, French; *cupha, cuphia*, Inf. Latin.) A close cap for the head. This article of dress is seen early in the thirteenth century. In illuminations of the reign of

Willemin, 'Monuments Inédits.'

Harleian MS. No. 1471. 13th century.

Henry III. it is always represented white, apparently of linen, and tied under the chin like a child's night-cap. On the heads of men hunting and of knights in armour it has a most ludicrous and unpicturesque appearance. Later it formed a distinctive portion of the ecclesiastical and legal costume, and in the latter profession has descended to the present day, but so diminished and transformed that it is scarcely recognisable. In the reign of Henry VI. it ceases to be tied under the chin, and becomes a close skull-cap like the *callot* of the Roman Catholic clergy, and of various colours. Little alteration appears to have taken place in it, down to the time of the

Legal Personages.
From MSS. of the 14th century.

Restoration, amongst the gentlemen at the bar, the judges on the bench, or the dignitaries of the Church; but the introduction of wigs seems to have caused its transformation into a circular black patch, which was removed from the head itself to the crown of the foreign usurper of its state and dignity. Coifs were worn by women in the seventeenth century. In the comedy of 'Eastward Hoe,' printed in 1605, Girtred asks her sister, "Do you wear your quoif with a London licket?" and in a satirical catalogue of a fashionable lady's wardrobe in 1631, we read of

"Coyfes, gorgets, fringes, rowles, fillets, and hair laces."
 Rhodon and Iris, Dram. Past.

(See further under COIF DE MAILLES and HEAD-DRESS.)

COIF DE FER. A steel skull-cap, worn by the military in the thirteenth century. "Item, W. Bordel loriculam suam cum coifeâ ferreâ." (Madox, 'Formulare Anglicanum,' p. 423.)

Coif de Fer. From a scholastic Bible,
14th century, in the Doucean Collection.

Wall-painting in Old Palace at Westminster and
Royal MS. 16 G vi. *Circa* 1350.

From effigy of Le Botiler, St. Bride's,
Glamorganshire.

By some antiquaries it is supposed identical with the cervellière (see the late Mr. Gage Rook-wode's description of the wall-paintings discovered in the old Palace of Westminster, in 'Testamenta Vetusta'); and in the absence of more precise information the question is an open one. The fact that the cervellière and coif de fer are not mentioned in any document in conjunction with each other is negative evidence in favour of the opinion that they were one and the same head-piece indifferently so designated, the earliest name for it being cervellière. Mr. Fairholt mentions the *coiffette* as an iron skull-cap of the same period, in form like the cervellière, but I have not met with the word else-where, and can only consider it a diminutive of coif, not specifying a distinctly different head-piece. In Edward I.'s time the coif de fer took the form of the head, and was worn under as well as over the coif de mailles. When over, it was occasionally ornamented. The effigy of Le Botiler in St. Bride's Church, Glamorganshire, affords us an example of a coif de fer displaying heraldic devices, the covered cup on each side the fleur-de-lys being a bearing of the family. (See woodcuts, page 120.)

COIF DE MAILLES. A cap of chain or scale mail, distinct from the hood of mail, whether continuous or separate, over which it was worn as an additional defence in the thirteenth century, sometimes surmounted by a coif or chapel de fer or heaume, and at others covering the coif or close

From Royal MS. 16 G vi. 14th century.

iron skull-cap without further protection. In the romance of 'Launcelot de Lac' (MS. Royal, 20 D iv. Brit. Mus.) a warrior is said to have struck so severe a blow with the pommel of his sword upon the heaume of his antagonist that he beat it in and forced the mail of his coif ("les mailles de la coife") into his skull. Froissart tells us (tome iii. chap. 50) that two knights (the Lord de la Rochefoucault and Sir William de Montférant) in a tournament at Bordeaux struck each other on the heaume with such force that the buckles apper-taining to the straps were broken and the heaumes cast to the ground, and the champions finished their course bare-headed except-ing their "*coeffes*," which Lord Berners renders "*coyves;*" but I agree with Mr. Strutt, who quotes this anecdote, in believing that these coifs

Coif de Mailles. From effigy of Sir Robert de Manley, preserved at Goodrich Court.

were made of linen, quilted or padded, and were worn next the head to protect it from injury by the pressure of the helm. An excellent example of this sort of coif is engraved in Willemin's 'Monuments Inédits' from the metal covering of a copy of the Gospels in the National Library at Paris, the subject being the soldiers sleeping beside the sepulchre. One of them has thrown back the mail hood, which lies in folds on his shoulders, and displays most distinctly the coif of linen, or it may be of leather, which he wears under it. It has a stuffed roll at the back to protect the neck being chafed or bruised by the rubbing or pres-sure of the mail. A further illustration is afforded us by Froissart himself, who, in a subsequent chapter, tells us the Comte d'Armagnac took off his bascinet and remained with his head uncovered save only a coif of linen (" coiffe de toille "), tome iv. chap. 5. In addition see under HEAUME and HAWBERK.

From Willemin's 'Monuments Inédits.'

COINTOISE, QUINTISE, QUENTYSE. (*Quinteux, quinteuse,* fanciful, French.) A term applied to dresses, kerchiefs, or other ornamental portions of attire, *quaintly* or fantastically cut in the shape of leaves, flowers, or other devices,—a fashion which arose in the twelfth century, and prevailed to an extent in the two succeeding, that neither the Sumptuary Laws, the satires of the poets, nor the solemn denunciations of the clergy, had power to restrain. William Guiart, *sub anno* 1105, says :—

"Cil ont le jour mise
Sur ses armes une cointise,"

which he describes as red powdered with mullets of silver, implying that it was a surcoat embroidered with armorial bearings. But it must be remembered that Guiart was a writer of the fourteenth century, and the passage is therefore only valuable as showing that in his time a surcoat of some form was known as a *cointise.*

Matthew Paris informs us that the nobility who attended the marriage of the daughter of Henry III. to Alexander, King of Scotland, A.D. 1251, were attired in habits of silk, commonly called *cointises ;* and a robe ordered for the same English sovereign to be made of the best purple-coloured samite, embroidered with three little leopards in front and three behind, is described as a *quintise,* showing that it was the cut of the garment and not the particular class of it which entitled it to the name.

William de Lorris, whose portion of the 'Roman de la Rose' was written before 1262, describes Mirth attired

> " D'une robe moult deguisée,
> Qui fut en maint lieu incissée
> Et decouppée par quientise."—l. 839.

which Chaucer translates :—

> " Wrought was his robe in strange guise,
> And al to slyttered for quientise
> In many a place, low and high."

The illuminations in MSS. of the above periods display numerous examples of these *slyttered,* dagged and jagged dresses : but the earliest copies of the 'Roman de la Rose' that I have met with being of the fourteenth century, and the superb one in the Harleian Library as late as the reign of Henry VII., we have no contemporary illustration of the "robe" in which the original author has arrayed "Deduyt."

The scarf which is occasionally seen ornamenting the helmets of the knights of the Middle Ages

Cointise on Helm of Thomas, Earl of Lancaster.

is also called a cointise (see woodcut) ; and what is now termed by heralds the mantling of a helmet, is supposed to have had its origin in this fashion. After all, this can only be offered as a fairly founded conjecture, as we have no means of positively identifying any pictorial representation of the habit in question, but many specimens will be found in this work of the mode in which the edges and borders of every species of vestment, the sleeves of gowns and the tippets of hoods, were cut and slashed with more or less taste and ingenuity by the fashionable tailors of the reigns of Richard II. and the three Henrys who succeeded him. (See DAGGES.)

COLBERTEEN, COLBERTAIN, GOLBERTIERNE. "A kind of open lace with a square grounding." (Randal Holmes, 1688.) "A lace resembling network, being of the manufacture of Monsieur Colbert, a French statesman." ('Ladies' Dict.' 1694.) Evelyn mentions it in his description of a lady's toilette :—

> " Twice twelve long smocks of holland fine,
> With cambric sleeves rich point to join,
> For she despises colberteen."
>
> *Tyrannus, or the Mode.* 1661.

And Dean Swift, in 1708, writes :—

> " Instead of homespun coifs were seen
> Good pinners edged with colberteen."
>
> *Baucis and Philemon.*

The word does not occur in French, although the lace was named after the celebrated French minister, Colbert, a great patron of the arts and sciences, who established the manufacture of point lace in France, and died in 1683. (See LACE, POINT D'ALENÇON.)

COLLAR. (*Collarium*, Inf. Latin, from *collara*, Latin and Italian ; *collier*, French; *collar*, Spanish.) See under BAND, COAT, HAWBERK, and TORQUE.

COLLAR OF AN ORDER OF KNIGHTHOOD. The special gift of a sovereign prince, the investiture with which accompanies the highest order of knighthood in England, viz. that of Grand Cross. The number of orders of knighthood in Europe is considerable, and the history of their original foundation in the majority of them purely legendary. Our own "most noble order of the Garter" may, probably, challenge the right to be acknowledged the oldest order in existence, notwithstanding the pretensions implied by the title of "the most ancient order of the Thistle of St. Andrew." The order of the Bath is the latest of those of the United Kingdom which come within the scope of this work, that of St. Patrick being founded by King George III. for his kingdom of Ireland, Feb. 5, 1783, and those of "St. Michael and St. George" and "the Star of India" having been instituted during the present century.

Under this head, however, we have only to treat of collars, and seniority must, therefore, be accorded to the order of "the Golden Fleece," founded by Philip the Good, Duke of Burgundy, at Bruges, Feb. 10, 1429-30 : the right to confer which, since 1700, has, by special convention, been equally exercised by the emperors of Austria and the kings of Spain. The collar is composed of the briquet or steel, which was a badge of Burgundy, and the flint or firestone emitting flames, the pendant being the figure of a sheep, representing "the Golden Fleece" of Jason (*vide* Plate V. fig. 1).

The collar of the order of St. Michael was (probably in imitation of that of the Golden Fleece) made a portion of the insignia of the order at its first institution by Louis XI. of France, August 1, 1469. A meeting of the first chapter is engraved in Montfaucon's 'Monarchie Française.' It appears from a portrait of the founder, engraved in the same work, to have consisted originally of escallop shells linked together by a single chain of gold, having a medallion with the image of St. Michael upon it, pendant from the centre (*vide* Plate V. fig. 2) ; but in the reign of his successor, Charles VIII., the chain is double, and the shells are interspersed with bars of gold connecting the chains (*vide* Plate V. fig. 3). The order was suppressed in 1790, re-established by Louis XVIII. November 16, 1816, and has never been conferred since 1830.

The collar of the order of the Garter with the great and lesser George, as now worn, was added to the badge of the order apparently by King Henry VIII., in portraits of whose time at least it is first depicted. Previously to that period the figure of St. George slaying the dragon was worn appended to family collars or simply gold chains. I have unfortunately lost a drawing made by a friend, now deceased, of a rare example of a St. George appended to a collar of SS., and cannot remember in what church he found the effigy. The collar of the order is of gold, and consists of twenty-six pieces, representing buckled garters, alternately enclosing a red rose charged with a white one, and a white rose charged with a red one, the garters being connected by knots of gold. Appended to the centre buckle is the figure of St. George on horseback transfixing the dragon, enamelled in the proper colours (*vide* Plate V. fig. 4).

The collar of the Knights of the Thistle is traditionally coeval with the foundation of the order by James V. of Scotland, in or about the year 1450; but we have no authority for the collar, and the order fell into disuse and was revived by James II. of England, May 29, 1687. The revolution in the following year caused it to fall again in abeyance, but it was again revived by Queen Anne, December 31, 1703, and to the pendant figure of St. Andrew a radiant star was added in 1714-15. The collar is composed of golden thistles and sprigs of rue enamelled proper, being the typical insignia of the Scots and Picts. The pendant star is of gold, the figure of St. Andrew in a green tunic with a purple surcoat "standing upon a mound vert and supporting his cross, argent" (*vide* Plate V. fig. 6).

The order of the St. Esprit was founded by Henry III. of France, December 31, 1578; and in Montfaucon's 'Monarchie Française,' plate 283, there is an engraving from a painting of the period of the Comte de Nevers being invested with the collar of the order in the first chapter of it, held January 1, 1579. It was originally composed of fleur-de-lys, or, cantoned with flames of the same,

enamelled gules, intermixed with three cyphers or monograms of gold formed of the letters H and L, for Henry and Louise of Lorraine his queen (*vide* Plate V. fig. 5). Henry IV. removed the cypher L, and substituted a trophy of arms.

Collar of the Order of the St. Esprit, altered by Henri Quatre.

The order of the Bath was instituted by George I., May 18, 1725, the collar being added on June 1 following. An instrument dated Hanover, Nov. 16 of the same year, describes the collar as composed of nine imperial crowns of gold, five demi-arches visible, no caps, and eight roses and thistles (the shamrock was added subsequently) issuing from a sceptre, all enamelled proper, linked together with white knots. Appended to one of the knots was an oval medallion, azure, charged with a sceptre in pale or, from which issued a rose and a thistle between three imperial crowns or, the whole within a circle bearing the motto "Tria juncta in uno" (*vide* Plate V. fig. 7).

Previously to that date, however, the medallion was worn by knights, suspended by a ribbon. An example of this is to be seen in the effigy of Sir William Spenser, in Brington Church, Northamptonshire (*vide* Albert Hartshorne's 'Recumbent Effigies'), knighted by James I. in 1606, and who died in 1636. The three crowns and the motto, "Tria juncta in uno," show the medallion to be not earlier than the accession of James, 1603.

In addition to the collars of the "Golden Fleece," "Saint Michael," and the "Saint Esprit," those of four other foreign orders, instituted previously to 1760, claim our attention under this head not only for their importance, but from the connection of their history with that of our own royal family, so intimately allied by marriage with the sovereigns of Russia, Prussia, and Denmark.

The first is the order of the Elephant in Denmark, traditionally instituted in the thirteenth century, and actually founded by King Christian I. at the marriage of his son John with the daughter of Ernest, Duke of Saxony, in 1478. In an elaborate history of the order, printed in 1704,[*] engravings are given of five varieties of the collar, which appears to have undergone continued alterations. One is composed of elephants with castles on their backs, linked alternately with crosses patoncé. In another, the

Varieties of the Collar of the Order of the Elephant. 1478–1514.

elephants are linked together by pairs of spurs; and in a third example, by patriarchal crosses. The pendant was originally a medallion on which was represented the Virgin with the infant Saviour in her arms, in one example standing, but in the rest sitting, with her feet resting on the crescent moon, the whole surrounded by a glory. This medallion was speedily exchanged for the figure of an elephant, which was also subjected to various alterations, the reasons for which and the exact periods of their occurrence would require a volume for their elucidation. The above work contains an engraving from a

* 'Breviarium Equestre seu de illustrissimo et inclytissimo ordini de Elephantino ex posthumo et manuscripto Ivarii Hertzholmii et continuato a Jano Bircherodio Jani fil.' Fol. Havniæ, anno MDCCIV.

1
Golden Fleece.

2
St. Michael.

3
St. Michael.

4
Garter.

5
Saint-Esprit.

6
St. Andrew.

7
Bath.

8
Yorkist Suns and Roses.

9
Yorkist Suns and Roses.

10
Yorkist Suns and Roses.

11
Yorkist Suns and Roses.

12
Lancastrian Collar of SS.

13
Lancastrian Collar of SS.

14
Lancastrian Collar of SS.

portrait of an early knight companion of the order, dated 1494, in which the collar is composed of castles between pairs of elephants entwining each other's trunk, the pendant being an elephant. The latest example given in it, which is expressly marked as "Noviss. insignia," differs in no important detail from the collar worn by his late Majesty George IV., of which an accurate drawing exists in the College of Arms.

Collar of Elephant. Reign of John, 1481.

2. 1. 3.

1. Frederick II. 1559.
2. Christian IV. 1588.
3. Same reign. 1611.

Collar of the Elephant, belonging to his late Majesty King George IV.

During the reigns of Frederick II. and Christian IV. the housing of the pendant elephant was charged with a badge, viz., the letter F entwined by an S, in an oval, for Frederick II.; the figure 4 within a crowned C for Christian IV., and an arm in armour holding a sword, being the device of the order of the Armed Hand, instituted by the latter sovereign in commemoration of the victory over the Swedes at Colmar, December 3, 1611. The Indian on the neck of the elephant appears to have been an addition in the reign of Christian V., at which time also the housing is charged with five diamonds in cross, as in the latest example.

The second is the Dannebrog, also a Danish order, which it was imperative the knight should possess before he could be invested with that of the Elephant. Its original foundation is popularly attributed to Waldemar II., surnamed the Victorious, in 1219. Its actual institution, with the present insignia, is due to Christian V., King of Denmark, in 1671. The collar is composed of the letters

Collar of the Order of the Dannebrog.

W and C (the initials of the legendary founder and the reviver), each surmounted with the royal crown of Denmark, and within the letter C the figure 5, linked alternately by double chains of gold with crosses enamelled white. The pendant is a cross patée enamelled white, charged with a cross nodulée, gules, known as the "cross of the Dannebrog."

The third is that of St. Andrew of Russia, instituted by the Czar Peter the Great in 1698. The collar is composed of trophies and eagles linked alternately by gold chains, the pendant being the Russian eagle with two heads, each ducally crowned, surmounted by an imperial crown, and charged on the breast with a figure of St. Andrew on his cross, all enamelled proper. Our engraving is from a carefully made drawing of the collar formerly worn by King George IV., preserved in the College of Arms.

Collar of the Order of St. Andrew of Russia. Collar of the Order of the Black Eagle of Prussia.

The fourth is that of the Black Eagle of Prussia, founded by Frederick the Great, 12th of January, 1701. The collar is composed of circular gold plates, each bearing four cyphers of the letters F R, crowned, and between each plate the Prussian eagle, enamelled black, holding in its claws a golden thunderbolt ; pendant, a gold cross of eight points, enamelled blue ; in the centre, the letters F R in cypher ; and in each angle the Prussian eagle, enamelled black.

This article being strictly confined to collars, the reader is referred, for further information respecting orders of knighthood, to RIBBON, ROBE, and STAR.

COLLAR (FAMILY or LIVERY). These decorations were totally distinct from the collars of orders of knighthood, and, as their names indicate, were assumed by various royal and noble families, and worn, not only by themselves, but bestowed upon their friends, the officers of their households, and their adherents and partisans, who, in the language of that day, had "livery" of them.

One of the earliest and best known in England is the collar of SS, or Esses ; but, like that of the Golden Fleece and the Garter, its origin has never been ascertained. The earliest example yet discovered is in the effigy of Sir John Swinford, in Spratton Church, Northamptonshire, engraved in Albert Hartshorne's 'Recumbent Effigies.' Sir John died in 1371 (44th of Edward III.), a fact which, unless it can be shown that the effigy was sculptured more than a quarter of a century after his death, would of itself dispose of the hitherto-received opinion that the collar first appeared in the reign of Henry IV. of England. The earliest description of it at present recorded, is in a wardrobe account of Henry of Lancaster, Earl of Derby, taken in the 15th of Richard II. (1391–2), in which there is an entry

of one collar of gold, with seventeen letters of S made in the shape of feathers, with inscriptions on them, and (as I read it) some device or badge on the *torret* (ring) of the collar : " Pro ı coler auri facto pro domino Henrico Lancastrie, Comiti Derb. cum xvij. literis de S ad modum plumarum cum rotulis et scripturis in eisdem cum *signo** in *torrecto* ejusdem." Some antiquaries have suggested that *signo* is a clerical error, and that we should read *cigno* ; a theory which has certainly some claim to consideration. It is unfortunate no more precise description is given us of the details of the decoration, as they might have proved a clue to the mystery which still involves this interesting subject, notwithstanding the incessant and laborious researches of so many antiquaries, at the head of whom it is but justice to place the late Mr. John Gough Nichols, who has published some most valuable papers upon family collars in the 'Gentleman's Magazine,' vols. xvii., xviii., and xix. It appears to have been composed of an indefinite number of the letter from which it takes its name, either fixed separately on a foundation of metal, velvet, or some other material—for it cannot be distinguished in sculpture or painting—or linked together as a chain by themselves. A curious example of the former fashion exists in a piece of sculpture in the south aisle of Southwell Minster. It is the head of a regal personage, forming one of the corbels of the arch of a doorway originally communicating with the Archbishop's palace. The archway is attributed by architects

Corbel in Southwell Minster.

to the commencement of the fifteenth century (*temp.* Henry IV.) ; but the style of hair and beard of the bust is of rather an earlier period. The collar is represented as a strap of velvet, or leather, with the letter S, either embroidered or in metal, sewed upon it at considerable distances one from the other, buckled close round the throat, the end passed under, and then suffered to hang down straight, in the fashion of the Garter.

Another very early representation of it was formerly to be seen in a window of old St. Paul's church, accompanying the arms of John of Gaunt, Duke of Lancaster, a drawing of which was fortunately made by Nicholas Charles, Lancaster herald, and is now in the British Museum. Neither of these early examples has any pendant attached to it.

Collar of SS. From a window of old St. Paul's. Collar of SS. From MS., College of Arms.

In the latter form of a chain, it has continued to the present day. When bestowed by the Sovereign, it confers the degree of esquire on the recipient. The above engraving is from a pen-and-ink drawing by Augustine Vincent, Windsor herald ; in the College of Arms described as " the collar of SS in England, wherewith esquires be made."

The letters S are here linked together by knots, and terminate with two portcullises and a pendant

* Mr. J. G. Nichols suggests *cigno*, which has probability in its favour.

rose. It is still worn, with certain differences, by the Lord Chief Justices, the Lord Chief Baron of the Exchequer, the Lord Mayor of London, the kings of arms, the heralds, and the sergeants-at-arms.

Sir Edward Coke.

Appended is a woodcut from a portrait of Lord Chief Justice Sir Edward Coke, in which he is represented wearing the collar as depicted above; and it may be interesting to state that the identical collar is said to be still in existence, and at present worn by the Right Hon. Lord Coleridge.

According to Upton, 'De Re Militarii,' the SS of the herald's collar were, in the fifteenth century (the time in which he wrote), alternately silver and sable; and as Leigh translates the passage, in the time of Elizabeth, without any observation, it would appear that no change had taken place before that period. Such a distinction, however, is not visible in any picture of a herald I have met with. They are now all of silver, without knots or portcullises, and have the rose, thistle, and shamrock, surmounted by the crown of silver gilt, both in front and behind.

Pendants are occasionally seen attached to the collar of SS in the fifteenth century. To that on the effigy of the poet Gower in the church of St. Mary Overy, Southwark, we find a medallion appended, bearing the figure of a swan (Plate V., fig. 14), a very suggestive circumstance when it is remembered that the swan was the badge of the Bohuns, whose heiress was the first wife of Henry IV.; and it is on record that collars of SS with pendants charged with a swan were made, not only for Gower, but for others, as the livery of the house of Lancaster. The queen of Henry IV., Joan of Navarre, is, however, represented in her effigy in Canterbury Cathedral, wearing a collar of SS without any pendant; but the ends of the collar are linked together in front by a trefoil ornament, and below the link is a ring to which any pendant might be attached. It is remarkable that this is the case in the majority of instances. (See Plate V., fig. 12.)

One of these links was found in the Thames, February 1843. It is of iron, once probably silvered or gilded, and about one inch and three-eighths in width. Each plate is pierced with two trefoils, and was attached to the strap or band by three small rivets. The junction link is trefoil-shaped, with two points between each lobe, and a triple boss in the centre. A letter S of the mixed metal called "latten" was found with it, which had been affixed to a leather band. It is fairly presumed that this is the only relic of a mediæval collar of SS in existence. It is beyond the purpose of this work to enter more deeply into the apparently interminable controversy respecting the origin of this decoration,

Links of Collar of SS. Found in the Thames.

as no satisfactory result has at present rewarded the researches of the archæologists, but a few more words bearing on the subject will be found under the head of LIVERY, and the reader is also referred to the essays of Mr. J. G. Nichols, in the 'Gentleman's Magazine' above mentioned.

In the latter half of the fifteenth century we meet with numerous representations of the livery collars of the rival houses of York, consisting of suns and roses (vide Plate V. figs. 8, 9, 10, and 11). To the two first is appended the white lion of March, the badge of Edward IV.; fig. 8, from the brass of Henry Bourchier, Earl of Essex, at Little Easton Church, Essex, 1483, being a specimen of the suns and roses placed alternately on a band of velvet, as in the instances before mentioned of the collars of SS; while in fig. 9, from the effigy of a Yorkist knight, at Aston Church, they are linked together, and form an independent chain. Fig. 10 is from the effigy of the Countess of Arundel, in Arundel Church, Sussex, 1487, in which the suns and roses are connected by oak-leaves, a badge of the Fitz-Allans. Fig. 11, from the effigy of one of the Nevilles, probably Ralph, second Earl

of Westmoreland, 1484, at Branspeth, Durham, affords an example of the badges intermingled, the "rose en soleil." The black bull of Clare, badge of George, Duke of Clarence, is appended to the collar of Nicholas Fitz-Herbert, in Norbury Church, Derbyshire, and the white boar of Richard, Duke of Glcster (Richard III.), to that of his son Ralph in the same edifice. From the 'Inventories of the Exchequer' (1st of Henry IV.), we learn that Edmund of Langley, Duke of York, had a collar of his livery composed of seven "linketts" (*quære*, lockets, *i.e.* fetter-locks) and six white falcons (the badges of his house), weighing five ounces, and that Anne of Bohemia, the first wife of Richard II., had a collar of her livery consisting of branches of rosemary, with—as it would appear from another entry—an ostrich dependent from it. Unfortunately no drawing of either of these most interesting decorations has been handed down to us.

A still more interesting example of the "rose en soleil" is presented to us in the collar with which Henry VII. is depicted in a portrait at the Society of Anti-

quaries. It would be more accurately described as the sun in the rose, but that there appears a repetition of the flower in jewels in the centre of the rays. The particular point of interest in this collar, however, is the fact of the connection of the two badges by knots, and the consequent presumption that this collar suggested the idea of that of the Garter. In addition to this there is a portrait at Windsor Castle formerly believed to be that of Arthur, Prince of Wales, eldest son of Henry VII., but recently shown by Mr. Scharf to be that of

Collar. From portrait of Henry VII.

his brother Henry, afterwards Henry VIII., when young. It is composed of red and white roses linked together alternately by knots, as in the former instance, the centre rose being red, with three pear-shaped pearls depending from it. The similarity of this collar to that of the Garter, subsequently introduced by this Prince, justifies our belief that it was its immediate precursor.

Portrait of Henry VIII., when young. From her Majesty's Collection, Windsor Castle.

Collar of Thomas, Lord Berkeley. At Wootton-under-Edge, Gloucestershire. 1417.

Mermaid. Enlarged from engraving of Collar of Thomas, Lord Berkeley.

An early instance of a private family collar occurs in the brass of Thomas, Lord Berkeley, at Wootton-under-Edge, Gloucestershire, A.D. 1417. Over the camail of his bascinet he wears a band charged with mermaids, the badge of the Berkeleys.

Mr. Hollis has engraved the brass of a knight (unknown), in Mildenhall Church, Suffolk, wearing a collar to which is appended a crown surmounting a (black?) dog. Another curious example is in the

From brass of a Knight, Mildenhall Church, Suffolk.

Collar of Thomas de Markenfield. In Ripon Cathedral.

effigy of Thomas de Markenfield, in Ripon Cathedral. His collar is composed of park palings, with the figure of a deer lodged, as it is heraldically termed, similar to, if not identical with, the arms of the town of Derby. I have not been able to find anything in the meagre information we possess of the family of Markenfield which can account for its adoption. Family or livery collars are not met with after the reign of Henry VII., unless those of S seen on the Spenser effigies in Brimpton Church, Northamptonshire, are admitted to be such. (See LIVERY, PUISANE, and TORQUES.)

COLLERET. A piece of armour protecting the neck, mentioned in deeds and inventories of the fourteenth century. In 1694 a colleret is described, amongst the articles of female apparel, as "a kind of gorget that goes about the neck." ('Ladies' Dictionary.')

COLOBIUM. An ancient ecclesiastical vestment reaching to the ankles, and having either no sleeves or short ones to the elbow only. It also formed a portion of the coronation dress of the kings of England. (See ROBE.)

COMMODE. A very high head-dress, worn by ladies in the reign of William III., and of which the name was surely satirical, as anything more incommodious could scarcely be invented.

> "On my head a huge commode sat sticking,
> Which made me show as tall again."
> *Deil tak the War,* in Tom d'Urfey's coll. *Wit and Mirth.*

It was also called a "tower," which was certainly more appropriate. The cap was plain, and

Commodes. *Temp.* William and Mary and Queen Anne.

close-fitting behind; but the front displayed a tower of three or four stories high—a pile of ribbons and lace disposed in regular and alternate tiers, or the ribbons were formed into high stiffened bows, and covered or not, as it might happen, by a lace scarf or veil that streamed down each side of the pinnacle. In the 'Ladies' Dictionary,' 1694, it is described as "a frame of wire two or three stories high, fitted to the head, and covered with tiffany or other thin silks, being now compleated into the whole head-dress." The pencil alone can give an idea of the monstrosity.

The commode went out of fashion in the reign of Queen Anne. Addison, writing in 1711, remarks, "I remember ladies who were once near seven foot high, that at present want some inches of four." See the portrait of Madame de Lude, at p. 144, in illustration of the article CRAVAT.

CONFIDANT. "A small curl next the ear." ('Ladies' Dictionary,' 1694.)

COPE. (*Capa*, Latin; *chape*, French.) This word was applied, originally, to a cloak with a hood to it, whether worn by the laity or the clergy (see CAPA); but it became ultimately restricted to the ecclesiastical vestment known at present by that name, and which is worn on certain occasions in lieu of the chasuble. In an illumination representing the coronation of Henry IV., but executed towards the close of the fifteenth century, the bishops who are placing the crown on the king's head are arrayed in copes and not in chasubles; and "copes were in common use till at least the Great Rebellion" (Rev. John Jebb on 'Choral Service'). Archbishop Cranmer, at the consecration of a bishop in 1550, wore mitre and cope; and it was worn not only by the dignitaries of the Church,

Bishop in Cope.

Gentlemen of Queen Elizabeth's Chapel in Copes.

but even by the gentlemen of the Queen's chapel, in the reign of Elizabeth, it being amongst the vestments and ornaments retained by the Protestant Church at the time of the Reformation. In the third volume of the 'Monumenta Vetusta,' published by the Society of Antiquaries of London, there is an engraving of the funeral procession of Elizabeth, from a drawing believed to be by Camden, in which the said gentlemen are depicted in magnificently embroidered copes, and, as Mr. Fairholt truly observes, "exhibit a strange mixture of Popish, Protestant, and secular costumes." Strype, in his 'Annals of the Reformation' (book i., p. 23), tells us that on St. George's day, 1561, "all her Majesty's chapel came through the hall in copes, to the number of thirty."

In the fourteenth century the cowled frock of a friar was called a cope. "Coped as a frere" occurs in Piers Ploughman's 'Vision,' in which it is alone mentioned as the distinguishing habit of a hermit:

> "Great loobies and long,
> That were loth to work,
> Clothed them in copes,
> To be known from others,
> And arrayed them as hermits,
> Their ease to have."

Gower, in his 'Confessio Amantis,' describes "a route of ladies all clothed alike in copes and kirtles, departed white and blue, and embroidered all over with fanciful devices;" evidently using the word "cope" for "mantle."

In fine, it would appear that "cope," like "coat" and many other names, has been indifferently applied, at various periods, to articles of apparel dissimilar in form and material; both cope and coat, however, signifying an outer garment, the former sometimes with and sometimes without a hood, from which latter appendage to it Mr. Pugin considers it derived its name. "In many early illuminations," he adds, "even where ornamental copes are figured, the hoods are red, and hang loosely over the shoulders. The embroidered hoods, attached to the back merely as ornaments, are not older than the fourteenth century." "The cope has suffered less deterioration of form than any of the sacred vestments; and the two great defects observable in the modern ones are stiffness of material and inappropriate ornaments in the orphreys and hoods." ('Glossary of Eccles. Ornament and Costume,' p. 73.) In the Roman Catholic Church there were two kinds of copes—the *cappa choralis*, or quire cope, and the *cappa pluvialis*, or processional cope; the former being much richer in work and material than the other, which was used out of doors. The cope was fastened on the breast by a clasp called a "morse," some of which were of the most magnificent description. (See MORSE.)

COPOTAIN. (See HAT.)

CORDON. (French.) The tasselled lace or string of a mantle; also the broad ribbon of knights of the first class of an order. The grand cordon of the principal French order, that of the Saint Esprit, is light blue, and the term "un cordon bleu" was used to distinguish a knight privileged to wear that decoration. It is applied in common parlance also to a first-rate *chef de cuisine*, and generally to persons who have obtained the reputation of excelling in their respective arts. (See further under RIBBON.)

CORIUM. (Latin.) The name given to various kinds of body-armour composed of leather, and worn in Europe to the middle of the fourteenth century. It was known to the Romans, and many

Anglo-Saxon Warriors, 10th century. From Harleian MS. 603.

examples are to be seen in Anglo-Saxon illuminations. In some instances it is made to imitate scale armour; in others it appears composed of overlapping pieces, the lower edges being vandyked or

escalloped. In one figure is an attempt to copy the Roman *lambrequins*, as the French have named the straps of metal appended to the classical cuirass. (See woodcuts above, from Harleian MS. 603.)

Harold II. is said to have counselled the adoption of leathern armour by the troops sent to drive the Welsh out of their fastnesses, as lighter and less fatiguing in such mountain warfare. The Bayeux Tapestry at a little later date affords us an example of the corium in the figure of Wido, or

Guy, Count of Ponthieu. From Bayeux Tapestry.

From Bodleian MS. *Temp.* Edward I.

Guy, Count of Ponthieu, who is depicted wearing one made to imitate scale mail, as before mentioned. One of the latest specimens is here subjoined from a miniature of the time of Edward I. The leaves or scales are painted of different colours. The MS. from which it is copied is in the Bodleian Library ('Arch.' D iv. f. 17).

CORNET, CORNETTE. A portion of the head-dress of ladies in the reign of Henry VIII. (See HEAD-DRESS.) In the seventeenth century it is described as " the upper pinner which dangles about the cheeks, hanging down with flaps." ('Ladies' Dictionary,' 1694.) A less courteous writer adds, "like hound's ears."

CORONAL. A chaplet or garland.

> " Her hair was payghted on hold
> With a coronal of gold."
> *Romance of Sir Degrevant*, 14th century.

CORONEL, CORNEL. The iron head of a tilting lance used for jousts of peace, where the object was to unhorse without wounding the opponent. Its similarity in some examples to a crown, or coronet, suggested most probably the name.

Cornels of Tilting Lances.
From Meyrick Collection.

CORONET. Originally a band of gold, more or less ornamented, worn by the nobility previously to the fourteenth century, when in civil attire or robes of state, and then

called "a circle," "a wreath," "a garland," or "a chaplet." The effigy of John of Eltham, Earl of Cornwall, second son of King Edward II., in St. Edmund's chapel, Westminster Abbey, and who died in October 1334,

is, says Sandford, who has engraved it in his 'Genealogical History of the Kings of England' (folio, London, 1677), "the most ancient portraiture of an earl, in my observation, that hath a coronet." It encircles his bascinet, and consists of a band or fillet of gold ornamented with jewels, and having on its upper rim an indefinite number of foliated ornaments which cannot be described as either trefoils or strawberry leaves.

Coronet on effigy of
Earl of Cornwall.

Coronet on effigy of Edward
the Black Prince.

Lionel Plantagenet, Duke of Clarence, who died in 1368, bequeaths two golden circlets; with one of which he states he was created a duke, and the other, with which his elder brother Edward had been created a prince: "Item lego Thomæ Waléys unum circulum aureum quo circulo frater meus et dominus creabatur in principum. Item Edmundo Mone lego illum circulum quo in ducem fui creatus." (Will dated 3rd October, 1368, and proved at Lambeth, 6th ides of June, 1369.) The helmet of Edward the Black Prince, in Canterbury, is encircled by a coronet composed of large and small leaves, like those of John of Eltham's; but in the initial letter

to the grant of the Duchy of Aquitaine to him, by his father, he is represented wearing simply a fillet of gold, with circular ornaments, which may be meant for roses, like the garland or chaplet on the head of Charles Comte d'Estampes, which is seen with other examples at p. 92, *ante*.

In a painting formerly on the wall at the east end of St. Stephen's chapel, Westminster, he was depicted in full armour; the front of his bascinet ornamented by a coronet, which was not a complete circle, but terminated a little behind the ears, the upper rim of the fillet enriched by clusters of three pearls, six of which clusters were visible in profile.

Coronets of Edward the
Black Prince.

Mr. Shaw, who has engraved the whole figure, considered it to have been painted about 1355. In an illumination executed some five-and-twenty years later, representing the prince with his young son, King Richard II., he is

Initial Letter to the Grant of the Duchy of Aquitaine by Edward III.
to the Black Prince.

represented wearing a very gracefully-designed coronet of golden roses, interspersed with pearls, and surmounted by trefoils, differing entirely from all the other examples.

The tilting helm of Richard, Earl of Arundel, 1346, has a coronet, out of which issues his crest of a demi-griffin; but the same kind of ornament is found upon the helm of a simple knight, Sir Edward de Thorpe, at Ashwell-Thorpe, county of Norfolk, about the same date (see CREST), and it is obvious, therefore, that the Earl of Arundel's is not distinctive of his particular rank.

Helm of Richard, Earl of
Arundel. From his seal.

In an illumination in Royal MS., E 15, representing King Henry VI. on his throne, presenting a sword to John Talbot, Earl of Shrewsbury, the earl has no coronet ; but all the six nobles attending the king have circlets, four being surmounted by pearls on the small points formed by the engrailing of the upper edge.

Coronets. From Royal MS., E 15. *Temp.* Henry VI.

Numerous examples of ladies wearing coronets of various descriptions are met with in illuminations of the fourteenth and fifteenth centuries, and some will be found illustrating the article HEAD-DRESS. I will give but two of the most remarkable here : the first, from the effigy of Beatrice, Countess of Arundel, in the church at Arundel, where it appears

Beatrice, Countess of Arundel.

Alice, Duchess of Suffolk.

surmounting the preposterous horned head-dress of the reign of Henry V. ; and the other, from the effigy of Alice, Duchess of Suffolk, Ewelme Church, Oxfordshire, 1475, displaying the royal fleurs-de-lys. Previous to the reign of Edward IV., therefore, the form of the coronets worn by the nobility of England appears to have been designed according to the taste of the wearers, and not prescribed by authority. A painting on glass, in the church at Great Malvern, of Arthur, eldest son of Henry VII., proves, indeed, that even as late as the commencement of the sixteenth century the coronet of the Prince of Wales was composed of alternate large and small trefoils, divided by clusters of three pearls each.

Coronet of Arthur, Prince of Wales.

No particular date has yet been assigned for the introduction of the forms which now distinguish the coronets of the different degrees of the peerage ; but the probability, in my opinion, is, they were designed by the heralds, after their incorporation by Richard III., but not adopted before the reign of Henry VIII. ; and a Royal Order, or Earl Marshal's Warrant, may one day be discovered which will settle the question.

At all events, it is about the latter period that the coronets of dukes, marquises, and earls appear distinguished by their present familiar features, a duke's coronet being a circle of gold richly chased, having on its upper edge eight strawberry leaves, only five of which are visible in heraldic delineations.

The coronet of a marquess is distinguished by four strawberry leaves between as many large pearls or balls of silver upon short points.

The earl's coronet is composed of eight strawberry leaves, and as many pearls or balls raised above the leaves on high points or pinnacles.

No nobleman below the degree of an earl was authorized to wear a coronet in England till the reign of James I., who appointed that a viscount should wear a circlet of gold with twelve pearls, or silver balls, closely set round the upper edge.

Amongst the Vincent MSS. in the College of Arms is a drawing of this date, carefully representing all the above-mentioned coronets, as well as that of the Prince of Wales and the circle or chaplet then worn by barons.

Prince.　　　　　　　　　　Duke.　　　　　　　　　　Marquess.

Earl.　　　　　　　　　　Viscount.　　　　　　　　　　Baron's Chaplet.

Charles II., shortly after his restoration, accorded to the barons, on their petition, the privilege of wearing a coronet in lieu of the chaplet they had thereunto been assigned, and ordered that it should consist of a circlet of gold with six large pearls or balls on its upper edge, four only of which are shown in heraldic drawings. The same sovereign, in 1665, issued his royal warrants to the kings of arms for Scotland and Ireland for the peers of those kingdoms to wear coronets similar to those of peers of the same rank in England.

Charles II. also ordered an arch to be added to the coronet of the Prince of Wales, which was previously only the rim of the crown; and by the same warrant, issued in February 1660, assigned to the other princes and princesses — sons and daughters of a sovereign, and to their sons and daughters—the coronets now borne by them.

As there was no Prince of Wales acknowledged in England from that period until the birth of George II., the first representation of the arched coronet occurs in 1751. But it is worthy of remark that in a print of the reign of James I., representing the catafalque of Henry, Prince of Wales, his effigy is depicted with an imperial crown of four arches; and also that in a MS. in Vincent's Collection at the College of Arms, known as Prince Arthur's Book (in consequence of the arms of that prince, in whose time it was executed, being painted on the first page), the coronet over the shield, as well as that on the head of the lion, the dexter supporter, has evidently had an arch to it which was subsequently expunged.

The extremely ugly bulging crimson velvet cap, with its gold knot and tassel, and border of ermine, most unbecoming to the face, appears in portraits and heraldic drawings towards the close of the seventeenth century. The improved taste of the present day has induced some of our peers to

Duke.　　　　　Marquess.　　　　　Earl.　　　　　Viscount.　　　　　Baron.

discard the deformity, and surmount their arms with the coronet only, as is the practice on the Continent. The coronets of the French, Italian, and other foreign nobility, bear very little similarity to those of ours. (See General History.)

Crest coronets appear in the fifteenth century, and are borne without distinction of rank. (See CREST.) They are generally blazoned ducal.

CORSE, CORSES, CORSET. This word is stated by Strutt and by Fairholt, who follows him, to be the name for a close body-garment, or a pair of stays, to which we apply it at the present

day ; but in the fourteenth century, when we first meet with the word, it evidently indicates an outer vestment. In a wardrobe account of the 18th and 19th of Edward III., there is an entry of "a corset of red velvet with eagles and garters for the queen," and mention of "corsets of cloth furred," given by the king to Queen Philippa. M. Viollet-le-Duc has a long article on this subject, profusely illustrated by engravings, in which he quotes numerous passages from French chronicles, wardrobe accounts, and other documents, showing that a garment called "a corset" was worn in France from the time of St. Louis to the commencement of the fifteenth century, by both sexes and all classes ; that it varied in length, shape, and amplitude ; that it was lined occasionally with fur, and had sleeves of every imaginable description. M. Douet-Darcy, in his notes on 'Les Comptes de l'Argenterie des Rois de France, au xive siècle,' cites an entry in which occur the words, "troy *jupons* appelez *corsets*." This description, which appears to have puzzled M. Douet-Darcy, throws in my opinion a clearer light upon the subject than any other has done. The jupon in the fourteenth century was the military garment which succeeded to the loose surcoat of the thirteenth. (See JUPON.) It fitted the body tightly ; and when we find that the steel breast-plate, over which it was worn, was at that period also called a corset (see below), it appears to me that the term was generally applied to various garments worn by men as well as by women which had nevertheless special names of their own, but all possessing the peculiar feature, that of closely fitting the person from the neck to the waist, such portion being still called "the body" of a dress in English, and *le corsage* in French. This interpretation can alone justify M. Viollet-le-Duc in his illustrating his article with representations of the kirtle, the cote-hardie, the jacket, the doublet, the pourpoint, and other vestments of the fourteenth and fifteenth centuries to which the term "corset" has not been applied by the writers of those times, who speak of them by the names they were popularly known by. (See under those heads.)

But there is more to be said on this subject. By the sumptuary laws of Edward IV., the wives of esquires and gentlemen, knights-bachelors and knights under the rank of lord, unless they were knights of the Garter, were forbidden to wear cloth of gold, velvet upon velvet, furs of sable, or "any kind of corses" worked with gold ; and women of inferior rank were prohibited from wearing "any corse of silk" made out of the realm.

Something like a bodice, it may be urged, appears about this time, the body of the dress being laced in front over a stomacher, as in Switzerland and in parts of the Continent it is seen to this day ; but I am not satisfied that such is the true meaning of the word. "Any kind of corses worked with gold" may equally be taken to signify any material of a certain quality so embroidered ; and the expression, "any corse of silk made out of the realm," can surely have no reference to stays, nor even to the body of a gown, for in Richard III.'s letter from York, dated 31st August, 1483, there is an order for "one yard three quarters corse of silk, meddled (mixed) with gold, and as much *black corse of silk for our spurs*." So that "corse" here evidently signifies, not an article of apparel, but the quality of the silk itself, from *corpus*, "corpse, body or substance," as we still use indifferently the words "corpse" or "corse" for a dead body, and "corps" for a body of soldiery.

CORSET. As early as the fourteenth century this term was applied, as I have stated above, to a breast-plate. In the inventory of Humphrey de Bohun, Earl of Hereford, 1322, occurs "un corset de fer ;" and in the order for the restitution of the armour of the Earl of March to his son, in 1331, mention is made of "vi corsets de feer." In the inventory of the armour of Louis X., King of France, 1316, is an entry of "2 cors d'acier." (Ducange, *sub* "Armatura.") How instructive is this example of the danger of drawing inferences from individual authorities !

CORSLET. Another name for a breast-plate, derived from the same root. It appears to have been of the kind chiefly worn by pikemen in the sixteenth and seventeenth centuries, and the soldiers wearing them were called by that name. In the statute of 1557, all temporal persons having estates of 1,000*l.* or upwards are to provide, among other munitions, "forty corslets furnished."

A document dated 1588, printed in 'Norfolk Archæology,' vol. i. p. 11, contains the following

entries:—" To Rich. West, of London, for x whight [white, *i.e.* bright steel] corseletts at xliiii*s.* a-peyce. To Thos. Hurst, of London, armourer, for vii blacke corseletts at xlvi*s.* a-peyce."

The term "corslet" also comprised the whole armour of a pikeman, and was not limited to the breast-plate alone. In the 7th of Charles I. we find, in Rymer's 'Fœdera,' " For the whole corslet, or footman's armour, russetted, viz. : breast, back, tassets, comb'd head-peice lyned and gorget lyned, 1*l.* 2*s.*" The white and black corslets, therefore, mentioned above as costing forty-four and forty-six shillings each, must be taken to have been not only of superior quality, but complete suits of armour, head-pieces included. (See BREAST-PLATE.)

COTTA. "A short surplice either with or without sleeves," according to Fairholt ; but, in fact, the common name for a tunic, or, as it is sometimes called, an upper shirt :

<p style="text-align:center">" Cotta seu camisia superanea."</p>

COUDES, COUTES. (*Coudières, cubitierres,* French.) Elbow-pieces of plate, which first

appear in the mixed armour of the latter half of the thirteenth century. In their earliest form they were only convex, or slightly conical, just covering the elbow, and secured by a strap and buckle round the arm. (See woodcut from a figure in the ' Roman d'Alexandre ' MS., date about 1270, Bib. Nat., Paris, copied by M. Viollet-le-Duc ; and another, from a brass at Minster, Isle of Sheppey, date about 1337.)

Roman d'Alexandre MS. 1270.

Brass at Minster.

As defences of plate, in addition to mail, became gradually adopted, side-pieces, circular, oval, and of various shapes, were added to the elbow-piece, forming a better protection to the inner part of the joint, in which a wound is extremely dangerous. (See woodcut from a statue of the early part of

From effigy of Sir Walter Arden, in Aston Church, Warwickshire.

From a statue. *Circa* 1320.

Froissart MS. 1440.

the fourteenth century, copied by M. Viollet-le-Duc.) Another example, for which we are indebted to him, he has taken from a MS. of Froissart in the Bib. Nat. at Paris, which he dates about 1440. In the absence of other specimens of costume from the same book, I cannot presume to question that date, and will only observe that it is of a form existing a hundred years earlier, and might, there-

From effigy of Robert de Marmion, West Fairfield Church, Yorkshire.

fore, be an old fashion revived. The effigy of Sir Walter Arden, in Aston Church, Warwickshire, of the time of Edward III., affords us an example of what Mr. Hewitt entitles the "cup-formed elbow-piece, connected with an ornamental disk or roundel."

Approaching the period of complete plate, we find the coude formed of one piece of plate only, and having articulations above and below to facilitate the action of the arm. (See woodcut from effigy of Robert de Marmion, West Fairfield Church, York-shire, date about 1400.) The side portions of these coudes are in some instances

From the brass of Sir Thomas Brounflet, in Wymington Church.

formed in the shape of fans. (See brass of Sir Thomas Brounflet, in Wymington Church, Bedford-shire, date about 1430. See also brass of Sir Robert Suckling, at p. 18, article ARMOUR.) This fashion, later in the century, was carried to a most extravagant height. Witness the following examples, from the brass of Richard Quatremayns, Esq., in St. Mary's Church, Thame, Oxfordshire, 1460, and the effigy of Sir Thomas Peyton, in Isleham Church, Cambridge, 1482.

From brass of Richard Quatremayns, Esq.,
St. Mary's, Thame, Oxfordshire.

From effigy of Sir Thomas Peyton,
Isleham Church, Cambridge.

Co-existent with these fan-shaped coudières was a pointed elbow-piece of more moderate proportions, but equally ribbed or fluted, in conformity with the rest of the suit, and secured on the arm by points or aiguillettes. (See three following examples from effigies of the reign of Edward IV., viz.: that of Sir Robert Harcourt, K.G., in Stanton Harcourt Church, 1471; Robert, Lord Hungerford, in Salisbury Cathedral; and one of the Erdington family, in Aston Church, Warwickshire.)

From effigy of
Sir Robert Harcourt, K.G. 1471.

Robert, Lord Hungerford, in
Salisbury Cathedral.

From effigy of an Erdington,
Aston Church.

For the form of the coude in the sixteenth century, I must refer the reader to BRASSARTS (p. 53 *ante*), where will be found a woodcut of one of the reign of Henry VIII., from the Meyrick Collection, encompassing the whole joint. After that period there was little variation of shape, but the coudes, with the rest of the armour, were elaborately embossed, engraved, and gilt, after the fashion of the day.

COURSING HAT. A head-piece with oreillets, worn in hastiludes in the sixteenth century.

COURTEPY. Derived by Killian from *Kort*, German (*curtus*), and *pije.* "Penula coactitis ex vilis crassioribus."

This is another garment very difficult to identify. In the Pro-logue to Chaucer's 'Canterbury Tales,' the description of the dress of the Clerk contains the information that

"Ful thread-bare was his *overest* courtepy,"

Coursing Hat. *Temp.* Elizabeth.

which certainly indicates an upper garment; and in Piers Ploughman's 'Vision,' the hermits are described as cutting their copes into courtpies, while in the Friar's Tale a yeoman is said to have worn a "courtepy" of green, without any intimation of its character. Camden says, "A short gabberdin" [gaberdeen] was called "a courtpie." (Remaines, p. 196.) Strutt disagrees with Camden,

and contends that it was a super-tunic, or surcoat, which, however, might also be called a gaberdeen in Elizabeth's time. What William de Lorris calls a "cotte" in the 'Roman de la Rose,' Chaucer translates as a "courtpy." (See COAT.) It was worn by both sexes, and was probably, as Strutt conceived, a short surcoat or super-tunic, to which a name, corrupted from the German, was given towards the close of the thirteenth century, and was out of fashion by the middle of the fourteenth. There are many such depicted in the miniatures of that period; but I will not undertake to point out the one which may actually represent it.

COUTEAU DE CHASSE. Hunting knife. In the sixteenth and seventeenth centuries the hilts and the sheaths were elaborately sculptured and ornamented. A case of hunting knives contained a fork, a bodkin, and various implements, the use of which might be required by the hunter. The subjoined example is from the late Meyrick Collection.

Couteau de Chasse. Meyrick Collection.
Temp. William III.

Implements in the Sheath.

2. 1. 3. 4.

1. Hunting Sword with Ivory Handle, time of Charles II.
2. The Sheath, containing a Knife.
3. A Hunting Sword, time of James II.
4. Another of the time of William III.

In the same collection, now unhappily dispersed, were other specimens of swords worn by huntsmen in the last two centuries. (See woodcuts above.)

COUTEL, CULTEL. (*Couteau,* French; *cultellus,* Latin.) A long knife or dagger; a weapon of the thirteenth and fourteenth centuries carried by the Ribauds and Pillards—irregular foot-soldiers, whose office appears to have been to rush upon the knights and esquires who had been unhorsed or wounded, and either despatch them or take them prisoners. "Et là, entre les Anglais, avoit Pillards et Ribaux, Gallois et Cornouaillois, qui portoient grands *coutilles,* et venoient entre leurs gens d'armes et leur archers qui leur faisoient voie et occivrent sans merci." (Froissart, ch. 293, *sub anno* 1346.) In another passage he calls them "grands *couteaux.*" In a statute of William, King of Scotland (1165, 1214), quoted by Mr. Hewitt, the coutel is expressly called a dagger, "et cultellum

qui dicitur *dagger*,"—a definition also given by Knighton and Walsingham in the fourteenth century. (See DAGGER.) The weapon gave its name to the lawless men who bore it: "Hominem malum quem cultellarium dicimus." (Statute of the Count of Toulouse, A.D. 1152.) It seems to have varied in size, and I am inclined to think the larger sort received the name of "coutel-hache," progressively altered into CUTLASS, which see.

COVENTRY-BLUE. Thread of that colour extremely popular with all classes in the sixteenth century, and for the making of which Coventry was famous in the reign of Elizabeth. In 'A compendious and brief Examination of certayne ordinary Complaynts of divers of our Countrymen in these our Days,' by William Stafford, 1581, is the following passage:—"I have heard say that the chiefe trade of Coventry was heretofore in making blue threde, and then the towne was riche, even upon that trade, in manner only; and now our threde comes all from beyonde sea; wherefore that trade is now decaied, and thereby the towne likewise."

It was principally used for embroidering linen.

> "JENKIN. She gave me a shirt-collar, wrought over with no counterfeit stuff.
> "GEORGE. What, was it gold?
> "JENKIN. Nay, 'twas better than gold.
> "GEORGE. What was it?
> "JENKIN. Right *Coventry-blue*."
> *The Pinner of Wakefield*, 1599.

> "It was a simple napkin, wrought with Coventry-blue."
> *Laugh and lie down, or the Worldes Folly*, 1605.

COVERCHIEF, KERCHIEF, KERCHER. (*Couvre-chef*, French.) A veil or covering for a woman's head, and made of finer or coarser materials, according to the wearer's means or condition.

The couvre-chef was worn by women of every rank in England, both Anglo-Saxon and Norman. By the former it was known as the "heafods-rægel," or head-rail. Examples of it in illuminations of the eleventh and twelfth centuries are numberless. It seems to have been broad enough to cover the head completely, so that no hair could be seen, and then wrapped round the neck and passed over the shoulders. One end of it is sometimes seen loose, and depicted flowing, manifesting, as Mr. Strutt has observed, "some conception of grace and elegance in the artist;" but it is more frequently

Anglo-Saxon Lady. Cotton. MS. Claudius, B iv.

Anglo-Saxon Lady. Cotton. MS. Cleopatra, C viii.

Anglo-Norman Lady. Cotton. MS., C iv.

Anglo-Norman Lady. Bodleian Library, 6, 14.

represented with both ends concealed, and so enveloping the head and neck that only the face is visible, as it is in a hood, from which contemporary article of attire it is sometimes difficult to distinguish it.

It is painted of various colours, and that it was of different materials is evident from the folds being sometimes small and abundant, and at others large and few.

In the thirteenth century we read of "keverchiefs of silk" ('Romance of the Seven Sages'); and "cloths of fyne golde all about your head" are promised by the king to his daughter, in 'The Squire of Low Degree.'

> "Her kercheves were well schyre,
> Arayed with rich gold wyre."
> *Lay of Sir Launfal.*

> "Her kerchefes were curious with many a proude prene [pin]."
> *Adventures of Arthur.*

In the fourteenth century the kerchief had ceased to be the head-dress of the higher orders (see HEAD-DRESS), but continued to be worn, in various forms, by the wives and daughters of the middle and lower classes. Several appear to have been worn together; but in what mode, is neither clearly described nor depicted. Chaucer, in his 'Canterbury Tales,' tells us that the kerchers of the Wife of Bath were

> "———— full fine of ground ;
> I durste swear they *weighed a pound*,[*]
> That on the Sonday were upon her head."

As they are said to have been of fine texture, there must have been several to weigh a pound, and would have been folded, perhaps, and laid one upon the other.

The coarser couvre-chefs seem to have been made of linen, and in the fifteenth and sixteenth centuries were called "cloths." Elynor Running, the ale-wife, is described by Skelton (*temp.* Henry VII.) as having

> "———— cloths upon her head,
> They weigh a sow of lead."

Nicholas Dyer, of Feversham, by his will, 29th October, 1540, leaves to his sister, Alice Birkendyke, "two kerchiefs of Holland." In the History of John of Whichcomb (the celebrated Jack of Newbury) the maidens who were spinning had

> "Milk-white kerchers on their heads ;"

but the precise mode of wearing them, whether fastened to the hair with pins or bodkins, or tied under the chin, as market-women wear them at the present day, is left to our imagination. (See further under HEAD-DRESS and VEIL.)

COWL. The hood of a monk's or friar's gown, attached to the back of the collar, and pulled over the head or thrown behind, as may be desired. (See HOOD.)

CRACKOWES. Long-toed hose and shoes introduced during the reign of Richard II., and so called from the city of Cracow in Poland. (See HOSE and SHOE.)

CRAPE. See CRISP.

CRAVAT. (*Crabbat*, French.) A neckcloth or neckerchief. The author of the 'Ladies' Dictionary' tells us that the word "is properly an adjective, and signifies 'comely, handsome, gracious;' but it is often used substantively for a new-fashioned gorget which women wear, or a riding-band

[*] Mr. Strutt reads, "weyden *ten* pounds," and renders "weyden," *value.* I find no such interpretation in the Glossarists.

which men wear." The cravat all of lace, or of fine linen with ends of lace, is first seen at the close of the reign of Charles II., in England, by whom it is said to have been introduced from France, where it superseded the bands and falling collars of that period, and can scarcely be distinguished from them in the early examples. Another derivation of the name is suggested by the above authority, who adds, "also a cravate, worn first, they say, by the Croats in Germany." Napoléon Landais gives the same derivation : "CRAVATE (des *Cravates*, aujourd'hui *Croates*, de qui les Français empruntèrent cette partie d'habillement pendant la guerre qu'ils eurent en 1636 avec l'Empereur)." ('Dictionnaire Général,' Paris, 1834.)

From portrait of Mons. Colbert, at Versailles.

King William III. From his portrait by Vischer.

Charles II., in the last year of his reign, is charged 20*l.* 12*s.* for "a new cravat to be worn on the birthday of his dear brother ;" and 36*l.* 10*s.* is charged to James II. for the cravat of Venice lace to wear on the day of his coronation. (Great Wardrobe Accounts for 1683-4, and 1685-6.)

In the reign of William III. the cravat was worn extremely long by men of fashion, the ends being occasionally passed through the button-holes of the waistcoat ; and a little later it was also known by its English name of "neckcloth."

In 'Mist's Journal,' 1727, a receipt in rhyme for making a beau instructs us to

"—— take of fine linen enough to wrap him in ;
Right Mechlin must twist round his bosom and wrist."

The portrait of William III., who as well as his queen was extravagantly fond of lace, represents him with a cravat of point-lace, the fineness of which may be estimated by an item in one of his Majesty's lace bills : "To six point cravats, 158*l.*" (Great Wardrobe Accounts, 1688 to 1702.) A beau of the reign of Queen Anne informs us : "I tied the collar of my shirt with half an ell of black ribbon, which appeared under my neckcloth."

Cravat. *Temp.* Queen Anne. From a print of the period.

The battle of Steinkerque, 3rd August, 1692, introduced a new-fashioned cravat, which was adopted not only by men, but by the women in France. It was reported that the French officers, dressing themselves in great haste for the battle, twisted their cravats carelessly round their necks ; and in commemoration of the victory achieved by the Mareschal de Luxembourg over the Prince of Orange on that day, a similar negligent mode of wearing the cravat obtained for it the name of a "steinkerque." (See woodcut of the Dauphin, afterwards Louis XV., on the next page, from a print of the period. The lace ends of the steinkerk are drawn through the buttonhole of his coat.) It soon travelled into England, and, as in France, was worn by both sexes. In Sir John Vanbrugh's comedy, 'The Relapse,' 1697, occurs : "I hope your lordship is

pleased with your steinkerk." In the 'Prologue to First Part of Don Quixote,' 1694, the "modish spark" is told he may

> " paint and lie in paste,
> Wear a huge steinkirk twisted to the waist."

From a French print of the period.

From portrait of " Le Grand Dauphin en Steinkerke."

And in illustration of the latter line Mr. Fairholt gives a woodcut of a neckcloth the long ends of which are most precisely plaited, in the form of a pig-tail or the hair of a Swiss or German peasant-girl. He does not quote his authority, unfortunately, and as I have never met with another example I am inclined to think the original drawing or print must have been a caricature. In many portraits, both French and English, the cravat is seen, as in that of the Dauphin above, loosely put about the neck and *twisted*, as it may be termed ; but not tightly plaited, as in the annexed copy of the woodcut in Fairholt's 'Costume in England.' Nor was it specially of black silk, as stated in a note to that work, p. 356, but generally of fine linen or lace. At Ham House there was a portrait of a Countess of Dysart, *temp.* Queen Anne, in a riding-dress, consisting of a three-cornered cocked-hat, long coat and waist-coat, and a Mechlin steinkerk ; but that

From Fairholt's 'Costume in England.'

ladies wore them of other stuffs and colours, is shown by the following entry in the account-book of Isabella, Duchess of Grafton, under date 1708 : "To a green steinkerk, 1*l.* 1*s.* 6*d.*" (' History of Lace,' by Mrs. Bury Palliser. 8vo. London, 1865.)

The steinkerk worn by ladies was, in fact, nothing more than a kerchief of lace rolled about the neck instead of being spread over the shoulders. Lady Easy, in Cibber's admirable comedy, 'The Careless Husband,' takes the steinkerk off her neck to cover Sir Charles's head while he is sleeping. In the modern editions it is of course called a handkerchief. An old French print of " Madame la Duchesse de Lude en Steinkerke " perfectly illustrates this fashion, which is extremely graceful, and also affords us another example of the commode, or tower, which is anything but graceful.

Madame la Duchesse de Lude " en Steinkerke."

" Many people," says Mrs. Palliser, " still possess among their family relics, long oval-shaped brooches of topaz or Bristol stones, and wonder what they were used for. These old-fashioned articles of jewellery were worn to fasten (when not passed through the button-hole) the lace steinkerk, so prevalent, not only among the nobility, but worn by all classes."

Dr. John Harris, afterwards Bishop of Llandaff, in a 'Treatise upon the Mode, or Farewell to French Kicks,' published in 1715, speaks, amongst other fashions copied from the French, of the beads that are fastened to the ends of the cravats "to correct the stubbornness of their muslin," but such adjuncts are not visible in paintings.

The long cravats and steinkerks were ousted by stocks and frills; but the neckcloth reappeared towards the end of the last century, in a most formidable fashion. I leave it, however, in this work, in

Thomas Guy.

John Dunton.

the reign of George II., and with an example of it in the portrait of Thomas Guy, the philanthropic founder of Guy's Hospital, who died in 1724, and of John Dunton, printer, bookseller and polygrapher, 1733.

CREST. (*Crista*, Latin.) This word, familiar to us as the name of an ornament surmounting the helmet, and since the thirteenth century a portion of the insignia of a gentleman of coat-armour, signified, in classical times, a comb terminating in a peak in front of the casque, and decorated with horsehair; and the helmets of the early Anglo-Saxons, the Franks, and other nations established in Europe after the decline of the Roman empire, exhibit a serrated comb, like that of a cock. Towards the close of the twelfth century something like the mediæval crest appears, one of the most remarkable examples being that on the seal of Richard I. It would seem that they were unknown in Scotland before the year 1388, when we are told that the Scottish army before Berwick saw "twa noveltyes"

> "That forthwith Scotland had been nane :
> *Tymeris* [timbres] *for helmetys war the tane,*
> The tother crakys was of war" [*i.e.* artillery].

Crests do not appear to have been very generally worn in France; but in Flanders, Germany, and Italy, they are found on the helmets of knights of all ranks.

An interesting specimen, most probably English, was lost to this country by the ignorance and impolitic parsimony of the authorities of the Tower, and is now in the Musée d'Artillerie at Paris. I fortunately secured a careful drawing of it. (See HELM.)

The crest, if not issuing out of a coronet, or placed on a chapeau, was encircled at its base by a *torse* or wreath of the colours of the knight's arms, placed over an ornamental covering called the lambrequin, or mantling, which was sometimes embroidered with the badge of the wearer.

In King René's 'Livre de Tournois' are the instructions for constructing and fastening the crest, wreath, and mantling on the helmet at that period, illustrated by drawings. Similar illustrations will

be found also in the 'Blason d'Armoiries,' a splendid MS. in the Harleian Collection, No. 4038. (See HELMET.)

The earliest appearance of a crest in England is on the second seal of Richard I., in which the king is represented wearing a cylindrical helmet surmounted by a semicircle of points, or a demi-soleil,

Crest of Richard I.

within which is the figure of a lion passant. We cannot, from the impression of the seal, decide whether this lion was a figure carved in wood or cast in metal bodily, surmounting the helmet under an arch of iron, or merely painted on each side of a flat semicircular plate of iron, of which the whole crest was formed; but analogy rather points to the latter, as we have several instances of a fan-like ornament, variously decorated, surmounting helmets of the thirteenth and even of the fourteenth century. In most of the early examples the crest will be found to be a repetition of the coat, and instances occur as late as the fourteenth century; witness the splendid one of Sir Geoffrey Louterell (*circa* 1340), as depicted in the 'Louterell Psalter:'

Crest of Sir Geoffrey Louterell.

but as we proceed we discover new devices in great variety, the majority, perhaps, differing entirely from any borne on the shield. Such is the escarboucle on the helmet of John, Earl of Warren, his arms being chequé *or* and *azure*, and the wyvern on that of Thomas, Earl of Lancaster, whose arms were those of England (see p. 122, under COINTOISE). In the

Crest of John, Earl of Warren.

Crest of Sir Edward de Thorpe, Ashwellthorpe Church, Norfolk.

Crest of Sir Humphrey Stafford. From his effigy.

fifteenth century the coronet or the torse, with the mantlings or lambrequins, usually accompanies the crest, which is at that time rarely seen in England except on the tilting-helm (*vide* those of Sir Edward de Thorpe, Ashwellthorpe Church, Norfolk, and of Sir Humphrey Stafford, from their effigies); and, though occasionally surmounting the salade during the wars of the Roses, was eventually displaced by the increasing taste for feathers: by which must be understood not the heraldic panache, as in the above engraving, but a plume of ostrich feathers overshadowing the helmet or streaming down in profusion from the back of it. (See under FEATHERS and PANACHE.)

CRÈVECŒUR. "By some called 'heart-breaker,' is the curled lock at the nape of the neck; and generally there are two of them." ('Ladies' Dictionary,' 1694.)

CRISP. (*Crispa vel crespa*, Latin; *crêpe*, French; *crespon*, Spanish.) The well-known manufacture, crape, derives its name from this source; immediately from the French *crêpe*, and

through the French from the Latin *crispus*, frizzled or curled, indicative of its texture. In the thirteenth and fourteenth centuries we repeatedly meet with the following words,

CRISPINE, CRESPINE, CRESPINETTE, in descriptions of a lady's head-dress. In the 'Roman de la Rose,' Pygmalion is satirically represented by Jean de Meun as trying on his statue, Galatea, all the fashionable apparel of the poet's period. Amongst the head-dresses, he says that over her hair, which was braided with gold tissue and small pearls, he placed "the *crespine*, with a most costly fastening ; and over the *crespinette* a coronet of gold, richly beset with precious stones."

> " Et tresures gentilz et gresles
> De soye d'or à menus perles,
> Et dessus la crespine attache
> Une moult precieuse attache,
> Et par dessus la crespinete
> Une couronne d'or pourtraiete
> Ou moult a precieuses pierres
> Et beaulx chastons a quatre esquierres." &c.
>
> ll. 21883–21890.

I have quoted the whole passage, as I am not satisfied with my own translation of it, nor with any other I have met with. "Attache" signifies an ornament composed of a cluster of jewels attached to, or fastening together, any portion of attire or head-dress : "Attache de diamants— assemblages de diamants mis en œuvre" (Napoléon Landais) ; as well as in its more familiar sense, a string, band, or tie. We may therefore read that he fastened the crespine over her hair by a clasp or ornament of jewels, or attached the ornament to it. Again, *crespinete* is said to be the diminutive of *crespine ;* but in this instance, are we to consider it the same article, or a portion of it so called ? And, after all, what was the *crespine?* for we have no description of its exact form, or the material it was made of. Mr. Fairholt considers it to be "a network to confine the hair of ladies." It originated with the *calantica* of the ancients, and appears in the Middle Ages taking all forms, and bearing many names, as *tresson, dorelot,* &c. Borel simply calls it a "coiffure," made of crape or gauze. Of the reticulated head-dress of the thirteenth and fourteenth centuries we have a host of examples, both in painting and sculpture ; but it remains a question with me whether *crespine* and *crespinete* were the names of the gold net or "soye d'or" confining the hair, or of a diaphanous veil or covering of crape or gauze bound over it by a circlet of gold, or fastened to it by an *attache* of jewels. Examples abound in effigies and miniatures contemporary with the writers of the 'Roman de la Rose,'—Guillaume de Lorris, who died about 1260, and Jean de Meun, *dit* Clopinel, his continuator, living in 1300. The reticulated head-dress, in one form or another, lasted in fashion to the end of the fifteenth century ; but the names of *crespine* and *crespinete* are not met with after the fourteenth (see HEAD-DRESS). Ducange (*sub voce* CRESPA) quotes an ordinance in the Chamber of Accounts at Paris, which shows that there were artisans in that city who were called *crespiniers :* "Quiconques veult etre *crespiniers* à Paris de fil et de soi, *c'est à savoir ouvriers de coiffes à dames,* et toiles à oreilliers, et de paveillons, que on met par dessus les autels que on fait a l'aguille et au mestier," &c. (Ex Cam. Comput. fol. 139, 1°.) By this it would appear that it was the material that gave the name to the *coiffure,* and that it was used also for the coverings of cushions and altars, and to ornament garments. "De gonellis dominarum frexatis cum gironibus, *crispis* et butonis." (Stat. Ferar., *anno* 1279, apud Muratori.) *Crespa* is also rendered a fold or plait. "Vox Italica, *ruga,* Gall. *pli* [plis]. Vestis ornamentum." (Ducange, *ut supra.*) (See HEAD-DRESS.)

CROC or *CROOK.* A cornuted club used by all classes in warfare, until the end of the fourteenth century. The Anglo-Norman poet Guiart, describing the weapons of the irregular soldiers called Ribauds, in 1214, says:

> "Li uns une pilete porte,
> L'autre croc ou maine-torte."

Mr. Hewitt remarks on this passage, "The *croc* was probably the bill ;" and adds, "The *maine-torte* is a *knotted* club." "Torte," however, does not signify knotted, but crooked or twisted ; and in the above

Croc. From MS. Roman de Tristan, Bib. Nat., Paris.

line the words "ou maine-torte" may be taken not as indicating an entirely different weapon, but simply a variety of it (see MACE), or even as the Norman name for the weapon, "a croc *or* crooked club ;" the strait knotted club being called by the Normans *baston*, as we have seen under that head (p. 37). Not only shepherds, but rustics of other descriptions, and even youths of higher orders, are depicted, in Anglo-Norman MSS. of the eleventh century, with crook-headed staves in their hands. It was used by country people for pulling down the dead branches of trees, and is called to this day a *crook-lug* in Gloucestershire (Halliwell).

Norman Youth. Cotton. MS., Nero, C iv.

CROCK. "A kind of musquet." (Halliwell.) (See also HARQUEBUSS.)

CROCKET. "A large roll of hair, much worn in the time of Edward I." (Halliwell), and generally in the fourteenth century.

> "Be not proud of thy croket,
> Yn the cherche to tyf and set."
> > MS. Harleian, No. 1701, fol. 22.

> "His croket kempt, and thereon set
> A nouche with a chapelet."—Gower.

CROCKS. Locks of hair. (Relig. Antiq. 134, f. 171.) "Under hair in the neck." (Halliwell.)

Cross-staff of Archbishop Warham.

Arms of the See of Canterbury.

CROSS, ARCHIEPISCOPAL, PATRIARCHAL, and *PAPAL,* improperly called by some writers a crozier, is a staff headed with a cross and not with a crook. (See CROZIER.) The cross borne by or before archbishops has, in the earliest examples, the form called by heralds *patée* or *patoncé,* as it is drawn in the arms of the Sees of Canterbury, Armagh, and Dublin, and an instance occurs as late as 1520 on the tomb of Archbishop Warham, in Canterbury Cathedral. The cross of a patriarch has two transverse bars, the upper shorter than the lower ; and the cross of the Pope three, the lowest being the longest. (Pugin's 'Glossary of Ecclesiastical Ornament and Costume,' 4to. Lond. 1842, p. 192 ; Parker's 'Glossary of Heraldry,' 8vo. Oxford, 1847.) The details of these crosses vary, however, considerably in their ornamentation, particularly in the terminations of the bars, or limbs, as they are sometimes called, nor do I find any strict rule observed in the appropriation of the double and single crosses by the mediæval draughtsmen. In a series of drawings illustrating the life of Thomas à Becket, Archbishop of Canterbury, Royal MS., 2 B vii., all of which have been engraved by Mr. Strutt in the supplement to his 'Regal and Ecclesiastical Antiquities,' the Archbishop is in every instance represented bearing the double or patriarchal cross. He is depicted receiving it at his consecration, appearing with it before the King (Henry II.), and also when resigning his see to the Pope, who restores to him the insignia of his office. Our woodcut is from the drawing representing his reception by the Abbot of Pontigny on his return

from Rome. In the last subject but two, which is that of his murder, the cross in the hand of his cross-bearer has but a single transverse bar.

Here is the figure of an archbishop from a drawing of the thirteenth century in a MS. marked

Thomas à Becket and the Abbot of Pontigny.

Varieties of the Archiepiscopal Cross.

Archbishop. 13th century.

Royal, 2 A xxii., British Museum, holding the staff with a single cross ; while in another, formerly in the possession of the late Mr. Douce, representing Cardinal Wolsey attending King Henry VIII. to the Field of the Cloth of Gold, the double as well as the single cross is borne before him.

In addition to these conflicting examples, a MS. at Lambeth Palace, executed by a herald for Archbishop Laud himself, presents us with the arms of the See of Canterbury, accompanied by the cross patriarchal, while the Patriarch of Constantinople in the time of Elizabeth is represented bearing the crozier! (See CROZIER.) The single cross is, however, the most general form, and I have been unable to obtain any satisfactory reasons for the exceptional instances, which are not noticed by Mr. Pugin or the author of 'Parker's Glossary.' The above woodcut exhibits three varieties of the single cross from MSS. of the Middle Ages and the wall-paintings in the Old Palace at Westminster. These, as well as the great processional crosses, were sometimes of gold, of elaborate workmanship, beautifully enamelled, and richly set with jewels. Mr. Shaw has engraved views of the front and back of a magnificent processional cross, in his 'Dresses and Decorations.'

CROSS-BOW. See ARBALEST, LATCH, and PRODD.

CROSS-CLOTH. "A band worn by ladies, crossing the forehead." (Fairholt's 'Costume in England.') He quotes, however, no authority, and Mr. Pugin in his 'Glossary,' p. 71, explains cross-cloth as "a cloth or veil to cover the crosses in Lent;" but see FOREHEAD CLOTH.

CROWN. This symbol of sovereignty is coeval with the rank it denotes, and the varieties of its form are almost innumerable. The crown of the Pharaohs, kings of Upper and Lower Egypt, is perhaps the most ancient of which we have an authentic representation. Next to that the sculptures at Persepolis engraved in Sir Robert Kerr Porter's work exhibit the crown of the early kings

of Persia. The Greek coins and the Etruscan vases furnish us with many interesting examples. Of the crown of Charlemagne we possess accurate drawings. Those of the Franks, Merovingians, and Anglo-Saxons have been handed down to us in sculpture and painting from the earliest periods, and the seals and effigies of the monarchs of England exhibit a complete series of their crowns from the eleventh century to the present day. It is with the latter we have chiefly to do in this portion of the work, and by reference to the accompanying plate the reader will learn more at a glance than from pages of description.

Alfred seems to have been the first English monarch who wore a crown, as previously to his accession we only hear of *election* and *consecration*, and ever afterwards of *coronation*. As early as the reign of Henry III., Robert of Gloucester alludes to a tradition that " Pope Leon him (Alfred) blessed as well as the king's crown of this land," which, he adds, " in this land yet is," thereby distinctly asserting that a crown considered as Alfred's was in existence in the thirteenth century.

Sir Henry Spelman, in his Life of Alfred, says, " In the arched room in the cloisters of Westminster Abbey, where the ancient regalia of this kingdom are kept, upon a box which is the cabinet to the antientest crown there is (as I am informed) an inscription to this purpose, ' Hæc est principialior corona cum qua coronabantur reges Ælfredus, Edwardus,' &c. ; and the crown (which to this purpose were worth observing) is of a very ancient work, with flowers adorned with stones of somewhat a plain setting." And this account is corroborated by the inventory made by order of the Parliament of that portion of the regalia found in Westminster Abbey in 1649, wherein the only crown beside that of the Queen is called "King Alfred's crowne," which is described as being made " of gould wyre worke set with slight stones and two little bells." The gold, weighing seventy-nine ounces and a half, was valued at £3 an ounce, making £248 10s. It would appear, therefore, that the crown with which it was customary to crown all the kings of England was King Alfred's, and

King Edgar. From Cotton. MS. Tiberius, A iii.

only obtained the name of "St. Edward the Confessor's" because it had descended to him, and had been entrusted by him to the care of the abbot and monks of Westminster.

As to its form we have no authentic description or representation. The earliest drawing of an English crown I have met with occurs in a MS. in the Cotton Collection, British Museum, marked Vespasianus, A viii., being a book of grants made by King Edgar to the Abbey of Winchester, A.D. 966. In it that monarch is depicted wearing an open crown with three foliated pinnacles, of the plainest character, without any jewels (see Plate VI. fig. 1) ; and such are generally seen in Anglo-Saxon illuminations, but varieties are also found, and we cannot now discriminate between the fanciful designs of the artist and a faithful representation of an actual crown of the period. Each monarch may also have had, even in those days, his own state crown made to fit him, and most likely after his own taste. For instance, in the Cotton. MS. Tiberius, A iii., is another representation of Edgar wearing a square crown, of which extremely inconvenient shape many examples are to be met with in Frankish and Anglo-Saxon MSS. of the tenth and eleventh centuries (see Plate VI. figs. 3 and 6) ; but in this instance it is apparently jewelled, and is otherwise more tastefully ornamented on the upper rim. Edward the Confessor is represented on his great seal wearing the kyne-helme or royal helmet : but on one of his silver coins in the British Museum there is an indication of an arched crown (Plate VI. fig. 4), while in all other representations he is portrayed with an open crown similar to those above mentioned (fig. 5, copied from the Bayeux Tapestry). Harold is also represented in one instance in a square crown (fig. 6). The crowns of William the Conqueror and

1
Edgar. Cotton M.S
Vespasianus, A. VIII.

2
Cotton. MS.
Claudius B 4.

3
Cotton. MS.
Tiberius C. 6.

4
Edward the Confessor.
Silver Coin, Brit. Mus.

5
Edward the Confessor.
Bayeux Tapestry.

6
Harold II.
Anglo-Saxon MS.

7
William I.
Coin, Brit. Mus.

8
William II. Silver
Coin, Brit. Mus.

9
Henry I.
Great Seal, Brit. Mus.

10
Henry II.
Effigy at Fontevraud.

11
Richard I.
Effigy at Fontevraud.

12
John. Effigy in
Worcester Cathedral.

13
Henry III. Effigy in
Westminster Abbey.

14
Edward I. Great
Seal, Brit. Mus.

15
Edward II.
Effigy at Gloucester.

16
Edward III.
Great Seal,
Guildhall Library.

17
Richard II. Painting in
Westminster Abbey,

18
Henry IV. Effigy in Canterbury Cathedral.

20
Henry VI. Glass Painting.
Hall Window, Ockwell's
House, Maidenhead.

19
Henry V. Miniature in
Book, Corpus Christi
Lib. Camb.

21
Edward IV.
M.S. in Lambeth Library.

22
Richard III. Initial to MS.
formerly belonging to this king,
now in Brit. Mus.

DIEV ET MON DROIT

23
Henry VII. King's Coll. Chapel. Cambridge.

24
Henry VIII. Great Seal in Guildhall
Library, made A.D. 1539, for the Field of
the Cloth of Gold.

25
Edward VI. Stone Carving above Entrance Gates
at Penshurst.

26
Mary. From a rare French
Print.

27
James I Great Seal,
Guildhall Library.

28
Charles I.
Coronation Medal,
Guildhall Library.

29
Charles II.
Coronation Medal,
Guildhall Library.

William Rufus, the first Norman kings of England, are nearly of the same form as the arched one of the Confessor on his silver coin (figs. 7 and 8), and the well-known predilections of the latter for everything Norman may justify the belief that he had a crown made after the fashion of some Norman coronet, adding, probably, the arches which appear in Germany as early as the reign of the Emperor Henry II., 1015. Froissart, in his account of the coronation of Henry IV. of England, distinctly describes the crown of St. Edward as "archée en croix," which may be translated either "arched across" by a single bar, or "arched in form of a cross" by two intersecting arches, which would render it more like the later crowns. Henry I., on his great seal, is represented with an open crown with three pinnacles surmounted by trefoils, and having an appendage on each side similarly terminated (Plate VI. fig. 9), presumed by some writers to have steadied the crown by fastening it under the chin, but they are distinguishable in the crowns of his father and brother, and their length in those examples clearly shows that could not be their purpose. The rudeness of the delineations of this period renders it idle to speculate on these minor details. Some drawings of this date give one the notion of a fender or a fire-grate rather than that of a regal diadem.

With the reign of Henry II. and those of his sons Richard and John we arrive at a period affording us much more authentic evidence (figs. 10, 11, 12). The sepulchral effigies of our sovereigns furnish us with some fine examples of their crowns of State. Those of the kings and their queens at Fontevraud appear to be nearly all of the same pattern, and may have been executed by the same sculptor. The crown carried before Richard I. at his coronation is said to have been a large one of gold set with rich jewels, so heavy that two earls supported it after it was placed on his head, which might well be the case if it were King Alfred's crown, of which the gold alone, as I have mentioned, weighed upwards of six pounds. It was afterwards exchanged for a lighter one, such as that most probably on his effigy. King John appears to have had several crowns of State. In 1204, in his order to the masters and almoners of the New Temple, who had at that time the custody of the regalia, he mentions "our golden crown made in London," and in 1208 he received from Germany a large crown of a very splendid description. The loss of all his baggage in the Welland, when crossing the Wash near Wisbeach, in 1216, just before his death, rendered it necessary to crown his young son, Henry III., at Gloucester with a simple fillet of gold, London being at that time in the hands of Louis the Dauphin, and consequently the ancient crown of England not obtainable. The crown of John, on Plate VI. fig. 12, is from his effigy at Worcester. It has been sadly broken. The crown of Henry III. on his effigy in Westminster Abbey is plain but elegant, and exhibits, for the first time in England, the unmistakable fleurs-de-lys (fig. 13). In Rymer's 'Fœdera' there is a description and valuation of three crowns of gold sent by Henry to Paris, and pledged there to raise funds during his contention with the Barons. They were redeemed and brought back to England in 1272.

The crown of Edward I. is from his seal (fig. 14). It resembles his father's, but only three out of four fleurs-de-lys are visible, in lieu of five out of eight, which would probably be the number surrounding King Henry's.

The crown of Edward II. is composed of oak leaves, with small trefoils between them (fig. 15).

If the effigy of Edward III. ever had a crown, it has disappeared. Our figure is from his great seal. The circlet is surmounted by strawberry leaves and an ornament composed of three pearls, alternately (fig. 16).

The crown of Richard II. is carefully painted in his portrait in the Jerusalem Chamber at Westminster, a coloured copy of which appeared with the First Part of this work.

That of Henry IV., from his effigy in Canterbury Cathedral (fig. 18), is perhaps the most elaborate of the whole series, and here we see again the strawberry leaf alternately with the fleur-de-lys. A crown called "The Harry Crown" was broken up and distributed, by way of pledge, by Henry V. ; but from the description of the portions it does not appear to have been similar to the one on his effigy. "To Sir John Coloyk was pledged a great fleur-de-lys of the said crown, garnished with one great balays [ruby of a pink colour], and one other balays, one ruby, three great sapphires and two great pearls." "To John Pudsey, Esq., a pinnacle of the aforesaid crown, garnished with two sapphires, one square balays, and six pearls." "To Maurice Brune and John Saundish, two other pinnacles of

the same crown, similarly garnished." He also pawned a great circle of gold, the whole of the lower portion apparently of the crown itself, garnished with fifty-six balays, forty sapphires, eight diamonds, and seven great pearls, weighing altogether four pounds, and valued at 800*l.* sterling of the money of that period.

We have no description of the crown of Henry V.; and the head of his effigy in Westminster Abbey having been of silver, was stolen, crown and all, in the reign of Henry VIII. Our example is from a miniature of him in a book once his own, and now in Corpus Christi Library, Cambridge. It appears to be of plain gold, with perhaps six pinnacles, only four of which are visible, surmounted by trefoil ornaments (fig. 19).

From the time of Henry VI. the State crowns of England are always represented with arches, and the cross patée is first seen in the reign of that pious king, alternating with the fleurs-de-lys, and also surmounting the crown, upon a mound or globe (fig. 20). See crowns of Edward IV., Richard III., Henry VII., and Henry VIII., from contemporary authorities.

The crown of Edward VI. was found in an iron chest, in 1649. It weighed two pounds one ounce. It was enriched with one fair diamond valued at 200*l.*; thirteen other diamonds, ten rubies, one emerald, one sapphire valued at 80*l.*, and seventy pearls. The gold was valued at 73*l.* 16*s.* 8*d.*; the whole of the jewels at 355*l.* This crown has been erroneously supposed to have been Edward the Confessor's; but it was probably "the very rich crown" purposely made for his Grace, and the third with which he was crowned at Westminster. (See Coronation of Edward VI., Leland's 'Collectanea.')

The State crowns of Mary and Elizabeth vary in nearly every representation.

Of the crown of England, *temp.* James I., we have a most minute account in an 'Inventory of the Jewelles remaining in an yron cheste in the secrete Jewel-house, w'in the Tower of London,' made by order of the Earl of Dorset in 1604, and signed at the beginning and the end by the king himself:—

"First a crowne imperyale of gold, sett about the nether border with ix[en] greate pointed dyamondes, and betweene everye dyamonde a knott of perle sett by five pearles in a knott in the upper border, eight rock rubies, and xx[tie] rounde perles, the fower arches being set eche of them with a table dyamonde, a table rubye, an emeralde, and uppon two of the arches xviii[en] perles, and uppon the other two arches xvij[en] perles, and betweene everye arche a greate ballace set in a colet of golde, and upon the topp a very greate ballace perced, and a little cross of gold upon the top enamelled blewe." This crown having four arches, was probably made previously to the reign of Edward IV., and one of those used in the coronation of Edward VI.

A crown called the State crown of Charles I., found in the upper jewel-house in the Tower, was valued as follows:—

	£
Eight-and-twenty diamonds, at 6*l.* each	168
Sapphires and rubies	380
Two emeralds	5
Two hundred and thirty-two pearls, at 15*s.* each	174
One-and-twenty rubies	16
Seven pounds and seven ounces of gold, valued at 40*l.* per pound, with six ounces abated for stones	280
	1,023

In one of the fleurs-de-lys of this crown there appears to have been "a picture of the Virgin Mary," probably enamelled, a curious feature in the crown of a Protestant monarch, and which induces me to believe it was not a crown made for Charles I., but the old imperial one of the fifteenth century, the second placed upon the head of the sovereign at his coronation.

All the regalia was subsequently broken up and sold in 1649. New crowns had therefore to be made for Charles II., after which period they gradually assumed the ungraceful shape with which our eyes are familiar in the ordinary representations of the crown of England, and on which the crown made for her present Majesty is a great improvement.

CROZIER. (*Crocea, crocia,* Latin.) ."Bacculinum pastoralis" (Ducange). The pastoral staff, resembling a shepherd's crook (whence its name), borne by bishops, mitred abbots and abbesses. The earliest example I remember to have seen is said to be of the close of the tenth century, in a MS. in the Harleian Collection marked 2908, described as 'Abbot Elfnoth's Book of Prayers,' the frontispiece to which represents the abbot, who died in 980, presenting his book to St. Augustine, who founded his monastery in Canterbury (*vide* fig. 1 in adjoined woodcut and the illustration to DALMATIC). I am inclined, however, to date the illumination nearly a century later, as previously to that period the bishops appear to have borne a plain staff with a crutch-head called a "Tau cross," or "T cross" (*vide* CRUTCH, and also figure of Odo, Bishop of Bayeux, from his seal, p. 93 *ante*). The said Odo is accused of having carried off "a rare crozier of sapphire" from Durham Cathedral, which he despoiled in 1078; but we have no further description of it. At all events, in its earliest form it was extremely simple, resembling the Roman *lituus*, which is said to have been its prototype, and continued so till the commencement of the twelfth century (see

Fig. 2.　　Fig. 1.　　　　　　Fig. 3.
1. Crozier of Abbot Elfnoth.
2. Bishop's Crozier, 11th century.
3. Crozier of Bishop Wainflete.

fig. 2 in woodcut from Cotton. MS., C iv., close of the eleventh century), after which there is a gradual appearance of ornamentation, as may be observed in the subjoined engraving of one of a series of ancient drawings representing the 'Visions of King Henry I.'

Vision of Henry I.

During the twelfth and thirteenth centuries the ornamentation rapidly increased, and the highest art and most costly materials, including a profusion of precious stones, were employed in its construction. A splendid one which belonged to William of Wykeham, 1390, is still preserved in New College Chapel at Oxford, and numerous examples are to be found in the sepulchral effigies of our bishops throughout the country, most of them being engraved in the works of Carter, Stodhard, Hollis, Shaw, and other English antiquaries.

An instance of an archbishop with a crozier occurs in the brass of Samuel Harsnet, Archbishop of York, 1631, in Chigwell Church, Essex, and that of a Patriarch with a crozier, in a work of the sixteenth century (see next page).

The crozier of an abbot appears not to have differed from that of a bishop (see that of Abbot Elfnoth in the above woodcut); but, according to some authorities, it should *always* have the

sudarium attached to it. Judging from the representations of it, such does not appear to have been the case. The crozier with the sudarium attached to it is, however, depicted in the arms of the Abbey of St. Bennet de Hulme. In sculpture or painting, also, it has been ruled that the convoluted head of the crozier should be turned outward when borne by a bishop, in token of his jurisdiction extending throughout his see, and inward by an abbot, whose power is limited to his own house. This direction appears to have been equally neglected. Here is a full-length figure of Abbot

Wethamstede, Abbot of St. Alban's. Patriarch of Constantinople. Isabel Hervey, Abbess of Elstow.

Wethamstede, of St. Alban's, from a painting in the Golden Register of that abbey, by Alan Strayler, who is commemorated in it.

Under CROSS, ARCHIEPISCOPAL, we have also given the figure of the Abbot of Pontigny receiving Archbishop à Becket. Above is that of the Patriarch of Constantinople in 1591, with a crozier, from Bertelli, 'Diversarum Nationum Habitus.' The brass of Isabel Hervey, Abbess of Elstow, in Bedfordshire, described by Mr. Fairholt as "a rare example of an abbess *in ponti-ficalibus*," exhibits an equal neglect of the above regulation by mediæval artists, and renders the authority of the rule doubtful. In the church of St. Martin, at Laon, is a monumental effigy of an abbess who died in 1354, corresponding in nearly all its details with the brass of Isabel Hervey. It is engraved in M. J. Quicherat's 'Histoire du Costume en France,' 8vo., Paris, 1875, p. 226, and the author informs us in the text that the crozier was first accorded to abbesses at the close of the thirteenth century, but without quoting his authority.

CRUCHES. "The small locks that dangle on the forehead." ('Ladies' Dictionary,' 1694.)

CRUELL, CREWELL. "Fine worsted, formerly much in use for fringe, garters, &c." (Halliwell, *in voce.*)

CRUTCH. The name given to an ancient form of the cross, the Greek TAU or T cross, seen in the hands of the highest ecclesiastical dignitaries. Odo, Bishop of Bayeux, is represented with

one on his seal (*vide* page 93 *ante*), apparently the predecessor of the pastoral staff. The name is preserved to us in the familiar one of Crutched Friars, in which locality, as Stow tells us, " sometime stood one house of Crouched (or Crossed) Friars, founded by Ralph Hosiar and William Sabernes, about the year 1298," and the shape is very clearly depicted in the arms of several religious houses, viz., those of the abbeys of Warter and Sempringham, the house of Newborough, the monastery of Kirkham, &c.

CUFF. Cuffs were originally formed by the turning back of the termination of the sleeves at the wrist, and are first visible in ladies' dresses in the fifteenth century (see woodcut annexed). In an inventory taken in the eighth year of Henry VIII., three yards of "crimosin cloth of gold of damask" are allowed for "the edging, facing, and *cuffs*" of a gown for the queen.

They are mentioned amongst the articles of a fashionable lady's attire in the old play of 'Lingua,' *temp.* James I. Also in the following line :—

Crutch.

> "Shadowes, rebatoes, ribbands, ruffs, cuffs, falls."
> *Rhodon and Iris*, 1631.

And amongst those of a beau of that period :—

> " I would put on
> The Savoy chain about my neck, the ruff,
> The cuffs of Flanders."—Ben Jonson, *New Inn*, 1629.

Cuff. 1490. Cuff. From Cotton.
MS., 15th cent.

Whether of Flemish fashion or of Flemish material is left to conjecture. The Low Countries were celebrated for the manufacture of linen, and Flanders disputes with Venice the invention of lace.

In the inventories of the seventeenth and eighteenth centuries we constantly find entries of cuffs of Mechlin lace, and "the cuffs of Flanders" alluded to were most probably of that much-prized material. The portrait, at Versailles, of Mary, Queen of Hungary, Governess of the Netherlands in

Lace Cuff of Queen of Hungary. 1530.

1530, presents us with a specimen of a cuff of lace, most probably of Flemish manufacture, and a still more splendid example is seen in that of Anne of Austria, queen of Louis XIII., 1615, from her portrait in the same collection. The engravings, by Hollar, of Englishwomen of his own time, many of which will be found copied for this work, afford specimens of the plain linen cuffs worn by females of all ranks in or about 1640, and it is unnecessary to repeat them. (See page 33.) Ruffles were called " ruff cuffs " in the latter half of the seventeenth century :

> " Ruff cuffs about his wrists."—*Lord Mayor's Pageant*, 1664.

In male attire cuffs make their appearance later than they do in that of the fair sex. For them also we must refer the reader to the woodcuts illustrating the article COAT, and also to the General History.

Lace Cuff of Anne of Austria. 1615.

CUIRASS. Another of the many names used at various periods to designate the breast-plate. It appears to have been first adopted in England in the reign of Charles I., when some regiments

of light cavalry were formed, equipped in buff coats with breasts and backs only, and called *cuirassiers*, more probably from the buff leather (*cuir*) than from the steel breast-plate. According to a treatise published at Cambridge, entitled 'Militarie Instruction for the Cavalrie,' dated 1632, we find that force divided into four classes, "the lancier, the cuirassier, the harquebuse and carbine, and the dragone." The cuirass, discarded in the English army at the commencement of the last century, was re-assumed after the battle of Waterloo, and, as we need scarcely remark, now gleams on the breasts of the 1st and 2nd Life Guards and the Royal Horse Guards Blue.

CUIR-BOUILLY. (*Cuir bouillie*, French.) A preparation of leather by boiling, which was largely employed in the Middle Ages, in addition to as well as in lieu of metal armour.

> "His jambeaux were of cuir-bouly."—Chaucer, *Rime of Sir Topaz.*

It was much used for elbow, knee, and shin pieces (bainbergs) in the thirteenth century (see page 29), and sometimes for the head, in addition to the coif of mail or plate. Examples of its application in the latter form are to be seen in the effigies in the Temple Church, London, and M. Viollet-le-Duc gives us an interesting one from a statue at Ghent ('Armes de Guerre,' huitième partie, p. 152).

CUIRTAIN. (Gaelic.) White twilled cloth made from fine wool, and for interior garments and hose, by the Scotch. *Cuirt* signifies "manufacture," and *an* is a Gaelic diminutive: hence in the Keltic manner of compounding words, *cuirt-an* would mean the lesser or finer manufacture.

CUISSES, CUISHES, CUISARTS, QUISSHES. (*Cuissot, cuisard*, French.) Armour for the

thighs (*cuisses*) introduced about the middle of the fourteenth century, and then constructed of cuir-bouilli and other materials, which were gradually superseded by plate. In early examples they consist of one, two, or three small plates overlapping each other, riveted to the genouillière or knee-piece, and not reaching above the mid-thigh, round which they were secured over the mail chausses by straps and buckles. Later they were formed of one piece only, and reached to the top of the thigh, and finally they were furnished with a back piece, enclosing the whole of the thigh in plate armour. The mail chausses had then been exchanged for breeches, or hose of velvet or leather, and the inside

14th century.

MS. Bib. Nat., Paris. 1370.

of the knee-joint only was protected by a gusset of chain. In the fifteenth century, the era of complete plate, specimens are seen of cuisses with a ridge on the upper portion to prevent the point of a lance or spear gliding up under the jupon. (See the second figure in subjoined woodcuts.)

MS. Bib. Nat., Paris. 1370. Statue of Comte d'Eu. 1397. Miroir Historical. MS. *circa* 1440.

Few changes, and these simply in the way of ornament—such as fluting, engraving, and embossing—occurred from the middle of the fifteenth century to the end of the seventeenth, when they were superseded by taces or tassets (which see). Beneath are engravings from a suit of the reign of Henry VI. or Edward IV., of one of the reign of Henry VII., and of another of the reign of Henry VIII., all formerly in the Meyrick Collection.

Temp. Henry VI. or Edward IV. Front and side view.　　　*Temp.* Henry VII.　　　*Temp.* Henry VIII.

CUKER. This word occurs in the 'Townley Mysteries,' and is said by Mr. Fairholt to be some portion of a woman's head-dress. "The cuker hangs so side [wide], now furred with a cat's skin." I am inclined to think it was a kind of cloak.

CULETS, CULESSETS. The skirt of articulated plates attached to the back-plate, in the sixteenth century; also called "garde de reins." They were last worn by the troops called lancers, in the reign of Charles I. ('Militarie Instruction for the Cavalrie,' Cambridge, 1632. See woodcut, p. 56.)

CUPÉE. "A pinner that hangs close to the head." ('Ladies' Dictionary,' 1694.)

"The setté, cupée, place aright."—Evelyn.

CURAT. Another name for a cuirass or breast-plate. "For iij curats without hedpiceys, xxxs.," occurs in an account of payments at Norwich in 1588. ('Norfolk Archæology,' vol. i.)

CURTANA. The name of the principal of the three swords which, independently of the sword of State, are borne before the sovereigns of England at their coronation, and known as "the Sword of Mercy." It is a flat sword without point, the end of the blade being square. The origin of the name is at present unknown, though obviously suggestive of shortness; but the existence of a sword so named, and carried by a nobleman of the highest rank on such occasions, can be clearly traced to the accession of Henry III., at whose coronation, A.D. 1236, it was borne by the Earl of Chester, and described by Matthew Paris as the sword of St. Edward : "Comite Cestriæ *gladium S. Edwardi* qui *curtem* dicitur ante regem bajulante."

It may, therefore, be fairly presumed that the sword had been borne before the preceding kings of England from the time of the Confessor, who, as we have seen under CROWN, entrusted the whole

of the regalia to the custody of the abbot and monks of Westminster. The sword called St. Edward's may, consequently, have been as old as the crown so named, which I have given my reasons for presuming was actually Alfred's (see p. 150 *ante*). We hear of the curtana again, as being borne by the Earl of Lancaster at the coronation of Edward II. : "Et gladium qui vocatur curtana portavit Comes Lancastriæ." (Rot. Claus. 1st Ed. II. : Rymer, Fœd., vol. iii. p. 63, A.D. 1308.)

It is mentioned again in the 'Liber Regalis,' amongst the claims of service for the coronation of Richard II., and also at the time of Henry IV. (Chron. Rishanger, Cotton. MS. Faust. B ix.) In the wardrobe account for the year 1483, first of Richard III., we find, "iij swerdes, whereof oon with a flat poynte, called curtana." And thenceforth it is named in all accounts of coronations. On the deposition of Charles I. the regalia was removed from Westminster to the Tower, and an inventory taken 13th, 14th, and 15th August, 1649. The crowns, sceptres, &c., were, by order of Parliament, "totallie broken and defaced;" but amongst some old and worthless articles left at Westminster, "in an iron chest where they were formerly kept," were "three swords with scabbards of cloth of gold," valued at one pound each. What became of them has not transpired, but they certainly were not those carried at the coronation of Charles II., or they would still be in existence, and the curtana of to-day, whenever made, cannot lay claim to any great antiquity.

CUT-WORK. (*Opus cissum*, Latin ; *punto tagliato*, Italian ; *point coupée*, French.) A very early sort of lace, deriving its name from the mode of its manufacture, the fine cloth on which the pattern was worked with a needle being cut away, leaving the design perfect. It is supposed to have been identical with what was known as Greek work, and made by the nuns in Italy in the twelfth century. It does not appear, however, to have been known in England before the reign of Elizabeth, as the "cut-work" of which we hear in the time of Richard II. signified the edges or borders of the gowns, tunics, hoods, and every kind of garment cut into fanciful shapes, which were so greatly the fashion in the fourteenth and fifteenth centuries, and, in the reigns of Henry VII. and Henry VIII., was the name given to the dagging, pouncing, and slashing of the doublets and hose, so familiar to us in the portraits of that period, and to the extravagant taste for which the unfortunate shoemaker of Norwich was, by his vanity, made a victim. (See DAGGES.) The lace called "cut-work" is first mentioned amongst the New Year's gifts to Queen Elizabeth, and in the wardrobe accounts it is described as of Italian and Flemish manufacture ; the former being the most expensive, either on account of its rarity or of the superiority of its execution. "One yard of double Italian cut-work, a quarter of a yard wide, 55s. 4d." "For one yard of double Flanders cut-work, worked with Italian purl, 33s. 4d." (Great Wardrobe Account, 33rd and 34th Elizabeth.)

Under the date of January 1, 1577–78, are entries of a night-coif of white cut-work, flourished with silver and set with spangles, the gift of Lady Ratcliffe ; a suit of ruffs of cut-work, by Sir Philip Sidney, and various other articles for the toilet by less distinguished personages. Cut-work continued in fashion during the reigns of James I. and Charles I., by which time it was made in England, for in 1635, by a royal proclamation, having for its object the protection of home fabrics, the use of foreign purles, cut-works, or bone laces, or any commodities laced or edged therewith, is strictly prohibited, and all purles, cut-works, and bone laces, English made, are ordered to be taken to a house near the sign of the "Red Hart," in Fore Street without Cripplegate, and there sealed by Thomas Smith or his deputy. (Rymer's ' Fœdera.')

> "This comes of wearing
> Scarlet, gold lace, and cut-works."
> Ben Jonson, *The Devil is an Ass*, 1616.

> "She showed me gowns and head-tires,
> Embroidered waistcoats, smocks seamed thro' with cut-works."
> Beaumont and Fletcher, *Four Plays in One*, 1647.

Cut-work, as well as laces of all descriptions, fell under the ban of the Puritans, and after that period it is rarely heard of. (See LACE.)

CUTLASS. The name of this weapon, familiar to us at the present day, appears to have been gradually corrupted from its original appellation in the fifteenth century, when it is first met with in the form of coutel-hache, to coutel-axe, cuttle-axe, curtle-axe, and coutelace. In the Meyrick

Cutlass. 16th century. Meyrick Collection.

Collection were two specimens, one of the reign of Henry VI., and the other, with an Andrea Ferrara blade, of the commencement of the sixteenth century. Both have fortunately been engraved by Skelton, and copied for this work. A third, engraved by M. Demmin, absurdly called "British,"

Cutlass. *Temp.* Henry VI. Meyrick Collection.

The Apostle Peter. From a rare engraving. 1598.

Cutlass, or Coutel. 16th century. From Demmin.

but attributed by him to the time of Edward II., having the words "Edwardus" and "prins agile" (*sic*) on the blade, which do not appear in his woodcut, I give here upon his authority. I am inclined, however, to consider it a coutel of the sixteenth century, requesting the reader to compare it with one in the hand of the Apostle Peter, from a rare engraving representing the betrayal of Christ, with the monogram of Henry Goltzius, and the date 1598.

CYCLAS, CICLATON, CINGLATON, SYGLATON. A garment made of a rich stuff or silk, manufactured in the Cyclades, according to Guillaume le Breton: "Stamina Phœnicum, serum, Cycladumque labores." (Philippid. lib. 9.) It was worn by both sexes, and known in Germany in 1083, when we are told that Judith, daughter of Wenceslaus, King of Bohemia, wore a cyclas resembling a dalmatie ("instar Dalmaticæ"), embroidered or interwoven with gold, and a mantle of similar embroidery. ('Monachus Pegaviensis,' *sub anno* 1096.) We first hear of it in England when, at the coronation of Henry III. and his queen, the citizens of London who attended the ceremony wore cyclades worked with gold, over vestments of silk: "Sericis vestimenti ornati cycladibus auro textis circumdata." (Matthew Paris, 'Hist. Major,' *sub anno* 1236.) Mr. Giles, in his translation

of this passage, renders *cycladibus* "mantles." Surcoats, worn by knights over their armour in the thirteenth century, were also called 'cyclasses or syglatons, another form of the word :

> "Armez d'un haubergeon,
> Couvert d'un singlaton."

Some authors have imagined that the surcoat of the fourteenth century which is cut away in front, and called "the uneven surcoat" by Mr. Hewitt, is the cyclas; but I am not aware of any authority that would justify me in adopting the opinion of any writer who has ventured to describe it.

> "Varacher fait despoiller environ
> Paris revetir d'un riche syglaton."
> *Macavie*, 13th century, v. 2527.

In the 'Roman de Gaydon,' a work of the same period, we find that the stuff itself was used for the making of standards :

> "Brandit la haute don verneil syglaton."—v. 10095.

And also mantles :

> "Et bon mantiaus forrez de syglatons."—Ibid., v. 100155.

That is, I take it, not furred *with* syglaton ; but furred mantles *of* syglaton.

Spanish syglatons, "des siglatons d'Espagnes," are mentioned amongst costly presents in 'Le Roman d'Alexandre,' also a work of the thirteenth century ; but whether vestments of Spanish make and fashion, or the material itself of Spanish manufacture, is open to argument. My own opinion is in favour of the latter interpretation. (See SURCOAT.)

CYPRUS, CYPRESS, SIPERS. A thin gauzy stuff fabricated in the island of Cyprus, or imported from thence, whence its name. It was much used for ladies' veils, and for mourning attire generally. Autolycus, the pedlar, in Shakespere's 'Winter's Tale,' includes amongst his wares :

> "Cyprus black as e'er was crow."—Act iv. scene 3.

In an old church inventory, mention is made of

> "A pyx cloth of sipers fringed with grene silke and red."
> Pugin's *Glossary*, p. 71.

When Anne Bullen, at that time Countess of Pembroke, danced with Francis I. at Calais, attended by seven other ladies in costly and quaint masking attire, they were brought into the chamber "by four damsels in crimson satin with tabards of fine cypress." (Cavendish's 'Life of Wolsey.') No colour is mentioned, but it could scarcely be black.

CZAR. In an inventory in my possession, superscribed "An Account of my Cousin Archer's Clothes," written in 1707, is the following entry :—"2 neckcloths, 1 czar." I have never seen the mention of such an article elsewhere, and can but presume it was some kind of cravat, so named after Peter the Great, who had visited England in 1698, and was a most important personage at the beginning of the following century.

 AG, DAGG, TACK. A pistol so called, varying only from the ordinary firearm in the shape of the butt end, that of the latter terminating in a knob like the pommel of a sword-hilt, while the dag had a butt like that of a musquet. Such distinction is, however, unnoticed by Mr. Hewitt and M. Demmin, the latter not even naming the dag ; and Sir Samuel Meyrick, to whom it is due, does not quote any authority for his opinion, which may possibly have been founded simply on his own observation, not to be lightly disregarded.

The earliest mention I have found of it is in an inventory, taken in 1547, of stores in the different arsenals in England, wherein are the following curious entries :—"One dagge with two pieces in one stock. Two *tackes after the fashion of a dagger*, with *fier locks*, varnished, with redde stocks, shethes covered with black vellet (velvet), garnished with silver and guilt, with powder flaskes and touch boxes of black vellet, garnished with iron guilt. Two tackes *hafted like a knyff*, with *fier locks* and doble locks."

Wheel-lock Dag. *Temp.* Edward VI. Meyrick Collection.

That it was only another name for a pistol, howsoever derived, is evident from the many passages in old plays and entries in inventories in which it appears. In the Instructions of the Privy Council to the citizens of Norwich in 1584, it is suggested that the light horseman shall be furnished with "a case of pistols," which is subsequently called "a case of daggs." ('Norfolk Archæology,' vol. i.) In an inventory of the date of 1603 is an entry of "two little pocket dagges." (Gage's 'Antiquities of Hengrave,' p. 30.) The following quotations from old plays and works of the seventeenth century have been collected by Mr. Fairholt.

In the 'Spanish Tragedy,' 1603, one of the characters about to slay another "shoots the dag," and the watch enter, exclaiming, " Hark, gentlemen ! This is a pistol shot ! "

> " He would show me how to hold the dagge,
> To draw the cock, to charge and set the flint."
> *Jack Drum's Entertainment*, 1616.

> " My dagge was levelled at his heart."
> *Arden of Faversham.*

" The Prince yet always bare himself so wisely that he could not without some stir be thrust down openly ; and riding on his journey, he was once shot with a dagge secretly." (Ascham's Works, by Bennet, p. 21.)

To these may be added one from ' Love's Cure, or the Martial Maid :'

> " What do you call this gun ?—a dag?
> CLARA. I'll give thee a French petronel."—Act ii. sc. 2.

The Scotch called it a *tack*. The stocks of the Highland tacks were generally of iron or brass, sometimes inlaid with silver. In the Meyrick Collection there was a brace of Highland tacks, dated 1626, with slender barrels, which, as well as the stocks, were wholly of brass. (Skelton's engraved specimens.) The subjoined examples are also copied from Skelton, the first two being wheel-lock dags of the time of Elizabeth, and the third a Highland firelock tack of the time of George II., the stock of iron inlaid with silver. The little knob between the scroll ends of the butt is the head of a picker which screws into it.

1, 2. Wheel-lock Dags. *Temp.* Elizabeth.
3. Highland Firelock Tack. *Temp.* George II.

Sir Samuel Meyrick remarks on this subject: "Strange as it may seem that the word 'dag' should signify a firearm and not a dagger, like the French *dague*, yet in the Italian language *pistolese* implies a great dagger or wood-knife. See Florio, 1st and 2nd edition." ('Critical Inquiry into Antient Armour,' vol. iii. p. 6, note); and therein we undoubtedly find "Pistola, a dag or pistol;" "Pistolese, a great dagger, a wood-knife." The fact is pregnant with interest to the etymologist as well as to the antiquary, taken in conjunction also with the entries in the inventory of 1547, "Two tacks after the fashion of a dagger," and "Two tacks hafted like a knife," which increase the complication. (See PISTOL.) Other derivations are suggested from the Hebrew *douack* (*acuere*), and from *dacia*, the latter extremely curious and well deserving attention.

DAGGER. (*Dague*, French; *daga*, Italian and Spanish; *duger* or *dage*, Teuton; *dagh*, Welsh; *dolch*, German.) M. Demmin derives this word from the Celtic *dag*, a point. ('Weapons of War.') The dagger is one of the earliest of all offensive weapons, by whatever name it might be known. Examples have been found of the flint and the bronze period. The parazonium of the Greeks and Romans; the sica or hand-seax of the Anglo-Saxons; the scramasax of the Germans; the skeine of the ancient Irish; the bidag or dirk of the Scotch Highlanders; the dague, poignard, or miséricorde of the French; the stiletto of the Italians—are all varieties of the same arm; the war-knife or coutel of the common soldiery being the immediate predecessor of the dagger in England, or rather one and the same weapon under another name. Thus we find in a statute of William, King of Scotland (*circa* 1180), "Habeat equum, habergeon, capitium et ferro et *cultellum qui dicitur dagger;*" and Thomas Walsingham, a historian of the fifteenth century, says (page 254), "Mox extracto *cultello quem dagger vulgo dicitur,*" showing that, as late even as his day, the coutel and the dagger were identical. Henry Knighton also, commenting on the appearance of ladies at a tournament in very masculine attire, tells us they wore "*cultellos quos daggerios vulgariter dicunt,* in pouchiis desuper impositis." ('De eventibus Angliæ,' *sub anno* 1348.) Ducange (*in voce* DAGGER), quoting from an ancient Latin Chronicle, shows that it was considered identical with the sica: "Habens sicam vel daggam ut latus." "Dague de Praguerie" occurs in a French work also quoted by the same author; but whether of Prague manufacture, or of a peculiar form, does not appear. It is in the fourteenth century that the dagger is first seen as a constant appendage to the belt of the knight, or the girdles of the civilians, the latter of whom generally wore it stuck in their purses or pouches—"in pouchiis impositis," as described by Knighton. Illustrations of this fashion are numerous in miniatures of the fifteenth century (see

1. Dagger, from Effigy in Hereford Cathedral.—2. Miséricorde, temp. Ed. III.—3. Dagger, Hen. VI.—4. Dagger, Ed. IV.—5. Dagger, Hen. VII.—6, 7. Daggers, Ed. VI.—8, 9. Daggers, Q. Eliz.—10. Dagger, Chas. I.—11. Miséricorde, Ed. IV.—12. Miséricorde, Hen. VIII.—13. Miséricorde, Ed. VI.—14. Miséricorde, Q. Mary.—15. Miséricorde, Q. Eliz.—16, 17. Spanish Stillettes, 16th cent.—18, 19. Hilts of Florentine Poignards, same period.

woodcuts below). The accompanying plate contains specimens of daggers from the reign of Edward III. to that of Charles I.; all, with the exception of the one from the effigy of a supposed De Bohun in Hereford Cathedral, are copied from Skelton's accurate engravings of the originals in the Meyrick Collection: but we subjoin woodcuts of daggers from knightly effigies of the fourteenth and fifteenth centuries in further illustration; and for the mode of wearing them by men in armour of that time, refer the reader to BELT (MILITARY) and Plate IV.

That daggers differed considerably in length is sufficiently evident from our plate; and we find them specified as long and short by various writers: "*Longum* daggarum suum extraxit;" "A son costé chascun la *courte* dague;" "La *courte* dague pour son homme aborder." (*Vide* Ducange, *in voce* DAGGER.) The long tapering three-sided dagger, called a "miséricorde," formed expressly to pierce

Daggers. From effigies of the 14th and 15th centuries.

the joints of the armour of a fallen foe, and so called from the *coup de grâce* it gave, or, as some suggest, the cry for mercy it extorted, was known by that name as early as the thirteenth century in France and England. Mention is made of it in the charter of Arras, in 1221: "Quicumque cultellum cum cuspide, vel curtam sphatulam vel *misericordiam*," &c.; and at the commencement of the fourteenth century the allusions to it are numerous: Jean de Meun, in his continuation of the 'Roman de la Rose,' actually describing Pity with a miséricorde in her hand, one could almost suppose satirically suggesting that she evinced her compassion for the suffering by putting them out of their misery.

"Pitié, qui à tout bien s'accorde,
 Tenoit une miséricorde,
 En lieu despée, en piteux termes
 Decourant de plors e de larmes."—l. 16214.

Mr. Albert Way, in his Glossary appended to the second edition of Meyrick's 'Critical Inquiry,' quotes a letter dated 1375, in which occurs the following passage:—"Garni et premuni d'une grant coutille ou miséricorde."

Plate VII. contains examples of miséricordes from the reign of Edward III. to that of Charles I., all from originals in the Meyrick Collection. Daggers were not only worn stuck through their pouches

Roman de la Rose. MS. 15th century.

MSS. in the Doucean Collection, Bodleian Library, Oxford.

by persons in civil attire, but slung by laces or belts over the shoulder, or suspended from the girdle. (See cuts annexed, and figures of Henry VIII. and of Henry, Earl of Surrey, after portraits by Holbein, at p. 107 *ante*.)

In the reign of Elizabeth the dagger was almost always worn behind, the hilt just sufficiently projecting to be readily grasped by the right hand. Daggers of this period are occasionally seen combined with a pistol (*vide* Plate VII., fig. 9).

Before the close of the seventeenth century the dagger had ceased to be the weapon of anyone but an assassin in England. In Scotland, however, under the name of bidag or dirk, it remains to the

Scottish Dagger, 14¼ inches. From Count of Nieuwerke's Collection.

Iron Dagger, Scottish. From Prince Charles of Prussia's Collection.

Scotch Dirks or Bidags.

present day an indispensable portion of the full equipment of a Highland chieftain, and, under the latter name, exists in the side-arm of a midshipman in the Royal Navy.

For the Irish dagger see SKEINE.

DAGGES. A term applied to the fantastic cutting and slashing of garments or the borders of them. The fashion appears as early as the reign of Henry I., and was carried to such an excess that

Dagged Dress of a Minstrel. *Temp.* Edward I.
Sloane MS., No. 2983.

sumptuary laws were fruitlessly enacted forbidding it, as early as the year 1188. In 1407, eighth of Henry IV., it was ordained that no man, let his condition be what it might, should be permitted to wear a gown or garment cut or slashed into pieces in the form of letters, rose-leaves, and posies of various kinds, or any such like devices, under the penalty of forfeiting the same, and that no tailor should presume to make such a gown or garment under the pain of imprisonment and fine, and his liberation depended on the king's pleasure.

I have already, under the head of COINTISE, pointed out the allusion to the fashion in the 'Roman de la Rose,' and quoted Chaucer's translation of the passage. In the 'Parson's Tale,' the latter writer speaks of "the waste of cloth in vanity:" "So much pounsenen of chesel to make holes, so much *daggen* of sheres;" and adds that even "if they wolden give such pounsened and *dagged* clothing to the poure people, it is not convenient to wear for their estate." Another contemporary poet censures the clergy for not preaching against these fashions :—

"For wolde they blame the barnas
That brought new gysis
And drive out the *dagges*,
And all the Dutch cotes."
Alliterative Poem on the Deposition of Richard II. : Camden Society.

It is not clear whether by "*Dutch* cotes" the author means that they were made after the fashion prevalent in Holland at that period, or introduced from Germany (Deutschland), as we learn that Henry, Duke of Lancaster, on his return to England, was attired in "a courte jacques a la fachon d'Almayne." I shall show, in the General History, how prevalent this fashion was throughout Europe in the fourteenth and fifteenth centuries. Harding, in his Chronicle, who tells us he received his information from Robert Ireleffe, who was Clerk of the Green Cloth to Richard II., says,—

"Cut worke* was great both in court and townes,
Bothe in men's hoodes and also in their gownes."

* Not to be confounded with the lace so called in the sixteenth century. (See under LACE.)

The 'Metrical History of the Deposition of Richard II.' (Harleian MS., No. 1319) contains, amongst many interesting illuminations, one representing the author, Jehan Creton, presenting his book to the Gascon knight who had requested him to accompany him to England. The gown and hood of the knight afford us an example of the cut-work of that period, the edges of the former being cut into long lobes, and those of the chaperon into the shape of rose-leaves. The gown of the poet also has its edges similarly indented.

Knight and Poet. *Temp.* Richard II. Harleian MS., No. 1319.

Henry V. From Arundel MS., No. 38.

Dagged Dress. *Temp.* Henry VI.
Harleian MS., No. 2278.

Dagged Dress. *Temp.* Henry VI.
Harleian MS., No. 2278.

Knight. 15th century.
University Library, Wurzburg.

In an illumination representing Occleve presenting his book to Henry V., in a MS. in the Arundel Collection, British Museum, marked 38, the king is dressed in a blue gown, the ample sleeves of which are lined with ermine and have escalloped edges.

Undeterred by the penal enactments of the previous reign which were still in force, the fashion of slashing, pouncing, dagging, indenting, &c., continued to rage both in England and on the Continent to the middle of the seventeenth century. An

illumination in a MS. copy of 'The Life of St. Edmund,' by Lydgate (Harleian Collection, No. 2278), *temp.* Henry VI., supplies us with several absurdly extravagant specimens. (See also woodcuts, page 163 *ante.*)

Not only the civil but the military classes were fascinated by this caprice. The borders of the cloaks worn over their armour, and of the sleeves of the doublet worn under it, are "slittered" and jagged unmercifully. The cloak of the Earl of Salisbury (page 104 *ante*) is very modestly escalloped; but the sleeves of a knight copied by Hæfner from a miniature in the University Library at Wurzburg, are actually cut into jagged strips. The magnificent copy of the 'Roman de la Rose' which has already furnished us with so much illustration, gives us the dress of a minstrel whose large sleeves have their

Minstrel. From 'Roman de la Rose.'

edges cut into the long lobes we have seen in the dress of the knight of Gascony and of Jehan Creton. So many examples will be found amongst our illustrations of other subjects, and especially in the General History, that it is unnecessary to multiply them here. At the end of the fifteenth century dagging and slashing was transferred from the edges to the body of the garment. Camden tells an amusing story of Sir Philip Calthrop, in the time of King Henry VIII. "This knight bought on a time as much fine French tawney cloath as should make him a gown, and sent it to his taylour's (in Norwich), to be made. John Drakes, a shoemaker of that town, coming to the same taylour's, and seeing the knight's gown cloath lying there, liking it well, caused the taylour to buy him as much of the same cloth and price, to the same intent; and further bad him to make it in the same fashion that the knight would have his made of. Not long after, the knight coming to the taylour's to take measure of his gown, perceveth the like gown cloth lying there, asked of the taylour whose it was. Quoth the taylour, 'It is John Drakes', who will have it made of the self same fashion that yours is made of.' 'Well,' said the knight, 'in good time be it; I will,' said he, 'have mine made as full of cuts as thy sheers can make it.' 'It shall be done,' said the taylour. Whereupon, because the time drew near, he made haste of both their garments. John Drakes had no time to goe to the taylour's till Christmas day, for serving of customers, when he had hoped to have worn his gown; perceiving the same to be full of cuts, began to swear with the taylour, for the making his gown after that sort. 'I have done nothing,' quoth the taylour, 'but that you bad me; for as Sir Philip Calthrop's is, even so have I made your's.' 'By my latchet,' quoth John Drakes, 'I will never wear gentleman's fashion again.'"

I shall revert to this story under the head of GOWN; but must say a few words respecting the derivation of "dag." In the 'Promptorium Parvulorum' we find, "DAGGE *of clothe, fractillus;*" "DAGGYDE, *fractillosus;*" "DAGGYN, *fractillo;*"—the Low-Latin translation corresponding with that of the Anglo-Saxon "DAG, anything that is loose, dagling, danglen:" and Mr. Albert Way, in his note (p. 112), observes that "Chaucer uses the diminutive *dagon.* Thus, in the 'Sompnoure's Tale,' the importunate friar who went from house to house to collect anything he could lay hands on, craves, 'A dagon of your blanket, leve dame;' daggesweyne being the name for a bed-covering, or a garment formed of frieze, or some material with long thrums, like a carpet." Horman says, "My bed is covered with a daggeswaine and a quilt. Some dagswaynys have long thrumys (*fractillos*) and *iagg,* on bothe sydes; some but on one;" and Andrew Borde, 'Introduction of Knowlege,' 1542, puts the following speech into the mouths of the Fryslanders:—

"And symple rayment doth serve us full well;
With dagswaynes and roudges [ruggs] we be content."

That the derivation from the Saxon "dag," in the sense of "loose, dangling," is justified by the above quotations, I do not deny; but "dagging of shears" implies cutting or piercing, and must

surely be derived from the same source as dagger—a weapon that *dags*, i.e. cuts and stabs; and a pistol might also be called a dag, because the ball it projects pierces the object at which it is fired, as we have already seen under DAG, that a great dagger is called in Italian "pistolese." "To dag sheep, is to cut off the skirts of the fleece," and "Dag locks (of *dag*, Saxon), the wool so cut off." (Baily.) Jag is but another form of the word: "Jagge or dagge of a garment;" "Jaggyd or daggyd." (Promp. Parv. *ut supra*.) "He hath a pleasure in geagged garments." (Horman.) "I iagge or cutte a garment." (Palsgrave.) Let me not, however, lose myself and my reader in the seductive but bewildering mazes of etymology.

DALMATIC. A long robe or super-tunic, partly open at the sides, so named from its being of Dalmatian origin (Durandus, lib. iii. cap. 11); an ecclesiastical vestment, and also a portion of the coronation robes of sovereign princes. It was usually composed of white silk with purple stripes: "Vestis sacerdotalis candida cum clavis purpureis;" the sleeves larger and longer than those of the tunic, the left sleeve being ornamented with fringe or tassels, and the right made plain for the sake of convenience. (Ducange, *sub voce* DALMATICA; and Pugin, Glossary, p. 103.) The colour appears, however, to have been arbitrary, for we find them of purple, crimson, blue, gold tissue, and covered with costly embroidery.

When the body of St. Cuthbert, Bishop of Lindisfarne, who died in 689, was disinterred in 1004, it is recorded that among the other episcopal vestments in which he had been buried, was found his dalmatic of purple.

In the inventory of old St. Paul's Cathedral are the following entries:—"Item, tunica et dalmatica de *rubeo* sameto, cum strieto aurifrigeo, cum borduris in posteriore parti et floris cum capitibus draconum de auro. . . . Item, tunica et dalmatica *indici* coloris, Henrici de Wengham, cum tribus aurifrigiis et listo in scapulis ante et nigro, diversi operis. . . . Dalmatica virgulata albo et nigro cum bullonibus de margaritis," and several others of white and blue baldekin, richly embroidered with birds in gold, and various devices. (Dugdale's 'History of St. Paul's.') Alcuin (Lib. de divin. Offic.) says that the dalmatic was introduced by St. Silvester, A.D. 314–335; but though, as Mr. Pugin observes, the more general use of it may have been established by that pope, we read long before in the 'Life of St. Cyprian, Bishop of Carthage,' by Pontius, A.D. 258, that, "when he had *put off from him his dalmatic*, and given it to his deacons, he stood in his linen (alb):" "Et cum se dalmatica exspoliasset (Cyprianus) et diaconibus tradidisset in linea stetit." It was anciently the custom for the pope to confer the use of the dalmatic as a privilege on bishops, who granted it in turn to their deacons. According to Georgius, the dalmatic was at one time proper only to the deacons of Rome, and conceded gradually to deacons generally. As late as St. Cuthbert's time, instances occur of popes granting the use of the dalmatic to the clergy of different places.

As long as the old Gallican Litany was kept up—that is, to the time of Hadrian or Adrian I., A.D. 772–795—when Charlemagne introduced the Roman rite in lieu of it, the French deacons did not wear dalmatics, but were vested in alb and stole only. They then came into general use, the Emperor himself presenting many dalmatics to different churches. Shortly afterwards, many priests assumed the use of the dalmatic under the chasuble, after the manner of bishops; but the practice was not sanctioned by authority. Later the privilege of wearing the tunic and dalmatic under the chasuble was granted to abbots, and finally conceded to kings and emperors, both at their coronation and when assisting at High Mass. (Pugin, *ut supra*.)

The frontispiece to an Anglo-Saxon MS. of the tenth or eleventh century, 'Abbot Elfnoth's Book of Prayers' (Harleian MS., No. 2908), representing him offering his book to St. Augustine, depicts both the abbot and the archbishop in the dalmatic beneath the chasuble, with double stripes and a peculiar ornamentation, which can only be described by the pencil. It is remarkable that in the Bayeux Tapestry the priesthood are undistinguished by any clerical costume, and that Archbishop Stigand wears the stole and the chasuble over a long tunic reaching to the feet, which bears no resemblance whatever to the dalmatic (*vide* page 93). A similar remark may be made respecting the figure of Bishop Odo on his seal, engraved on the same page, which represents him with the chasuble and long tunic

Abbot Elfnoth and St. Augustine. Harleian MS., No. 2908.

Consecration of St. Guthlac by Hedda, Bishop of Winchester. Harleian Charters, Y 6.

English Deacon in Dalmatic. From Pugin's
Glossary.

only, no dalmatic or stole being indicated. An early and unmistakable appearance of the dalmatic occurs in the figure of the bishop on the same page, from a MS. of the twelfth century, who is attired in a complete suit of vestments—chasuble, dalmatic, stole, tunic, and alb ; the dalmatic being decorated and bordered with orphreys and arched at the sides. In the figure of an archbishop (page 149) from a drawing of the latter end of the twelfth century, the dalmatic in its more familiar form is clearly depicted, and also in the consecration of St. Guthlac, by Bishop Hedda, of Winchester, from a MS. of the same period. (See foot of last page.) In neither of these examples is the stole visible.

The dalmatic is mentioned very early amongst the coronation robes of the kings of England. In the account of the coronation of Richard I., " primo tunica deinde dalmatica." The dalmatic of King John was of a dark purple colour, " nigra purpura." (Patent Roll, 9th John.) Walsingham, in his account of the coronation of Richard II., says that the king was first invested with the tunic of St. Edward, and then with the dalmatic. Being worn over the tunic, it is frequently called a super-tunic, and also a tunic simply, as in point of fact it was. Henry VI. is said to have been attired, at his coronation, " as a bishop that should sing mass, with a dalmatic *like a tunic*, and a stole about his neck." (MS. W Y, College of Arms.) How Mr. Taylor, in his ' Glory of Regality,' could describe the dalmatic as an " open pall, which is a three-cornered mantle in fashion of a cope," having himself quoted the above plain statement from the same MS. in the College of Arms, I am at a loss to imagine. He could scarcely be misled by the absurd blunder in Sandford's ' History of the Coronation of James II.,' which has been pointed out by Mr. Pugin. The true form of the dalmatic is given at the foot of last page, from the careful drawings of the latter gentleman.

DAMASK. A rich description of figured satin or linen, receiving its name from the city of Damascus, where it is presumed to have been first manufactured. It was known in England in the thirteenth century. In a romance of that period, ' The Squire of Low Degree,' we read of

> " Damask white and azure blewe,
> Well diapered with lillies new."

A gown of purple *capah* damask, whatever that may be, is mentioned in an inventory of the apparel of Henry VIII. (Harleian MS., No. 2284.) It is presumable, from many indications, that the peculiarity distinguishing the manufacture was the pattern and not the stuff itself. Damascus was equally celebrated for its art in metallurgy, and particularly for the ornamentation of sword-blades and other articles of steel by inlaying them with gold and silver. " To damask," therefore, became a familiar phrase. " Damasquiner, to worke in damaske worke ; to flourish, carve, or engrave damaske worke." (Cotgrave.) (See DIAPER.)

DEMI-BRASSARTS. Half armour for the arm, as the name implies ; but it is not clear what particular portion. (See BRASSART.)

DEMI-HAG or *HAQUE.* A smaller sort of haquebutt. (See HAQUEBUTT.) In an inventory of arms taken 1st Edward VI., 1547 (Lib. Soc. Ant.), occurs " Demy-hackes stocked."

DEMI-JAMBES. Armour for the front of the legs only. (See JAMBES.)

DEMI-PLACCATE. (See PLAC-CATE.)

Demi-hag. Meyrick Collection.

DIAPER. A fine species of linen, the manufacture of the city of Ypres (Anderson, ' History of Commerce '), equally celebrated with Damascus for its productions of the loom. The cloth of

Ypres (d'ypres) was highly estimated in England as early as the thirteenth century; and Chaucer, speaking of the Wife of Bath, tells us—

> "Of cloth making she had such an haunt,
> She passed hem of Ypres and of Gaunte."
> *Prologue to Canterbury Tales.*

The peculiarity of the cloth of Ypres was, like that of Damascus, in the pattern, as the term "to diaper" is still in heraldry employed to signify the covering of the field of an escutcheon with scroll or lattice-work, flowers, or other devices, independently of the armorial bearings. "Diapering is a term in drawing. It chiefly serveth to counterfeit cloth of gold, silver, *damask*, brancht velvet, camblets, &c." (Peacham, 'Compleat Gentleman,' p. 345.) Cloths so woven in ornamental patterns were, therefore, called diapers. Thus in the 'Roman de Gaydon' we read of a knight attired in his "cote à armer d'un diaspre gaydi," *i.e.* his armorial bearings were embroidered on a surcoat of diaper, as another might have displayed his on a surcoat of damask. See, for instance, the annexed engraving of the shield of Robert de Vere, Earl of Oxford, *obiit* 1221, from his effigy formerly at

Shield of Robert de Vere.

Earle's Colne Priory, Essex. The fleur-de-lys and roses in frets and circles are a floral pattern or diapering, and not a quarter of France, as blazoned by Vincent, or an heraldic difference. Another example is afforded to us by the painted windows at Tewkesbury, where the three clarions *or* are placed on a field *gules*, diapered with flowers in circles, thus sufficiently illustrating the lines from 'The Squire of Low Degree,' quoted above, wherein the "damask white and blue" is described as "diapered with lillies new;" that is to say, covered all over with a pattern of lilies in the style of the cloth made at Ypres. In the same manner, Damascus itself having obtained a reputation for its manufactures, which, as I have stated above, had originated the term "to damask," damasks of Ypres might have been spoken of with the same propriety as diapers of Damascus, or,

Diaper Surcoat. Tewkesbury.

as we find in fact, diapers of Antioch ("Dyapres d'Antioch"), mentioned in the 'Roman Alexandre,' written about 1203. (MS. Bodleian Lib. 264.)

It is necessary, however, to observe that some glossarists derive the word diaper from the Italian *diaspro* (jaspis), the jasper, which it was supposed to resemble from its shifting lights. "Variegatus, diversicolor, instar jaspidis." (Ducange, *in voce.*) Nevertheless, I incline to the former opinion.

DIRK. See DAGGER.

DOSSUS. From *dos*, French, being the fur from the back of the squirrel: "Dos de l'écureuil du Nord"—the same as the fur called *petit gris*, much esteemed in the Middle Ages. (Quicherat, 'Histoire du Costume en France.' 8vo, Paris, 1875, p. 141.) The allusions to it under its French name are numberless. (See GRIS.)

DOMINO. "A kind of hood or habit for the head worn by canons, and hence, also, a fashion of a veil used by some women that mourn." (Cotgrave.)

"A hood worn by canons, also a woman's mourning veil." ('Ladies' Dict.') It appears, how-

ever, in Italy as a masquerade dress as early as the sixteenth century. (See Vecellio, 'Habiti Antichi,' and Bertelli, 'Divers. Nat. Habitus.')

DOUBLET. This article of apparel, though deriving its appellation from the French *doublée* (lined), is, in that language, more generally known by the name of *pourpoint*, of which, in fact, it was merely a variety. The term *doblet*, or *doublet*, occurs in French documents of the fourteenth century, the period when it at first appears in England. It is not observable in the civil costume of this country before the middle of the following century, when, in the reign of Edward IV., it is frequently mentioned in the wardrobe accounts and inventories. Mr. Strutt says, "In its original state, the doublet had no sleeves ; but to render it more convenient the sleeves were afterwards added, and at length it became a common garment, and being universally adopted, it superseded the tunic. As the form and adjustments of this vestment were continually altering, it required many denominations to distinguish them from each other ; in the end it lost its own name, and the waistcoat became its substitute." ('Dress and Habits,' vol. ii., Part v.) He qualifies the latter statement in the following page, by remarking, "That does not, however, appear to have been the case till such time as the latter appellation was totally dropped, for the waistcoat was a garment used at the same time that the doublet was in fashion," and, as he correctly adds, "was worn under it." (See WAISTCOAT.)

In an inventory of the wardrobe of Edward IV. (MS. Harl., No. 4780) occurs, "Item, a doublet of crymosyn velvet, lined with holland cloth, and interlined with busk." The price charged by the tailor for making doublets for the use of the king, and finding the linings for the same, was six shillings and eightpence each.

In the third, and again in the twenty-second year of that king's reign, Acts of Parliament were passed, in which doublets are specially alluded to. Yeomen and all persons of inferior degrees were forbidden to stuff their doublets with wool, cotton or caddis ; and no knight under the rank of a lord, no esquire, gentleman, or other person, was permitted to wear the extremely short gowns, jackets, cloaks, and doublets which had come into fashion, and excited the anger of the clergy and the satire of the poets and the annalists : and if any tailor made such garments, contrary to the provisions of the Act, the same were to be forfeited.

Monstrelet, writing at this period, brings the same complaints against the fashions in France, which had no doubt originated those in England. "The jackets, pourpoints (or doublets)," he tells us, "were cut shorter than ever, and the sleeves of them slit so as to show their large, loose, white shirts ; the shoulders were padded out with large waddings called 'mahoitres ;' and so capricious were the beaux of the period, that he who to-day was shortly clothed, was habited to-morrow down to the ground." That is, they wore long gowns over their doublets, the upper portion of which was disclosed by the broad collars, generally of fur, rolled back over the shoulders. See GOWN.

It is difficult to distinguish the pourpoint, or doublet, from the jacket, at this period. I believe, however, that the doublet was originally an under-garment, and the jacket or jerkin always an outer one. Subjoined are figures of gallants of the times of Edward IV. and of Henry VII. in short dresses, some terminating even at the waist, and others but little below it, which, with their sleeves slit at the elbows so as to show their white shirts, appear to illustrate the description of the French chronicler. I must specially call the attention of the student to the plaiting of the backs and

Doublet. *Temp.* Edward IV.

little skirts of these doublets (if doublets they be), and point out how faithfully they are represented in the steel back-plates of this period, an example of which is engraved at page 54 *ante.*

Doublet. *Temp*. Henry VII.

Doublet. *Temp*. Henry VII.

Amongst the articles of apparel ordered for the young Prince Edward (by right Edward V.), to wear at the coronation of his usurping uncle Richard III., was a stomacher and doublet of black satin;

Doublet. Early 16th century.

Doublet. *Temp*. Elizabeth. From portrait of Sir Wm. Russell.

and for Richard himself, to ride from the Tower to Westminster, on the day before his coronation, a doublet and stomacher of blue cloth of gold "wrought with nets and pine-apples." ('Wardrobe Account and Inventory,' by Piers Comtys, the King's Wardrober.) From York, Richard writes for a host of articles of apparel, amongst which are green satin doublets, of purple and tawny satin, lined with galand (?) cloth, and outlined with buske. Perhaps we should read " Holland cloth" (see p. 171, l. 18).

In the following reign we acquire a little more information about the doublet, which was occasionally laced over a stomacher, as in female attire. In 'The Boke of Curtasye,' a MS. of that date, the chamberlain is commanded to provide against his master's uprising, amongst other clothing, "a *doublette*" and a stomacher; and in another work of the same time, 'The Boke of Kervynge,' he is instructed "to warme" (his sovereign) "his petticoat, his doublet, and his stomacher," and to "lace his doublet hole by hole." This fashion is constantly seen in illuminations and paintings of the period.

Pease-cod bellied Doublets. *Temp*. Elizabeth. From Randle Holmes and Bertelli.

In the reign of Henry VIII. the doublet increases in importance and magnificence in the clothing of the upper classes. The wardrobe accounts and inventories I have already quoted with reference to the caps, cloaks, and coats of this time ; and the pages of the contemporary chronicler, Hall, afford us ample descriptions of the doublet. In the eighth year of that reign, we find the following entries : " A doblet of yelowe bawdykn covered with yelow satin, with hose to the same. A doblet and a payr of hose of russet velvet, with over-all upon cloth of gold. A doblet and hose of blacke tylsent (tinsel), like byrd's eyes. A doblet and hose of blacke tylsent and purpul velvette framed and cutte. A doblet, jaquet, and hose of blacke velvette, cut upon cloth of gold, embrouderede. A doblet of russett cloth of gold of tissew checkered, with hose to the same. A doblet, hose, and jaquet, of purpul velvete, embroudered, and cut upon cloth of golde, and lyned with black satin." These were all for the king's use, and following them is an entry of " a doblet of white tylsent, cut upon cloth of gold, embroudered, with hose to the same, and clasps and anglettes (aglets) of gold, delivered to the Duke of Buckingham."

It is of importance to observe, that in these entries the doublet is always accompanied by the

hose, attached to it by points, which was not the case with the jacket, a short loose coat worn over it in lieu of a cloak. Knights of the Garter, and the sons and heirs of barons and knights, were permitted the use of crimson velvet and tinsel in their doublets, the sons and heirs of certain other privileged persons were limited to black velvet, and all classes beneath them were confined to the use of less costly materials—cloth of a certain price, frieze, and leather.

As we advance into the sixteenth century, we find the doublet lengthened in the waist (see woodcut from portrait of Sir William Russell, page 172), till towards the close of that period, the latter years of Queen Elizabeth, it had become a positive deformity, still familiar to the present eye in the scarcely exaggerated costume of that most popular of puppets, Punch (see last page). Stubbs, writing in 1583, says of the doublet, " The fashion is to have them hang down to the middle of the thighs, though not always quite so low, being so hard quilted, stuffed, bombasted, and sewed, as they can neither work nor yet well play in them, through the excessive heat and stiffness thereof ; and therefore are forced to wear them loose about them for the most part, otherwise they could very hardly either stoop or bow themselves to the ground, so stiff and sturdy they stand about them." " Certain I am," he declares, " there never was any kind of apparel invented that could more disproportion the body of a man than their doublets with great bellies do, hanging down beneath the groin, as I have said, and stuffed with four or five, or six pounde of bombast at the least. I say nothing of what their doublets be made ; some of satin, taffata, silk, grograine, chamlet, gold, silver, and what not ; slashed, jagged, cut, carved, pinched, and laced with all kinds of costly lace of divers and sundry colours, of all which, if I could stand upon particularly, rather time than matter would be wanting." These doublets Bulwer, in his ' Pedigree of the English Gallant,' calls " Pease-cod bellied doublets." They had long been out of fashion at the time he wrote (1653), but he speaks of them with equal reprobation. " The women also," Stubbs tells us, " have doublets and jerkins as the men have, buttoned up to the breast, and made with wings, welts, and pinions on the shoulder-points, as man's apparel in all respects ; and though this be a kind of attire proper only to a man, yet they blush not to wear it." Holinshed likewise, in his ' Chronicle,' remarks, " For women also, it is much to be lamented, that they do now far exceed the lightness of our men,

Lady in winged and buttoned Doublet (?). From a print, 1631.

Doublet. *Temp.* Charles I. From a print, 1646.

and such staring attire as in time past was supposed meet for none but light housewives only, is now become an habit for chaste and other matrons. What should I say of their doublets full of jags and

cuts, and sleeves of sundry colours ? " Goddard, in his 'Mastiff's Whelp,' speaks of " A buttoned bodice skirted doublet-wise," as a portion of the riding-dress of ladies in the time of Elizabeth (page 45 *ante*), which may have been the same article of attire.

<table>
<tr><td>Countryman in Doublet. From Randle Holmes, 1660.</td><td>Skirted Doublet. From a scarce print by Marshall.</td></tr>
</table>

Doublets of various lengths and fashions continued to be worn by all classes to the time of Charles II., when they were superseded for a brief season by the vest, and ultimately by the waistcoat ; and we find Pepys, in the earlier part of that reign, making similar observations on the dress of the ladies to those of Stubbs and Holinshed in the reign of Elizabeth. On the 11th of June, 1666, he records, " Walking in the galleries at Whitehall, I find the ladies of honour dressed in their riding-garbs, with coats and doublets with deep skirts, just for all the world like men, and buttoned their doublets up the breast, with periwigs and hats, so that only for a long petticoat dragging under their men's coats, nobody could take them for women."

DOWLAS. A coarse cloth imported from Brittany, and worn by the lower classes in England in the sixteenth century. Shakespere mentions it in the First Part of his ' King Henry IV. :'

" HOSTESS. I bought you a dozen of shirts to your back.
FALSTAFF. Dowlas ! filthy dowlas ! I have given them away to bakers' wives, and they have made bolters of them."—Act iii. sc. 3.

DRAGON. A small kind of blunderbuss or carbine, with a dragon's head at its muzzle, presumed by Sir Samuel R. Meyrick to have given the name of dragons (dragoons) to the French troops so called, first raised by Charles de Cossé, Mareschal de Brissac, A.D. 1600. This is stated by Père Daniel (' Hist. de la Mil. Fran.,' tome ii. p. 489), on the authority of Chevalier Melzo, whose work entitled 'Regole Militari sopra il governo della Cavalleria,' was printed in 1611, but neither Melzo nor Daniel mentions the dragon, the former calling the firearm an arquebus, and the latter ascribing the name of dragons to the fury and impetuosity of their attack.

The first reliable information we have obtained concerning the subject is from Markham, who, in

his 'Souldier's Accidence,' published in 1645, describing the cavalry of his own time, says : " The last sort of which our horse troopes are composed are called dragoons, which are a kinde of footmen on horsebacke, and do now indeed succeed the light horsemen, and are of singular use in all actions of warre. The armes defensive are an open head piece with cheeks, and a good buffe coat, with deepe skirts ; and for offensive armes they have a faire *dragon* fitted with an iron worke, to be carried in a belt of leather, which is buckled over the right shoulder and under the lefte arme, having a turnill of iron work with a ring, through which the piece runnes up and downe ; and these dragons are short pieces of sixteen inches the barrell, and full musquet bore, with firelocks or snaphaunces, also a belt with a flaske, pryming box, key, and bullet bag, and a good sword." No allusion whatever, observe, to the derivation of the name either of the piece or of the troops armed with it.

Demmin does not mention the dragon in his ' Weapons of War ;' and Mr. Hewitt, who quotes Markham, says :—" The name of these troops seems clearly to be derived from the weapon they carried, the ' faire dragon' named above, and not, as we have been told, from the *draconarii* of the Romans, or from their resemblance to the fiery dragon of the fables, or from their dragon-like character, or from their piece having its muzzle in the form of a dragon's head (*which it never had*). Just as a cannon was called a serpent or a falcon, and a large harquebus a musquet (from *muschette*, a bird of prey of the hawk kind), was this arm named a dragon, simply to give to it one of the unappropriated names significant of maleficence."

Dragon. Meyrick Collection.

While inclined to agree with him as regards the derivation, I must demur to his declaration "which it never had," as an example of the time of Elizabeth, formerly in the Meyrick Collection, and engraved by Skelton, *had* " a muzzle in the form of a dragon's head," as the reader may satisfy himself by the woodcut appended, which, if it be not a solitary specimen, is certainly evidence in favour of Meyrick's opinion, endorsed by Albert Way in his Glossary to the 2nd edition.

DRAWERS. " Feminalia," as they are called in Latin by Eginhart in his description of the dress of Charlemagne, were worn by the Franks and the Saxons as early, at least, as the ninth century. Some writers have confounded them with the braies (*braccæ*) of the Gauls and Belgic Britons, and very naturally so, as previously to the sixteenth century, when the word breeches became identified with those nether portions of male attire which in these decorous days are alluded to as " unmentionables " and " inexpressibles," the Saxon *brech* was, in its later form, constantly used to indicate what we now call drawers, to go without which in the Middle Ages was made a penance and considered a shame.

Drawers. Anglo-Norman MS., 13th century.

In the reign of Richard II., we are told by Froissart, who had his information from Henry Christall, that the four kings of Ireland who came to pay their homage to the English monarch wore no breeches, and that he (Christall) ordered some of linen cloth to be made for them.

In the reign of Henry VII. there is a direction in ' The Boke of Curtasye ' for the chamberlain to provide against his master's uprising " a clene sherte and breche."

In 1650 Cotgrave explains " drawers " as " coarse stockings to draw over others." " To put on drawers, *se houser, se trouzer*." Bailey, in 1736, has

not the word at all. Our example, from an Anglo-Norman MS. of the thirteenth century, will be sufficient to show how they were worn and fastened below the knees.

DUCK BILLS. Shoes so called from the shape of the toes, worn in the ·latter half of the fifteenth century. (See POULAINE and SHOES.)

DUNSTER. A cloth so called from the place of its manufacture, in the west of Somersetshire, mentioned in Acts of Parliament 3rd Edward III., 4th and 6th Edward VI., &c.

DUTCHESS. "A knot to be put immediately above the tower" (*i.e.* the commode). ('Ladies' Dictionary,' 1694.)

ARRINGS. These well-known ornaments were undoubtedly worn in England in the time of the Anglo-Saxons, and, probably, by the Romanized Britons. A silver earring of an early type was found in one of the barrows on Breach Downs, near Canterbury, and was in the possession of the late Lord Londesborough ; but, both here and on the Continent, after the commencement of the tenth century, the fashion appears to have declined, and earrings are neither found in graves nor discernible in paintings or sculpture. M. Viollet-le-Duc, who notices the fact, observes that the style of head-dress and of wearing the hair, during the twelfth century, may in some measure account for it ; and certainly the Hæfods rægel of the Saxon ladies in the tenth and eleventh centuries, and the couvrechefs of the Normans at the same period, rendered any decoration of the ear very unnecessary, as it was rarely to be seen uncovered abroad or at home. In the thirteenth century, however, we find mention of them in the 'Roman de la Rose.' Pygmalion is described by Jean de Meung amusing himself by dressing his beloved statue in all the gayest garments and costly ornaments then in vogue, and amongst the latter—

"met à ses deux oreilletes
Deux verges d'or pendans greletes ;"

but we have no graphic description of their form, and neither monument nor miniature is found to assist us. Even the industry of Mr. Fairholt has been vainly exerted to discover a delineation of a mediæval earring previous to the middle of the fourteenth century, and that is only in the curious but very untrustworthy copy of the 'Romance of King Meliadus,' which, attributed to the time of Edward III., has been tampered with by generations of illuminators to the latter end of the fifteenth century, so that it requires the most minute and critical examination to enable one to decide on the date of a drawing in it within a hundred and fifty years ; and during nearly the whole of that period the ear, as will be evident to the reader on referring to the article HEAD-DRESS, was entirely concealed.

In the sixteenth century the alteration of the coiffure re-introduced the wearing of earrings, and we find the old censor Stubbs, in the reign of Queen Elizabeth, including them in his denunciations. " The women," he tells us, " are not ashamed to make holes in their ears whereat they hang rings and other jewels of gold and precious stones." ('Anatomie of Abuses.') Paul Hentzer, in his account of his journey to England in that reign, describing the dress of Elizabeth, says, " The Queen had in her ears two pearls, with very rich drops." Two large pearls with a third depending from them are seen in her left ear, in her portrait by Zucchero. Pear-shaped pearl drops appear also in Crispin de Passe's rare print, from her portrait by Isaac Oliver, in the dress she wore in her progress to St. Paul's to return thanks for the defeat of the Spanish Armada.

Continual mention is made of them by writers of the seventeenth century, at which period they were given as love tokens.

" Given earrings we will wear."
Cupid's Revenge, by Beaumont and Fletcher.

Earrings were also worn by men at the same period—a foreign fashion introduced most probably into

England from France, as we find that most effeminate of princes, Henri III., and his courtiers affecting them exceedingly. Hall, in his 'Satires,' speaks of

> "Tattelus, the new come traveller,
> With his disguised coate and ringed ear."—Book vi. sat. 1.

So Hutton, in his 'Epigrams,' 1619, has

> "Superbus swaggers with a ring in's eare."

Holinshed, in his 'Chronicle,' says, "Some lusty courtiers, also, and gentlemen of courage do wear either rings of gold, stones, or pearls in their ears, whereby they imagine the workmanship of God to be no little amended." Oldys, in his 'Life of Sir Walter Raghley,' mentions the diamond earrings of the great favourite of James I., George Villiers, Duke of Buckingham; and numerous allusions to the fashion are to be found in the dramatists of the day: it is unnecessary to quote them. Men are not seen wearing them after the restoration of Charles II.; but there was a singular fashion existing at the same time on the Continent, which found its way into England about the time of James I.,

ÆTATIS SVE 34

viz. the wearing of two or three strings of black silk in the left ear, hanging down to the shoulder. An example may be seen in a portrait at Hampton Court, said to be that of Shakespere, but on no reliable authority; and another in a copy of a portrait of, I think, some Danish nobleman, so decorated, about the same date, but my pencilled note

Ear-string. Danish nobleman.

Ear-string. Portrait: Hampton Court.

is effaced. The fashion, however, undoubtedly had a brief existence; and as I have not met

with any allusion to it in any work on Costume I am acquainted with, I take the liberty of introducing it under the name of

EAR-STRING, and illustrating it by woodcuts from copies of the portraits above mentioned.

ELBOW-GAUNTLET. A long gauntlet of plate, adopted from the Asiatics in the sixteenth century. The annexed cut is from Skelton's etching of an embossed one in the Meyrick Collection, *temp.* Queen Elizabeth. One composed of overlapping pieces of leather, of the time of Cromwell, and another of the kind called silk armour, the outer covering being of that material, of the reign of Charles II., are also here engraved from the same collection.

ELBOW-PIECES. See COUDES.

Elbow-gauntlet. 16th cent.

Elbow-gauntlets of Leather. 17th century.

EMBROIDERY. A history of embroidery would require a volume to itself; and the art is so well known, and so generally practised in these days, that any technical explanation of it is not requisite in a work of this description. Mr. Fairholt dismisses the subject in a few words, "Variegated needlework, commonly used for the decoration of dress, from the French *broder*. Chaucer says of the young Squire in the 'Canterbury Tales,'—

> 'Embroudered was he as it were a mede,
> All of fresh flowers, white and red.'"

('Hist. Cost. in England,' Glossary, p. 494.)

I will not be so brief, however, as Mr. Fairholt. The art of embroidery, felicitously styled in Latin *acupictus* (painting with the needle), was not only known and practised by the Anglo-Saxons, but they had attained such proficiency in it that as early as the seventh century, Adhelm, Bishop of Sherborne, speaks of the admirable skill of the English females; and their reputation increased so rapidly abroad, that the name of *Anglicum opus* was given on the Continent to all rare work of that description. In the splendid Benedictional of the tenth century from which we have introduced a figure in illustration of the article CLOAK, page 100, numerous examples will be found of elaborately embroidered garments, and our early chronicles teem with descriptions of mantles, tunics, surcoats, and even boots and shoes, sumptuously embroidered with gold, silver, coloured silks, intermixed with pearls and precious stones. Matthew Paris states, that when Robert, Abbot of St. Alban's, visited his countryman, Pope Adrian IV. (1155–59), at Rome, he presented him with three mitres and a pair of sandals, embroidered in a wonderful manner ("operis mirifici") by Christiana, Prioress of Markgate. ('Vitâ Abattûm,' p. 71.) In the 37th of Edward III., an Act was passed forbidding persons whose incomes did not exceed four hundred marks yearly, to wear habits "embroidered" with jewellery; and all persons under the rank of knighthood, or of less incomes than two hundred pounds per annum, were prohibited from wearing embroidered garments of any sort. In the fifteenth and sixteenth centuries the embroidering of linen and cambric with blue and black silk was very prevalent, and its effects extremely picturesque. In the course of this work, many instances will be cited, and examples given of it. Embroidery has been from the earliest times a favourite occupation with ladies, and ranks to this day amongst the most beautiful and highly prized species of ornamentation.

ENGAGEANTS. "Double ruffles that fall over the wrists." ('Ladies' Dictionary,' 1694.) They are mentioned in France in the 'Mercure Galant,' 1683, and were in high fashion there in 1688. They seem to have been introduced here shortly afterwards, for Evelyn ('Mundus Muliebris,' 1690) says,—

> "About her sleeves are engageants."

In the lace bills of Queen Mary II., in the British Museum (Add. MS., No. 5751), under the date 1694, are the following entries:—

	£	s.	d.
1¾ yd. point for a broad pair of engageants, at £5 10s.	9	12	6
3½ yd. for a double pair of ditto, at £5 10s.	19	5	0
1 pair of point engageants	30	0	0

Mrs. Bury Palliser, in her admirable 'History of Lace,' tells us that concerning the wearing of these ruffles "à deux rangs," or "à trois rangs," there was much etiquette.

EPAULIÈRES, EPAULLETES, EPAULETS. Shoulder-plates either of one piece, or articulated. They are first seen shortly after the commencement of the fourteenth century in various forms, plain or ornamented, roundels or cups, lions' heads, &c., simply covering the point of the shoulder or defending only the front of it.

They were fastened by laces or points to the sleeve of the hauberk. Examples are here given from a brass of a knight in Minster Church, Isle of Sheppy (fig. 1); the sculptured effigy of a knight in St. Peter's Church, Sandwich (fig. 2); and the brass of one of the De Creke family, Westly Waterless, Cambridgeshire (fig. 3).

1. Brass in Minster Church. 2. Effigy. St. Peter's, Sandwich. 3. Brass in Westly Waterless.

Others may be seen on Plate II. of this work (figs. 1 and 9), the latter of which it is difficult to distinguish from an ailette, worn at the same period, or one of those roundels, gussets of plate or palettes, as they have been indifferently called, made to protect the armpit, or "vif de l'harnois," as the French at that time termed it. (See also ARMOUR, p. 18, and BRASSARTS, p. 53 *ante*.)

These shoulder-pieces were succeeded by plates encompassing the shoulder and upper part of the arm, overlapping each other and riveted to the brassart. The number of these plates varies from two to five or six, constructed so as to slide up as the arm was raised. The subjoined examples are from effigies of the end of the fourteenth and of the first half of the fifteenth centuries. Fig. 4, from brass of Sir John Argentine, Horseheath, Cambridgeshire, 1386; fig. 5, brass of a knight at Laughton, Lincolnshire, 1400; fig. 6, from a brass of a knight of the Eresby family in Spilsby Church, Lincolnshire, presents us with an instance of the plates extending so as to pass over the breastplate, and thereby render unnecessary the roundel above mentioned; and fig. 7, from the brass of Sir John de Brewes in Weston Church, Sussex, 1421, very clearly illustrates the overlapping of the plates of these articulated epaulières.

4. Brass of Sir John Argentine. 5. Brass of a Knight at Laughton. 6. Brass in Spilsby Church. 7. Brass of Sir John de Brewes.

Later in the century further protection was provided for the shoulders by large plates of one piece placed over the epaulières, called pauldrons. (See under that word.)

The epaulets now worn by officers of the navy and army are of a later date than 1760, and therefore do not come within the scope of this Cyclopædia.

ERMINE. (*Hermine,* French; *ermelinus, hermillinus, armelina,* Latin.) One of the most highly esteemed furs of the Middle Ages. Its name is derived from Armenia, from whence it appears to have been first imported. (Ducange, *in voce* Hermillina.) Described by the glossarist as the skin of the Pontic mouse (*Mus ponticus*), it is, in fact, that of a species of polecat (*Mustella erminea*), about nine inches long, with a tail about four, and which has two coats. In winter it

is white, and its tail is tipped with black, and it then bears the name of ermine; but during the spring it changes to a beautiful brown above and yellowish white beneath; it is then called the rosetel. The winter skins are those which have been always most valued, and were as early as the twelfth century an important article of commerce. They are mentioned as *Hereminæ pelles* in the Council of London, A.D. 1138, cap. 15. In the reign of Edward III. the privilege of wearing garments lined or faced with ermine was strictly limited to the royal family and nobles possessing 1,000*l.* per annum. In the reign of Henry IV. it was extended to the nobility generally and to all degrees down to knights bannerets and certain official personages. I have not met with it in illuminations nor in descriptions of costume in romances before the thirteenth century. Subsequent to the reign of Henry III. its occurrence is common.

ESCHELLES. "A stomacher laced or riboned in the form of the steps of a ladder, *lately very much in request.*" ('Ladies' Dictionary,' 1694.)

ESCLAIRES, ESCLARES. This word occurs in the third clause of a sumptuary law of the 37th of Edward III., in which the wives and children of certain classes are forbidden to use " esclaires, crinales, or trœfles." In the fifth clause of the same Act the wives and children of knights possessing lands or tenements to the value of 200*l.* per annum are prohibited from wearing esclaires or any kind of precious stones "unless it be upon their heads." I must confess with Mr. Strutt, who quotes this Act in his 'Dress and Habits' (vol. ii. chap. ii. p. 105, ed. 1842), that I am unable at present to offer even a conjecture of the nature of the ornament or article of attire so denominated. "Esclaire" is an old term in French falconry ("Oiseau d'une belle forme," Landais); but I have not met with it in any other sense. "Éclair," a flash of lightning, would lead us to imagine that the name had been given to some ornament for its brilliancy, or, in the sense of *clear*, some diaphanous veil or caul for the head. "Crinales" may, as Mr. Strutt suggests, be bodkins or hairpins enriched with jewels, and "trœfles" some ornament in the form of a trefoil (*tréfle*, French), a very favourite one in goldsmiths' work, jewellery, and embroidery at that period. But with respect to esclaires, " J'ai besoin moi-même d'être éclairé."

ESPADON. (*Espada*, Spanish, "a sword.") A long straight sword of Spanish origin. Our woodcut is from the engraving by Skelton of one in the late Meyrick Collection. The blade was four feet in length.

ESTOC. A short sword made only to thrust with. " Ense a estoc," "a stabbing sword." Used by mounted men, *temp.* Edward I., and worn on the right side in a belt or slung on the saddle of the horse. It is mentioned in a judgment of the Parliament of Paris in 1268, quoted by Mr. Hewitt (vol. i. p. 314), and is seen in the brass of John Lementhorp, Esq., in Great St. Helen's Church, London, 1510, and engraved in the same work (vol. iii. p. 582). In appearance it differs only from the ordinary sword of the period in being generally smaller.

Espadon. Meyrick Collection.

ÉTUI. (French.) "By contraction *Twee*," (Boyer.) A case formerly worn by ladies at their waists, as it is now the fashion to wear a châtelaine. Some were of gold or silver, with paintings in enamel. The two examples given herewith are particularly interesting, as they were once the property of Mrs. Bendish, the granddaughter of Oliver Cromwell, and were bequeathed by her to Mr. Lewson, her husband's nephew. They are now the property of Mr. G. Shervill of Lincoln's Inn Fields, by whose kind permission they have been engraved for this work. In the comedy of 'The Suspicious Husband,' Clarinda being desirous to delay her entrance into her house, exclaims, "Ha! sure I have not dropped my twee?" (Act ii. scene 2.) In the modern editions the article is changed to a fan.

Étui.

Étui.

ALBALA. See Furbelow.

FALCASTRA, FALCASTRUM, FALK. (*Falco*, Latin.) The name of a primitive weapon formed of a scythe (*faux*, French) fixed on a pole. Some rudely constructed, which were used by the peasantry in Monmouth's rebellion, 1685, are preserved in the Tower Armoury. It is mentioned in the Statute of Arms, 36th Henry III., amongst the commoner weapons, but distinguished from the guisarme, " Falces, gisarmus, et alia arma minuta ;" and in the Statute of Winchester, 1286, in nearly the same order, in French, " Faus, gisarmes e cotaus e autres minues armes." We have no particular description of the falk or faux which would enable us positively to identify it with either the bill, the glaive, or the guisarme, to all of which it has been compared, and with, by some writers, confounded. Strictly adhering to the plan I have laid down, I do not attempt to depict it, as any drawing of it must be purely imaginative. M. Viollet-le-Duc has given us his opinion with illustrations under Fauchart, which word see for my commentary upon them.

FALCHION. (*Fauchon*, French ; *falx*, Latin.) We are in nearly a similar state of uncertainty

Falchion. Durham Cathedral.

Falchion. From Cotton. MS. 14 E 2.

Falchion. Royal MS. 2 B 7.

respecting this weapon, of which we have no contemporary description, and the name whereof has been employed by poets to signify simply a sword.

It is mentioned by Guiart, a writer of the thirteenth century:

> " La ou les presses sont plus drues
> Et la chaple aux espees nues,
> Aux fauchons, aux coutiaux à pointes."
> *Chronique.*

and is presumed by several antiquaries to be depicted on the wall-paintings at Westminster I have so frequently referred to in this work. (See woodcut below.) It is the prototype of the German sabre

Falchion. From painting on the wall at Westminster. Falchion. From the 'Loutrel Psalter.'

(*zabel*) and the Oriental scimitar. Varieties of it are found throughout the thirteenth, fourteenth, and fifteenth centuries: notably in Royal MS. 2 B 7 ; in the 'Loutrel Psalter;' the Cotton MS. Nero, D 2, date about 1420 ; and in several tapestries of the latter half of that century. An original weapon of this class, of about the time of Edward I., is presented to the Bishop of Durham on his first entrance into his diocese, by the Lord of Sockburn, who holds the manor by that tenure ; it is engraved at the head of this article. (Surtees' 'Durham,' vol. iii. p. 244.)

FALDING. According to Skinner, a coarse kind of cloth, like frieze. Chaucer's Shipman, in the 'Canterbury Tales,' is described as dressed

> " All in a gown of falding to the knee ;"

and Tyrwhitt, in his note on this passage, quotes Helmoldus, who, in his 'Sclavonic Chronicle,' speaks of " indumenta lanea, quæ nos appellamus faldones." (Lib. v. cap. 1.)

It was used for covering furniture in the fourteenth century. The Clerk in the 'Miller's Tale' had

> " His presses covered with a faldyng red ;"

and Mr. Fairholt suggests that a coarse red woollen cloth of home manufacture and dye, still worn by the Irish peasant women for jackets and petticoats, may be, probably, identical with the ancient " faldyng."

FALL. See BAND, page 32 *ante.* " French falls." ('Eastward Hoe,' 1605.)

> " There she sat with her poking stick stiffening a fall."
> *Laugh and lie down, or the World's Folly*, 1605.

This line alludes, probably, to a sort of ruff that was sometimes called a " falling band." Five yards of lawn are purchased by a character in an old play by Dekker, " to make falling bands of the fashion, three falling one upon the other, for that's the new edition now." ('Honest Whore,' 1604. See RUFF.)

FAL-LALLS. Ornamental ribbons worn about the dress. "Lace and fal-lalls, and a large looking-glass to see her old ugly face in, frivolous expenses to please my proud lady." (Sir Thomas Clayton.)

"His dress, his bows, and fine fal-lals."—Evelyn.

FAN. This indispensable "lady's companion" makes its first appearance in England in the sixteenth century and the reign of Queen Elizabeth, who, in her portrait by Nicholas Hilleard, is represented with one (see woodcut annexed).

They were made of feathers, and hung to the girdle by a gold or silver chain (see woodcut below). The handles were composed of gold, silver, or ivory of elaborate workmanship, and were sometimes inlaid with precious stones. Silver-handled fans are mentioned in Hall's 'Satires,' and in the Sidney Papers is an account of a fan presented as a New Year's gift to Queen Elizabeth, the handle of which was studded with diamonds. Some handles were very long. Gosson, in his 'Pleasant Quippes for Upstart Gentlewomen,' 1598, remarks:

Fan. From portrait of Queen Elizabeth.

"Were fannes and flappes of feathers fond
 To flit away the flisking flies,
As tail of mare that hangs on ground
 When heat of summer doth arise,
The wit of women we might praise,
For finding out so great an ease.

"But seeing they are still in hand,
 In house, in field, in church, in street,
In summer, winter, water, land,
 In colde, in heate, in dry, in weet,
I judge they are for wives such tooles
As bables are in playes for fooles."

The fans used in Italy at that period, shaped like a small square flag or vane, do not appear to have been popular here. (See General History.)

English Lady of Quality. From Hollar's
 'Ornatus Muliebris,' 1640.

"The first approach to the modern fan," observes Mr. Fairholt, "may be seen in a print of the early part of the seventeenth century. The long handle is still retained, and the fan, although arranged in folds, does not appear to be capable of being folded." Such folding fans, however, soon came into use, and may be seen in Plate VIII., figs. 2 and 6, from portraits of Queen Anne of Denmark. Her Majesty has indeed furnished us with the majority of the examples in our Plate; figs. 3, 4, and 5 being copied from other portraits of her. About the middle of the century they became larger, and the stems of ivory were richly carved and decorated.

During the reign of Anne they were made so large, that Sir Roger de Coverley declares he would allow the widow he courted, "the profits of a windmill for her fans." ('Spectator,' No. 295.) Fan painting became a separate profession in the middle of the seventeenth century. Mythological and fancy subjects were depicted on them, and some of the time of Louis XV. are still extant, and bring large prices, the designs being in a very superior style of art. (See Plate VIII., No. 9.)

FANON. One of the names given to an embroidered scarf worn by the priest in the Roman Church over his left arm. (See MANIPLE.)

FARTHINGALE, VARDINGALE, VERDINGALE. (*Vertugale, vertugade, vertugadin,* French.) This progenitrix of the hoop petticoat and the later crinoline has a pedigree long enough

1. Engraving of English Noblewoman, by Gaspar Rutz, 1581.—2, 3, 4, 5, 6. Various portraits of Anne of Denmark, Queen of James I., engraved by John Myssens, Simon de Pass, Elstrack, and others.—7. Engraving by Hollar.—8. Speed's Map of England.—9. 18th Century.

almost to satisfy a Welshman. It is simply another name, coined in France in the sixteenth century, for one of those contrivances for imparting some particular form the caprice of Fashion at various periods has suggested should be given to the distinguishing garment of her female votaries.

"Placing both hands upon her whalebone hips,
 Puffed up with a round circling farthingale."—Hall's *Satires*, 1599.

The vertugale or vertugade is spoken of in the reign of Henry II. of France, 1547–1558, the contemporary of our sovereigns Edward VI. and Mary Tudor. It is alluded to as a sort of cage worn

Round Farthingale. Queen Elizabeth.

Wheel Farthingale. Anne of Denmark, Queen of James I.

Farthingale. Lady Hunsdon.

under the petticoat, to which we see at that period it gave the shape of a bell, increasing in amplitude and rotundity with the trunk hose of the opposite sex, which reached, in the reign of Elizabeth, the most preposterous dimensions. (See figure of her in a round farthingale, from the frontispiece to Gosson's 'Quippes.') Towards the close of her reign the vardingale gave to the wearer the appearance of "standing in a drum," as Sir Roger de Coverley in 'The Spectator' describes the portrait of his "great, great grandmother." This was called the "wheel farthingale," in which Queen Elizabeth is attired in her best-known portraits, and this fashion lasted during the whole of the reign of her successor, James I., whose consort, Anne of Denmark, is painted in a precisely similar "unnatural disguisement," the ornamental plaits surrounding the waist resembling the spokes of a wheel. (See woodcut above.)

Bulwer, in his 'Pedigree of the English Gallant,' records that when Sir Peter Wych was sent ambassador to the Grand Seignior from James I.,

Citizen's Wife in Farthingale. From
Speed's Maps.

English Lady in Farthingale.
From Speed's Maps.

his lady accompanied him to Constantinople, and the Sultaness, having heard much of her, desired to see her; whereupon Lady Wych, attended by her waiting women, all of them dressed in their great vardingales, waited upon her Highness. The Sultaness received her visitors with great respect, but, struck by the extraordinary extension of the hips of the whole party, seriously inquired if that shape were peculiar to the natural formation of Englishwomen, and Lady Wych was obliged to explain the whole mystery of the dress in order to convince her that she and her companions were not really so deformed as they appeared to be. The farthingale was still worn, though of rather more moderate dimensions, in the reign of Charles I. In the dramatic pastoral called 'Rhodon and Iris,' first acted 3rd of May, 1631, at Norwich, the author, alluding to the caprices of a lady of fashion, says :

> "Now calls she for a boisterous fardingal,
> Then to her hips she'll have her garments fall."

And Evelyn tells us, under the date of " 1662, May 30th. The Queene (Catharine of Braganza) arriv'd with a traine of Portuguese ladies, in their monstrous fardingals or guard-infantas Her Majesty in the same habit. Her foretop long and turned aside very strangely."

It vanished during the reign of Charles II., to reappear in the hoop of the eighteenth century.

FAVOUR. "A love gift." (Fairholt.) A ribbon, a glove, a kerchief, &c., worn on the breast, in the hat, or in the Middle Ages attached to the crest of the *favoured* knight in a tournament, and even in mortal combat.

> "Nodding and shaking of thy spangled crest,
> Where women's favors hang like labels down."
> > Marlowe's *Tragedy of Edward II.*, 1598.

The word is still in use as " wedding favours."

FAVOURITE. A lock of hair so called, mentioned by Evelyn. "A sort of modish lock dangling on the temples." ('Ladies' Dictionary,' 1694.) " Then the favourites hang loose upon the temple, with a languishing lock in the middle." (Farquhar, 'Sir Harry Wildair.')

FEATHERS. It is remarkable that these most graceful and effective ornaments appeared to have been utterly ignored by all the races inhabiting the North of Europe till, at the earliest, the close of the thirteenth century. In my 'History of British Costume,' 1834, I first called attention to a MS. of that period in the library of his Royal Highness the late Duke of Sussex, entitled 'L'Histoire de l'Ancien Monde,' and to the appearance of something like a feather on the heaumes of some of the knights depicted in combat in one of the illuminations, at the same time observing that in other instances in the same MS. it is so evidently the scarf or cointise which assumes that form, that I have still a doubt as to the actual intention of the artist. Since that period, full forty years have passed without my discovering any unquestionable instance of feathers worn in military or civil costume previous to the reign of Edward III., when they also make their first appearance in heraldry, as badges of the royal family. In none of the old romances, replete as they are with descriptions of dress and armour, is there any allusion to feathers earlier than the middle of the fourteenth century.

It is true that the Sieur de Joinville, in his 'Histoire de St. Louis,' speaks of seeing the king one day in summer with " un chapel de paon blanc sur sa teste," which M. Viollet-le-Duc explains, "c'est à dire, *orné* de plumes de paon." If De Joinville's words admit of that interpretation, is it not remarkable that neither in the numerous representations of the sainted sovereign in every variety of costume, collected and engraved in Père Montfaucon's 'Monarchie Française,' nor in those of his family and the nobles of his Court, a solitary feather should be seen to support it? I venture to suggest that by " un chapel de paon blanc" we should understand a cap, bonnet, or chaplet *composed* of white peacocks' feathers, not the long feathers of the tail which, two hundred years afterwards, were worn in such profusion by the nobles of the courts of Charles VIII. and Louis XII., but the plumage of the neck or body on the skin of the bird, sewn upon a foundation of cloth or other materials, as feather tippets and muffs are made at this present day. Caps and chaplets, or wreaths, made of

feathers and leaves, are frequently met with at a later period in England, and might have been worn in France in the time of Louis IX.; but a cap *and* feathers ("ornés de plumes") has yet to be discovered in the thirteenth century.

In the curious MS. the 'Roman du Roi Meliadus' (Add. MS. Brit. Mus., No. 12,228), before alluded to, and of which the earliest illuminations are certainly of the fourteenth century, we find the high conical cap with a single feather in front, which appears about the same time in Abbot Litlington's 'Missal,' incorrectly called by Strutt the 'Liber Regalis,' and in other works contemporary with the reigns of Edward III. and Richard II.; but their first appearance in military costume is in the reign of Henry V., when they were fixed in a small tube or socket, made for their reception on the apex of the bassinet. (See Plate III., fig. 10.) When more than one was worn in that position, it was generally termed a "panache," the word "plume" being applied at a later period, when one or more feathers were worn at the side or back of the head-piece. Towards the close of the fifteenth century the wearing of feathers became general, and was carried by the upper classes, both civil and military, to an excess that was almost ludicrous, and can only be described by the pencil. (See page 76 *ante*, and HELMET.) The ladies as usual followed suit (see page 79 *ante*), and from that period feathers have been more or less worn by all classes and both sexes. The display of feathers made by Henry VIII. and Francis I., when

> "Those suns of glory, those two lights of men
> Met in the vale of Andres" (Ardres),

has been faithfully handed down to us by contemporary painters and sculptors, and the fashion is alluded to by Shakespere in the play above quoted, where Lord Lovel, speaking of the "travelled gallants" of that day, says:

> "They must leave these remnants
> Of fool and feather that they got in France."
> *Henry VIII.*, Act ii. sc. 3.

For the way in which they were worn during the remainder of the sixteenth and seventeenth centuries, the reader is referred (to avoid repetition) to the articles CAP, HAT, HEAD-DRESS, and the GENERAL HISTORY. "No fool but has his feather," is an expression in Marston's play 'The Malcontent,' 1604.

> "Appoint the feather maker not to faile
> To plume my head with his best estridge tail."
> Rowland's *A pair of Spy Knaves.*

In Middleton's play, 'The Roaring Girl,' there is the scene of a feather shop, and Mrs. Tiltyard, the mistress, asks Jack Dapper, a young gallant:

> "What feather would you have, sir?
> These are most worn and most in fashion
> Amongst the brave gallants,
> I can inform you 'tis the general feather."

Dapper replies —

> "And therefore I dislike it
> Show me a spangled feather;"

and it is afterwards said, "He looks for all the world, with those spangled feathers, like a nobleman's bedpost." Jewelling the stem of a feather was a fashion in the fifteenth century (see page 85), but the feathers here spoken of were spangled all over.

The introduction of the cocked-hat limited the use of feathers by the male sex to trimmings for the brims, a fashion that lasted till the reign of George II. The ladies, however, never have utterly discarded them from their toilette, and it is unlikely that they ever will.

FELT. (*Feutre*, French; *feltrum, filtrum*, Latin.) "A sort of coarse wool, or wool and hair. Felt hats were first made in England by Spaniards and Dutchmen in the beginning of the reign of Henry VIII." (Bailey. See HAT.) Felt was also used for the stuffing of garments. In Heywood's

play of ' Four P's,' it is said that the devil on a high holiday is "feutred in fashion abominable." Way, in his note to " Feelte or Quylte " (' Promptorium Parvulorum '), says, " The term ' felt ' appears to have signified at a very early period a material formed of wool not woven but compacted together, suitable even for a garment of defence, so that the gambeson is sometimes termed feltrum." (See GAMBESON.)

Military Flail. Meyrick Collection.

FENDACE. "A protection for the throat, afterwards replaced by the gorget." (Fairholt, ' Costume in England,' p. 499.)

FIBULA. See BROOCH.

FIGURERO. "A kind of stuff." (' Ladies' Dictionary,' 1694.)

FIRELOCK. The musquet fired by flint and steel, invented, according to Meyrick, in France about the year 1630 ; but wheel-lock musquets and pistols were, however, called firelocks long previous to the invention of the snaphaunce, which was certainly not a French invention, as Meyrick himself admits, attributing it to the Dutch. (See SNAPHAUNCE.) Flint-lock would have been a better name for this class of firearms, which, from a line I have quoted from ' Jack Drum's Entertainment ' (see DAGG), would appear to have been known as early as 1616.

FIRMAMENT. A name given to a cluster of jewellery or a quantity of pins headed with "precious stones, diamonds, and the like," worn by ladies "to make their heads shine and look in their towers (commodes) like stars." (' Ladies' Dictionary,' 1694.)

Military Flail. From MS. in Benet College Library, Cambridge.

FLAIL. " From the Latin *flagellum* and the German *flegel*," says M. Demmin, "is a weapon whose name indicates its shape." Like the falx, it was an agricultural implement converted into a weapon of war. It was known certainly as early as the thirteenth century, as the annexed woodcut is from a figure in Strutt's ' Horda Angel Kynan,' copied by him from a MS. of Matthew Paris in Benet College Library at Cambridge. M. Demmin says, " The first mention of it is found in MSS. of the beginning of the eleventh century," but he favours us with no authority. Adelung quotes an early Latin document in which the flail is mentioned under the name of *flaellum :* " Cum. ducentis hominibus in armis electis gleatis et cum flaellis." (' Fragment. Hist. Dalphin,' t. ii. p. 64 ; Hewitt, vol. i. p. 327.) It was used as late as the reign of Henry VIII., but then only in sea-fights and the trenches. Several specimens are in the National Armoury and were in the Meyrick Collection. One from the latter is here engraved. It is of the fifteenth century, and has a hook which, when inserted into a ring on the staff, keeps it from swaying about, and renders it safer to carry. "A jerk, however," remarks Sir S. Meyrick, " will in an instant disengage it, and render it ready for service."

FLANDAN. "A kind of pinner joined with a cornet." (' Ladies' Dictionary,' 1694.)

FLO. A name for an arrow.

> " Robyn bent his joly bowe,
> Therein he set a flo."
> *Sloane MS.*, 2593.

> " Gandelyn bent his good bowe,
> And set therein a flo."
> Ritson's *Ancient Songs*, p. 51.

FLOCKET. Skelton, describing the dress of Eleanor Rumming, speaks of her "furred flocket." Halliwell says it was "a loose garment with large sleeves," and that "it is spelt *flokkard* in the 'Howard Household Book.'"

FLORENCE. A cloth manufactured in that city, mentioned in the reign of Richard III.

FONTANGE. "A modish top-knot," deriving its name from Mademoiselle de Fontange, one of the favourites of Louis XIV. ('Ladies' Dictionary,' 1694.) The story goes that one day when hunting with the king the wind disarranged her hair, which fell about her shoulders, upon which she took off one of her garters and tied it up hastily with that. His Majesty was so pleased with the effect that he requested her to continue to wear her hair dressed in that fashion. Next day, of course, the ladies of the Court appeared with their hair bound up with a ribbon with a bow in front, which attained the name of a "fontange." But the fashion did not stop there. Lace was added to the ribbon, a caul or cap to the lace, a frame of wire was invented to support the rapidly-rising edifice, which culminated in the commode or tower, the bow of ribbon being still retained, and giving to the whole structure the additional name of fontange.

The fall of this tower is variously accounted for. One version recounts that Louis, disgusted at the extravagant height which the head-dresses had attained to, remarked, on the 24th October, 1699, " Cette coiffure me paroissait désagréable," and the next day, Friday, the 25th, at the Duchess of Burgundy's reception, all the ladies of the Court appeared in low head-dresses. Another is that the king to the day of his death complained that no one paid the least attention to his objections till there arrived " une inconnue, une guenille d'Angleterre " (no less a personage than Lady Sandwich, the English Ambassadress), " avec une petite coiffure basse," and that the princesses and all the ladies of the Court immediately went from one extremity to the other. All that we know for certain is that the 'Mercure Gallant,' for November 1699, observed that " La hauteur des anciennes coiffures commence à paraître ridicule ; " and that in the 'Dictionnaire de Furetière' of 1701 the fontange is described as a simple bow of ribbon, its original character. (See COMMODE.)

FOREHEAD CLOTH. A band formerly used by ladies to prevent wrinkles. (Halliwell.) A forehead cloth appears as one of the New Year gifts to Queen Elizabeth in 1578: "A night coif of cammeryk, cut work, and spangells, with a forehead cloth, and a night border of cut work with bone lace." "Found in a ditch, four laced forehead cloths." ('London Gazette,' October 1677.)

Military Forks. (See next page.)

FORK, MILITARY. The peaceful hayfork, converted like the flail and the scythe into a formidable weapon of war, is spoken of as borne by the Saxon irregular soldiery in the army of Harold II. in 1066—peasants hastily called to arms from the surrounding country, who hurried to confront the invader with the nearest implement at hand.

> " Li vilains des viles aplouent
> Tels armes portent com ils trouvent ;
> Machus portent è grans pels
> Forches ferrées è tinels."
> Wace, *Roman de Rou,* l. 1289.

The fork, once adopted as a military weapon, was used throughout the Middle Ages, undergoing certain alterations.

A fourchue à crochet—that is, furnished with a hook to catch the bridle of a horse, which could afterwards be cut by the blade substituted for one of the prongs—was in the Meyrick Collection, date uncertain, with another acting as a hallebarde, *temp.* Queen Elizabeth. Both are engraved for this work from Skelton's 'Specimens.' (See preceding page.)

FRELANGE. "Frelange, fontange, favorite." (Evelyn, 'Tyrannus, or la Mode.') (See HEAD-DRESS.)

FRET. An heraldic term applied to the reticulated head-dress or net made of gold or silver wire in which the hair of ladies in the Middle Ages was confined.

> " A fret of golde she had next her hair."
> Chaucer, *Legend of a Good Woman.*

The word was also used to describe any sort of ornament of a lattice-work pattern. " Item una tunica de samitto rubeo frestata de auro " (fretted with gold). (Ducange, under FRESTATUS, and also under FRECTÆ, where the heraldic term is derived from *fretes,* arrows placed lattice-wise.)

FRIDAL. "Fridal next upper panier set." (Evelyn, 'Tyrannus, or la Mode.') (See HEAD-DRESS.)

FRIEZE, FRIZE. A coarse woollen cloth. Frieze of Coventry is mentioned in the first year of the reign of Henry IV., 1399. It was much used by the commonalty in the sixteenth century for doublets, jerkins, and gowns. The lines made by Charles Brandon, Duke of Suffolk, on his marriage with the Queen Dowager of France, sister of Henry VIII., are no doubt familiar to many of my readers :—

> " Cloth of gold, do not despize
> To match thyself with cloth of frize.
> Cloth of frize, be not too bold,
> Though thou be matched with cloth of gold."

FRINGE. This ornamental edging to articles of apparel dates from a very early period. It was originally the ends of the threads which composed the stuffs, fastened together to prevent their unravelling, and consisted therefore of as many coloured threads as there were varieties in them ; hence all the old fringes are party-coloured, and the majority mingled with gold. It was much used in ecclesiastical vestments at the ends of the pallium, stole, and maniple, and the infulæ of the mitre ; round veils, at the lower edge of copes, and round the open sides and edges of dalmatics. (Pugin's Glossary.) Examples will be found under all those heads in this work. Fringes are not much seen or heard of in civil costume before the fifteenth century. The mention of them then becomes frequent. Fringes of Venice gold at six shillings and eightpence an ounce, and fringes of silk at one shilling and

fourpence an ounce, are mentioned in the wardrobe roll of Edward IV., at which time fringe-making had become a craft. In Hall's description of a Court masque in the reign of Henry VIII. ladies are reported to have been attired in garments like tabards, "fringed gold." In the reign of Elizabeth we hear of their wearing "fringed and embroidered petticoats." (Warner's 'Albion's England.')

Some were contented with a single row of fringe at the bottom of the garment; but others extended this finery to five or six rows one above another, and these rows they called feet; so that a petticoat of six feet was one with six rows of fringe upon it. (Randle Holme; Strutt's 'Dress and Habits.') Fringe was also much used for the ornamentation of gloves and waistcoats. "Fringe of gold for a waistcoat" at four and sixpence the ounce is an entry in an inventory of the wearing apparel of Charles II., and fringed waistcoats were in fashion during the first half of the eighteenth century. (See WAISTCOAT.)

FROCK. (*Froccus, floccus,* Latin.) Here is another word that has been applied to many different garments. Originally it appears to have been a monastic garb. The Austin Friar, censuring the pride of the Franciscans, says:—

> "In coting of their copes
> Is more cloth folded
> Than was in St. Francis' frock
> When he them first made."
> Piers Ploughman's *Creed.*

"A coat of velvet made like a frock" is said by Hall to have been worn by Henry VIII. when he met Anne of Cleves (p. 114 *ante*). Cotgrave translates frock "souquenie," which was the name of a woman's garment in the thirteenth century, and also refers to the porters' and carters' frocks of his day (1650), which was the same as the countryman's smock-frock of ours.

I need scarcely advert to the frock of a child or a young girl, or the frock-coat of a gentleman, or observe that "frock dress" upon cards of invitation to royal entertainments means neither one nor the other. Strutt considers the clerical frock to be the same as the rochet. To "unfrock" a clergyman is a phrase still in use.

FRONTLET. See HEAD-DRESS and HOOD.

FUR. Notices of various furs worn in England will be found under separate heads. They consisted principally of biche (the skin of the female deer), budge (lambskin), calabrere, cicimus, dossus, ermine, foxes, foynes and fitches (*i.e.*, pole-cats and weasels), greys or gris, jenets, lettice, leuzerns, martins, minever, sables, squirrels, wolves, and vair.

FURBELOWS. (Corrupted from the French *falbalas*.) Flounces of silk, lace, or other materials for the trimmings of dresses, scarfs, &c.

"3 yards ½ of rich silver ruff'd scollop lace falbala" was bought of John Bampton, the Court milliner, in 1693, for Mary, Queen of William III. 'The Old Mode and the New, or Country Miss with her Furbelow,' is the title of a play by Tom Durfey, and furbelow scarfs and gowns are mentioned in his collection of songs called 'Wit and Mirth.' In 1730 we read: "Furbelows are not confined to scarfs, but they must have furbelow'd gowns, and furbelow'd petticoats, and furbelow'd aprons, and, as I have heard, furbelow'd smocks too." ('Pleasant Art of Money-catching.')

In the play entitled 'Tunbridge Wells,' printed in 1727, mention is made of "furbelows with three hundred yards in a gown and petticoat."

FUSEE, FUSIL. See GUN.

FUSTIAN. A species of cotton cloth much used by the Normans, particularly by the clergy, and appropriated to some orders for their chasubles. The Cistercians were forbidden to wear them made of any material but linen or fustian. A stronger description was first manufactured in England,

at Norwich, *temp.* Edward VI. It was much used for doublets and jackets in the fifteenth century, at which time it appears to have been imported from Italy. "Fustians of Naples" are named in a petition to Parliament from the manufacturers of Norwich, 1st of Philip and Mary, 1554. The name was corrupted in England into "fustiananapes," and "fustian and apes," *i.e.* "fustian à Naples." Thus in Middleton's play, 'Anything for a Quiet Life,' 1662: "One of my neighbours, in courtesy to salute me with his musket, set on fire my fustian and apes breeches." (Act i. scene 1.)

"Fustian anapes" is also mentioned in 'The Strange Man telling Fortunes to Englishmen,' 1662. (Halliwell, *in voce.*) "Tripe de velours, *mock velvet, fustian an apes.*" (Cotgrave.) The latter interpretation is noticeable. "The fustian and apes breeches" above mentioned, would most likely have been made of mock velvet. As late as 1660 we find an entry by Pepys, "July 5. This morning my brother Tom brought me my jackanapes coat with silver buttons."

ABARDINE. (*Gaban, gallebardine, gallivardine*, French.) What is a gabardine? "A rough Irish mantle," "a horseman's cloak," or "a long cassock," according to Blount ('Glossographia'); or "a cloake of felt for raynie weather," according to Cotgrave; or the same article as "a courtpie," according to Camden. Palsgrave has "mantyll, a gaberdyne." The word does not occur in the 'Promptorium,' and is first met with, I believe, in the sixteenth century. In Shakespere's 'Merchant of Venice,' Shylock reminds Antonio that he "spat upon his Jewish gabardine," which indicates rather "a long cassock" than a cloak or a mantle. Cesare Vecellio, a contemporary, tells us that the Jews differed in nothing, as far as regarded dress, from Venetians of the same profession—merchants, doctors, &c.—with the exception of a yellow bonnet, which they were compelled to wear by order of the Government. ('Habiti Antichi,' &c.) We are, therefore, without information as to the *Jewish* gabardine, if it had any national peculiarity.

Again, according to Shakespere, Caliban, in 'The Tempest,' is supposed to wear a gabardine, as Trinculo, seeing him stretched on the ground, apparently dead, says, "The storm is come again; my best way is to creep under his gabardine." But who can tell how the monster was attired in Shakespere's time, or what Shakespere meant by a gabardine? Mr. Fairholt quotes Sir John Suckling's play, 'The Goblins,' 1641, in which one of the characters exhorts the others, "Under your gabardines wear pistols all," and this line is in favour of a cloak; but, alas! we are no nearer to identification.

GADLYNGS. The spikes on the knuckles of gauntlets in the fourteenth century. (See Gauntlet.)

GAIN-PAIN, GAYN-PAYNE. (*Gagne-pain*, "bread-earner," French.) The name given to a sword or any other weapon by which a soldier earns his bread. "Thence will the French souldier terme ofttimes his sword, and sometimes his harquebuse, 'son gaine-pain.'" (Cotgrave.) The word occurs in a poem of the fourteenth century—

"Dont i est gaigne pains nommé
Car par li est gaignies li pains."
Pelerinage du Monde, by Guigneville.

Some other weapon appears to be alluded to in a passage quoted by Halliwell from a MS. in Sion College: "After I tooke the gaynepayne *and* the sword with which I garde me; and sithe whane I was thus armed, I putte the targe to my syde." ('Dictionary of Archaic Words.') I find, however, in a MS. of the fifteenth century quoted by M. Viollet-le-Duc, that the word is applied by the writer to a little gauntlet. "Item, a la main droite y a ung petit gantellet lequel se appelle *gaigne-pain*," which perfectly explains the passage in the Sion MS.

GALLACHE, GALOCHES. (*Galage, galloche*, French; *galloza, galoza*, Italian.) This word, according to M. Guicherat ('Histoire du Costume en France'), is derived from the leathern shoes with

thick or wooden soles worn by the Gauls, and adopted by the Romans with other Gaulish fashions, under the names of *gallicæ* and *galliculæ*. The Monk of St. Gall speaks of the galliculæ worn by Charlemagne. " Galoches de bois " were worn in France in bad weather in the fourteenth century. (*Ibid.*)

Galages at 4*d.* the pair, and galages d'estreyne (close or tight-fitting ?), at the same price, are entered amongst the articles of apparel which belonged to our Henry V., and may be the sort of clog or patten seen in the illuminations of the times of Henry VI. and Edward IV. (*Vide* CLOG, and the chromolithograph of the latter sovereign receiving a book from its author, issued with Part III. of this work.)

Elyott, in 1550, has under "*solea*, a shoe called a galage or patten, which hath nothyng on the feete but oneley latchettes." Cotgrave, on the contrary, says, " A wooden shooe or patten made all of a peece *without any latchet* or tye of leather, and worne by the poore clowne in winter,"—the sabot, in fact, of the French peasant.

In the seventeenth century galaches are again alluded to as worn by the labouring classes :

> " For they be like foul wagnoires overgrast,
> That if thy gallage once sticketh fast
> The more to winde it out thou doest swinke
> Thou mought aye deeper and deeper sinke."
>
> Greene's *Ghost-hunting Conycatchers*, 1626.

In France, it would seem, they had been discarded about that date by fashionable gallants. Talle-mant de Reaux says :—" Voiture était quelquefois si familier qu'on l'a vu quitter ses galoches en présence de Madame la Princesse pour se chauffer les pieds ; " and adds, " C'étoit déjà bien assez de familiarité que d'avoir des galoches." (Guicherat, p. 474.) But in England, as late as 1665, Pepys records under the date November 15 :—" Lady Batten, walking in the dirt, dropped one of her *galloches*, which she wore over her spick and span new white shoes."

GALLIEGASCOIGNES. A sort of hose or leggings introduced from Gascony, in France. " Caligæ gallivasconiæ sic dicta quia vascones istius modi caligis utuntur." (Skinner, 'Etymologicon.') " Of the vesture of salvation make some of us babies and apes coats, others stout trusses and devills breeches ; some gallygascoyns, or a shipman's hose like the Anabaptists." (Pierce Penniless's 'Supplication to the Devil,' 1592.) " Round gascoynes " are also mentioned in the same work.

GALLOON. Worsted lace. " A jacket edged with blue galloon " is mentioned as the dress of a country girl in the reign of Queen Anne. (Durfey's 'Wit and Mirth.') Gold and silver galloon for the edging of cocked hats is also spoken of at that period.

GAMASHES. " High boots, buskins, or startups." (Randle Holme, 'Accademie of Ar-morie,' 1688.)

GAMBESON. A stuffed and quilted body-garment worn under the hauberk, but also without it, being considered a sufficient protection from the weapons of the thirteenth and fourteenth centuries.

The name, according to Meyrick, is derived from the Saxon *wambe* (the abdomen), and con-sequently called in Germany a *wambais*, since corrupted into wammes, wambeys, wambasium, gambiex, gambaison, gamboisson, gambycho, gambocio, gambison, gamvisium, gombeson, ganbeson, goubisson, and gobisson. In the Scandinavian it was called "panzar," by a similar derivation. "*Panza*, abdomen, alvus, whence *panzeria*, lorica quæ ventrum tegit." (Adelung.) (*Panse, pansière,* French.) In the 'Speculum Regale,' an Icelandic chronicle of the twelfth century, a knight is directed to wear two garments so named. He is first to put on a " blautarn panzara," one of soft linen, which should reach to the middle of the thigh (a shirt or tunic, in fact) ; then a breast defence of iron (" breost biorg ") ; above that a good byrnie or hauberk, and over all another panzar as long as the first, but without sleeves. Neither of these panzars is described as quilted ; but in the same chronicle we find " *thungarn* panzara," thick or strong panzar, which is distinguished from the *blautarn*, or soft linen panzar ; and as the advice in that instance is to wear the former, *or* a hauberk, it was, no doubt, the quilted wambais of the Germans, and the gambeson of the Normans, which, as we learn from

the 'Chronicon Colmariense,' *sub anno* 1298, was stuffed with wool, tow, and old pieces of cloth: "Wambasia, id est tunicam spissam ex lino et stuppa vel veteribus pannis consutam." The gambeson was, in fact, a similar "coat of defence" to the aketon, but not identical with it, as some antiquaries have contended; and the description given above of the four different garments—the tunic, the iron breast-guard, the hauberk, and the panzar, worn one over the other—singularly illustrates that of Chaucer two centuries later, of the equipment of Sir Topaz, more than once cited in this work: the only difference being that the stuffed haketon is next to the shirt instead of the soft linen panzar, and the surcoat, or "coat armour," takes its place over the hauberk. The gambeson is also called "propuncto," a pourpoint, in the Statutes of Fréjus, 1235, from the quilting and stitching of it. Such sort of work is consequently termed "pourpointerie," and the garments so constructed are said to be gamboised or gamboisée. Many examples of it will be referred to in this Dictionary; I shall here, therefore, give but one from a miniature of the fourteenth century (Bib. National, Paris, No. 393), in which a knight is depicted sitting undressed with his gambeson and other armour about him. (See ACTON and POURPOINT.)

Gambeson. From MS. 14th century.

GARDE DE BRAS. An additional protection (*pièce de renfort*) for the left arm, to the coude or elbow-piece of which it was fastened by straps and a screw. It was only used for jousting, and first appears about the end of the fifteenth century. The following examples are copied from various suits formerly in the Meyrick Collection, all of the sixteenth century.

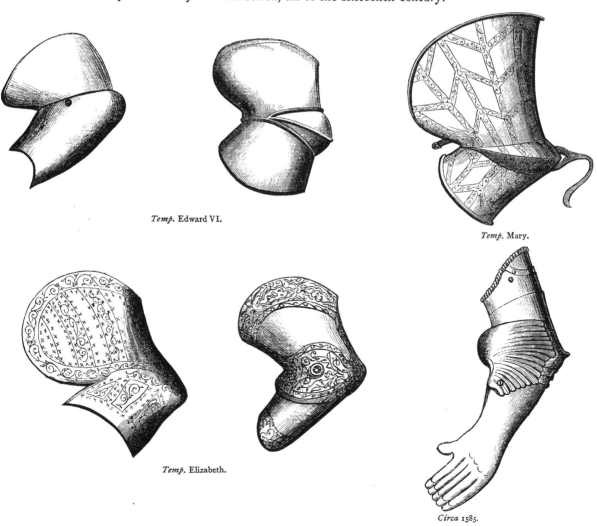

Temp. Edward VI.

Temp. Mary.

Temp. Elizabeth.

Circa 1585.

Some suits exhibit a garde de bras of smaller dimensions for the left arm. We give one (see last figure on previous page) from a suit of the sixteenth century. The gauntlet and vambrace are one piece of plate, and the fingers immovable.

Vambraces of the time of Richard III., the upper half of the cylinder overlapping the lower with so great a projection as to appear, when represented on paper, like an additional piece, more especially from being terminated by a shell-shaped protection for the bend of the arm, have been termed gardes de bras. Mr. Fairholt has inadvertently engraved one in his 'Costume in England' (p. 504), under that title. (See VAMBRACE.)

GARDE DE CUISSES. A very small plate worn as an additional protection to the thigh. Meyrick says, "It is a very rare piece of armour." There was one in his collection. There is no specimen in the Tower.

GARDE DE REINS. The same as CULETS or CULESSETS, which see. Also, for examples, see woodcut, p. 56.

GARDE (GRAND). The grand garde was a piece of plate armour, invented towards the close of the fifteenth century for the protection of the left shoulder and breast of the knight in the jousts or tournaments. It was affixed to the breastplate by three screws, and enabled the wearer to dispense with a shield. Like the garde de bras, it was only used for jousting.

Grand Garde. Meyrick Collection.

GARTER. (*Jartier, jarretier,* French, from *jarret,* the ham of the leg.) It would be difficult to give the earliest date to garters. The bandages which confined the hose of the Saxons and Normans, and are still worn in the Abruzzi and other parts of Europe, cannot fairly be ranked in the category; they have no affinity to the short garter and buckle which forms the badge of the celebrated order; while, in the absence of all proof, probability is in favour of such garters being worn by women, whose hose were in shape precisely the stockings of the present day, as will be shown under that heading. The earliest mention of them as connected with male attire that I have lighted on is in Bocaccio, who, in the second novel of the second day, tells us that Rinaldo, who has been robbed and stripped of all his apparel, even to his shoes, gets back everything but his garters, "un paio di cintolini." The 'Decamerone' was written in the reign of Edward III., and in the portrait of Cimabue, the painter, by Simon Memmi, *circa* 1300, engraved in Bonnard's 'Costumes,' both legs are gartered with gold beneath the knee—for what purpose beyond ornament it would be hard to say, as he wears the long chausses or hose which at that period ascended to the middle of the thighs, where they were attached to the drawers.

It is remarkable, however, that in all the illuminations of the fourteenth and fifteenth centuries, we never see anything like a garter in any illumination or monumental effigy, except that which is the special insignia of "the most noble order" aforesaid. In the sixteenth and seventeenth centuries they became a most prominent article of male attire. It is then we begin to hear of

Cimabue.

"Spangled garters worth a copyhold."—John Taylor the Water Poet.

Stowe says, "At this day men of meane rank weare garters and shoe roses of more than five pounds price." They were, in the time of James I., small sashes of silk, tied in a large bow, and the ends of point lace. Evelyn, in his 'Tyrannus, or la Mode,' 1661, speaks of the diamond buckles worn by women of fashion with their garters.

Garter.
Temp. James I.

Garter and Shoe Rose. From an engraving by Bosse, *circa* 1640.

GAUDICHETUM. This word occurs in the will of Odo de Rossillon, 1298, quoted by Ducange under ARMATURA, in which he bequeaths to the Lord Peter de Montancelin a complete suit of armour (" unam integram armaturam"), every article of which is separately and distinctly enumerated : "Videlicet, meum heaume à visiere, meum bassignatum, meum porpoinctum de cendallo, meum godbartum, meum gorgretum, meas buculas, meum *gaudichetum*, meas trumulieres d'acier, meos cuissellos, meas chantones, meum magnum cutellum et meam parvam ensem." With the majority of these we are well acquainted : two or three have been differently interpreted, but gaudichetum is dismissed even by Ducange, with the vague definition, "armaturæ genus." Fairholt, quoting Meyrick, suggests a body-covering like the aketon, but *perhaps* the gorget, which is not likely, as " meum gorgretum " has just previously been mentioned. Way, in his edition of Meyrick's ' Critical Inquiry,' leaves the question as he found it ; and Mr. Hewitt, the latest English writer on the subject, although he quotes the will more than once, passes over the word in complete silence. I find no allusion to it in any foreign author within my knowledge, and, what is more remarkable, it has not hitherto been found in any other document. The absence of any mention of a "haqueton," or "gambeson," to be worn under the armour, the "pourpoint of cendal" being evidently the outer garment, gives probability to Meyrick's suggestion, that gaudichetum (gaudichet) was a body-covering of that description, if not indeed one of them under some local name.

GAUNT, CLOTH OF. The city of Ghent, or Gand, in Flanders, commonly spelt *Gaunt* in the Middle Ages, was celebrated very early for its cloth and linen manufactures, as, indeed, were most of the Flemish cities before the thirteenth century. I have already quoted under DIAPER the lines from Chaucer's ' Wife of Bath :'

> " Of cloth-making she had such a haunt,
> She passed them of Ypres and of Gaunt."

GAUNTLET. (*Gand,* glove, French.) Gauntlets make their appearance in the reign of Edward I. ; previously to that period the hands were protected by the ends of the sleeves of the

Gauntlets of Leather. From effigy of Dubois.

hauberk, which were made long enough to cover the tips of the fingers, having an oval-shaped aperture, through which the hand could be withdrawn at the wearer's pleasure. (See HAUBERK.) When the sleeves were subsequently made to terminate at the wrist, gauntlets of leather, the exterior coated with scales or other formed pieces of plate, became indispensable. Some of leather only are seen on the effigy of Dubois, engraved by Stothard, and in the mutilated effigy in St. Peter's, Sandwich.

Scaled Gauntlets from brass of Sir R. de Burlingthorpe.

An example of the scaled gauntlet is given from the brass of Sir Richard de Burlingthorpe, *circa* 1310, engraved by Waller in his beautiful work on Brasses. Mr. Waller suggests, that the scales may have been of horn or whalebone. They are without tops, or, as we should now call them, cuffs.

Three views of a leather gauntlet coated with a vambrace of cuir bouillie are here engraved from a copy of M. Viollet-le-Duc of an example in a MS. of the thirteenth century, and show the method of securing the vambrace to the hand and arm by straps and buttons.

Leather Gauntlets. From Viollet-le-Duc.

Later all the gauntlets have cuffs of more or less depth ; the hand, from the wrist to the knuckles, is covered with a plain piece of steel, and the fingers with articulated pieces. In the reign of

Gauntlet. Edward the Black Prince.

From the brass of Sir John Quintin.

Edward III. sharp points of steel, called "gadlings," are placed on every knuckle. A fine specimen exists in the gauntlet of the Black Prince, suspended over his tomb in Canterbury Cathedral. On some of the knuckles are small figures of lions. The gauntlets on his effigy have no lions.

In the reign of Henry IV. a new fashion makes its appearance. The gauntlets, of which the articulated fingers are alone visible, are additionally defended by a single plate enclosing them from the edge of the cuff to the knuckles with richly engraved borders. The brass of Sir John St. Quintin, at Bransburton, Yorkshire, 1397, affords us a most instructive example, as the position of the right hand distinctly shows the form of the plate on the inner side, and the edge of the gauntlet appears between those of the steel covering. The effigy of his wife presents us with similar terminations to her sleeves, producing the same effect, though of course with very different materials. (See SLEEVE.) Another instance of this fashion occurs in the brass of a knight in South Kelsey Church, Lincolnshire, engraved in Mr. Hewitt's work, vol. iii. p. 400, and dated by him about 1420. The mitten-like covering is plainer, having only an ornamental border round the cuff, and, but for the St. Quintin brass, would have been inexplicable to us.

From brass of a Knight in South Kelsey Church.

From this period we are enabled to illustrate this article from existing specimens, which I have preferred, as on other occasions throughout this work, to select from Skelton's engravings of the dispersed Meyrick Collection, believing that the public cannot be too generally made acquainted with the loss the country has sustained through "the penny wise but pound foolish" conduct of the Government, to whom it was offered on the most advantageous terms.

To the above must be added a close gauntlet, of the time of Henry VIII., for the right hand,

Gauntlet worn by Henry Prince of Wales, (date 1610), From the Meyrick Collection.

which is so contrived that the sword could not be wrested out of it, and long gauntlets of the times of Elizabeth and of Charles I., formerly in the Meyrick Collection.

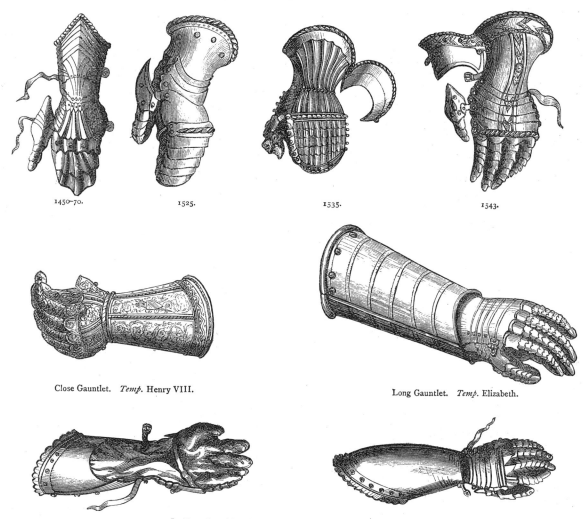

1450-70. 1525. 1535. 1543.

Close Gauntlet. *Temp.* Henry VIII.

Long Gauntlet. *Temp.* Elizabeth.

Inside and outside of Long (or Elbow) Gauntlet. *Temp.* Charles I.

An elbow-gauntlet of the same period, made after an Oriental pattern, and long buff gauntlets of the time of Charles II. and the Commonwealth, will be found under ELBOW-GAUNTLETS. (See Plate IX. for a finely engraved and gilt right-hand gauntlet made for Henry, Prince of Wales, son of James I., also in the Meyrick Collection.)

GAVELOCK, GAVELOCES, GAVESLOTUS, GAVELOT. "A species of javelin, but sometimes with a double axe at its head." (Glossary to Meyrick's 'Critical Inquiry,' vol. iii.) Matthew Paris, *sub anno* 1256, says, "Frizones igitur ipsum Willelmum cum *jaculis quæ vulgariter gaveloces* appelant, quorum maxime notitiam habent et usum, Danisque securibus et gesis hostiliter insequuntur."

> "Gaverlos et maches li ruent
> C'est merveilles qu'ils ne le tuent."
> *Roman de Robert le Diable.*

> "Et mainte gaverlot pour lancier."
> *Roman de Cleomades.*

In a letter remissory, dated 1377, occurs the following—"Lequel couvreur print une fourchefiere et son filz un demi-glaive ou gavelot;" and in another, dated 1455, "Icellui Brumin de son gavrelot fery

Philipot en la cuisse, et la perça tout ultre." Another says, "Gravelot, javeline que l'on appelle en pais (Flanders) *gaurlot.*" There is nothing in the above quotations which supports the assertion of Mr. Way, that the gavelock sometimes had a double axe at its head. It would seem that he had confused the "gaveloces" mentioned by Matthew Paris with the "Danisque securibus" which precedes it. It is certainly called a demi-glaive in the fourteenth century; but that expression does not signify a double axe. (See GLAIVE.) It was, in my opinion, a broad-bladed javelin, which could pierce as well as cut; but we have no trustworthy graphic illustration of it. In Alfric's 'Vocabulary' it is spelt *gafelucas,* and distinctly the term for a spear, "hastilitia."

GAZZATUM. A fine species of silk or linen, apparently what we now call gauze, and conjectured to have received its name from Gaza, in Palestine, where it was manufactured. With other delicate stuffs, it was prohibited to the monastic orders. "Brunetam nigram, gazzatum et alium quemcunque pannum notabiliter delicatum, interdicimus universis." (Concil. Baden, 1279.)

GENOUILLIÈRES. Knee-pieces. Like the coudes, or elbow-pieces, they were introduced as additional protections in the military equipment during the thirteenth century. The earliest of these knee-caps were apparently of cuir bouillie, succeeded by plate. Some of gamboised stuff, extremely ornamental, are seen at the commencement of the fourteenth century.

The knee-pieces are so intimately connected with the cuisses (thigh-pieces), and the greaves, jambeaux, or bainbergs, protections for the legs, that for examples later than the thirteenth century we must refer the reader to those articles, limiting our illustrations of the present to the earlier specimens.

Where the hauberk is so long as to reach to the knee, or nearly so, as in some of the effigies in the Temple Church, it is difficult to decide whether the coverings of the knees are simply caps or portions of the leathern breeches of which we have given an example from one of those effigies at page 95. It is very probable, indeed, that the caps were affixed to them as an additional protection; but where the hauberk is shorter, and the knees entirely visible, the genouillières present themselves first as round plates, slightly convex, and only just covering the point of the knee, as we have seen in the case of the coudes, or elbow-pieces (see page 138).

The first of the examples annexed is from the effigy of a knight in Salisbury Cathedral, supposed to be that of the second William Longuespé, slain at the battle of Massoura, in 1250. The effigy is of some twenty years' later date. The next specimens are from the brass of Sir John d'Aubernon, at Stoke d'Aubernon, Surrey, 1277. The knee-caps here are not simple roundels or disks, but embrace the whole knee, and are richly ornamented. The two following are of the fourteenth century, and also embrace

Genouillière. From effigy of William Longuespé, 1250-70.　　Brass of Sir John d'Aubernon, 1277.　　Lord Fitzalan, 1302.　　Sir John Giffard, 1358.　　Genouillière, connecting thigh and leg pieces, 1370.

the whole knee. The first is from the effigy of Brian Lord Fitzalan, of Bedale, in Bedale Church, Yorkshire, who died in 1302. It is evidently intended to represent plate, and is ornamented with two shields. The lower edge of the knee-cap has a belt or border with studs, and the upper one was

no doubt equally so encircled, but the hauberk descends an inch or two over it, and we can therefore only judge by analogy and comparison with those of Sir John d'Aubernon. The second is from the brass of Sir John Giffard, Bowers Giffard, Essex, 1358. These genouillières are of a new type, and their form rather difficult to understand from the drawing. He has thigh-pieces of gamboised leather, and it is doubtful whether they cover the knee and terminate in the escalloped edging below the genouillière, here assuming the shape of a rose (a return to the old fashion), or whether the edging is a portion of the genouillière itself, in which case the whole is pourpointerie. The gradual introduction of cuisses and greaves or jambeaux of plate connected with the knee-piece, and so forming a complete defence of steel for the leg, from the mid-thigh to the ankle, renders it necessary (as previously observed), in order to avoid repetition, to refer the reader to CUISSE and JAMB for examples of the fifteenth, sixteenth, and the first half of the seventeenth centuries, after which armour for the legs was abandoned. (See ARMOUR and GENERAL HISTORY, where they will be found partaking of the general character of the armour of the time.)

GIPICIERRE. (From *gibier*, game, French.) Originally, no doubt, the game-bag of the sportsman; but later, the term appears to have been applied to a purse generally, as in the case of aulmonière, which certainly was in the first instance a bag to contain alms. A fine specimen of a gipicierre of cuir bouilly, of the fourteenth century, is or was in the collection of Mr. C. Roach Smith, and has been engraved by Fairholt for his 'Glossary.' In the 'Livre de Chasse' of Gaston Phœbus there is no example of a pouch or purse differing in size or character from those generally worn in the Middle Ages, so much as would enable one to pronounce it a game-bag. In the group of huntsmen engraved at page 31 *ante*, from that MS., one of the foremost has a gipicierre similar in form to that of Mr. Smith's, with a broad-bladed knife stuck through the straps of it, the usual fashion in the fifteenth century. (See figures at page 31; also under AULMONIÈRE and PURSE.)

Gipicierre of the 14th cent. In the Collection of C. R. Smith, Esq.

GIPON, GUIPON. See JUPON.

GIRDLE. I have thought it better to distinguish the waist-belt of civil costume from the sword-belt, with which, as well as the belt of knighthood, it is mixed up by some French authors under the general heading of *ceinture*.

To "gird the loins" is a custom as old, of course, as garments themselves; but in this part of our work we have only to speak of the varieties of that simple and indispensable article which the progress of art and the caprice of fashion introduced during the six or seven centuries following the death of Edward the Confessor and the Norman invasion.

The girdles of the Saxons and Normans, as we see them depicted in illuminations or needle-work tapestry, present no peculiarity of form or ornament, but those of persons of distinction were of the costliest materials, and occasionally ornamented with jewels, as we learn that Charlemagne's was; and though Eginhart is then speaking of the belt in which the emperor wore his sword, it must be remembered that in those days the baltheus served the double purpose of a sword-belt and a civil girdle, and at all events the one worn without the sword would be equally splendid. The costume of the Saxon females, as represented in the drawings of the time, affords us no opportunity of observing their girdles; but in the Danish ballad of Ingefred and Gerdrune ('Kæmpe Vizer,' p. 662), mention is made of Ingefred's "golden girdle," and in the poem on Boewolf it is said :

"Waltheow came forth,
The Queen of Hrothgar;
 * * *
Encircled with gold she went,
The Queen of the freelike people,
To sit by her lord."

We may fairly presume, from the general similarity of the dress of the Franks, the Saxons, the Danes and the Normans, that what we read on such matters about one nation is tolerably illustrative of the habits of the others.

It is in the twelfth century, however, that we first acquire ocular demonstration and comprehensible information respecting girdles. The effigies of our early Norman sovereigns and their consorts at Fontevraud and in England are very full of detail and of undoubted authority. Berengaria, Queen of Richard I., wears an ornamented girdle, one end of which, having passed through the buckle, hangs down in front below the knee,—a fashion of which there are examples, we shall find, to the seventeenth century. To the girdle is appended a small aulmonière, one of the earliest instances.

Berengaria, Queen of Richard I.

The girdle of King John's effigy in Worcester Cathedral was gilt; and in an inventory of the jewels belonging to him, mention is made of a belt or girdle wrought with gold and adorned with gems.

The author of the 'Roman de Garin' describes his hero as clad in a bliaut of samite, with what Mr. Strutt translates "a girdle with great fillets of fine gold and precious gems attached to it;" but the original reads "*baudre,*" and a baldric, as I have endeavoured to show, is not a waist-belt. A more dependable quotation is made from Matthew Paris, who, under the date 1234, mentions amongst the presents made by Henry III. to the King of France, girdles of silk with gold buckles: "Firmacula aurea *cingula* serica."

The subjoined examples are from the brasses of Chief Justice Sir Richard Willoughby, Willoughby Church, 1329; Sir Simon de Felbrigge, in Felbrigg Church, Norfolk, 1351; Robert Atteleath, in St. Margaret's Church, Lynn, Norfolk, 1376; and Thomas Bokenham, St. Stephen's Church, Norwich, 1460.

In the reign of Edward III. girdles (*ceintures*) ornamented with gold or silver are strictly prohibited to all persons under the estate of knighthood, or not possessed of property to the amount of two hundred pounds per annum. Those who came within the latter class were permitted to wear girdles "reasonably" embellished with silver. Similar prohibitions respecting the ornamentation of girdles with gold, silver, or silk, are found in all the sumptuary laws down to the sixteenth century.

Brass in Willoughby Church, of Sir Richard Willoughby, Chief Justice, 1329.

Sir Simon de Felbrigge, Felbrigg Church, Norfolk, 1351.

Robert Atteleath, St. Margaret's Church, Lynn, 1376.

Thomas Bokenham, St. Stephen's Church, Norwich, 1460.

A portion of a stamped leather girdle of the end of the fourteenth century, in the museum of

Charles Roach Smith, Esq., is here engraved. Fairholt conjectured it to be " one of the caddis leather girdles so often mentioned as manufactured at Cadiz of English leather." (' Hist. Cost.,' p. 508.)

Girdle of Stamped Leather. 14th century.

Piers Ploughman reproaches the priests of his day (fourteenth century) with wearing girdles of silver, and the Ploughman in Chaucer's 'Canterbury Tales' is equally severe on their

> " Chaunge of clothyng every daye,
> With golden gyrdles great and small."

Girdles were, however, a prescribed portion of the costume of the clergy when vested for service. They were put on after the alb when vesting for mass. A bishop's girdle had a double sash depending from it (Durandus), now worn only by the Pope. Riculfus, Bishop of Helena, bequeathed to his church, A.D. 916, five girdles, one with gold and precious stones, four others with gold. Falco, Judge of Bisegli, gave to the church of St. Margaret a girdle of red hair. (Pugin's Glossary, p. 136.)

Pope Boniface VIII. was found in his tomb with his rochet girt about with a belt of leather covered with red silk, with four cords of red silk depending from it. The inventories of St. Paul's and Canterbury Cathedrals contain several descriptions of girdles.

From brass of
Lady Pennebrygg.

The Serjeant-at-law in the 'Canterbury Tales' is described as wearing a girdle of silk, barred or striped with different colours ; while the Haberdasher, Carpenter, Weaver, Dyer, and Tapestry-worker, all members "of a solempne and a great fraternitye," had, in contempt of the sumptuary laws, their girdles neatly ornamented with silver. As we advance into the fifteenth century the examples multiply, and the progress of art affords us more distinct and faithful information respecting the details.

The brass of Lady Pennebrygg in Shottesbrooke Church, Berkshire, who died in 1401, presents us with a beautiful specimen. The girdle is fastened in front after the fashion of " the garter" and the military belt of that period, and the long pendant is terminated by a tastefully designed shape. Other examples are subjoined from various sources.

1. 2. 3.

1. From the brass of Anne Whytyng in Kentisbere Church, Devon.
2. From tapestry formerly in the possession of Ady Repton, Esq., date about 1490. A cord of yellow and red silk, with jewelled ornaments.
3. Brass of the wife of Robert Rugge in St. John Maddermart Church, Norwich, 1558. Her girdle appears to have been of silk, tied round the waist, the ends drawn through gold annulets, giving them the form of tassels.

For the broad belts and buckles of the ladies' dresses in the second half of the century, we must refer the reader to the article GOWN. They were more like what we should call waistbands

than girdles, and examples of many varieties of girdles worn by persons of all classes will also be seen throughout this work. A singular fashion of girdles and baldrics, having bells and other orna-

mental objects appended to them, appears in the male costume of the fifteenth century (see p. 30), and a splendid example of the reign of Henry VIII. at page 24, under AULMONIÈRE. To the girdle were attached the purse and dagger, the rosary, the pen and inkhorn, and occasionally books, according to the position or profession of the wearer. (See figure annexed from the fine MS., 'Le Roman de la Rose,' we have so often quoted.) "Let your book at your girdle be tyed," is the advice of Hypocrisy in a poem called 'Lusty Juventus,' quoted by Mr. Fairholt. "A velvet gyrdle" and "one lether girdle" are entries in the inventory of the goods and chattels of Sir Thomas Boynton, Knight, taken 28th February, 1581. "As good a man as was e'er girt in a girdle." ('Two Angry Women of Abingdon,' 1599.) "May my girdle break if I fail," was a familiar expression in the mouths of persons of that period, arising, as Mr. Fairholt observes, from the custom of the purse being suspended from it.

Throughout the sixteenth century girdles of all descriptions are constantly seen in paintings, and alluded to by writers. We have less of them in the succeeding century, but they were still worn by ladies; and in the inventory of female apparel, dated 1707, which I have quoted at page 160, are the following entries:—"3 plain girdles," "1 silver girdle and stomacher." On the abolition of the latter article waist-belts and sashes came again into use, and

'Roman de la Rose.' Harleian MS. 4425.

have lately been more fashionable than ever.

GITE, JETT. A name of which the derivation is unknown, and which first appears in its Low Latin form of *ghita* in the reign of Edward III., 1348: "Two ghita for the Lady Joan, one of green long cloth, of the suit of her robe, worked, with a rosary, and within it brute men and brute animals. The other ghita of long black brown cloth, worked, with gold circles, and within each circle a lion couchant; and a third ghita powdered throughout with gold leaves." The gite has been hitherto considered a gown. "They had also about this time a kinde of gowne called a *git.*" (Camden's 'Remaines,' p. 196.) Git or jet is, however, the word which is used by writers of the fifteenth century to express what we should call a caprice, a fashion:

"Also there is another new jett,
 A foul waste of cloth and excessive:
There goeth no less in a man's tippet
 Than a yard of broad cloth, by my life."
 Occleve, *Pride and Waste Clothing of Lorde's men.*

The word jett is here certainly not used to express any particular garment whatever. It can only be understood in the sense of a new whim or invention, while the ghita is as evidently a garment of some sort; and as those described above were ordered to be prepared for the marriage and *voyage* of the Princess Joan, fourth daughter of Edward III., and one of them to be "of green long cloth, of the suit of her robe," they were probably cloaks or mantles, so called, being of a new fashion. The 'Promptorium Parvulorum' has "GET, or manner of custome. *Modus, consuetudo;*" and in a note by Way are the following quotations. Palsgrave gives "gette, a custom; newe jette, *guèse nouvelle.*"

In a poem on the dissolute lives of the clergy in the reign of Edward II. ('Political Songs,' ed. Wright, p. 329), some, it is said,

"Adihteth him a gay wench of the newe jet."—line 118.
"Yit a poynte of the new gett to telle will I not blyn
Of prankyd gownes and shulders upset, mos and flockes sewyd wythin."
Townley Mysteries, 342.

Chaucer says the "gay pardoner" thought he rode "all of the newe get," or fashion, and he also uses the word in the sense of crafty contrivance, where he relates the deceit practised by the alchemist by means of a stick filled with silver filings :

"And with his stikke above the crosslet,
That was ordained with that false get,
He stirreth the coles."
Promptorium Parvulorum, page 191.

Mr. Way has, however, apparently overlooked that Chaucer also tells us that the wife of the miller of Trompynton followed her husband on holydays "in a gyte of *reed*" (red), and that the Wife of Bath boasted that on similar occasions she put on her "gay *skarlet* gytes." In both of these instances he assuredly alludes to the dresses themselves, and not to the novelty of their fashion. The question remains, therefore, nearly as we found it.

GLAIVE. (*Gleef,* German.) A broad-bladed cutting weapon at the end of a long staff, deriving its name, according to Meyrick, from the Welsh *cleddyv,* a sword, in which sense it is as frequently used by the Picts as the word "brand." It appears, indeed, to have been applied in the Middle Ages to any description of trenchant weapon, and great confusion has resulted from it, which I must endeavour to dispel. The Welsh name for it was *llanvaur,* literally "the blade weapon ;" and that it was originally the national weapon, and considered so to the close of the fifteenth century, is fairly proved by the fact that in the first year of the reign of Richard III. (1483) an order was issued by Nicholas Spicer for the impressment of smiths for making two hundred Welsh glaives (Harleian MS., No. 443), and twenty shillings and sixpence was charged for thirty glaives with their staves made at Abergavenny and Llanllolvr. M. Demmin classes the glaive with the war-scythe (the falx or fauchart), the guisarme, and the bill, and gives woodcuts of what he denominates "glaive guisarmes" and "guisarme bills," apparently overlooking the fact that the glaive and the bill have no affinity to the fauchart or war-scythe, the sharp edge of the latter being on the inner side of the curve, while that of the two former weapons, in conformity with the sword and the axe, *their* prototypes, is on the outer. M. Viollet-le-Duc, who engraves an undeniable bill in company with other blade weapons in illustration of FAUCHART, says under GLAIVE, on the authority of Froissart, that it was a name for a lance, also that during the twelfth and thirteenth centuries the name "glaive" was understood to signify a lance : "S'entend aux xiie. et xiiie. siècles comme lance ;" and that later, towards the end of the fourteenth century, the name of glaive was given to the sword as well as to all trenchant weapons. The sword, as I have already stated, was, in poetical phraseology, certainly called a glaive ; and it is possible, considering the way in which names were bandied about in those days, that the lance may have been similarly treated ; but the quotations M. Viollet-le-Duc brings in support of his views are by no means conclusive, and even if they were, they could not assimilate forms, and the lance would remain as distinct from the glaive as a fork from a knife, whatever you might please to call them. But his definition is most extraordinary : "La glaive est en effet le poignard, l'épée courte emmanché au bout d'un bâton, et la lance prend le nom de glaive quand son fer s'allonge portant deux tranchants." If it ever did so, it was certainly no longer a lance ; but where is the proof of this transition ? I admit Froissart says (tome i. p. 529), "Et consuit un castellan de son glaive si roidement qu'il lui perça toutes ses armures et lui passa la lance parmi le corps," by which I understand the blade (*la lame*) of the glaive, not that the glaive in the least resembled a lance, or that they were one and the same weapon. A thrust of a blade with so sharp a point as the glaive possessed, as late even as the reign of Henry VII. (see examples below), would have made a ghastly wound in a man's body ; but the

best proof that they were totally distinct weapons, however capriciously named, is that glaives are invariably distinguished from all others by the authors of the Middle Ages.

1. Glaive, *circa* 1395: Viollet-le-Duc. 2, 3. Demmin. 4. Glaive: Harleian MS., 4374; 15th cent. 5, 6. *Temp*. Henry VII.: Meyrick Collection.
7, 8, 9, 10. Glaives, *temp*. Henry VIII.: Meyrick Collection. 11. Venetian, 1550. Ibid.

"Touz ses parents et touz ses hommes
Saillent à lances *et* à glaives."

Meraugis de Portlesquez, 13th cent.

M. Viollet-le-Duc, who himself quotes the above lines, would have us understand that "glaives" here signifies "swords;" but what says Chaucer?

"And whet their tongue as sharp as sword *or* glaive.

Again, in the 27th Coventry Mystery we have the line:

"With axes, glaives, *and* swords bright;"

and as late as the reign of Elizabeth, in the play of 'Arden of Feversham:'

"O mistress! the mayor and all the watch
Are coming towards our house with glaives *and* bills."

Surely it will not be said that these writers of the thirteenth, fourteenth, fifteenth, and sixteenth centuries were ignorant of weapons as familiar to their sight as those of the present day are to ours, and yet we find them in their several instances clearly distinguishing the glaive from the lance, the sword, and the bill. (See further under LANCE and SWORD.) The Llanvaur, or blade weapon of the Welsh, composed of a sword (*cleddyv*) attached to the end of a staff, whenever first introduced, retained its unmistakeable features till late in the fifteenth century, towards the close of which the lateral spikes and projections, the former suggested by the guisarme and the latter by the bill or the halbard, were, it would appear, gradually added. In the sixteenth century they were richly engraved, and, while still preserving their sword-like form, so elaborately ornamented that we find them more used for processional splendour than actual warfare. After the reign of Elizabeth they are seen no more except in armouries, of which they form a most effective feature.

GLAUDKYN. Mr. Strutt considers this to have been a species of gown. It is often mentioned in the inventory taken in the eighth year of King Henry VIII., but Strutt observes that "either the garment went out of fashion soon, or was called by another name at the latter part of his reign, as it is not specified by that denomination in the wardrobe accounts then made." (Vol. ii. p. 249, ed. 1842.) His second suggestion is, probably, the more correct. The instances of such changes are common; many are commented upon in this work, and multiply seriously the difficulty of its compilation.

"Twenty-one yards and a quarter of white cloth of silver, cut and pointed upon cloth of gold, with a border of the same richly embroidered," were allowed "for a glaudkin with wide sleeves for the king's grace, and the same quantity of yellow cloth of gold upon satin for the lining of the same glaudkin." (Harleian MS., No. 2234.) The wide sleeves and the magnificence of the materials for the lining, as well as for the exterior, certainly tend to support Mr. Strutt's opinion that the glaudkyn must have been an outer garment of some description, opening in front, so that the lining would be seen. I can only concur with him in that opinion, having as yet found nothing that could throw a light on the subject.

GLIBB. A long lock of hair worn over the forehead by the ancient Irish, and prohibited by an Act of Parliament, 30th Henry VIII., 1539.

GLOVE. Gloves do not appear to have been worn in England before the end of the tenth or beginning of the eleventh century, and their manufacture would seem to be at that period specially German, as five pair of gloves made a considerable part of the duty paid to our English sovereign, Ethelred II. (979–1016), by a society of German merchants, for the protection of their trade in this country ('Leges Ethelredi,' apud Brompton); a proof, as Mr. Strutt justly observes, of their great rarity and consequent limitation to the most exalted personages. The long sleeves of the gowns supplied their place by being brought over the hand, and the cloak or mantle was made to answer the same purpose. Something like a glove is seen on the left hand of a female in the MS. called 'Abbot

Elfnoth's Book of Prayers,' presumed to be of the close of the tenth century. It has a thumb, but no

separate fingers, and is painted blue in the miniature. A pair of similar gloves occurs in a MS. about the time of Henry I., having long streamers depending from them, in accordance with the preposterous fashion of that period. It is remarkable that no gloves are visible in the Bayeux Tapestry; not even on the hands of Harold, who, in one compartment, is depicted carrying a hawk. Wace, the Norman poet, in his 'Roman de Rou,' tells a story of Raoul Taisson, Lord of Cingueleis, playfully striking William, Duke of Normandy, with his glove previously to the battle of Valesdune, in 1047; and in 1066 the gloves of Conan, Duke of Brittany, were poisoned at the instigation, it is strongly suspected, of the unscrupulous Duke William aforesaid: but it is certainly not before the thirteenth century that gloves became generally worn in England. At the commencement of it, Ordericus Vitalis records that Ranulph Flambard, the execrable Bishop of Durham—who, on the death of his patron, William Rufus, was arrested and imprisoned in the Tower of London by order of the new king, Henry I.—contrived to escape from confinement by lowering himself by a cord which he had fastened to a mullion in the centre window of the tower, but, having forgotten to put on his gloves, his hands were excoriated to the bone.

The same author also tells us that in the latter part of the century the young Normans covered their hands with gloves too long and wide for doing anything needful. The effigies of Henry II. and Richard I., at Fontevraud, display gloves with jewels on the back of them, in accordance with the account given by Matthew Paris of the

Cotton. MS. Nero, C iv. *Temp.* Henry I.

funeral of Henry II., 1189, on which occasion the body was arrayed in his coronation robes, having a golden crown on his head and gloves on his hands, &c. King John's effigy at the same place, and also that at Worcester, where he was buried, have the jewelled gloves, and, what is of more importance, such were found on his hands when his coffin was opened in 1797.

Jewelled gloves were also worn by the dignified clergy. They appear to have been of white silk or linen, and beautifully embroidered. Bruno, Bishop of Segni, says they were of linen, assigning as a reason that the hands which they cover should be chaste, clean, and free from all impurity, as if silk would not have been equally appropriate. This statement is only

The Gloves of William of Wykeham.

to be received as an example of that passion for symbolizing which has been so detrimental to the cause of truth and obstructive in the progress of inquiry. The gloves of Boniface VIII. were of white silk worked beautifully with the needle, and ornamented with a rich border studded with pearls (Bzovius apud Georgium); and those which were worn by William of Wykeham, and are still preserved at New College, Oxford, are of red silk, with the sacred monogram, surrounded by a glory, embroidered with gold on the backs. I append an engraving of them, from a drawing kindly made for me by a lady. "At what time it became the custom for the colour of the gloves to be changed according to the colour of the vestments is not known." (Pugin's Glossary, p. 137.)

Effigy of King John.

Painting on wall.
13th cent.

In one of those most instructive authorities, the paintings formerly on the walls of the old Palace of Westminster, to which I have so frequently referred, is the figure of Antiochus seated on his throne, in his royal robes, and on his hands are long white gloves reaching half-way up the forearm, with a broad stripe of gold embroidery down the back from the top to the knuckles. They fit the arm tightly.

When the tomb of Edward I. at Winchester was opened in 1774, jewelled gloves were found on his hands, and gloves had come into general use in the fourteenth century amongst the better classes, who were accustomed, according to Mr. Fairholt, to carry them in their hands. They are certainly so represented in the annexed group from the MS. of San Grael in the Royal Collection, British Museum, marked 14 E 3, and apparently of the time of Edward II.

Royal MS. 14 E 3. *Temp.* Edward II.

It is not, however, till the sixteenth century that we find constant allusions to and frequent representations of them in portraits. Several interesting specimens also exist in public and private collections, both here and on the Continent. Gloves were customary New Year's gifts in the sixteenth century, but being more expensive than all could afford to purchase, money was given instead, which was called " glove-money." Sir Thomas More, as Lord Chancellor, having decided in favour of a Mrs. Croaker in a suit against Lord Arundel, the lady, in token of her gratitude, presented Sir Thomas on the following New Year's Day with a pair of gloves containing fifty angels. "It would be against good manners," said the Chancellor, "to forsake a gentlewoman's New Year's gift, and I accept the gloves ; the lining you will be pleased to bestow elsewhere." Hall, the chronicler, in his description of a tournament in the reign of Henry VIII., says, "One ware on his head-piece his lady's sleeve, another the glove of his dearlyng."

The practice of wearing portions of ladies' attire in men's hats or on their helmets has been already noticed under other headings, and an excellent example is afforded us by the portrait of Clifford, Earl of Cumberland, who wears in his hat a lady's glove. (See HAT.)

Lyly in his 'Alexander and Campaspe," 1584, alludes to it :—

> *Parmenio.* " Thy men are turned to women, thy soldiers to lovers, gloves worn in velvet caps instead of plumes on graven helmets."

"Twelve pare of gloves" is an entry in Sir Thomas Boynton's inventory, 1581.

In the Museum at Saffron Walden is preserved a beautifully embroidered lady's glove of this

Glove of Mary Queen of Scots.

period, said to have belonged to the unfortunate Mary Queen of Scots, and to have been given by her on the morning of her execution to one of the Dayrell family. It is engraved in the illustrated Catalogue of the Musum, 8vo, Saffron Walden, 1845. (See cut annexed.)

The tops of the men's gloves were sometimes of red leather, the rest being white : "Hark you, mistris ; what hidden virtue is in this glove that you should bid me weare it ? Is't good against sore eyes, or will it charm the tooth-ache ? Or are these red tops being steept in white wine soluble, will 't kill the itch ? . . . If it have none of these, and prove no more but a bare glove of halfe-a-crown a pair, 'twill be but halfe a courtesy." (Beaumont and Fletcher, 'Scornful Lady,' 1616.) "Five or six pair of the white innocent wedding gloves" are mentioned by Dekker in his 'Untrussing of the Humorous Poet,' 1599. In Jonson's comedy 'The New Inn,' a gallant speaks of his gloves as "the natives of Madrid." They were highly perfumed and richly embroidered with gold and silver.

The short sleeves of the ladies' dresses in the reign of Charles II. introduced the long kid glove,

which continued fashionable till within my recollection. "Gloves trimmed and laced as fine as Nell's," are mentioned by Evelyn in his description of a lady's toilette; also "Twelve dozen *martial* whole and half" (*i.e.* short and long), and

> "Some of chicken skin for night,
> To keep her hands plump, soft, and white."

Long gloves are seen in the portrait of Mary, queen of William III., by Vischer. "1 pair of thred gloves" occurs in the inventory of a lady's wardrobe, in 1707. Bickerstaff, in 1710, speaks of the fringed gloves worn by the gentlemen at that time. The fringe and the tops disappeared before the middle of the century, and little or no alteration in form has since taken place in men's gloves. Appended are specimens of gloves of the seventeenth century; for those of the first half of the eighteenth century, see woodcuts, p. 116.

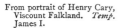

| From portrait of Henry Cary, Viscount Falkland. *Temp.* James I. | From portrait of Thomas Cecil, 1st Earl of Exeter, by Jansen. 1621. | From portrait of James, Marquis of Hamilton, by Van Somer. 1624. | From portrait of Henry Wriothesley, Earl of Southampton, by Mirevelt. 1624. |

GODBERT. (*Godbertus, Godebertus,* Inf. Latin.) Another name for the hauberk, according to some glossarists. It is mentioned in the will of Odo de Rousillon, quoted at page 199; and in an account, dated 1336, quoted by Mr. Albert Way (Meyrick's 'Critical Inquiry,' 2nd ed.), occurs, "Item duos godebertos *de mayllia,* valoris vi*s.* gross," which undoubtedly shows that they were military garments of some description; but, on the other hand, we find in the accounts of Etienne de la Fontaine, the French king's silversmith, dated 1351, this item, "Pour une foureure de dos de lièvres de Norrwie a fourrer une godebert a Maistre Jean le fol," which as certainly was not a military garment, and in another account at Paris, "Item, godebert de Lorillac, *obole* la pièce." Now, when we look at the extremely small value of these articles, it is impossible to believe they could have been of such importance as a hauberk or garment of any size; and the one lined or edged with Norwegian hares' fur for Jean le fol, proves, I think, that "godebert," which Mr. Way translates literally "good protection," was the name for some article of civil as well as military costume, forming an additional defence for the neck or chest from the cold when lined with fur in the former, and from the lance when composed of mail in the latter.

GODENDA, GODENDAC, GODENDARD. A Flemish weapon particularly described by Guiart in the twelfth century. Literally, "Good day."

> "Tiex baston qu'il portent en guerre
> Ont nom 'godendac' en la terre.
> *Godendac,* c'est '*bon jour*' à dire,
> Qui en François le veut decrire
> Cil baston sont long et traitis
> Pour ferir à deux mains faitis.
> Et quant l'en en faut au descendre
> Se cil qui fiert y veut entendre.
> Et il en sache bien ouvrez.
> Tantost peu son cop recouvrer
> Et ferir sans s'aller mocquant

> Du bout devant en estoquant
> Son ennemi parmi le ventre
> Et le fers est agus qui entre
> Legierement de plaine assiete
> Partous les lieus ou l'en en giete
> S'armeures ne le detiennent
> Cel que les grans godendas tiennent
> Qui l'ont à deux poins empoignez
> Sont un poi des rancs esloignez
> De bien ferir ne sont pas laches."
>
> *Sub anno* 1298.

The above lines so minutely describe a very rare weapon, of which M. Viollet-le-Duc has engraved three examples, that we can have no hesitation in identifying them as godendacs.

The staff was from five to six feet long. It was wielded with both hands. If the bearer missed his blow with the blade, he made a thrust with the spike, without losing time in recovering his weapon.

The one in the choice collection at Pierrefonds (the third in the annexed cut) has no spike, and resembles a pole-axe of the fifteenth century, of which there is an example from the Meyrick Collection engraved at p. 26. Another is in the Tower, and pole-axe would be a much more sensible appellation for it than the satirical one by which it was known to Guiart.

Mr. Hewitt considers it to be the Flemish name for a halbard.

GOLIONE. "A kind of gown." (Halliwell.)

> " And cast on her his golione,
> Whiche of the skyn of a lione
> Was made."—Gower.

GONJO. "Body armour, perhaps the gambeson." (Meyrick.)

It is mentioned in a letter remissory dated 1349 : " Aycardus de Miromonte cum hominibus armatis diversorum armorum generibus, utpote platinis, gonjonibus spaleriis, clipeis," &c.

GORGET. (*Gorge*, the throat, French.) This word, as it is well known, is applied to various articles of costume, both civil and military. With respect to the latter, there were gorgets of all descriptions, known by different names—Saxon, Anglo-Norman, German, and Low Latin—some of which it were difficult, if not impossible, to identify.

1. 2. 3.
Godendacs.
1 and 2. From MS. *circa* 1450.
3. From the Collection at Pierrefonds.

There were numerous varieties both of chain and plate. The alcato mentioned by Matthew Paris, as worn by the Crusaders in the thirteenth century, was most probably of chain, and the cargan, judging from the derivation of the word, was undoubtedly so ; but there appear throat defences composed of several small plates. (*Vide* woodcut annexed from Sloane MS., No. 346, and the figure of a Despencer from the painted windows at Tewkesbury, page 16 of this work ; also fig. 5, Plate II., in which some of the plates are represented cut into the shape of leaves.) The collarium mentioned by Matthew Paris—who, *sub anno* 1252, relates how Roger de Lambourne slew a knight in a tournament, who had imprudently entered the lists " sine collario "—may have been either of plate or chain. So in Ducange : " Venitque ictus inter cassidem et collarium dejecitque caput ejus multum a corpore."

Gorget. Sloane MS., No. 346.

The introduction of the camail in the fourteenth century prevents us ascertaining whether or not a gorget was worn under it ; but early in the fifteenth (*temp.* Henry V.) gorgets of plate became common.

Gorget of plate over Gorget of mail. Brass in Spilsby Church, Lincolnshire. 1410.

Gorget of plate. Brass of Sir Thomas de St. Quintin, Harpham Church, Yorkshire. 1420.

Standard of mail. Brass of Richard Quatre-
mayns, Esq. 1460.

In the reign of Henry VI. appears the "standard of mail," as it is termed, the lower edge of which is generally indented. The hausecol (a revival of a fashion of the thirteenth century) afforded an additional protection to the throat (see HAUSECOL), to nearly the close of the fifteenth century, after which period we possess many existing specimens of the gorget, as it was then invariably called in all its varieties, down to the little gilt toy hung round the neck by a piece of dark blue ribbon, which was worn by officers when on duty within my recollection.

Gorget. 1525. Gorget. 1535. Gorget. 1540.

Gorget, 1620. Pikeman's Gorget. 1635. Gorget. 1645.

Gorget (*gorgière, gorgerette,* French) is also the name for an article of female costume which we meet with as early as the reign of Edward I., when it appears to be nearly the same as the wimple (which see). Jean de Meun calls it a towel (*touaille*):

"La gorge et les gorgerons sont deshors la touelle
Ou il n'a que trois tours à la tourne bouelle
Mais il a d'espingles demy une escuelle
Fichée en deux cornes et entour la touelle.
Par dieu j'ai en mon cueur pense mainte fiée
Quant je veoye dame si faictement lyée
Que son touaille faist à son menton clouée
Ou qu'elle en eut l'espingles dedans la chaire ployée."

Codicille de Jean de Meun, l. 1225.

An example of this extremely ugly fashion is already given at page 103 of this work, and others will be found under HEAD-DRESS.

The fashion was too ugly to last; and though examples occur in the fourteenth and fifteenth centuries (see woodcuts below), its use was apparently limited to widows or aged females. Indeed, the barbe only differs from the gorget and wimple in being plaited.

In a Royal MS. numbered 15 F 2, of the time of Richard III., there appears a lady with a very richly-embroidered collar, edged with ermine, which may possibly have been called in that day a gorget or a gorgière.

The gorgerette or gorgière of the fifteenth century was a graceful neckerchief, much like that worn by ladies at present, and known by the various names of *chemisette, canezou,* habit shirt, or tucker.

M. Viollet-le-Duc gives us several very modern-like specimens of what he considers the gorgière of the fifteenth century ; but I hesitate to adopt that term in connection with them, at least so far as England is concerned, not finding any authority for it in the writers of that period, by whom the word "gorget," as applied to female apparel, is not mentioned.

Gorget. Royal MS. 20 C 5. 14th century.

Gorgière, 15th century, according to M. Viollet-le-Duc. *Temp.* Henry VI.

Gorget. Cotton. MS. Nero, D 4.
Temp. Edward IV.

Royal MS. 15 F 2. *Temp.* Richard III.

In the sixteenth century, however, the word is of constant occurrence, but without any description that would enable us to identify it in paintings of the period. In an inventory of the apparel of one of the queens of Henry VIII. (Harleian MS. No. 1419) is an entry of a gorget of silver tissue, in length one yard and three quarters—leaving us to guess in what form such a quantity of stuff was disposed round the throat, unless as in the example just given. A French writer of that time (quoted by M. Guicherat) contrasts the gorgerette with the collerette :

> " La collerette par raison establie
> Garde la chair de chaleur et noirceur ;
> La gorgerette habile la partie
> Honnestement afin qu'on ne mesdie."

Still we obtain no information as to its shape or exact position. Mr. Strutt observes : " I do not think the gorget was ever universally used, and probably it is for that reason we know so little about it." (' Dress and Habits,' vol. ii. p. 258, edition 1842.)

In 1596 Stephen Gosson writes :

"These Holland smocks as white as snow,
 And gorgets brave with drawn work wrought,
A tempting ware they are, you know,
 Wherewith as nets vaine youths are caught."
Pleasant Quippes for Upstart New-fangled Gentlewomen.

The gorget is again mentioned in the pastoral of 'Rhodon and Iris,' 1631, amongst the apparel of the fantastical Lady Eglantine :

"Coyfes, gorgets, fringes, roules, fillets, and hair laces."

Also in 'The Muses' Looking Glass,' a comedy written by Thomas Randolph, A.D. 1635 :

"What serves your lawful pride of setting pins
 But to gain gew-gaws, and to knit together
Gorgets, strip-neckcloths, laces, ribbands, ruffs,
 And many other such like toys as these."

The coarse definition of Baret (quoted by Halliwell *in voce*) leaves no doubt, however, that as early as 1580 the gorget was simply a kerchief wherewith women covered their bosoms. In the time of the Commonwealth it received the name of "whisk" (see WHISK) ; but we meet with it again under the old appellation in the days of William and Mary. Congreve, in his comedy, 'The Way of the World,' produced in 1700, makes Lady Wishfort say to Foible when discharging her, " Go hang out an old Frisoneer gorget with a yard of yellow colberteen again ! " (Act v. scene 5.) Landais appears to draw a distinction between the *gorgière* and the *gorgerette*. The former he describes as " collet antique de femme qui couvrait *la gorge et le cou*," and the latter as " sorte d'ajustement de femme qui couvre *une partie de la gorge* " ('Dictionnaire Général') ; and I think the distinction borne out by the reduction of the gorget of the thirteenth century, which enveloped the whole throat and breast, to the gorgerette of the fifteenth, which covered only a portion of the latter.

GOWN. (*Gunna*, Saxon ; *gwn*, Welsh ; *guanacum*, Inf. Latin.) The term "gown," like that of "coat," has occasioned much confusion and disputation by the capricious application of it to different articles of dress, or by the bestowal of new appellations on some special varieties at particular periods. For three centuries nearly all upper garments were called cotes, the gown worn by women being occasionally distinguished by the name it still bears in France, *robe*—a term which in England is limited to regal and official costume. (See ROBE.)

Gown. Anglo-Saxon. 10th cent.

The Romano-British females appear to have worn two tunics, the upper one shorter than the under, one or both of which, called by the Welsh *gwn*, we find Latinized by Varro, *guanacum*. The Anglo-Saxon women of all classes are usually represented in long, loose, flowing garments reaching to the feet, which they almost conceal (see pp. 100 and 141) ; but that they also possessed a shorter one is evident from the words of a Bishop of Winchester, who sends as a present "a *short gunna* sewed in our manner" ('Mag. Bib.' 16, p. 2) ; and we find a pictorial illustration of it in the annexed figure from Harleian MS. No. 2908. Examples of the longer dress will be found under CLOAK, COAT, GITE, SUPERTUNIC, SURCOAT, SUSQUENIE, and other articles in this work and in the General History.

Little difference is visible amongst the earliest Anglo-Norman ladies ; but the terms *cote, surcote*, and *robe* are those by which the exterior garment is usually distinguished.

"Robbes factes par grand devises,
 De beaux draps de soie et de laine,
 De scarlates, de tiretain."
Roman de la Rose.

The French had, however, at that time adopted the term *gone* or *gonele ;* but, according to M. Viollet-le-Duc, it was applied in France to a hooded cloak or a monk's frock.

It is in the fourteenth century, in the reign of Richard II., that the word "gown" in its present signification appears applied to garments of various materials appertaining to men as well as to women. The anonymous author of a work of his time, cited by Camden in his 'Remaines,' p. 194, and called 'Eulogium,' says, "The commons were besotted in excess of apparel, in wide surcoats reaching to their loyns, some in a garment reaching to their heels, close before and strowting out on the side, so that on the back they make men seem women, and these they call by a ridiculous name, *gown.*" Why ridiculous I do not comprehend, unless for the reason adduced by the author, that it "made men seem women." Of these particular gowns an example will be found at page 165 *ante ;* and the illuminations in MSS. of that period swarm with them. They are remarkable for the height of the collars, which button close round the neck and take the line of the cheekbone. From the metrical romances of the Middle Ages, which are replete with valuable descriptions of costume, we learn that knights in the fourteenth century wore gowns over their armour—

> " Gay gowns of green
> To hold their armour clean,
> And keep it from the wet."
> *The Avowynge of King Arthur.*

Gown. *Temp.* Henry IV. and Henry V.

Gown. *Temp.* Henry VI.

From that time to the end of the seventeenth century the gown was a garment as common to the male as to the female sex, but varieties of it had special appellations, which, in conformity with the plan of this work, will be described under their separate headings. (See GLAUDKYN, HOUPELAND, HUKE, SHAMEW.) The citizens of London appeared before Richard II. in white and red gowns, "gonnis albis et rubeis," the king's livery colours. (Knighton, *sub anno* 1386.) Harding, the chronicler, upon the authority of Robert Ireleffe, Clerk of the Green Cloth to Richard II., speaks of

> " Yeomen and gromes in cloth of silk arrayed,
> Satin and damaske, in doublettes and in gownes."

Chaucer also makes his Parson complain of the "costly furring of the gowns and the superfluity

in the length of them, trailing in the dung and in the mire, on horseback and eke on foot, as well of man as of woman." He himself, and Gower, his brother poet, are both depicted in gowns. A

Gowns. *Temp*. Edward IV.

Gowns. *Temp*. Henry VII.

gown belonging to Henry V., of purple damask without lining, another of black velvet with sleeves of samite and lined with fur, are mentioned in an inventory of the royal wardrobe.

It would be tedious to record all the entries of gowns of various descriptions which occur in the inventories and wardrobe accounts of the thirteenth century. We find mention of long gowns, short gowns, half gowns, strait gowns, loose gowns, riding gowns, cassock gowns, night gowns, and tenice gowns; others named after the country from which they were imported, the fashion copied, or the material manufactured, such as Turkey gowns and Spanish gowns.

A few extracts, however, may be interesting as enabling the reader to form an idea of the costly nature of some of these garments. Richard III. writes for his short gowns of crimson cloth of gold, "that one with droppue (drops), and that other with nett (a favourite pattern at that period), lined with green velvet." Drops are mentioned again in another document of this date: "Eight yards of blue cloth of gold wrought with *droops*" were given to the Duke of Buckingham. Long gowns of crimson velvet, lined with white sarcenet, and others of white cloth of gold, were provided for the henchmen and pages of the king and queen to wear at the coronation. It is curious to find that the poor young prince by right King Edward V. received for the same ceremony from his usurping uncle splendid apparel for himself and his attendants, including a short gown made of two yards and three quarters of crimson cloth of gold lined with black velvet, a long gown of the same stuff lined with green damask, and a shorter one of purple velvet, also lined with green damask. Examples of the long gowns worn about this period are given in our chromolithograph from the contemporary MS., Royal, 15 E iv., which represents King Edward IV. receiving a book from its author, with four other personages, two of whom are presumed to be the Dukes of Gloucester and Clarence.

Henry VII. appears in a long gown in the picture of himself and family painted by Holbein, and also in his statue in Westminster Abbey; and long gowns are much more frequently met with in paintings and sculptures of his reign. They have generally broad collars of fur or velvet, rolled back over their shoulders. Some were worn loose and ample; others are fitted more closely to the shape, gathered at the back in plaits to the waist, like the doublets of the day, and confined by a girdle or sash. (See figures on opposite page.)

Some curious descriptions of the gowns worn by Henry VIII. occur in the wardrobe accounts and inventories of his reign we have already quoted, and must continue to quote occasionally, throughout this work. Amongst them we find "a gown of crimson velvet with a square cape," and "a gown of velvet with a round cape;" "a gown of purple *capha* damask, furred with sables, and a border embroidered and fringed with Venice gold, having thirty-one buttons of gold." (Harleian MSS. 2284 and 1419.) I am at a loss to explain "*capha* damask." In the same accounts are entries of "a Turquey (Turkey) gown of new making (new fashion), of black velvet, with two small guards (borders) of silver, furred with leuzernes (skin of the lynx or ounce), having seventy-seven round buttons of gold, black enamelled;" "a short Spanish gown of a new making;" "a long Spanish gown of the same;" and "a riding gown of black velvet, with plaits at the back, lined with black satin."

Henry VII. From his monument.

Hall, the chronicler, tells us that the Duke of Buckingham, at the coronation of Henry VIII., wore "a gown all of goldsmith's work, very costly." ('Union in Vit. Henry VIII.,' p. 3.)

The story told by Camden about Sir Philip Calthorpe's gown (see under DAGGES, p. 166) must be reverted to here, as I believe the term "gown" to have been misapplied to the garment so extravagantly cut to pieces. Slashing and puffing were carried to the greatest excess in those days. Every article of male apparel, including the bonnet and the shoes, were "as full of cuts" as they could be made, saving the gown. At least I have never seen, in the costume of any country, a

garment that could fairly be termed a gown, whether long or short, so treated. Therefore I consider that either the person who related the anecdote to Camden applied the name of gown to some other body garment, or that Sir Philip sacrificed his fine French tawny cloth by having it so ridiculously disfigured that he could not wear it himself, and thereby punished the vain shoemaker, as well as

Henry VIII. delivering the Bible to Cranmer and Cromwell.

escaped being vulgarly imitated by him. I think it necessary to make this observation, as, coming from so high an authority as Camden, the statement that gentlemen wore slashed *gowns* in the reign of Henry VIII. might continue to pass without question.

The following items occur in the will of a country gentleman, dated 1573:—" I give unto my brother, Mr. William Sheney, my best black gown, garded and faced with velvet. . . . Also I will unto my brother, Thomas Marcal, my new shepe coloured gowne, garded with velvet and faced with cony; also I give unto my son Tyble my shorte gown faced with wolf and laid with billement's lace; also I give unto my brother Cowper my other shorte gown faced with foxe." (Fairholt, ' Cost. in England,' p. 268; Britton and Brayley's 'Graphic Illustrator.')

From this period the gown is more rarely heard of in male costume, becoming gradually limited to men of age and gravity, who adhered to their old fashions and viewed with disgust the introduction of the foppish and scarcely decent dresses of the courtiers of Henry III. of France, and the bombasted doublets and hose which ludicrously disguised "the paragon of animals" in the reign of Queen Elizabeth. In an old play entitled 'Appius and Virginia,' A.D. 1575, quoted by Fairholt, the

Costume of English Merchant. *Temp*. Elizabeth.

Vice or Buffoon says :—

" A proper gentleman I am of truthe ;
Yea that ye may see by my long side gowne."

And in Sir Thomas Boynton's inventory, taken in 1581, we find only "one taffitye gowne, with a cloth gowne," valued at £8 the two. Gowns were still worn by legal and official personages, merchants, physicians, and citizens; blue gowns in winter by the apprentices of London, who wore blue coats in the summer; and at the end of the seventeenth century, with the exception of morning and night or bed gowns, the term had altogether disappeared from the catalogue of a private gentleman's wardrobe, while still holding high place in that of every lady.

To return to the ladies, whom we left in the reign of Richard II., but shall now hand down to the reign of George III.

We are indebted to Mr. Fairholt for a copy of a curious drawing in a MS. in the National Library at Paris, No. 6857, written in the fifteenth century, representing a lady who is being assisted by her maid in dressing, and whose gown lies at

her feet, which he describes as being of blue cloth, with white fur cuffs, collar, and border. The head-dresses of both mistress and maid are of the same fashion as those worn in the reign of Henry VI., and accord with the form of the gown, which was worn with little variation during the greater portion of the fifteenth century.

The gowns during the reigns of Richard II. and Henry IV. came up high on the neck, the collars fitting it tightly like those of the men. A change is visible in the reign of Henry V. and in that of his son. They were made with turnover collars and very short-waisted. In the reign of Edward IV. the waist was lengthened, and the corsage opened down to it displayed the placard or stomacher, above which again was seen the gorget or gorgerette. The waist was confined by a broad belt or a richly-ornamented girdle. The trains continued to excite censure and ridicule, on account of their extravagant length—a fashion which, condemned as early as the twelfth century, has survived to the present day ; so long in the front, too, that they were obliged to hold them up when walking, as in the time of Edward I.

From a MS. in the Nat. Library, Paris.

Gown. *Temp.* Henry V.

Gown. *Temp.* Henry VI.

The second of the three figures on the following page shows us a lady in a splendid gown of cloth of gold, as much embarrassed by her train as any *élégante* in a modern drawing-room. Some few examples are seen about the same period of gowns without trains, and having extremely broad borders of fur or of velvet, but they are quite in the minority.

The sleeve, tight from shoulder to wrist, where it terminated with a cuff of fur, velvet, or whatever material the gown was trimmed with, appears in this reign ; but the long hanging sleeves were still worn, and continued more or less in fashion to the time of Elizabeth. (See SLEEVE.)

The gowns of ladies in the reign of Henry VII. differed little at the commencement from those of the two preceding, but the fashion soon changed, and the rage for slashing and puffing is

Gown. *Temp.* Henry VI.

Gown. *Temp.* Edward IV.

Gown. *Temp.* Edward IV.

Gown. *Temp.* Edward IV.

Gown. *Temp.* Henry VII.

displayed as extensively in the costume of the female as in that of the male sex. The fashion seems to have changed again before the termination of his reign; and we could not, perhaps, give the

reader a better example than the statue of Henry's queen, Elizabeth of York, in his chapel in Westminster Abbey, which was Holbein's authority for her portrait in the well-known picture painted by him of the King's family.

Gown. *Temp.* Henry VII.

Gown, showing make of back. *Temp.* Henry VII.

Elizabeth, Queen of Henry VII.

The female costume of the reign of Henry VIII. is copiously illustrated by painters and engravers. We have the portraits, half or whole length, of all his wives to begin with, and, in addition to the pencil, the pen contributes a mass of information.

In the inventory of the eighth year of his reign which I have so often quoted, great difference appears in the quantities of stuff allowed at different times for the making of gowns for the Queen (Catharine of Arragon). One entry gives " three yards of purple cloth of gold tissue for a gown for the Queen's grace:" while in another we find "thirteen yards of rich cloth of gold for a gown for the Queen;" "ten yards of damask silver to line a gown for the Queen," and "eleven yards of black cloth of tissue" for the same purpose. Three yards of stuff could certainly not be sufficient for a gown for the Queen; but it does not follow that they were required for the entire garment. In those days the bodies, sleeves, and skirts were each independent of the other.

"Gowns of blue velvet, cut and lined with cloth of gold, made after the fashion of Savoy," were worn by the four ladies who danced with the King and three noblemen in a masque in the sixth year of his reign; but Hall, who gives this description, does not inform us respecting their shape. The same writer is diffuse in his descriptions of similar entertainments; but as the shapes of the dresses worn in them, however magnificent, were purely fanciful, they would not assist us in this inquiry. What is more to the purpose, he tells us that Anne of Cleves wore, at her first interview with Henry VIII., "a ryche gowne of cloth of gold raised, made round, without any trayne after the Dutch fashion."

We have also the description by an eye-witness of the dress of Queen Catharine (Parr) in the year 1543–44. Her gown he describes as a "delentara" of cloth of gold, with sleeves lined with crimson satin, and trimmed with three-piled crimson velvet, and her train was more than two yards long. Her girdle was of gold, with very large pendants.

The same writer (Pedro de Gante, secretary to the Spanish Duke de Najara, who visited Henry in the above year) also describes the dress of the Princess Mary, whose gown or loose robe, which here he calls "*tropon*," was of violet-coloured three-piled velvet. The gowns at this date were of the shape called *en éteignoir*, open in front, from the waist downward—"*compass-wise*," as Hall calls it— so as to show the kirtle or petticoat, which De Gante calls a "*saya*," the Queen's being of brocade and the Princess's of cloth of gold.

Of Queen Catharine Parr there is a portrait representing her in a gown similar in shape; but the sleeves are trimmed with fur instead of velvet. It is made round without a train, after the Dutch fashion, like that of Anne of Cleves described above.

Queen Jane Seymour. From Holbein's
family picture.

Catharine Parr, Queen of Henry VIII. From her
portrait at Glendon Hall, Northamptonshire.

No particular change appears to have taken place in the gown during the brief reign of Edward VI., perhaps arising from the fact that there was no queen to bring in with her the fashions of her own country; for it is observable that the marriages of our sovereigns with foreign princesses have rarely failed to influence the mode of dress in their adopted country. Several changes are noticeable, however, as we advance in the sixteenth century, which will be better understood by our engravings.

On the next page we have the authentic portrait of Queen Mary, by Sir Antonio More, painted in 1558, the last of her reign, and that of her sister, Princess Elizabeth (afterwards Queen), formerly supposed to have been painted in 1545 by Holbein, "when in her twelfth year" (Shaw's 'Dresses and Decorations'); but we now know that Holbein died two years before that date, and when Elizabeth was only ten; and, besides, the portrait is evidently that of a young woman of seventeen or eighteen, and not a girl between eleven and twelve, and, by whomsoever painted, represents the Princess a year or two previous to the accession of her sister, at which period she was twenty.

The Princess is in a richly-figured crimson satin gown, square-cut at the neck, and bordered with jewels ; the waist long and tapering to a point, and the skirts open in front, showing a splendidly-embroidered kirtle of cloth of gold, the sleeves of the same stuff, rivalling in size those of the gown.

Queen Mary. From portrait by Antonio More.

Princess Elizabeth (afterwards Queen).

The Queen is pictured in a gown of violet-coloured velvet, edged with grey fur, made high in the neck, with a stand-up collar ; the sleeves tight at the shoulder, and widening as they descend, terminated by a profusion of grey fur ; the skirt open in front, like that of the Princess, and exhibiting a similarly gorgeous petticoat or kirtle of embroidered cloth of gold. The fashion succeeding this is indicated in our engraving at page 79 of this work, from a miniature of Queen Elizabeth at the commencement of her reign. The gown is not confined at the waist, but branches off from the neck, discovering a doublet and petticoat of embroidery. It has a high collar buttoned up close round the throat, and surmounted by a small ruff, which about this time is first visible. The sleeves are like those of the men so complained of in the reign of Edward IV., making the wearers appear high-shouldered, but they reach only to the elbow, whence they are supplemented by lawn or some fine sort of material, like bishops' sleeves, to the wrist, where they terminate with a ruff-cuff. This fashion will be further illustrated under SLEEVE.

Another example of a gown of this period occurs in the full-length portrait of Mary Queen of Scots, engraved plate 260 of Montfaucon's 'Histoire de la Monarchie Française,' which we give as being one of the least known to the public. It is, or was, in the collection of M. de Gaignières, at Paris.

We now arrive at the reign of Elizabeth, and, accustomed as the general reader must be to the sight of her in her great ruff and still greater fardingale, as usually depicted, he will most probably be unprepared to find the variety of costume which existed during the forty-five years she held " sovereign sway and masterdom " over England.

Stubbs, to whose grumbling gossip we are so greatly indebted, says of the women : " Their gowns be no less famous than the rest, for some are of silk, some of grogram, some of taffata, some of scarlet, and some of fine cloth, of ten, twenty, or forty shillings the yard ;" (two pounds of the money of the reign of Elizabeth !) " but if the whole garment be not of silk or velvet, then the same must be layed with lace two or three fingers broad, all over the gown, or else the most part ; or if

it be not so, as lace is not fine enough now, then it must be garded with great gards of velvet,

Mary Queen of Scots.

English Lady of Quality. From engraving by Gaspar Rutz, 1588.

A Bell. *Temp.* James I.

every gard four or five fingers broad at the least, and edged with costly lace. And as these gowns be of divers colours, so are they of divers fashions, changing with the moon ; for some be of the new fashion and some of the old, some with sleeves hanging down to their skirts, trailing on the ground, and cast over their shoulders like cowtails. Some have sleeves much shorter, cut up the arm, drawn out with sundry colours and pointed with silk ribbands, and very gallantly tied with love-knotts—for so they call them ; some have capes reaching down to the middle of their backs, faced with velvet or else with some fine-wrought taffata at the least, and fringed about very bravely, and some are plaited and crested down the back wonderfully, with more knacks than I can express."

Above is given a lady of the reign of Elizabeth, dated 1588. It is from a foreign source, but has all the character of the time, and displays some of the varieties of fashion described by Strutt, being "garded with great gards of velvet," and having long hanging sleeves, reaching from the shoulders to the skirts. Other examples of this reign have been given under FARDINGALE, notably of the Maiden Queen herself and one of her ladies-in-waiting. It is, therefore, unnecessary to reproduce them here ; for that reason we also refer our readers to the same article for the female costume of the reign of James I., as they will find there an engraving of his queen, Anne of Denmark. A silver bell, engraved by Mr. Shaw from one preserved in a collection at Paris, affords an example of a variety of the fashions of this period.

In the comedy of 'The London Prodigal,' 1605, a "fringed gown" is spoken of as an old-fashioned garment at that date :—

> "Go as my mother went—that's a jest indeed !
> Why, she went in a fringed gown, a single
> Coif, and a white cap."—Act 3, sc. 1.

And in 'Eastward Hoe !' a play of the same date, the buffin gown is mentioned as a dress of the commonalty. (See BUFFIN GOWN.) Grogram gowns are also spoken of in the same play. (See GROGRAM.)

The gowns of Englishwomen of all classes are amply illustrated by the beautiful etchings of Hollar in his series entitled 'Ornatus Muliebris Anglicanum,' 1640. He has depicted for us in their

English Gentlewomen.

Lady Mayoress. Merchant's Wife.

daily attire the lady of quality, the gentlewoman, the lady mayoress, the merchant's wife, the citizen's wife and daughter, and the countrywoman—all so faithfully that I have only to transfer them to these pages without comment or explanation. Two of them have already found their place in this work at page 33, and a third at page 186, and need not be repeated. I subjoin eight others, which will, I think, sufficiently display the general female costume of this period.

Citizens' Wives.

Citizen's Daughter. English Countrywoman.

The Puritanical dress of Cromwell's time differed more in the gravity of colour and absence of ornament, than in form, from that of the reign of Charles I.

"The gowns of the 'beauties' of the Court of Charles II.," says a recent writer, "resemble

drapery more than any fixed shape, and are made extremely low in front and over the shoulders, with slashed sleeves and quantities of lace and jewels." ('Book of Costume,' by a Lady of Rank, 1846.) But their well-known portraits at Hampton Court afford us little information respecting the exact form or details of the dress.

The portrait at Wentworth of the celebrated Margaret Cavendish, Duchess of Newcastle, who died 1673, painted by Abraham Van Diepenbeck, may really be depended upon, and we subjoin a reduced copy of the engraving from it published by Harding. In this reign we are also assisted by the diverting diary of Pepys and the humorous muse of John Evelyn. Under the date of the 1st of May, 1669, the former writes : " Up betimes. My wife extraordinary fine, with her flowered tabby gown that she made two years ago, now laced, exceedingly pretty, and, indeed, was fine all over." A "Japan gown" was sent to Mrs. Pepys in December 1663. Evelyn, in his rhyming catalogue of a lady's toilet, mentions—

> " One black gown of rich silk, which odd is
> Without one coloured embroidered boddice."

The gowns in the brief reign of James II. present us with no very particular characteristics, except in the increase of lace and ribbons in the trimming of them. There is still the pointed stomacher and length of waist, both rendered still smaller by the tight lacing of the "whalebone prison," as Bulwer calls it, which has consigned so many of our fair countrywomen to an early grave ; the gown open from the point of the stomacher, and looped back with ribbons, and by the nobility with jewels, in order to display the rich petticoat ; the sleeves varying in length and fashion, but never extending beyond the elbow, whence fell a profusion of lace ruf_ fles or "engageants," as they were called, of point d'Espagne or point de Venise ; and this fashion, with little or no important alteration, lasted during the succeeding reign of William and Mary, and, I might add, Queen Anne.

Duchess of Newcastle. From her portrait at Wentworth.

The newspapers of those days afford us much information respecting dress, from the description of articles of attire lost or for sale advertised in them. In 1700 Lady Anderson, whose house was robbed during a fire in Red Lion Square, lost an orange damask gown lined with striped silk. The following items occur in the inventory of the 21st of November, 1707, already quoted :—

> "j : yellow gown & pettycoate
> j : red & yellow gown & pettycoate
> j : red & green gown & pettycoate
> j : white stuff gown & petticoate
> j : green stuff gown & petticoate
> j : black cloath gown & coate
> j : morning gown & a riding gown."

"A red and dove-coloured damask gown, flowered with large trees," was advertised as stolen in the *Post Boy* of the 15th of November, 1709. In the *Spectator*, 1712, the sale is advertised of " an Isabella [*i.e.* dun] coloured *Kincob* gown, flowered with green and gold, a dark-coloured cloth gown and petticoat, with two silver orrises [lace so called] ; a purple and gold *Atlas* gown, with a scarlet and gold Atlas petticoat edged with silver ; a blue and gold Atlas gown and petticoat ; and a blue and silver silk gown and petticoat "—all the property of Mr. Peter Paggen, of Love Lane, near Eastcheap, brewer, and probably the dresses of females of his family. (Malcolm's 'Anecdotes of the Manners and Customs of London,' vol. ii.)

In 1711 the *Spectator* (No. 129) declares that the dress was so covered with lace frills and flounces

that "every part of the garment was in curl, and caused a lady of fashion to look like one of those animals which in the country we call a Friesland hen."

In the reign of "the good Queen Anne" was introduced the true heir and successor of the fardingale—the enormous, inconvenient, and ridiculous hoop, of which I shall speak specially under PETTICOAT.

The reigns of George I. and George II. have Hogarth for their illustrator. There was not much change of fashion during that of the former. "There was no queen in England, and the ladies who accompanied his Majesty were neither by birth, propriety of conduct, age, nor beauty, qualified to make any impression on prevailing modes." (Noble.) Peaked stomachers, tight lacing, sleeves fitting close to the arm and terminating at the elbow with lace ruffles, were still the mode; but the gowns are generally without trains, and have very little (if any) flounces or trimmings of any description. A dress which appears to have been something between a gown and a cloak, called a mantua, is first mentioned about this period; and the sacque or sack, introduced from France in the reign of Charles II., held its ground through all the successive reigns to very nearly the end of the eighteenth century. (See MANTUA and SACK.)

A little more impulse was given to fashion by the arrival of Caroline, queen of George II. Malcolm, quoting from the *Evening Post* and other newspapers of the day, furnishes us with much information respecting the materials of which the dresses of the higher classes were composed. On the king's birthday, in 1735, "The queen was in a beautiful suit, made of silk of the produce of Georgia, and the same was acknowledged to excel that of any other country. . . . The ladies wore flowered silks of various sorts, of a large pattern, but mostly with a white ground, with wide, short sleeves and short petticoats; their gowns were pinned up variously behind, though mostly narrow.

Ladies of the reign of George II. From prints of the period.

Some few had gold or silver nets on their petticoats and to their facings and robings, and some had gold and silver nets on their gown sleeves. . . . Lady Harcourt's gown is specially described as 'a white ground rich silk, embossed with gold and silver, and fine-coloured flowers of a large pattern.'"

The middle classes then, as ever, imitated to the extent of their means, and too frequently far beyond them, the dress of persons of quality; but countrywomen and domestics are seldom seen depicted in gowns, except of that description which within my recollection was, and is still, I believe, termed a bed-gown, and resembled a jacket rather than a gown, of white or coloured cotton or calico, with a string to tie about the waist. (See also NEGLIGÉE.)

GOWN (MORNING). The morning gown, as we now understand the term (the *robe de chambre* of the French), is constantly mentioned in the eighteenth century, and was, as now, frequently made of very rich materials. In 1714, "Mr. John Osheal was robbed of a rich yellow flowered satin morning gown, lined with a cherry-coloured satin, with a pocket on the right side." Several examples are given in the engravings of Hogarth. It is sometimes called a night-gown: "Also I give unto Thomas Walker my night-gown faced with cony, with one lace also" (Will, dated 1573, quoted in Brayley and Britton's 'Graphic Illustrator'); generally so, when speaking of those of ladies. Evelyn, in his catalogue of a lady's toilette, records, "Three night-gowns of rich Indian stuff;" and, as late as the end of the reign of George II., we read of "a garnet-coloured lustring night-gown, with a tobine stripe of green and white, trimmed with floss of the same colour, and lined with straw-coloured lutestring."

That a loose cloak or gown was worn by both sexes in undress from a very early period there can be no doubt. (See CHOPA.)

GREAVES. Armour for the front of the legs. (See JAMBS.)

GROGRAM. (*Gros grains*, French.) Stuffs of various descriptions have received the name of "grogram," which is derived from the texture and not the material itself, a variation in it being caused by the warp threads passing over two of the shoots, and taking up one only. Cotgrave calls the grogram woven at Lisle *camelot*, camlet. Bailey says: "A sort of stuff all silk; it is, in reality, no more than a taffety coarser and thicker than ordinary." Fairholt, who speaks of it as "a coarse woollen cloth," tells us that "the mixed liquor called *grog* obtained its name from the admiral who originally ordered it to be given to the sailors, and who, from wearing a grogram coat, was called by them 'Old Grog.'"

Grogram is named amongst the woollen cloths woven in England in the time of Charles II., but some sort of grogram was known, if not made, in this country, as early as the reign of Elizabeth. (See page 226.) In the comedy of 'Eastward Hoe!' printed in 1605, Girtred speaks of lining "a grogram gown clean through with velvet." (Act i. scene 1.)

GUARD. A band of gold, silver, or velvet lace. Garments so ornamented were said to be *guarded.* "Frances, I'll have thee go like a citizen, in a guarded gown and a French hood." ('The London Prodigal,' 1605.) And in 'Eastward Hoe!' quoted above, Girtred asks her sister if she wears her "stamel petticoat with two guards."

> "To strutt in purple or rich scarlet dye,
> With silver barres begarded thriftily."—FitzGeffrey's *Satyres*, 1617.

The fashion seems to have arisen in the reign of Henry VIII., and was carried to a great excess in that of Elizabeth. The reader will meet with allusions to it throughout these volumes.

GUIGE. The strap which supported the shield by being passed round the neck of the knight. (See SHIELD.)

GUISARME, GYSARME. This very ancient weapon, written also by various authors gisarme, guissarme, juisarme, jasarme, quisarme, has had nearly as many derivations and descriptions as modes of spelling. By some it has been called a partizan, by others a *bipennis* or double-axe; the name derived from *arma acuta*, or *arme aiguisée*, which would equally well apply to any sharp, cutting weapon. Skinner suggests *bisarma*, and Barbazan would deduce it from *acuere*.

The lance or javelin of the Gauls and Franks was called *gæsum*, and is thus described by the scholiast Agathias, a lawyer and native of Myrina, who wrote in the sixth century: "It is of moderate length, and covered with iron, bent on each side in the form of hooks, which they make use of to wound the enemy, or entangle his buckler in such a manner that his body being exposed they may run him through with their swords." This description tallies better, I think, than any other with the weapon which the Normans in the eleventh century speak of as a guisarme, which was a lance with a hook at its side, and the corruption of gæsum into guisarme is easy and probable.

Wace, who often mentions it in his 'Roman de Rou,' evidently gives the Norman name of guisarme to the Saxon bill, as I have already observed under that heading (page 42 *ante*). A similar confusion occurs in the Statute of Arms of King William of Scotland, 1165—1214, quoted by Mr. Hewitt ('Anc. Armour,' vol. i. p. 50), arising from a similar cause, viz. the people of one country calling the weapon of another by a name of their own: "Et qui minus habet quam xl. solidos habeat gysarm, quod dicitur hand-axe;" the lowland Scotch

Guisarme. Meyrick Collection.

having given their name to the guisarme as the Normans had previously given theirs of guisarme to the Saxon byl.

In the time of Charles VII. of France, it would appear that soldiers armed with voulges were called in that country "guisarmiers." (See VOULGE.) M. Viollet-le-Duc observes that the goad with which oxen are driven is called a *gise;* and though he makes no comment on the fact, it certainly offers us a new and more direct derivation than any yet suggested. The drover would be as likely to come armed with his goad as the thresher with his flail, the mower with his scythe, the haymaker with his fork, or the woodman with his bill-hook, and thus the *gise*-arm would be added to the other military weapons constructed from the peaceful implements of the field and the farm-yard. The absence of a representation of anything resembling the weapon now generally known as the guisarme, either in the Bayeux Tapestry or in any illuminations of the eleventh and twelfth centuries, is a fact however which calls for more consideration than has hitherto been bestowed on it. M. Demmin, who classes the "guisarme" with the scythe weapons, the glaive and the bill, suggests that its name was derived from the followers of the House of Guise, who were called *Guisards*, apparently unaware or forgetful that it occurs in the writings of Wace and Guiart, and several of the most early Anglo-Norman romances. Our example is from one in the Meyrick Collection. There are several in the Tower; but the exact date of any specimen is not ascertainable, as they were used to the end of the fifteenth century. Olivier de la Marche, a chronicler born in 1425, speaks of the great antiquity of the guisarme, and defines it as a combination of a dagger and a battle-axe.

GUN. Fortunately there is no occasion for me to plunge into the apparently interminable controversy respecting the introduction of cannon. I have to speak only of hand fire-arms, which were a later invention, and can be more easily traced to their origin: "An Italian writer, coeval with the discovery, having fortunately preserved a very minute detail of the fact." (Meyrick.)

Billius, or Billi, a learned Milanese nobleman, acquaints us that they were first employed at the siege of Lucca in the year 1430. He tells us that the Florentines were provided with artillery which, by the force of gunpowder, discharged large stones; but the Lucquese, perceiving they did very little execution, came at last to despise them, and every day renewed their sallies, to the great slaughter of their enemies, by the help of small fire-arms, to which the Florentines were strangers, and which before this period were unknown in Italy. Still more distinctly he says: "*They invented a new kind of weapon.* In their hands they held a sort of club, about a cubit and a half in length, to which was affixed an iron tube, which, being filled with sulphur and nitre, by the force of fire emitted iron bullets. The blow, if it hit, was certain destruction; neither armour nor shields were sufficient protection, for often men two or three deep, if fired upon, would be transpierced by a single bullet."

Juvenal des Ursins, however, mentions "canons à main" as being used at the siege of Arras, as early as 1414. Meyrick observes upon this, that Juvenal wrote between 1438 and 1468, and considers the minute description of a contemporary author more entitled to credit. Nevertheless, the late Emperor of the French has appended to the first volume of his 'Études sur l'Artillerie' an inventory of stores at Paris, in 1428, wherein are mentioned "xvii. canons à main dont les deux sont de cuivre et les xv. de fer sans chambre,"—this being two years earlier than the siege of Lucca. It is just possible, however, that the *invention* of the Lucquese might be the fixing of the iron tube on a stock, which was the first improvement of the hand-cannon, as it originally had no such convenient adjunct, and would have become too hot to hold after a few discharges. At all events, no mention of the hand-cannon has been found, as yet, earlier than the fifteenth century, towards the middle of which it was in use throughout Europe, and known in England as the hand-gun.

In one of the 'Paston Letters,' written from Norfolk *circa* 1459, it is said, "They have made wickets on every quarter of the house to shoot out of, both with bows and with hand-guns; and the holes that be made for hand-guns, they be scarce knee high from the plancher."

In a MS. Brit. Mus., marked Royal, 15 E 4, there is the figure of a soldier firing a hand-gun of the earliest form, although the book is dedicated to Edward V., and must therefore have been com-

pleted in 1485. It is without a stock, and is fired by a match applied to the touch-hole, which is on the top of the piece. This was the sort of hand-gun in use during the first half of the fifteenth century. The first improvement appears to have been made in the reign of Henry VI., when the touch-hole was placed at the side, and beneath it a pan for holding priming powder. A hand-gun of this description, united with a battle-axe, all of iron, was in the Meyrick Collection, and is here copied from the engraving in Skelton, plate cxiv.

Hand-gun and Battle-axe.

Pan of the above.

Hand-gun. Royal MS. 15 E 4.

The next improvement was the addition, already mentioned, of the wooden stock, which, if the Milanese nobleman is to be believed, was used in 1430 at Lucca.

Two examples of the reign of Edward IV. are here appended from MSS., the first written *circa* 1470, and the other in 1473.

Hand-gun, 1468. Burney MSS. No. 169.

Hand-gun with stock. Royal MS., 18 E 5.

The third improvement consisted in adding a cover to the pan, to prevent the powder being blown away by the wind. A hand-gun of brass, in a painted wooden stock, with the arms of Austria

on it, showing its German origin, was in the armoury at Goodrich Court, and, in addition to the cover of the pan, was provided with a perforated piece of brass near the breech, through which to look at the sight on the muzzle, so that the eye might not be diverted whilst the match was applied to the powder; a sliding cap in the butt also covered a recess to hold bullets. The date of the gun was about 1480. I append an engraving of it from Skelton.

Hand-gun of brass. *Circa* 1480.

The match-lock, invented towards the end of the century, having been suggested, it is said, by the trigger of the cross-bow, acquired for the hand-gun the name of arcabouza or arquebus, "a bow with a mouth," corrupted into harquebus (which see); and the word "gun," though still retained in the language, was thenceforth used in a general sense only; the constant improvements in hand-fire-arms during the sixteenth and seventeenth centuries giving rise to various other names, viz. caliver, carbine, dragon, esclopette, fusil, fowling-piece, musquet, rifle, snaphaunce, dag, pistol, and petronel. Descriptions of these will be found under their separate heads, or incidentally in the notices of the match-lock, wheel-lock, or other features by which they were distinguished. I shall, therefore, only give here two examples of guns of the seventeenth century, which most nearly approach those within the memory of this generation.

The first is a flint-lock, self-loading gun of the time of Charles I., and akin to the modern revolver, having a cylinder containing eight charges, movable by lifting up a little spring on the top of

Flint-lock Gun. *Temp.* Charles I.

the barrel, by which means a fresh touch-hole is brought under the hammer on removing its sliding cover. Seven out of the eight recesses in the cylinder always appear in sight just where it unites with the barrel, and, as the charges are previously put into these, a ramrod becomes unnecessary.

The next is a flint-lock, self-loading and priming gun of the time of Cromwell. There are two perforations in the butt, covered by a plate, which is represented lifted up in our woodcut. The upper

Flint-lock, self-loading and priming Gun. *Temp.* Cromwell.

one contains a pipe, into which was placed the fine powder for priming, which then ran down into a touch-box affixed to the side of the pan. The lower answered the purpose of a flask, to hold the coarse powder for charging. This gun has also a cylinder at the bottom of the barrel, placed with

its axis at right angles to it. In this cylinder is a recess, in which a bullet may be inserted, and by turning a lever this is brought into its proper place, a sufficient portion of charge and priming obtained, the pan shut, and the gun cocked ready for firing. Another, with revolving barrel and loaded at the breech, of the time of Charles II., was in the same collection.

Here, therefore, we have a breech-loader and a revolver; and the percussion gun is really the only important addition to fire-arms which the present century has to boast of.

GUSSET. (*Gousset*, French.) A piece of chain mail cut almost of a triangular or lozenge shape, which was fixed to the *haustement* or garment under the armour by means of arming points. There were commonly eight required for a suit—two to protect the arm-pits, two in the joints of the elbows, two in the joints of the knees, and two upon the insteps. (Meyrick.) The small plates of various shapes worn at the junction of the arms for the same purpose are called gussets by Mr. Hewitt, and pallets by Sir S. Meyrick. In the romance of 'Morte d'Arthure' the word is spelt *gowces :*

> " Umbegrippys a spere and to a gome [*i.e.* man] rynnys
> That bare of gowles fulle gaye with gowces of silvere."
> MS. Lincoln, f. 42, apud Halliwell *in voce.*

To me, however, the line appears to have an heraldic signification, and seems to imply that the man bore for his arms, gules charged with gowces (? *gouts*) of silver, or, as heralds would say, " guttée argent." Cotgrave has " Gousset, a gusset. The piece of armour or of a shirt whereby the armhole is covered."

ABERGEON, HAUBERGEON. This military garment, which rejoices in some fourteen or fifteen Latin names, differing from each other in the most ingenious manner as respects their orthography, is still without a satisfactory identification. That it was originally a coat or jacket of chain mail there is plenty of evidence :

> " Armez de cotes à leur tailles
> Et de bon hauberjons à mailles."—Guiart, 1304.

And as late as 1361 there is an entry in an account of the stores in Dover Castle of " habrejons *et autres hernous de maile ;*" at the same time there is equal proof that in the fourteenth century there were habergeons of plate. " Un haubergeon *d'acier* à manicles" is mentioned in the inventory of Louis Hutin, 1316. That it was smaller than the hauberk is also evident from its being distinguished from it by the epithet *minor :* " Lorica iv. denar : Lorica minor, quæ vulgo Halsbergol dicitur." (Teloneum S. Andomari : Hewitt, vol. i. p. 132.) That it was occasionally worn under the hauberk is clear from the often-quoted lines in Chaucer's 'Rhyme of Sir Thopas,' wherein he says :

> " And over that " (his habergeon) " a fine hauberk ;"

while the same poet, in the Prologue to the 'Canterbury Tales,' describing the Knight, says :

> " Of fustian he werred a gipoun
> Alle besmotered with his habergeon ;"

showing that in this instance the habergeon had been usually worn over the jupon, which was itself generally worn over all. (See JUPON.) The fact is, that in the military equipment, as well as in civil costume, the name which at one time designated some special article was afterwards bestowed on something widely differing from it, either in form or material. I have already pointed out several curious instances, and, as I proceed, shall have to call attention to some still more extraordinary.

That the haubergeon, whether of mail or of plate, was, as I have stated above, smaller and lighter than the hauberk—of which it would appear, by its name alone, to have been a diminutive—there are several circumstances to prove. One of the earliest—I might say the only—description of the haubergeon is given us by Wace in the 'Roman de Rou.' He tells us that at the battle of Hastings, Odo, Bishop of Bayeux, wore a haubergeon over a white shirt (his alb), and that it was loose in the body and tight in the sleeves :

> " Lé fut li cors, juste la manche ;"

and we must remember that although Wace wrote in the reign of Henry II., the Norman haubergeon was still a familiar object to him. William, Duke of Normandy, is as distinctly described in a hauberk :

> "Son bon haubert fist demander ;"

and in no instance is it ever confounded with the haubergeon.

Another significant fact is elicited by an ordinance of John, King of France, in 1351, quoted by Mr. Hewitt (vol. ii. p. 16), in which we find mention made of a class of men-at-arms, ranking after the knights and esquires, denominated varlets or haubergeons, no doubt from the armour allotted to them : " Chacun chevalier, escuyer et varlet armé sur son cheval d'armes. . . Et ce mesme serement

aussi feront les chevaliers, escuyers et haubergeons qui serront dessous les dits bannerez ; et voulons que les dits bannerez sachent par nom et par seurnom et aient cognoissance des gens d'armes et haubergeons qui seront en leur compagnie." (' Collection des Ordonnances,' tome iv. p. 67.)

Still, with the exception of Wace's description of the haubergeon of Bishop Odo, we have no hint to guide us as to its form in the twelfth and thirteenth centuries, when it was of chain ; and we are equally ignorant of its size and character in the fourteenth, when there is evidence of its being a plate of steel (" haubergeon d'acier ") ; we are also still left in doubt as to which sort of haubergeon Chaucer alludes in his ' Rhyme of Sir Thopas,' or in the ' Knight's Tale.' In the glossary appended to the second edition of Meyrick's ' Critical Inquiry,' which was revised by the late Mr. Albert Way, halsbergol is described as " a haubergeon or coat of mail which at first comprehended the breeches that were attached to it, and subsequently the jacket only." What authority can be produced for this statement I am at a loss to imagine. Not one is quoted by Mr. Way in support of it, and the words of Wace are directly opposed to the idea of breeches being attached to the haubergeon, while they plainly testify to sleeves.

The Bayeux Tapestry affords us no assistance in this inquiry, as Odo is represented in it armed precisely as all the other knights—an evident inaccuracy, not only because at variance with Wace, but also because, as a Churchman, he was forbidden to wear such armour, and evaded the prohibition by putting on an alb, at that time an indispensable ecclesiastical vestment, the long white skirts of which would descend far below the haubergeon and give a clerical character to his equipment.

Mr. Fairholt has given us a copy of a very interesting illumination in a MS. in the National Library at Paris (' Le Livre des Femmes Nobles,' translated from Boccaccio), in which a knight is depicted arming himself ; and the MS. being of the time of Chaucer, it illustrates to a great degree the often-quoted description of the armour of Sir Thopas.

In this miniature the knight is represented in what was called the " haustement," a close-fitting body - garment, with chausses fastened to it by points, over which " he is throwing," according to Mr. Fairholt, " his quilted hacketon ;" his hauberk of mail lies upon the ground before him, on which is placed his bascinet, with a beaked vizor and a camail ; his jambeaux and his gauntlets lie beside them. Still, if the garment he is putting on be indeed a hacketon, we miss the haubergeon, which was to be the next in order, and are left in doubt whether it would have been of mail or of plate. The illumination in the MS. in the National Library at Paris, from which we borrowed the figure of the gambeson engraved for page 197, represents a similar subject, but leaves us still at a loss respecting

From a MS. in Nat. Library, Paris. Close of the 14th century.

one of the garments so precisely enumerated by Chaucer. We find the shirt, the gambeson in lieu of the " aketon," the armorial jupon or " cote armure," the vizored bascinet with camail, the heaume, the gauntlets, and the shield, but no haubergeon, and must therefore unwillingly abstain from any attempt to represent it, trusting that some hitherto undiscovered or overlooked authority may, previous to the conclusion of this work, enable me to supply not only this deficiency, but others occasioned by similar want of direct evidence. In conclusion, I can only observe that it is impro-bable that a knight would wear two coats of mail, one over the other ; and that, consequently, when the hauberk was of chain, the haubergeon was necessarily of plate. (See HAUBERK.)

HABILLEMENT, ABILLEMENT, BILLIMENT. This word, though in its ordinary sense signifying clothing of any description, is, by ancient English writers, principally applied in its contracted form of billiment or billament to a lady's head-dress, or ornaments for her hair or her neck. Thus Baret : " Billaments. The attire or ornamentes of a woman's head or necke." ('Alvearie,' 1580.)

Halliwell observes : "It is generally glossed habillements, which is hardly correct." Cotgrave, under BAVOLET, says : "A billement or head-attire worne by the women of Picardie." Also, under DORLOT : "A jewell or pretty trinket, as a chaine, brooche, ring, aglet, button, *billement*, &c., wherewith a woman sets out her apparell or decks herself." And under DORURE : "A billement or jewell of two pieces." (1650.) Billiment lace is constantly spoken of in the sixteenth century (see LACE).

HACKBUT, HAQUEBUT, HAGGEBUSH. See HARQUEBUS.

HACKETON. See ACTON.

HAIR. The mode of wearing the hair is so intimately connected and indeed regulated by the dress of the period, that no costume can be correct if particular attention be not paid to it. In these days, when it has become the fashion to be "bearded like the pard," the incongruous appearance of some of "the wealthy curled darlings of our isle" at fancy balls or in private theatricals becomes absolutely ludicrous from the neglect of this important feature. As numerous examples will be found in the pages of this work of the prevailing custom in each particular age and country in civilized Europe, particularly under HEAD-DRESS and WIG, I shall limit my observations in this place to a brief notice of the most remarkable in this kingdom.

The ancient Britons, like the Gauls, wore long, bushy hair, beard, and moustache. The Romanized Britons shaved their faces and adopted the shorter hair of their conquerors. The Saxons are generally represented with long hair parted in front, forked beards, and moustaches; but in the tenth and eleventh centuries, with the exception of old men, they appear to have cropped their locks and shaved their chins, preserving only their moustaches. Long hair was a distinguishing characteristic of the Teutonic tribes. It was a mark of the highest rank amongst the Franks, none of whom, save princes of the blood and the nobility, were permitted to wear it in flowing ringlets; an express law commanding the commonalty to cut their hair close round the middle of the forehead, "ad frontam mediam circumtonsos." (Jus Capillitii.) The beard was also held in the greatest reverence by them, and to touch it stood in lieu of a solemn oath. ('Aimoin,' lib. i. cap. 4.) The Danes were remarkable for the pride they took in their long hair. Harold, surnamed Harfagre, *i.e.* Fair Hair, on account of the length and beauty of his locks—which, Torfæus tells us, were like golden or silken threads, and flowed in thick ringlets to his girdle—made a vow to his mistress to neglect his precious curls till he had completed the conquest of Norway for her love ('Hist. Nor.' tom. ii. lib. 1); and a young Danish warrior, about to be beheaded, begged of his executioner that his hair might not be touched by a slave nor stained with his blood (Jomscrikinga Saga in Bartholinus, 'De Caus. contempt. Mort.,' lib. i. cap. 5). In the Anglo-Saxon poem on Beowulf we also find mention of

"The long-haired one, illustrious in battle,
The bright lord of the Danes."

On their settlement in England the Danes are reported to have adhered to their national habits, paying great attention to the cultivation of their hair and combing it carefully every day. The Knyghtlinga Saga describes Canute's hair as hanging profusely over his shoulders; but previous to the close of his reign cropping was introduced from France, and in the Register of Hyde Abbey he is represented with short hair, beard, and moustache. (*Vide* page 101.)

The continual presence of the head-rail, veil, or couvrechef in drawings of the Saxon and Danish women leaves us with little information respecting the mode in which they dressed their hair in the earlier periods of their history, that little being derived only from an occasional brief allusion by some contemporary writer. The probability is, that if dressed at all, it was plaited in long tails, as appears to have been the custom of the Franks; an Oriental fashion, the earliest, it may be, in the world, and likely to last in some portions of it to its end.

The wife described by Adhelm, Bishop of Sherborne, who wrote in the eighth century, is mentioned as having her *twisted locks* delicately curled by the irons of those adorning her. The hair of the religious virgin, on the contrary, was entirely neglected. ('De laud. Virg.' p. 370.) In

the Anglo-Saxon poem of 'Judith,' also, the heroine is repeatedly designated as the maid "with the twisted locks :" —

> " The maid of the Creator,
> With the twisted locks."

> " She with the twisted locks
> Then struck her hateful enemy.
>
> *　　*　　*　　*
>
> The most illustrious virgin
> Conducted and led them,
> Resplendent with her twisted locks,
> To the bright city of Bethulia."
>
> Frag. *Judith*, ed. Thwaites.

Twisted, however, taking Adhelm's mention of *irons* into consideration, may certainly mean *curled*, and we have no pictorial illustration to support the suggestion of plaiting, which has only the contemporary fashion of the Franks in its favour.

The Bayeux Tapestry illustrates the curious custom of the Normans in the eleventh century of shaving the back of the head, after the manner, as we are told by Rodolphus Glaber, of the nobles of Aquitaine, who followed their Princess Constance to Paris in 998, on the occasion of her marriage with Robert II., King of France.

Three months after the coronation of William the Conqueror he returned to Normandy, attended by some of his new subjects, and great admiration was excited by the beauty of the long hair of the English.

The couvrechef of the Norman women, like the head-rail of the Saxon, prevents us speaking decidedly as to the dressing of their hair ; but in the few instances where it is shown, it is long and sometimes plaited in two or more divisions. In a MS. in the Cotton. Lib. (Nero, C iv.) the tails appear to be in cases, presumably of silk, which are coloured white, with a red stripe twisting round them.

The Norman courtiers appear to have been fascinated by the long hair of the Saxons, and some rushed, with the usual extravagance of fashion, from closely-cropped and shaven heads, to the opposite extreme. Ordericus Vitalis says : "They parted their hair from the crown of the head on each side of the forehead, and let their locks grow long like women. . . . Their locks are curled with hot irons, and instead of wearing caps they bind their heads with fillets." William of Malmesbury also, who lived

Norman Lady. From Cotton. MS. Nero, C iv.

a little later, complains of the flowing hair and extravagant attire of the men in the reign of Rufus. In 1095 a decree was passed against long hair by the Council of Rouen, but without effect.

The fashion of wearing long beards reappeared in the reign of Henry I., and was equally reprobated by the clergy. Bishop Serlo, in his sermon, and Vitalis, in his 'Ecclesiastical History,' both compare the men of their day to "filthy goats." (See woodcut annexed from figures in the MS. just quoted : Nero, C iv.)

In 1104, when Henry I. was in Normandy, the said Bishop Serlo preached so eloquently against long hair that the monarch and his courtiers were moved to tears ; and, taking advantage of the impression he had made, the enthusiastic prelate whipped a pair of scissors out of his sleeve and cropped the whole congregation. This was followed up by a Royal edict against long hair, but which proved as ineffective with the general public as had been the previous decree of the Council of Rouen. Even Henry himself

Long Beards. From Cotton. MS. Nero, C. iv.

appears to have relapsed, unless he has been misrepresented by the sculptor to whom we owe the statues of that monarch and his queen, Maude or Adelaide of Louvain, on the west front of Rochester Cathedral. Although the heads are much damaged, the hair of both is nearly perfect. The king has a profusion upon his shoulders, and the queen displays two tails that reach down to her knees.

Statues of Henry I. and his queen, Maude (?), Rochester Cathedral.

The chessmen found in the Isle of Lewis in 1831, a portion of which was purchased by the British Museum, and the remainder by the late Lord Londesborough, afford us some valuable examples of the mode of wearing the hair by the higher orders in the twelfth century. The king's is parted into four tails behind, not plaited, but curled or "twisted" very carefully, each ending in a

Chessmen of the 12th century.

point. (Compare it with that of King Henry above.) The queen's is also twisted tightly in two tails, but not allowed to hang down like that of Queen Maude. They are looped up from the nape of the neck, and the ends secured under the veil or couvrechef, which is drawn together and knotted in the centre, the ends looped up in like manner.

At all events, the fashion was raging in the succeeding reign of Stephen, when in 1139 it received a sudden check from a curious circumstance. A young soldier, whose chief pride was in his luxuriant locks, which hung down below his waist, dreamed one night that a person came to him and strangled him with his own darling ringlets. The effect of this dream was so great upon him that he immediately trimmed them to a rational length. His companions followed his example, and, superstition spreading the alarm, cropping became again the order of the day ; but this reformation, adds the historian, like those previously, was of very short duration. Scarcely had a year elapsed before the people returned to their favourite follies, and such as would be thought courtiers permitted their hair to grow to such a shameful length that they resembled women rather than men ; those to whom nature had denied an abundance of hair supplying the deficiency by artificial means. Upwards of seven centuries have passed, and the satirist has still the same folly to waste his wit upon.

The old Norman custom of close shaving appears to have been re-introduced by Henry II., whose beard in his effigy at Fontévraud is pencilled like a miniature ; and in the early part of the reign of Richard I. a seditious Londoner was called "William with the beard," from his obstinately wearing it in defiance of the revived practice. He was soon, however, in fashion again, for before the end of the reign of Cœur de Lion beards and moustaches were generally worn again, but not of such formidable dimensions as in the days of Henry I. and Stephen.

In the reign of John the hair of the men was curled with crisping irons, and bound with fillets and ribbons, and the beaux of the period went abroad without caps that it might be seen and admired. Beards and moustaches were worn or not, as fancy dictated, all legislation concerning them being disregarded or abandoned.

The effigy of Henry III. presents us with a particular style of hair-dressing, which, wonderful to relate, appears to have remained in fashion with the male sex for at least a hundred years. Its first appearance, indeed, is in an effigy of Robert Consul, of Gloucester, the illegitimate son of Henry I., who died in 1147 ; but the effigy is evidently of a much later date. The fashion is by no means unbe-

Robert Consul.

Henry III.

coming, but, considering the uniformity of all the examples during so long a period, it is obvious that the crisping irons we have heard of must have played an important part in the arrangement, as every man could not possibly have had natural curly hair of one particular pattern. (*Vide* also the head of an effigy of a Septvans, Plate II. fig. 10 ; that of Brian Lord Fitzalan, page 16 ; and of Charles Comte d'Estampes, p. 92.) This fashion is alluded to by writers of the thirteenth and fourteenth centuries. (See CROCKET and CROCKS.) Chaucer, describing the appearance of the young Squire in the 'Canterbury Tales,' tells us—

"His locks were crull as they were laide in presse ;"

and in 'The Knight's Tale' the "yellow haire" of a lady is said to have been

"broided [braided] in a tresse
Behind her backe ; a yarde long, I guess."

The appearance of "the Franklein" (*i.e.* a country gentleman and landowner) is not described, but here is an example from the brass of one in Shottesbrooke Church, Berkshire (*temp.* Edward III.).

Brass of a Franklin in Shottesbrooke Church, Berkshire. *Temp.* Edward III.

In some instances the hair of ladies of rank in the fourteenth century is depicted flowing freely down the back ; and no doubt it was so worn by the wives and daughters of the artisans and labouring classes : but more frequently it is confined in a net of gold, silver, or silk, described as a caul, and occasionally braided and arranged in the most elaborate manner, as will be found under HEAD-DRESS.

No particular fashion appears to have prevailed amongst the gentlemen of the fourteenth century with respect to beards or moustaches. They seem to have been worn or not

Beard of Edward III. From his effigy.

according to fancy. Edward I. on his seals is represented close shaven, as are many knights and nobles during his reign and that of his son, the miserable King Edward II. The beard of the latter on his effigy is elaborately curled. Edward III. displays a handsome venerable beard ; Richard II. a smooth chin in his portrait at Westminster (see chromolithograph published with Part I.) : but in the Metrical History of his deposition he is represented with a long, forked beard of the old Anglo-Saxon pattern, and in his effigy he is represented with moderate moustaches and two small tufts of

Beard of Edward II.

hair on his chin.

Towards the close of the reign of Henry IV. the men returned to the cropping style. The effigy of the monarch himself gives one an idea of his head having been

Head of Henry IV. From his effigy at Canterbury.

actually shaven, as not a particle of hair is to be seen beneath the crown. He has a short curled beard and moderate moustaches. In the reign of Henry V. this fashion of cropping and close shaving increased. The King's hair is cut close above his ears, and he has not a hair on his face (see page 165), and during the reign of Henry VI. the absence of beard, whisker, and moustache is remarkable. (See the head of John Duke of Bedford, *temp.* Henry VI.) The silence of the clergy and the satirists on this subject is conclusive as to the non-existence of any cause of complaint in these matters. Amongst the fashions reprobated and ridiculed by the writers of that period, not a word is said about hair. In the reign of Edward IV. an important change took place. The face was still closely shorn ; but the hair was allowed to grow long, not only at the sides, where it was worn in great clumps or bushes, but also on the forehead, where it hung, in some

Beard of Richard II.

Henry IV., full face.

John Duke of Bedford. From the Bedford Missal.

cases, over the eyes. In a ballad "against excess in apparel," written at this period (Harleian MSS., No. 372), the "proud gallants heartless" are told :

"Your long hair into your eyne
Have brought this land to great pyne."

The head-dresses worn by the ladies at this period entirely concealed the hair, with the exception of a single lock, which formed a loop on the forehead ; a curious fashion, which existed in France at the same time, and most probably originated there. (See cut on opposite page.)

An occasional instance may be found of the hair hanging loose down the back : but it is either that of a very young girl or a bride, it being an old custom for brides to be married with their hair dishevelled.

Loop ot Hair on forehead. 1470–90.

"Untie your folded thoughts,
And let them dangle loose as a bride's hair."

Queens also wore their hair in the same manner at their coronations. Elizabeth of York, queen of Henry VII., wore her fair, yellow hair hanging down plain behind her back, "with a calle of pipes over it." (Leland.)

The wife of John Winchcomb, or Jack of Newbury, by which name he is better known, wore on her head, at her wedding, "a billiment of gold, and her hair, as yellow as gold, hanging down behind her, which was curiously combed and plaited, according to the manner of these days." (History of John Winchcomb.)

The long, flowing hair of the gentlemen was curtailed in the reign of Henry VIII., who gave peremptory orders for all his attendants and courtiers to poll their heads. Short hair, in consequence, became fashionable, and continued so for a considerable time. Beards and moustaches were worn at pleasure; but they seem to have been carefully cultivated by those who grew them. The time wasted in trimming them is thus alluded to by Hooper in his 'Declaration of the Ten Commandments,' 1548: "There is not so much as he that hath but 40s. by the year, but is as long in the morning to set his beard in order as a goodly craftsman would be in looming a piece of kersey."

The portrait of Edward VI., by Holbein, illustrates the more natural mode of wearing the hair in his reign, and, we might add, that of his sister Mary.

Arriving at the time of Elizabeth, we are almost overwhelmed by the flood of information respecting hair-dressing and beards which is poured upon us by the writers of that period. To begin with Stubbs, from whom we have already quoted so much concerning the "abuses" of fashion during the reign of "the Virgin Queen," he tells us the barbers "have invented such strange fashions of monstrous manners of cuttings, trimmings, shavings, and washings, that you would wonder to see. They have one manner of cut called the French cut, another the Spanish cut; one the Dutch cut, another the Italian; one the new cut, another the old; one the gentleman's cut, another the common cut; one cut of the Court, another of the country; with infinite the like vanities, which I overpass. They have also other kinds of cuts innumerable; and therefore, when you come to be trimmed, they will ask you, Will you be cut to look terrible to your enemy or amiable to your friend, grim and stern in countenance or pleasant and demure? for they have divers kinds of cuts for all these purposes, or else they lie. Then when they have done all their feats, it is a world to consider how their *mowchatowes* [moustaches] must be preserved or laid out from one cheek to another, and turned up like two horns towards the forehead." ('Anatomie of Abuses,' 1583.)

Edward VI.

Robert Greene, the contemporary of Stubbs, makes a barber ask a customer, "Sir, will you have your worship's hair cut after the Italian manner, short and round, and then frounst with the curling-iron to make it look like a half-moon in a mist; or like a Spaniard, long at the ears, and

curled like the two ends of an old cast periwig? Or will you be Frenchified, with a lovelock down to your shoulders, wherein you may weave your mistress's favour." ('Quip for an Upstart Courtier,' 1592.) The latter fashion is mentioned by Bishop Hall in his 'Satires:'

> "His hair, French-like, stares on his frightened head;
> One lock, Amazon-like, dishevelled."

Greene himself is abused by Harvey for wearing "ruffianly hair;" and Nash says, "he cherished continually, without cutting, a jolly long red peake, like the spire of a steeple, whereat a man might hang a jewell, it was so sharp and pendant."

Greene is still more instructive as to the various shapes of the beards. "After the barber has dressed the head," says the satirist, "he descends as low as his beard, and asketh whether he please to be shaven or no? whether he will have his peak cut short and sharp—amiable, like an *inamorato;* or broad, pendant, like a spade—to be terrible, like a warrior and *soldado?* whether he will have his *crates* cut low, like a juniper bush, or his *suberche* taken away with a razor? if it be his pleasure to have his *appendices* primed, or his *mouchaches* fostered or twined about his ears like the branches of a vine, or cut down to the lip with the Italian lash, to make him look like a half-faced baby in brass? These quaint terms, barbers, you greet Master Velvet-breeches withal, and at every word a snap with your scissors, and a cringe with your knee; whereas, when you come to poor Cloth-breeches, you either cut his beard at your own pleasure, or else, in disdain, ask him if he will be trimmed with Christ's cut, round like the half of a Holland cheese." ('Quip for an Upstart Courtier,' 1592.)

Holinshed also, in his Chronicle, observes: "I will say nothing of our heads, which sometimes are polled, sometimes curled, or suffered to grow at length like women's locks, many times cut off above or under the ears round, as by a wooden dish. Neither will I meddle with the varietie of beards, of which some are shaven from the chin, like those of the Turks; not a few cut short, like to the beard of Marquis Otto; some made round like a scrubbing brush, others with 'a *piquedevant,*' (O! fine fashion!) or now and then suffered to grow long, the barbers being grown to be so

Swallow-tail Beard.
1596.

cunning in this behalf as the tailors: and therefore if a man have a lean and strait face, a Marquis Otto's cut will make it broad and large; if it be flatter like, a long, slender beard will make it seem the narrower; if he be weasel-backed, then much hair left on his cheeks will make its owner look big, like a bowdled hen, and so grim as a goose."

Tom Nash, in 1596, mentions "the swallow-tail cut," of which the annexed is an example furnished by Fairholt.

Randle Holmes speaks of "the broad or cathedral beard, so called because bishops and grave men of the Church anciently did wear such beards." He also mentions "the British beard," which, he says, "hath long *mockedoes* [moustaches] on the higher lip hanging down either side the chin, all the rest of the face being bare; the forked beard is a broad beard, ending in two points; the mouse-eaten beard, when the beard groweth scatteringly, but here a tuft and there a tuft."

Piquedevant Beard.

In Lyly's 'Midas,' 1591, Motto the barber says to his boy, "Besides, I instructed thee in the phrases of our eloquent occupation, as—'How, sir, will you be trimmed? Will you have your beard like a spade or a bodkin? A pent-house on your upper lip, or an ally on your chin? A low curl on your head like a bull, or a dangling lock like a Spaniard? Your moustachios sharp at the ends like shoemakers' awls, or hanging down to your mouth like goats' flakes?'" (Act iii. scene 2.)

Taylor, the Water-poet, gives us a description in rhyme of the variety of beards in his day:

> "Now a few lines on paper I will put
> Of men's beards' strange and variable cut,
> In which there's some that take as vain a pride
> As almost in all other things beside.

> Some are reaped most substantial like a brush,
> Which makes a natural wit known by the bush ;
> And, in my time, of some men I have heard
> Whose wisdom hath been only wealth and beard.
> Many of these the proverb well doth fit,
> Which says,—bush natural, more hair than wit.
> Some seem as they were starched stiff and fine,
> Like to the bristles of some angry swine;
> And some, to set their love's desire on edge,
> Are cut and pruned like a quickset hedge ;
> Some like a spade, some like a fork ; some square,
> Some round ; some mowed like stubble, some stark bare.
> Some sharp, stiletto fashion, dagger-like,
> That may with whispering a man's eyes outpike ;
> Some with the hammer cut, or Roman T,—
> Their beards extravagant reformed must be ;
> Some with the quadrate, some triangle fashion ;
> Some circular, some oval in translation ;
> Some perpendicular in longitude ;
> Some like a thicket for their crassitude ;
> That heights, depths, breadths, triform, square, oval, round,
> And rules geometrical in beards are found."
>
> *Superbiæ Flagellum.*

Mr. Fairholt, who quotes the above, observes that the poet has omitted to describe his own beard, "which was fashioned like a screw," and gives an engraving of it from a copy of Taylor's portrait drawn by the late Mr. J. A. Repton, F.S.A., who printed for private circulation, in 1839, a small 8vo of 36 pages, entitled 'Some Account of the Beard and Moustachio, chiefly from the Sixteenth to the Eighteenth Century,' illustrated by thirty-eight examples, of some of which we shall avail ourselves.

Screw Beard. From the portrait of Taylor, the Water-poet.

The last edict concerning the hair issued by Henry VIII., before alluded to, did not affect the beard, which from that period was worn at pleasure, and, as we have seen in Queen Elizabeth's time, trimmed after a fashion indicative of the wearer's profession or pursuits. Examples of the various beards above mentioned are here subjoined.

Spade Beard.

Sharp or Stiletto Beard.

T Beard.

The dressing of the ladies' hair in the time of Elizabeth was most elaborate, notwithstanding one of her many enactments respecting costume, in which she peremptorily prohibits the wearing of long or curled hair. False hair was also worn to an enormous extent, and particularly by the Queen herself. In a great wardrobe account of the latter end of her reign, no less than 200 loops and tufts of hair are accounted for, and as many " inventions," as they are called, of hair in the form of leaves, besides others in the shape of pyramids, globes, and endless devices.

Our old friend Stubbs, speaking of the ladies in 1585, says : " Then follow the trimming and thicking of their heades in laying out their haire to shewe, which of force must be curled, frizzled, and crisped, laid out (a world to see) on wreathes and borders, from one ear to the other. And lest it should fall down, it is under-propped with forks, wires, and I cannot tell what, like grim, sterne monsters rather than chaste Christian matrones. Then, on the edges of their boulstred haire (for it standeth crested rounde about their frontiers, and hanging over their faces like pendices or vailes with glass windowes on every side), there is laide great wreathes of gold and silver, curiously wrought

and cunningly applied to the temple of their heads. And for fear of lacking anything to set forth their pride withall at their haire thus wreathed and crested, are hanged bugles (I dare not say bables),

Queen Elizabeth.

ouches, rynges, gold, silver, glasses, and other such childish gewgawes." To which he might have added a profusion of diamonds, pearls, and jewels of every kind, beside feathers.

The well-known portraits of Queen Elizabeth illustrate this style of ornamentation in all its minutiæ. Paul Hentzer, who has given us an account of his journey to England, describing the dress of the Queen, says, " She wore false hair, and that red."

No special alteration is to be noticed in the reign of James I., though a line of Robert Middleton's alludes to some change in the shape of a beard :

> " Why dost thou weare this beard ?
> 'Tis clean gone out of fashion."
> *Time's Metamorphosis,* 1608.

The principal novelty in the reign of Charles I. is the appearance of a peculiar sort of lovelock. This fashion, derived from France, caused a tremendous commotion in England. It was a long ringlet of hair worn on the left side of the head, and allowed to stream down the shoulder, sometimes as far as the elbow. An excellent example is afforded us by the portrait of Sir Thomas Meautys. I say a peculiar sort of lovelock, because we have already seen mention made of lovelocks in the reign of

Sir Thomas Meautys.

Elizabeth, in illustration of which fashion Mr. Fairholt curiously refers the reader to a woodcut from a print published in 1646, which we have had engraved for another purpose in this work (*vide* page 174), and must be taken for a much later variety of the custom. Prynne wrote a quarto volume against it, entitled 'The Unloveliness of Lovelocks,' in which he relates the story of a nobleman who was dangerously ill, and who, on his recovery, " declared publicly his detestation of his effeminate, fantastic lovelock, which he then sensibly perceived to be but a cord of vanity, by which he had given the Devil holdfast to lead him at his pleasure, and who would never resign his prey as long as he nourished

this unlovely bush," whereupon he ordered the barber to cut it off. Hall, in his 'Loathsomenesse of Long Haïre,' 1654, also attacks the fashion, but it continued to flourish amongst the Cavaliers, who wore long hair in contrast to the Roundheads. The T beard was still worn, as appears from the play of 'The Queen of Corinth,' 1647 :

> " He strokes his beard,
> Which now he puts i' th' posture of a T,
> The Roman T ; your T beard is in fashion."
>
> Act iv. sc. 1.

The triple portrait of Charles I., by Vandyke, is the best example of the general mode of wearing the hair, beard, and moustache at this period.

Charles I. From portrait by Vandyke.

From tomb in Morley Church, Nottingham. 1657.

For the ladies of this period, we must refer the reader to our copies of the engravings of Hollar, who has faithfully rendered the costume of every class of women of his time, adding one from the figure of a daughter of Sir Hyasith Sacheverel, on the tomb in Morley Church, Nottingham, A.D. 1657. This style, corresponding with the long curls and ringlets worn by the men, was carried to greater extent in the succeeding reign by the addition of false hair, in emulation of the perukes then introduced, and such additions were called *merkins*. In Massinger's play of 'The City Madam,' printed in 1659, Luke, upbraiding the rich merchant's wife, says :

> " The reverend hood cast off, your *borrowed* hair,
> Powdered and curled, was by your dresser's art
> Formed like a coronet, hanged with diamonds
> And richest orient pearls."

The Puritans wore the hair short ; but the Roundheads appear to have carried cropping to an extreme, according to a song printed in 1641, entitled 'The Character of a Roundhead:'

" What creature's this, with his short hairs,
 His little band and huge long ears,
 That this new faith hath founded?
 The Puritans wore never such,
 The saints themselves had ne'er so much ;—
 Oh, such a knave's a Roundhead!"

The portraits of Oliver Cromwell do not represent him as wearing short hair, and in that of his brother Richard, by Cooper, the hair falls in thick curls on the shoulder. A print of Ireton

John Lilburne.

represents him also with luxuriant hair. Colonel John Lilburne, however, is cropped and shorn as close as possible, and the name of Roundhead vouches for the veracity of the general description.

With Charles II. came the peruke, and we here, therefore, take leave of the gentlemen for the present ; but not of the ladies, although the word peruke is to be found in the list of articles of their toilets as early as the reign of Elizabeth, but in their case it simply means the additional locks or tresses already spoken of, and of which the use may be traced to very ancient times indeed. (See PERIWIG.) Under the date of 1662, Pepys writes : "By and by comes *la Belle* Pierce to see my wife, and to bring her a *pair* of perukes of hair, as the fashion is for ladies to wear, which are pretty, and of my wife's own hair." Three years afterwards he says (March 13th) : "This day my wife began to wear light coloured locks, quite white almost, which, though it made her look very pretty, yet, not being natural, vexes me, that I will not have her wear them."

Randle Holmes says, the ladies wore "false locks set on wyres, to make them stand at a distance from the head," and accompanies the information with the figure of a lady "with a pair of locks and curls which were in great fashion in 1670." (See cut annexed, from Fairholt's ' Costume

in England,' showing the large rolls of hair supported by hidden wires, decorated with wreaths of pearls, and having three ringlets on each side, hanging down almost to the shoulder.)

Another fashion Holmes speaks of as a *taure*. " Some term this curled forehead a bull-head, from the French word *taure*, because *taure* is a bull. It was the fashion of women to wear bull-heads, or bull-like foreheads, *anno* 1674, and about that time."

1670.

Taure fashion, 1674.

That in the reigns of Charles II. and James II. there were more simple and graceful modes of hairdressing than those just described, every visitor to Hampton Court Palace—and who can tell their number?—must be perfectly well aware. I have only spoken of such occasional caprices of fashion as we still see in our own day, some of which might vie in ugliness with those of any period. The commode and caps of various kinds came in towards the close of the seventeenth century, and we shall consequently continue this subject under HEAD-DRESS. It will be also abundantly illustrated by examples of contemporaneous continental fashions in the GENERAL HISTORY.

HALBARD, HALBERT. (*Halebarde,* French.) The name of this weapon is derived by Sir Samuel Meyrick from the Teutonic *Alle Bard,* "cleave all": but M. Demmin suggests that it is either from the German *Halb-Barthe,* "half battle-axe," or from *Alte Barthe,* "old battle-axe," as in Scandinavia and Germany it was known in the earliest times, though not in France till the Swiss introduced it in 1420. I incline to the latter derivation, as *Barthe* does signify an axe, and I have failed to find any word that would justify the translation of *Bard* as "cleave," his authority for so doing not being given by Sir Samuel.

The President Claude Fauchet, whose 'Origines des Dignitez' was printed in 1600, considers that the halbard was a Swiss or German weapon, and informs us that he found in the journal of a curé of St. Michael, of Angers, that in 1475 the King ("j'entends Louis XI.") ordered certain new

Henry VII. Henry VIII. Edward VI. Mary.

weapons of war ("nouveaux ferrements de guerre"), called "hallebardes," to be made in Angers and other good cities.

They appear in England some few years later, and were in use from the reign of Henry VII. to within my recollection, being carried by sergeants in the Guards and other infantry regiments in the reign of George III.

Charles I. Charles II.

Charles I.

Elizabeth.

William III. George I.

The Meyrick Collection contained specimens of every period, and the above selections have been made from the engravings of them by Skelton.

HANDEWARPES. Coloured cloths mentioned in an Act of Parliament, 4th of Edward VI., 1551. "Formerly much made in Essex." (Halliwell.)

HAND-GUN. See GUN.

HANDKERCHIEF. This now familiar word is not met with earlier than the sixteenth century, when it appears to have been most incongruously compounded, and was still further corrupted by the addition of "pocket" or "neck," equally singular positions for a "head-covering" to occupy· A much more appropriate name for it is retained in the dialect of Lincolnshire, where it is still called a "hand-cloth," and is probably identical with the "swat-cloth" of the Anglo-Saxons (in Latin "mappula" and "*mani*pulus"), which was worn on the left side in Saxon times and carried in the hand in the Middle Ages. "Facitergium" and "*manu*tergium" were also words in use during the latter period for the same useful article : "Facitergium et manutergium a tergendo faciem vel *manus* dictum." (Isidorus, lib. xix. cap. 25.) "Fascitergium i togilla sive parvulum guasape ad tergendum faciem." (Joan. de Janua.) "Fascitergium *touaille; touaille* à torcher la face." (*Vide* Ducange *in voce*, also ORARIUM and SUDARIUM.)

We thus trace our pocket companion to its primitive state of a cloth or towel to wipe the face

or the *hand* with, fully justifying its Saxon and Lincolnshire appellations—used by the hand and carried in the hand when, in the sixteenth century, the couvrechef was no longer worn, and kerchief had lost its original meaning, but retained its name as a cloth or clout, and in that sense the term "handkerchief" was generally adopted without any apprehension of incongruity. For the addition of "pocket" we must turn to the French "mouchoir *de poche*," of which our word is simply a translation.

Henry VIII. used "handkerchers of Holland frynged with Venice gold, redd and white silk;" others edged with gold and silver, and some "of Flanders' worke." Amongst the New Year's gifts to Queen Mary (Tudor), 1556, were "six handkerchers edged with passamayne of golde and silke," presented by Mrs. Penne, nurse to the late King Edward.

Laced handkerchiefs, and handkerchiefs of silk and cambric richly embroidered and trimmed with gold lace, were fashionable in the reign of Elizabeth. "Maydes and gentlewomen gave to their favourites, as tokens of their love, little handkerchiefs of about three or four inches square, wrought round about with a button at each corner." (Stowe's 'Annals.') "Handkerchief buttons!" was a street cry in London in the reign of Charles I., and they are mentioned again, 12th of Charles II., amongst others the importation of which was prohibited. (See BUTTON.)

To embroider handkerchiefs with the celebrated blue thread of Coventry was a favourite occupation for women in the days of Elizabeth and James I. : "I have lost my thimble and a skein of Coventry blue. I had to work Gregory Litchfield a handkerchief."

Shakespere makes Othello give a handkerchief "spotted with strawberries" to Desdemona. Cassio, who finds it, gives it to Bianca to take the work out.

Handkerchiefs of *point coupé*, or cut work, are mentioned in the reign of James I. :

> "A cutwork handkerchief she gave to me."
> Ben Jonson, *Bartholomew Fair*, 1614.

In the *Intelligencer* for June 5th, 1665, is the following advertisement :—"Lost, six handkerchers wrapt up in a brown paper, two laced, one point-laced, set on tiffany ; the two laced ones had been worn, the other four new." And in the *London Gazette* of December 5th—9th, 1672 :—"Lost, a lawn pocket handkercher, with a broad hem, laced round with a fine point lace, about four fingers broad, marked with an R in red silk."

Evelyn in one of his satirical poems, describing a lady's toilet, includes, amongst a host of other articles,

> "Of pocket mouchoirs, nose to drain,
> A dozen laced, a dozen plain."
> *Voyage to Maryland*, 1690.

"Nineteen handkershifts" are mentioned in the 'Account of my Cousin Archer's Cloths,' in 1707; but they are not particularly described. It is unnecessary to prolong this article; but see NAPKIN and NECKERCHIEF.

HAND-RUFF. The original term for the RUFFLE, which see.

HAND-SEAX. A sword or dagger worn by the Anglo-Saxons. There has been much barren controversy about this weapon, from the use of which it has been supposed by some they derived their name. Mr. Sharon Turner, in his 'History of the Anglo-Saxons,' vol. i. p. 115, observes that the Sakai, or Sacæ, are the people from whom the descent of the Saxons may be inferred with the least violation of probability, and that Sakaisuna, or the sons of the Sakai, abbreviated into Saksun, seems a reasonable etymology of the word Saxon. Strabo, Pliny, and Ptolemy furnish the strongest evidence in support of this opinion ; but it is the weapon and not the nation I have to speak of. The late John Kemble, an acknowledged authority on Anglo-Saxon subjects, defines the *seax* to be "ensis quidam curvatus,"—the short curved sword without a hilt seen

in the hands of the Dacians in the combats sculptured on the Column of Trajan, and known to the Romans by the name of *sica*. It is recorded by the Venerable Bede that Cwichelm, King of Wessex, A.D. 625, sent an assassin to Edwin, King of Northumbria, armed with a poisoned two-edged sica, with which, while pretending to deliver a message to the unsuspecting monarch, he made a blow at him, which must have proved fatal but for the devotion of an attendant thegn named Lilla, who, having no shield, threw himself between the villain and his intended victim and received the weapon in his own body. The thrust, we are told, was given with such force that the sica passed through the loyal thegn, and slightly wounded Edwin. The word *sica* is in King Alfred's Anglo-Saxon version translated *seax*, and is rendered "a dagger" by Turner, and "a sword" by Palgrave; but whether crooked or straight does not appear from this story. It must, however, have been a dagger of some length to have gone through one man's body and wounded another; and though "twi-ecced" (two-edged), it does not follow that it should be curved, nor can I understand such a thrust being made with a crooked weapon of any description.

The well-known story told by Nennius of the treacherous massacre of the Britons at a friendly feast by Hengist and his Saxons, whom he commanded at a certain moment to draw the seaxes they had concealed under their garments ("nimed eure saxes"), has no trustworthy foundation, and, if it had, would not afford us any information respecting the shape of the weapon. What is of more importance is the fact, that amongst all the undoubted Saxon weapons which have been exhumed in England, not one in the slightest degree curved or crooked should have been found. Coupled with another fact, namely, that in no Anglo-Saxon MS. has any illumination been hitherto discovered in which a curved sword or dagger is depicted, I await something like evidence before I adopt the definition of Kemble above quoted, or admit that *seax* or *sachs* was anything more than a general name for a sword, dagger or knife of any form. That the Saxons who invaded Thuringia in the sixth century had crooked swords by their sides, is the statement of Witechind, who wrote four hundred years later; and who, as Sharon Turner remarks, "though a Saxon himself, appears to have been completely ignorant of Saxon antiquities" (vol. i. p. 236). As to Fabricius, a writer of the *sixteenth* century, who says he "saw in an ancient picture of a Saxon a sword bent in a semilunar shape," it would be waste of time to question the value of such testimony.

That "in the Copenhagen Museum is a weapon which seems exactly to answer this description of the Northern *seax*" (Hewitt, vol. i. p. 35), I do not dispute; but what proof does Mr. Worsaae, who has engraved it, give that it is Anglo-Saxon, or can be assigned with confidence to any particular people?

M. Demmin has engraved several specimens of a sword or dagger which he attributes to the Germans and Merovingians, and calls a *scrama-sax*. *Sax* meaning a knife, "*scrama*," he says, "may be derived from *scamata*, a line traced on the sand between two Greek combatants, or from *scaran*, to shear, from which the German *Schere*, scissors, is derived. The scrama-sax is thus a weapon used *in duels*, or a cutting knife."

I should not have quoted this rather inconclusive deduction had I not felt bound by my prospectus to lay before my readers the latest opinions of the best authorities, and on the subject of arms and armour M. Demmin undoubtedly ranks amongst the foremost in industry, intelligence, and erudition; but with all respect for his judgment, I hesitate to adopt the derivation of *scrama* from *scamata*, or to assume that the barbaric nations of the North had a special weapon for personal combat. Whatever may be the origin of that word—and I avoid multiplying mere conjectures—I believe it will be found to indicate specially the weapon of the soldier; the war-knife, whether dagger or sword, but most probably the latter (the long seax) in contradistinction to the ordinary household implement (the *met-seax*, meat or eating knife), which is to this day called a *sax* in Lincolnshire. (See Halliwell *in voce*.) *Nægel-seax* was the Saxon name for a small knife used for paring the nails, and there can be no question as to the meaning of the word *seax* generally. The doubt is respecting the form of the hand-seax wielded by the warrior. That weapons more or less curved were borne by most or all of the various races that poured into Europe from the North and the East may be fairly admitted; but had the Saxons retained such as their national arms and

ever fought with or worn them in Britain, it is next to impossible that not a single specimen should have been found in their tumuli, nor a solitary example appear in any of their drawings or needlework tapestries from the days of Hengist and Horsa to that of the battle of Hastings. (See SWORD.)

HANGER. A small sword worn by gentlemen with morning dress in the seventeenth century. "14 Sept. 1668. This day my cousin Thomas dropped his hanger and it was lost."—Pepys. Shuter, a popular comedian of the time of Garrick, is said to have been the last man who wore one in the streets of London.

HANGERS, also called CARRIAGES (which see). Mr. Knight, in his 'Pictorial Shakspere,' introduced amongst the illustrations of the fifth act of Hamlet, in which "hangers" and "carriages" are mentioned, several engravings of sword-belts, erroneously described as hangers, the hangers attached to them not being visible. The true form of this appendage to the girdle will be seen in fig. 9, Plate IV. Original specimens are rare. There were two or three in the Meyrick Collection, obtained from the "Rust-kammer" at Dresden. They were of leather; but they were often of velvet, richly embroidered, and sometimes jewelled.

HANSELINE. An article of apparel, spoken of with reprobation by the Parson in Chaucer's 'Canterbury Tales,' who classes it with a slop: "Secondly, upon the other side, to speak of the horrible disordinate scantiness of clothing as be these cut slops or hanselines, that through their shortness and the wrappings of their hose, which are departed of two colours, white and red, white and blue, white and black, or black and red, make the wearer seem as though the fire of St. Anthony or other such mischance had cankered and consumed one-half of their bodies." Strutt has not attempted a description of this garment, but Hanselein is the German diminutive of Hans (Jack), and has, I imagine, been applied to the short or *little* Jack which Froissart mentions at this date as of German origin. (See JACKET.) The epithet "cut slop," also applied to it, shows that it was a shortened habit, but, like too many others, we are unable to identify it. (See SLOP.)

HARNESS. (*Harnois, harnais,* French; *arnesia,* Latin.) This term is generally applied to body armour throughout the Middle Ages; but I have occasionally found it include weapons. (*Vide* Glossary to Meyrick.) I therefore consider it is not improbable that in the passage in Rous's 'History of the Earl of Warwick' which I have quoted under BESAGNES, at p. 41, "The Erle smote up his vizor thrice and brake his besagnes and other harneys," the word *besagnes*, which I believe has not been met with elsewhere, may have been a clerical error for besag*ues*, the military pick, or some other knightly weapon, and not any portion of armour. Another occurrence of the word would solve the mystery.

HARQUEBUS, ARQUEBUS. Meyrick, in the valuable paper on Hand Fire-arms contributed to the 'Archæologia,' vol. xxii., has given us considerable information respecting this improvement of the hand-gun. Philippe de Commines, he tells us, is the first author who brings to our notice the arquebus. In his account of the battle of Morat, fought on the 22nd of June, 1476, he enumerates in the confederate army ten thousand arquebusiers, and in the same year he speaks of M. de Beures, of the house of Croy, who commanded the arquebusiers in the town of Nancy. In the commentary of Francis Carpenzi on Philippe de Commines, we read, "He led the first line himself with six hundred light-armed horse, as many with hand-guns, and the same number of arquebusiers,—a name certainly new, nor as yet, that I know, given in Latin."

In England, on the first foundation of the yeomen guard in 1485, one-half were armed with bows and the other with arquebuses. When the hand-gun received a contrivance suggested by the trigger of the cross-bow, to convey with certainty and instantaneous motion the burning match to the pan, it acquired the appellation of arquebus, corrupted into harquebus. Fauchet, who wrote his 'Livre d'Origine des Armes' in the time of Henry II. of France, informs us (page 57) that it was so called

from the Italian *arca-bouza*, corrupted from *bocca*, and signified a bow with a mouth; and the resemblance of its stock to that of the cross-bow may be seen in Skelton's Specimens before adverted to. To the Italians, therefore, we must assign the invention of the trigger, as well as the original invention of the hand-cannon.

The Latin name for the hand-gun was *tormentum manuarium*, those of this weapon *sclopus* and *arcus-busus*, since which "buss" has invariably signified a gun.* Previous to the new invention, the match had been held in the hand in using the hand-gun as well as the hand-cannon. The match-lock was now added and distinguished the arquebus. In its early form, judging from old prints, it seems to have been merely a piece of iron in the form of the letter S reversed, and made to turn on a pivot in its centre, whence it was called a "serpentine." The upper part was slit to hold the match, and was brought down upon the pan by the lower being pushed up by the hand, when it was intended to ignite the powder. In this simple state it seems to have remained till towards the middle of the sixteenth century, when the lower part of the S was got rid of, and a trigger, in the situation and form of that still used, substituted instead.

M. Demmin ignores altogether the derivation of arquebus from *arca-bouza*, and says it was so called from the German word "Hack-Buss" (*Hagen-Busche*), or "cannon with catch." It is singular that he should not have noticed the passage in Fauchet, who, dedicating his book to Henry III. of France, 1584, must have lived sufficiently near the time of the invention of the harquebus to be an authority on the subject, and more particularly as the words of the worthy president rather support than contradict his opinion. "Cet instrument," he says, speaking of the hand-cannon, "s'appela depuis haquebute, et maintenant a pris le nom de harquebuze; que ceux qui pensent le nom était italien luy ont donné: comme qui dirait arc-à-trou, que les Italiens appellent *bouze*." He does not, therefore, corroborate the latter assertion, while he decidedly states that the earlier name of the "instrument" was *haquebute*, under which we continually find mention of it in England: "Guilt harquebuts (in store) 397." "Harquebutt complete viiis." ('Survey of Tower of London,' 1559.)

It is also repeatedly called harque*bush* and hag*bush*, which brings it still nearer to M. Demmin's derivation: "Harquebush complete viiis." "Item in the gonner's chamber, 23 hagbushes of brasse."

We must leave the Germans and the Italians to contend for the honour of having invented the weapon, or named it, and illustrate this article by an engraving of a harquebus which belonged to King Henry VIII., now in the national armoury, Tower of London.

Harquebus of Henry VIII., with trigger.

The Lock of a later one, with its serpentine.

HAT. (*Haet*, Saxon; *Hutt*, German.)

The earliest form of hat introduced to the inhabitants of Britain was evidently the *petasus* of the Romans, but there is no proof that it was ever adopted by them, nor do we find the Saxons or Danes

* Thus we have *blunder-* or, more correctly, *donder-buss*, thunder-gun.

represented as wearing them, caps being the general head-covering of the men of all Keltic or Gothic races, as far as discoverable, previous to the tenth century. As cabin appears to have been the parent of caps, so hut seems to have been the progenitor of hat. It is at least noticeable that both cap and hat have received their names from similar habitations. Strutt says, "The hat of the Saxons was, I doubt not, made of various materials, but by no means seems to be a part of dress universally adopted. From its general appearance I have supposed it to have been of skins, with the shaggy part turned upwards : and probably it might often be so ; but they had also felt or woollen hats at this period, which their own records testify." What "general appearance" he refers to I am at a loss to say, as in no Saxon illumination have I ever seen anything like a hat. But that the words "fellen haet" occur in their records I freely admit, questioning only whether *haet* was at that time a term used indifferently for cap, bonnet, or any kind of head-gear. Shortly after the Norman Conquest, however, the hat I have described as resembling the *petasus* unmistakeably presents itself, as an extra covering for the head, I presume, in bad weather, as it is slung, after the manner of its Roman prototype, at the back of its owner, who wears commonly either a round bonnet or a hood, the hat being substituted for the former, or worn over the latter, as occasion required. Travellers in general, but pilgrims particularly, are rarely depicted without one. They were probably made of felt, or some such substance, and in some instances, as Mr. Strutt has observed, appear to have been covered with the skin of an animal. (See, for instance, the hat of the pilgrim painted on the wall of the Old Palace of Westminster, which is evidently covered with the same skin which forms his cloak.) At what exact period the skin of the beaver was first used in the manufacture of hats is at present undecided, but such were imported from Flanders before the end of the fourteenth century. The Merchant in Chaucer's 'Canterbury Tales' is described as wearing

From a wall-painting in the Old Palace at Westminster.

"On his head a Flaundrish bever hat ;"

and in the Freere's Tale the gay yeoman had

"An hat upon his hed with fringes black."

Hats had also been adopted by women previous to this date. The Wife of Bath, we are told, wore a hat

"As broad as is a buckler or a targe."

Mr. Adey Repton—who collected many notices of hats, and illustrated them with drawings for his paper on this subject, read to the Society of Antiquaries of London, 19th of May, 1831, and which was published the following year in the twenty-fourth volume of the 'Archæologia'—has quoted an English translation of Froissart's Chronicle for other instances, overlooking the fact that the original passages are in French, and that the words *chapeau* and *chapelle* do not invariably signify hat (see those words). At the same time, hats were worn in Froissart's day, as I have just shown, and throughout the fifteenth century ; but caps and hoods were far more general. "Fine felt hats" are mentioned in Lydgate's 'London Lyckpenny,' *temp.* Henry VI. In the journal of Beckington, secretary to that sovereign, occurs "a scarlet hat given as a New Year's gift." Among the entries in the inventory of the effects of Sir John Fastolfe, 1459, are "a hatte of bever lyned withe damaske," "ij strawen [straw] hattes," "i prikkyng [riding] hat cover'd with blake felwet" (velvet). In the 'Ship of Fools,' printed in 1517, the gallants of Henry VII.'s day are described as wearing "ample bonnets, with low necks, and guarded like as it were for despite, and thereupon the great hats, that is set all upon one side." Examples of this latter fashion I have given under CAP, p. 76 ; but I have called them

bonnets, which appear about this period to be losing their distinctive appellation. In the reign of Henry VIII. hats are more frequently mentioned, but the great proportion of the head-coverings we find represented in paintings or tapestries are better entitled to the name of bonnet. Nevertheless, we read of "hattes powdered with armyns" (ermines), "hattes of cremosyn velvet, hattes after dauncers' fashions, with feasaunts' feathers in them." "Item, paid for a hatte and plume for the King in Boleyn, xvs.," &c. The portraits of the reign of Queen Elizabeth furnish us with a host of examples of undeniable hats, and we here append a few from those collected by Mr. Repton.

1. Sir Philip Sidney. 2. George Clifford, Earl of Cumberland. 3. Douglas, Earl of Morton.

4. Thomas Sackville, Earl of Dorset. Died 1608. 5. From a painting of the Court of Wards. *Temp.* Elizabeth.

That of George Clifford, Earl of Cumberland (fig. 2), illustrates the practice of wearing a lady's glove in the hat, alluded to at page 211 *ante.* Figs. 3 and 5 afford us varieties of the high-crowned hat which the writers of the time call "the steeple" and "the sugar-loaf" hat. Stubbs, describing the hats of his day, says, "Sometimes they use them sharp on the crown, perking up like the shear or shaft of a steeple, standing a quarter of a yard above the crown of their heads, some more, some less, to please the fantasies of their wavering minds. Other some be flat, and broad on the crown, like the battlement of a house; another sort have round crowns, sometimes with one kind of a band, sometimes with another; now black, now white, now russet, now red, now green, now yellow, now this, now that; never constant with one colour or fashion two months to an end. And as the fashion be rare and strange, so is the stuffe whereof their hats be made divers also; for some are of silk, some of velvet, some of taffata, some of sarcenet, some of wool, and, which is more curious, some of a certain kind of fine hair: these they call *bever hats,** of twenty, thirty, and forty shillings a piece, fetched from beyond the sea, whence a great sort of other varieties do come. And so common a thing it is, that every serving man, countryman and other, even all indifferently, do wear these hats; for he is of no account or estimation among men if he have not a velvet or taffata hat, and that must be pinched and cunningly carved of the best fashion. And good profitable hats be these,

* Mr. Fairholt, quoting this passage, says, "This is the earliest notice of the beaver hat we have." The entry in the inventory of Sir J. Fastolfe must have escaped him.

for the longer you wear them the fewer holes they have." The concluding part of this *tirade* is rather puzzling, as he appears to describe a style of hat, or rather bonnet, much worn in the reign of Henry VIII., but not to be seen in any paintings or engravings of the period the satirist is ridiculing. At least, I can find no hats of Elizabeth's time that answer the description of being " pinched and cunningly carved," or having " holes " in them, all which would perfectly apply to the Milan bonnets of the first half of the century. (*Vide* p. 76.)

Yeoman of the Guard. *Temp.* Elizabeth.

Speaking of the ornaments of the hat, Stubbs continues thus : " Besides this, of late there is a new fashion of wearing their hattes sprung up amongst them, which they father upon the Frenchmen, namely, to wear them without bands ; but how unseemly a fashion that is, let the wise judge." Jewels were worn in hats (as they had formerly been in caps and bonnets) during the reign of James I., and a portion of that of his unfortunate son Charles.

The letter of James to his son and his great favourite, the Duke of Buckingham, who had accompanied Prince Charles to Spain in 1623, has been frequently printed and quoted. "I send you for your wearing the 'Three Brethren,' that ye knowe full well, but newlie sette, and the Mirroure of France,

Thomas Egerton, Lord High Chancellor. 1603.

Howard, Earl of Northampton. *Obiit* 1614.

Bacon, Viscount St. Alban's, 1618.

Thomas Cecil, 1st Earl of Exeter. *Obiit* 1622.

the fellowe of the Portugall dyament, quiche I wolde wishe you to weare alone in your hatte with a little blakke feather. As for thee, my sweet gosseppe, I send thee a faire table dyamonde and I have hung a faire peare pearle to it, for wearing on thy hatte or quahir thow plaises. If my babie will not spare the anker from his mistress, he may well lend thee his rounde broache to weare, and yet he shall have jewels to weare in his hatte for three great days."

In 'Timon of Athens' a character complains that " He [Timon] gave me a jewel the other day, and now he has beaten it out of my hat." (Act iii.)

> " And his hat turned up
> With a silver clasp on his leer side."
> Ben Jonson, *Tale of a Tub.*

The same author writes:

> "Honour's a good broach to wear in a man's hat at all times."
>
> *Poetaster.*

And in his 'Magnetic Lady:'

> "Altho' he ha' got his head into a beaver
> · With a huge feather, 's but a currier's son."
>
> Act iii. sc. 4.

A song by Heywood bears testimony to the value set on beaver hats in the days of Elizabeth:

> "The Spaniard's constant to his block,
> The French inconstant ever; ·
> But of all felts that may be felt,
> Give me your English beaver."

A hat called a copotain, capatain, and coptankt hat was worn in the reign of Elizabeth and her successor. Gascoigne, in 'Herbes' (p. 154), has

> "A copthank hat made on a Flemish block;"

and also in his Epilogue, p. 216:

> "With high copt hats and feathers flaunts a flaunt."

This "high copt hat" is fairly presumed to be the hat with a high conical crown so commonly seen in the reigns of Elizabeth and James I., and designated by Bulwer in his 'Artificial Changeling,' 1653, as the sugar-loaf hat, which, according to his account, became fashionable again in the reign of Charles I., and was worn by women as well as men. "I pray," he says, "what were our sugar-loaf hats, so mightily affected of late both by men and women, so incommodious for us that every puffe of wind deprived us of them, requiring the employment of one hand to keep them on?"

The high-crowned hats worn by women of all classes in the reign of Charles I. are amply illustrated by the engravings of Hollar (see pp. 227, 228, *ante*).

G. Withers. From his 'Emblems,' 1635.

Oliver the Painter.

Before the reign of Charles II. the high-crowned hat began to be less worn. In one of his escapes during the interregnum, he was disguised as a mean person "wearing a very greasy old grey steeple crowned hat, with the brim turned up, without lining or hat-band." (Stukely, 'Itin. Curiosa.')

In 1656 the high-crowned hat appears to have been considered old-fashioned. In a translation of that date of Don Quevedon's Visions, it is said, "Ye can't see a high-crowned hat but presently ye cry, this or that's of the mode or date of Queen Dick."

Of feathers worn in hats little need be added to what has been said already under the head of FEATHERS (p. 188), and examples will be found not only in this article but throughout the work. In Skelton's 'Bouge of Court' it is said of Riot, that

> "An estridge fedder of a capon's tayle
> He set up fresshely upon his hat alofte."

Dekker, in his 'Horn-Book' (1609), observes, "When your noble gallants consecrate their hours to their mistresses and to revelling, they wear feathers then chiefly in their hats, being one of the fairest ensigns of their bravery."

Gervase Markham, in 1607, describes the sort of hat that should be worn by equestrians as follows :—" A hat which will sit close and firme upon your heade, with an indifferent narrow verge or brim, so that in the saults or bounds of the horse it may neither through widenesse ór unwieldinesse fall from your head, nor with the breadth of the brim fall into your eies and impeach your sight, both which are verie grosse errors."

Hats of the latter half of the 17th century. From prints of the period.

Velvet hats were still worn in the days of Charles II. Pepys, under the date of August 25, 1660, says, "This night Willever brought me home my velvet coat and hat, the first that ever I had."

On the 27th June, in the following year, is the entry—"This day Mr. Halden sent me a beaver, which cost me £4 5s.,"—an enormous price for a hat, considering the value of the money of that period.

In 1666 (June 11th), he records his seeing the ladies of honour at Whitehall in their riding habits, with hats and periwigs. This fashion of hats and periwigs for ladies in their riding costume is mentioned by Addison, in the reign of Queen Anne, and by the writers of the time of George II.

The rim or brim of the hat, notwithstanding, increased greatly during the reigns of Charles I. and Charles II., becoming so broad that when much worn they were liable to hang down, and from thence such hats obtained the name of "slouched hats." The broad brim was ornamented with feathers all round, and the fashion continued through the reigns of James II. and William III.; but from the inconvenience of the falling of the very broad brim, as objected to by Markham, one portion of it was turned up, either at the front, back, or one side of the head, which was called "cocking" it; and as

King William III. From three portraits, the last (a print) dated 1692.

this was done according to the wearer's fancy, the hats similarly turned up obtained the name of the person who set the peculiar fashion, and the style in which the unfortunate Duke of Monmouth wore his was distinguished as "the Monmouth cock." As late as the reign of Anne, we are informed by the 'Spectator' (No. 129), "During our progress through the most western parts of the kingdom, we fancied ourselves in King Charles II.'s reign, the people having made very little variations in their dress since that time. The smartest of the country squires appear still in the Monmouth cock." In

the course of time two sides of the hat were turned up, and in the reign of William and Mary, a third portion, which formed the complete cocked hat, and from its three equidistant points was called, within my recollection, "Egham, Staines, and Windsor." In the reign of Queen Anne we find in the 'Tatler,' No. 94, the petition of a haberdasher of hats, in which it is stated that "the use of gold and silver galloon upon hats has been almost universal, being undistinguishably worn by soldiers, squires, lords, footmen, beaux, sportsmen," &c., and that "by wearing such hats upon their heads, instead of under their arms, they would last so much longer. That hats shall frequent all the winter the finest and best assemblies, without any ornament at all, and in May shall be tucked up with gold or silver, to keep company with rustics, and ride in the rain."

The famous battle of Ramilies, in 1706, introduced the "Ramilie cock." The cocked hat had a variety of shapes in the reign of Anne. In No. 526 of the 'Spectator,' "John Sly, a haberdasher of hats and tobacconist," is directed to take down the names of such country gentlemen as have left the hunting for the military cock of the hat on the approach of peace. In No. 532 is a letter written in the name of the said John Sly, in which he states that he is preparing hats for the several kinds of heads that make figures in the realm of Great Britain, with cocks significant of their powers and faculties. His hats for men of the faculties of law and physic do but just turn up to give a little life to their sagacity; his military hats glare full in the face, and he has prepared a familiar easy cock for all good companions between the above-mentioned extremes. Nov. 25, 1712, John Sly writes to say that he has seen of late French hats of a prodigious magnitude pass his observatory. George II. reviewed the Guards in 1727, habited in grey cloth faced with purple, with a purple feather in his hat, and the three eldest princesses went to Richmond in riding habits, with hats and feathers and periwigs. ('Whitehall Evening Post,' August 17.) The 'Weekly Register' of July 10, 1731, affords us the following information :—" The high-crowned hat, after having been confined to cots and villages for so long a time, is become the favourite mode of quality, and is the politest distinction of a fashionable undress." "The hat and peruke, which has been sometimes made part of a lady's riding equipage, is such an odd kind of affectation that I hardly know under what species to range it."

Laced Cocked Hat, with feather edging. (Hogarth.)

Clergyman's Hat. (Hogarth.)

In the 'Rambler,' No. 109, dated 1751, is a letter from a young gentleman who says his mother would rather follow him to the grave than see him "sneak about with dirty shoes and blotted fingers, hair unpowdered, and a hat uncocked." In 1753, 'The Adventurer,' No. 101, describes the metamorphosis of a greenhorn into "a blood," as the dashing young men of that day were styled. "My hat," says he, "which had been cocked with great exactness in an equilateral triangle, I discarded, and purchased one of a more fashionable size, the fore corner of which projected near two inches further than those on each side, and was moulded into the shape of a spout." This fashion was, however, of brief endurance, as we find that he afterwards altered the shape of his hat, "the fore corner" of which "was considerably elevated and shortened, so that it no longer resembled a spout, but the corners of a minced pye."

The cocked hat, in the middle of the last century, was considered as a mark of gentility, professional rank, and distinction from the lower orders, who wore them uncocked. It was generally carried under the arm at this period :—

"A pretty black beaver tuck'd under his arm :
If placed on his head, it might keep him too warm."

Monsieur à la Mode, 1752.

In a periodical paper called 'The World,' published in 1755, No. 122 contains an account of a poor physician walking in the streets of London in a threadbare coat, and a hat void of shape and colour under his arm; "which," he says, "I assure you, I do not carry there for ornament, nor for fear of damaging my wig, but to point out to those who pass by that I am a physician." In another number of the same paper (202) the military hat is thus described :—

> "That hat adorns his head,
> Graced and distinguished by the smart cockade,
> Conspicuous badge which only heroes wear."

The chapter on Hats contained in the 'London Chronicle' for 1762, vol. xi., is, strictly speaking, just too late in date to claim insertion in this work, as George III. ascended the throne October 25, 1760; but as it refers to fashions of that time, in recording their alteration I shall not confine myself to the prescribed limits.

"Hats," says the writer, "are now worn, upon an average, six inches and three-fifths broad in the brim, and cocked between Quaker and Kevenhuller. Some have their hats open before like a church spout, or the tin scales they weigh flour in; some wear them rather sharper, like the nose of a greyhound, and we can distinguish by the taste of the hat the mode of the wearer's mind. There is a military cock and the mercantile cock, and, while the beaux of St. James's wear their hats under their arms, the beaux of Moorfields-mall wear theirs diagonally over the left or right eye; sailors wear their hats uniformly tucked down to the crown, and look as if they carried a triangular apple-pasty upon their heads.

"I hope no person will think us disaffected, but when we meet with any of the new-raised infantry wearing the buttons of their hats bluff before, and the trefoil white worsted shaking as they step, we cannot help thinking of French figure-dancers.

"With the Quakers it is a point of their faith not to wear a button, or loop tight up: their hats spread over their heads like a pent-house, and darken the outward man to signify they have the inward light.

"Some wear their hats, with the corner that should come over their foreheads high into the air; these are the Gawkies. Others do not above half cover their heads, which is, indeed, owing to the shallowness of their crowns; but, between beaver and eyebrows, expose a blank forehead, which looks like a sandy road in a surveyor's plan."

After some satirical comments on the above fashions, the writer adds :—"A gold button and loop to a plain hat distinguishes a person to be a little lunatic; a gold band round it shows the owner to be very dangerously infected; and if a tassel is added, the patient is incurable. A man with a hat larger than common represents the fable of the mountain in labour; and the hats edged round with a gold binding belong to brothers of the turf."

The hats worn by the dignified clergy of the Roman Catholic Church demand a brief notice in this place. The various ranks are distinguished by the colour. The cardinal's hat is red; those of the archbishop and bishop, green; the hat of an abbot, black. The red hat was granted to cardinals by Pope Innocent IV., at the Council of Lyons, A.D. 1245; and, according to De Corbio, first worn by them in the following year. I have not found any date for the green hat, but believe it to have been

From Jeffrey's Collection, published in 1757.
a, 1700—1715; *b*, 1735; *c*, 1745; *d*, 1755.

much later. For the black, no order was necessary, as it was the colour commonly adopted by the clergy. In form the clerical hat differed little from those worn by pilgrims, travellers, and generally by the laity, in the twelfth and thirteenth centuries, having, like them, cords by which they could be

slung behind or tied under the chin. (See woodcut from examples in Royal MS. 16 G 5, and figure
of a cardinal from tapestry at St. Médard's, Paris.)

Cardinals' Hats, 14th century. From Royal MS. 16 G 5.

Cardinal. From Tapestry at St. Médard's, Paris.

Cardinal Beaufort. Winchester Cathedral.

In the fifteenth century the crown of the hat became taller and hemispherical, with a narrow
brim. (*Vide* woodcut from effigy of Cardinal Beaufort in Winchester Cathedral.) The cords were
lengthened and knotted in front. In the sixteenth century the crown of the hat was much depressed,
and the brim considerably enlarged, taking the form, in fact, which it has retained to the present
day. In addition to the colours, the rank of the different classes was distinguished, according to
foreign heraldic authorities, by the number of tassels which terminated the cords. The arms of
cardinals are surmounted with red hats, the cords of which have each fifteen tassels. Those of
archbishops and bishops exhibit ten tassels, and those of abbots three tassels. (*Vide* engravings
annexed.)

Cardinal.

Archbishop and Bishop.

Abbot.

In Parker's 'Glossary of Heraldry' it is stated (p. 72) that "prothonotaries use a similar hat,
with two rows of tassels," and that "a black hat with one tassel on each side belongs to all other
clergymen." No authority is given for these statements. In a note, also, it is said that examples
occur of cardinals' hats with a less number of tassels, and that the same remark applies to those of

the continental bishops. I have merely to remark that no uniformity as to the number of tassels appears to have existed as late as the reign of Henry VIII. in England. The arms of Wolsey are surmounted in MSS. of that period with a hat, the cords of which have only six tassels; and the hat of Dr. William Haryngton, Prothonotary of St. Paul's, London, has cords with three tassels. No rule appears to have been strictly preserved even by the heralds, at least in England, and the examples appended exhibit an indifference to such a regulation even in Catholic countries.

Cardinal, 16th century.
From Bertelli, 1591.

Cardinal. From Caspar Rutz, 1581.

HAT (IRON). See IRON HAT.

HAT (WIRE). See WIRE HAT.

HAT-BAND. Of this ornament for the hat I have already spoken incidentally. Hat-bands of gold and silver, and sometimes of jewels, were worn by the nobility and wealthy gentlemen in the sixteenth and seventeenth centuries, and, of course, by those who affected to be such.

In Samuel Rowland's 'Pair of Spy Knaves' he describes the "roaring boy" of his day, and says :—

> "What our neat fantastics newest hatch,
> That at the second hand he's sure to catch :
> If it be feather time, he wears a feather,
> A golden hat-band or a silver either."

In Ben Jonson's play of 'Every Man out of his Humour,' printed in 1599, one of the characters (Fastidious Brisk), giving an account of a duel, says he had on a gold cable hat-band, then new come up, of massy goldsmiths' work, which he wore about a murrey French hat (*i.e.* a hat of a mulberry colour), the brims of which were thick embroidered with gold twist and spangles (act iv. sc. 5). Also in the introduction to the same play we read :

> "But that a rook by wearing a py'd feather,
> The cable hat-band," &c.

In his play of 'The New Inn,' 1620, mention is made of

"The Naples hat,
With the Rome hat-band;"
Act ii. sc. 2.

but we have no indication of its peculiarity. The cable hat-band, however, is, I think, depicted surrounding the hat of Lord Chancellor Egerton (see p. 257), and of the Earl of Dorset (p. 256).

In the Lord Mayor's pageant for 1664, there was a character attired like a grave citizen after the ancient manner, who wore "a broad brimmed hat" with "a large Cypresse hat-band" (*i.e.* a hat-band of Cyprus silk). Such hat-bands may be indicated by the sash-like bands on the hats of Douglas Earl of Morton (p. 256), and of the yeoman of the guard of Elizabeth (p. 257).

The cocking of the hat rendered the band as a matter of ornament unnecessary, as when turned up on three sides it would have been absolutely invisible. The latest appearance of it is in the flat crowned hat of the clergyman in Hogarth's picture, which is surrounded by a slender band of the cable pattern (p. 260).

HAUBERK. (*Halsberg,* German ; *hauberc, haubert,* French ; *alsbergum,* Latin.) Very little is known of the origin of this military garment, more familiarly called a coat of mail. The opinion formerly entertained that it was introduced from the East by the Norman Crusaders has long since been found untenable, as numberless examples exist of representations of it in Anglo-Saxon and Norman illuminations, as well as mention of it long antecedent to the Crusades ; and that it was invented by the Germans, as suggested by Sir Samuel Meyrick, in consequence of its name being derived from the German, is as erroneous as his first derivation of Hals-berg, "from *hauen,* to hew or cut, and *berg,* a defence ; that is, a protection against cuts or stabs," but which was corrected in the edition of 1842. "Halsberg" is literally neck or throat guard, and would be as applicable to the camail or to a gorget, whether of chain or plate, as to the hauberk, which in its earliest form was a shirt or tunic, probably of leather or quilted linen, on which rings were sewn, and did not protect the neck at all. This I consider to be one of the many cases in which the name of some similar—or, it may be, perfectly different—article of attire has been given to a garment of later invention or adoption by a foreign nation. "The Enigma" of Aldhelm, Bishop of Sherborne, who died in 709, has been often cited to show that chain mail was known to the Anglo-Saxons as early as the seventh century. It is headed "De Lorica," the name given by the Romans to every description of armour for the body, and is as follows :

"Roscida me genuit gelido de viscere tellus ;
Non sum setigero lanarum vellere facta.
Licia nulla trahunt, nec garrula fila resultant,
Nec crocea seres, texunt lanugine vermes.
Nec radiis carpor duro nec pectine pulsor ;
Et tamen en ! vestis vulgi sermone vocabor
Spicula non vereor longis exempta pharetris."

I have given it in the original, that those whom it may concern may translate it for themselves. To the general reader I need only observe that there is not a word in "The Enigma" clearly indicating that the *lorica* was of linked rings (the *lorica catena* of the Romans). It merely states that, although "produced from the cold bowels of the dewy earth, and neither spun from the wool of the sheep nor the yellow down of the silkworm, nor woven in a loom, nor carded by the wool-comb," it is, strange to say, called a garment. The description would equally apply to a cuirass of metal. In the tenth century, however, we read in the Northern romances of "the shining iron rings" of the battle-mail by "hard hands *well locked,*" and of "the grey vestments of war." No doubt these passages allude to the *gheringed-byrn* of the Saxons (their name for the hauberk), the tunic covered with rings which we find in their illuminations, and which the continual inroads of the heavily-armed Danes compelled them to assume in self-defence. But granting this, what becomes of the theory—for it is

nothing more—that the Saxon and early Norman hauberks were formed of rings sewn flat on a foundation of leather, or some other strong material? M. Demmin has adopted it without question or giving any reason for doing so. "All these coats of mail," he says, "may be divided into four sorts of ringed coats: coats made of flat rings sewed on side by side; coats made of oval rings, each one so placed as to overlap half the next; coats made of lozenge-shaped pieces of metal; and coats with scales" (p. 41). The last two sorts are not made of rings of any description; but where is the authority for the preceding two? The contemporary illuminated MSS., the Bayeux Tapestry, and the seals of the kings and nobles of the eleventh and twelfth centuries? Undoubtedly they convey to the eye, without exception, that idea precisely. (See, for examples, the figure of Abraham in armour, at p. 14 *ante*, from the Anglo-Saxon MS. in the Cotton. Lib. marked Claudius, B iv.; the figures of William Duke of Normandy and two other warriors on the following page (15); figs. 1, 2, 3, 4, and 5, in the accompanying plate, and the great seals of Henry I. of England and Alexander I. of Scotland here engraved.)

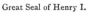

Great Seal of Henry I.

Great Seal of Alexander I.

That not a vestige of this description of armour should have been preserved or discovered is accounted for by the supposition that the foundation of leather or linen had perished; but that answer is not satisfactory to those who contend that there is no foundation for the theory, which is not only unsupported by contemporary description, but actually contradicted by it, and that the appearance of flat rings unlinked, in representations of Saxon and early Norman armour, is caused solely from the incapacity of the draughtsman or embroiderer of that day to indicate chain-mail more artistically. This subject will, however, be further discussed under the article MAIL, and I therefore now turn to another equally vexed question, the shape of the hauberk, which is of quite as much importance to the artist as the details of its composition. That its earliest known form was that of a shirt or tunic reaching to the knee, with sleeves terminating a little below the elbow, there is evidence enough; but in the Bayeux Tapestry, a work of the eleventh century, it is represented in numberless instances so as to convey the idea of its having breeches or short trousers attached to or of one piece with it. Mr. Way has stated this to be a peculiarity of the haubergeon, an assertion I have taken the liberty to dispute in my notice of that military garment at page 237. Mr. Fairholt and Mr. Hewitt concur in giving such continuations to the hauberk,—an opinion which I feel equally unable to adopt. As long ago as the first publication of my 'History of British Costume,' I observed, "Both Normans and Saxons are represented" (in the Bayeux Tapestry) "in the ringed tunic which descends below the knee, and, being cut up a little way before and behind for convenience in riding, appears, from the rudeness of this representation, as though it terminated in short trousers." To this I appended the following note:—"That it does not do so, is proved not only by the appearance of the tunic alone, as carried by the Normans to the ships" (*vide* article on ARMOUR, p. 14), "but by the evident impossibility of getting into a garment so made. Amongst the last incidents in the Tapestry, we find

one of the victors stripping a dead warrior of his armour, which he is pulling over his head inverted, an act incompatible with any other form than that of a simple shirt or tunic." (See Plate X. fig. 1.) Mr. Fairholt quotes my opinion on this point in his 'Costume in England,' but adds, "that so many examples of such a body armour occur—too distinctly delineated about the thigh to be considered bad drawing, or an imperfect representation of the opening in the long tunic—that it certainly appears to have been thus worn, though it may have been divided at the waist." Now let the reader examine the annexed woodcut, and then compare it with fig. 3, Plate X., and observe how narrowly the draughtsman of the latter has escaped misleading the spectator into the belief that he also intended to represent a hauberk terminating in trousers.

Death of Harold. From Bayeux Tapestry.

The subsequent researches of forty years (not only mine, but those of the most eminent anti-quaries of Europe) have failed, however, to produce the slightest additional evidence either on one side or the other, with the exception of an equally doubtful drawing discovered by M. Viollet-le-Duc, in a MS. formerly in the library at Strasburg, unfortunately destroyed by the bombardment of the city by the Prussians in 1870, and which has sufficed to add another important name to those already mentioned as supporters of the trouser theory. M. Viollet-le-Duc has engraved a group from this MS., which he attributes to the end of the twelfth century, and observes, " Le haubert ne se termine pas par une jupe fendue, mais en manière de braies, à peu près comme l'était la cotte à armer normande." The group has been carefully copied by our artist (see opposite page), and, without raising a question as to the minute fidelity of M. Viollet-le-Duc's engraving, I contend that the hauberks present the same appearance as those in the Bayeux Tapestry, and, like them, may be taken to represent "jupes fendues," quite as confidently as " caleçons amples." The Bayeux Tapestry, in which are found the other examples relied upon as authorities for the trousers, presents us *itself* with the strongest testi-mony against them in the instances I have pointed out : viz., the figures of the hauberks which are being carried to the ships, and the stripping of the dead warrior.

Sir S. Meyrick suggests the mode by which such a garment might be put on, viz. by inserting the legs first, and then passing the arms through the sleeves ; but to effect this it would be necessary that the body of the hauberk should open longitudinally, either before or behind, from the neck, as low at least as the waist, and there is not the slightest indication of its doing so in any example, nor in such a case could the Duke of Normandy have possibly mistaken the back for the front of his hauberk, as he is said to have done. Mr. Fairholt attempts a compromise, by observing that the breeches might perhaps have been separate articles of attire, and attached in some way to the hauberk, but no sign of separation exists in the examples he has selected ; and as the figures are without girdles or waist-belts of any description, it cannot be argued that the point of junction was there, but hidden

by the belt passing over it.　Granting even that the rudeness of the workmanship is to be allowed to account for this defect, while the same plea is rejected as a reason for the other, the consequence would be that Mr. Way's description of the haubergeon would receive support, but Mr. Fairholt's idea of the hauberk be utterly demolished.　M. Viollet-le-Duc's attempted solution of the difficulty is astounding.　He says, " On voit sur la poitrine du cavalier le *plastron volet,* qui s'ouvrait de haut

From MS. formerly in the Strasburg Library.

en bas et permettait de passer le corps par cette ouverture, enfin d'enfourcher les cuisses, le camail étant rapporté."　This was Meyrick's idea as far as regarded the *way* by which a man might possibly put on such a garment, but he cautiously abstained from indicating the exact portion of it at which he could obtain entrance.　M. Viollet-le-Duc has taken a bolder step, and asserted, as if on authority, that the knight stepped into his hauberk through its neck !　The case therefore, for the present, stands thus : if the hauberk, as depicted in certain portions of the Bayeux Tapestry and the aforesaid manuscript, is intended to represent a garment with breeches reaching to the knees, which are *of one piece with the body,* we must believe, 1. That the Anglo-Saxons and Normans of the eleventh century had simultaneously invented and assumed a military habit unknown at any other period in any other country ; and 2. That it was an ephemeral fashion, abandoned immediately after the battle of Hastings, as no other representation has been found of it, nor any mention of it by a contemporary writer.

Some of my readers may consider I have wasted too many words in the discussion of this question ; but I consider it my duty in such cases to lay before them the opinions of all writers of authority, and enable them thereby to form their own with the assistance of the accompanying illustrations.

The earliest hauberks, as I have already pointed out, did not protect the throat ; but those in the Bayeux Tapestry exhibit an additional defence for the chest in an oblong piece of ringed, mascled, or scaled armour fastened in front (see pages 14 and 15), which appears to have had a border to it of the same colour and material as that which terminates the sleeves and the skirts.　This is the " plastron volet " which M. Viollet-le-Duc points out as covering the aperture through which the knight thrust himself, feet foremost, into his armour.　Putting aside the utter impracticability of

such an act, he appears to have overlooked the fact that the hauberks of the figures he has copied from the Strasburg MS. have no "plastron volet" to support his theory. They are of one entire piece; and if there were any opening large enough to admit the passage of the body, it must have been at the back. Well, here is from his own work the representation of the back of a hauberk of the

From Viollet-le-Duc.

Female in Hauberk, 14th century.
From Painted Chamber, Westminster.

same date (vol. v. p. 78), and our readers may judge for themselves whether such an opening as is there indicated could be made available for the purpose in question. In the twelfth century these pecu-liarities disappear, the sleeves are extended to the wrists, and in the thirteenth cover the hands, which could be slipped out of them when desirable, through an oval opening corresponding with the palm.

The hauberk was also constructed with a hood or coif of mail, which could be drawn over the head or flung back on the shoulders at pleasure (see fig. 7, Plate X.). Examples of this fashion occur as early as the eleventh century. The introduction of the bascinet and camail in the fourteenth cen-tury rendered the hood unnecessary, and the gauntlet about the same period had a similar effect on the sleeve, which again terminated at the wrists. During the reigns of Edward II. and Edward III., additional defences of plate were gradually adopted for the elbows, shoulders, arms (see BRASSART, COUDES, EPAULIÈRE, RERE-BRACE, and VANT-BRACE), and eventually the breast, back-plate, and tassets combined to cover the hauberk entirely. It continued to be worn, however, to the end of the fifteenth century, and examples are to be found of its use as late as the reign of Henry VIII.

HAUMUDEYS. (Corrupted from *aulmonière*, a purse.) In the romance of 'Alexander' the hero receives "an haumudeys" full of gold. (Ellis's 'Romances,' vol. i. p. 74; Fairholt, 'Costume in England,' p. 523.)

HAUSE-COL. A name given to a chin-piece of steel, which was worn with the salade of the fifteenth century, a combination of a gorget and a mentonière. It is rarely to be met with, but constantly depicted in paintings of the reign of Edward IV.

The introduction of the close helmet, with vizor and beaver, rendered the hause-col unnecessary. It disappeared, therefore, in the reign of Henry VII. Something very like it is seen in the group of

knights on horseback of the time of Edward I. (p. 17). M. Viollet-le-Duc calls it a beaver ("une bavierre"), and some foreign writers apply the term hause-col to the common steel gorget, which only protects the throat.

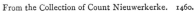

From the Collection of Count Nieuwerkerke. 1460.

Salade and Hause-col. Tower of London.
Temp. Edward IV.

(See also fig. 5 on page 91 *ante.*)

HAUSTEMENT. (A corruption of *ajustement.*) An under-garment closely fitting (adjusted to) the body, over which the armour was worn (see cut, page 237, in which it appears to have been without sleeves). The hose or chausses are fastened to it by points.

HEAD-DRESS. Under this very comprehensive title I propose to speak of all the various species of head-gear which have not specific names attached to them, and therefore are not described in separate articles. This notice will affect the ladies alone, as head-dress does not apply to anything worn by the male sex; and even with the ladies the history of head-dressing, distinct from hair-dressing, does not commence before quite the close of the twelfth century, the couvrechef up to that period having been worn by all classes of females, and the hair, when visible, appearing without ornaments of any description.

It is not, indeed, until the second half of the thirteenth century that we begin to read of elaborate head-dresses, our earliest information being derived from the 'Roman de la Rose,' already so often referred to, by Guillaume de Lorris and Jean de Meun (1260–1300).

The plaited tails which had been previously worn by all ranks were, in the reign of Henry III., unbound, and the hair was turned up behind and confined in a net, or by the higher classes in a caul of gold thread, sometimes richly begemmed and encircled by a band or fillet of gold, also occasionally jewelled. This reticulated head-dress is apparently that which is so repeatedly alluded to by writers of the thirteenth century as crispine and crespinette (see p. 147), and lasted in some style or another for nearly 300 years; the veil and wimple worn with it frequently prevent its being seen on the monumental effigies of the reigns of Henry III. and Edward I. When the caul was not worn, the hair was plaited and bound closely upon the head by fillets of silk or richer materials. (See engravings annexed.)

Female Head-dresses. 13th century.

Garlands or chaplets of flowers, either natural or of goldsmiths' work, were also much worn by the younger females. (See CHAPLET.) Some very ugly fashions were introduced at the close of the thirteenth century, and justifiably provoked the censure and satire of the contemporary poets. This was the invention of bosses and horns, the allusions to which by the satirists misled some antiquaries into the belief that what is more familiarly known as the horned head-dress was worn nearly a century before they are pictorially delineated. In a paper of mine, read at the Worcester Congress of the British Archæological Association, I combated this opinion, and gave, I think, sufficient proof that those allusions were not to any high-peaked or forked attire placed on the head, as in the fifteenth century, but to the terminations of the gorget or wimple, and certain convolutions of the hair on each side of the head, which might suggest to a satirist the appellation of ram's horns ; for in a poem printed by M. Jubinel, entitled 'Les Cornettes,' people are directed to cry, "Hurte *bélier !*" and in another satire the protuberances are called *bosses.*

> "Foremost in bower were bosses brought."
> *Harleian MS.* 2253.

> "Her hair was hyghted on hold
> With a coronal of gold.
> *　　*　　*　　*
> Sche was freely and fair,
> And well hyr seemed her gear,
> With rich bosses a payr,
> That derely were by-dyght."
> *Romance of Syr Degrevant.*

"What shall we say of the ladies when they come to festivals ? They look at each other's heads, and carry bosses like horned beasts" ("portent les boces com cornues bestes "). "If any one be without horns, she becomes an object of scandal." (Royal MS. 8 E 17.)

Now Jean de Meun, who died in 1260, is, I believe, the earliest writer who mentions horns in connection with a lady's head-dress, and he distinctly describes them as a portion of the gorget worn by females at that time, which was raised to a point on each side of the face as high as the ears : "fichée en deux cornes et entour la touelle." (See the whole passage under GORGET, p. 214, and the woodcut from Sloane MS., p. 113.) There is another mention of the horns in the same poem (line 1407 *et infra*), in which they are expressly stated to be "sur les oreilles," where those formed by the peaks of the gorget are seen when the veil is cast off or thrown back. Next, as to the "bosses," with which the horns are associated, the following engravings will fully illustrate the subject.

Jeanne de Senlis. 1306.

Jeanne de Sancerre. 1350.

Sloane MS. No. 3983.

Lady of the Ryther Family. *Circa* 1300.

Donna Savelli. Rome, 1315.

Can de la Scala. 1329.

Figs. 1 and 2 exhibit the bosses formed by the convolutions of the hair, which was plaited and tightly rolled up on each side. Fig. 4 shows distinctly the distension of the peaks or horns of the gorget by the plaited hair, which is pressed out against them, illustrating the passage in the "Testament de Jehan de Meun," in which he states that between the towel (as he calls the gorget) and the temple and horns there is a space through which a rat might pass, or the largest weasel between this and Arras.

> "Entre la touelle
> Et la temple et les cornes pourroit passer un rat,
> Ou la greigneur moustelée qui soit jusques Arras."

The veil which covers the head is also confined by a fillet of silk or gold according to the fashion described in the same work, of tying a ribbon, lace, or chaplet tightly round their heads, *over their horns.*

> "Plus fort : car sur les cornes entour le hanapel
> Seuglent estroit leur testes d'un latz ou dung chapel."
> *Codicille,* v. 1253-4.

Surely the fact of tying a lace tightly round the head *over* the horns is conclusive as to their position at the sides of the head, and not above it.

Fig. 3 presents us with a coif which indicates a disposition of the hair beneath it to take the form of a ram's horn; and fig. 5 has the bracket or gibbet spoken of by the satirist :

> "Je ne scay s'on appelle potances ou corbeaulx
> A qui soubtient leurs cornes quilz tiennct pour si beaulx ;
> May ca scay bien que saincte Elizabeaulx
> N'est pas en Paradis pour portez ces lambeaulx."

In support of these authorities and arguments, there is the significant and incontrovertible fact that nothing like the horned head-dress of the fifteenth century has been discovered either in the paintings or sculptures of any preceding period either in England or on the Continent.

A new fashion appears to have obtained favour in the reign of Edward II. which it would be difficult to describe; and the reader is therefore referred to the annexed woodcut, from a figure in Sloane MS. No. 346. The reticulated head-dress became more conspicuous in the reign of Edward III. That of his Queen Philippa affords a good example, and the MSS. and effigies of the latter half of the fourteenth century present us with a host of varieties of head-gear independent.

Sloane MS. No. 346.

Queen Philippa. From her effigy, Westminster Abbey.

Head-dresses, 1377—1422.

The reign of Henry V. is remarkable for the first appearance of what may be truly termed a horned head-dress. One of the most extravagant has been already given at page 135, from the effigy of Beatrice, Countess of Arundel. On the following page are four other examples of less costly materials.

The satirical effusions of such writers as Jean de Meun and Geoffrey de la Tour Landry seem to have had no other effect upon the ladies than to induce them, in the true spirit of contradiction, to justify to the fullest extent the odious comparisons of their censors. "Fortunately, however" (as I have remarked elsewhere), "for the painter or the actress, the fashion does not appear to have been so general as to render its introduction on the canvas or on the stage indispensable. The simple golden network and the quaint but elegant head-tire, consisting of a roll of rich stuff sometimes descending in a peak on the forehead or circling the brow like a turban, exist to extricate the lovers of the picturesque from so disagreeable a dilemma. Taste is ever the true friend of Fashion, and can see and amend her little follies while most admiring her inventions."*

Temp. Henry IV.

Temp. Henry V.

Temp. Henry V.

Mitre Head-dress. *Temp.* Henry VI.
From effigy of Lady Vernon, Tong, Salop.

The reign of Henry VI. is characterised by what is called the heart or mitre-shaped head-dress, some varieties of which are exceedingly high, with tippets or veils attached to them.

Isabella of Bavaria, queen of Charles VI. of France, is represented in a MS. of the fifteenth century with a heart-shaped head-dress high enough to give us belief in the story that she carried the fashion to such an extent that the doors of the Palace at Vincennes were obliged to be altered to allow ingress and egress to the Queen and the ladies attending her, when in full dress. The miniature was engraved for Montfaucon's 'Monarchie Française,' and subsequently by Shaw ('Dresses and Decorations'). We

Head-dresses. *Temp.* Henry VI.

* 'History of British Costume,' p. 204.

reproduce it here, as it affords an example of another head-dress in fashion at the same period, which I consider, however, to be later than the time of Isabella, who died in 1435, and never could have

Ladies, *circa* 1450, from a drawing in the portfolio of M. de Gagnières, Paris.

seen the head-dresses which the painters have given her in this and other instances, and to the representations of which may probably be attributed the origin of the preposterous story above mentioned.

Turban Head-dresses. *Temp.* Edward IV.

A MS. in the Harleian Collection, No. 2255, fol. 6, contains a ditty by Lydgate against the forked coiffures which the ladies indulged in at this period, beginning—

"Off God and kynd procedith al bewte,"

and in which he assures them that

"Beauty will show though horns were away."

Large turbans of the true Turkish form, made of the richest materials, are frequently seen in MSS. of the ·middle of the fifteenth century, and continued in fashion during the greater portion of the reign of Edward IV.

· At the same time, however, arose one of the most remarkable head-dresses ever known, examples of which exist to the present day in Normandy, where it is generally known by the name of *Cauchoise*, from the " pays de Caux " in that province. This was the " steeple head-dress," as it has been called by English antiquaries ; but its particular name in France appears to have been " Hennin ;" no derivation of it having been vouchsafed to us, even by M. Viollet-le-Duc.

Marie, Duchess of Burgundy, born 1457, died 1482. From her portrait.

Originating in France, it was not long before it was adopted in England ; and it is to French writers we are indebted for a verbal description of it. Monstrelet ('Chroniques') tells us that about the year 1467 the ladies wore on their heads round caps gradually diminishing to the height of half an ell or three quarters, and that some had them with loose kerchiefs atop, hanging down sometimes as low as the ground. Paradin, a later author, says : " The ladies ornamented their heads with certain rolls of linen pointed like steeples, generally half and sometimes three-quarters of an ell in height. These were called by some 'great butterflies,' from having two large wings on each side resembling those of that insect. The high cap was covered with a fine piece of lawn hanging down to the ground, the greater part of which was tucked under the arm. The ladies of middle rank wore caps of cloth, consisting of several breadths or bands twisted round the head, with two wings on the sides, like apes' ears ; others, again, of higher condition wore caps of velvet half a yard high,· which, in these days, would appear very unseemly." The latter head-dress I consider to be the one figured at page 78, article CAP. The one with wings " like apes' ears " I am at a loss to identify ; but of the steeple and butterfly head-dresses the examples and varieties are almost innumerable.

Addison, in the 'Spectator,' has a pleasant letter on this subject, comparing the steeple head-dress to the *commode* or *tower* of his day ; and following Paradin, he says : " The women might possibly have carried this Gothic building much higher had not a famous monk, Thomas Connecte by name, attacked it with great zeal and resolution. This holy man travelled from place to place to preach down this monstrous *commode*, and succeeded so well in it, that, as the magicians sacrificed their books to the flames upon the preaching of the Apostle, many of the women threw down their head-dresses in the middle of his sermon, and made a bonfire of them within sight of the pulpit. He was so renowned, as well for the sanctity of his life as his manner of preaching, that he had often a congregation of twenty thousand people, the men placing themselves on the one side of his pulpit and the women on the other, that appeared (to use the similitude of an ingenious writer) like a forest of cedars with their heads reaching to the clouds. He so warmed and animated the people against

this monstrous ornament that it lay under a kind of persecution, and, whenever it appeared in public, was pelted down by the rabble, who flung stones at the persons who wore it. But, notwithstanding this prodigy vanished while the preacher was amongst them, it began to appear again some months after his departure, or, to tell it in M. Paradin's own words, 'The women, like snails in a fright, had

Head-dresses. *Temp*. Henry VI.

drawn in their horns, and shot them out again as soon as the danger was over.'" ('Spectator,' No. 81, and Argentre's 'Histoire de Bretagne.') In a MS. copy of Froissart, Harleian Lib. No. 4379, written during the last half of the fifteenth century, there is a drawing of a sow walking on stilts and

Lady Elizabeth Say. From her brass.

playing the harp, having on her head one of these steeples with its appendages (see woodcut annexed, also pp. 215, 221, 222, *ante*).

In the brief reign of Richard III. we bid farewell to steeples and horns. The hair is confined in a cylindrical cap or caul of gold or embroidered stuff projecting from the back of the head, and covered by a kerchief of the most diaphanous description, stiffened out to resemble wings. Some of these kerchiefs are extremely large, and paned or chequered with fine gold thread; others are simply transparent, and scarcely exceed the size of the caul. (See woodcut annexed, and also figure of Lady and Child, p. 215 *ante*.)

Steeple Head-dress.

As usual the fashion changed from one extreme to the other; and in the reign of Henry VII. a new head-dress makes its appearance, partaking more of the hood than the cap, and suggesting the idea of the spire having been taken down from the church, leaving the gable end of the roof with its barge boards untampered with. To justify this simile the reader is referred to the engravings, which tell their own story better than any words can do. (See next page.)

The group we have given exhibits the caps and cauls of gold net or embroidery, from beneath which the hair escaping hung down the shoulders half-way to the ground,—a fashion continued from the earliest period to the reign of Henry VII., whose queen, Elizabeth of York, at her corona-

tion wore "her fair yellow hair hanging down plain behind her back," with "a calle of pipes over it" (Leland) ; while the third figure wears over her caul the head-dress I have alluded to, looking as if the lower part of the steeple head-dress, the absolute covering for the head, had been preserved when

1490.

Head-dresses. *Temp.* Henry VII.

they threw away the pinnacle that surmounted it. On the sides of it is the ornament already noticed as the *clog* or *clock* mentioned in the "ordinances" of Margaret, Countess of Richmond, mother of Henry VII., for "the reformation of apparell for great estates of women in the tyme of mourning." (Compare the two head-dresses at page 242 *ante*. See also the figures on page 223.)

It would be an almost endless task to picture or describe the variety of head-dresses which are presented to us by the effigies, paintings, and tapestries of the fifteenth and sixteenth centuries. I have limited my selection to the most remarkable and such as are particularly characteristic of their periods, as far as I can venture to date them. Here is one which has been engraved by Hollis from the effigy of

Effigy in Aston Church, Warwickshire.

a lady of the Arden family in Aston Church, Warwickshire, unlike any I can remember to have met with ; and as the personage has not been identified, I hesitate to assign it positively to any particular portion of the fifteenth century, but am inclined to consider it, in accordance with Mr. Fairholt, who has copied it, as an early type of that head-dress which portraits of the reign of Henry VIII. have made so familiar to us, and which has obtained the name of "diamond-shaped." The example from Aston Church is of a singularly cumbrous character ; the inner folds of white

Side view of the same.

linen, the outer of purple cloth or silk, edged with yellow (gold?), and overlapping each other. Even composed of the lightest materials, it must have been as oppressive as it was unbecoming.

The aforesaid diamond-shaped head-dress appears in the portraits of Elizabeth of York, queen of Henry VII., and of Jane Seymour, third wife of Henry VIII., by Holbein, which have been copied for this work, and given by us at pages 223 and 224 *ante*. That of Katharine of Arragon, Henry VIII.'s first wife, by the same great painter, engraved by Harding from the original miniature in the possession of his Grace the Duke of Buccleuch, will suffice to illustrate it here. Whether this head-dress is the French hood so often mentioned at this date, or the three-cornered miniver cap spoken of by Stubbs and others (see p. 80), I am unable to determine ; but I shall return

to it in the article HOOD and the GENERAL HISTORY.
The former is distinctly described as being
worn with the French hood ; but the latter appears to
me the ornamental border of the diamond-shaped head-
dress : "Payed for a frontlet loste in a wager to my
Lady Margaret, iiij liᵃ."

But in another account I find it associated with a
bonnet : "Item, a bonnet of black velvet, 15s. Item, a
frontlet for the same bonnet, 12s."

Hall, in his 'Chronicles,' describes some wonderful
head-dresses worn by ladies in the entertainments at
Court during the reign of Henry VIII. ; but many
appear to have been assumed for masking attire. The
following examples, however, from tapestries of the
time, formerly in the possession of Mr. Adey Repton,
may be accepted as faithful representations of some of
the fashions of the first half of the sixteenth century.

The brief reigns of Edward VI. and of his half-
sister, Queen Mary, present us with no remarkable novelty.

Katharine of Arragon. From Holbein.

It is at this time we hear of bongraces and
frontlets.

Hoods, caps, coifs, and cauls, the latter
of costly materials, were still in fashion. Of Queen Mary, Holinshed relates that she wore a caul

Ladies' Head-dresses in the reign of Henry VIII. From tapestries of the time.

"that was so massive and ponderous with gold and jewels that she was fain to beare up her head with
her hand." Her portrait has been already given at page 225, also that of Elizabeth, previous to her
accession. For the head-dress of the latter as queen we must also refer the reader to page 246.
I should rather say, one of her head-dresses, for they appear to have been numberless. A list
of her "attiers," as they are termed, is curious, as it informs us that the word caul was applied to false
hair, of which Queen Elizabeth wore a constant change, but generally of a red colour (see p. 246) :
"Item, one cawle of hair set with pearles in number xliij. Item, one do. set with pearles of sundry
sort and bigness, with seed pearle between them chevronwise, cxij. Item, a cawle with nine true loves
of pearle and seven buttons of gold, in each button a rubie."

It appears, therefore, that these cauls of hair were head-dresses in themselves, with jewels and
other ornaments arranged in them, ready to be worn at any moment.

Feathers, which first appear worn by ladies in the reign of Henry VIII., in the bonnets of that
day (see p. 79), were now placed in the hair, and became an important feature in the head-dresses of
women of rank or fashion. (See portrait of Queen Elizabeth, p. 246, and portrait of Anne of
Denmark, p. 187, also p. 174.)

The head-dresses of the seventeenth century consisted chiefly of hoods and caps, to which articles
we must refer the reader, and we have already spoken of the hair-dressing of that epoch. The
fontange and the commode or tower have also been specially described (pages 191 and 130), and we

therefore arrive at the reign of Queen Anne before we meet with a novelty in *coiffure* that calls for our attention.

The commode had not long disappeared when a successor to it arose in 1715, in a head-dress of feathers arranged tier above tier, as yards of lace and ribbon had been in the former monstrosity. Addison, who had just rejoiced in the fall of the tower, attacks the new invention, to which he gives the name of the old. " I pretend not," he says, " to draw a single quill against that immense crop of plumes, which is already risen to an amazing height, and unless timely singed by the bright eyes that glitter beneath will shortly be able to overshadow them.

" Lady Porcupine's commode is started at least a foot and a half since Sunday last But so

Feather Head-dress. 1715.

long as the commodity circulates, and the outside of a fine lady's head is con- verted into the inside of her pillow, or, if Fate so order it, to the top of her hearse, there is no harm in the consumption, and the milliner, upholsterer, and undertaker may live in amicable correspondence and mutual dependence on each other."

During the reigns of the first two Georges the head-dresses of the ladies were principally composed of lace, the passion for which had been gradually increasing since the days of Charles II. These coiffures were called *heads* as early as the reign of William and Mary. In 1700 the family of George Heneage lost, in the confusion occasioned by a fire in Red Lion Square, " a head with very fine looped lace of very great value." Malcolm, in his ' Anecdotes of Dress,' quotes the following prices of some of these heads from the advertise- ments of the Lace Chamber at Ludgate Hill : " One Brussels head at £40 ; one ground Brussels head at £30 ; one looped Brussels head at £30."

In ' The Weekly Register' of June 10th, 1731, a writer, reviewing the fashions, says, " I now come to the head-dress, the very highest point of female elegance, and here I find such a variety of modes, such a medley of decoration, that it is hard to know where to fix : lace and cambrick, gauze and fringe, feathers and ribands, create such a confusion, occasion such frequent changes, that it defies our judgment or taste to reconcile them to any standard or reduce them to any order." What was considered impossible by a contemporary can hardly be expected from a person writing nearly a century and a half later. But we have already reached the reign of George II., and two or three other notices of fashionable head-dresses will bring us to its termination.

Under the date of 1735, Malcolm extracts an account of the dresses worn at the Drawing Room on the occasion of the King's birthday, whereby it appears that the ladies " wore chiefly fine escalloped laced heads, and dressed mostly English. Some few had their hair curled down on the sides, but most of them had it pinned up quite straight, and almost all of them with powder *both before and behind;* some few had their heads made up Dutch, some with cockades of ribands at the side, and others with artificial flowers." There is no mention of the Court plume, so conspicuous in the reign of George III., nor of any feathers whatever, though much worn in the riding-hats of the ladies at that date.

In ' The Connoisseur,' 1754 (No. 36), we are told that " long lappets, the horse-shoe cap, the Brussels head, and the prudish mob pinned under the chin, have all had their day. The present mode has routed out all these superfluous excrescences, and in room of a slip of cambric or lace has planted a whimsical sprig of spangles or artificial flowerets."

I shall conclude this article with an account of " the most extraordinary invention for the adorn- ment of the head, of this or any other age," as it has been justly characterised by a modern writer, and which received the name of *capriole* or *cabriole.*

In No. 112 of ' The Connoisseur' (1756), we are told that, " instead of a cap, the mode is for every female to load her head with some kind of carriage." . . . " The curiosity," says the writer, " I had of knowing the purport of this invention, and the general name of these machines, led me to make inquiries of a fashionable milliner at the Court end of the town. She obliges me with the sight

of one of these equipages designed for the head of a lady of quality, which I surveyed with much admiration, and, placing it in the palm of my hand, could not help fancying myself Gulliver taking up the Empress of Lilliput in her state-coach. The vehicle itself was constructed of gold threads, and was drawn by six dappled greys of blown glass, with a coachman, postilion, and gentleman within, of the same brittle manufacture. Upon further inquiry the milliner told me, with a smile, that it was difficult to give a reason for inventions so full of whim."

An author of that day says, "Be it remembered that in this year many ladies of fortune and fashion, willing to set an example of prudence and economy to their inferiors, did invent and make public, without a patent, a machine for the head, in form of a post-chaise and horses, and another imitating a chair and chairmen, which were frequently worn by persons of distinction. I have been particular," he adds, "in noting the exact time of the rise of this invention : first, because foreigners should not attempt to rob us of the honour of it ; and secondly, that it may serve as an æra or epocha to future chronologists." ('Wise Men's Wonderful Discoveries.') This fantastical and ridiculous fashion, I regret to say, appears from the above statement to be of English birth, and not, as in almost every other instance, of foreign, and generally French, origin. It is not alluded to by Quicherat, who could not have overlooked so remarkable an eccentricity ; but the name may have been suggested by the well-known French vehicle, the cabriolet, after which, in 1763, we find a peculiar head-dress of ribbon was entitled. The satirists were not likely to pass over in silence this freak of fashion.

> "Here on a fair one's head-dress sparkling sticks,
> Swinging on silver springs, a coach-and-six.
> There on a sprig or slop'd pompon you see
> A chariot, sulky, chaise or vis-à-vis."

Also in a poem called 'Modern Morning,' Cælia exclaims :

> "Nelly !—Where is the creature fled ?
> Put my post-chaise upon my head ;"

and in the same poem the maid informs her mistress, "Your chair and chairman, Mame, are brought," and we are informed that the ladies have taken to wearing a broad-wheel waggon as an improvement to the above fashion. We append an example of this latter absurdity from Mr. Adey Repton's papers ('Archæologia,' vol. xxvii.).

Then in prose we read, "Those heads which are not able to bear a coach-and-six (for vehicles of this sort are very apt to crack the brain) so far act consistently as to make use of a post-chariot, or a single-horse chaise, with a beau perching in the middle."

Waggon Head-dress.

Of the national head-dresses of the Scotch and Irish women our information is sadly meagre. The former before they married wore a ribbon, or, as it was called, a *snood*, with which alone they were allowed to ornament their hair. After they married they exchanged the *snood* for a *curch* or *breid* of linen tied under the chin. In Martin's time their head-dress was "a kerchief of fine linen straight about the head." Of the Irish we are simply told by Speed, who wrote in the reign of James I., that the women "wore their haire plaited in a curious manner, hanging down their backs and shoulders from under the folden wreaths of fine linen rolled about their heads,"—a custom in England as ancient as the Conquest. Morryson, a writer of the same date, says, "Their heads be covered after the Turkish manner with many ells of linen, only the Turkish heads or turbans are round at the top and broader in the sides, not much unlike a cheese-mob, if it had a hole to put in the head." (See BINNOGUE.)

For further information respecting ladies' head-dresses the reader is referred to notices of the component portions of some of the most remarkable under their special designations, and also to the illustrations in the GENERAL HISTORY.

HEAD-RAIL. See COVERCHIEF.

HELM. (*Helme*, Anglo-Saxon ; *Topfhelm*, German ; *hiaume, heaume*, French ; *elme*, Italian ; *hialmar*, Icelandic.) The term "helm" was applied, in the eleventh and twelfth centuries, by both Saxons and Normans, to the conical steel cap, with a nose-guard, which was the common head-piece of the day, and is depicted in contemporary illuminations, sculptures, and tapestries. (See pages 14 and 15.) Towards the end of the latter epoch it became gradually restricted to the improved and more important casque, enclosing all the head with the exception of the face, which was defended by an aventaile or vizor. (See page 23.)

It is from this date that I shall trace the helm to its final disappearance in the reign of Henry VIII., referring the reader to our drawings and engravings of the most instructive examples. No. 1 on the accompanying plate is the earliest I have ever met with. It was discovered in a church at Faversham, and, as I stated in a communication to the British Archæological Association, there is some probability that it may have belonged to King Stephen, or to his son Eustace, both of whom were buried in the Abbey there. It has the conical crown of the Norman head-piece, with that distinguishing feature of it, the nasal ; and, at all events, cannot be dated later than their time, 1135–1154. It will scarcely be believed that this most interesting and at present unique relic of ancient English armour was coldly rejected by the authorities at the Tower, and allowed to go to Paris, where it now enriches the Musée de l'Artillerie ! If any doubt existed of its authenticity, it would be dissipated by an examination of No. 2, which, strange to say, *is* in our National Armoury. The crown has lost its cone, and the advance to the flat-topped cylindrical helm is clearly indicated, while the retention of the nasal and the partial alteration of the occularium show its near relationship to the former example, and induce us to attribute it to the reign of Henry II.

No. 3 is the earliest example of the cylindrical flat-topped helm of the twelfth century which is known to be extant. A portion of the original chain-mail is attached to it. It was purchased by the late Lord Londesborough, and is now in the magnificent collection which, by the kindness of his son and successor, is exhibited at the Alexandra Palace. It had evidently been furnished with a vizor or aventaile of some description, which fitted into the sockets still remaining on the right side of the face, and was secured on the other side by a hook or pin passing through the socket there. This plate or grating was removable, and might occasionally have been exchanged for a nasal, or single bar of iron, the affixing of which, by screws and nuts at each end, appears to have been provided for. The seals of this period exhibit all sorts of contrivances for defending the face, some varieties of which I have given at page 23. On the flat crown is a cross of the form called by heralds *bottonée* or *treflée*, and a cross, the transverse line of which has similarly-shaped terminations, is represented by the metal work connected with the opening for the face. An upright ring is screwed into the centre of the crown, as we find in so many examples of this and the following century, previous to the appearance of crests. It was probably used for attaching a *cointise*, or scarf, to the helm, as we find in later instances. Lord Londesborough's helm came from a church in Norfolk, where it had long been exhibited by the sexton as "*a Popish lantern.*"

No. 4 is a perfect example of the flat-topped cylindrical helm of the early part of the thirteenth century. A plain cross strengthens as well as ornaments the crown. The front is entirely closed, with the exception of two horizontal slits for vision. This specimen—also, I believe, unique—is the property of the Earl of Warwick. It was discovered in the ruins of Eynsford Castle, Kent, and may fairly be considered to have belonged to one of the knightly family of that name, seated there in the reign of King John. Of this type are the helms on the heads of the effigies at Furness Abbey and Durham ; and numberless representations of each are to be found in contemporary sculptures, seals, and illuminations. M. Demmin engraves a flat-topped helm preserved in the Museum at Prague, but says that it "is altogether so light that it looks like a counterfeit." A MS. of the thirteenth century, in the Vatican, however, contains the figure of a man in armour with a helm of precisely this peculiar shape, and painted, as was a custom of that day, with the armorial insignia of the wearer —in this instance *azure*, a bend *or*. If the Prague helm be a counterfeit, therefore, it must have been manufactured from one which was genuine, and I am inclined to give it the benefit of the doubt. (See first figure next page.)

PLATE XI.

No. 5 is another form of helm in use about the same period, flat-topped and ornamented with a cross, like those above mentioned, but open in front, the face being defended by a plate with horizontal slits for sight and perforations for breathing, working upon hinges fixed at the side, so that it could be flung back like a door to display the countenance or admit more air. This great curiosity, *mirabile dictu!* was purchased for the Tower, and is now in our National Collection; but another of the same date, equally interesting, was allowed to follow the Faversham helm to the Museum of Artillery, Paris.

Subjoined is a series of helms from German authorities, copied by M. Demmin, and dating from 1195 to 1298; *temp.* King John, Henry III., and Edward I., in England.

| 1195. | 1195. | 1200. | 1298. | 1298. |

No. 6 is a helm of the reign of Edward I., the coif de fer over which it was worn taking at that period the form of the head. The semblance of a cross is still preserved by a strong perpendicular bar of iron dividing the occularium. The ring at the lower end of the bar was used to fasten the helm to the gorget, and prevent its being turned round by the stroke of a lance. In the romance of 'Lancelot de Lac' (thirteenth century), the helmet of a knight is said to have been so turned that the edges grazed his shoulders, and "ses armes estoient toutes ensanglantées." This curious helm, which came from Wells, in Norfolk, was purchased by the late Lord Londesborough.

In the centre of the front rank of the group here given, copied from the wall-paintings in the Old Palace at Westminster, a helm of this period is seen, corresponding in its general features with the one in the Londesborough Collection.

No. 7 is drawn from the monument of Sir William de Staunton, *circa* 1324, in Staunton Church, Notts, no helm of this form having been yet discovered, either in England or elsewhere. It is characteristic of the reign of Edward II., and has obtained from its shape the name of "sugar-loaf." The outline, when viewed from the front, describes pretty nearly the pointed arch which superseded the old Norman round one in the thirteenth century. An interesting illustration of this resemblance is furnished us by the figure of a knight putting on a helm of this description, the niche in which the statue is placed presenting the arch aforesaid. (See next page.) Another example of the sugar-loaf helm, in a MS. of the early part of the fourteenth century, Royal Lib. Brit. Mus., 20 D 1, exhibits it as falling from the head of an overthrown knight, and shows the laces by which it was attached to his hauberk, and the coif de fer worn under it.

From wall-painting, Westminster.
Temp. Edward I.

These helms are generally depicted as secured more perfectly by a chain to a plate on the breast of the hauberk, called, from its position, a *mammellière*, for which purpose there was a ring at the edge of the helm, in front, from which the chain depended, as seen in the one from Wells, above mentioned. (See MAMMELLIÈRE.) Another ring is frequently seen on the apex, to which was attached the "cointise." (See page 122, and the figures over-leaf of knights armed for the joust and the tournament, from Royal MS. 14 E 3.) A slight alteration of shape is observable in the Staunton helm.

The front projects, and forms an angle at the intersecting point of the cross (in this instance fleury), which is still preserved as a defence and an ornament.

Statue, *circa* 1320.

From Royal MS. Brit. Mus., 20 D 1.

From Royal MS. Brit. Mus., 14 E 3.

Helm found at Sevenoaks.

No. 8 is copied from the original helm of Edward the Black Prince, which hangs over his tomb in Canterbury Cathedral. On the right side of it are perforations forming the outlines of a crown.

No. 9 is of the same date (reign of Edward III.), and was formerly in the Meyrick Collection. It was presented to Sir Samuel by the Dean and Chapter of Hereford Cathedral, wherein it had for 500 years been suspended above the monument of Sir Richard Pembridge. Into whose possession it has passed, I am ignorant.

A third very fine example, discovered near Sevenoaks, Kent, was exhibited at the meeting of the British Archæological Association, February 26, 1852, and is here reduced from the engraving by Mr. Llewellyn Jewitt, in vol. vii. of the Society's journal, p. 161. The perforations are in the shape of a fleur-de-lys, and the bar which strengthens the front and forms the upright of the cross is fleur-de-lisé at each extremity. The

bascinet, over which the helm was placed, had, towards the middle of the fourteenth century, assumed a more pointed character, and the helm consequently was made to correspond with it.

An alteration is also noticeable in the occularium, which is no longer a slit cut in the metal itself, but formed by an opening left between the upper and the lower portion, the helm being now constructed of three pieces—the crown, a front plate and a back plate, riveted strongly together.

Nos. 10 and 11 may be dated a little later than the last, being varieties of a type commonly met with during the reigns of Richard II. and Henry IV. By the compression of the sides and the curving in of the line towards the neck, a sharper angle was produced, giving to the helm, when seen in profile, a beak-like appearance, as in No. 10; some examples presenting an obtuse angle, as in No. 11. The former exhibits a most interesting feature: a portion of the crest in metal, riveted to the crown of the helm, representing the neck of a bird or griffin, collared and originally chained, as the ring in front of the collar indicates. The head has been, unfortunately, broken off immediately above the collar, or the owner might have been identified.

This relic has also been lost to our National Armoury, and suffered to enrich that of Paris. The engraving of it in M. Demmin's work is so incorrect, that it is scarcely recognisable.

No. 11 is, I am happy to say, by some fortunate accident, in the Tower of London. When or how acquired, is not stated by Mr. Hewitt in his valuable Catalogue published in 1859. It affords us an early example of the undivided occularium. The cone is sharper than that of No. 9. The perforations around it were for the fixing of the crest and wreath, and perhaps mantling. The ring in front is no longer required for a chain, but, together with the strap behind, serves to fasten the helm to the placate and the back-plate.

No. 12 is the helm of the popular and heroic Henry V., which with his saddle and shield may be seen by those who have good eyes, far above his tomb in Westminster Abbey. This form, with little variation, except in the gradual depression of the crown, was preserved during the fifteenth century; but the introduction, first of the vizored bascinet, and subsequently of the salade and hause-col, led to the ultimate disuse of these heavier and more cumbrous head-pieces in battle, and they were only worn in the lists, whence they have acquired the name of "tilting helmets."

Two of nearly the same date are preserved in Cobham Church, Kent. One of them is figured in the accompanying plate, No. 13. I have selected it, because the indentation of the crown contains four staples for the fixing of the crest, which the companion helm has not.

Nos. 14 and 15 represent two most interesting examples; the former being the helm of King Henry VI., and the latter that of King Edward IV., which had been suspended over their monuments in St. George's Chapel at Windsor, and, but for a most curious chain of circumstances, might have been lost to this country for ever. (See 'Journal of the Brit. Archæolog. Assoc.,' vol. viii. p. 136, note.) The helm of Henry VI. is of the sort familiarised to us by engravings of the heraldic helmets, the occularium being protected by several arched bars. That of Edward IV. is more of the form of No. 11, the spike on the top being probably the main support of the crest. Such a helm, it may be as well to remark, was worn for the *combat à l'outrance*, whilst the more open-faced helm, simply defended by bars, was confined to the jousts of peace, when the head of the lance was furnished with a cornel, and the point of the sword was *rebated*—that is, blunted. (See JOUSTING ARMOUR in GENERAL HISTORY.)

No. 16 is in the Londesborough Collection, and was formerly suspended over the monument of Sir John Crosby, in Great St. Helen's Church, Bishopsgate, London. He died in 1475 (14th of Edward IV.), and I would particularly refer the reader to the first article in this work, viz. ABACOT, and the plate which illustrates it; the remarkable height and shape of the crown of this helm, which is certainly of the latter half of the fifteenth century, perfectly corresponding with those of the caps of estate or knightly chapeaux of that period worn over the helm, and either surmounted by a crest or encircled by a coronet. The abacot, or high cap of estate, ensigned with two crowns, belonging to King Henry VI., which fell into the hands of his pursuers, and was presented to Edward IV. at York, in 1463, would be worn over just such a helm at that date, which is only twelve years before the

death of Sir John Crosby. Another helm of nearly the same age is also in the Londesborough Collection (see woodcut), but I know nothing of its history.

No. 17 is the tilting helm of Sir John Fogge, in Ashford Church, Kent, *temp.* Edward IV. ; No. 18, another in the late Meyrick Collection ; No. 19, one formerly belonging to Mr. Brocas, of the time of Henry VII. ; and No. 20, an example of the latest form of the tilting helm in the reigns of Henry VIII. and his contemporaries Francis I. and the Emperor Maximilian.

Helm in Londesborough Collection.

HELMET. (*Elmetto*, Italian ; *hiaumet, armet* (?), French.) This word is more familiar to English ears, in consequence of its having been in general use for the last three or four hundred years, in this country, to designate nearly every sort of military head-piece, classical, mediæval, or modern, without distinction, from the four-combed, horsehair-crested one of Agamemnon to the skull-cap of a policeman. Strictly speaking, it is the diminutive of helm, and was first applied to the smaller head-piece which superseded it in England towards the end of the fifteenth century. It appears, however, much earlier in Italy, whence we derive the name ; that is, if the date attributed to the battle-piece by Uccello in our National Gallery can be depended upon, but which I am inclined to question from all the details of the armour, as I have already observed under ARMET, page 12, where also I have given woodcuts of two helmets from that picture. The battle of St. Egidio, which it is supposed to represent, was fought in 1417. The armour is at least half a century later by comparison with any Italian or European example. Uccello died in 1479, aged 83, and not in 1432, as stated in Bryan's 'Dictionary of Painters and Engravers ;' and if he were the painter of the four pictures attributed to him in the Catalogue of the National Gallery, of which the Battle of St. Egidio is one, must, in accordance with the usual practice of mediæval artists, have represented his warriors in the armour of the time in which he painted them, and not in that of the action he commemorated. This is not the place for further discussion of the subject.* All I have to observe at present is, that the helmets in that picture exhibit that remarkable feature—a disk at the back—which has been supposed to be characteristic of the armet, or *"petit heaume,"* and is not met with in the works of any other artist previous to the last quarter of the fifteenth century. M. Viollet-le-Duc, who considers the close helmet to have been invented *circa* 1435, describes one with a disk ("rondelle ou volet") in the Musée d'Artillerie at Paris, and adds, "Cet armet date des dernières années du xvᵉ. siècle ;" an opinion which is fully borne out by the absence, as I have observed, of any representation of such a head-piece in painting or sculpture of an earlier period.† The first instance I have met with is in the miniatures of an illuminated MS. in the Bibliothèque at Paris, of the historical poem 'Le Deploration de Gènes,' by Jean des Marets, describing the war of Louis XII. with the revolted Genoese in 1507, and which appears to be the identical copy presented to Anne de Bretagne, the queen of Louis, by the author. In two of these miniatures, engraved in Montfaucon's 'Monarchie Française,' plates 196, 197—the first representing the departure of Louis from Alexandrie de la Paille, and the second, the French forces attacking the Genoese forts—the helmet with its disk or rondelle is frequently depicted. This MS. is, of course, as late as the commencement of the sixteenth century, and of the reign of our Henry VII. The engravings are very poor, and the original drawings cannot be relied upon for linear accuracy or the minutiæ of detail. Louis is represented in a head-piece partaking more of the character of a casquetel than a helmet. It has an umbril, but neither vizor nor beaver. The rondelle, however, is clearly indicated behind it. Nearly all the knights and men-at-arms are depicted in close helmets with vizors and rondelles ; and as the backs of the majority are towards us, if they had been drawn larger and more carefully we might have derived some satisfactory information respecting the object

* I have an engraving of another of the four pictures attributed to Pauolo di Dono, who obtained the name of *Uccello* for his ability in painting birds. I shall revert to this subject in the General History.

† I am, therefore, at a loss to know why M. Viollet-le-Duc dates one of precisely the same type in the Collection at Pierrefonds as early as 1444.

BATTLE (CALLED "OF S.ᵗ EGIDIO")

FROM THE PICTURE BY UCCELLO IN THE NATIONAL GALLERY.

of this curious feature, which occupies a place between the two ends of a plate of considerable breadth,—a sort of mentonnière or hausecol that encircles the neck and terminates behind without meeting. I must refer the reader to the woodcuts annexed, as I feel a verbal description is extremely unsatisfactory.

Head-pieces (French). A.D. 1507.

It will be observed that no feathers or scarves are attached to the rondelles, either in these or any other representations of them, so that could not have been their purport, as imagined by some modern writers.

The helmet of the splendid suit of armour presented, according to tradition, by the Emperor Maximilian I. to Henry VIII. on his marriage with Katharine of Aragon, and now in the Tower (see page 19), and which is of the class termed Burgonet (*vide in voce*, p. 64), had originally one of those disks affixed to it; but, alas! like the gauntlets of the same suit, it has gone the way of other articles of value and rarity in that long-uncared-for collection. (*Vide* Hewitt's 'Official Catalogue,' 1859, p. 6.) In the picture at Hampton Court of the meeting of Francis I. and Henry VIII. at Ardres, the disk is also represented, and in the reign of the latter sovereign it disappears.

The earliest example of a helmet I can find in England is that on the effigy of Thomas Duke of Clarence, killed at the battle of Baugy, in 1421. The monument to him and to her first husband was erected by his widow Margaret, who died on New Year's Eve, 1441, and it is uncertain at what precise period during the twenty years after the Duke's death the effigy was executed, but it may be fairly taken to be a specimen of the first form of the close head-piece suggested by the salade and the precursor of the burginot or burgonet. (See p. 65.)

One of the improvements on this early helmet was the adoption from the salade of the moveable lames at the nape of the neck, which enabled the head to be thrown back with ease. The vizor also was adopted from the bascinet, which had been superseded by the salade, and protected the whole face without a beaver. The helmet was put on by throwing up the lower part of it, that guarded the chin and throat as well as the vizor, which turned upon the same screw. Our example is from a fluted helmet in the Meyrick Collection, engraved by Skelton, and of the middle of the reign of Henry VII., 1490. The next is from the same collection and work, and, though dated by Sir S. Meyrick *circa* 1525, appears to me much earlier, being little more than a vizored bascinet, with a collar

Helmet, 1490. Vizor closed. The Same. Vizor raised. Front and side view of Helmet. *Temp.* Henry VIII.

of chain to it. The form of the breastplate and other portions of the suit to which it undoubtedly belonged, fixes it however to the reign of Henry VIII., but leaves us at liberty to consider it the continuation of an old type in existence at the same time as the burgonet. The occularium also resembles that of the helm of the previous century. We give two views of it, a front and a profile.

At p. 12 will be found what Meyrick considered an armet of the sixteenth century, and his opinion of the distinction between the armet grand and the armet petit. It is probable that had he survived he might have reversed that opinion, or produced stronger authority for it. The only one he has quoted is very vague, and as late as 1549. It is an *ordonnance* of Henry II. of France respecting the armour of a man-at-arms, and directs that " Le dit homme d'armes sera tenu porter *armet petit et grand*, gardebras, cuirasse, cuissots, devant de grèves," &c. Sir Samuel himself was not by any means confident as to the interpretation of this passage. " I have not been able to discover," he adds, " the difference between the great and little armet, but conjecture that at this period the word ' armet ' had lost its distinctive meaning, and become a general term for any helmet. If so, the great armet would imply the close helmet, and the little armet the open one or casque. Still, however, I am inclined to think that the ' armet petit et grand ' was a helmet that could form either, according to the wish of the wearer ;" * and having in his collection a helmet with three bars, over which a beaver composed of three plates could be fixed and as well as the bars be removed at pleasure, he suggested that this was an armet grand when the beaver was on, and petit when it was taken off. Nothing has occurred, however, to corroborate this opinion, and I simply record it with this observation, that in his letterpress to Skelton's ' Engraved Specimens of the Goodrich Court Collection,' the suggestion becomes an assertion, which is repeated by Mr. Fairholt ; and a mere conjecture is thus handed down to the next generation as an ascertained fact. I have given an engraving of the helmet alluded to by Meyrick with the article ARMET, p. 12, and have only to point out that it neither has the roundel at the back nor does it open behind, which have been considered by others to be the distinctive features of an armet. I subjoin here engravings from drawings of two helmets—one in the collection made by the late Emperor of the French at Pierrefonds, and the other in the Musée d'Artillerie, Paris—which fulfil both those conditions, but the dates accorded to them by M. Viollet-le-Duc are, I submit with all deference, rather too early.

Figs. 1 and 2. Two views of Helmet from the Collection at Pierrefonds. Fig. 3. From the Musée d'Artillerie, Paris.

Burgonet, 1556.

The burgonet has been already described at p. 65. Here is, however, a later one of the time of Philip and Mary, with a door opening on the right side of the vizor for the admission of air. It has a pipe at the back for the insertion of a plume.

An alteration is noticeable about the middle of the sixteenth century in the form of the crown of the helmet, which became higher, and was surmounted by a comb. The introduction of the morion from Spain restricted the use of the helmet to actual warfare or the tilt-yard, and it disappeared

* ' Critical Inquiry,' 2nd Edit., 1842, vol. iii. p. 4.

in England at the end of the seventeenth century, to be resuscitated in the nineteenth by the Life Guards and Dragoons of the last two Georges.

Barred Helmet, 1553. Helmet, 1558.

Helmet, 1560. Helmet, 1592. Helmet, 1625.

The word "head-piece" occurs in almost every official document in the latter half of the seventeenth century, in lieu of "helmet."

HERIGAUS, HERYGOUD. (Anglo-Norman.) "Upper cloaks; see Robt. Glouc., p. 548, absurdly glossed *dewclaws, spurrs.*" (Halliwell, *in voce.*) "An herygoud with honginde sleven." (Harleian MS. 2253, *temp.* Edward II.) "Harrygoud is still a name in the North for a low person." (Halliwell, *ut supra.*)

HERLOTS. (Anglo-Norman.) In an anonymous work called the 'Eulogium,' cited by Camden ('Remaines,' page 195), and apparently of the date of Richard II., we read: "Their hose are of two colours, or pied with more, which they tie to their paltocks with white latchets called *herlots*, without any breeches" (drawers). (See PALTOCK.)

HEUK, HUKE, HYKE. (*Huka,* Latin.) "Peplum muliebre Brabanticum, Flandres *huycke.*" "Cum peplo Brabantico nigro *hukam* vulgo vocant." (Ducange.) No satisfactory information has yet been obtained respecting the shape of this article of apparel which would enable us to identify it. Fairholt says: "An outer garment or mantle worn by women in the fourteenth century, and afterwards adopted by men. The word was subsequently applied to a tight-fitting dress worn by both sexes; thus a jacque or huke of brigandine is mentioned *temp.* Henry VI., as part of an archer's dress." He gives no authority for any of these statements. The latter, however, I find in an *ordonnance* of Charles VII. of France; but a jacque can hardly be called a tight-fitting dress. (See JACK.) Halliwell has, "A kind of loose upper garment, sometimes furnished with a hood, and originally worn by men and soldiers; but in later times the term seems to have been applied exclusively to a sort of cloak worn by women." This is equally indefinite; and when we

read, in addition to the gloss of Ducange, that Minsheu calls it "a mantle such as women use in Spaine, Germanie, and the Low Countries, when they goe abroad," while Kennett (Lansdowne MS. 1033) says it is "a woman's capp or bonnet," the confusion becomes "worse confounded." Long ago I suggested that the heukes of scarlet cloth and camlet which we first hear of in England in the reign of Henry V., were cloaks similar to those still called heukes by the Moors of Barbary and Morocco. The garment as well as the name was most probably derived from that people, and passed through Spain into France and Flanders. In 1276 it is mentioned by that name in the statutes of the Consulate of Marseilles regulating the prices of apparel: "Huca cum caputio vel almussæ cum pennis. Huca cum cendato et caputio vel almussa. Huca de panno serico, vel de cameleto cum cendato. Huca fregata." Here is sufficient proof that the heuk was worn with a hood or an aumusse, which is a very similar head-covering, also that it was made of silk and of camlet; but no intimation is given us of its form, nor to which sex it was appropriated. Another quotation supplied to us by Ducange shows that it was worn by men : "Ceux qui ont tournoie sous les bannières en droit soi sont vestu de pourpoints pareils avec heuques d'orfèverie ou autres habillements." Jac. Valerius : "Du droit d'armes et de noblesse." The fifteenth century furnishes us with further information. A letter-remissory, dated 1404, tells us, "Le suppliant print une huque noire que estoit a son dit maistre, qu'il vesti." Another, dated 1408, has, "Icelle Boudiere ala en une des chambres de l'hostel et apporta une huque fourrée qu'elle bailla en gage a laditte Perette qui print laditte huque." A third notice occurs in the same year: "Une hucque de brunette et une robe de brun vert a femme. Icellui Jehan boula sa main dessoutz sa heuque en querant un coustel." The last sentence is conclusive as to its being at that time a loose outer garment, under which Jehan was feeling for his knife or dagger. We next come to the inventory of the wardrobe of Henry V., (Rot. Parl., Harleian MS. 7068), wherein we find one heuke of camlet, together with a chaperon of the same, valued at twenty-six shillings and sixpence, and another heuke of scarlet by itself prized at thirteen shillings and fourpence; also five hukes of black damask embroidered with silver, and one

Joan of Arc, from Tapestry.

garnished with silver-gilt spangles. In France about this period, Juvenal des Ursins records that in 1413 there was a distribution among the inhabitants of Paris of violet huques on which were sewn large white crosses, with the motto "Le droict chemin." M. Quicherat, who quotes this passage, says : "As to the huque, formerly a woman's mantle, it was transformed into a short cassock for men, a cassock without sleeves, girdle, or buttons, which remained open from top to bottom in front. It was equally the dress of the citizen and the soldier." But he refers us to no authority for this description, which otherwise would corroborate Halliwell. In an indenture of retainer of the 19th Henry VI. (1439), whereby Sir James Ormond, Kt., retains James Skidmore, of Herefordshire, Esq., to serve under him in the expedition against France by Richard Duke of York, one of the covenants is, that "The seid James shall take for himself and his seid archers huk of my seid Lord the duk, paying for theym like as othr souldiers of their degrees do ;" which shows that the huke worn by archers in that reign was some sort of over-coat of the colours of their respective leaders. In the 13th article of the Act of Accusation of Jeanne d'Arc she is charged with having pretended that it was in obedience to the injunctions of Heaven that she had worn garments lined with fur and embroidered with gold, and it is especially noted that on the day she was taken she had on a huque of cloth of gold, "ouverte de tous les côtés." In illustration of this passage, M. Quicherat has given a copy of a representation of Jeanne, at the time of her meeting Charles VII., in a tapestry of

German execution, preserved in the Museum at Orleans, and in which he describes her as wearing over a pourpoint a "huque dechiquettée;" that is, cut into fanciful forms at the edges—a fashion at that period already noticed under DAGGES, p. 164; and "Item j, *jagged* huke of black sengle," occurs in the inventory of Sir John Fastolfe's wardrobe, 1459.
Here, then, we have a drawing of what M. Quicherat considers a huke; but it is impossible to make anything out of it so as to identify it with any other garment of the fifteenth century, and thereby arrive at some conclusion. A much more distinct delineation of it is given in M. La Croix's splendid work, of which we engrave a copy. It has the appearance of a tabard without sleeves, the edges or border cut after the fashion above mentioned; and in the Harleian MS., No. 4375, at fol. 123, is the figure of a soldier wearing a garment with escalloped edges precisely similar to the "huque dechiquettée" of the maid of Orleans. Now a friend has kindly pointed out to me, in the 'Percy Reliques,' series iii. book 1, a song said to have been sung before Queen Elizabeth in 1575, entitled 'King Ryence's Challenge,' which contains the following lines :—

"And heraults in hewkes hooting high,
 Cried 'Largesse! largesse! Chevaliers très-hardis!'"

Soldier, from Harleian MS. No. 4375.

This, taken in conjunction with the character of the garment Jeanne wears over her armour in the Orleans Tapestry, would certainly seem to prove that in the fifteenth century the herald's tabard was comprised in the category of hukes; and I find as early as 1295 (*temp.* Edward I.), in the 'Statute d'Armes,' or 'Statutum Armorum de Torneamentis,' as it is indifferently called, that the kings of arms (or of heralds) are commanded to appear in their hukes of arms (whatever the shape may have been): "E que nul roy des haraunz ne menestrats portent privez armez ne autrefois lurs espees sanz poynte et q'e les reys des haraunz eyent lur *huces* des armez saunz plus." There can be no doubt that the "huce of arms" was a coat of arms, whether in the shape at that time of a tabard or not. Meyrick translates "huces" "mantles," following Minsheu. Another evidence of its being frequently made of costly materials occurs in Bacon's 'New Atalantis,' where it is said, "As we were thus in conference, there came one that seemed to be a messenger in a *rich luke*." M. Quicherat also speaks of the huque being furnished with hanging sleeves ("manches volantes"), after which alteration it took the name of paletot, &c. This is very interesting information, but, unfortunately, he does not favour us with his authority for it; and, while not for an instant doubting that he has satisfied himself as to its accuracy, I cannot do more than give it upon his responsibility.

In the reign of Henry VII., the heuk is mentioned by Skelton as the garment of a woman in humble life. Describing Eleanor Rumming, a noted hostess of his time, he says,—

"In her furr'd flocket,
 And grey russet rocket,
 Her duke [huke] of Lincoln green,
 It had been hers, I weene,
 More than forty yeare,
 And so it doth appeare,
 And the greene lace threads
 Look like sea-weeds,
 Withered like hay,
 The wool worn away."

Forty years from (say) 1500 would make the heuk of Lincoln green to have been coeval with Henry VI., and therefore prove that heuks were worn by both sexes at that date, as one of the *crimes* of the Maid of Orleans was wearing male attire.

But assuredly the form of a tabard was not that of the heuks which Minsheu tells us were worn by women " in Spaine, Germanie, and the Low Countries," in his day, and, as I believe, are still to be seen in those long black cloaks so familiar to the tourist in the market-places of Antwerp or Brussels. Nor can the tabard in any way be likened to " a woman's cap or bonnet," in accordance with the definition of Kennett. Here, then, is another instance of the confusion caused by the capricious application of a name to various dissimilar objects. I cannot venture to do more than point out the discrepancies in the evidence, and leave the reader to draw his own conclusions. Meanwhile I adhere to my opinion, that the heuk was originally a hooded cloak or mantle of Moorish origin, and was worn in Europe in the thirteenth century by both sexes and persons of all conditions ; the latest notice of it being in the 'Ladies' Dictionary,' 1694, where it is said to be " a Dutch attire, covering the head, face, and all the body." See also Way's note in 'Promptorium Parvulorum.'

HOLY-WATER SPRINKLER, or MORNING STAR. A formidable weapon of Oriental origin, and used in Europe from a very early period, by foot-soldiers on attacking cavalry. It is so called from the way its spikes scattered blood,—a grim jest, dating at least from the eleventh century.

M. Demmin classes it with the military flail, and says

Holy-Water Sprinkler or Fixed Morning Star. Demi-Holy-Water Sprinkler. Petty Holy-Water Morning Star or Holy-
 Morning Star. Sprinkler. Water Sprinkler.

in a note, "Some authors erroneously give this name [holy-water sprinkler] to the *morning star*," which is a similar weapon, the spiked ball being affixed to the head of the staff, instead of attached to a chain. I do not dispute his distinction, which is the reverse of that of Meyrick, but the weapons are of such close kindred, and so constantly called indifferently by either name, that I shall speak of them together under this heading. To the left, then, is a holy-water sprinkler, according to Demmin, or a morning star, according to Meyrick; and to the right is a holy-water sprinkler, according to Meyrick, or a morning star, according to Demmin.

In this latter example, the head is mallet-shaped. It is bound with iron, and furnished with five formidable iron spikes. M. Demmin says, the name *Morgenstern*, by which it was known in Germany and Switzerland, was derived from the ominous jest of wishing the enemy good morning with it, when they had been surprised in camp or city. The second cut from the left is what Meyrick calls "a fixed morning star, or kind of holy-water sprinkler."

The third is that of a demi-holy-water sprinkler, with four guns in it. It was made to hang at the saddle-bow, for which purpose there is a hook. The iron cap at the end is furnished with a spear-like blade. It has four short barrels, each of which was fired with a match, and its touch-hole protected by a sliding piece of wood. The last is described by Meyrick as "a petty holy-water sprinkler, to hang at the saddle-bow. The whole, except the handle, is of iron." It was used as a mace. All the above examples are of the fifteenth century, and were in the collection at Goodrich Court. In the Tower is a holy-water sprinkler with three guns, similar to the third just described. In the Survey of 1765, it was entered as " King Henry yᵉ 8th's walking staff," and by that absurd title it is still called by the warders.

HOOD. This familiar term has, like so many others, been applied to various articles of attire, so dissimilar in appearance at different periods that, without the aid of the pencil, very erroneous ideas might be conceived of it. It is best known to the general public in its original form, that of the cowl, as it is otherwise called, of the monastic habit, the *cucullus* of the Romans. It was not limited, however, to the monastic orders; but was then, as it has continued to be to the present day, a usual appendage to cloaks worn by persons of all classes and both sexes. (See CLOAK.) Although *hood* is the Saxon *hod*, it does not appear to have been an article of attire generally worn by them. The Anglo-Saxon *mentil*, usually depicted, has no hood attached to it; the men went bare-headed, or wore caps of the Phrygian form, and the women the veil or coverchief. It is not till after the Norman fusion that we find wayfarers and rustics represented in cloaks with hoods to them. The capa was a short hooded cloak which was common in Normandy. The young Duke William had barely time to throw a capa over him when escaping from the conspirators at Valonges; and the balandrana, the supertotus,

Cotton. MS., Nero, C iv.

Doucean MS., Bodleian, Oxford.

and other out-of-door garments were furnished with hoods. These are all constantly mentioned in the eleventh century in England. Here are two rustics of the twelfth century. Fig. 1 is from that most instructive MS. in the Cotton. Coll., Brit. Mus., marked Nero, C iv. Fig. 2 is from one of Mr. Douce's

rare MSS., now in the Bodleian Museum, Oxford. The hood of the latter is of a piece with his cloak, and of a very peculiar form. Whether its squareness was caused by some framework inside, or simply by the stiffness of the material, which appears to be in this instance of the coarsest description, must be left to conjecture. The other figure has a hood of the usual form, of which examples will be found in various portions of this work.

It is with the hood as a separate article of attire that I have specially to deal under this heading, and the earliest instances appear in the thirteenth century, when it is known by its Norman names of chaperon and aumusse.

Women, 14th Century.

The latter, which was more especially a canonical vestment, though not limited to the clergy, has been already noticed under AMESS (page 6, *ante*); but as it continued to be worn by women for three centuries, contemporaneously with the chaperon, occasional examples will be given of it here. One of the best is afforded us in the effigy of a lady of the

Aumusse.

Chaperon.

early part of the fourteenth century, engraved in the 'Antiquités Nationales,' tome ii., and also by M. Quicherat, who dates it *circa* 1330, and who tells us that in France it nearly superseded the chaperon, but went out of fashion on the accession of the Valois family, which was in 1328; but, as in England, I find a hood of that description worn long afterwards by the *bourgeoisie* and lower orders.

Charles le Bon.

The chaperon worn by men in the reign of Edward II. was a sort of pointed bag with an oval opening for the face; the point, sometimes of great length, hanging down behind, or twisted round the head, or, if short, sticking up or dangling according to fancy or circumstances. These tails were called tippets and *liripipes*. (See pages 118 and 198, *ante*.) Henry Knighton, a chronicler of the reign of Edward III., writing about 1348, in his description of ladies riding to a tournament and affecting a masculine appearance, says, they wore short hoods and liripipes, wrapped about their heads like cords. An engraving in Montfaucon of a portrait of Charles the Good, of Flanders, curiously illustrates this fashion. (See woodcut annexed.) In the 'Eulogium,' an anonymous writer of the fourteenth century, cited by Camden, speaking of the dress of the men in the reign of Richard II., says, "Their hoods are little, tied under the chin and buttoned, like the women's."

Varieties of Hood, 14th Century, from 'Loutrel Psalter.'

The various modes of wearing the hood by men and women in the first half of the fourteenth century is abundantly illustrated in the 'Loutrel Psalter,' to which we have been already indebted.

The figures selected by Strutt from a MS. in the Bodleian, No. 264, for the illustration of "Hoodman blind," in his 'Sports and Pastimes of the People of England,' are also very good examples of the form

From Bodleian MS., No. 264.

of the chaperon at this period. The players who are blinded have their hoods reversed upon their heads for that purpose; those of their companions, both male and female, being twisted and knotted to buffet them. Thence our modern game of "blind man's *buff*." Another shaped hood, however, makes its appearance about this time, which forcibly recalls to us that worn by the Norman shepherd, noticed at the commencement of this article. The subjoined cut is from the 'Romance of St. Graal and St. Lancelot' (Additional MSS. Brit. Mus., No. 10,293). "It represents," says Mr. Fairholt (who has engraved it), "a countrywoman in the act of churning, to whom a blind beggar is approaching to ask alms, carrying his child on his back, both wearing these hoods. The countrywoman at her churn is a good specimen of costume: her head is warmly tied up in her kerchief; she wears an apron, and her gown is prudently pinned up around her, showing her dark petticoat beneath." I have

From Add. MS. Brit. Mus., No. 10,293.

given the whole group, as I am not quite sure that what Mr. Fairholt calls a kerchief is not some arrangement of a hood, knotted on one side. There are several instances of this peculiar *coiffure*, and, as I have not included it under HEAD-DRESS, I take the opportunity of inserting it here.

In the reign of Richard II., 1377–1399, a new mode of wearing the hood becomes apparent. The

whim must have occurred to some leader of fashion, most probably in France, to put his head into the oval opening made for the face, and then, gathering up the portion intended to cover the shoulders in the form of a fan, bind it in an erect position by twisting the long tippet or tail round the head, and tuck in the end of it. I have endeavoured to render this clear by the two following diagrams.

But the reader will better comprehend the process by observing its effect in the subsequent examples; for the fashion having lasted for nearly a hundred years, the varieties resulting from taste or caprice

Hoods of the latter half of the 14th Century.

are almost innumerable. In the first example a cap is worn over the hood. The second illustrates the fashion I have just spoken of, and the other five are simply varieties of the same head-dress.

About the middle of the fifteenth century, the chaperon, from being a pointed and long-tailed hood, which could either be drawn over the head and shoulders or twisted into fanciful shapes and worn turban-wise, was converted into a head-dress of a more formal description, which, although it retained the name of hood, lost all similitude to the cowl, capuchon, or aumusse, and became a cap, with a crown closely fitting the head, and a stuffed roll around it, on one side of which depended some of the material it was composed of, arranged in imitation of the previous fashion, and on the other side a broad band of the same stuff hung down nearly to the ground, or was passed once or twice round the neck, or the end tucked into the girdle, according to the fancy or convenience of the wearer. (*Vide* examples next page.)

Henry VI. and his Queen

Receiving a Book from John Talbot, Earl of Shrewsbury.

(From Royal MS. 15 E 6.)

The edges of the tippets (liripipes) of these hoods were frequently escalloped or cut into the form of leaves, or other fanciful devices. In the 'Eulogium,' which I have quoted from before, p. 292, we are told that their *liripipes* reach to their heels all jagged."

Temp. Henry VI.

Temp. Edward IV.

Latest forms of the Chaperon. 15th Century.

In the latter part of the fifteenth century caps and bonnets were more worn, the hood being slung by the tippet over the shoulder, to be assumed at pleasure. In the sixteenth century it ceased to be worn, but still formed a portion of the costume of the Order of the Garter, and of similar institutions, as well as of legal and official personages, by whom it was worn over the shoulder only

(see woodcut from Ashmole's 'History of the Order'); at first in its own shape, but of smaller dimensions, diminishing and changing in form till it became no longer recognizable on the backs of our clergy, or other persons, whose particular rank it is still considered to indicate.

Hood of Knight of the Garter, from Ashmole's 'History of the Order.'

Head-dresses resembling the turbaned and tippeted hood of the gentlemen were worn by the ladies of the fifteenth century (see p. 273), but the wives and daughters of citizens and the commonalty in general wore either varieties of the aumusse or hoods of a very peculiar shape, some having ears to them, which, I think, may be the head-dress alluded to by Paradin as having at the side wings "like apes' ears," though it does not answer the rest of his description (see p. 274, *ante*). The annexed engraving is copied from Fairholt, who has, unfortunately, omitted to refer to the original.

Hood with apes' ears.

The hoods and aumusses worn by women in the fifteenth century vary so much in form that a verbal description of a tithe of them would be tedious, even if comprehensible, which descriptions of such articles rarely are. I subjoin, therefore, examples of the most characteristic from a splendid copy of Froissart's 'Chronicles,' written at that period, in the Harleian Lib. (Brit. Mus., Nos. 4379 and 4380), and other contemporary sources, which will instruct the reader more clearly and rapidly than any quantity of letter-press could do.

Varieties of Hoods worn by women *Temp.* Henry VI. and Edward IV.

The sixteenth century introduces us to a most puzzling species of head-gear—the *French hood*. Holinshed tells us that Anne of Cleves, the day after her arrival in England, wore "a French hood after the English fashion, which became her exceeding well." In anticipation of the attainder of Catherine Howard, Henry VIII. took possession of all her personal property, but was graciously pleased to allow her six changes of apparel, and "six French hoods with edgings of goldsmiths' work, but without pearl or diamond." (State Papers.) From that time, throughout the succeeding reigns of Edward VI., Mary, Elizabeth, James, and Charles I., we constantly hear of the French hood, but nowhere do we meet with a description of it sufficiently clear to enable us to identify it with any particular head-dress which the pencil has depicted during those hundred and forty years. Bulwer, in his 'Pedigree of the English Gallant,' is the only writer I am aware of who gives us the slightest hint of its shape. "Our enormous French hoods," he says, "that vaine modell of an unruly member, the tongue,

an abusive invention might be derived from some unicorn-like dress of haire among the barbarous Indians." This is confused enough, and it is difficult to imagine anything like a tongue which at

Country People.

Domestics.

Varieties of Hoods worn by the Commonalty. 15th century.

the same time could be compared to a unicorn. The mediæval hood, the chaperon of the fourteenth and fifteenth centuries, had been succeeded by several fantastic head-dresses, which might be called anything. (See pages 275-276, and also woodcut annexed, from a brass of Thomas Pounder and wife in the chancel of St. Mary Key, Ipswich, dated 1525, which shows us a hood worn over a pointed caul or cap, as appears from the head-dresses of the daughters, who wear the caul without the hood, which is an approach to that which has been named by modern writers the "diamond-shaped.") Whether we see in it "the French hood after the English fashion," which Holinshed speaks of as so becoming to Anne of Cleves, or are to consider the one in which she is represented by Holbein as a variety

From brass in Church of St. Mary Key, Ipswich. 1525.

of it, we have no means of deciding; but in either case, it could not possibly be the hood abused by Bulwer in 1653, as no such head-dress is to be seen after the reign of Edward VI. at the latest. Amongst the examples, however, to which I have just referred, is one (page 277) which, first appearing in the reign of Henry VIII., was worn by all classes of women down to Bulwer's time, and, with the exception of the epithet "enormous," may to a certain degree justify his description. I subjoin specimens of it from the reign of Elizabeth, appending to them Bulwer's own representation of it, in the last stage of its existence.

Varieties of the French Hood.

In its earliest form, it strongly resembles the well-known head-dress of the Roman women of the present day; but the pendent portion of the hood, which is usually flat and occasionally turned up and brought forward over the head, giving it the Italian character alluded to, is in Bulwer's book drawn in a shape which certainly may be compared to that unruly member, the tongue, though scarcely to the horn of a unicorn. Seen in profile, however, some of these head-dresses might, by a stretch of the imagination, justify even that comparison : *ex. grat.* the annexed copy of an effigy in Broxbourne

Daughter of Sir H. Cock, Kt. (1609), in Broxbourne Church, Herts.

Church. Fairholt, in describing one of these head-dresses (see woodcut annexed from a tomb in Swarkeston Church, Derbyshire), says, " Her hair is combed back in a roll over the forehead, and she wears a small hood or coif with a frontlet. These frontlets were sometimes allowed to hang down the back, but were as frequently turned over the head, as this lady wears hers, and brought forward to shade the face, according to the taste of the wearer." Surely this is a mistake. This appendage to the hood could never have been called a frontlet. The frontlets so continually alluded to in the sixteenth century were distinct articles of attire, and apparently of a decorative character. It is classed with other ornaments and adjuncts to the toilet. The Pedlar, in Heywood's interlude, ' The Four P's,' says,—

Effigy in Swarkeston Church, Derbyshire.

> " Forsothe women have many lets,
> And they be masked in many nets,
> As frontlets, fillets, partlets, and bracelets ;"

and when mentioned in the same passage with a hood, it is distinctly separate and not as a portion of it. In Lyly's ' Midas,' 1592, is the following enumeration :—" Hoods, frontlets, wires, cauls, curling-irons, periwigs, bodkins, fillets, hair-laces, ribbons, rolls, knot-strings, glasses, &c."

Averse as I am to speculation in these matters, I cannot help expressing my opinion that the frontlet was an ornamental band or border of some description, which could be worn at pleasure either with the hood or the bonnet; as also could another unidentified article of costume, the bongrace, which we have seen was an adjunct to the French hood (*vide* p. 46), and, at the same time, is associated with the bonnet.

> " Tell me precisely what avails it weare
> A bongrace bonnet."—*FitzGeffrey's Satyres*, 1617.

If the previous cuts really represent the French hood—and it is difficult to contest the assertion of Bulwer, to whom it must have been familiar—where is an example of either a frontlet or a bongrace being worn with it? *Davus sum non Œdipus,* and I frankly admit that I am unable at present to do more than lay the best information I have been enabled to collect before my readers. My notice of the French costume at this period in the GENERAL HISTORY may possibly throw a little more light on this very obscure subject. The French hood, whatever it might be, seems to have fallen into decadence before the Restoration, as in Massinger's 'City Madam,' printed in 1659, the servant exclaims, "My young ladies in buffin gowns and green aprons! tear them off!—and a French hood too—*now 'tis out of fashion;* a fool's cap would be better!"

We now come to another form of hood, respecting which we have the fullest description and the clearest pictorial illustration—the hood of the second half of the sixteenth century.

Elizabeth Sacheverel, in Morley Church, Derbyshire. 1657.

Wife of Jonathan Sacheverel, Morley Church. 1662.

One of the earliest specimens is afforded us in the effigy of Elizabeth Sacheverel, in Morley Church, Derbyshire, A.D. 1657. It is little more than a kerchief tied under the chin, though, of course, made up in that form for the sake of convenience. In the puritanical days of the Protectorate, the material was, as may be anticipated, black; and the effigy of another lady of the same serious family, in the aforementioned church, A.D. 1662, presents us, in addition to the close black hood, with an ample hooded cloak of the same sombre hue, of which many examples exist in monuments of this period, and foreshadows the capuchin and the calèche of the succeeding century. The Restoration naturally brought gaiety of colour as well as of manners with it, and shortly after the arrival of the "merry monarch" and his court at Whitehall we find our invaluable friend Pepys recording, under date May 14, 1664, "To church, it being Whit-Sunday; my wife very fine in a new yellow bird's-eye hood, as the fashion is now." Hoods of this description continued to be worn to the end of the reigns of the first two Georges. In a print of Romain de Hooge's Landing of King William III. is the annexed example. Fairholt, who has engraved it,

From a print of Romain de Hooge.

Milkmaid. 1698.

says it was secured to the summit of the hair, and thence spread upon the shoulders, to which it was affixed. It was worn in this style not only by ladies of fashion, but by country lasses, as appears by a print of 1698, in Misson's 'Mémoires,' where a milkmaid is represented in her May-day attire with a hat over her hood. Hoods of Flanders' lace were fashionable in 1700: one was stolen with other articles from Lady Anderson's house in Red Lion Square, that year. Hoods of various colours were worn by ladies at the Opera in 1711: "As I was standing in the hinder part of the box, I took notice of a little cluster of women sitting together, in the prettiest coloured hoods I ever saw. One of them was blue, another yellow, and another philamot; the fourth was of a pink colour, and the fifth of a pale green. I am informed this fashion spreads daily, insomuch that the Whig and Tory ladies begin already to hang out different colours, and to show their principles in their head-dresses." In 1712 the prevailing fashion was cherry colour.

In No. 272 of the 'Spectator' is the following advertisement from the Parish Vestry, dated January 9, 1711-12:—"All ladies who come to church in the new-fashioned hoods are desired to be there before divine service begins, lest they divert the attention of the congregation." Mazzarine hoods are mentioned in Shadwell's 'Bury Fair,' 1720:—

"What do you lack, ladies fair?
Mazzarine hoods, fontanges, girdles?"

Hoods were displaced by caps and bonnets in the reign of George II.

HOOD (FOOL'S). The phrase of "a cap and bells" has been so long associated with folly, and "a fool's cap" the degrading distinction of the stupid schoolboy, that it may surprise some of my readers to hear that a cap was by no means the ordinary head-dress of the household jester, and that it would be difficult to find a contemporary pictorial illustration of one. The domestic fool wore, at least as late as the sixteenth century (and he disappeared in the seventeenth), the hood common to all classes in the eleventh century—Fosbrook says, "resembling a monk's cowl, which at a very early period it was certainly designed to imitate." For the latter opinion I find no authority, and consider it to be founded on the popular idea which the critical study of antiquities has proved to be erroneous—viz., that the monastic and ecclesiastic costume was originally distinct from that of the laity; whereas, with very few exceptions, it was the attire of the people generally, and became distinct simply from the rules of the various councils prohibiting the clergy from assuming the garments introduced by successive caprices of fashion and increasing taste for extravagance in apparel, "costly array," and "superfluity of clothing," to which we find them so extremely addicted. The fool's hood was distinguished from that of his master or of his master's chaplain by the addition of a cock's comb or asses' ears, or bells, sometimes all together. Even its being of two or more colours was not a peculiarity in the fourteenth century (previous to which we have no reliable information), as parti-coloured dresses were worn by men of every degree in the reign of Edward III., and continued to be more or less in fashion during a considerable portion of the fifteenth century.

In Minshew's 'Dictionary,' 1627, under the word "coxcomb," it is stated that "natural idiots and fools have (accustomed) and do still accustom themselves to weare in their *cappes* cocke's feathers, or a *hat* with the necke and head of a cocke on the top and a bell thereon;" but I have seen no representation of such caps or hats. Of the hoods there are endless examples; and one of the most interesting is a dance of fools (probably the fools in a morris dance) in a MS. in the Bodleian Library, Oxford, No. 964, written about the year 1344. Here we see the square hood of the shepherd of the twelfth century (*vide* page 291), and of the beggar and his son (*vide* page 293), exaggerated, and with bells at their extremities. The musicians are similarly attired. The chaperon of the fourteenth century had superseded all other forms; and the one now under consideration existed only as an old-fashioned and perhaps cast-off article of apparel for some brief period amongst rustics and mendicants. Mummers, masquers, and morris dancers would, however, then as now, cling to ancient customs and costumes; and the subjoined woodcuts curiously illustrate the practice.

Dance of Fools. MS. Bod., No. 964.

In the sixteenth century there is mention of a cap; but the hood is still the principal feature. In a wardrobe account dated June 28, 1536, are the following entries concerning the attire of William Sommars, the jester to King Henry VIII.:—"Item, for making a doublet of worsted, lined with canvas and cotton, for William Som'ar, our fool; item, for making of a coat and *cap* of green cloth fringed with red crule and lined with frize for our said fool. Item, for making a coat of green cloth with a *hood* to the same, fringed with white crule. Item, for making a ditto coat with a *hood* of green cloth fringed with crule of red and white colours for our said fool."

Of the domestic fool's hood during the Middle Ages, the following examples will be sufficient. They might be multiplied *ad infinitum*.

Royal MS. 15 D 3.　　　　　Royal MS. 2 B 7.　　　　　Harleian MS. 2287.

HOOP. This well-abused and ridiculed assistant to a fashionable lady's dress, within the recollection of many now living, as it was indispensable to Court costume in "the days when George the Third was king," is first spoken of in the reign of Elizabeth, and was, therefore, a contemporary of the farthingale, which it survived and succeeded. Stephen Gosson, in his 'Pleasant Quippes for upstart new-fangled Gentlewomen,' 1596, says :—

> "These hoopes that hips and haunch do hide
> And heave aloft the gay hoyst traine,
> As they are now in use for pride,
> So did they first begin of paine."

And it might be argued that he was alluding to the farthingale ; but that Dr. Forman, another writer of the same period, mentions them as distinct objects. In his description of Queen Guinever, he says that she wore "noe hoope, noe fardingalle."

Strutt has engraved a hooped petticoat of the middle of the seventeenth century, which he copied from a German vocabulary ; but its dimensions are so exceedingly moderate, that it could not have provoked the censure or the satire of the most rigid Puritan. It is in the reign of Queen Anne that the hoop starts forth again as a novelty, and in 1711, Sir Roger de Coverley, in the 'Spectator,' calls it "the new-fashioned petticoat," and, comparing it with the farthingale, observes that " his great-great-grandmother appears as if she stood in a large drum, whereas the ladies now walk as if they were in a go-cart." Those of my readers who have ever seen that now obsolete vehicle, will acknowledge the aptness of the comparison. Mr. Fairholt has engraved one of these "pyramidical bell-hoops," as he calls them, from a print of the year 1721, and the appearance of a lady in it vividly recalls to us the form given to the petticoat in the sixteenth century, previous to the introduction of the

From a German Vocabulary, *circa* 1650.

farthingale. It is therefore probable that the bell-hoop, or some similar contrivance, was known to the ladies of the reign of Henry VIII. (See FARTHINGALE.) In 1718 it is thus commented upon by a writer in the 'Weekly Journal:'—"Nothing can be imagined more unnatural, and consequently

less agreeable. When a slender virgin stands upon a basis so exorbitantly wide, she resembles a funnel—a figure of no great elegancy: and I have seen many fine ladies of a low stature who, when they sail in their hoops about an apartment, look like children in go-carts." I have already noticed the aptness of the latter simile, used seven years previously by Addison. The comparison to a funnel would have been improved by the addition of the word "inverted."

"A lawyer of the Middle Temple" relates, in No. 129 of the 'Spectator,' the startling effect produced on the congregation of a west-country church by the entrance of the lady of the manor, newly returned from London, "in a little head-dress and a hooped petticoat," with the latter of which she "filled the area of the church," and he informs us that he found that "the farther he got from town the petticoat grew scantier and scantier, and about threescore miles from London was so very unfashionable that a woman might walk in it without any manner of inconvenience."

The annexed woodcut exhibits the hoop itself, from one lying on the floor in the night scene of Hogarth's 'Marriage à la Mode,' and the appearance of it when on the same great artist has

From Hogarth's 'Marriage à la Mode.'

satirically illustrated in his picture of 'Taste in High Life,' where the Venus de Medicis is depicted in one. Our other examples are from a print dated 1745, when the hoop had increased at the sides and diminished in front. A pamphlet was published in that year, entitled 'The Enormous Abomination of the Hoop-Petticoat as it now is.' A few years later it subsided to such a degree as to be scarcely noticeable in some figures; but in 1757 it reappears, expanding right and left into the shape which, after it had ceased to be worn in the morning, it retained at Court during the reign of George III.

Hoops from a print dated 1745.

HOSE. The Saxon name for the coverings of the legs, which were called CHAUSSES by the Normans (see page 95), under which head their probable origin has been stated. *Scin hose (i.e.,*

leather hose) are mentioned in Anglo-Saxon documents : but they might possibly be a sort of buskin, or short boot, now and then met with, or literally leather stockings. The long hose, with feet to them, become first noticeable in the fourteenth century, when the short jackets, doublets, and other similar garments, with their "horrible disordinate scantiness," awakened the wrath of Chaucer, who declares that "the wrapping of their hose, which are departed of two colours—white and red, white and blue, white and black, or black and red—make the wearer seem as though the fire of St. Anthony, or other such mischance, had cankered and consumed one-half of their bodies." This fashion of wearing hose of two colours, "which rendered uncertain the fellowship of the legs, and the common term of a pair perfectly inadmissible," continued to brave the anger and satire of the poets and chroniclers for upwards of a hundred years, after which it was limited to henchmen, pages, and grooms, and disappeared entirely about the middle of the sixteenth century. The dress of the jester, therefore, was only distinguished by his cock's comb or asses' ears, his bells or his bauble, till after the reign of Henry VIII. These long hose were fastened to the jacket or doublet by points, or latchets, called herlots. Poins, in Shakespere's 'First Part of Henry the Fourth,' puns on the word :

> " FALSTAFF : Their points being broken—
> POINS : Down fell their hose."—Act ii., sc. 4.

The hose of persons of condition were made of the finest cloth or velvet. " Hosyn enclosyd of the most costyous cloth of cremsyn," are mentioned in the 25th 'Coventry Mystery.' Purple velvet hose are mentioned in 'Maroccus extaticus,' 1595 ; but the latter would, from the date, have been the trunk hose, which were in fact breeches. The introduction of the latter at the commencement of the sixteenth century caused a revolution in the nether garments of the male sex, which ended in confounding the old name of hose with the new name of stocking, for the derivation of which, and further information on this subject, see STOCKING.

HOUPPELANDE. This is the name we find given at the end of the fourteenth century to a garment which French antiquaries have agreed in assigning to one of the varieties of gowns introduced during the reign of Charles VI., and which travelled over to England, and was highly fashionable in the reign of Richard II. Strutt calls it a loose upper garment of the super-tunic kind, and Fairholt simply quotes him without comment. M. Viollet-le-Duc, as usual, gives us half-a-dozen widely different garments, all of which he classes under houppelande. I regret that in this, as in other instances, I cannot share his confidence. It would save me a world of trouble. One of the forms he

Group from ' Metrical History of the Deposition of
Richard II.' Harleian MS. 1319.

Talbot, Earl of Shrewsbury. From Royal MS. 15 E 6.

selects is a long loose robe like a morning gown, with ample sleeves, such as we so frequently meet with in illuminations of the fourteenth century, and which corresponds with Strutt's definition of it

(see woodcut). Froissart relates that when Charles VI. of France heard of the attempted assassination of the Constable de Clisson, in Paris, he determined to save him, and, rising hastily, put on only a houppelande and a pair of shoes. ('Chroniques,' livre iv. chap. xl. *sub anno* 1392.)

On the day of the coronation of Henry IV., A.D. 1399, we are told the lords wore a long tunic, called a houppelande, of scarlet, with a long mantle over it; and the knights and esquires wore the scarlet houppelande without the mantle. Quicherat quotes the following dialogue between two shepherds, from a pastoral written *circa* 1385, by Froissart, who was a poet as well as an historian. He has modernized the old French of the original for the convenience of his readers, and for the same reason I shall adopt his version:

"Houppelande, vrai Dieu! eh donc qu'est-ce que cela peut être? Dis-le moi. Je connais bien une panetière, un casaquin, une gibecière; mais j'ignore, et c'est pourquoi je te le demande, quelle raison te fait parler de vêtir une houppelande?"

"Je vais te le dire; écoute bien: c'est à cause de la nouvelle mode. J'en vis porter une l'autre jour, manche flottant devant, manche flottant derrière. Je ne sais si cet habit coute cher; mais certes il vaut qu'on le paye un bon prix. Il est bon l'été et l'hiver: on peut s'y envelopper; on peut mettre dessous ce qu'on veut; on y cacherait une marine [a basket], et c'est ce qui me fait songer à me vêtir d'une houppelande."

We derive little information from this description beyond the fact that it was a loose, comfortable garment in which a man could wrap himself, with hanging sleeves *before and behind*—a mistake of the describer, I imagine, unless he is alluding to their amplitude—and that it was large enough to hide a basket under. It appears that there were long houppelandes and short houppelandes, some reaching only to the mid-thigh. M. Viollet-le-Duc gives one engraving of what he calls a houppelande, which is a common cloak with large sleeves and a hood to it. The ladies also are said to have worn houppelandes, and there is a trial recorded respecting one in which it is indifferently called "*robe* ou houppelande." ('Les Arrêts d'Amour de Martial d'Auvergne.') If the figures with which M. Viollet-le-Duc illustrates his article on this subject are to be relied upon as illustrations of the houppelande, we have already represented it under GOWN, at pp. 217, 221, and 222, and DAGGES, at page 165; and as far as the ladies are concerned, those of the reign of Henry VII., at page 223, might as properly be called houppelandes. Neither M. Viollet-le-Duc nor M. Quicherat has suggested any derivation of the word. *Hopa* in Spanish is rendered "a long cassock with sleeves;" and *Hopalanda*, "the train of a gown worn by students." The houppelande was, therefore, probably introduced from Spain.

HOUSIA. (*Housse*, French; *houcia*, Latin.) "Tunica talaris." (Ducange.) Like heuke, it is also applied to a tabard: "Præcissimus quod nec monachi nigri nec canonici regulares in *Hissis* [*sic* in MS.], vel tabardis equitant." (Stat. Synod. Joannis Episcop. Leodiensis.) By some it is called a toga: "Togam scilicet housse." (Art. Reg. Franc.) The housse appears to have been of two lengths: "Nullus habitum deferat nisi tabaldam seu houssiam *longam* de Bruneta." ('Hist. Coll. Navarrei,' Paris.) "Item Jacobo Ruello suam capam cum houcia *curta* et capucio fourrato de variis." ('Testamentum Remigii de Summa,' 1360.)

Well may Strutt describe the housse as "an outer garment combining cloak and tunic." He might have added, toga and tabard; but what idea can possibly be conveyed to the reader of the form of this "outer garment," any more than that of half-a-score of other articles of clothing rejoicing in as many names, not one of which can be confidently appropriated to them? I am almost inclined to believe that the housse (houcia) and the heuke or *huce* (huka) are identical, not that we should be much nearer understanding the precise form of the garment, as the latter is called a cloak, a cap, a tabard, a jack, with or without sleeves, with or without a hood, &c. &c.; but the amalgamation of a few of these "indefinite articles," on unquestionable authority, would be a great relief to future glossarists.

HOUVE. (*Howve*, Saxon; *huva*, Latin; *huve*, French.) A hood, cap, or coif. Also, according to Ducange,

HUVET, HOUVETTE. (*Huvata*, Latin). "Ornamentum capitis mulierum, 'une huve de soie.' *Huvet*, in eodem sensu : 'Le suppliant fery la ditte femme un ou deux cops parmi le visage dont le huvet de sa teste chez à terre.'" (Lit. Remiss., 1387.) "Lesquelx se pririrent à icelle Marqué et lui tirerent par force sa coiffe ou houvet que celle avoit sur sa teste hors de sa chief." (Rursum aliæ ann. 1391.) It was worn by both sexes :

> "I pray you all that ye not you greve,
> Though I answer, and somdel set his houve."
> Chaucer, *The Reves Prologue.*

In the same writer's 'Troilus and Cresseide,' "an houve above a cap" signifies a hood over a cap. (B. iii., l. 775.)

> "Then came a hundred
> In houves of silk ;
> Sergeants, it seemed,
> That served at the bar.
> Shall no sergeant for his service
> Weare a silk houve?
> Nor no pelure in his cloak
> For pleading at the bar?"
> *Piers Ploughman's Vision.*

The name of "huvet" or "huvette" was applied to a steel head-piece in the fifteenth century—a capeline or coif de fer. "Lesquelx entrerent la maison d'un armoiseur et la prindrent chacun une huvette ou capeline," 1421. (Ducange, *in voce.*)

HUNGERLAND BAND. A collar worn by ladies in the seventeenth century. Luke, in Massinger's play of 'The City Madam,' 1659, mentions it in his description of the rich merchant's wife :

> "Your Hungerland bands and Spanish quellio ruffs."

It was probably made or worn after some Hungarian fashion. I have not met with it elsewhere.

HURE. In a satire on the Consistory Court, *temp.* Edward II., printed in T. Wright's 'Political Songs,' the Principal of the Court is described as

> "An old churl in a black *hure.*"

Mr. Fairholt explains this as "a gown worn by clerical and legal men ;" but I do not find that either clerical or legal men wore black gowns in the time of Edward II., and hure is a covering for the head. "Pilleus est ornamentum *capitis sacerdotes* vel graduati. Anglice, a hure or a pyllyon." (Royal MS., Brit. Mus., 12 B i. 12. *Vide* Halliwell *in voce.*) Hure, indeed, is still a provincialism for head, and also for hair. "Hure-sore," when the skin of the head is sore from cold : Cheshire. (Halliwell, *ut supra.*) The word is derived, according to Casseneuve and De Duchat, from the old French *huressé*, which signified *herissé.* "Il a une vilaine hure"—an unsightly head of hair. "*Hure*, the head of a beare, wolfe, wild boare, or any other savage or dangerous beaste ; (hence) also, a staring, horrid, unkembed or ill-kept pate of hair." (Cotgrave.)

HUSKYN. A head-piece of the skull or pot description, worn by archers in the sixteenth century. (Grose's 'Mil. Ant.' vol. ii. p. 272.)

NCLE, INKLE. A sort of tape used as a trimming to dress. In the corporate accounts of Norwich, 1587, a charge is made "for white *incle* to lay upon the soldiers' coats." An old countrywoman "with *incle* about her hat" is mentioned in the comedy of 'The Triumphant Widow,' 1677. (*Vide* Bailey, Halliwell, Fairholt.) The latter says, "It was generally of a yellow colour, but sometimes striped blue and pink, or blue and red," and that it was worn by the humbler classes as a trimming until the end of the seventeenth century.

INDE, YNDE. This word was used in the Middle Ages for "blue."

> "The tother hew next to fynde
> Is al blew, men calleth ynde."
> *Cursor Mundi,*—MS. Coll. Trin., Cantab.

> "Their kirtles were of inde cendel,
> Ylaced, small, jolyf, and well."
> *Lay of Syr Launfal, circa* 1300.

> "Couleurs jaunes, indes et rouges."—Guiart, *sub anno* 1304.

INFULÆ. The pendent ornaments at the back of a mitre. (See MITRE, also VITTÆ.)

IRON HAT. The English translation of the French *chapel de fer ;* but, unless by poetic licence, not "applied," as Fairholt states, "in the romances of the Middle Ages to the cylindrical flat-topped helmet worn by the soldiers of the Crusades and others." The iron hat, steel hat, or kettle hat, as it was indifferently called by the English writers, was not a variety of the heaume ; but literally a hat of metal, made in the form of the hats commonly worn by civilians of the same period. M. Demmin has given many specimens of these iron head-pieces, and, by comparing them with the hats engraved in this work, the appropriateness of the term will be fully acknowledged. The author of 'The Romance of Alexander,' quoted by Mr. Fairholt, in which are the lines,—

> "Of some were the brayn out-spat
> All under their iron hat,"—.

was not a contemporary of the Crusades, and either uses the word in a poetic sense and for the convenience of the rhyme, or, as usual with mediæval writers, arrays his personages in the costume of his own time. Thus also we find—

> "He set his stroke on his yron hat."
> *Romance of Richard Cœur de Lyon,* 14th cent.

In prose descriptions and official documents, the distinction made between helms and iron hats, or other head-pieces, is always very noticeable. Thus in an inventory of arms and armour taken at Holy Island, in 1437, we read, "Arma imprimis v. *galee* cum v. umbrell. et iiij. vantels.

Item i. *steilhatt.* Item ij. shelles de *basenetts*," &c. The steel hat is kept distinct from the five helms and the bascinets.

The six following examples have been selected as varieties of the *chapel de fer*, more distinctly entitled by their form to the appellation of "hat."

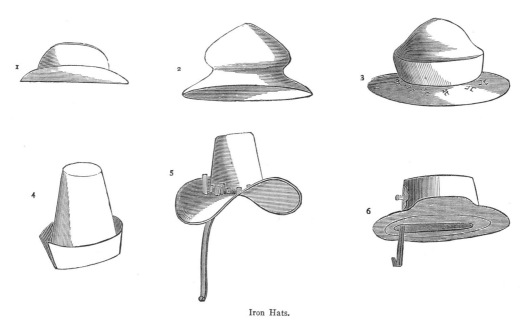

Iron Hats.

Fig. 1. German iron hat (*Eisenhut*), twelfth century, from the frescoes in the Cathedral at Brunswick, painted previous to 1195. It is of the form of the hat slung at the backs of travellers of that date. Figs. 2 and 3. Iron hats (also German), fifteenth century, from the museums of Copenhagen and Nuremberg; probably of the class called kettle hats, as if reversed they might be taken for kettles. Fig. 4. Iron hat, fifteenth century, copied by M. Hefner-Alteneck from a painting in Schwaebisch Hall. Fig. 5. Iron hat which belonged to Charles I. of England; Warwick Castle. Fig. 6. Iron hat worn by the household foot-soldiers of Louis XIV. of France; Musée de l'Artillerie.

ISABELLA. A colour, so named from the Infanta Isabella Clara Eugenia, wife of the Archduke Albert of Austria, who, in 1601, made a vow not to change her linen until the town of Ostend was taken. The siege lasted three years and three months, by the termination of which her highness's underclothing had attained a hue which it was difficult to designate; but dresses and ribbons were dyed in imitation of it, and called "couleur Isabella." (La Rousse, 'Dictionnaire Universelle.')

Boyer says, "Sorte de couleur qui participe du blanc et du jaune," and describes "un cheval Isabelle" as "a yellow-dun horse." Landais has, "Couleur qui participe du blanc ou jaune et de la couleur de chair." Others state it to have been iron-grey. (*Vide* Harte's notes to his 'Eulogium.') It was fashionable in France for upwards of a hundred years.

ACK. (*Jacques*, French; *giacco*, Italian.) A loose coat or tunic, made originally of jacked leather, whence its name; as in so many other instances the same appellation was bestowed on garments differing from it both in shape and material. We first hear of it in the fourteenth century. In a letter remissory, dated Paris, 1374, it is thus mentioned: "Prædictus monachus monachali habitu abjecto se armavit, et indutus *quodam indumento vulgariter Jacque nuncupato*,"—"a certain garment commonly called a Jacque." That it was a military garment at this time in England is clearly shown by Walsingham, who, under the date of 1379, says: "Quod mille *loricas* vel *tunicas* quas vulgo *Jackes* vocant, redemerit de manibus creditorum," distinctly classing it with coats or tunics of mail. The same historian tells us that when the riotous followers of Wat Tyler and Jack Straw, in 1381, plundered and burnt the palace of the Duke of Lancaster in the Savoy, they took his jack, which the author calls the Duke's most precious garment, "vestimentum preciosissimum ipsius," and stuck it on a spear to shoot at; but finding their arrows could not damage it sufficiently, they chopped it to pieces with their swords and axes. By "most precious" we must understand most valuable as a defensive garment, and not for the costly nature of the materials. The difficulty the rioters found in destroying it proves the goodness of the workmanship. An order of Louis XI., King of France, gives us all the particulars of the construction of a jack of the fifteenth century: "And first they must have for the said jacks, thirty, or at least twenty-five, folds of cloth, and a stag's skin; those of thirty, with the stag's skin, being the best cloth that has been worn and rendered flexible, is best for this purpose, and these jacks should be made in four quarters. The sleeves should be as strong as the body, with the exception of the leather, and the arm-hole (*assiette*) of the sleeve must be large, which arm-hole should be placed near the collar, not on the bone of the shoulder, that it may be broad under the arm-pit and full under the arm, sufficiently ample and large on the sides below. The collar should be like the rest of the jack, but not made too high behind, to allow room for the salade. This jack should be laced in front, and under the opening must be a hanging piece (*porte piece*) of the same strength as the jack itself. Thus the jack will be secure and easy, provided there be a pourpoint without sleeves or collar of two folds of cloth, that shall be only four fingers broad on the shoulder; to which pourpoint shall be attached the chausses. Thus shall the wearer float, as it were, within his jack, and be at his ease; for never have been seen half-a-dozen men killed by stabs or arrow wounds in such jacks, particularly if they be troops accustomed to fighting." (Meyrick, 'Crit. Inquiry,' vol. ii. p. 140; Daniel, 'Mil. Franç.' tome i. p. 242.) Mr. Hewitt observes that the military jack "appears to have been of four kinds: it was a quilted coat; or it was pourpointed of leather and canvas in many folds; or it was formed of mail or of small plates like brigandine armour." It was occasionally covered with velvet. "Item, do et lego Petro Mawley filio meo, unum jack defencionis opertum nigro velveto." ('York Wills,' A.D. 1391.) The quilted jack was sometimes stuffed with silk:

> "Il fut bien armez de ce qu'il luy failli,
> L'ut une jacque mult fort de bonne soie emplis."
> *Chronique de Bertrand du Guesclin.*

Jacks of gymold (gimmel?) mail are mentioned as early as Edward III. (Capell's 'Prolusions'), and Florio renders *giacco* "a jacke of maile." What can we understand by this, but a short coat or jacket of chain which could not differ greatly from a haubergeon, while the stuffed and quilted jack appears to be almost identical with the haqueton? The jack was the usual "coat of fence" of the archer, the guisarmier, and the cross-bow men in the fifteenth century. I have some hesitation in selecting an illustration of this jack, but believe the annexed woodcut may probably represent it. Coquillart, a French writer, calls it a pourpoint made of chamois leather, stuffed with flocks, and reaching to the knees, and reviles it as "a great villanous English jack."

> "C'etoit un pourpoint de chamois,
> Farci de boure sur et sous,
> Un grand vilain jaque d'Anglois,
> Qui lui pendoit jusqu'aux genous."

Soldier in Jack.

Meyrick considered that a French author designating this pourpoint an English jack, indicated that the garment had originated in England; but we hear also of "Northern jacks," and I believe Coquillart uses the epithet only to explain that the one he is speaking of was of English make, each country, no doubt, having its own style of form and peculiarity of fabrication. Lacombe ('Dictionnaire du vieux langage François'), cited by Meyrick ('Archæologia,' vol. xix.), only repeats the description I have extracted from the order of Louis XI., making, however, an awful blunder of substituting "thirty *buckskins*" for thirty folds of cloth! In an indenture of retainers, *temp.* Henry VI., it is ordered that "all the said archers" are "specially to have good jakks of defence." Amongst the effects of Sir John Fastolfe, in the same reign, are "vi jakkes stufyd with horne," also "j jakke of black lynen clothe stuffyd with mayle." In both these cases, for "stufyd" we should read "lined" in brigantine fashion; the brigantine being a species of jack, and often confounded with it: nor must we forget that during this same reign of Henry VI. we have seen it confounded with the heuk, "a jacque or huke of brigandine." "Ordonnons qu'en chacune paroisse de nostre royaume y aura un archer qui sera et se tiendra continuellement en habillement suffisant et convenable de salade, casque, espee, arc, trousses, *jacque ou huque de brigandine*." (Ordonnance of Charles VII. of France, 1448; Daniel, 'Hist. de la Mil. de France,' tome i. p. 238.) In the inventory of the goods and household stuff of Dame Frances Talbot, of Pepperhill, co. Salop, taken 28th of Nov. 1567, occurs, "Item, thyrtye and one *jackes or habbergynes;*" and to complete the confusion, Père Daniel in his notes on the above passage tells us, "C'etoient ces especes de jaques qu'on appelloit du nom de gobisson, de gambisson, de gambaison." So that a jack was a pourpoint, a heuk, a brigantine, a haubergeon, and a gambeson; and why not also a hacketon, which was composed of the very same material? (See ACTON.) But surely the jack which we find co-existing with all these garments must have had some peculiarity by which it was distinguishable from them, and known as a jack in England, France, Germany, and Italy for nearly four centuries? My opinion is, that the peculiarity was its amplitude. With the exception of the heuk—and we are by no means clear as to that—all the other garments above named were made to fit the body, and terminated a little below the waist, whereas the jack was so loose that the wearer is described as floating in it, and so long that it reached to his knees. Such is the garment in which the soldier is represented in the above woodcut. What to me, however, is most remarkable, is that in the numberless pictures of battles to be found in the illuminated MSS. of the fourteenth and fifteenth centuries, this figure is the solitary example I have met with which presents itself of so common an article of military costume.

As in some other instances, the name of the military habit appears to have been given also to a civil one. Froissart tells us that Henry, Duke of Lancaster, on his return to England, entered London in a "courte jacques de drap d'or à la façhon d'Almayne." That this short jack of the

German fashion was an article of civil attire depends greatly upon our view of the material of which it was composed. If simply of cloth of gold, it was decidedly so ; but if the cloth of gold was only the exterior covering of the jack, it may have been as stout a coat of defence as that of his father before mentioned, or as those "stufyd with horne" or "with mayle," which we have just read of, and "the German fashion" might allude to the shortness of "the garment," as in England we find it reaching to the knees ; but in a MS. of the fourteenth century quoted by Meyrick ('Crit. Inquiry,' vol. ii. p. 18), a knight is described as "armatus de jupone, de tunica ferrea, et jaque de veluto ;" the jack in this case having apparently changed place with the jupon. Indeed, there is the following line in the 'Chronicle of Bertrand de Guesclin :'—"Each had a jack *above* his hauberk ;" but there is no end to these seeming contradictions, arising from the capricious bestowal of the same appellation on some-times totally different objects. At the siege of Lord Gordon's castle in Inverness, Mary Queen of Scots is reported to have said that "she regretted nothing but that she was not a man, to know what life it was to lie in the fields all night, or to walk upon the causeway with a jack and a knapsack, a Glasgow buckler and a broadsword." (Randolph's Letter, 18th September, 1562.) It was surely not "a great villanous English jack" that she desired to parade in.

Jacks are mentioned to the end of the sixteenth century, "jacks of mail" being worn in the border counties betwixt England and Scotland in 1593, and in Switzerland at the same date (Sutcliffe's 'Practice of Arms') ; and in an inventory taken at Hengrave, Suffolk, in 1603, I find an entry of "xi jackes of plate," but we know nothing of their form or construction. The buff coat eventually displaced them in the sixteenth century.

JACK-BOOT. See Boot.

JACKET. (*Jacquette, jacquetton,* French.) The diminutive of jack. A short body garment, varying in form and material according to the caprices of fashion, changes of season, and called

by several different names ; amongst the rest, I suspect, that of "hanslein, or little jack," as I have already stated. Whether the "courte jacques à la façhon d'Almayne," worn by Henry, Duke of Lancaster, on his entry into London, as mentioned above, was what we should now call a jacket, has yet to be determined. Under one name or another we meet with this garment from about the middle of the fourteenth century. Froissart speaks of "une simple cotte ou jaquette," used in hot weather, which Lord Berners translates "a syngle jacket," that is, without lining. (Liv. ii. chap. 17.)

Jackets of various fashions are constantly met with in illuminations of the latter half of the fifteenth century. Sub-joined are several examples from MSS. of that period. (See also the figure supposed to represent Richard, Duke of Gloucester, in our chromo-lithograph issued with Part III.) In an inventory of apparel of Henry VIII. (MS. Harleian, 2284) mention is made of "four-quarter jackets of black satin with and without sleeves ;" and "seven yards of russet satin" was allowed to make a jacket for the king. In winter the sleeves were lined with fur. (Strutt, 'Dress and Habits,' vol. ii. p. 242, edit. 1843.) (See Jerkin, Paltock, Slop.)

Jacket. *Temp.* Edward IV. Harl. MS. 4379.

In the following group of soldiery of the reign of Henry VIII., the first, third, and fourth figures are represented in jackets slashed and puffed in the fashion of the day.

In the last century countrywomen and domestics wore jackets of various materials, principally of cotton. (See woodcut in the next page, from a print of the time of George II.)

A little or lighter jack, called a jacquetton, was appointed by Louis XI. of France to be

Edward ⋅ IV. and Richard Duke of Gloucester.
(*From Royal M.S. 15 E. 4.*)

'History of Thebes.' *Temp.* Edward IV. Royal MS. 14 E 4. Royal MS. 15 E 4.

Soldiery. Time of Henry VIII. Maidservant in Jacket. *Temp.* George II.

worn by the Franc-archers, who had previously been armed in the great cumbersome jack described p. 308. "Item Hectori de Montebruno capitaneo gardæ, idem Dom. Noster Rex exsolvi ordinavit per dictum christianissimum Dom. Regem Francorum, hæredem suum universalem xxv. marcas

argenti per ipsum Dom. capitaneum gardæ exbursatas in faciendo fieri *jacquetanos* saggitatorum sive archeriorum dicte Domini Regis." (Meyrick, 'Crit. Inquiry,' vol. ii. p. 142.)

JAMBS. (*Jambeaux*, French.) Armour for the legs. (See BAINBERGS.)

> "His jambeaux were of cuir-bouilly."
> Chaucer's *Rhyme of Sir Thopas.*

Defences of plate for the leg were therefore not universal till the fifteenth century; but they had appeared as early as the reign of Edward II. In the inventory of the effects of Piers Gaveston

From statue at St. Denis. Early 14th century.

in 1313 is the following entry:—"Item, deux pieces de jambers *de feer* vieulx et noveaux." (Rymer's 'Fœdera,' vol. ii. p. 203.) They were also called by the classical name of greaves, while, like them, only protecting the front of the leg. "Item, iij paires de greves et iij paires de pouliers d'acier." (Inventory of Louis X. of France, A.D. 1316.) These were fastened over the chausses of mail by straps and buckles (see pp. 17, 29, and 156), and under the foot also by another strap and buckle. (See woodcut annexed, from a statue early in the fourteenth century.)

For a few years afterwards the whole leg was occasionally cased in iron; but the examples are rare previous to the latter half of the century. The jambs were then composed each of two pieces, which opened upon hinges on the outside, and were buckled together on the inside. A pair of jambs closed lie beside the hauberk of the knight in our woodcut, p. 237 (*temp.* close of the fourteenth century). One, belonging to a suit of the fifteenth century, formerly in the Meyrick Collection, is engraved here. No alteration of consequence appears in them during the sixteenth century, towards the termination of which they were falling into disuse, and were finally superseded by boots in the reign of James I.

From the Meyrick Collection.

JANETAIRE, GENETAIRE. A javelin, so named from the Spanish *ginet,* on which weapon there was a treatise by Sabzado in the library of the late Mr. Francis Douce, now added to the Bodleian.

The janetaire is frequently mentioned in the Letters Remissory of the reign of Charles VI. of France. In one, dated 1478, it is called a "lance genestaire;" but in another, dated 1480, it is more particularly stated to be a javelin of Spanish origin: "javeline ou genetaire autrement appellée 'javeline d'Espaigne.'"

JARDINE, JARDINÉ. "Jardine, a single pinner next the bow mark, or bourgoyn." ('Ladies' Dict.,' 1694.) "Bourgoigne, jardiné, cornett." (Evelyn, 'Voyage to Maryland.')

JAVELIN, JAVELOT, GAVELOCE. A short spear or dart, known to nearly all nations in all ages of which we have any record. It appears to have been one of the weapons of the early inhabitants of these islands, the Caledonians using it with the *amentum,* i.e. a strap fixed to the centre of the javelin, by which it could be recovered by the thrower if flung at a short distance. It was the national weapon of the Welsh and the Irish in the time of Rufus. William Guiart, the Norman poet, mentions it under the name of dart in 1302:

> "La veissier au remuer,
> Lances brandie et dars ruer,
> Qui trespercent coton et bourre;"

alluding to their effect on the hacketons and gambesons, which were stuffed with cotton and flocks.

In 1320 we find gaverlots included in a list of prohibited weapons. "Quicunque portaverit lanceas, gaverlotos, telas, balistas," &c. ('Stat. Senescal. Bellicad.' Meyrick, 'Crit. Inquiry,' vol. ii. p. 167.)

Gavelines are mentioned in letters remissory of the reigns of Charles VII. and Louis XII. of France, *ann.* 1455 and 1504 ; but the critical student had better consult for himself the articles of Ducange on this subject, as the terms applied to the javelin proper have also been used to designate other weapons, such as a demi-glaive, "un baston ferée," &c. (*Vide* gaveloces, gaverlotos, gerba, gevelina, gravarina, javarina, javelina—I was about to add "cum multis aliis," for I could increase the catalogue.) What is more to our purpose is the information of Monstrelet, that at the siege of Rouen by Henry V. in 1418 there were in the king's army a great many Irish, principally on foot, "ayans chacun une targette et petits javelots ;" and the fact that as late as Edward VI. javelins are enumerated amongst the weapons of England. In an inventory taken in the first year of that king's reign of the royal stores and habiliments of war in the different arsenals and garrisons throughout the realm, are the following entries :—In different storehouses— " Item, ten javelins with brode heddes partly guilt, with long brassel staves, garnished with vallet (velvet) and tassels. Javelyns with staves trymed with white, greene, and blacke silke and fustayne." These, however, are not likely to have been used for war. The invention and rapid improvement of hand-firearms had rendered such missile weapons utterly inefficacious. The javelins with broad heads partly gilt and their staves gaily garnished with velvet and silk and tassels were never intended to be hurled at an enemy, but

Javelin. Harl. MS. 4374. 1480.

evidently for ceremonial and processional purposes. "Javelin men" formed the ordinary escort of the sheriff of a county when he proceeded to meet the judges on the opening of the assizes, and are still, I believe, supposed to form part of his retinue. The last javelin thrown in warfare was, I should think, not very much later in date than the one depicted above from the Harleian MS. No. 4374, written and illuminated about 1480, and declared by Mr. Hewitt to be by far the best example ever observed by him.

JAZERINE, JAZERANT, JESSERAUNT. (*Ghiazerino,* Italian.) This is one of the numerous contrivances of the Middle Ages to supply the place of the heavier armour of chain and plate, with the superadded weight and encumbrances of hacketon, gambeson, or other defences, considered necessary for the protection of the person. Like the brigantine work, it was composed of small overlapping pieces of steel, fastened by one edge upon canvas, which was covered with cloth, silk, or velvet, the gilt heads of the rivets that secured the plates forming an ornament on the outside. It was used for cuisses, brassarts, and other portions of harness ; but very generally in the fourteenth and fifteenth centuries for jackets. It is mentioned as early as 1316, in the curious inventory of the arms and armour of Louis X., "le Hutin," King of France. "Item, un pars et un bras de jazeran d'acier. Item, un jazerant d'acier. Item, une couverture de jazeran de fer." The latter was a housing for a horse.

"Dont chascun et cheval couvert de jazerant."
Chronique de Bertrand du Guesclin.

Hauberks were made of this work, and distinguished from those made of chain :

"Sor l'auqueton vesti l'hauberk-jazeran."
Roman de Gaydon.

Philippe de Commines tells us that "the Dukes of Berry and Britaine were mounted on small ambling nags, and armed with slight brigandines, light and thin, yea, and some said they were not plated,

but studded only with a few gilt nailes upon the satin for the lesse weight, but I will not affirm it for a truth." What are here called brigandines were in fact jazerants, or imitations of them,—satin jackets, not plated, but studded with "gilt nailes," as suggested. Jazerant jackets are frequently called brigandines, and there appears a tendency in recent writers to confound them; but though similar to a certain degree in construction, they are very different in appearance (see BRIGANDINE). The iron plates of the brigandine were quilted into the canvas lozengewise, and when covered with rich stuffs or cloth of gold, presented a smooth surface, whereas the plates of the jazerant were riveted together, forming a garment of themselves (see woodcut annexed, from Grose's 'Military Antiquities,' vol. ii. plate 30: the original was in a collection of curiosities at the once celebrated Don Saltero's

Jazerant Jacket without covering. Grose's 'Mil. Ant.'

coffee-house, in Cheyne Walk, Chelsea); the gilt heads of the rivets that fastened the plates studding the satin or velvet that covered them. Mr. Hewitt has engraved a jazerant jacket, which he also calls a brigandine, from Hefner's 'Trachten des Mittelalters,' the original of which is in the museum of the Grand Duke of Darmstadt. It is described as "of red velvet, lined with steel scales overlapping each other; these are fastened with brass rivets, of which the gilt heads form an ornament on the outside of the velvet (precisely the distinguishing character of the jazerant, as I have pointed out). The scales are angular at the sides of the garment, rounded at the back and front. They are made of pure steel, which has been tinned to preserve it from rust. *The whole coat is perfectly flexible*,"—another distinction of the jazerant, as the brigandine is not. If the reader will compare the annexed woodcut of the Darmstadt jazerant with that of a brigandine jacket at page 59 *ante*, he will comprehend the difference more easily than from any verbal description. There was a perfect jazerant jacket, faced with rich Genoa velvet, in the Meyrick Collection, but unfortunately it only appears in Skelton's engravings on the small figure of a guisarmier, as formerly set up in the armoury at Goodrich Court, and is of no value as an illustration here; but I reproduce from the same plate some of the details, viz., a specimen of the steel laminæ

Jazerant Jacket covered. Museum, Darmstadt.

Interior of Jazerant Jacket.

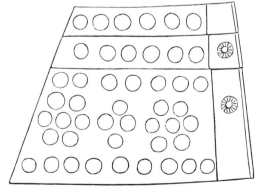

Exterior of part of skirt of Jazerant Jacket.

which were at the back, differing, as in the Darmstadt jacket, from those at the sides, and a portion of the exterior of the short skirt, showing the effect of the studs or gilt nail-heads.

Mr. Hewitt adds, truly enough, that "real specimens of this kind of armour will be found in the Tower Collection, though they are *portions* only of brigandine jackets." There are four portions of jazerant armour there, and I will tell the reader the state in which I found them five years ago, when, at the request of the late Sir Henry Storks, I undertook to re-arrange the collection. They were all fastened together by large gilt modern livery buttons! There are, however, three complete brigandine jackets in the Tower, one on the figure of an archer in the Elizabethan armoury, but no jazerant jacket, and I have dilated on this subject more than might be necessary for the general reader, in order to prevent the artist from being misled by the confusion of two apparently similar, but really very distinct, military garments. Not even Ducange has attempted to suggest a derivation of the name of jazerant : "Lorica annulis contexta, Ital. *ghiazzerino*, nostris vulgo *cotte de maille*," —implying that *ghiazzerino* was the Italian for a coat of *chain* mail. *Annulis*, coat ; but whence *ghiazzerino*, or *ghiazerino*, according to John Villaneus? Meyrick entertained an idea that the construction of a jazerant resembled that of a clinker-built coat ; but I can find no foundation for the fancy. Florio has not the word at all. I am by no means desirous of adding to the multitude of mere conjectures by which such subjects are surrounded, and, indeed, have none to offer ; but as there must have been some reason for distinguishing the jazerant jacket from that worn by the *Brigans*, and thence called brigandine, I will call the attention of the student to the term employed to indicate the work of the former, when used for general purposes, as early as the fourteenth century. It was called *jazequenée*. " Item, trois paires de couvertures gamboisiées des armes le roy et unes indes jazequenée." (Inventory of Louis le Hutin, 1316.) Here we have three pairs of housings, gamboised (*i.e.* wadded and quilted), and embroidered with the king's arms, and one blue* *jaze*quened (*i.e.* made after the fashion of a jazerant). The term is evidently analogous to *damas*quinée, *damas*cined, which we know to have been derived from the city of Damascus, where the process, if not invented, was carried to perfection ; and I therefore humbly suggest that we must look much farther abroad, and in an Eastern direction, for the derivation of *jaze*rant.

JERKIN. A short body-garment of the jacket or doublet description, for either of which it appears to have been used indiscriminately during the sixteenth century. Thus in the 'Two Gentlemen of Verona :'—

> "THURIO : And how quote my folly ?
> VALENTINE : I quote it in your jerkin.
> THURIO : My jerkin is a doublet."
>
> Act ii. scene 4.

A jerkin of purple velvet, with purple satin sleeves, embroidered all over with Venice gold, was presented to King Henry VIII. in 1535, by Sir Richard Cromwell. Another of crimson velvet, with " wyde sleeves " of the like-coloured satin, is mentioned in an inventory. (MS. Harleian, No. 1419.)

Halliwell, in his folio edition of Shakspeare, vol. ii., says the jerkin was merely an outside coat, worn generally over the doublet, which it greatly resembled, but sometimes worn by itself. Its exact shape and fashion varied at different times, and the only absolute definition of it I ever met with occurs in Meriton's 'Clavis,' 1697, the compiler stating that " a jerkin is a kind of a jacket or upper doublet, with four skirts or laps." This characteristic feature is clearly depicted in the buff coat, as frequently called a buff jerkin, engraved page 64 *ante.* Edward de Vere, Earl of Oxford, about the fourteenth or fifteenth year of Queen Elizabeth, brought from Italy several curious articles of dress, and amongst them a jerkin of leather, perfumed, which was a species of luxury unknown to the English before that time. (Stow's 'Annals,' p. 868.)

In the very instructive will of a country gentleman, dated 1573, and printed by Brayley and Britton in their 'Graphic Illustrator,' there are the following references to the jerkin :—" Also I give

* Meyrick invariably translates *inde* or *ynde*, 'Indian.' Whether justly so in the present instance is a question worth consideration.

unto Strowde my frize jerkin, with silk buttons; also I give Symon de Bishoppe, the smyth, my other frize jerkin, with stone buttons." The word has become quite obsolete, while jacket is as much in request as ever.

JEWES-WORK. I am not aware of this expression occurring in any other passage than that eternally-quoted one from Chaucer's 'Rhyme of Sir Thopas'—

> "And over that a fine hauberk
> Was all y-wrought with Jewes work,
> Full strong it was of *plate*."

Mr. Fairholt suggests "probably damasked;" but in the 'Roman de Gaydon' we read—

> "Sor l'auqueton vesti l'auberk-jazeran."

Here we have distinctly mentioned a hauberk of jazerine work, not of chain, as that of Sir Thopas was popularly supposed to be, and which consequently rendered the assertion "full strong it was of plate" incomprehensible. If, however, Chaucer, by his "*fine* hauberk," intended to describe a "hauberk-jazeran," *i.e.* "jazequenée," the expression "full strong it was of plate" is perfectly appropriate, and we are not driven to the conclusion that hauberk signified in some instances a breastplate. More-over, we learn that this peculiar armour was called "Jew's work," being most probably fabricated originally or specially by that ingenious people, and thereby a clue may be obtained to the derivation of the word "jazerant."

JIPOCOAT. In the 'Mercurius Politicus,' No. 603, for Feb. 1660, one Paul Jollife, a joiner by trade, is advertised as an escaped murderer, and his dress is described as a grey suit and jipocoat, his suit trimmed with "black ribbons and silver twist." Fairholt, who prints this in a note to his second edition (p. 251), offers no explanation. *Quære,* Gipecoat, from "gipe, an upper frock or cassock." (Anglo-Norman, Halliwell.)

JOAN. A woman's cap. It was in fashion about 1760, and is mentioned as late as 1780:

> "Now dressed in a cap, now naked in none,
> Now loose in a mob, now close in a joan."
> *Universal Magazine,* 1780.

JORNET. Stow, in his account of the setting of the Midsummer Watch in London, 1598, says, "They were habited in bright harness, some over gilt, and every one a jornet of scarlet thereupon." Fairholt defines this to be "a loose travelling cloak, from the French *journade,* and therefore similar to the military cloak still worn by our Horse Guards." Ducange has "Vestis species sagum, chlamys, vulgo *surtout, casaque;* Italian, *giornea.*" In a letter remissory, 1476, which he quotes, we read: "Lequel cop le suppliant destourna tellement qu'il ne fust point lors blesscié sauf que sa journade fut parée tout oultre;" and Monstrelet, under date 1452, describes the "varlet" or attendant on a herald as clad in a journade, on which was the badge of the Duke (of Burgundy), "c'est à scavoir la croix de Saint Andrieu." M. Viollet-le-Duc presents us with six examples of the journade according to his idea of it, every one differing more or less from the others; but as he does not descend lower than the fifteenth century, he does not assist us in forming an opinion of our own of the shape or nature of an English jornet of the reign of Elizabeth. Quicherat describes it in the time of Charles VII. and Louis XII. of France as a coat with great sleeves; and I, according to my rule, decline to speculate without a fact to guide me.

JUMP. "A jacket, *jump,* or loose coat, reaching to the thighs, buttoned down before, open or slit up behind half-way, with sleeves to the wrist." Such is Randle Holme's description of a jump in

his days. The word afterwards became applied to a woman's bodice, at what exact period I cannot say; but in 'A Receipt for Modern Dress,' published in 1753, a lady is recommended to wear

"A short pair of jumps, half an ell from your chin."

Jumps were still worn in 1780, as in the 'Universal Magazine' for that year the line occurs—

"Now a shape in neat stays, now a slattern in jumps."

JUPON, GIPON, JUPEL. (*Jupe, jube,* French; *giupone,* Italian; *aljuba,* Spanish.) A military garment that succeeded the surcoat in the first half of the fourteenth century. Meyrick says "the word is of Arabic origin," and derives it from "*guibba,* the Moorish thorax." ('Crit. Inquiry,' Glossary.) It was generally embroidered with the armorial ensigns of the knight, but was occasionally plain or diapered.

"Of fustian he wered a gipon
All besmotred with his habergeon."

These lines would lead us to the conclusion that the jupon was occasionally an under-garment; but we must not suffer ourselves to be bewildered by isolated passages of poetry, the writers of which avail themselves to the fullest extent of the licence allowed to their craft. It will be time enough when we know what Chaucer meant us to understand by the terms "gipon" and "habergeon." These pages contain too many proofs of the indiscriminate nomenclature indulged in during the Middle Ages, and of the arbitrary transference of terms to utterly dissimilar objects at different periods, to induce us to waste our time or that of our readers in an attempt to reconcile apparent contradictions involving no question of importance.

That *jube* or *jupe* in France signified at one time or other an under-garment of the shirt or tunic description common to both sexes, has as little to do with our present subject as the fact that *jupe* and *jupon* signify in that country at present a much more important and characteristic article of female apparel. I have to deal here with the only vestment known in England as a jupon or gipon, and of which so many magnificent examples are furnished to us by the monumental effigies in this kingdom, that a selection becomes almost invidious. Often, however, as it has been engraved, I cannot resist reproducing the effigy of Edward the Black Prince from his tomb in Canterbury Cathedral, accompanying it with a copy of the jupon itself, which still hangs above

Effigy of Edward the Black Prince.

Jupon of Edward the Black Prince in Canterbury Cathedral.

Add. MSS. Brit. Mus. 12,228.

it. It is composed of fine buckram, quilted longitudinally in stripes about three-quarters of an inch

thick. The velvet facing, originally blue and crimson, has faded to a yellowish brown, and the fleurs-de-lys and lions are embroidered on it in gold thread. It accords with the one sculptured on the effigy, with the exception of its having very short sleeves, and was drawn in tight to the body by lacing behind. In earlier examples it was fastened at the sides, as was the surcoat that preceded it. A miniature in the curious 'Roman du Roi Meliadus' (Add. MSS. Brit. Mus., No. 12,228) exhibits a king putting on his jupon, which, though it appears to have clasps down the front, is only open at the sides, and would have to be fastened there by laces, or straps and buckles, notwithstanding that the delineator has omitted to indicate the process. One peculiarity of the jupon is the precision with

Statue of Hartmann von Kronberg, 1372, from his tomb at Kronberg.

which it is adapted to the form, partly by the pièce d'acier, plastron, breast-plate, or whatever name you may choose to give it, which was worn beneath it, and partly by the lacing of it tightly in at the waist. The smartest officer of Prussian Uhlans might envy the *fit* of a jupon of the reign of Richard II.

The skirt of the jupon descended a little below the military belt, which encircled the hips, and the edge of it was usually cut into some fanciful pattern. (*Vide* Plate IV., figs. 6 and 8; also the subjoined specimens from various effigies of the fourteenth century.)

Sir Humphrey Littlebury, Holbeach Church.

Sir Guy Bryan, Abbey Church, Tewkesbury. 1391.

A Basset at Atherington.

Michael de la Pole. Wingfield Church, Suffolk. 1415.

Patterns of the borders of Jupons.

JUSTICO. In a ballad called 'The New-made Gentlewoman,' written in the reign of Charles II., this word occurs :

" My justico and black patches I wear."

Mr. Fairholt suggests that the name may be a corruption of "juste-au-corps," a term by which sometimes the jupon was designated, and in this case applied to some close-bodied garment worn by females. He is no doubt right, for a sort of jacket called a *justacorps* came into fashion in Paris about 1650. M. Quicherat informs us that a pretty Parisienne, the wife of a maître-de-comptes named Belot, was the first who appeared in it. The habit was adopted by ladies for riding or hunting ; but many a *bourgeoise*, he adds, who neither rode nor hunted, in order to give herself an air of fashion, went to church in a justacorps. (' Histoire de Costume en France,' p. 504.)

ENDAL. A coarse woollen cloth, so named from the town of Kendal in Westmoreland, where it was first made. It is mentioned in a statute of the 13th of Richard II., A.D. 1389. Thynne describes a countryman as

> "A man aboute a fiftie yeares of age,
> Of Kendall very coarse his coate was made."
> *Pride and Lowliness.*

And in Laleham's account of the entertainment of Queen Elizabeth at Kenilworth in 1575, the minstrel is said to have been attired in "a side (long) gown of Kendal green."

"FALSTAFF : But as the Devil would have it, three misbegotten knaves in Kendal green came at my back and let drive at me."—*King Henry IV., Part I.,* Act ii. sc. 4.

The cloth continued to be called Kendal after its manufacture had been carried on in other counties. Hall, in his 'Life of Henry VIII.,' has an anecdote of a nobleman, disguised as Robin Hood, coming one morning, by way of pastime, "suddenly into the chamber where the queen and her ladies were sitting. He was attended by twelve noblemen all apparelled in short coats of *Kentish* Kendal."

"I know when a serving-man was content to go in a Kendal coat in summer, and a frieze coat in winter." (Stafford, 'Briefe Conceipte of English Policye,' 1581.)

KERCHIEF. See COUVRECHEF, HANDKERCHIEF, NAPKIN, NECKERCHIEF, and VEIL.

KERCHIEF OF PLEASAUNCE. A kerchief or scarf given by a lady to a knight to wear for her sake on his helm or his arm. "Moreover there is y-kome into England a knyght out of Spayne, with a kerchief of pleasaunce y-wrapped about hys arme, the gwych knyght will runne a course wyth a sharpe spere for his sovēyn lady's sake." ('Paston Letters,' vol. ii. p. 6.) (See COINTOISE and HELM.)

KERSEY, CARSEY. A woollen cloth, made originally at Kersey in Suffolk, whence its name. Kerseys made in Suffolk and Essex are mentioned in the 15th of Edward III. There were various kinds of kerseys : ordinary kerseys, sorting kerseys, Devonshire kerseys (called washers or wash whites), check kerseys, kerseys called "dozens," and kerseys called "straits ;" all mentioned in the reigns of Henry VIII. and Edward VI., varying according to the texture, in length, breadth, and weight of the piece, which was strictly regulated by statutes. (*Vide* Ruffhead, vol. ii. pp. 118, 429, and 441 ; Strutt, 'Dress and Habits,' vol. ii. part v.)

Stow says the making of Devonshire kerseys began about 1505. Hall, in his 'Satires,' describes a person wearing

> "White carsey hose, patched on either knee."

Some kerseys were very fine and used for superior clothing, such as our modern kerseymere, so named from the position of the original factory on the *mere* or water which runs through the village of Kersey. Stafford, speaking of the serving-men of his day, says : "Now will he look to have at the

least for summer, a coat of the finest cloth that may be gotten for money, and his hosen of the finest kersey, and that of some strange dye, as Flanders dye or French puce, that a prince or great lord can wear no finer if he wear cloth." ('Briefe Conceipte of English Policye,' 1581.) Bailey, in 1736, has: "Kersey (q. d. *Coarse say*)."

KETTLE HAT. A headpiece frequently mentioned in documents of the Middle Ages:—

> " Keste of his ketille hatte."
> *Morte d'Arthure.*

"Also to Harry my son, a haberion, a kettil hat." (Will of Sir William Langford, Knt., 24th of August, 1411.) (See IRON HAT.) A leathern hat according to the 'Prompt. Parvul.'; probably, like the palet, originally of leather. (See PALET.)

KEVENHULLER HAT. "Hats are now worn, upon an average, six inches and three-fifths broad in the brim and cocked between Quaker and Kevenhuller." ("Chapter of Hats," 'London Chronicle,' vol. xi., 1762.)

> "When Anna ruled and Kevenhuller fought,
> The hat its title from the hero caught."
> *Art of dressing the Hair*, 1770.

Neither Malcolm, who quotes the 'London Chronicle,' nor Fairholt, who found the above lines in the 'Art of dressing the Hair,' has taken the trouble to identify the personage whose name has been handed down to us in his hat.

The Austrian family of Khevenhüller is a noble and princely one; but in the genealogical account of it in Zedler, Meyer, and other authorities, I can find but one of the name to whom the above lines might apply.

Louis Andrew, Count Khevenhüller, born in 1683, Colonel of Hussars, served with distinction under Prince Eugène at the siege of Peeterwardein in 1716, and of Belgrade in 1717; became a field-marshal, and succeeded on the death of the Prince to several of his offices. (Meyer's 'Conversations-Lexicon.') But then "Anna" died two years before "the hero" became celebrated, and we do not hear of "the hat" till some forty years later.

KILT. See PHILLIBEG.

KIRTLE. (*Cyrtle*, of *Cyrt*, Saxon; *kort* and *kurtz*, German, "short.") Here we have another term which has been applied, at different periods, to nearly every imaginable garment worn by male or female in these islands,—a petticoat, safeguard or riding-hood, long cloak, long mantle reaching to the ground, with a hood to it that entirely covered the face, and usually red; an apron, a jacket, and a loose gown! (*Vide* Dyce's notes to Skelton.) Gifford, in his notes to Ben Jonson (vol. ii. p. 260), only adds to the confusion. He says, "The term was used in a twofold sense, sometimes for the jacket merely, and sometimes for the train or upper petticoat attached to it: a full kirtle was always a jacket and a petticoat; a half-kirtle (a term which frequently occurs) was either the one or the other"! Did Mr. Gifford ever hear of an Anglo-Saxon *curtle*, when jackets were not and petticoats unimagined? And yet Mr. Dyce thought this "the most satisfactory explanation of the garment." That the kirtle was originally a short linen under-garment there can be no doubt: its very name implies shortness. In the Icelandic 'Song of Thrym,' the line occurs—

> "A maiden kirtle hung *to his knees*."

In a romance called the 'Chevalier Assigne' (MS. Cotton. Caligula, A 2), a child inquires, "What heavy kyrtell is this with holes so thycke?" and he is told it is "an hauberk," *i.e.* a coat of mail which seldom reached even to the knee. That it was of linen appears from its being mentioned

in the will of Wynfleda amongst "other linen webb," and in one place described as "*white;*" and that in the Anglo-Saxon period it must have been an under-garment, is a natural inference to be drawn from the fact that no portion of it is discernible in the costume of any female represented by their illuminators, unless the sleeves tight to the wrist, which do not belong to the gunna or gown, may be considered to appertain to the kirtle, and not to another under-garment, which is as long as the outer one, and for which we have no distinct name, and are consequently compelled to call it a tunic, as the gown is rendered by the Latin writers "supertunic." To the Normans the name of kirtle was unknown; but an equivalent is presented to us in the French *cote*, the outer garment being distinguished by the French *robe, surcote*, and other appellations, which, as my readers are by this time fully aware, there still exists the greatest difficulty of identifying with the dresses depicted. In the present instance I have only to deal with the kirtle. The word crops up again with the revival of Saxon English in the fourteenth century. Chaucer, in his translation of the celebrated 'Roman de la Rose,' renders the line—

"Qui estoient en pure cottes,"

by

"In kirtles and no other weed."

And that it was still an under-garment is evident from this passage in 'The Franklin's Tale,' wherein Aurelius says :—

"My debt shall be quit
Towards you, how so that I ever fare,
To you a begging in my *kirtle bare.*"

In the old romance of 'Richard Cœur de Lion,' the author tells us that when his hero attacked the lion—

"Syngle in a kertyl he stode."

While the clerk, Absolon, in Chaucer's 'Miller's Tale,' is said to have been

"Y-clad full small and *properly*,
All in a kirtle of light watchet."

The word "properly" implies that he was decently and sufficiently attired in a kirtle. But—

"Thereupon he had a gay surplice,
As whyte as is a blossome in the ryse."

In the 'Lay of Sir Launfal,' written about 1300, the Knight unexpectedly sees issuing from an ancient forest—

"Gentle maidens two ;
Their kerteles were of inde sendel,
Y-laced, small, jolyf and well,
There might none gayer go !"

Here the kirtle is distinctly a gay outer garment of Indian or blue silk, like the robe or gown ; but then we find that over their kirtles they wore "mantles," that

"were of green velvet
Y-bordered with gold right well y-sette,
Y-pellured with gris and gros."

The original of this romance is in French, and, of course, the word "kirtle" does not occur in it. The two ladies are simply said to be richly dressed and very tightly laced :

"Vestue ierent richement,
Lacies moult estreitement."

We gather from this, however, that the kirtle worn by ladies in England in the reign of Edward I.

(for it is the English translator we must look to for information respecting the costume of his countrywomen) was a tight-fitting dress, which must have had sleeves, and could be worn with a mantle abroad, or without one at home :

> " In kirtle alone she served in hall."
> *MS. Harl.* 978.

And over which, at pleasure, could be worn a *surcote*, robe, or other garment of ampler dimensions, and with one of those voluminous trains which excited the wrath and ridicule of contemporary writers. The kirtles, therefore, of ladies of rank were composed of materials as costly as those of their robes or mantles, of which they divested themselves for convenience, as well as a mark of humility when waiting on distinguished guests :

> " To morrowe thou shalt serve in halle,
> In a kurtyll of ryche palle,
> Before thy nobull kynge."
> *Emare,* Cotton. MS. Calig. A 2.

I have not the hardihood to select from the numerous miniatures and effigies of the fourteenth century any figure, and say decidedly "there is a kirtle." Amongst those already engraved for the illustration of COAT and COAT-HARDY, one may possibly be seen, and some further light may be thrown on the subject in our inquiries respecting the SUPERTUNIC and SURCOAT. We have yet to meet with the kirtle under different forms, but in some rather more comprehensible. Elynor Rumming, the hostess of Henry VII.'s time, is described by Skelton, the poet-laureate to that monarch, with

> " Her kirtle Bristow red ;"

and in the ' History of Jack of Newbury,' the bride is said to have been habited in a gown of sheep's russet, and a kirtle of fine worsted.

In a wardrobe account of apparel belonging to the Royal Family, in the eighth year of Henry VIII. (MS. Harl., No. 2284), six yards, a half, and half a quarter of cloth are allowed for a kirtle for the queen (Katharine of Arragon), and seven yards of purple cloth of damask gold for another kirtle for the queen, while only three yards of tawny satin were required to make a kirtle "for my Lady the Princesse," probably, as Mr. Strutt suggests, the Lady Mary, the king's sister, at that time about twenty years of age ; "but why so small a quantity should be allowed for her, and so much for the Queen," he adds, "I am not able to determine." Nor am I : but it is, I think, pretty clear that the kirtles of women had, as early as the fourteenth century, been made of various lengths, and retained merely in name the character of "a curtal weed," though three yards of satin would certainly be very short allowance for any garment for a young lady of twenty. In ' Piers Plough-man,' the priests are said to have " cut their coats, and made them into curtells," which indicates that the kirtles worn by men in the fourteenth century were short ; but the kirtle which formed part of the robes of the Knights of the Bath was full, and reached to the heels like the gown of a woman : we are therefore justified in considering the same variety to have existed in the kirtles worn by ladies. The kirtle is sometimes confounded, in later times, with the petticoat ; but a passage in Stubbs's ' Anatomie ' shows that they were distinct articles of apparel in the reign of Elizabeth. After attacking the petticoats of the finest cloth and dye, fringed with silk of changeable colours, he says, " But what is more vain, of whatever the petticoat be, yet must they have kirtles—for so they call them—of silk, velvet, grograin, taffata, satin, or scarlet, bordered with gards, lace, fringe, and I cannot tell what." Whether the richly-embroidered garment which is displayed by the opening of the gown in front, during the sixteenth century, is to be considered the kirtle or the petticoat, who is to decide ? Pedro de Gante calls those he saw worn by Queen Catherine Parr and Princess Mary, *sayas,* which may mean either one or the other. Except in poetry, we hear little of kirtle after the reign of James I., and in all cases implying a petticoat.

In the first year of Richard III., Jane Shore did penance, walking before the cross at procession,

with a lighted taper in her hand, barefooted, and having only her kirtle upon her back. (Speed's 'Chronicle,' p. 704.) In 1483, the custom of wearing the kirtle alone had been long discarded, and was considered a degradation. The kirtle of Jane Shore, we may be sure, was on this occasion neither of silk nor of velvet; but an under-garment of linen, probably provided for the purpose. "In her penance she went in countenance and pose demure, so womanlie, that albeit she was out of all araie save her kirtle onlie, yet went she so faire and lovelie," &c. (Hardyng's 'Chron.' *sub anno.*)

KNAPSACK. (*Knapsac,* Flemish.) A case or bag in which soldiers or travellers carry their provisions and other necessaries. Bailey derives it from the Saxon *cnape,* a boy, and "*sack,* a bag, q. d. a boy's bag." The word is, however, Flemish, and in the Glossary to Meyrick's 'Crit. Inquiry,' 2nd edit., it is said to be derived "from *knappen,* food, it being for the soldiers' victuals;" but *knappen* in Flemish is not "food." It is the verb "to eat,"—"manger, mascher" (Mellema, 'Promptuaire ou Dictionnaire François-Flameng,' 1610). It also signifies "to take" (*prendre, apprehender*), whence our slang term "to nab" anything, or take anyone into custody; but *cnape,* Saxon, and *knape,* Flemish, both signify, not only a boy, but a servant, formerly called knave and varlet (*knapeschap,* "service en serviteur"); and as knapsacks were no doubt carried by serving-men long before they were given to soldiers, I consider Bailey's derivation is nearest the true one. The knapsack was mentioned by Mary Queen of Scots in 1562 (see p. 310). Knapsacks were carried by infantry, *temp.* James I. His son and successor, Charles, thus alludes to it: "The constitution of this Church shall not be repealed till I see more religious motives than soldiers carry in their knapsacks."

KNEE-COP. The old English name for the genouillière, "always used in the ancient inventories of the Tower of London." (Hewitt.)

KNOP. (Danish and Saxon.) A button, also a tassel to the cord of a mantle.

"Knoppis fine, of gold ameled" [enamelled].
Chaucer's *Romance of the Rose,* l. 1080.

"Physick shall his furred cloak for food sell,
And his cloak of Calabrie with all his knops of gold."
Piers Ploughman.

Elizabeth of York, queen of Henry VII., on the day of her coronation, wore "a mantle of white cloth of gold damask, furred with ermine, fastened on her breast with a large lace curiously wrought with gold and silk, with rich knoppes of gold at the end tasselled." (Cotton. MS. Julius, B xii.)

KNOT. A bow of ribbon, gold or silver lace, or other materials. Independently of breast knots, top knots, shoulder knots, and sword knots, many other knots appear to have been fashionable in the eighteenth century. In an inventory of the date of 1707, which I have before quoted, occur entries of "suits of knots," viz. :

"j. silver and white suit of knotts.
j. cherry and silver suit of knotts.
j. blew and silver knott.
j. suit of scarlett knott.
j. suit of yellow knotts.
j. blew knott.
j. white knott."

ACE. (*Lacez,* Anglo-Norman ; *lacet,* French.) This word in its earliest sense signified a line or small cord·of silk, thread, or other materials used to brace, tie, fasten, or unite portions of apparel, both civil and military— buskins, shoes, doublets, sleeves, surcoats, jupons, I need scarcely add stays and the bodies of ladies' dresses. Examples will be found illustrating the various articles above mentioned under their separate heads. (See also HELM.)

LACE (BRIDE). Bride-laces are constantly mentioned in accounts of or allusions to weddings in the sixteenth century, and had probably a much earlier origin. Lace in this instance certainly signifies band or ribbon. In the 'History of John Whitcomb,' the celebrated Jack of Newbury, *temp.* Henry VIII., it is related that the bride "was led to church between two boys with bride-laces and rosemary tied about their sleeves." When Queen Elizabeth visited Kenilworth in 1577, a country wedding was arranged to take place for her amusement. "First came all the lusty lads and bold bachelors of the parish, every wight with his blue bridesman's bride-lace upon a branch of green broom."

In Ben Jonson's masque of 'Love's Welcome at Welbeck,' six maids attending on the bride are described as "attired with buckram bride-laces begilt." "What these bride-laces exactly were," says Mrs. Palliser, "we cannot now tell. They continued in fashion till the Puritans put down all festivals, ruined the commerce of Coventry, and the fabric of blue thread ceased for ever." This is assuming that the "blue bridesman's bride-laces," mentioned above, were made of or ornamented with Coventry blue. I have met with no painting or engraving of a marriage or a bridal procession that can add to our information on this subject. I imagine that the bride-lace was what we should now call "a wedding favour."

LACE OF A MANTLE. The cordon by which it was sustained on the shoulders. In 'The Merchant's Second Tale,' attributed to Chaucer, occurs the line,

"He unlacyd his mantel, and let it down glide;"

and in the 'Romance of Ipomedon' it is said the hero

"Drew a lace of silk full clere; adowne then fell his mantyll."
Harleian MS., 2252.

LACE (TAWDRY). Laces bought at a fair held in the chapel of St. Etheldreda or St. Audrey, daughter of King Anna, who founded the Abbey of Ely. "It was formerly the custom in England for women to wear a necklace of fine silk, called tawdry lace, from St. Audrey. She had in her youth been used to wear carcanets of jewels, and afterwards, being tormented with violent pains in the neck, was wont to say that Heaven in His mercy had thus punished her for her love of vanity. She died of a swelling in the neck." (Southey's 'Omniana,' vol. i. p. 8.)

"MOPSA : You promised me a tawdry lace."
Shakespeare, *Winter's Tale*, act iv. sc. 3.

"Bind your fillets faste,
And girde in your waste,
For more fineness with a tawdry lace."
Spenser, *Shepherd's Calendar*.

Hence our modern words "tawdry" and "tawdriness," now applied to glaring, tasteless decoration. Originally, it seems to have signified simply a lace of a coarser description, popular with country women, and consequently accounted common or vulgar. It might possibly be of two or more colours, as well were the points or aiguillets, which were also laces. Coles has "Tawdry lace : Fimbriæ mondinis Sanctæ Etheldredæ emptæ." *Fimbriæ* would imply edgings or borders ; but the above direction to "*girde in your waste* for more fineness (*i.e.,* to make it more slender) with *a* tawdry lace," is surely a proof that it was a lace of the line or cord description. Drayton defines it "a rural necklace." (Halliwell *in voce*.)

LACE, in its later sense, signifying that delicate and beautiful fabric which is one of the most admirable ornaments of costume, requires, and deserves, a volume to itself for its history and illustration ; and Mrs. Bury Palliser has fulfilled that requirement in so charming and exhaustive a work, that I should simply refer my readers to it, were I not bound to give our subscribers something more than a definition of the word such as they would find in any English dictionary, and that Mrs. Palliser and her publishers, Messrs. Sampson Low and Co., have kindly permitted us to illustrate our article with reproductions of a few of the beautiful plates which so worthily adorn her valuable book.

That "lace" is purely an English word, derived from the Anglo-Norman *lacier,* "to lace, bind, tie, fasten," &c., is clear from the fact that it is not to be found in any other language. Lace is called in French *passement, dentelle,* and *guipure ;* in German, *Spitzen ;* in Italian, *merletto* and *trina ;* in Genoese, *pizzo ;* in Spanish, *encaje ;* in Portuguese, *renda ;* in Dutch, *kanten ;* and in Flemish, *peerlen.* In no two countries in Europe do we find it called by the same name. It appears in England under its French appellation of "passement" in the fifteenth, and "dentelle" in the sixteenth century ; but the word "lace," in its present signification, is first met with in the inventory of Sir Thomas L'Estrange, of Hunstanton, county of Norfolk, in 1519, wherein "a yard of lace for hym," to trim apparently a shirt of Holland cloth, is charged 8*d.* Lace is of two sorts—needlework, commonly called "point," and pillow. The first is made with a needle on a parchment pattern, and termed "needle point." In the making of the second a stuffed cushion is employed, on which the parchment is fixed, with small holes pricked through to mark the pattern. In these holes pins are stuck, and the threads with which the lace is formed are wound upon "bobbins," formerly bones, now small pieces of wood. By the twisting and crossing of these threads the ground of the lace is made, and the pattern formed by interweaving it with a thicker thread, according to the design upon the parchment. "Such has been the pillow," says Mrs. Palliser, "and the manner of using it for more than three centuries." ('History of Lace.')

Flanders and Italy contend with each other for the honour of the invention of point lace. The evidence favours Italy ; and, according to tradition, Spain learned the art from her, and communicated it to Flanders, who, in return, taught Spain how to make pillow lace. That the latter was first made in the Low Countries we have the evidence of contemporary paintings. In a side chapel of the choir of St. Peter's, at Louvain, is an altar-piece by Quentin Matsys, date 1495, in which a girl is represented making lace with bobbins on a pillow as at present. ('Mémoires de l'Académie de Bruxelles,' by the Baron Reiffenberg. 1820.)

So much for the origin and modes of lace-making, with which I have less to do than with its application to costume. I must limit myself to a brief enumeration of the varieties of lace in use in England towards the close of the seventeenth century :—1. Point, of which the most esteemed was

made at Venice, Genoa, Brussels, and in Spain. The points of Genoa, however, which were so
prized in the seventeenth century, were all the work of the pillow; the term, Mrs. Palliser informs us,
"being sometimes incorrectly applied to pillow lace, as point de Malines, point de Valenciennes," &c.

Venice Point Lace.

('Hist. of Lace,' p. 28.) 2. Bisette, a narrow, coarse-thread pillow lace, made in the environs of Paris
by the country women, principally for their own use. 3. Gueuse, a thread pillow lace of a very
simple character, called "beggar's lace" in England. 4. Campane, a white, narrow, fine pillow
lace, used to edge or border other laces. "A kind of narrow, picked lace." (Evelyn's 'Fop's Dic-
tionary,' 1690.) "A kind of narrow lace, picked or scalloped." ('Ladies' Dictionary,' 1694; already
mentioned, p. 72.) Campane lace was also made of gold thread and coloured silks for trimmings.
5. Mignonette, a fine pillow lace, from two to three inches wide, made of Lille thread, blanched at

Antwerp, and principally manufactured in France and Switzerland. 6. Valenciennes, a pillow lace greatly esteemed in the seventeenth century. 7. Mechlin. All the laces of Flanders, with the

Genoa Point Lace.

exception of Brussels, were known in commerce by the general name of "Mechlin." 8. French point, comprising the lace made at Alençon, Argentan, Aurillac, and Paris, the latter also called "point double" and "point des champs." 9. Bone lace, so called from the bones of which the bobbins were

Old Brussels Point Lace.

originally made, was introduced into England in the sixteenth century, and, as well as point or needlework lace, was speedily brought to such perfection that it became the rage abroad. Much, however, of what was called "English point" was smuggled into this country from Brussels, and found

a ready and profitable market in Paris as "point d'Angleterre," as will be shown hereafter. Blonde or silk lace is of later date. Caen, in Normandy, was celebrated for its manufacture in 1745. It was both black and white, and such laces were sometimes called "Nankins," the silk being imported from Nankin in China.

Such were the principal kinds of lace which we find worn in England during the last three centuries, exclusive of gold and silver lace, of which I shall speak presently.

Glimpses of some of them under other names are caught at least as early as the reign of Henry VII.; but much confusion has been caused by mistaking the gold, silver, silk, and thread laces used for fastening dresses, otherwise called "points," for needlework or pillow lace. A MS. in the Harleian Library, giving "directions for making many sorts of laces which were in fashion in the times of Henry VI. and Edward IV.," misled Mr. Strutt, who has made long extracts from it, and given a list of sixteen or seventeen laces, of which fortunately Mrs. Palliser found specimens in another MS. of later date, and has therefore been enabled to correct the error.

Spanish Point Lace.

It is not till we arrive at the time of Elizabeth, that we find needlework and bone lace struggling for precedence with the cut-work of the previous centuries (see page 158 *ante*). The passion for lace increased during the reign of her successor. Lord Bacon says, "Our English dames are much given to the wearing of costly lace; and if they be brought from Italy, France, or Flanders, they are in much esteem." (Letter to Sir George Villiers.) The bone lace trade of England suffered much at this period from the importation of the foreign fabrics; but nevertheless the art continued to improve so greatly, that in the following reign of Charles I. it was in high estimation in France. Presents of English bone lace were sent by Queen Henrietta Maria and by the Earl of Leicester to the Queen of France. The Countess of Leicester, writing to her husband on this subject, 7th February, 1636, says, "The present for the Queen of France I will be careful to provide, but it cannot be handsome for that proportion of money which you do mention; for these bone laces, if they be good, are dear, and I will send the best, for the honour of my nation and my own credit." An Act of Parliament was passed in this reign prohibiting the introduction of laces made beyond seas.

Though the rigid rule of the Puritans during the Commonwealth seriously affected the home manufacture, and partially suppressed the wearing of lace of any description, some of the most

earnest republicans continued to indulge their taste for such worldly vanities ; Sir Thomas Fairfax wearing trunk hose trimmed with rich Flanders lace, and a falling band of the same costly material. Even Cromwell's own mother wore a handkerchief of which the broad point lace could alone be seen ; and as if in mockery, the dead body of the Protector was dressed up in purple velvet, ermine, and

Valenciennes Point Lace.

the finest Flanders lace. ('The Cromwell Family ;' 'Book of Costume,' 1846 ; 'History of Lace.') Charles II., in the first year after his restoration, issued a proclamation (November 20, 1661) enforcing the Act of his father prohibiting the entry of foreign bone lace into these kingdoms, and in the following year another Act of Parliament was passed, by which all bone lace brought into the country is ordered to be forfeited, and a penalty of 100*l.* paid by the offender. (Statutes at Large, 14 Car. II. c. 13.) But in the same year he granted a licence to a certain John Eaton to import

such quantities of lace made beyond the seas " as may be for the wear of the Queen, our dear mother the Queen, our dear brother James, Duke of York, and the rest of the royal family," speciously adding, "to the end the same may be patterns for the manufacture of these commodities here, notwithstanding the late statute forbidding their importation." (State Papers, vol. iv., No. 25.) The prohibitions only increased smuggling, as the example set by the king and the court of wearing foreign lace made its acquisition, by any means, more desirable. Linen, cravats, handkerchiefs, aprons, night-caps, boots, fans, gloves, masks, were all trimmed with the finest Venice or Brussels lace; the latter of which became gene-

Mechlin Point Lace.

rally known as "point d'Angleterre" from the following circumstances: —In 1662 the English lace merchants being at a loss how to supply the quantity of Brussels point required at the court of Charles II., in consequence of the prohibitive Acts of Parliament above mentioned, invited Flemish lace-makers to settle in England; but the scheme was unsuccessful, England not producing the necessary flax, and the lace was

Old Flemish Point Lace.

therefore of an inferior quality. They then adopted the expedient of buying up all the choicest laces in the Brussels market, and, smuggling them over to England, sold them under the name of "English point." "From this period," says Mrs. Palliser, "point de Bruxelles became more and more unknown, and was at last effaced by 'point d'Angleterre,' a name it still retains."

Mr. Pepys commemorates, in 1662, the richly-laced petticoats of Lady Castlemain, which, he says, it did him good to look at; and Evelyn gives an elaborate description of the "all Flanders laced" under-garments of a lady of fashion of the same period. The newspapers also teem with advertisements of point and other lace lost or stolen, instances of which will be found under various heads in this dictionary. It is at this time we hear so much in England of Colberteen, a lace so called after the French minister Colbert, who, in 1665, established the manufacture of point lace

at Alençon, the only lace in that country not made on the pillow, and which, also known as point de France, supplanted point de Venise. Strange to say, however, Colberteen is never mentioned in France; and though constantly alluded to and described by writers in this country (see page 122 *ante*), even Mrs. Palliser is puzzled to account for its origin, or satisfactorily define its quality. "It is difficult," she says, "now to ascertain what description of lace was that styled Colberteen;" and alluding to the assertion of Evelyn in his 'Fop's Dictionary,' 1690, that it was "a lace resembling net-work, of the fabric of Monsieur Colbert" (an assertion repeated in the 'Ladies' Dictionary,' 1694), observes, "This is more incomprehensible still, for point d'Alençon is the only lace that can be specially styled of 'the fabric' of Colbert, and Colberteen appears to have been

Point d'Alençon Lace.

a coarse production." I can only suggest that it was an inferior lace made in imitation of "the fabric" of Colbert, and acquired the name of that celebrated statesman in England, where alone it appears to have been so designated. Not the least mention is made of it by the latest and most exhaustive writer on French costume, M. Quicherat, whose vigilance it could scarcely have escaped, had it ever been known or worn as Colberteen at any period in France. It is true that the author of a book entitled 'Six Weeks in France,' printed in 1691, speaking of Paris, says, "You shall see here the finer sort of people flaunting it in tawdry gauze or Colbertine;" but then we must remember it is an Englishman who so calls it, who might not, like Dean Swift, know

> "The difference between
> Rich Flanders lace and Colberteen."
> *Cadenas and Vanessa.*

The question is, what would a French lady have called the lace he noticed? It is very unlikely that a coarse inferior sort of lace, such as Colberteen is represented to have been, would have been worn by "the finer people" of Paris.

James II. paid 36*l*. 10*s*. for the cravat of point de Venise he wore on the day of his coronation, and died at St. Germains in a night-cap richly trimmed with Brussels lace, called a "toquet," which is still to be seen in the Museum at Dunkirk. In the reign of William and Mary, the passion for wearing lace appears to have culminated. The commodes of the ladies, the cravats of the gentlemen, and the ruffles of both sexes, demanded an immense supply. "Never yet," says Mrs. Palliser, "were

such sums expended on lace as in the days of William and Mary." The king's lace bills for 1690 amounted to 1603*l.*, and in 1695–6 to 2459*l.* 19*s.* The queen's lace bill for 1694 amounted to 1918*l.* Queen Anne repealed the Acts prohibiting the introduction of Flanders lace, but rigidly excluded the points of France, which had the usual effect of making the latter the most fashionable. Mechlin and Brussels lace are in this reign distinguished from the general fabrics of Flanders. Her Majesty's lace bill for 1712, for Mechlin and Brussels lace, amounted to 1418*l.* 14*s.*

There is nothing particularly new respecting lace recorded during the reigns of the first two Georges. Extravagant prices were still paid for Brussels lace. In 1748, we read of "ruffles of twelve pounds a yard." ('Apology for Mrs. T. C. Philips.') The lace apron of the Duchess of Queensberry which Beau Nash stripped her of, and flung on the back benches amongst the waiting

Devonshire Point Lace.

women, was of the finest point, and cost two hundred guineas. (Goldsmith, 'Life of Richard Nash, of Bath,' 1762.) English lace at this period, however, had reached its highest state of perfection. Daniel Defoe, writing in 1726, describes the bone lace of Aylesbury as not much inferior to that of Flanders, and such was its reputation that he tells us "the French buy and sell the finest laces at Paris under the name of 'dentelles d'Angleterre.'" Newport-Pagnell, Blandford, Honiton, and several other towns, were celebrated for their productions. A lace called "trolly" was made in Devonshire, in the reign of George II., which has been sold at the high price of five guineas a yard. It was used for lappets and scarfs. A trolly head is mentioned by Mrs. Delany in a letter dated 1756.

I have yet to speak of

LACE (GOLD AND SILVER). Gold lace of some description appears to have been manufactured at a very early period. A piece of gold lace, four inches long and two and a half broad, was found in a Scandinavian barrow near Wareham, county Dorset, in 1767, in company with some human

bones sewn up in a deer's skin, and deposited in the trunk of an oak-tree. It was black and decayed, but a lozenge pattern was traceable upon it, such as is seen on the borders of Anglo-Saxon and Danish dresses of the tenth or eleventh century. Much information cannot, however, be derived from this solitary specimen, and we must take care not to confound the embroidery of that period, the "opus Anglicanum" for which the English women were so celebrated, with the manufacture of gold and silver lace in the present sense of the word. Of such lace I can neither find mention nor detect representation anterior to the notices of the needle and pillow lace I have just been describing, and I will not undertake to say which of the fabrics has a claim to precedence in point of date. The borders of the tunics and mantles of the royal and noble personages previous to that period were, I consider, strips or bands of cloth of gold or silver, either plain or embroidered with coloured silks, like the dresses. (See ORPHREY; also the chromo-lithograph of the royal effigies at Fontévraud, issued with Part VIII.)

That Venice was early celebrated for her fabrics of gold and silver, is proved by the constant allusions to them in the inventories, wills, and wardrobe rolls of the sixteenth century.

One of the earliest notices I have yet lighted upon occurs in an inventory of apparel of Henry VIII. (MS. Harleian, No. 1419): "One (pair of hose) of purple silk and Venice gold, woven like unto a caul, lined with blue silver sarcenet, edged with a *passemain* of purple silk and gold, wrought at Milan." Hall, describing the dress in which Henry met Anne of Cleves, says, "It was a coat of velvet, somewhat made like a frock, embroidered all over with flatted gold of damask, with *small lace* mixed between *of the same gold*, and *other laces of the same* going transversewise, that the ground little appeared." There can be no doubt about the nature of this decoration, and from that period gold and silver lace, described as parchment and billiment lace, is constantly mentioned. "One jerkyn of cloth of silver, with long cuts downrighte, bound with a billiment lace of Venice silver and black silk," is an entry in an inventory of the robes of King Edward VI. It is therefore incomprehensible, presuming the fragment found at Wareham to have been actually gold lace, how five hundred years should have elapsed without any other example being discovered, or the slightest intimation of such a manufacture having existed. "Passement lace of gold and silver" is mentioned in a sumptuary law of Queen Mary; and on arriving at the reign of Elizabeth, the instances are too numerous for quotation here: amongst them the mention of "bone lace of gold" may be adduced, in support of my belief of the coeval invention of thread and metal lace. Parchment lace, apparently the same as that which was called "guipure" in France, is another sort of gold and silver lace, constantly mentioned during the sixteenth and seventeenth centuries. The word "guipure" is not to be found in English inventories or wardrobe accounts; but in a French inventory of the clothes of Mary, Queen of Scots, taken at the Abbey of Lillebourg, in 1561–2, and preserved in the Record Office, Dublin, it frequently occurs, most capriciously spelt, but always described as of gold and silver— "quimpeures d'argent," "geynpeurs d'or," &c. As it is also called "dentelle à cartisane," from the slips of parchment of which it was partly composed, the conclusion that it was identical with parchment lace can scarcely be erroneous. In the inventory of Sir Robert Bowes, dated 1558, there occurs the entry of "one cassock of wrought velvet with p'chment lace of gold;" and "parchment lace of watchett and silver, at 7s. 3d. the ounce," appears in the list of laces belonging to Queen Elizabeth. (Additional MSS. Brit. Mus., 5751.) Besides billiment and parchment lace, we hear much at this period of purle, both gold and silver; but as it is chiefly mentioned in connection with ruffs and ruffles, I conjecture that it was a fine thread lace worked with gold and silver, and not to be classed with that which was made and used for the purpose of laying flat in rows or guards, as they were called, upon the cloaks, doublets, petticoats, or other articles of apparel *—a fashion carried to an extravagant extent from the days of Elizabeth to the end of the seventeenth century.

In the reign of Charles I., the manufacture of gold and silver lace in England had improved to such a degree that the officers of the Customs, in 1629, stated it to be their opinion that the duties on

* "Of the difference between purles and true lace it is difficult now to decide. The former word is of frequent occurrence among the New Year gifts, where we have 'sleeves covered all over with purle;' and in one case the sleeves are offered unmade, with a piece of purle upon a paper to edge them." ('History of Lace,' p. 285.)

gold and silver thread would decay; "for the invention of Venice gold and silver lace within the kingdom is come to that perfection that it will be made here more cheap than it can be brought from beyond seas." (State Papers, vol. cxlix.)

The entry of foreign-made gold and silver lace was prohibited by Queen Anne, in 1711, under penalty of forfeiture and a fine of five pounds, in consequence of the rage existing for its acquirement. Ladies even trimmed their stays with it. (See STAY.) Malcolm tells us of a green silk knit waistcoat, with gold and silver flowers all over it, and about fourteen yards of gold and silver thick lace on it, lost by a Mrs. Beale in 1712. ('Manners and Customs,' vol. v. p. 320.) It is unnecessary to prolong this article, as the use of gold and silver lace for the binding of cocked hats and the general adornment of both civil and military attire, during the past century, is sufficiently well known, and will also be found illustrated in various portions of these volumes. I cannot, however, quit this subject without expressing the great obligations I, in common with all who are interested in the history of Costume, am under to Mrs. Bury Palliser, who has collected in her charming volume a host of facts extracted from authorities many of which might, but for her references, have been overlooked or never consulted. Those of my readers who desire to be thoroughly acquainted with a fabric which, to use the fair writer's own words, "has from its first origin been an object of interest to all classes, from the potentate to the peasant," have a rich mine of instruction and entertainment provided for them in the fascinating pages of 'A History of Lace, by Fanny Bury Palliser.'

LACE (*LIVERY*). See LIVERY.

LAKE (*CLOTH OF*). "A kind of fine linen, or perhaps rather lawn." (Strutt, 'Dress and Habits,' part iv., cap. i.)

German suit with Lamboys. Early 16th cent.

"He did on next his white lere
Of cloth of lake, full fine and clere,
A *brech* and eke a *shirt*."
Chaucer, *Rhyme of Sir Thopas*.

Scarcely "lawn," I should say, as the drawers also were made of it. Kilian says *luecken* (Belg.) signifies both linen and woollen cloth. I am more inclined to define it cloth of Liège, as that city is called *Luyc* in Flemish. (Mellema, 'Promptuaire ou Dictionnaire François-Flameng;' Rotterdam, 1610.) Liège has still its manufactories of cloth and serge, and the corruption of Luyc into Lake is an easy one.

LAMBOYS. (*Lambeaux*, French.) The imitation in steel of the puckered skirts called "bases" in the reigns of Henry VII. and Henry VIII. (See BASES.) A fine example exists in the splendid suit of armour in the Tower said to have been presented to Henry VIII. on his marriage with Katharine of Arragon, by the Emperor Maximilian. (See it engraved at page 19 of this work.) I am not aware of any other suit in this country with lamboys, and the fashion appears to have been limited, or at least peculiar, to Germany and the Maximilian era. I can therefore only additionally illustrate it by another suit of German manufacture, engraved in Hefner, from one in the Ambras Collection, now at Vienna. A curious indication of the approach of this fashion occurs in the brass of John Gaynsford, Esq., at Crowhurst in Surrey, who died in 1450, some forty years before the accession of Maximilian. The skirt of the suit is composed of nine hoops of steel, divided by perpendicular lines, widening as they descend; the curving of the horizontal lines giving the

appearance of folds, such as are seen in the skirts of the civil dresses of the same period. It would be interesting to know whether the armour he is represented in was of German manufacture.

LAMBREQUIN. (Also from *Lambeaux.*) The mantling of the helm with escalloped or jagged edges, terminating in one or two tails with tassels. The lambrequins form a picturesque feature in heraldic decoration. The mantlings of the helmets in some of the old Garter plates are remarkable for the taste and ingenuity with which they are designed. They were generally of the colours of the armorial bearings, and sometimes embroidered with the badge of the family.

From Garter Plate of
Humfrey, Earl of Stafford.
1460.

Brass to Sir John Say, in
Broxbourne Church,
Hertfordshire.

Helmets with Lambrequins. 15th century.

LAMES. (*Laminæ,* Latin.) The steel bands or hoops of which the tassets were formed. (See Tassets.)

LANCE. The special weapon of the knight from the earliest times of chivalry. Lances were of various kinds, those borne in war differing from those used for jousting or running at the ring. The

From 'The Lives of the Two Offas,' a MS. of the 13th century.

early Norman lance differs in nothing from a spear (for which, indeed, it was the Norman name), except that it was in some instances decorated with a small streamer, called a "gonfanon," similar to that which flutters from the lances of our light cavalry of the present day. No alteration appears to have taken place during the twelfth and thirteenth centuries. The above cut is from 'The Lives of the Two Offas,' a MS. of the latter date. The "schaft" of the lance appears to have been from thirteen to fourteen feet long.

> "A schaft he bar, styff and strong,
> Of fourteen feet it was long."
> *Romance of Richard Cœur de Lion.*

In the romance of 'Petit Jehan de Saintré,' it is said, "Le roy fit mesurer les lances qui devoient estre de la poincte jusqu'à l'arrest de treize pieds de long." This shaft was originally of ash, but in Chaucer's day it was of cypress wood:

> "His spere was of fine cipres,
> That bodeth warre and nothing pees,
> The head full sharpe i-grounde."

Tilting Lances. 15th century. Meyrick Collection.

Bordeaux and Toulouse were celebrated in the Middle Ages for the manufacture of spear-heads. For the tournament the heads were ordered to be blunted (Matthew Paris, *sub anno* 1252); and in the fourteenth century it was directed they should be made in a form which received the name of "coronel," probably from its resemblance to a crown. (See CORONEL.) About the same period a small round plate to protect the hand was affixed to the shaft, afterwards known as the "vam-plate" (*avant plate*), and the rest for the lance was invented. (See LANCE-REST.) In the following century the shaft, instead of being of the same thickness throughout, increased in size from the point downwards, and a grip was made in it for the hand. The shaft in the time of Edward IV. was fluted, and the butt-ends were variously shaped. The tilting lance was extremely thick, and painted spirally with the colours of the wearer. The war lance had lost its gonfanon or "penonçel," as it is called by writers of the close of the fourteenth century, some of whom appear, most incomprehensibly, to confound the lance with the glaive, to which it bore no resemblance whatever. (See GLAIVE.) Thus Christine de Pisan says, "Au penonçel du glaive dont il fut occis;" the glaive never having had, as far as I know, anything like a streamer attached to it. We have, however, seen so

Bourdonass. Tower. 16th cent. War Lance. Meyrick. 16th cent.

many extraordinary misappropriations of names in articles of dress, that we need not do more than point to this one in weapons, particularly as it was very short-lived, and the lance retained its name throughout, as I have shown already. (See p. 209.) The shafts of some lances were hollow: they were called "bourdonasses." (See BOURDONASS.) They are spoken of disparagingly by Froissart and Commines as weapons of war, but were used especially for tilting at the ring. Of this class is the enormous lance shown at the Tower as that of Charles Brandon, Duke of Suffolk, which, were it solid, could not have been used by any man. Meyrick says, "falsely called the lance of Charles Brandon" ('Crit. Inquiry,' vol. ii. p. 188, edit. 1842), but gives no reason for his assertion. It was certainly so called in Queen Elizabeth's time, when it was shown as such to Paul Hentzner; and as many then living must have known the Duke personally, there seems no more reason to doubt that it was his lance than to question his claim to the fine suit of armour with which it is associated. The mistake is in allowing the public to believe that the shaft is solid, and that, consequently, no knight less stalwart than the portly Duke of Suffolk could possibly have lifted it. (See woodcut above from a

Tilting Lance. 1666.

drawing made expressly for this work, also that of a war-lance of the sixteenth century painted with the arms of Nuremberg, which was formerly in the Meyrick Collection.) Our latest example is from Pluvinel, 'Instruction du Roy,' 1666, showing the shape of the lance then used for tilting at the ring and the quintaine.

LANCE-GAY. A smaller kind of lance or javelin.

> "And in his hand a launcegay."
> > Chaucer, *Rhyme of Sir Thopas,* l. 15,161.

Wace, as early as the twelfth century, says,

> "E vos avez lances agües."
> > *Roman de Rou,* l. 12,907.

But I cannot agree with Mr. Hewitt that this is an early form of the word, or that the writer meant anything beyond the literal translation of his statement, "and you have sharp lances." It is much more likely that, as suggested by Meyrick, the word is compounded of the French "lance" and the Arabic "zagaye," a light spear still in use in the East and amongst the Caffres of Africa, only that we find the name translated *archegaie:* "Hommes armés à l'usage de Castille, lancans et *jettans* dards et archegayes," 1386. At all events it was a missile weapon:

> "Aux Bretons estoit bel esbat
> Dardes, javelots, lances-gayes,
> Savoient *jetter* et faire playes."
> > *Guillaume de St. André.*

It appears that this weapon had become so common and so dangerous to the king's peace in the reign of Richard II. that it was forbidden by statute to be carried within the realm. "Item, est ordeignez, &c., que nul home chivache deinz le roialme armez, ne ovesq' lancegay deinz mesme le roialme, les queux lancegayes soient de tout oustez deinz le dit roialme come chose deufendue par nostre Sr. le Roi sur peine de forfaiture dicelx lancegaies, armures et autres herneys quelconques." ('Stat. of the Realm,' 7 Richard II., 1383.) It would seem as if this prohibition had really had the effect of *ousting* the lancegay for good and all: for, though mentioned in a letter remissory in France in 1389, no one seems to have heard of it afterwards in England.

LANCE-REST. A kind of bracket of iron affixed to the right side of the breast-plate in order to support the lance. It first appears as a simple hook in the latter half of the fourteenth century, but becomes a much more elaborate contrivance subsequently. Some were made with a hinge to fold back upon the breast-plate when not in use. In the sixteenth century they were furnished with a queue or tail, as it was called, nearly a foot long, with a curve at the end of it, which prevented the butt of the shaft from rising when the lance was "in rest," and relieved the combatant of the entire weight of it.

Lance-rest with queue.
16th century.

Rest and pin.

Breast-plate with Lance-rest.

LANGUE DE BŒUF. A weapon of the partizan description, so named from the shape of the blade, otherwise called a VOULGE (which see). The guards armed with this weapon were called "Langue de Bœufetiers,"—whence the word "Beefeaters," according to some ; others derive the latter from "buffet," of which the Yeomen of the Guard are supposed to have had especial charge. No authority has been produced for either.

LANIERS. Straps, originally of leather, for the purpose of securing pieces of armour, &c. "Lanière : a long and narrow band or thong of leather." (Cotgrave.) Also cords of silk used for similar purposes. In the accounts of Lucas le Borgne, tailor of Philippe de Valois, printed by Leber, the following items occur, under the date of 1338 : "ij livres de soie de plusieurs couleurs pour faire *lanières* pour le roy." Charles VI., in 1398, in consequence of a change in the fashion of nether garments, granted licence to the *chaussetiers* of Paris to sell "chausses garnies d'aguilettes ou lanières." (Leber, 'Invent.,' 467.) Laniers, in fact, was simply another word for "points" (which see). Chaucer, in 'The Knight's Tale,' speaks of

> "Nailing the speares and helmes bokelong,
> Gigging of shields and *laniers lacing*."

Langue de
Bœuf.

LAPPET. The lace pendants of a lady's head-dress in the eighteenth century. In the 'London Magazine' for October 1732, the description of a young lady's introduction to a party of fashionable women winds up with, "in short, the head-dresses with the peaks, lappets, and roundings, and the several habits, with the sleeves, robings, plates, lacings, embroideries, and other ornaments, were so various in their cut and shape, that my niece imagined she was in an assembly of the wives and daughters of the foreign ministers then in town," &c.

LATCH. The English name of the cross-bow in the sixteenth century. In a MS. of the time of Henry VII. (Royal Lib., Brit. Mus., 69 C viii.), dated 1495, the mode of using the cross-bow is depicted with the butts, or "dead mark," as they were called, at which it was the custom to practise. In 1508 Henry VII. prohibited, by statute, the use of the cross-bow, with a reservation

Fig. 1.

Figs. 1 and 2. Latches. *Temp.* Henry VIII.

Fig. 2.

Fig. 3.

Fig. 4.

Fig. 5.

Fig. 6.

Fig. 7.

Figs. 3 and 4. Latches. *Temp.* Queen Elizabeth. Fig. 5. Latch. *Temp.* Philip and Mary. Fig. 6. Windlass. Fig. 7. Goat's-foot lever.

in favour of the nobility. "No man shall shoot with a cross-bow without the king's licence, except he be a lord, or have two hundred marks of land." The latch was an improvement on the arbalest, and was bent by a windlass of much simpler form than the cumbrous machinery of the cranequin employed to bend the arbalest. The earliest occurrence of the name of latch that I am aware of is in an inventory of the " ordynaunce and munitions belonging to the fort of Archeclief beside the peere of Dover," taken in the first year of the reign of Edward VI., A.D. 1547 : " Cross-bowes called latches, winlasses for them—130." (MS. in the Library of the Society of Antiquaries.)

In all earlier documents that I have seen, when the arbalest is not mentioned, the term cross-bow

alone is employed. The name of latch is not to be found in the 'Promptorium Parvulorum,' 1440. Grose is the first writer who speaks of it, and his authority is no other than the inventory above quoted. Meyrick follows Grose, adding nothing to our information. Fosbroke and Fairholt briefly copy Meyrick. Mr. Hewitt and M. Demmin ignore the word altogether. Its derivation and the date of its application to the cross-bow have still to be ascertained. The above examples are from originals of the sixteenth century, formerly in the Meyrick Collection.

LATCHET. (*Lacet*, French.) The strap to fasten a clog or a shoe. (Also see HERLOT.)

LAWN. A species of fine linen, first brought into England in the reign of Elizabeth (Stow's 'Chron.,' pp. 868, 869), and much used for ruffs, ruffles, bands, handkerchiefs, shirts, and even boot tops. John Owen, Dean of Christ Church and Vice-Chancellor of Oxford, is described as appearing, in 1652, "in querpo, like a young scholar," with "a lawn band" and "Spanish boots with large lawn tops."

LENI-CROICH. The large saffron-coloured shirt worn by the Irish as late at least as the sixteenth century. (See GENERAL HISTORY.)

LETTICE. (*Lattizi*, Italian.) A fur much worn in the fifteenth and sixteenth centuries. "Letice : a beast of a whitish-grey colour." (Cotgrave.) That it resembled ermine may be assumed from a passage in an Italian novel by Franco Sacchetti, in which an official appointed to enforce the Sumptuary Laws respecting apparel, charges a woman with wearing ermine, which was prohibited to persons of her estate. She tells him it is not ermine ; " it is lattizi." (Novella, 137.) In the fourth year of the reign of Henry IV., it was ordered that no man not being a banneret, or person of high estate, should use the furs of ermine, lettice, or marten. Lattice or lettice caps were in great favour with ladies in the time of Elizabeth, and about the middle of her reign were forbidden to be worn by any unless she were "a gentlewoman born, having arms." (See page 80.)

LEUZERNS, LUZARNES, LUCERN. A fur mentioned in the wardrobe accounts of the reign of Henry VIII. (see page 219). Cotgrave has, " A luzarne : loupcervier," and under the latter word says, "a kind of white wolfe, or beast ingendred between a hind and a wolf, whose skin is much esteemed by great men ; yet some (not believing that those beasts will or can mingle) imagine it rather to bee the spotted linx or ounce, or a kind therof." Luzarne is probably a corruption of loupcervier. The fur might be that of the lynx or ounce, but wolf's fur is mentioned in wills and inventories of the sixteenth century, and that of a white wolf, perhaps, was considered a rarity. In a parliamentary scheme, dated 1549 (printed in the Egerton Papers, p. 11), it was proposed that "no man under the degree of an earl be allowed to wear luzarnes." (Halliwell, *in voce* "Lucern.") "Item, for making of a shamew of blacke printed satin, embroidered with damaske golde, and furred with *luzardis* of our stores, the bodies and sleeves lyned with buckram of our g^t wardrobe." (Wardrobe Account, 28th June, 8th Henry VIII., 1516.) "Twelve *lusarnis* skins" are also mentioned in the same document.

LINCOLN-GREEN. A favourite colour with archers, foresters, huntsmen, yeomen, &c., and so named from the place of its manufacture. "Lincoln anciently dyed the best green in England." (Selden's Notes to Drayton's 'Polyolbion,' Song 25.)

LINEN. Cloth made of flax. "The fabrication of linen in this kingdom was not carried to any great extent before the middle of the last century," says Strutt, writing in 1796 ; but that it was made here in the time of the Anglo-Saxons he has himself furnished us with abundant proof. Linen was indiscriminately worn by every class of persons whose circumstances allowed them to purchase it. Even the military tunic was made of it (see TUNIC); and Paulus Diaconus, describing the dresses

of the Lombards, says they were chiefly of linen, "like those of the Anglo-Saxons." ('De gestis Longobardi,' lib. iv. cap. 3.) It was, however, particularly appropriated to such garments as were worn next the skin. The Venerable Bede notices, as a rare instance of humility and self-denial in Etheldrytha, Abbess of Ely, that she never would wear linen, but contented herself with such garments as were made of wool ('Eccles. Hist.,' lib. iv. cap. 19), the wearing of wool next the skin being enjoined by the canons as a very severe penance. (Johnson's 'Canons,' A.D. 963, can. 64.) This fact must not be considered incompatible with that of the gorgeous apparel worn by royal Anglo-Saxon nuns, recorded at page 100 of this volume, and which is illustrated by an engraving of this very Etheldrytha, from the splendid Benedictional belonging to the Duke of Devonshire. The self-mortification was limited to the under-clothing. Kings and nobles clad in cloth of gold wore hair shirts by way of penance as late as the sixteenth century. One was found on the body of James IV., King of Scotland, killed at Flodden, 1513.

Whether the English manufacture declined after the coming in of the Normans, or that the demand was greater than the home market could supply, does not appear; but it is certain that in the fourteenth and fifteenth centuries much linen was imported from abroad, cloth of Lake (Liège?), cloth of Rennes (from the town of that name in Brittany), "cloth of Yprès" (diaper), and of "Gaunt" (Ghent), being specially alluded to; but tunics of English linen are mentioned in the wardrobe accounts of the reign of Edward III. The linen most commonly noticed and apparently worn by persons of rank or opulence in England during the Middle Ages, was generally known by the name of "Holland;" the cloth woven in that country being much esteemed, and the name has descended to the present day. "Perhaps," Mr. Strutt remarks, "it was thought to be more generally beneficial to procure this article by exchange than to make it at home, especially when the cultivation of hemp and flax was not conceived to be worth the attention of our farmers. Of course the materials must have been imported, and probably at too high a rate to leave the least hope of obtaining a sufficient profit, after all the expenses were paid, to tempt the trial. How far these were the difficulties that affected the minds of the cloth-workers, I cannot pretend to say: but whatever the objections might be, they were obviated by degrees; the speculation was set on foot; and the manufacturing of linen appeared, as it were, in a state of infancy about the time that Charles II. ascended the throne of England." ('Dress and Habits,' Part V. chap. i.) In the fifteenth year of that monarch's reign, an Act was passed for the encouragement of the manufactories of all kinds of linen cloth and tapestry made from hemp or flax, by virtue of which any person, either a native or a foreigner, might establish such manufactories in any place in England or Wales, without paying any acknowledgment, fee, or gratuity for the same.

LINSEY-WOLSEY. A coarse woollen stuff first manufactured at Linsey, in Suffolk. It is mentioned, *temp.* Henry VII., by Skelton, in his 'Why come ye not to Court?'

> "To weve all in one loom
> A webb' of lylse-wulse."

LINSTOCK. An invention of the time of our Edward VI., 1547–1553, consisting of a pike with branches on each side, sometimes terminating in birds' or serpents' heads, which held a lighted match for firing cannon; the pike enabling the cannoneer to defend himself at the same time, whereas previously he had to fling down his match in order to take up his halbard, and was slain while so doing. Here are four examples from the Meyrick Collection, engraved by Skelton:

Fig. 1. An Italian linstock, earliest form. The match was wound round the staff and one of the branches which held the lighted end.

Fig. 2. An English one of the commencement of the reign of Elizabeth, affording more security for the match, which was passed through the open mouths of the heads.

Fig. 3. Another of the same reign, improved by the addition of adjusting screws to keep the match tight, like the cock of a matchlock.

Fig. 4. A linstock of the time of Charles I.; the nuts of the adjusting screws giving to the terminations of the branches the appearance of the heads of peacocks.

Fig. 1. Fig. 2. Fig. 3. Fig. 4.

LIRIPIPES. The long tails or tippets of the chaperons of the fifteenth century. (See HOOD.)

LIVERY. An abbreviation of the word " delivery," and in costume signifying the gown, coat, or hood given by a sovereign or nobleman to his servants, soldiers, or retainers, and being of his colours ; sometimes his badge or collar. The summer and winter garments distributed by Edward I. to the officers and retainers of his court (" *Roba æstivalis*" and " *hiemalis*," Wardrobe Book, 28 Edward I., and Household Ordinances) afford an early instance. " The practice of distributing such tokens of general adherence to the service or interests of the individual who granted them for the maintenance of any private quarrel was carried to an injurious extent during the reigns of Edward III. and Richard II., and was forbidden by several statutes, which allowed liveries to be worn only by menials or the members of guilds," &c. (Note by Albert Way, 'Prompt. Parvulorum,' *in voce.*) The " liverie des chaperons," often mentioned in these statutes, was a hood which, being of a colour strongly contrasted with that of the garment, was a kind of livery much in fashion, and well adapted to serve as a distinctive mark. The statute of 7th Henry IV. (1406) expressly permits the adoption of such distinctive dress by fraternities and *les gens de mistere*, the trades of the cities of the realm being ordained with good intent ; and thus we find Chaucer in 'The Canterbury Tales' describing the haberdasher, carpenter, weaver, dyer, and tapestry-worker as all

" yclothed in a lyvere
Of a solempne and grete fraternitie."

By the same statute lords, knights, and esquires were allowed, in time of war, to distinguish their retainers by similar external marks, the prototypes of military uniform, as the permission granted to the members of guilds and fraternities is represented to this day in the gowns of the liverymen of the City of London. The first adoption of liveries by the guilds of London was in the 19th of Edward III., 1346, each member paying his own share of the cost. The livery consisted of a coat, surcoat, gown, and hood, the latter two being reserved for ceremonials, and completing the whole suit in 1348. (Herbert's 'History of the Livery Companies of London.') As early, however, as 1299, on the occasion of the marriage of Edward I. to his second wife, Margaret, we hear of six hundred of the citizens of London riding in his procession, in one livery of red and white, with the cognizances of their

crafts embroidered on their sleeves, but I consider these to have been the colours of the city generally, and not of the guilds.

In the third year of the reign of Henry V. it was ordered that "in future no officer of the city shall receive livery or vestment from any other craft or fraternity than his own." The liverymen of the City of London, however, and probably, Strutt suggests, the burghers of other cities in England also, exclusive of the livery and badges belonging to their own companies, frequently complimented the Mayor by appearing in his. "Such of them," says Stow, "as chose to do so, gave at least twenty shillings in a purse with the name of the donor marked on it, and the wardens delivered it to the Mayor by the 1st of December; for which every man had sent to him four yards of broad cloth, rowed or striped athwart with a different colour, to make him a gown; and these were called *rey gowns*, which were then the livery of the Lord Mayor and also of the sheriffs, but each differing from the others in colours. Rey gowns and parti-coloured gowns—the right side of one colour and the left of another—continued to be worn by the liverymen and officers of the City of London till the reign of Henry VIII., in the sixteenth year of whose reign Sir William Bayly, being then Mayor, alleging that 'the cloths of rey were evilly wrought,' requested that his officers might that year, contrary to ancient usage, wear cloth of one colour; which request was granted. In later times each man gave forty shillings to the Mayor for benevolence, and received four yards of broad cloth for his gown. This condition was performed by Sir Thomas White in the first year of Queen Mary; but Sir Thomas Lodge, instead of four yards of broad cloth, gave three yards of satin for a doublet; and since that time the three yards of satin are turned into a silver spoon." (Stow's 'Survey,' p. 652.) The Grocers' Company in 1414 wore scarlet and green, which in 1428 was changed to scarlet and black. Sanguine or blood colour, rayed and combined with green, were leading colours in other companies. (Herbert's 'Hist.')

Badges and collars of livery were numerous in England till the reign of Henry VII. (See under BADGE and COLLAR, FAMILY.) Such were the badges of Richard II., "à la guyse de cerfs blancs," for the wearing of which, after his deposition, his last faithful adherent was imprisoned by Henry IV. in the Castle of Chester (Holinshed, *sub anno* 1399), and the collars of the princes of the houses of York and Lancaster. The livery colours of Richard II. were, according to Knyghton, white and red. The family or livery colours of the house of York were "murrey" (*i.e.*, mulberry, a sort of reddish purple) and blue; those of Lancaster, white and blue. The Tudors adopted white and green; and the Stuarts, red and yellow. The scarlet and blue liveries of the English royal family are the national colours of the kingdom, as presented in the Royal Arms, and not those of a particular house. They appear to date from about the same period as the regular national uniform (see UNIFORM), and have remained unaltered since the accession of Queen Anne, as far as the sovereign and the heir apparent are concerned; but in the reign of George III. the liveries of all the younger and collateral branches were crimson and green.

The livery lace with which the coats of coachmen and footmen were plentifully bedizened at the beginning of the last century, when not of gold or silver, was made of silk or worsted of the family colours, with occasionally the badge, crest, coronet, or other portions of their armorial insignia woven into it. Several of our ancient families have continued to give such liveries to their menservants down to the present day, preserving the original patterns. The coats of the drummers and fifers of our Foot Guards are laced much in the same style as they were in the days of the first two Georges.

LOCKET. An ornament now only worn attached to a chain or ribbon about the neck of a lady, but at the beginning of the last century upon the arm. One of hair set in gold, "under a cut crystal set round with ten rose diamonds," was lost by a lady in 1702. (Malcolm, 'Manners and Customs,' vol. v. p. 313.) (See also SHEATH.)

LOCKRAM. A coarse sort of linen, originally manufactured in Brittany. "A wrought wastcoate on her backe and a lockram smocke worth threepence." ('Marrocus Extaticus,' 1595.) "There was a finer sort of which shirt-bands were made." (Halliwell.)

LOO-MASK. See Mask.

LOVE-KNOT. See Sleeve.

LOVE-LOCK. See Hair, p. 246.

LUTESTRING or *LUSTRING.* "Of *lustre*, French. Brightness, glossyness." (Bailey.) A silk much used for ladies' dresses in the last century. "Lustring petticoats" are mentioned in an advertisement of apparel stolen from a Mrs. Hankisson, as early as 1680. (Malcolm, 'Manners and Customs,' vol. ii. p. 331.) In the fourth year of the reign of William and Mary, an Act was passed for the encouragement of the making of alamode and lutestring silks in England, and several heavy duties were imposed upon all such silks imported from the Continent, and the year following those duties were increased. It was stated to Parliament that the making of these silks was *lately established* in this kingdom. (See Alamode, p. 5 ; and read "William" for "Philip.")

ACE. (From the French *masse* or *massue*, a club.) A weapon most probably of Oriental origin, and the successor of the baston of the eleventh century, which was an iron-tipped staff, or simply a wooden bludgeon or knotted club, as seen in the hands of William, Duke of Normandy, and Odo, Bishop of Bayeux, in the Bayeux Tapestry. (See BASTON, and page 15 *ante.*) Maces were the special weapons of pugnacious prelates, who thereby evaded the denunciation against those who smite with the sword. Subsequently we find them made of iron, bronze, and lead, the latter being called *plombées* or *plommées* (*plumbata*).

> " With hys hevy mace of steel
> There he gaff the kyng hys dele."
> *Romance of Richard Cœur de Lion.*

> " Hys mace he toke in hys honde, tho
> That was made of yoten bras."
> Ibid.

> " Sus hyaume e sus cervellieres
> Prennent plommées à descendre."
> Guiart.

> " Le sire de Chin tenoit une plombée."
> Froissart, i. 680.

The heads of the maces were fashioned in a variety of forms. Something like a mace with a trefoil-shaped head is depicted in the Bayeux Tapestry as flying through the air; but it has been conjectured to represent the sword of Taillefer, which he is said by Gaimar to have flung up and caught three times as the battle began :

> " Quand iij. fors ont getté l'espée," &c.

In a representation of the battle of Hastings, drawn in the reign of Edward I. (Cotton. MS. Vitellius, A 13), the maces have plain globular heads. (See woodcut.) Some of the fifteenth and sixteenth centuries are remarkably picturesque. (See Plate XII.)

A smaller kind of mace was called " massuelle," and another " quadrell," the latter appellation indicating the four lateral projections forming almost the leaves of a flower. (See Plate XII., fig. 16.) Our examples are all from the Meyrick Collection, which was exceedingly rich in maces, and to them I refer the reader.

MS. Vitellius, A 13.

MS. Royal, 16 G 6.

Masuels (*masuellis*) are named amongst the other weapons which the turbulent citizens of London were forbidden to use by King Edward III., in the first year of his reign, 1327 ; and quadrells are mentioned by Peris de Puteo, " Vel

quadrellos vel mazas ferratas in arzono." ('Tractatus de re Miletari et Duello.' Printed in 1543.) The mace continued to be a weapon of war till the commencement of the sixteenth century, and, having first been combined with the pistol, was finally superseded by it.

The mace was used in the tournament and also in the joust of peace. In 'The Knight's Tale' of Chaucer, the herald ends his proclamation by bidding the knights to

"goth forth and ley on faste,
With long sword and with mace fight your fille :"

which we are told they accordingly did, and

"With mighty maces the bones they to-breste."

For the joust of peace, however, the mace was made of wood, and had a hilt like a sword, to which a cord was attached, whereby it might be recovered if struck or dropped from the hand. " Et peult on qui veult, atacher son espée ou sa masse à une deliée chaesne, tresse ou cordon autour du bras, ou à sa sainture, à ce que se elles eschapoient de la main, on les peust recouvrer sans cheoir à terre." ('Livre de Tournois du Roi René.') We annex an engraving of the mace from that curious treatise. It has the form of a club, its original character; and that some hard knocks could be dealt with it is clear from the directions for the stuffing of felt of the pourpoint to be three fingers thick on the shoulders, arms, and back, "parce que les coups des masses et des epées descendent plus voulentiers en endroits dessu-dis que en autres lieux."

Maces were also the peculiar weapons of the king's sergeants-at-arms, both in England and France, as early as the fourteenth century. Two incised slabs, formerly in the church of Culture-Sainte Cathérine, Paris, demolished during the reign of Louis XIV., have been engraved by M. Le Noir, in the first volume of his 'Musée des Monuments Français.' On them are represented four sergeants-at-arms, two in armour and two in civil costume, each with his mace, which is richly ornamented and, as from other authorities we learn, of silver, and enamelled with fleurs-de-lys.

From incised slab.
15th century.

Mace for joust of
peace.

The church was founded by Louis IX. (St. Louis), at the prayer of the sergeants-at-arms, in commemoration of their successful defence of the bridge at the battle of Bovines, A.D. 1214; but the costume, both civil and military, is at least two hundred years later, corresponding with that of England in the reign of Henry V. As the four maces are exactly alike, it is unnecessary to engrave more than one of them, observing that, although it is of the form made in the fifteenth century, it is not improbable that, being used for processional and state purposes, a more ancient type may have been followed by the maker, and we may see in it the sort of mace borne by the "servientes armorum," a body-guard instituted by Philip Augustus, for the protection of his person from the emissaries of the Old Man of the Mountain, who had menaced him.

There is a nearly complete series of representations of processional maces to be extracted from the illuminations of the thirteenth and fourteenth centuries. In a copy of Peter Langtoft's 'Chronicle' (Royal MS., 10 A 2), there are two figures of sergeants-at-arms with their maces. In a book which belonged to Humphrey, Duke of Gloucester (Royal MS., 16 G 6), is another; also in a MS. *temp.* Richard II. (Royal MS., 20 B 6).

Royal MS., 10 A 2. 13th century.

By an ordinance of Thomas, Duke

Fig.1 Mace, temp. Henry V. 2.3. Henry VI. 4. Edward IV. 5.6. Henry VII. 7. 8. 9. 10. Henry VIII. 11. Edward VI. 12. Massuelle, temp.
Richard III. 13. temp. Henry VII, with hand-gun. 14. Henry VIII. 15. Phillip & Mary. 16. Quadrelle, temp. Edward IV.

of Lancaster, during the siege of Caen in 1414, we find the maces of the English sergeants-at-arms were of silver.

Royal MS., 16 G 6. 14th century.

From a painting of the end of the 15th century, in the Lord Hastings Chapel at Windsor.

In our chromo-lithograph plate of Henry VI. and his queen receiving a book from John Talbot, Earl of Shrewsbury, issued with Part IV. of this work, will be found the earliest example of the mace surmounted by a crown, as are the maces of the sergeants-at-arms of the present day, no longer a military body-guard, but still attendants on the royal person.

The maces borne before the Lord Chancellor, the Lord Mayor of London, and other civic dignitaries, do not require any notice here.

MAHOITRES. The French term for the wadding used for stuffing out the shoulders of the gowns, jackets, and doublets in the reign of Edward IV. "Et à leurs robes gros mahoistres sur leurs épaules, pour les faire apparoir plus fournis et de plus belle en colure, et pareillement à leurs pourpoints, lesquelles on garnissoit fort de bourre." (Jacques Duclercq, 'Chronique,' *sub anno* 1467.)

Royal MS.
16 E 6.

> "Yt a point of the new gett to telle I will not blin,
> Of prankyd gowndes and shoulders up set, mos and flocks sewed within,
> To use such guise they will not let, they say it is no sin."
> *Townley Mysteries.*

A sumptuary law of Edward IV., in the third year of his reign, enacts that "no yeoman or any other person under the degree of a yeoman shall wear, in the apparel for his body, any bolsters, nor stuffing of wool, cotton, or caddis in his pourpoint or doublet, but a lining only according to the same, under the penalty of six shillings and eightpence." (Ruffhead, vol. ix.)

MAIL. (*Maille,* French.) The name for all metal armour not composed of large plates. Two derivations have been proposed for this word: the first from the Latin *macula*, a net; and the second from the British *mael*, signifying iron generally. They are equally probable, and I have not met with any evidence that would induce me to offer an opinion in favour of one or the other.

I have already, under HAUBERK, approached the apparently interminable controversy respecting ringed mail, and what are by some asserted to be merely various modes of representing it, while others as stoutly contend that there were several distinct sorts of mail existing at the same period,

and are clearly indicated in the representations alluded to. The propounder of the latter theory was Sir Samuel (then Doctor) Meyrick, who first critically investigated the subject of ancient arms and armour, and laid down those great landmarks which must be the guides of all future explorers, whatever debatable points may present themselves in their path. Meyrick distinguishes eight sorts of body-armour, popularly called "coats of mail," in use during the eleventh, twelfth, and thirteenth centuries—viz., ringed, trellised, rustred, mascled, scaled, tegulated, banded, and chain. In his favour are two important facts :—1. The occurrence of the majority of these names in the descriptions of armour by contemporary writers ; and, 2. The numerous contemporary delineations of armour, both English and foreign, which fairly answer to those descriptions, and justify his nomenclature.

I subjoin examples of all ; but the reader will find some of them already given under previous headings, and especially in Plate X., illustrating HAUBERK, page 264.

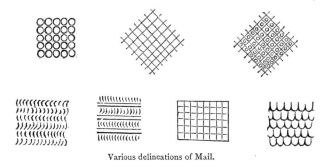

Various delineations of Mail.

Ringed mail is constantly mentioned by Saxon, Norman, and Scandinavian writers. The "gherynged byrn" of the first, and the "hringa brynio" of the last, must signify a tunic of rings ; but how disposed is left to conjecture. Interlaced ring or simple chain mail was known to all the Northern nations from the earliest period of their history. "Trellised" is a term used by the Norman romancers of the thirteenth century :

> " En son dos veste une broigne trelicé."
> *Roman de Garin.*

> " L'Escu li perce et la broigne treslit."
> *Roman de Gaydon.*

David, Earl of Huntingdon, and Milo, Earl of Gloucester, are represented on their seals in armour which may be called "trellised," the former having in the centre of each diamond or lozenge-shaped division a round knot or stud. Of this description of armour an example occurs as late as Edward I. on the legs of the figure from the Bodleian MS. of that date, page 133 *ante.* This trellised work can scarcely, I think, be called "mail." It appears to me to be more like brigandine or jazerant fabric, the iron plates being quilted inside a tunic of leather, and the studs to which they were riveted forming an ornament without. But the armour of Milo is precisely the same as the trellised hauberks in the Bayeux Tapestry (see page 14), and on the figure from a psalter of the eleventh century (page 15). The mode in which this trellis-work is represented leaves us in doubt as to whether the lozenges formed by the diagonal lines are small pieces of plate of that form sewn or riveted on a tunic of leather or other strong material, or the lines themselves intended to indicate a quilted garment like the brigandine. If the former, there is nothing to distinguish it from the mascled, which is defined to be a tunic of cloth, stag or elk skin, on which were sewn or riveted lozenge-shaped plates of steel as closely as possible together—such plates being called "mascles," from the

Mascle. Rustre.

Latin *macula*, the mesh of a net ; and Johannes de Janua expressly says the mascle was a small angular piece of iron with a hole through it, of which hauberks were made. If his description be correct, the mascled armour was no other than the rustred, for the rustre is what is called in heraldry "a mascle round pierced," while the mascle is correctly a lozenge voided. (See figures annexed.) Taking into consideration that the heraldic terms

are derived from those of the pieces of armour themselves in use at the dawn of the science in the twelfth century, the annexed three shields may be usefully compared with the various examples of mail before us.

The mascle is mentioned by Guillaume le Breton, a contemporary of Richard Cœur de Lion :

"Inter
Pictus et ora fidit maculis toracis."
Philipiedos.

" Restitit uncino maculis hærente plicatis."

But I have not met with the rustre except as a charge in heraldry, and it is incorrectly described by Meyrick and Demmin as a large flat *ring*.

Scale armour requires no definition of mine. It is the *lorica squamata* of the Romans, and was imitated in leather by the Normans. William Rufus on his great seal appears in a hauberk of scales —in his case most likely of metal. On the Trajan Column is the figure of a mounted Dacian warrior : both the horse and his rider are encased in scale armour. (See GENERAL HISTORY.)

William Rufus. From his Great Seal.

Milo FitzWalter, Governor of Gloucester.
Temp. Henry I.

Richard, Constable of Chester.
Temp. Stephen.

"Tegulated" is the name given by Meyrick to an armour composed of square or oblong plates. Many representations of it exist ; but I have not met with a description or even an allusion to it by such a name, and Meyrick declares himself to be responsible for the adoption of it. Unlike scale armour, the plates did not overlap each other.

"Banded" is another description of mail which has been so named from its appearance, and not on any ancient authority. Its composition still remains a subject of controversy. The latest suggestion is that of Mr. J. Green Waller, to whom we are indebted for a most valuable volume of engravings of Sepulchral Brasses, and who is consequently fully entitled to speak on such a subject. I will revert to this presently.

Double chain mail completes the list of the armours enumerated by Meyrick and those who have followed him. His opponents assert that what he considered to indicate these several sorts of mail was nothing more than the rude attempts of different artists to represent chain or scale mail. They have, however, this difficulty to contend with :—If such were the case, how was it that the limner or the "tapisser," to use Chaucer's expression, constantly employed two and sometimes three distinctly different modes of depicting such armour in the same figure ? In the Bayeux Tapestry four out of the seven examples I have given are frequently, and in some instances two or more of them, depicted

as composing the whole equipment (see page 14, where, of the two Norman hauberks copied from that curious relic, one is represented as trellised, the other as tegulated, with short sleeves of ringed armour, while the warriors beside them are in mixed armour, the one to the left having a ringed coat with trellised sleeves, and the lower part of the hauberk being rustred, and the upper with the sleeves and the coif ringed). Surely the worker of these figures must have intentionally made these marked differences, and for what possible reason if not to represent distinct descriptions of armour?

If the reader will refer to Plate X., illustrating HAUBERK, and compare figs. 4 and 5, representing Norman warriors, and taken from MSS. of the same period (Cotton. Lib., Nero, C. iv., and Harleian Roll, Y 6), I think he will be perplexed to account for the difference the illuminators have made in the delineation of their military garments upon any other ground than an intention to depict, as faithfully as their ability permitted, two thoroughly distinct kinds—one composed of rings sewn flat and separately upon a foundation of some strong material, as in figs. 1, 2, 3, and 6 on the same plate; and the other, of overlapping rings, indicated in the conventional style of the day, which pervaded all Europe, by regular rows of semicircles alternately facing right and left, and which is more clearly exemplified in the sculpture of the period. (See the effigies in the Temple Church, London.) But for the information we derive from such invaluable memorials we should be induced to consider garments so marked by the pencil to be meant for garments of pourpointerie. An examination of the few fragments of ancient chain that have been fortunately preserved to us, and of the improved painting and statuary of the thirteenth century, will satisfy the student that the attempt of the earlier limner or sculptor to produce the effect of chain mail was, after all, not so contemptible.

I am not quite convinced that what has been called "trellised" armour, the "broigne trelicé" of the Norman romancers, is to be recognized in the examples referred to at page 59, under that head, although not an inappropriate name for it. In Mr. Way's notes to HABURYONE, in the 'Promptorium Parvulorum,' my attention has been attracted by a quotation from the 'Ortus Vocabulorum:'—"Bilix, loricaque contexitur duobus liciis accumulatis, a hawbergion; ita trilix;" followed by another from the 'Catholicum Anglicum:'—"An haberion, lorica; hæc trilix est lorica ex tribus (liciis) confecta." Here, undoubtedly, the terms "bilix" and "trilix" refer to the construction of the broigne, and not to the trellis or lattice character of its exterior, recalling the line of Virgil:

"*Loricam* consertam hamis, auroque *trilicem.*"
Æn. III. v. 467.

(See Ducange also, under TRILICES LORICÆ.) The armour of David, Earl of Huntingdon, is more of the later brigandine sort, I fancy, composed of a tunic, quilted in a diamond-shaped pattern, with plates of the same form, inside the studs of the rivets that secured the plates, appearing in the centres of the diamonds.

Of mascled and rustred armour we have no representation to be depended upon. The former word signifying, as I have already said, the "mesh of a net," might be applied with equal propriety to a coat of chain; and *maculis*, in some instances, is used to signify "rings." John, a monk of Marmoustier, in Touraine, a contemporary of Geoffrey Plantagenet, in his description of the armour of the latter when he was knighted by his father-in-law, Henry I., says, "He was invested with a matchless hauberk" (*lorica incomparabile*), of which the double "maclis" of iron were so closely interwoven that it was impenetrable by the point of the lance or the arrow. Nicholas de Brayn, also, in his 'Life of Louis VIII.' says:

"Nexilibus maclis vestis distincta notatur."

It would have been impossible to interweave plates of iron, and Meyrick himself renders the words "double chains or links." ('Archæologia,' vol. xix.)

Of what has been termed "tegulated" armour, an excellent example is afforded us in a group of warriors of the close of the eleventh century engraved in Hefner's 'Trachten,' and from which I borrow one figure. No one can possibly contend that this is a conventional mode of representing chain mail. Mr. Hewitt calls it "scale mail;" but I think it differs from scale armour in an

important particular. It appears to me that the square tile-shaped plates are placed contiguously, and not overlapping each other as the scales do.

From Hefner's 'Trachten.'

Whatever doubts may still exist respecting the flat-ringed, mascled, or trellised armour, there can be none respecting the construction of the scaled or the tegulated, for which there must have been a foundation of linen, leather, or some stout material. Meyrick's theory is also supported by the significant word "desmaillent," which occurs so frequently in accounts of conflicts by the contemporary Anglo-Norman romancers :—

> "Et le hauberc vait après demaillent,
> Aussi le cope come fit un bouquerant."
> *Roman d'Aubery.*

> "Hyaumes fondent, targes different,
> Mailles chichent des gorjerelles."
> Guiart, *sub anno* 1285.

And again—

> "Bascinet fondent, boucliers faillent,
> Haubers et gorgieres desmaillent."
> Ibid., *sub anno* 1304.

Such language could only apply to hauberks and gorgets of which the exterior was covered with rings, or small plates, that could be cut or wrenched off from the stuff on which they were sewn or riveted.

Banded mail has proved a much greater "ænigma" than the "vestura" celebrated by Bishop Adhelm. It was so named from the double lines which both in painting and sculpture divide the courses of rings, and have the appearance of bands of either leather or metal; and such armour is represented in illuminations, painted glass, seals, and statues, by artists of every nation in Europe, during the thirteenth century, occasionally mixed with other descriptions of mail or brigandine work, but invariably distinguished from it in the most unmistakable manner. (See, for instance, the adjoined engraving of two figures from a German illumination representing the Massacre of the Innocents, in one of the Addit. MSS. in the British Museum, numbered 17,687.) Mr. J. Green Waller justly remarked in his lecture on 'Arms and Armour' delivered at the London Institution, March 16, 1870 : "All sorts of theories have been raised by French, German, and English *savants*, none satisfactory, some absurdly impossible, *i.e.* in a practical point of view ;" and produced in illustration of the subject a hauberk from Northern India, the collar of which was strengthened by passing a thong of leather through each intermediate row of rings ; —"thus," he continued, "giving additional firmness and strength, and yet preserving flexibility ; the very conditions required, and its resemblance to the conventional representations in brasses, effigies, &c., is as close as can be expected. To

Addit. MSS. Brit. Mus., No. 17,687.

find a specimen like this, showing us so simple a contrivance in use among the Orientals, from whom we certainly obtained the interlaced mail itself, will probably save us from any further ingenious

and improbable theories." Alas! I fear not. I annex an engraving of the specimen exhibited, copied from his own woodcut at page 14 of his lecture, printed for private circulation; and, while fully admitting the great interest and curiosity of it, regret that I cannot endorse his opinion that its resemblance to the peculiar armour in question is "as close as can be expected."

North Indian Mail.
Exhibited by Mr. Waller.

Mr. Hewitt, who found in Newton Solney Church, Derbyshire, a mutilated effigy of a knight in banded mail, has given us a careful copy of a portion of it, and, on comparing it with Mr. Waller's specimen, an important distinction immediately strikes us. The bands or cords, pipes, tubes, or whatever you may please to call them (for they are round and not flat, observe, as they appear in paintings), do not pass through the rings, as in the Oriental example, but divide them in regular courses; how connected with them being still a mystery. I give another example (there are only four at present known in sculpture) from the effigy of Sir Robert de Keynes,

From effigy of Knight at Section.
Newton Solney.

in Dodford Church, county Northampton, 1305, to which the same remarks apply. The chisel is more instructive than the pencil or the burin, and in the reign of Henry III., to which epoch the Solney effigy must be attributed, the art of the sculptor had greatly revived, and the most minute details of costume or armour were scrupulously attended to, and represented with Chinese fidelity.

Sir Robert de Keynes, Dodford, co. Northampton, from
Hartshorne's 'Recumbent Effigies.'

With respect to the construction of banded mail, therefore, only one little ray of light has glimmered upon us since the subject was first canvassed. It is tolerably certain, from the occasional rare instances which afford us a glimpse of the interior of the hauberk, that it was an independent garment, having no stuffed or quilted foundation; as it presents the same appearance within as without. And this is really all that at present is known on the subject.

With a word respecting double chain mail, I shall conclude an article which might be prolonged *ad infinitum*, by quoting the various opinions of native and foreign antiquaries, the majority differing more or less from each other, without advancing the least step towards a settlement of one of the questions in dispute. Mr. Hewitt has collected those of the greater number up to the date of the publication of his work in 1860. Since that date we have had the assistance of MM. Viollet-le-Duc, Demmin, and Quicherat, yet on this score remain no whit the wiser. Meyrick still holds his main positions; and though his classifications may be cavilled at, and some minor points contested, no one has hitherto succeeded in giving us a better general view of the body armour worn in England previous to the reign of Edward I. From the accession of that sovereign to the end of the reign of Henry IV., double chain mail, *i.e.* each link being formed with four rings instead of two, is clearly discernible in effigies of the fourteenth century, and actual specimens have descended to our day (see woodcut below). The rings are called by the French "grains d'orge." Chambly,

Portion of a Gusset.

département de l'Oise, in France, is stated by M. Demmin to have been celebrated for its manufacture.

Chain mail continued to be worn long after the introduction of plate armour; and a fine description, made of very small rings, was used for gussets to protect the arm-pit, instep, inner joint of the elbow, &c. In the Meyrick Collection were several gussets:

Double Chain Mail.

one is engraved in Skelton's 'Specimens,' of which we give a portion of the full size, also some of the links of a hauberk of double chain mail from Senegalia, where it had been preserved for several centuries. Only every other row of rings is riveted.

MALLET. See MARTEL DE FER.

MAMELIÈRES. Circular plates fastened upon the surcoat of the knight, just upon the breasts, with rings in the centre, from which depended chains, attached one to the sword-hilt, the other to the heaume, which was placed over the coif de fer during action. The fashion was introduced in the reign of Edward I., and continued till that of Henry V. "2 mamellieres et deux chaienes pour icelle mameliere" occurs in an account of Étienne de la Fontaine, silversmith to John II., king of France, in 1352. They appear by the context to have been of silver and gilt. Some are formed in the shape of lions' heads (see woodcut from effigy in St. Peter's Church, Sandwich), and they were generally ornamental in design of whatever metal composed. (See also the effigy of a Blanchfront in Alvechurch, Worcestershire, and the brass of a knight in Minster Church, Isle of Sheppey : the latter has only one mamelière ; it is on the left breast, and the chain passing over the left shoulder was attached to the heaume behind him.)

From St. Peter's, Sandwich. From Alvechurch, Worcestershire. From Minster, Isle of Sheppey.

MANDILION, MANDEVILE. (*Mandil, mandille,* French.) A loose jacket or jerkin. Stubbs, speaking of the coats and jerkins worn in his day by the people of England, says, "Then as they be divers in colours, so they be divers in fashions ; for some be made with collars and some without ; some close to the body, some loose, which they call *mandilians,* covering the whole of the body down to the thighs, like bags or sacks that were drawn over them, hiding the dimensions and lineaments of the same."

Randle Holmes, of Chester, writing *circa* 1660, says, "The men, besides the convenience of the cloak, had a certain kind of a loose garment called a 'mandevile,' much like to our jacket or jumps, but without sleeves, only having holes to put the arms through ; yet some were made with sleeves, but for no other use than to hang at the back." (Harleian MS. 4375.) He accompanies his description with a drawing, which is here copied, of a man in a mandevile—without sleeves, I presume, or he would have arranged the figure so as to indicate them. Jackets and jerkins are constantly depicted in paintings and prints of the sixteenth and seventeenth centuries with sleeves pendent from the shoulders, merely ornamental. They are also observable in the dresses of women of the same date. They were called by the French "manches perdues." (See SLEEVE.) Neither Stubbs nor

Mandeville. From Randle Holmes.

Laquais (in Mandille ?). From Montfaucon.

Holmes informs us whence the name of this garment. Florio has only " Capacchino : a mandellion, a jacket, a jerkin ;" Cotgrave, " Mandil, a mandilian or loose cassocke."

" French dublet and the Spanish hose to breech it,
Short cloaks, old mandillions, we beseech it."
 Rowlande's *Knave of Harts*, 1613.

Harrison mentions " the mandillion worne to Collie-Weston ward," *i.e.* awry ; " Colly Weston " being a Cheshire saying for anything that goes wrong. (*Vide* Halliwell *in voce*.) Mandilion appears to have been the most popular name for the garment whencesoever derived. Mandils or mandilles were most probably introduced from France, where we first hear of them in the reign of Charles IX., when Claude Hallon in his 'Mémoires' tells us they had become the especial dress of the footmen ("laquais") of the great nobility, having previously been a military garment, under that very accommodating name, " cassock." His description of it does not accord with the representation of the English mandilion, as he says it was " un habillement fait en manière d'une tunique d'Église qui a les manches non cousues, mais vagues sur les bras." M. Quicherat, who quotes this passage, adds, " C'était donc une courte dalmatique ;" but Montfaucon has furnished us with an engraving of one of these " laquais " in a costume which, it cannot be doubted, exhibits the mandille as worn by them, but is only described in the text as " un habit d'une forme tout à fait singulière et extraordinaire." In the original painting of the time of Henry III. of France, brother and successor of Charles IX., the dress is red striped with blue, and the hat red. It bears a strong family resemblance to a tabard.

MANIPLE, also named *FANON*. (*Fanula, manipulus*, 'Prompt. Parvulorum.') " Quartum sacerdotis indumentum mappula sive mantile est quod vulgo fanonem vocant." (Rabanus Maurus, 'Inst. Clar.,' c. 18.) Originally a piece of fine linen, used by the priest as a handkerchief and attached to the girdle, but when sacrificing carried in the hand or loosely over the left arm. " *Fanon*, a fannell or maniple, a scarfe-like ornament worne on the left arme of a sacrificing priest." (Cotgrave.) The maniple in the time of Pope Gregory the Great, 590-604, was borne only by priests and deacons. The use of it was subsequently accorded to the sub-deacons when specially in charge of the plate and ornaments of the altar. (Victor Gay, 'Annales Archéologiques,' t. vii. p. 134.) Mr. Albert Way, in his note

to "Fanyn" ('Prompt. Parv.,' 149), says, "The etymology of this appellation of the sacred vestment, termed also the 'maniple,' is uncertain. The Latin *pannus* has been suggested; the German *Fahne,* or the Anglo-Saxon word of the like signification, 'fana, *vexillum.*' The resemblance of the maniple to the pennon on the lance, called in France *fanon* or *phanon,* is obvious." I see no resemblance whatever. "The word," he continues, "can hardly, however, be of Anglo-Saxon derivation, as in Ælfric's 'Glossary,' written towards the close of the tenth century, the maniple is termed '*manualis,* handlin,' and among the gifts of Bishop Leofric to Exeter Cathedral, about 1050, are mentioned 'iv.

Termination of Maniple. 13th cent.

subdiacones handlin.' (MS. Bodl. Arch. D 2, 16.) Leo IV., P.P., towards the middle of the ninth century, ordained thus: 'Nullus cantet sine amictu, sine albâ, stolâ, fanone et casula.' The rich ornamentation of the maniple early rendered it unsuitable for its original purpose. A specimen discovered at Durham, in the tomb attributed to St. Cuthbert, is still preserved there; it is elaborately embroidered with figures of saints on a ground woven with gold, and appears, from the inscription upon it, to have been wrought by direction of Elflæda, queen of Edward the Elder, for Frithelstan, Bishop of Winchester, 905." Mr. Way suggests that it was probably brought to Durham with other precious gifts by Athelstan, the successor of Edward, in 934. It measures $32\frac{1}{4}$ inches exclusive of the fringe at the ends, and is $2\frac{1}{4}$ inches in breadth.

The maniple is seen in the left hand of Stigant, Archbishop of Canterbury, in the Bayeux Tapestry (*vide* our engraving, p. 93); but it is frequently represented in the right in figures of the ninth century. Here are two examples, one from Willemin, 'Monuments inédits,' and the other from Louandre, 'Les Arts somptuaires.' From the twelfth century it is always seen on the left arm. (*Vide* the interesting statues in the portal of the Cathedral of Chartres,

From Willemin. From Louandre.

engraved by the late Mr. Henry Shaw in his 'Dresses and Decorations,' and by M. Viollet-le-Duc; also the termination of one of the thirteenth century preserved in the Cathedral of Troyes, herewith engraved.) The

From an effigy in Oulten Church.

maniple of Thomas à Becket, with his mitre, amice, chasuble, and stole, is still to be seen in the Cathedral of Sens. All these examples are richly embroidered and fringed: some had ornaments of goldsmiths' work at the ends; and in 915 Bishop Riculfe d'Héléna bequeathed to his successor six maniples embroidered with gold, one of which had little bells at its termination. A slight alteration of form in the ends of the maniple appears in later examples (see figure annexed from an effigy in Oulten Church, Suffolk).

MANTEAU. See MANTUA.

MANTELET. A little mantle or cloak worn by knights at tournaments.

> "A mantelet upon his shoulders hanging,
> Bret full of rubies red, as fire sparkling."
> Chaucer, *The Knight's Tale.*

> "That they be trapped in gete,
> Bothe telere and mantelete."
> *MS. Lincoln,* A 1, 17, f. 134.

From a statue in the portal of the Cathedral at Troyes.

The word is sometimes applied to the lambrequin of a helm. (See LAMBREQUIN.)

MANTLE. (*Mentil*, Saxon ; *mantel, manteau*, French.) Under the head of CLOAK I have already spoken of the mantle down to the period when the term became limited to a habit of state in England, which appears to have been about the middle of the fourteenth century ; but I shall return here to the reign of Henry II., who obtained the *sobriquet* of "court manteau," in consequence of his introduction of the short cloak worn in the province of Anjou. The regal mantle of that date could not be more satisfactorily illustrated than by the effigies of King Henry himself, his queen, and of their eldest son, the lion-hearted Richard, which formed the chromo-lithograph issued with our last Part. Carefully drawn and coloured by that justly celebrated artist Charles Alfred Stothard from the original effigies at Fontévraud, in Normandy, they have been transferred to our plate in *fac-simile* from his admirable work, 'The Monumental Effigies of Great Britain,' and may be thoroughly relied upon for the minutest details of form and ornamentation. The mantle of King Henry is of a colour which might have been originally a very dark crimson, but it had been painted over several times, and cannot be positively determined, and is described by Mr. Stothard, who discovered it by scraping, as a "deep reddish chocolate." It is perfectly plain, lined with a white material, and has a narrow border of gold round the top, and a broader one down the side as far as can be seen, from the right shoulder, on which it is fastened, to the left hand, sustaining one end of the mantle, which has been gathered up and drawn round the body beneath the girdle. The gold border does not appear on the lower edge of the mantle, which would seem, if allowed to fall down, scarcely to have been as long as the tunic. The mode by which it was fastened on the shoulder is not visible, but contemporary examples justify us in presuming that it was secured by a brooch or fibula.

The mantle of his queen is blue, embroidered all over with golden crescents, the lining a dark red. It is sustained on the shoulders by a gold cord which passes across the breast, and is without a border.

The mantle of Richard I. is plain blue, with a broad band or border of gold all round it, and it is fastened on the breast by a large but plain oval gold fibula, thus accidentally illustrating the three usual modes of wearing the mantle in the twelfth century.

Of the materials of these mantles I cannot speak confidently, but believe them to have been of cloth or silk, which were generally in use for garments at that period, velvet being first mentioned in the reign of Henry III. With respect to ornamentation, however, they were gorgeous. Richard I. is said to have had a mantle which was nearly covered with half-moons and orbs of solid silver, in imitation of the system of the heavenly bodies. The crescents on the mantle of Queen Eleanor, above mentioned, might be intended to represent a similar decoration. A star and a crescent appear on the seals of our Anglo-Norman monarchs, and are held to be badges of the family of Plantagenet. Our chromo-lithograph of a nobleman from an enamelled tablet formerly in the Cathedral at Mans, which was issued with Part V., affords an equally authentic example of the mantle worn by Normans of rank in the twelfth century. It displays a lining of the fur called "vair," the next in value and esteem to ermine, and from which the bearing in heraldry was taken. The figure is traditionally said to represent Geoffrey Plantagenet, father of Henry II.; but I have given my reasons for believing it to be the effigy of William FitzPatrick, first Earl of Salisbury (*vide* 'Journal of the Brit. Arch. Association,' vol. i. p. 16),—an opinion which, though hotly disputed, no evidence has hitherto been found to shake.

Coronation of Edward I. From an initial letter, MS. Harleian, 920.

No alteration appears to have taken place in the form of the mantle during the thirteenth and fourteenth centuries beyond lining them with ermine or lettice—a luxury forbidden in the reign of Edward III. to any but the royal family and nobles possessing upwards of

EFFIGIES AT FONTEVRAUD

Henry II.

Eleanor de Guienne.

Richard Cœur de Lion.

one thousand pounds per annum. Pure miniver and other expensive furs were limited to the use of knights and ladies whose income exceeded four hundred marks yearly. An initial letter in a Harleian MS., No. 926, contains a representation of the coronation of Edward I. (See previous page.) His

<table>
</table>

From a Scholastic Bible. Early 14th century.	Royal MS. Brit. Mus., 16 G 6. 14th century.

mantle is lined with ermine, and has also an ermine cape or collar covering the shoulders, and consequently preventing our ascertaining how it was fastened.

A curious illustration of the mantle occurs in a MS. collection of poems in the National Library at Paris, which has been copied by Mr. Fairholt. It is from a poem entitled 'Le Lai du Mantel d'honneur,' and the subject is a man displaying a mantle lined throughout with vair and having a rich scarlet border. Mr. Fairholt has failed to see in this example that it is the inside of the mantle that is presented to us, and describes it as " very gay in effect, the entire surface being laid out in a series of white escallops ; the groundwork of the whole (which is tinted in the engraving) is of a rich blue, with an edge like scales overlapping each row of patterns." This is precisely a mode of representing vair. (See cape of figure above.)

Mr. Fairholt was so accurate a draughtsman, that it is rather startling to find in the valuable work of M. Quicherat a very different representation of the same garment, from apparently the same authority. Not having the advantage of personally inspecting the MS. in question, I give both delineations, simply observing that the latter presents the appearance of a fur more resembling ermine than vair, but at all events the lining and not the exterior part of the mantle. (See next page.)

The romances of the thirteenth century are full of allusions to and descriptions of the magnificent mantles, lined with the most costly furs, that were worn by the knights and ladies whom they celebrate ; but silk, taffeta, cendal, and other light, thin stuffs were employed for lining summer garments of every description. The furred mantle is described by the later writers of that day as *mantella penulata*, and the word *penula* is often used by itself to express a mantle so lined or ornamented. King John, in the second year of his reign, ordered three mantles made of the fine cloth called " byssine," lined with fur, to be made for the queen : " Trium penularum de bissis (pro

byssis)." (Rot. Libertat., Memb. 2.)　Henry III. commanded two mantles furred with ermine to be made for his queen, to be ready against Christmas Day.　(Rot. Claus. 36 Hen. III., Memb. 4.)

From ' Le Lai du Mantel d'honneur,'
MS. Bib. Nat., Paris.　According to Fairholt.

The same figure according to Quicherat.

Mantles were not worn by unmarried women unless they were of high rank ; but noble maidens are generally described by the poets as attired in the most sumptuous imaginable :

From effigy of Lora, Lady Marmion,
West Tanfield Church, Yorkshire.

" En la lande qu'est verde et belle
　　Vit Melions une pucelle
　　Venir sor j bel palefroi
　　Molt erent riche si con roi
　　Un vermeil samit ot vestu
　　Estoit a las molt bien cosu.
　　A son col j mantel d'ermine
　　Aine meillor n'affubla reine."
　　　　　　　Le Lai de Melion, v. 83.

The mode of fastening the mantles on the shoulders varied excessively.　Brooches, buttons, bands, laces, rings, are all employed at the same period.　Two circular or diamond-shaped ornaments of gold of beautiful design and profusely jewelled, each furnished with a ring at the back, were sewn firmly on to the opposite edges of the mantle, and gold or silken cords were passed through the rings underneath and hung down with tassels in front.　By pulling these cords or laces, as they were called, the mantle could be drawn closer round the neck or the reverse at pleasure.　These ornaments, for which we have no name, are called by the old French writers *tassels* and *tasseaus*, from which we derive our English

Tasseau enlarged.　From effigy of Lady Marmion.

word *tassel*, signifying a very different object, and which the French term *houppe*.　(See TASSEL.)

The effigy of Edward III. in Westminster Abbey presents us with an example of the mantle being held on the shoulders by a richly embroidered band across the breast, while that of his son,

Pattern of embroidery on the band and borders of the robe and tunic of Edward III.

Edward III. From his effigy in Westminster Abbey.

William of Hatfield. From his effigy.

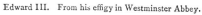

William of Hatfield, displays a mantle with *dagged* edges, fastened on the right shoulder by four buttons, the front portion being thrown back over the left shoulder.

Subjoined are a few examples of the various modes of fastening the mantle in the thirteenth and fourteenth centuries.

Fragment of statue from the Church of Eu, Normandy.

From a statue in the Museum of Toulouse.

Frankish Mantle. Viollet-le-Duc.

From a statue in the Museum of Toulouse. 12th cent.

From a statue in the Museum
of Toulouse. 14th cent.

Ring through
which the mantle
is passed on right
shoulder of an-
nexed figure.

From a statue in the Museum of Toulouse.

From the commencement of the fifteenth century to the close of the sixteenth, little alteration is observable in the mantles worn by either sex. They are longer and more ample, and gold cords with tassels at their terminations gradually supersede all other fastenings. The materials are generally of velvet, cloth of gold or silver, or the richest embroidery, and the linings of the most costly furs. A good example of the state mantle of a lady of the time of our Henry VI. is given at page 273. Many of the effigies of noble women of the latter half of the fifteenth century represent them in mantles embroidered with the armorial bearings of their husbands' family, having those of their own family upon their surcoats or kirtles. It may be a question, however, whether or not they ever wore such, as I know but one instance of such a fashion being represented in any picture of a scene in real life,* and never met with any allusion to it in contemporaneous writers. All the examples I have seen in collections of costume are copied from monuments, brasses, or painted glass. At Her Majesty's first *bal costumé*, many ladies were so attired, and the effect was undeniably extremely picturesque ; but the doubts I then entertained have not been dissipated by subsequent researches, and I am still inclined to believe that such heraldic decoration was limited to the surcoat, jupon, or tabard of the knight, and only extended to his lady for the purpose of identification. Nevertheless, I may be mistaken, and will therefore not omit this remarkable variety. Annexed are the effigies of Eleanor (de Beauchamp) Duchess of Somerset, 1467, and Anne (Nevil) Countess of Stafford ; the

Duchess of Somerset. Lady Chapel, Collegiate Church, Warwick. Countess of Stafford. Lichfield Cathedral.

former from the east window of the Lady Chapel in the Collegiate Church at Warwick, and the latter from the north window of Lichfield Cathedral. Sandford, who has engraved them in his 'Genealogical History,' says : "In the effigies of the Duchess Eleanor, it's observable that the arms of Edmond, Duke of Somerset, her husband, are embroidered upon her mantle, or upper garment, and there placed to signifie that the husband, as a cloak or mantle, is to shroud the wife from all those violent storms against which her tender sex is not capable of making a defence. The arms of her house are depicted upon her kirtle, which (being under cover of the husband, or upper garment) are

* The instance I have alluded to is the meeting of Jeanne de Bourbon, queen of Charles V. of France, with her mother the Duchess of Bourbon, after her long imprisonment by the English. It is engraved in Montfaucon from the original in the ' Livre des Homages de Clermont en Beauvoisis.'

to denote the family of which she has descended. From which take this for granted, that whereso-
ever you find the figure of a woman painted or carved in a mantle and a kirtle of arms, those on the
mantle are the arms of her husband, and those on her kirtle the ensigns of her blood and family; of
which (besides the present one) there are very many examples. The figure of Anne, Countess of
Stafford, is contrary to the former example, for here the arms of her family (being Nevil) are upon
her mantle; but the reason thereof is because she hath not any arms on her kirtle, and therefore the
insignia of her husband, Humphrey, Earl Stafford, are depicted on the lining of her mantle, which
being turned back, represents you with an exact impalement of the arms of Stafford and Nevil." All
this account, especially the last sentence, is purely heraldic, and contains no allusion to any ancient
fashion of dress, which it would surely have done had there existed in the time of Charles II., to
whom Sandford dedicated his History, any tradition or picture within the knowledge of the author,
who, as Lancaster Herald, had special opportunities for obtaining such information. I am still further
confirmed in my opinion by the silence of two such eminent and indefatigable antiquaries as
MM. Viollet-le-Duc and Quicherat, neither of whom take the least notice of the subject; the latter

Anne, Queen of Richard III.
From the Warwick Roll.

actually giving one example of a lady (Mahaut, Comtesse de
Boulogne, 1210) in an armorial surcoat, from a painted window in
the Cathedral at Chartres, in illustration of the *shape* only of the
garment, without a word respecting its heraldic decoration.

I shall be heartily glad to find myself mistaken, as the
quaint and gorgeous effect of such dresses is undoubtedly valuable
to the historical painter and the dramatist, and its future avoidance
by conscientious artists will be a loss to the picture gallery, the
stage, and the fancy ball-room; it would, however, be a dereliction
of duty on my part, considering the object of this work, not to call
the attention of the student of costume to the above facts, and
recommend him to investigate them.

Anne, the queen of Richard III., wore, the day before her
coronation, a mantle of white cloth of gold, trimmed with Venice
gold and furred with ermine, and additionally "garnished with
seventy annulets of silver gilt;" how disposed, the chronicler does
not inform us. Rous, in the 'Warwick Roll' preserved in the
College of Arms, has left us a drawing of her, and as he was her
contemporary we may rely on the accuracy of the costume. The
mantle is fastened by gold cords with tassels, which became the
ordinary mode in the fifteenth century. Mantles of state, in the
sixteenth century, took the form they have retained to the present
day, and will receive further notice under ROBE.

MANTUA. "A loose gown." (Bailey.) Worn by ladies in
the eighteenth century. The name may be derived from the French, as suggested by Mr. Fairholt,
who quotes Evelyn,—

"A curious hasp,
The manteau 'bout her neck to clasp."
Mundus Muliebris, 1690.

and says, "hence the term 'man*teau*-maker,' now generally but erroneously applied to makers of
ladies' gowns." ('Cost. in England.') I am, however, inclined to think that the "man*teau*" mentioned
by Evelyn in the seventeenth century, which he also in another passage describes as a species of
deshabille,—

"Three manteaux, nor can Madam less
Provision have for due *undress*,"—

was a garment distinctly different from the "man*tua*," so fashionable in the succeeding century; and

I agree with Bailey, who compiled his valuable Dictionary at the time the garment was so generally worn, and which he describes as "a loose gown worn by women," that it was "probably so called from Mantua, a dukedom in Italy,"—either, as I submit, from the fashion having been introduced from thence, or from the material of which it was made being of Mantuan manufacture, as we learn from an advertisement in 1731, that amongst other articles of dress stolen in the month of March that year, was "a rose-coloured paduasoy mantua, lined with a rich *Mantua silk* of the same colour." Later we hear of "Mantua petticoats" (see PETTICOAT); the name also of the fabricator of such articles being called a man*tua* (not man*teau*) maker, as the makers of Milan bonnets were called *milainers*, corrupted into "milliners." The French have no such word as "mantua" in their language. The earliest mention I have seen of the mantua is in the 'Gazette' of July 20, 1682, quoted by Malcolm, which gives the contents of a large portmantle (*portemanteau*, French) full of women's clothes, "lost or stolen," in which were "a mantua and petticoat of grey silk and silver stuff with broad silver lace; another mantua and petticoat, flowered with liver-coloured and some flesh-coloured spots." "A striped silk mantua" was in a parcel stolen about the same time. A black silk mantua is mentioned in the story of "Brunetta and Phillis." ('Spectator,' No. 80). I have not recognised a representation of it.

MARBRINUS, MARBUTTUS. (*Marbre*, French.) "A species of cloth composed of party-coloured worsted, interwoven in such a manner as to resemble the veins of marble, whence it received its appellation." (Strutt, 'Dress and Habits,' Part IV.) "Pannus ex filis diversi et varii colores textus." "Draps tixus de diverse lames comme marbrez." (Ordinat. Reg. Franc., tom. iii. p. 414.) In the accounts of Stephen de Font, 1351, quoted by Charpentier, the following varieties of marble cloth are enumerated, "Marbre verdelet, marbre vermeillet, marbre torrequin, marbre caignez, marbre acole, marbre de graine, marbre dozien."

The cloth was sometimes ornamented with figures of animals, and other devices embroidered upon the variegated ground, from which it received its appellation, "Tunica de quodam panno marmore spisso, cum rotis et griffonibus." ('Visit. Thesauri S. Pauli.')

MARRY-MUFFE. Mr. Fairholt says it was "a coarse common cloth," quoting apparently, as his authority, the following passage from a book printed in 1604, entitled 'Meeting of Gallants at an Ordinaire:'—" He that would have braved it, and been a vainglorious silken ass all the last summer, might have made a suit of satin cheaper in the plague time, than a suit of marry-muffe in the tearme time." There is nothing in this, however, to prove it was a coarse *cloth*, though such an inference may naturally be drawn from the context. Halliwell, *in voce* "Marry," has simply, "Marry-muff—Nonsense," without any quotation or reference to an authority. More evidence is required for a satisfactory definition.

MARTEL DE FER. (*Marteau, martel*, French.) "A weapon which had at one end a pick and at the other a hammer, axe-blade, half-moon, mace-head, or other termination." (Meyrick.) The original form of this weapon was, doubtless, the simple one of a hammer. Without going back to the Stone age and the Miolmer of Thor, we find that the rude levies of the eleventh and twelfth centuries were composed of labourers whose arms were the scythe and the fork, the goad, the hatchet, the bill, the pick, and the hammer,—the implements they were accustomed to handle, and the nearest within their reach. There were also a host of poorer and less respectable men named "ribaux" and "brigans," who swelled the ranks of an army, for the mere sake of plunder, and fought with any weapons they could lay their hands on,—

"Li uns une pilete porte,
L'autre croc ou mascue torte.

* * * * *

L'un tient une epee sans feurre,
L'autre un maillet, l'autre une hache."
Guiart, *Chronique Métrique*, v. 6635.

Some of these mallets were of considerable weight,—

> " Cil combattait d'un mail qui pesoit bien le quart
> De cent livres d'acier."
>
> *Combats des Trente*, 1351.

Twenty-five pounds weight of steel. Such were, therefore, wielded with both hands,—

> " Olivier de Cliçon dans la battaile va
> Et tenoit un martel, qu'à *ses deux mains* porta."
>
> *Chron. de Bertrand du Guesclin.*

> " Bertran de Glaiequin (Guesclin) fu au champ plenier
> Où il assaut Anglois au martel d'acier.
> Tout ainsy les abat com fait le bouchier."

Froissart, describing the tumults in Paris in 1382, says : " Et avoient et portoient maillets de fer et d'acier, parilleux bâtons pour effondre heaulmes et bassinets, si appeloit-on ces gens les routiers et

From Royal MS. 2 B 7.

les maillets de Paris." (Tome ii. p. 200.) The revolt has ever since then been called that of the Maillotins. At the battle of Rosebecque also, the same contemporary author informs us that the men of Bruges were armed with the mallet : " Et ceux du Franc de Bruges etoient armés la gregnieur parties de maillets."

It is uncertain when the amalgamation of the pick and the mallet took place ; but they are to be seen together in a miniature illustrating the story of Abimelech. (Royal MS. 2 B 7.) They were long-handled and short-handled. The latter were called in English " horsemen's hammers," from the German *Reiter-hammer*. Of the long-handled there is a good example in a drawing by Rous, the Warwickshire antiquary, of an encounter between Richard de Beauchamp, Earl of Warwick, and Sir Pandolf Malacet, at Verona, in 1408. It is in Cotton. MS. Julius, E 4, but the drawing is of the

From Cotton. MS. Julius, E 4.

Figs.1 and 2. temp. Edward IV. 3. Henry VII. 4.5.6.7.8. Henry VIII. 9.10. Edward VI. 11. temp. Elizabeth, combining a hand-gun. 12. William III. with flint-lock pistol.

latter half of the century. The hammers have spikes to them, like those known in Germany and Switzerland as "Luzern hammers," being a favourite weapon of the people of Lucerne. (Demmin.) In the narrative the Earl and Sir Pandolf are said to have fought upon this occasion with axes; but the weapons depicted are certainly more like what M. Demmin calls "pole-hammers" than pole-axes.

Of the shorter handled martels we give a series, from the reign of Edward IV. till they ceased to be used. (See Plate XIII.)

A celebrated warrior is popularly said to have received his second name from his use of this weapon—Geoffrey Martel. There is, however, no positive authority for the assertion; and M. de la Mairie, an eminent French antiquary, has pointed out that Martel is only another form of Martin, and the well-known charge in heraldry of "martlet, martellet," a little marten or swallow, appears to corroborate his opinion. A similar story might be told of William Malet, the companion of William the Conqueror, the origin of whose second name has not been hitherto ascertained.

MARTIAL GLOVES. "So called from the Frenchman's name pretending to make them better than all others." ('Ladies' Dict.,' 1694.) (See GLOVE.)

MASCLE. See MAIL.

MASK. Masks do not appear as ordinary articles of female costume in England previous to the reign of Queen Elizabeth.

They are mentioned by Stephen Gosson in 1592:

> "Weare masks for vailes to hide and holde,
> As Christians did and Turkes do use
> To hide the face from wantons bolde;
> Small cause then were at them to muse,
> But barring only wind and sun
> Of very pride they were begun."
> *Pleasant Quippes.*

> "Her mask so hinders me
> I cannot see her beauty's dignity."
> Marston's *Satires*, 1590.

French masks are alluded to by Ben Jonson in 'The Devil is an Ass.' They were probably the half masks called in France "loups," whence the English term "loo masks."

> "Loo masks and whole as wind do blow,
> And Miss abroad's disposed to go."
> *Mundus Muliebris*, 1690.

The whole mask, covering the entire face, was held between the teeth by means of a round bead fastened on the inside. James Earl of Perth, writing from Venice in 1695, says of the ladies there: "The upper part of their faces is concealed by people of condition with a white mask, like what the ladies used to go in with a chin-cloak long ago." From this we gather that white masks were worn in England within the Earl's remembrance. He was born in 1648. White masks with chin-cloaks, *i.e.* chin-cloths, mufflers, must therefore have been in fashion as late as the Commonwealth. During the reign of Queen Anne and the first half of the last century masks were still used by ladies in riding, and were worn appended to the waist by a string.

From Bulwer's 'Artificial Changeling.'

Of masks worn by actors, or for the purpose of disguisement by mummers or masqueraders, see GENERAL HISTORY.

From print by P. de Jode,
temp. James I.

From an old woodcut,
circa 1690.

From a print dated 1743.

MASSUELLE, MAZUEL. See MACE and Plate XII.

Match-box,
1639.

MATCH BOX or *PIPE.* A tube of pewter, latten, or tin carried by matchlock-men to protect the lighted match from the weather, and also conceal the light from the enemy. In 'England's Training,' by Edward Davies, 1619, the soldier is advised to have, when on the march in rainy weather, a case for his musquet, and for the match "an artificial pipe of pewter hanging at his girdle, as the coale by wet or water go not out." Ward in his 'Animadversions of Warre,' 1639, describes this pipe as " of tinne or latten, made like an elder pipe, about a foot long, with dyvers holes on eyther side, like the holes of a flute, to let in the ayre, to keepe the match from extinguishing." He also gives a print of it. (See cut annexed.) It was invented, he says, by the Prince of Orange for a night attack, " to carry the light matches in, so that the sparks of them might not be discovered." This seems to have been copied from Walhuysen's 'L'Art militaire pour l'Infanterie,' 1615, who says, " The musqueteer should also have a little tin tube of about a foot long, big enough to admit a match, and pierced full of little holes, that he may not be discovered by his match when he stands sentinel or goes on any expedition." Meyrick, who quotes this passage ('Crit. Inq.,' 1842, vol. iii. p. 74), adds in a foot-note, " This was the origin of the match-boxes till lately worn by our Grenadiers."

MATCH-LOCK. A gun fired by a lighted match being brought down upon the pan by a piece of iron called a "serpentine," instead of by the friction of a pyrite, as in the wheel-lock, or by collision of a flint and steel, as in the firelock or snaphaunce. (See HARQUEBUS.)

MAUL, MELL. A leaden mace or mallet, for it is not shown whether it was club-shaped like the one, or hammer-headed like the other ; nor is it clear whether the Latin words *malius* and *malleus*, and the French *mail* and *malliet*, are not occasionally used to indicate the maul : so we are not able to decide as to the date of its introduction, but there can be little doubt that it was a very early weapon. " Mailles de plomb " occurs in an extract from the 'Consuetudo Montium in Hannonia,' quoted by Ducange *in voce* " Plumbatæ," where it is classed with " plommées et autres bastons ayans fer, plomb, estain et autre metail."

In the old poem of 'Flodden Field,' quoted by Grose ('Ant. Arm.,' vol. ii. p. 278), the mell is distinctly mentioned :

> "Some made a mell of massy lead
> Which iron all about did bind."

And again :

> "Then on the English part with speed
> The bills slipt forth, the bows went back,
> The Moorish pikes and mells of lead
> Did deal there many a dreadful thwack."

Amongst the different storehouses at Calais there was one named "the malle chambre," in which there were then eight hundred and eighty leaden malles. (Brander's MS.) Ralph Smith recommends every archer to have, in addition to a pike and a dagger, "a mawle of leade of five foot in length."

MAUNCH. See SLEEVE.

Mentonière. From Meyrick Collection.

Demi-Mentonière. From Meyrick Collection.

MENTONIÈRE. A chin-piece, sometimes confounded with the beaver, its purpose being similar. It differed from the beaver in its not being attached to the helmet, as the latter was, and which also worked up and down upon a pivot or screw, while the mentonière was fastened to the breastplate or placate, and, like the hause-col, protected the neck as well as the chin, and was so far an improvement upon it that, although only called a "mentonière," it defended the whole face up to the eyes, and could be worn with a bourginot. The adjoined examples of a mentonière and a demi-mentonière are from Skelton's engravings of the originals, formerly in the Meyrick Collection.

MERKINS. See HAIR, p. 247.

MEURTRIÈRE. "Murderers, a certain knot in the hair, which ties and unties the curls." ('Mundus Muliebris,' 1690.) "A black knot that unties and ties the curles of the hair." ('Ladies' Dictionary,' 1694.)

> "All which with meurtriers unite."
> Evelyn, *Voyage to Maryland.*

MINIVER. (*Menu-vair*, French.) The white portion of the fur called "vair." (See VAIR.)

MISÉRICORDE. See DAGGER.

MITRE. (*Mitra*, Latin.) The episcopal bonnet, first worn by bishops about the close of the tenth, or beginning of the eleventh century, previous to which period it had no distinctive character. All classes wore caps or bonnets, and the clergy as well as the laity were forbidden to wear them during divine service by St. Augustine, on the authority of St. Paul. (De opere Monach. cap. 31.) Simeon, Archbishop of Thessalonica, also says that "All the bishops and priests of the Eastern Church, with the exception of the Patriarch of Alexandria, said mass bare-headed, because the Apostle St. Paul had directed that in honour of Jesus Christ we should be uncovered when we pray." (*Vide* Viollet-le-Duc ; article " Mitre.") In all sculptures and paintings previous to the twelfth century, the figures of bishops are represented either bare-headed or wearing a round bonnet slightly depressed in the centre, with two lappets pendent behind or at the side, which may have been the ends of the band or fillet with which the bonnet was bound ; but in the earliest examples they appear to come from beneath it (see figure of bishop, page 93). The bonnet at that time is always white. Towards the middle of the century a change took place in the form of the bonnet, the

depression being increased in the centre, causing the sides to rise in the form of two peaks or horns. (See woodcuts annexed, from the effigy of Ulger, Bishop of Angers, 1149, and an example of the

same period engraved by Willemin in his 'Monuments Français inédits.') A still greater change took place towards the end of the century, the bonnet being apparently worn with the elevated sides in front, which assumed a pointed form. An example fortunately exists of a mitre of the reign of Henry II., being no other than that of Thomas à Becket, which is preserved, with some of his vestments, in the Cathedral of Sens. From being of plain white linen, with at the utmost a band of gold embroidery, the mitre had rapidly become magnificently ornamented. The scroll-work in à Becket's mitre is of

From Willemin.

Bishop Ulger, 1149.

a most elegant pattern, and the "infulæ," or "fanons" as some call them, which are similarly ornamented, terminate in tassels.

Mitre of Thomas à Becket.

Some varieties in form are met with in the thirteenth century. (See one from an effigy in the Temple Church, London, and another from the tomb of Bishop Gifford at Worcester.) In the fourteenth century the mitre assumes a more imposing shape, and is enriched with jewels. The Ploughman in the 'Canterbury Tales' rails at the clergy in good set terms, for the splendour and luxury they indulged in. "Some of them have more than a couple of mitres ornamented with pearls, like the head of a queen."

Bishops used three kinds of mitres,—first, the simplex, of plain white linen; second, the aurifrigata, ornamented with gold orphreys; and third, the pretiosa, enriched with gold and jewels in the most sumptuous manner, to be worn at high feasts. (Pugin, 'Glossary of Eccles. Costume.') Mr. Pugin also tells us that the cleft of

From Temple Church, London.

Godfrey Gifford, Bishop of Worcester.

the mitre signifies knowledge of the Old and New Testaments, the front half representing one and the back the other, and its height the eminence in learning a bishop should have attained to. Mr. Fairholt observes upon this, that "at this rate the old or original mitre could have had no meaning."

1300.

1350.

1400.

The mitre continued to grow higher and more pointed, I presume, as the wearers increased in wisdom, till the middle of the fifteenth century. (See a magnificent example herewith engraved from Mr. Alfred Shaw's drawing of the Limerick mitre, 1408.) After which period it lost its sharp angles, and took more the form of the pointed arch, which it retains to the present day. (See page 131, and, as a later example, the annexed woodcut from the brass of Samuel Harsnett, Archbishop of York, who died 1631, in Chigwell Church, Essex.)

From brass of Samuel Harsnett, Archbishop of York.

Mitres were accorded by the Popes to the abbots of certain privileged houses, and in a few instances to laymen. Alexander II. gave permission to Wratislas, Duke of Bohemia, to wear a mitre as a mark of his esteem, and Innocent II. testified, by a like act, his regard for Roger, Count of Sicily. A mitre is also worn by the canons of certain foreign cathedrals on particular occasions.

MITTEN, MITAINE.
A sort of glove. "The term was not restricted to gloves without fingers. Ray inserts 'mittens' in his list of South and East country words, with the following explanation: 'Gloves made of linen or woollen, whether knit or stitched; sometimes also they call so gloves made of leather without fingers.'". (Halliwell, *in voce.*) (See GLOVE for an early example.) In Way's note to the word in the 'Promptorium Parvulorum,' he observes: "It is said in the 'Catholicon,' that a 'manus dicitur mantus quia manus tegat tantum, est enim brevis amictus, &c.,' the primary sense of the Latin term being a short garment or mantle;" and in the 'Ortus Vocabulorum,' we accordingly find "Mantus, a myteyn or a mantell." It is only as a mitten that we have to deal with the word here, though it is necessary to warn the student of the double signification.

Limerick Mitre. 1408.
Back view to show infulæ.

In 'A Tale of King Edward and the Shepherd,' fourteenth century, published by Hartshorne in his 'Metrical Tales,' occurs the line—

"The mytens *clutt* forgot he nought "—

which is explained by the description of the garb of the Ploughman in 'Piers Ploughman's Creed,' where mention is made of his "myteynes" made of "cloutes" (cloth), with the fingers "forwerd," or worn away. The Pardoner, in the 'Canterbury Tales,' also plays on the credulity of his hearers by assuring them that

"He that his hand will put into this mitaine,
He shall have multiplying of his graine."
v. 12307.

Mr. Fairholt quotes from the Coventry Mystery of the Nativity, a touching line of simplicity put into the mouth of the third shepherd, who, addressing the Infant Redeemer, says:

"Have here my myttens to put on thy hands,
Other treasure I have none to present thee with."

In the inventory of the effects of Sir Thomas Boynton, 1581, before quoted, occurs : " One pare of cloth myttons."

Lace mittens were commonly worn by women in the last century, and by the same term gloves with fingers reaching no further than the knuckles, were generally understood. See MUFFETEE.

MOCHADO, MOKKADO. "Moccado stuffe, mocayart, silk moccado." (Cotgrave.) There were two if not more sorts of stuffs called " mochado " or " mokkado." One, " a manufacture of silk, sometimes called ' mock velvet,' much used in the sixteenth and seventeenth centuries." (Fairholt.)

> " Alas ! what would our silk mercers be?
> What would they do, sweet Hempseed, without thee ?
> Rash, taffeta, paropa, and novato,
> Shagge, filizetta, damaske, and *mochado.*"
> Taylor's *Praise of Hempseed.*

The other a woollen stuff, made also in imitation of velvet, according to Halliwell. " My dream of being naked and my skyn all overwrought with worke like some kinde of tuft mockado with crosses blew and red." (' Doctor Dee's Diary.') In the play of the ' London Prodigal,' Civet says his father wore " a mocado coat, a pair of sattin sleeves, and a sattin buck." It was probably a mixed stuff of silk and wool, the silk predominating in the finer manufacture.

MODESTY BIT or *PIECE.* In a review of the female dress, in the ' Weekly Register,' 10th July, 1731, it is observed, " Sometimes the stomacher almost rises to the chin, and a modesty bit serves the purpose of a ruff ; at other times it is so complaisant as not to reach half-way, and the ' modesty ' is but a transparent shade to the beauties underneath." In the ' Guardian ' we are told that " a narrow lace which runs along the upper part of the stays, before being a part of the tucker, is called the ' modesty piece.' " " Modesty bits—out of fashion " is an announcement in the ' London Chronicle,' vol. xi., 1762.

MOILE. See SHOE.

MOKADOR, MOCKETER, MOCKET. A napkin, handkerchief, or bib. (Cotgrave ; Halliwell.)

> " Goo hom, lytyl babe, and sytt on thi moderes lap,
> And put a mokadoi aforn thi brest,
> And pray thi modyr to fede the with the pappe."
> *Twentieth Coventry Mystery.*

> " For eyne and nose the needeth a mokadour."
> Lydgate, *Minor Poems.*

(See MUCKINDER.)

MONMOUTH CAP. Mr. Fairholt says the Monmouth cap was worn by sailors, as appears from the following quotation in the notes to the last edition (Collier's) of ' Dodsley's Old Plays :'—

> " With Monmouth cap and cutlace by my side,
> Striding at least a yard at every stride,
> I'm come to tell you after much petition
> The Admiralty has given me a commission."
> *A Satyre on Sea Officers.*

But D'Urfey, in ' A Ballad on Caps,' printed in his ' Pills to purge Melancholy,' distinctly appropriates " the Monmouth cap " to the soldier, and " the thrum cap " to the sailor. (See p. 78 *ante.*) It must be remembered, however, that before the reign of George II. there was no regular uniform for the navy ; that naval commanders wore scarlet in the reign of Queen Elizabeth, and were armed like the military, while their ships' companies were sometimes clothed in the colours of their captains.

MONT-LA-HAUT. (*Monté-la-haut*, French.) "A certain wier that raises the head-dress by degrees or stories." ('Ladies' Dict.,' 1694.)

> " Monté-la-haut and palisade."
>
> Evelyn, *Voyage to Maryland.*

MORDAUNT. (*Mordant*, French ; *mordeo*, Latin.)

> " The mordaunt, wrought in noble gise,
> Was of a stone most precious."
>
> Chaucer, *Romaunt of the Rose.*

Mr. Fairholt, misled by the context, defines this " the tongue of a buckle ;" but there is nothing in the original French romance to justify it. Guillaume de Lorris, in describing the girdle of Riches, says,

> " La boucle d'un pierre fu
> Grosse et de moult grand vertu ;"

adding—

> " D'autre pierre fut le mordans ;"

not of the buckle, but of the girdle. "MORDANT—bout de métal fixé à l'extremité de la ceinture opposé à la boucle et qui facilitait l'introduction de la courroie ou de la bande d'étoffe à travers le passant de cette boucle." (Viollet-le-Duc.) The chape of the belt or girdle (see CHAPE). These metal terminations were sometimes of the finest workmanship, and richly ornamented with jewels. In all cases they were made heavy enough to keep the pendent portion of the girdle straight and steady in its position (see GIRDLE). The *tongue* of a buckle in French is *ardillon*.

MORIAN, MORION, MURRION. A head-piece of the sixteenth century, introduced by the Spaniards, who had copied it from the Moors, to the rest of Europe about 1550.

It is mentioned in the statute of the 4th and 5th of Philip and Mary, repealing all other Acts respecting keeping armour and horses.

Meyrick says the Spaniards added the peaks that came up before and behind about the commencement of the reign of Elizabeth, during which several alterations in its shape took place (see woodcuts below, from Meyrick Collection).

Morions. *Circa* 1560.

The morion was worn as late as the reign of Charles I.

High-combed Morions. 1570–1600.

MORNE, MORNETTE. The head of a tilting-lance used for jousts of peace, the point being rebated or turned back, to prevent injury to the knight's opponent.

"He who breaketh his spear morne to morne."

Regulations for the Justes at Westminster,
12 Feb. 1 Henry VIII. Heralds' Office.

MORNING STAR. See HOLY-WATER SPRINKLER.

MORRIS PIKE. See PIKE.

MORSE. (*Mors*, French.) The clasp or brooch which fastened the cope on the breast. Some most sumptuous examples exist in private collections, and have been engraved in various works. It was not specially distinguished except in size from the clasps and brooches used to fasten the mantles of princes, or other lay personages of distinction ; but the term "morse" or "mors" (from *mordre*, French ; *mordere*, Latin) is always applied to the ecclesiastical ornament. The subjoined engraving is from a magnificent specimen in the collection of the late Lord Londesborough. It is of silver gilt and enamelled, elaborately designed, and profusely ornamented with sapphires, rubies, pearls, and other jewels. A section (of the full size) is given of it to show the high relief of the workmanship, also the under part displaying the pln and the screws which hold on some of the ornaments. It varied in shape like other brooches ; but its most ordinary form was circular.

Morse. From the Collection of the late Lord Londesborough. Interior of same.

MOTON. A piece of armour used in the reigns of Henry VI., Edward IV., and Richard III., which appears to have been intended to protect the right arm-pit. The term occurs in the particular of the 'Abiliments for the Justiss of Pees,' among which are enumerated "a rerebrace, a moton." (Lansdowne MS., 285.) "The moton appears to have been a long plate terminated at top by a curve of peculiar form." (Meyrick, Glossary to 'Crit. Inquiry.') It is discernible in the brass of Richard Quartermayne, 1460, and the effigy of Sir Thomas Peyton, 1482. (See p. 139.)

Moton. From effigy of Sir Thos. Peyton.

MOULINET. See page 11.

MOUSTACHE. See HAIR.

MUCKINDER. A pocket handkerchief, also called a *muckinger* or a *merckiter.* (See MOKADOR.)

MUFF. Mr. Fairholt says the muff "does not appear in France before the time of Louis XIV., and was thence imported into this country *temp.* Charles II. ;" but if the reader will turn to page 226 of this work, he will have ocular proof of its being known here in the reign of Elizabeth, Gaspar Rutz having engraved the figure of an English lady of quality with a small muff pendent to her girdle, in a work published in 1588; and M. Quicherat testifies to their being a novel object in France in the reign of Henri Trois, 1574–1589, when, he observes, they could not create a name for it, "puisque celui de *manchon* désignait auparavant et désigna longtemps encore après, les manches qui n'allèrent que jusqu'au coude." The early muffs were made of satin or velvet, lined and trimmed with fur. They appeared, as we see, almost simultaneously in England; and at page 227 of this work will be seen the copy of an engraving by Hollar of an English gentlewoman of the reign of Charles I. with a muff entirely of fur. Annexed are copies of two muffs from engravings by Hollar—

Muff. Drawn by Hollar.

Muffs. *Temp.* William III.

Muff. Drawn by Hollar.

one particularly curious. In the reign of his son Charles II. we find the muff used by men, and *that* fashion may possibly have been introduced from France in his time. In the following reign they were small, hung round the neck by a ribbon, and ornamented with a bow in front. (See page 110.)

In a ballad describing the fair on the Thames during the great frost in 1683–4, a barrister is spoken of as

"A spark of the bar, with his cane and his muff."

Leopard-skin muffs were worn in 1702. (Malcolm, 'Manners and Customs.') In No. 16 of the 'Spectator,' A.D. 1710, the writer informs the public that he has received a letter desiring him "to be very satirical upon the little muff now in fashion." The late Mr. Crofton Croker had in his curious collection some tapestry of the latter half of the seventeenth century in which two muffs were represented, one apparently of yellow silk edged with sable, the other of ermine with a blue bow. Fairholt has engraved them. (See woodcuts above.) They are such as have lately been much in fashion. Feathered muffs are mentioned in Anstey's 'New Bath Guide,' and were in great vogue during the reign of George III. Mittens are called "muffs" in Yorkshire (Halliwell), whence

MUFFETEE. "A small muff worn over the wrist. Various dialects." (Halliwell.) A mitten of fur or worsted. "Scarlet and Saxon green *muffetees*" are mentioned as worn by men in a satirical song on male fashions *temp.* Queen Anne. (Fairholt.)

MUFFLER. "The term is connected with the Old French *muser* or *muzer*, to hide, or with *amuseler*, to cover the *museau* or *muffle*—a word which has been indiscriminately used for the mouth, nose, and even the whole of the face; hence our word *muzzle*." (Douce, 'Illustrations of Shakespere.') "A kerchief or like thing that men and women used to weare about their necke and cheekes; it may be used for a muffler." (Baret, 1580.)

"Now is she barefaced to be seen, straight on her muffler goes."
The Cobbler's Prophecy, 1594.

"I spy a great peard under her muffler."
Shakespere, *Merry Wives of Windsor,* act iv. sc. 2.

The muffler is alluded to as early as the middle of the fifteenth century in Scotland. By a sumptuary law of James II., contemporary with our Henry VI., A.D. 1457, it is ordered "that na woman cum to the kirk nor mercat with her face mussaled, that sche may nocht be kend, under the pane of escheit of the curchie," *i.e.* forfeiture of the kerchief or muffler. The practice lasted to the reign of Charles I.

Subjoined are examples of the time of Henry VIII. and of James I., the former from the picture of the siege of Boulogne, 1544, formerly at Cowdray, Sussex, and the latter from Speed's maps to his 'Theatre of Great Britain,' printed in 1611.

Muffler. *Temp.* Henry VIII.

Muffler. *Temp.* James I.

MURREY. Mulberry colour. (See page 343.)

MUSLIN. A fine fabric of Eastern manufacture, first made at Mousull, Turkey in Asia, whence, according to Marco Polo, it derived its name. It was much in request for ladies' dresses, aprons, and neckerchiefs, and men's neckcloths, at the close of the seventeenth century. "7 muslin aprons" and "j plain muslin head" are amongst the entries in the account of Mrs. Archer's clothes, 21st November, 1707, so often quoted. "Three new muslin India half handkerchiefs spotted with plated silver" are mentioned in an advertisement in 1731, quoted by Malcolm ('Manners and Customs,' vol. ii.).

MUSQUET. A long, heavy matchlock gun, introduced from Spain, and which eventually displaced the harquebus. The Chevalier Brantôme records that musquets were first used in the

North of Europe by the soldiers of the Duke of Alva against the Flemings in 1568: "Il fut le premier qui leur donna en mains les gros mousquets et que l'on vit les premiers en la guerre et parmi les compagnies," and adds that they very much astonished the Flemings, who had never seen them before—"non plus que nous" (the French)—and that those who were armed with them were called "mousquetaires." (Œuvres, tome iv.) From the same source we learn that it was Philip Strozzi, Colonel-general of the French infantry under Charles IX., who in 1573 first introduced the musquet to France; that he had great difficulty in inducing the soldiers to use it, and in order to do so had one always carried by a servant for himself at the siege of Rochelle in that year. "I and many who were with me" (says Brantôme) "saw the said M. de Strozzi kill a horse with his musquet at a distance of five hundred feet." The musquet, like the caliver, had a curved stock if of French manufacture; but the Spanish musquet had a straight stock, which Sir Roger Williams prefers: "For the recoyling, there is no hurte, if they be straight-stocked, after the Spanish manner; were they stocked crooked, after the French manner, to be discharged on the breast, fewe or none could abide their recoyling: but being discharged from the shoulder, after the Spanish manner, there is neither danger nor hurte." ('Brief Discourse of War.')

Brantôme was, however, not of that opinion, and takes credit to himself for having suggested the curved stock.

The English musquet seems to have been straight-stocked, like the Spanish. Below is an engraving of one of the time of Elizabeth, formerly in the Meyrick Collection. It weighed twenty pounds. (See SNAPHAUNCE and WHEEL-LOCK.)

English Musquet, *temp.* Elizabeth. From Meyrick Collection.

MUSQUET-REST. The weight of the musket rendered it necessary to have some support when fired. The musketeer therefore carried a staff with a forked head, which he stuck into the ground before him and rested his piece upon it, obtaining at the same time a steadier aim.

The musquet-rest had "a string which, tied and wrapped about his wrist, yielded him commoditie to traine his staffe after him, whilst he in skirmis charged his musket affresh." ('England's Trainings,' 1619.) The subjoined figures show the rest and the mode of carrying and using it.

Musqueteer. Sydney Roll, 1586

Early form of rest
From Hewitt,
Plate XII.

Musqueteer. Jacob de Gheyn, 1607.

Musqueteers. From Jacob de Gheyn.

MUSTARDE VILLARS. " In the nineteenth year of King Henry VI. there was bought for
an officer's gown two yards of cloth coloured 'mustard villars,' a colour now out of use, and two
yards of cloth coloured blew, price two shillings the yard." (Stow's 'Survey.') Mustarde villars has
been said to be a corruption of *moitié velours,* and Halliwell describes it as " a kind of mixed grey
woollen cloth," and consequently signifying the species of stuff. But Stow speaks of it here as a colour
distinctly. A town called Moustier de Villiers, near Harfleur, is mentioned by the historians of the
reign of Henry V. in their accounts of his expedition, and most probably gave its name to the colour
of the cloth there manufactured. That mustard colour cloth was much used for official dresses and
liveries in the fifteenth century is, however, undeniable. (See ROBE.)

MUSTILLER. This word occurs in a tournament statute of the reign of Edward I. : " E que
tuz les baneors que baners portent soient armez de mustilers et de quisors et de espaules et de
bacyn sanz plus." Hewitt calls it " a doubtful word," and Meyrick considers it to have been
" a species of bastard armour for the body, and probably composed of a quantity of wool just sheared
from the sheep "—a sort of gamboised armour. Fairholt copies Meyrick without comment. Why of
wool *just sheared* from the sheep ? Why of wool at all ? There is nothing in the word or in the
context to suggest wool or any material whatever. As to the suggestion that " mustiller " may be a
corruption of " mustarde villars," a cloth just described, I think that is disposed of by the fact that
the word *mustella* in Latin is a weasel ; and Ducange, under *Mostayla,* quoting a charter dated 1317, has
" tertia mensis præteriti fecit carricari lxii. giaras alquitrani et tria pondera de mostayla. An *mustela*
seu *mustelinæ pelles ?* nostris olim *moustoille* vel *moustele* pro *mustela. Belette." Mustelinus* signifies
" of or like a weasel," and *mustelinus color* " a tawny or yellowish colour ;" but a man could not
be armed with a colour. I think, however, that the fur of the weasel—much worn in the Middle
Ages—had more to do with the article in question than the wool of the sheep.

No one appears to have met with a recurrence of the word, which might have furnished us with
some clue to its derivation.

MUTCH. An old woman's close cap. (Fairholt.)

APKIN. A pocket-handkerchief was commonly so called in the sixteenth century, and is still called a pocket-napkin in Scotland and the north of England. (Halliwell; Ray; C. Knight, note to 'Othello.')

> "Your napkin is too little."
> *Othello,* act iii. sc. 2.

Mr. Knight shows that it was also used to signify a woman's neckerchief as recently as the Scotch proceedings in the Douglas cause, in which we find a lady described as constantly dressed in a hoop, with a large napkin on her breast. (Warner's 'Plan of a Glossary to Shakespeare,' 1768.)

NASAL. The bar or portion of a head-piece which protected the nose. (See ARMOUR, CASQUE, HELM.)

NECKCLOTH. The successor of the cravat, for which, indeed, it was but another name. (See CRAVAT.) In the inventory of a lady's wardrobe, 1707, occur entries of "2 neckcloths," "j white & gold neckcloth," which the lady no doubt wore with the "wastcoate," and the "cloth coat w^th a gold lace," when she "did ride abroad" in the masculine habit so fashionable amongst the fair equestrians of that period. Thomas Taylor, a youth who wandered from his home in 1680, is said in the advertisement describing his dress, to have worn "a lace neckcloth."

NECKERCHIEF, NECK-HANDKERCHIEF. I have already, under HANDKERCHIEF, sufficiently commented on the misappropriation of the term "kerchief," *i.e. couvrechef,* which, although the word is so distinctly significant of a covering for the head, has unaccountably been made to do duty for the hand and the shoulders. In the latter sense it is the successor of the falling-band and the partlet, and was denominated a "whisk" and a "napkin" in the last century (see those words). Neck-handkerchief was also used, within my recollection, to signify a man's neckcloth.

NECKLACE. An ornament of the fair sex of every race from the earliest ages (see GENERAL HISTORY). In these islands we find the British women wearing necklaces of jet, ivory, and amber, beads, shells, Kimmeridge coal, &c. Subjoined are two examples of these primitive decorations. I. Necklace of gold links hooked together, found near New Grange, co. Meath, Ireland, from the Londesborough Collection. 2. Necklace of Kimmeridge coal, found in Derbyshire. (See also under TORQUE.)

The headrail of the Anglo-Saxon ladies deprives us of graphic illustration of such personal ornaments; but we have written testimony of their use of them. In the old Anglian law, ornaments for the arms, hands, and neck are mentioned, and a mother was empowered by that law to bequeath to her son land, slaves, and money; and to her daughter, *murænas* (necklaces), *nuscas* (nouches?), *monilia* (collars), *inaures* (ear-rings), *vestos* (garments), *armillas* (bracelets), "vel quidquid ornamenti proprii videbatur habuisse." (Lindinbrog, 'Codex Legum,' p. 484.)

In Brithric's will, a necklace (neck-bracelet) of gold is valued at forty maneusa, about five pounds sterling. (Hickes, 'Diss. Ep.,' p. 51.) Golden vermiculated necklaces are mentioned in Dugdale'

Gold Necklace. From the Londesborough Collection.

'Monasticon.' We see and hear little of the personal ornaments of the Anglo-Norman ladies till we

Necklace of Kimmeridge coal.

reach the thirteenth century, excepting always the rich brooches which fastened the tunic or the mantles. Even in the minute account of the decoration of the statue of Galatea by Pygmalion, in the 'Roman de la Rose,' amongst all the goldsmiths' work and jewellery recorded there is no mention of a necklace. (See CHEVESAILLE.) Turning to the indisputable authorities preserved to us in the grand series of sepulchral effigies and brasses of the Middle Ages, it is observed by Mr. Fairholt, that the earliest ornament for the neck perceived upon them is a simple double chain of gold, like that worn by the wife of Sir Humphrey Stafford (1450) in Bromsgrove Church, Worcestershire, engraved by Hollis. The brass of Lady Say (1473) in Broxbourne Church, Hertfordshire, presents us with a magnificent example (see p. 275). Margaret, queen of James III. of Scotland, in the curious painting at Hampton Court—executed, it is presumed, between 1482 and 1484—has on a necklace composed of a double row of pearls, connected by oval-shaped jewels, attached to which is a trefoil in goldsmiths' work set with rubies, and having a large pear-shaped pearl pendent. During the reigns of Henry VII. and Henry VIII., there is a return to the neck-bracelet, or collar fashion (see CARCANET); but chains of gold or strings of pearl are also worn, with crosses or other ornaments appended to them. Queen Elizabeth, in her portrait by Hilliard, has a superb necklace of jewels, with large pear-shaped pearls

Queen Margaret.

depending from it at intervals; in addition, she wears two fine chains of gold. In the better known portrait of her by Isaac Oliver, in the dress she wore on the occasion of her state visit to St. Paul's, to return thanks for the defeat and dispersion of the Spanish Armada, and in that by Zucchero, she is depicted with several strings of pearls, some hanging below the waist. A similar fashion is observable in the portrait of Queen Anne of Denmark. The great passion for jewellery in neck ornaments appears to have declined from the beginning of the seventeenth century, on the Continent as well as in England. A single string of pearls without a pendant is the only decoration of the fair

necks of the beauties of Charles II., who appear to have considered the liberal display of their personal charms rendered needless "the foreign aid of ornament," and that "when unadorned"—I had nearly written "undressed"—they were "adorned the most."

Jewels from that period were scarcely ever worn, except on state occasions, in such profusion as they are at present. Examples of the most elaborate pendants to necklaces of the Middle Ages are given on Plate XIV. (See PENDANT.)

NEGLIGÉE. A loose open gown, worn by ladies, introduced about 1750. Malcolm ('Manners and Customs,' vol. v. p. 336) quotes an advertisement in 1751, of a lost trunk, containing, amongst other articles, "A scarlet tabby negligée, trimmed with gold; a white damask negligée, trimmed with a blue snail blond lace, with a petticoat of the same," and "a silver brocade negligée, trimmed with pink-coloured silk."

NETHERSTOCKS. See STOCKING.

NICED. "A breast cloth; a light wrapper for the bosom or neck." (Halliwell, 'Dictionary of Archaic Words.')

NIFELS. Mentioned in Act of the 3rd of Edward IV.: "No person in any part of these realms shall sell lawn, nifels, wimples, nor any other sort of coverchiefs, whereof the price of the plits shall exceed the sum of ten shillings." Mr. Strutt says in a foot-note, the word is spelt "nyefles" in the old translation, and suggests it was "probably a sort of veil." ('Dress and Habits,' vol. ii., Part 5.)

NIGHTCAP. See CAP, NIGHT, page 81.

NIGHT-RAIL. A night-dress for ladies. The old term for a night or bed gown (see page 230). "Books in women's hands are as much against the hair, methinks, as to see men wear stomachers or night-railes." (Middleton, 'Mayor of Quinborough,' act iii. scene 2.) Halliwell, who quotes this passage, says: "Mr. Dyce absurdly explains it (night-rail) night-gown," and tells us it was "a sort of veil or covering for the head, often worn by women at night,"—a definition which he supports by referring to Howell, who has "A night-rail for a woman, *toco* de muger de noches." To which he might have added from Cotgrave, "A night-raile (for a woman), pignon, pinon;" which certainly could not signify anything but a head-tire. Against this we have the evidence adduced by Mr. Fairholt, who, from a very rare print in his collection, representing a lady placed in the stocks for wearing one in the day-time, quotes the following lines, inscribed beneath the figure:—

> "The night-raile,—'tis a cunning, subtle thing;
> In summer it's coole, in winter heat doth bring.
> What! Same thing hot and cold? Strange paradox!
> Can that be thick that's thin? 'Tis heterodox.
> Yet will this lady have it orthodox.
> Wherefore we'll fairly put her in the stocks.
> Ladies, beware! From pride this errour came,
> So sure as chalk and cheese are not the same."

To this Mr. Fairholt adds, "In front of the lady stands a little girl, whose figure I engrave, as *it exhibits this peculiar fashion so well.* The lady appeals to her, 'Little miss, what say you?' She is too young to conceal discomfort for fashion's sake, and honestly answers:

> "'Madam, my night-raile gives no heate.
> You say yours does; 'tis but a cheate.
> Therefore pray, madam, keep your seate.'"

Now, there is nothing whatever in the above lines which gives us the least intimation of what a night-

rail might be. The description, such as it is, would apply to a cap as well as a gown, to a cloak as well as a petticoat ; but the engraving of the little girl, which is here copied, is certainly in favour of Mr. Dyce's definition. I can myself remember women wearing such a sort of dress at their toilets, and, when invalids, sitting up in their beds in it to receive visitors. Massinger, in 'The City Madam,' 1659, alludes to the latter custom :

> " Sickness feigned,
> That your night-rails at forty pounds apiece
> Might be seen with envy of the visitants."

Forty pounds at that time was a large sum to pay for a night-rail, whatever it might be, and we are not enlightened on that point, though the cost was un-doubtedly owing to the rich lace with which it was ornamented. "A laced night-rail and waistcoat" are advertised as lost in the 'London Gazette,' 20th July, 1682 ; and "Lost from behind a hackney coach (in) Lombard Street, a grounded lace night-rail," is in the 'London Gazette,' 8th August, 1695. Of a plainer sort is the one alluded to in the following line :—

> " Her gown was new-dyed and her night-rail clean."
> T. D'Urfey, *Twangdillo.*

Night-rail.

But, singularly enough, we are still left in the dark by these extracts as to the exact character of the night-rail, and can only point to the engraving of the " little miss " in Mr. Fairholt's rare print as a probable representation of it. Unfortunately he has not given us the figure of the lady, to account for whose punishment he refers to the following extract from Walker's 'Historical Memoirs of the Irish Bards :'—" Amongst many other ridiculous fashions that prevailed in this country since the days of Queen Anne was that of the ladies wearing bed-gowns in the streets about forty years ago. The *canaille* of Dublin were so disgusted with this fashion, or perhaps deemed it so prejudicial to trade, that they tried every expedient to abolish it. They insulted in the streets and public places those ladies who complied with it, and ridiculed it in ballads. But the only expedient that proved effectual was the prevailing on an unfortunate female who had been condemned for a murder to appear at the place of execution in a bed-gown." Walker's history was printed in 1818, and he speaks of this fashion as raging " *about forty years ago.*" That would place it in the reign of George III., *circa* 1778. Mr. Fairholt's print appears to have been of the reign of Queen Anne by the costume of the figure. The bed gown of which Walker speaks has to be identified with the night-rail of 1689 and 1695 before we can venture to consider the above anecdote as illustrative of the article in question.

NOUCH. See OUCH.

NOVATO. A stuff mentioned by Taylor the Water-poet, in his ' Praise of Hempseed.' (See page 370, under MOCHADO.)

CULARIUM. The aperture for sight in a head-piece. (See HELM, HELMET, SALADE.)

OLDHAM. A cloth of coarse construction, originally manufactured at the town of that name in the county of Norfolk. It was known in the time of Richard II.

ORARIUM. A scarf affixed to the pastoral staff as early as the thirteenth century. It was also called the " sudarium," being used for the same purposes. Annexed is an early example from an effigy of a bishop in the Temple Church, London, and another, in which the scarf is neatly plaited round the staff, from a copy of a curious painting of Abbot William de Bervold, which was formerly in the church of Wood Bastwick, county of Norfolk, but which was unhappily destroyed by fire in 1707. The term " orarium " was also applied to the stole and to the border of an ecclesiastical vestment.

OREILLETTES. (*Oreille*, French.) Ear-pieces attached to the casques of the fifteenth and sixteenth centuries. Some were fastened to it by a hinge, which enabled the wearer to turn them up if he desired to do so. (See page 85 for several varieties.)

ORLE. The wreath or torse which encircled the crest, composed ordinarily of silk of two colours twisted together, and representing the principal metal and tincture in the wearer's armorial bearings. In modern heraldry the crest is always placed upon a wreath, or what is at least intended to represent it.

ORPHREYS. (*Aurifrigium*, Latin.) Gold embroidery. Menage derives the Latin *aurifrigium* from *aurum Phrygium*, ascribing to Phrygia the invention of such embroideries. The women of England were celebrated in the earliest Saxon times for their skill with the needle. The art of embroidering seems to have been a portion of the education of girls of the highest rank. The four daughters of Edward

From effigy of a bishop in the Temple Church, London. From a portrait of Abbot de Bervold.

the Elder are highly praised for their productions; and Edgitha, the wife of the Confessor, was pre-eminent in her needlework. (Malmesbury, lib. ii.) Nor were such eulogiums confined to native historians. The Saxon embroideries were highly esteemed and eagerly bought on the Continent, where they obtained the name of "Anglicum opus." "Anglice nationis femine multum acu et auritexturâ egrigie viri in omni valent artificio." ('Gestis Gulielmi Ducis Norm. et Regis Angl.,' p. 211.) In the 'Chronicle of Casino' it appears that the jewelled work termed "Anglicum opus" was, at the commencement of the eleventh century, in high esteem even in Italy (Muratori, 'Script. Ital.,' iv. 360); and in the time of Boniface VIII., about the year 1300, are mentioned "v aurifrigia, quorum iij sunt de opere Cyprensi nobilissimo et unum est de opere Anglicano," &c. "Orfrey of a Westymont" (vestment). ('Prompt. Parv.') The word "opus," though signifying embroidery generally, was applied to the separate ornamental portions of clerical costume—the apparel of the alb, the amice, &c.—which could be detached from the vestment when it required washing, and were sewn on again when it was returned, or used at pleasure with the vestment of colour suitable to the day. Nor was it always of gold, though originally so, and *ouvré* in French signifies "wrought, figured, flowered."

> "Et un chapeau d'orfrays est neuf.
> Le plus beau fut de dix-neuf,
> Jamais nul jour vu, je n'avoye,
> Chapeau si beau *ouvré de soie*."
> *Roman de la Rose.*

The old romances teem with allusions to it:

> "Bien fu vestue d'une paille de Biterne
> Et un orfrois a vous dessus sa teste."
> *Roman de Garin.*

> "Vestus moult noblement de sendaus et d'orfrois."
> *Ibid.*

> "Vestus de samis et d'orfrois."
> *Philip Mousques.*

(*Vide* Ducange *sub* Aurifrigia et Auriphrygicum, also Way's note to *Orphrey* in 'Promptorium Parvulorum.')

ORRICE. Gold or silver lace, constantly mentioned in descriptions of dresses at the beginning of the eighteenth century.

OSNABURGH. "A coarse linen, manufactured at and named from that province in Hanover." (Fairholt.)

OUCH or NOUCH. An ornament of the brooch kind. Mr. Tyrwhitt, in his Glossary to Chaucer, considers that nouch is the true word, and ouch a corruption; "nurchin," in Teutonic, signifying a fibula, clasp, or buckle. Such may certainly have been the original form of the word; but both terms are used so indifferently by the same writer that it is a moot point which is to be preferred.

In the 'Clerk's Tale' Chaucer says:

> "A coronne on her head they han y-dressed,
> And sette her full of *nouches* great and small."

While in his 'House of Fame' he writes:

> "And they were set as thick of *ouchis*
> Fine, of the finest stones fair,
> That mene reden in the lapidaire."

In the inventory of the effects of Henry V. (Rot. Parl. 2 Henry VI.) occurs, " Item 6 broches et nouches d'or garniz de divers garnades pois 31*d.* d'or, pris 35*s.* ;" and in the 'Paston Letters,' under date 3rd April, 1469, we read, " Item, I send you the nouche with the dyamaunch (diamond) be the bearer hereof." At the same time we find

> " Of gyrdils and of browchis, of ouchis and rynggis,
> Pottys and pens and bollis, for the feast of Nowell."
>
> *MS. Lansdowne,* 416.

And Palgrave gives "OUCHE, a jewell, *bague.*" "Ouche for a bonnet, *afficquet, affichet.*" "The term, therefore," Halliwell observes, "seems to have been sometimes applied to various ornaments ;" and under NOUCH he says, "oftener spelt *ouche.*" (' Dict. of Archaic Words.')

ADUASOY. (*Soie de Padoue.*) A strong silk made at Padua, much used in the last century for ladies' dresses and gentlemen's coats. "A rose-coloured paduasoy mantua" was advertised as lost with other articles March 1731.

PALATINE. "That which used to be called a 'sable tippet,' but that name is changed to one that is supposed to be finer, because newer, and à la mode de France." ('Ladies' Dictionary,' 1694.)

PALET. "Armoure for the heed." (' Prompt. Parv.') A skull-cap made of leather or cuir-bouilli, whence originally the name. "Pelliris, galea ex coreo et pelle." ('Catholonicon.') "Pelliris, a helme of lethyr." ('Medulla Grammatices.') "Cassis, palette." (Vocab. Royal MS., 17 C 17.) Palet appears to have been a term adopted by us from the French : "Palet, sorte d'armure de tête" (Roquefort, 'Dictionnaire de la langue Romane.') Mr. Albert Way, who has diligently collected a mass of authorities in his note to the word in the 'Promptorium,' says, "It is not evident whether there was any distinctive difference between the palet and the kettle-hat ;" but an entry in the inventory of Sir Edward de Appleby, 48 Edward III., 1374, which he has himself quoted, shows, I think, that there was : "Item ij ketelhattes et ij paletes, pree vjs. viijd." The "*and* two palets" surely implies a distinction, which I am inclined to consider consisted in the former being at that period of steel, whatever might have been the material of which such head-pieces may originally have been made. The palet was not always of leather. A magnificent one of gold profusely jewelled is minutely described in an official record of the reign of Richard II.: "j palet d'or d'Espaigne qe poise en nobles ccccxxli. garn' ove gross baleys, perles, &c. ij jorves pur mesme le palet garnis ove saphirs, &c. j gross saphire, baleys et perles en le couwer du dic' palet ; xxxvj perles en iij botons, et ij claspes, pur mesmes le palet." ('Kalend of Exchecquer,' 22 Ric. II., 1398.) The entire value of this head-piece was estimated at £1708. In the inventory of the effects of Sir Simon Burley, beheaded in 1388, there is also mention of a palet of steel : "j paller (*sic*) de asser (acier) ;" and Charpentier cites a document dated 1382 in which a knight is described as armed in a haubergeon of steel, with "un palet *encamaillé* sur sa teste."

PALETTE is a term applied by Meyrick, Demmin, and other antiquaries, to the plates fastened in front of the arm-pits, to protect them at what is called "le defaut de la cuirasse," or "le vif de l'hauberk." Mr. Hewitt calls them "gussets of plate." They are of various forms, circular, oval, lunated, square, shield-shaped, &c., and, in some instances, secured to the armour by points (see Plate II. fig. 4 ; page 18, fig. 2 ; and page 19, fig. 3 ; also GUSSET.) They are first seen in England at the commencement of the fifteenth century (*temp.* Henry V.), and are found on suits of the reign of Henry VIII. Mathieu de Coucy, in his 'History of Charles VII. of France,' relates that at a joust in 1446, "l'Anglois frappa de sa lance le dit Louis tout dedans et au travers, sçavoir au dessous du bras et au vif de son harnais, par faute et manque d'y avoir un croissant ou gouchet." Mr. Hewitt,

who quotes this passage, refers us to an English example of crescent-shaped palettes or gussets, in the brass of a knight in South Kelsey Church, Lincolnshire, the date of which may be placed about 1420.

PALISADE. "A wire sustaining the hair next to the duchess or first knot." ('Mundus Muliebris,' 1690.)

PALL. (*Paille*, French, probably from *pallium*, Latin.) "Anciently *pallium*, as did *purpura*, signified in general any rich cloth." (Warton's 'History of English Poetry,' edit. 1840, vol. i. p. 169.)

> "The porter is proud withal,
> Every day he goeth in pall."
> *Minot's Poems*, 1352.

> "The knight off his mantille of palle,
> And over his wyfe he let it falle."
> *Lay of Sir Degrevant.*

And all are familiar with Milton's lines:

> "Sometime let gorgeous Tragedy
> In sceptred pall come sweeping by."

In the French romances we constantly meet with the word, *paile, palle, palie*, used in this sense. "Tyres et *pailes* d'outre mer." ('Roman d'Amile et Amis.')

> "Afublez d'un mantel sabelin,
> Ki fu cuvert d'un *palie* Alexandrine."
> *Chanson de Roland.*

> "Vestue fu d'un *palle* d'Aumarie."
> *Roman de Gaydon.*

PALLIUM. (Latin.) This word, which amongst the Romans signified "a cloak," was applied in the eighth century to a long band of white linen, about three fingers broad, which encircled the shoulders, the two extremities hanging down before and behind, as low as the bottom of the chasuble. It formed the distinctive ornament of an archbishop. Flodoard, in his 'History of Charlemagne,' tells us that Pope Zachary (741–752) sent the pallium to the metropolitans of Rouen, Rheims, and Sens. At first the pallium was sometimes ordered to be worn only on solemn occasions. Pope Leo IV. sent Archbishop Hinckmar a new pallium, with authority to wear it in ordinary, having previously conferred upon him one which he was only permitted to wear on certain particularized fête-days. The pallium was to be embroidered with four purple crosses before and behind, according to Durandus; but the number was occasionally exceeded. The pallium or pall forms a charge in the arms of the archbishopric of Canterbury. (See p. 148; also the figure of St. Augustine, p. 168.)

PALTOCK. This word occurs in an anonymous work of the fourteenth century, called 'Eulogium,' cited by Camden in his 'Remaines,' and appears to have been the name of some sort of jacket or doublet. "They have another weed of silk which they call 'a paltock.' Their hose are of two colours, or pied with more, which they tie to their paltocks with white latchets, called 'herlots,' without any breeches" (*i.e.* drawers). It would seem that the garment was introduced from Spain, during the reign of Edward III., and was most probably brought into fashion by the knights in the service of John of Gaunt, or Edward the Black Prince, whose communication with Spain was so frequent. *Paletoque* is a word still existing in the Spanish dictionary, and is rendered, "a kind of dress, like a scapular." The word seems compounded of *palla*, a cloak, and *toque*, a head-dress, which would induce a belief that the paltock had a hood or cowl attached to it; and Piers Ploughman, speaking of Antichrist, says, "With him came above a hundred proud priests habited in paltocks." It had either been originally, or it afterwards became, the dress of the common people, as *paleto*

signifies, in Spanish, "a clown," and the word *paletoquet*, in French, means "clownish." *Paletot* is also the modern, in French, for "an overcoat." Still we remain ignorant of the shape of the paltock. Cotgrave gives two contrary descriptions : 1. "A *long* thicke pelt or cassock." 2. "A garment like a *short* cloak with sleeves, or such a one as the most of our moderne pages are attired in." M. Quicherat, speaking of the paletot, says it was the huke "augmenté de manches volantes, laquelle huque depuis ce changement prit le nom de paletot." ('Hist. de Cost. en France,' p. 270.) But we have to be satisfied respecting the shape of the huke, before we can venture to add hanging sleeves to it.

PAMPILION. According to Sir Harris Nicolas, a sort of skin or fur, mentioned in the wardrobe accounts of Elizabeth, queen of Henry VII., and also in the privy purse expenses of Henry VIII. "A gown of black wrought velvet, *furred* with pampilion," was bought for Anne of Cleves. It is clear that the name must have been derived from some locality, and not from the animal which furnished the gown with its comfortable lining. There was a cloth called *papilloné*, much esteemed in France, as early as the thirteenth century.

PANACHE, PENACHE. (*Pennachio, penacho*, Spanish.) A group or tuft of feathers on the apex of the helmet or bascinet, a fashion introduced in the reign of Henry V., previous to which, they only appear as heraldic crests. The word "panache" is said to be generally used instead of "plume," for feathers placed upright on the helmet, the latter term being applied to them when worn behind it, as in later specimens, but there are exceptions ; for instance, Pegge, in his 'Anonymiana,' c. vii. p. 82 : "The pennach is a plume of feathers on a helmet. King Henry VIII., when he entered Bolenge [Boulogne], had one consisting of eight feathers of some Indian bird, and the length of each was four feet and a half. It was esteemed so valuable, as to have been a proper ransom for the king had he been taken." In this king's reign, the feathers were always worn at the back of the helmet, where a pipe was placed for their insertion. (See page 35 *ante;* also PLUMEHOLDER.)

Panache is said in the 'Ladies' Dictionary,' 1694, to signify also "any tassel of ribbons, very small." (See under POMANDER.)

PANES. The *dags* or slashes in doublets or other garments, made to show the under-dress, or lining of other coloured silk or rich stuff, which was drawn through them. The fashion, introduced towards the end of the fifteenth century, was carried to excess in the reigns of Henry VIII. and Elizabeth. "Hose paned with yellow drawn out with blue," are mentioned in 'Kind Hart's Dream,' 1592 ; and to "prank the breech with tissued panes," is spoken of as a custom by Bishop Hall, in his 'Satires,' 1598. Coryat, in his 'Crudities,' 1611, writing of the Swiss, who appear to have been the inventors of the fashion, says, "The Switzers weare no coates, but doublets and hose of panes, intermingled with red and yellow, and some with blue, trimmed with long puffes of yellow and blue sarcenet rising up within the panes."

PANTOBLES, PANTOFFLES. Slippers, according to Fairholt ; yet Stubbs, writing of ladies' shoes, seems to make a distinction. He says, "They have corked shoes, puisnets, pantoffles, *and* slippers."

"Give me my pantobles."
Peel's Play of *King Edward I.,* 1593.

"Rich pantibles in ostentation shown."
Massinger, *City Madam.*

In the inventory of Sir Thomas Boynton's effects, 1581, which I have previously quoted, occurs the following entry :—"Item, vi pare of velvet pantables, thre pare of lether pantables, ten pare of Spanish lether shoes, with other old shoes and pantables." "Pearl embroidered pantoffles" are mentioned as worn by ladies, in Massinger's play of 'The Guardian,' 1632 : act iii. scene 4.

PAROPA. A stuff mentioned by Taylor in his 'Praise of Hempseed,' in company with taffeta, mochado, and other mixed manufactures. (See page 370.)

PARTIZAN. (*Pertuisane*, French.) A weapon introduced in the reign of Edward IV. With respect to this weapon, Sir S. Meyrick remarks that the spetum and the ranseur (see those words) " are so nearly possessed of the same characteristics, viz. a blade with lateral projections, that if

Fig. 1. Fig. 2. Fig. 3. Fig. 4. Fig. 5.

Fig. 6. Fig. 7. Fig. 8.

Fig. 9.

we confine the word 'partizan' to the sense in which it was used in the sixteenth century, it might be retained for the whole. There exists, however, for our guidance a valuable though scarce work by Pietro Monti, printed at Milan in 1509, entitled 'Exercitiorum atque artis militaris Collectanea,' in which they are described with such minuteness, as well as named, that we have not that option." (Skelton, vol. ii.) The above examples are from the late Meyrick Collection.

Fig. 1 is a partizan of the time of Edward IV.; fig. 2, one rather later (*circa* 1500), answering Monti's description of it, who says that the blade, which greatly resembled that of an ancient sword, was not only pointed, but sharp on both edges; fig. 3, another of the reign of Henry VIII., the blade narrower and more sword-like, with lateral blades curving upwards. After this period the partizan, like the glaive, appears to have been unused in war, and borne only by the body-guards of princes, the blades being elaborately engraved and gilt. Fig. 4 is a German specimen of the time of our James I., made for the guard of Wolfgang Wilhelm, Elector Palatine of the Rhine. Fig. 5, one of the time of James I. and his son Charles I. Fig. 6 is a partizan of the guard of Alexander Farnese, Duke of Parma, 1586, contemporary with our Queen Elizabeth. It is elaborately engraved with the Duke's armorial bearings. Fig. 7 is one borne by the guard of Louis XIV., highly embossed and perforated, 1666; and fig. 8, German, of the time of William and Mary: it has upon it the arms of Mainz. Fig. 9, the point of fig. 7.

PARTLET. A neckerchief. The pedlar in Heywood's 'Four P.'s' speaks of it as an article of female attire. In an inventory of the reign of Henry VIII. there are entries of "two partlets of Venice gold knit, two partlets of Venice gold caul fashion; two partlets of white lawn, wrought with gold about the collars." The partlets are seen in numberless female portraits of the sixteenth century, beautifully embroidered with gold.

Minsheu has, " Partlet, mentioned in the statute 24 Henry VIII., c. 13, seemeth to be some part of a man's attire, viz., some loose collar of a doublet, to be set on or taken off by itself without the bodies, as the piccadillos nowadaies, or as men's bands or women's neckerchiefs, which are in some places, or at least have been within memorie, called partlets." "An old kind of band both for men and women." ('Ladies' Dict.,' 1694.)

PAS D'ÂNE. A species of guard for a sword in the sixteenth century. (Demmin.) See SWORD.

PASSAGÈRE. "A curled lock next the temples." ('Fop's Dictionary.')

PASS-GUARDS. Ridges on the shoulder-plates or pauldrons to ward off the blow of the lance. They first appear in armour *temp.* Henry VI. An early example is here given from the brass of John Dengayne at Quy, Cambridgeshire, *circa* 1460. (See also PAULDRONS.)

From brass of John Dengayne.

PATCHES. The absurd and hideous fashion of patching the face was introduced towards the close of the reign of Charles I. It is first spoken of by Bulwer in his 'Artificial Changeling,' 1650. "Our ladies," he says, "have lately entertained a vaine custom of spotting their faces out of an affectation of a mole, to set off their beauty, such as Venus had; and it is well if one black patch will serve to make their faces remarkable, for some fill their visages full of them, varied into all manner of shapes." To this account he appends an engraving, here reproduced, the extravagance of which would lead one to imagine it was an outrageous caricature, but that we have contemporary evidence that the draughtsman has made a faithful copy of his subject, for here is a verbal description of a fashionable lady in 1658 :

From Bulwer's 'Artificial Changeling.'

" Her patches are of every cut,
 For pimples or for scars.
 Here's all the wandering planets' signs,
 And some of the fixed stars,
 Already gummed to make them stick—
 They need no other sky."—*Wit Restored.*

And the coach and horses are specially alluded to by the author of 'England's Vanity, or God's Voice against Pride in Apparel,' 1683, who declares that the black patches remind him of plague spots, "the very tokens of death," and make him think that "the mourning coach and horses, all in black, and plying in their foreheads, stands ready harnessed to whirl them to Acheron; though," he adds, "I pity poor Charon for the darkness of the night, since the moon on the cheek is all in eclipse, and the poor stars on the temples are clouded in sables, and no comfort left him but the lozenges on the chin, which, if he please, he may pick off for his cold." It is astounding to think that so preposterous and unbecoming a fashion could endure for upwards of thirty years, and that even the men should have followed it. Glapthorne, in his 'Lady's Privilege,' 1640, says: "Look you, signor, if't be a lover's part you are to act, take a black spot or two. I can furnish you; 'twill make your face more amorous and appear more gracious in your mistress' eyes." In the 'Roxburghe Ballads' is a woodcut of a mercer of that period in his shop, offering his wares to his customers, his face being patched as ridiculously as the woman's engraved by Bulwer. In Queen Anne's time patches indicated the politics of the wearers. "About the middle of last winter," says the 'Spectator,' "I went to the Haymarket Theatre, where I could not but take notice of two parties of very fine women that had placed themselves in the opposite side-boxes, and seemed drawn up in a kind of battle array one against the other. After a short survey of them, I found they were patched differently; the faces on one hand being spotted on the right side of the forehead, and those of the other on the left. Upon inquiry I found that the body of Amazons on my right hand were Whigs, and those on my left Tories."

From the 'Roxburghe Ballads.'

PATRON. A case to hold pistol cartridges. Meyrick remarks: "It is curious that cartridges for pistols were of much earlier use than for larger hand-firearms, and that the patron or box to

Fig. 1.

Fig. 2.

hold them preceded cartouch boxes or pouches by an equal space of time. The former appear to have been known in the middle of the sixteenth century, about a hundred years before the latter." (Skelton's

'Eng. Spec.') Fig. 1 is a patron of steel, the ornamental parts inlaid with ivory, *temp.* Philip and Mary. It is represented open to show the wooden box with its six cylindrical apertures to hold as many cartridges. Fig. 2, one of steel, embossed, *temp.* Elizabeth. Both from the late Meyrick Collection. The word "patron" seems also to have been a name for these cartridges themselves, for Turner, in his 'Pallas Armata,' says: "Instead of these (bandoliers) let patrons be made such as horsemen use, whereof each musketeer should be provided of a dozen; these should be kept in a bag of strong leather or the skin of some beast well sew'd, that it be proof against rain. Thus he hath no more to do *but to bite off a little of the paper of his patron* and put his charge of powder and ball in at once." (P. 176.) It may therefore be a question whether the box gave its name to the cartridges or the cartridges gave theirs to the box.

PATTEN. The name was originally applied to the clog. The ringed patten is not older than the reign of Queen Anne, according to Fairholt; but the two lines quoted by him from 'Gammer Gurton's Needle,' a play of the sixteenth century, would induce one to believe that if not a ring, iron in some shape formed a portion of the patten of that period, as the clatter must have given rise to the saying his or her tongue runs on pattens, and the word is defined in the 'Ladies' Dictionary,' 1694, as "a wooden shoe with an iron bottom."

> "Had ye heard her how she began to scold,
> Her tonge it were on pattens, by Him that Judas sold."

The term occurs as early as the fourteenth century. "Their shoes and pattens are snouted and picked." ('Eulogium,' *temp.* Richard II.)

PAULDRONS. (*Paleron, espalleron,* Palgrave.) Shoulder-plates introduced in the reign of Henry VI. to cover the épaulières. (See ÉPAULIÈRES.) They will be best understood by the subjoined engravings.

Fig. 1 is from an effigy in Arkesdon Church, Essex, about 1440. Fig. 2, from brass of John Gaynsford, Esq., Crowhurst Church, Surrey, 1450. Fig. 3, from an Italian suit, 1484. Fig. 4, German suit, 1525. Figs. 5 and 6, right and left pauldrons of a fluted suit, 1535. Fig. 7, pauldron

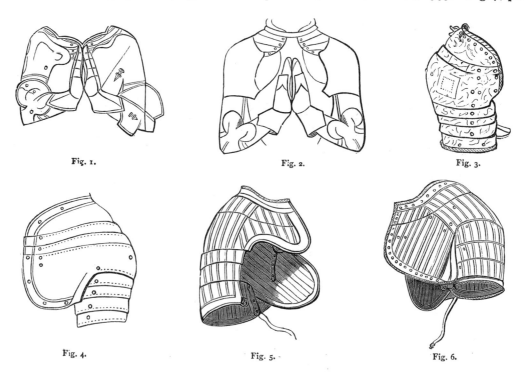

Fig. 1. Fig. 2. Fig. 3.

Fig. 4. Fig. 5. Fig. 6.

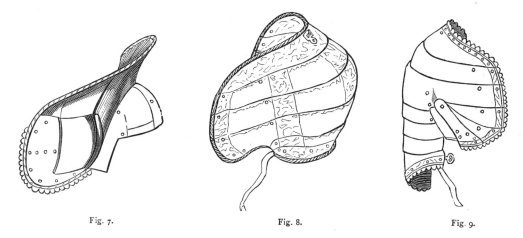

Fig. 7. Fig. 8. Fig. 9.

for left shoulder and pass-guard, all of one piece, about 1540. Fig. 8, pauldron for left shoulder, 1558. Fig. 9, pauldron for right shoulder, 1640. The seven last examples are from the originals formerly in the Meyrick Collection.

PAVADE. A long dagger.

> "Ay by his belt he bare a long pavade."
> Chaucer, *The Reeve's Tale.*

PECTORAL. A covering for the breast, either defensive or ornamental. The early Norman hauberks had pectorals of mail with borders of metal apparently gilt, and studs at the corners. (See ARMOUR.)

Pendant.

The term was also applied to the morse, to the front orphrey of the chasuble, and to the apparel on the breast of the alb and tunic. (Pugin, 'Glossary of Eccl. Cost.')

PELISSE. (From *pelles*, Latin ; *pelice*, *pelisson*, French.) A garment lined or trimmed with fur. King John orders a grey pelisson with nine bars of fur to be made for the queen.

PELLARD. Another name for the houpeland, according to Ducange : "*Pellarda*, pallie seu tunice species, nostris *houppelande.* Ital., *pelando.*"

Pendants.

PELLES. (Latin.) The general name for furs or skins.

> "Array'd with pellys aftyr the old gyse."
> *Twenty-fifth Coventry Mystery.*

PENDANTS, PENDULETS. The ornaments appended to necklaces, of which a splendid collection was made by the late Lord Londesborough, and is now in the possession of Lady Otho

Fitzgerald. (See Plate XIV., from engravings in the volume printed for private distribution by his lordship.)

PENISTONES. A sort of cloth, also called "forest whites," mentioned in statutes *temp.* Edward VI. and James I. (Ruffhead, vol. ii.)

PERIWIG. (*Perruque,* French.) According to Stow, the periwig was first brought into England about the time of the Massacre of St. Bartholomew; but as early as the first year of the reign of Edward VI. we find the following entries in a wardrobe account of articles required for the masques and revels: "8 coyffs of Venys gold w^th th^r perukes of here hanging to them, and longe labells of coloryd lawne : 5 coyffs of Venys golde with perukes of here." (Loseley MSS. p. 77.) They were worn by both sexes, and about 1595 they had become so much the fashion that it was dangerous for children to wander out of sight of their parents or attendants, as it was a common practice to entice them into some private place and deprive them of their hair for the manufacture of such articles. Bishop Hall, in 1598, relates an anecdote of a courtier who loses his periwig by a gust of wind, in lifting his hat to bow ('Satires'); and speaking of ladies, an author of the same date, quoted by Fairholt, describes one with

"Her sumptuous periwig, her curious curles."
Micro-cynicon, 1599.

The periwig of the sixteenth century was, however, nothing more than false hair worn by men and women, as in the present day, and the terms "periwig" and "peruke" were applied to a single lock or a set of ringlets. In a letter of Knollys to Cecil, published in Chalmers' 'Life of Mary Queen of Scots,' we read that "Mary Seaton, who is praised by this queen as the finest busker, that is to say, the finest dresser of a woman's head of hair that is to be seen in any country yesterday and this day she did set a curled hair upon the queen *that was said to be a perewyke,* that showed very delicate." The words I have italicised would seem to indicate that the fashion was a novelty at that date in Scotland. The wigs worn by actors were called periwigs. Shakespere makes Hamlet describe an actor as "a robustious, periwig-pated fellow," and in his comedy of 'The Two Gentlemen of Verona' Julia says :

"Her hair is auburn, mine is perfect yellow :
If that be all the difference in his love,
I'll get me such a coloured periwig."
Act iv. sc. 4.

In the verses against the 'Gentlewomen of Sicilia,' by Robert Green, A.D. 1593, are the following lines :

"Hair by birth as black as jet, what art can amend them ?
A periwig frounced to the front or curled with a bodkin."

And W. Vaughan, in his 'Golden Grove; Moralized in Three Books,' 1600–1608, speaks of periwigs being worn by women. It is not till we arrive at the time of Charles II. that we meet with the long wigs with which the pencil and the burin have made us so well acquainted, and of which many examples will be found in these volumes. (See pp. 110, 115, 116, 143, 144, 145.)

Duke of Marlborough. From portrait by Kneller.

Sir John Hawkins tells us, combing the peruke at the time when men of fashion wore large wigs was, even at public places, an act of gallantry. The combs for this purpose were of a very large size, of ivory or tortoiseshell, curiously chased and ornamented, and were carried in the pockets as constantly as the snuff-box at court. "On the Mall and in the boxes of the theatre, gentlemen conversed and combed their perukes. There is now in being a fine picture, by the elder Laroon, of John, Duke of Marlborough, at his levee, in which his Grace is represented dressed in a scarlet suit, with large white satin cuffs and a very long white peruke, which he combs,

1.2.3.4 From the Londesborough Collection.
5.6.7.8 From designs by Holbein. Brit. Mus.

while his valet, who stands behind him, adjusts the curls after the comb has passed through them."
('History of Music,' vol. iv. p. 447, note, 1777.) The custom is constantly alluded to in the plays of
Charles II.'s time, and continued till the reign of Queen Anne:

> " But as when vizard mask appears in pit,
> Straight every man who thinks himself a wit
> Perks up, and, managing his comb with grace,
> With his white wig sets off his nut-brown face."
>
> Dryden, *Prologue to Almanzor and Almahide.*

> " The gentlemen stay but to comb, madam, and will wait on you."
> Congreve, *Way of the World.*

That ladies, in the time of Charles II., wore the long wig in addition to the masculine habits
they assumed for riding, is vouched for by Pepys, in his amusing Diary, 1666. "June 11.—Walking
in the galleries at Whitehall, I find the ladies of honour dressed in their riding garbs, with coats
and doublets with deep skirts, just for all the world like mine, and buttoned their doublets up the
breast, with periwigs and with hats, so that only for a long petticoat dragging under their men's
coats, nobody could take them for women in any point whatever."

The wigs continued to increase in size till nearly the middle of the last century. Tom Brown,
describing a beau of his day, says, "His periwig was large enough to have loaded a camel."
('Letters from the Dead to the Living.') Several varieties, less cumbrous, were introduced, however,
during that period, called "travelling wigs" and "campaign wigs." Randle Holmes, in his 'Acci-

Campaign-wig.

Periwig with tail.

dence of Armory,' 1684, gives an engraving of the latter, which,
he says, "hath knots or bobs a dildo on each side, with a curled
forehead." He also gives an example of a periwig with a tail
and a plain peruke imitating a natural head of hair, and called
a " short bob."

The full-bottomed wig was worn by the learned professions
and those who affected particular gravity. Farquhar, in his
comedy of ' Love and a Bottle,' 1698, observes that " a full wig is imagined to be as
infallible a token of wit as the laurel."

"Perukes," says Malcolm, "were an highly important article in 1734. Those of right gray
human hair were four guineas each; light grizzle ties, three guineas; and other colours in proportion,
to twenty-five shillings. Right gray human hair cue perukes, from two guineas to fifteen shillings
each, which was the price for dark ones; and right gray bob perukes, two guineas and an half to
fifteen shillings, the price of dark bobs. Those mixed with horsehair were much lower. It will be
observed, from the gradations in price, that real gray hair was most in fashion, and dark of no
estimation." ('Manners and Customs,' vol. v. p. 333.)

In the reign of Queen Anne, in addition to very long and formally curled perukes, we hear of
black riding-wigs, bag-wigs, and nightcap-wigs. In the reign of George I., the famous battle of
Ramilies introduced the Ramilie wig, with a long, gradually diminishing plaited tail, called
the "Ramilie tail," which was tied with a great bow at the top and a smaller one at the
bottom. On the marriage of the Prince of Wales in 1736, "The officers of the horse and
foot guards wore Ramilie periwigs by His Majesty's order." (Read's 'Weekly Journal,'
1st May.) In the reign of George II. the tye-wig and the pigtail-wig have to be added
to the catalogue, and the bob-wig, first heard of in 1684, or one that was called after it,
is also spoken of. In 1742 Laurence Whyte observes that " bobs do supersede campaigns;"
and ten years later we read: " I cut off my hair and procured a brown bob periwig of
Wilding of the same colour, with a single row of curls just round the bottom, which I wore
very nicely combed and without powder." ('The Adventurer,' No. 101, 1753.)

Ramilie-wig.

In a poem quoted by Fairholt, entitled ' The Metamorphosis of the Town, or a View of the

Present Fashions,' printed in 1731, a country gentleman seated in the Mall exclaims to a London friend, who had pointed out to him some noble lords—

> "Lords call you them?
> As I live,
> The hair of one is tied behind
> And platted like a womankind !
> While t'other carries on his back,
> In silken bag, a monstrous pack.
> But pray what's that much like a whip,
> Which with the air does waving skip
> From side to side and hip to hip ?"

To which his friend replies—

> "Sir, do not look so fierce and big ;
> It is a modish pigtail-wig."

The pigtail in the next reign was sometimes tied up in a knot behind.

Pigtail-wig.

That ladies continued to wear wigs is clear from the fact that in 1682–3 the Princess Anne, the Countess of Pembroke, and several other ladies are described as having taken the air on horseback "attired very rich in close-bodied coats, hats and feathers, with short perukes" ('Loyal Protestant Intelligence,' March 13); also that in 1727, when King George II. reviewed the Guards, the three eldest princesses "went to Richmond in riding habits, with hats and feathers and periwigs." ('Whitehall Evening Post,' August 17, 1727.)

The periwig towards the middle of the last century lost much of its popularity and two-thirds of its name. Under the abbreviated appellation of "wig" it continued (and continues) to be worn by the higher orders of the clergy, the judges and members of the bar when in professional costume, the coachmen of the sovereign and some of the nobility, and a few elderly gentlemen ; but from the accession of George III. it ceased to be an indispensable adjunct to the daily dress of an Englishman.

PERREY. (*Pierrerie*, French.) Jewellery ; precious stones.

> "His mantell was of large entayle,
> Beset with perrey all about."
> Gower, *Confessio Amantis.*

PERSE. One of the many names for blue, indicating most probably some particular shade. Mr. Fairholt says, "sky-coloured *or* bluish grey," but gives no authority for his suggestions.

> "In sanguine and in perse he was clad alle."
> Chaucer, *Canterbury Tales.*

PERSIAN. A thin silk, used principally for lining coats, gowns, and petticoats, in the seventeenth century.

PETRONEL. A fire-arm, so called, according to President Claude Fauchet, from the French word *poitrinel,* because it was fired from the chest (*poitrine*), after the old manner. He says, it was a medium between the arquebus and the pistol ; and Meyrick, who quotes him, adds, " Much study and reflection has convinced me that it differed from the long dag merely in having its butt made broader, so as to rest in its position with proper firmness." ('Archæologia,' vol. xxii. p. 86.) Its resemblance to the dag, as he observes, is strongly hinted at in the play of 'Love's Cure ; or, the Martial Maid.' (See DAG.) Nicot, in his Dictionary, asserts that it was of large calibre, and, on account of its weight, carried in a broad baudrick over the shoulder ; but as "large" is a relative term, we must consider its application with reference to the long dag, or long pistol. (Meyrick, *ut supra.*) The petronel is mentioned in 1592, at the siege of Rouen by Henry IV. of France ; and in the

Hengrave Inventory, 1603, there is the following entry : " Item, iij pethernels." The annexed two examples are from the Meyrick Collection. Fig. 1, a wheel-lock petronel, *temp.* Elizabeth ; and fig. 2, another of the reign of James I.

Fig. 1.

Fig. 2.

PETTICOAT. (*Petit-cote*, French.) Literally, a little coat. We meet with this word first in an inventory of the apparel of Henry V., in which occurs an entry of a *petit* or *petite* coat of red damask ; but as it is described as having open sleeves, it must have been really a little coat, and had no affinity to its highly-honoured namesake. " Item, j petty cote de mayll" (mail), occurs in an inventory of armour taken in 1437. As late also as the reign of Henry VII., the petticoat appears amongst the articles of male attire. In a MS. of that date, entitled 'The Boke of Curtasye,' the chamberlain is commanded to provide against his master's uprising, " a clene shirte and breeches, a *pettycotte*, a doublette, a long cotte," &c. ; and the author of 'The Boke of Kervynge,' quoted by Strutt, says to a like personage, " Warme your soverayne his petticotte, his doublett, and his stomacher," &c., so that it is not till we arrive at the reign of Elizabeth that the petticoat appears in the catalogue of a lady's wardrobe, not, however, displacing the kirtle, but worn with it ; for that great *censor morum*, Stubbs, after telling us that the petticoats of the fair sex were in his day made of the best cloth and the finest dye, and even of silk, grograin, &c., fringed about the skirts with silk of a changeable colour, adds, " but what is more vain, of whatever the petticoat be, yet must they have kirtles—for so they call them—of silk, velvet, grograin, taffeta, satin, or scarlet, bordered with gards, lace, fringe, and I cannot tell what." And, unfortunately, he does not tell what these kirtles were like, or how they were worn with the petticoats. His expression, " for so they call them," would lead one to imply that the name of the mediæval garment had been transferred to some other article of attire,—a constant practice, and consequent source of confusion, as my readers must be already well aware. I have seen no painting or engraving which would enable me to distinguish the kirtle from the petticoat, or to affirm that the visible vestment is either one or the other.

The petticoat, however, survived the kirtle, or absorbed it, and was made of the richest materials the wearer could afford. In 'Eastward Hoe,' Girtred says, " My jewels be gone, and my gown, and my red velvet petticoat, that I was married in." (Act v. sc. 1.) Those of the noble and the wealthy were elaborately ornamented, and sometimes embroidered with pearls :

> " I will give thee a bushell of seed pearle
> To embroider thy petticoat."
> Davenant's *Just Italian*, 1630.

(See figure of Anne of Denmark, queen of James I., p. 187 *ante*.) John Evelyn, in the days of Charles II., mentions, amongst the various articles of a lady's toilette,

> " Short under-petticoats, pure, fine,
> Some of Japan stuff, some of Chine,
> With knee-high galoon bottomed ;
> Another quilted white and red,
> With a broad Flanders lace below."
> *Voyage to Maryland.*

And Pepys, in his 'Diary,' under date of 1663, speaks of a light-coloured cloth coat, with a gold edging in each seam, that, he says, "was the lace off my wife's best pettycoat, that she had when I married her."

Malcolm has numerous notices of the petticoats most in fashion at the end of the seventeenth and beginning of the following century. A petticoat lost between Hackney and London in 1684 is described as being "of musk-coloured silk shot with silver, on the right side the flowers trail silver, and the wrong side the ground silver, the flowers musk-coloured, with a deep white thread bone lace, a white fringe at the bottom and a gold one over it, six breadths, lined with Persian silk of the same colour." In 1688 Judith Simes, aged 20, left her home, and was advertised as wearing "a figured stuff gown lined with black crape and a black crape petticoat, with a red silk petticoat with black and white flowers, and betwixt the two petticoats a plain Bengal apron." ('Manners and Customs,' pp. 334, 337.) In 1700, he tells us, "the ladies wore Holland petticoats, embroidered in figures with different-coloured silks and gold, with broad orrice at the bottom." In 1712 a Mrs. Beale lost, amongst other clothes, "a petticoat of rich, strong flowered satin, red and white, all in great flowers or leaves, and scarlet flowers with black specks brocaded in, raised high like velvet or shag." "A green tabby petticoat trimmed with gold," "a white damask," one "trimmed with a blue snail blond lace," and another of "painted silk, the ground white, a running pattern of flowers and leaves, the edges of the leaves painted in silver, and the veins gold, with some birds and butterflies painted thereon," are amongst the apparel advertised as lost or stolen during the reign of George II., and sufficiently illustrate the style of ornamentation of the petticoat at the period to which I have limited my observations. Of the hoop petticoat I have already spoken under HOOP.

PETTICOAT BREECHES. See BREECHES and RHINEGRAVE.

PHEON. "A barbed javelin carried by sergeants-at-arms in the king's presence, as early as the reign of Richard I." (Fairholt.) A curious specimen of one is in the museum of Roach Smith, Esq., of Stroud, near Rochester, which is here engraved. The pheon is a charge in heraldry, and is used as a royal mark, which is called "the broad R," being a corruption of "the broad arrow."

Pheon.

PHILLIBEG. (*Feile-beag*, Gaelic, *i.e.* "The little or lesser covering.") At present this well-known Highland Scottish garment, more generally in England called "a kilt," is a separate article of apparel, and is put on like a woman's petticoat, and, like the petticoat, was originally, I consider, "a little coat," being the corresponding habit to the Irish *cota*, *filleadth* or *fallings*, and the British *pais*, which, with the mantle and the *truis* or trousers, formed the complete Gaulish and Celtic male costume. *Kilt* is a Lowland Scotch or Saxon word, signifying a shortened or tucked-up garment. "To kilt" is to tuck or truss up:

> " I'll kilt my coats aboon my knee,
> And follow my laddie through the water."

The period of the separation of the ancient *feile-beag* into a waistcoat and kilt is at present unknown, but I imagine about the accession of James VI. to the throne of England.

PICKADIL, PICKARDIL, PICCADILLO, PICCADILLY. "A pickadil is that round hem or the several divisions set together about the skirt of a garment or other thing. Also a kinde of stiffe collar made in fashion of a band. Hence perhaps the famous ordinary near St. James's called 'Pickadilly' took its denomination, because it was then the outmost or skirt house of the suburbs that way. Others say it took its name from this: that one Higgins, a taylor, who built it, got most of his estate by pickadilles, which in the last age were much worn in England." (Blount, 'Glosso-graphia,' 1656.) Philips says: "Pickardil is the hem about the skirt of a garment—the extremity or

utmost end of anything." ('World of Words,' 1693.) Minsheu describes it as "a peece fastened about the collar of a doublet" (1627); and Cotgrave (1650), "the several divisions or pieces fastened together about the brimme of the collar of a doublet." "*Pickedelekens* (Flemish), petits bords." (Mellema, 'Dictionnaire Flamang-François,' 1610.)

None of these definitions, however, give us the derivation of the word. Gifford, in his notes to Ben Jonson, says authoritatively: "*Picadil* is simply a diminutive of *picca* (Span. and Ital.), a spear-head; and was given to this article of foppery from a fancied resemblance of its stiffened plaits to the bristled points of these weapons;" but he adduces no proof of this, and it appears to me to be simply a plausible conjecture. The latest writer on costume (M. Quicherat), quoting a passage in a work called 'Sage Folie,' by Louis Garon, has "La picadille (petits festons de bordure)," but gives no derivation of the word, nor any more precise description of the article. It appears, however, from the context to have been some portion or ornament of a pourpoint (doublet), thereby answering to the definitions of Minsheu and Cotgrave. Barnaby Rich, who wrote in 1614, when the pickadil was in fashion, seems to have foreseen our perplexity, for he says: "He that some fortie or fiftie years sithens should have asked after a pickadilly, I wonder who could have understood him, or could have told what a pickadilly had been, either fish or flesh;" but, unfortunately, he leaves us in the same state of ignorance. Aubrey calls the place of entertainment above mentioned *Peccadillo*, a very significant form of the word, and which, after all, might be the original one, applied jestingly in the first instance to the trimmings, the "petits festons" of the skirts or borders of garments, and subsequently to a collar or band with a similar edging. King James I. being expected to visit Cambridge in 1625, an order was issued by the Vice-Chancellor against wearing pickadils, and the students are advised by a writer of the day to comply cheerfully:

> "Leave it, scholar, leave it, and take it not in snuff,
> For he that wears no pickadil by law may wear a ruff."
> Ruggle's *Ignoramus.*

Drayton says of a lady—

> "And in her fashion she is likewise thus.
> In everything she must be monstrous:
> Her pickadell above her crown up-beares,
> Her fardingale is set above her eares."
> *Poems*, p. 235.

Mr. Fairholt remarks on this passage: "The portraits of Isabella, Infanta of Spain, and wife to Ferdinand, Governor of the Netherlands, furnish us with an excellent specimen of the genuine Spanish *picadil*, in all its monstrosity, completely equalling Drayton's description;" but the Infanta wears a ruff, and the pickadil, according to Ruggle, quoted above, was not a ruff, which was to be worn in lieu of it. Nor in any case could it have been a "genuine *Spanish* picadil," as *picadil* in Spanish signifies "minced or hashed meat," and is not applied to any article of attire whatever. The wife of the Governor of the Netherlands might, however, have adopted the pickedelekens of the Flemish ladies; and I think the probabilities all point to the Low Countries as the birthplace of the pickadil. Having no means of distinguishing the pickadil from any other "stiff collar" or band, I cannot give a representation of it, though no doubt it appears in many paintings of the time of James I.

PIGACIA. See SHOE and SLEEVE.

PIGTAIL. This absurd appendage is first mentioned in the days of George II., when it made its appearance at the back of the wig (see p. 393); but the pigtail proper, composed of the hair of the wearer's head, was not generally worn before the following reign.

PIKE. The weapon of the English infantry from the reign of Edward IV. to that of George II.

It is mentioned in a MS. in the College of Arms, marked M 6, containing a copy of the Ordinances, &c., for a "Joust royal of peace" at Windsor, in 1466, as one of the weapons to be used on that occasion. The pike was introduced into France by the Switzers in the reign of Louis XI., being merely the lance or spear of the cavalry adapted to infantry. It soon became general in European armies. Morris or long pikes, those copied from the Moors, are continually mentioned in the reigns of Henry VIII. and Elizabeth, the staves of which were covered with little nails. In 1645 the length of the pike was fifteen feet besides the head; in 1670 eighteen feet altogether. The heads were always made of the best steel, and the staves of well-seasoned ash. From the hand downward they were protected for three or four feet with iron plates, to prevent their being cut in two by the swords of the cavalry. (Meyrick in Skelton, vol. ii.) Subjoined are specimens of the various heads of pikes formerly in the collection at Goodrich Court.

Pikeman. *Temp.* James I.

Henry VII. Henry VIII. Edward VI. Elizabeth. James I. Charles I. Cromwell. Charles II. Charles II.

PILCHE. "*Pelicium*, a pylche." (Nominale MS.) A coat or cloak of skins or fur. Two pilches made of a fur called "crist-gray" were remaining in the wardrobe of Henry V. after his decease, valued at ten shillings each. "Her pilche of ermine." ('The Seven Sages.')

> "His cloak was made for the weather,
> His pilch made of swine's leather."
> The Smith in *The Cobbler of Canterbury*, 1608.

> "After great heat cometh cold,
> No man cast his pilche away."
> Chaucer.

"A woollen or fur garment." ('Ladies' Dictionary,' 1694.)

PILCHER. A cant name in the sixteenth century for a sword-sheath: "Will you pluck your sword out of his pilcher by the ears?" (Shakespere, 'Romeo and Juliet,' act iii. sc. 1.)

PILE. The head of an arrow.

PILION, PILLION. (*Pileus*, Latin.) A round hat, such as those worn in the thirteenth century, like the *petasus* of the Romans, and seen, winged, on the figures of Mercury.

" Mercury shall give thee gifts manyfolde :
His pillion, sceptre, his winges, and his harpe."
Barclay, *Eclogue*, 4.

" Takyth his pyllyon and his cap
Into the good ale-tap."
Skelton, *Collin Cloute*.

The custom in Skelton's time of wearing a hat or bonnet over a close-fitting cap or coif, is amply illustrated under CAP, p. 76. In Cavendish's ' Life of Wolsey,' mention is made of " a round pillion of black velvet."

PILL or *PELL*. (*Pieu*, French, from *Palus*, Latin.) " Pieu de bois aiguisé." (Napoléon Landais.) A sharpened stake ; one of those rude weapons carried by the " villains " in the Norman armies.

" A machues et a grant peus."
Wace, *Roman de Rou*.

PIN. Some description of pin was used in the earliest period of British history. A thorn occasionally sufficed to secure the cloak of skin upon the shoulders.* Pins of bone and bronze are constantly found in British barrows, and amongst Roman remains in London. (See BODKIN.) A Saxon pin in the collection made by the late Lord Londesborough was of brass, the head gold, ornamented with red and blue stones and filagree work. It is engraved here from the volume printed by his lordship for private presentation. But these pins were either for the hair or fastening the mantle. (See, for instance, the pin represented fastening the pall of John Stratford, Archbishop of Canterbury, who died in 1348, on his effigy in the cloisters of Canterbury Cathedral.) They were consequently made for show, and were highly ornamented ; but pins for general purposes were used as early as the reign of Edward I. Jean de Meun, in the ' Roman de la Rose,' complaining of the ugly gorget worn by ladies in his time, describes it as wrapped two or three times round the neck, and then, being fastened with a great many pins, it was raised on either side of the face as high as the ears. " Par Dieu," he exclaims, " I have often thought, when I have seen a lady so closely tied up, that her neck-cloth was nailed to her chin, or that she had the pins hooked into her flesh." Pins were expensive in the thirteenth and fourteenth centuries, and were, consequently, given as presents by lovers to their mistresses. Chaucer says of his " jolly clerke " Absolon, that, when courting the carpenter's young wife,

Bone. From Mr.
Roach Smith's
Collection.

Brass and gold. From
Lord Londesborough's
Collection.

From effigy of Arch-
bishop Stratford.

" He sent her pinnes, methe, and spiced ale ;"

also in Heywood's play, the ' Pindar of Wakefield,' 1559,—

" My wench, here is an angel to buy pins."

The widow of John Whichcomb (the famous Jack of Newbury) is described as wearing, after she left off her weeds, " a fair train gown, stuck full of silver pins."

Metal pins are first mentioned in our statutes in 1488, but the date of their manufacture in

* Tacitus. Fosbroke tells us that thorns curiously scraped and dried were called by the poor women in Wales " pindraen," and were used by them in his time. (' Encyclopædia of Antiquities,' 1825, vol. i. p. 303.)

England is placed by Anderson in 1543 ('Hist. of Commerce,' vol. i. p. 516; vol. ii. p. 72), when they were first made of iron wire blanched.

PINNER. "A lady's head-dress, with long flaps hanging down the sides of the cheek." (Randle Holmes.) The "long flaps" were the pinners. They were either of lace entirely, or edged with it.

<div align="center">"Pinners edged with colberteen"</div>

are mentioned by Swift in his 'Baucis and Philemon,' 1708.

"Oh, sir, there's the prettiest fashion lately come over! So airy, so French, and all that! The pinners are double ruffled, with twelve plaits of a side, and open all from the face." (Farquhar, 'Sir Harry Wildair.')

"I have a fine laced suit of pinners that was my great grandmother's, that has been worn but twice these forty years, and my mother told me cost almost four pounds when it was new, and reaches down hither." (Fielding, 'Miss Lucy in Town.')

Pinner signified also in the seventeenth century an apron with a bib to it, pinned in front of the breast, the pincloth or pinafore of the present day. "A straw hat and pinner" is mentioned as a country girl's peculiar dress in 1674. (Prologue to Duffet's 'Spanish Rogue.')

PINSONS, PISNETS, PUISNETS. See SHOE, SLIPPER, and STARTUP.

PISTOL. Meyrick derives the name of this firearm from Pistoia, a city in Tuscany, where he considers it was first made. Demmin, however, says, "This weapon probably derives its name from *pistello*, which means 'pommel,' and not from Pistoia, for it appears not to have been first made at Pistoia, but at Perugia, where they made some small hand-cannon, a hand's span in length." But Meyrick's authority is Sir James Turner, who in his 'Pallas Armata' (1670) gives the name of the inventor, Camillo Vitelli, while M. Demmin adduces no proof in support of his opinion. His observation respecting the word "pistello" is, nevertheless, curious, as the peculiar distinction of the pistol is its pommel, the varying form of which enables us to affix to any example its approximate date, as will be seen below. There is also the remarkable fact I have already alluded to (p. 162) of *pistolese* signifying, in Italian, a great dagger or wood knife. Whence the derivation of that word? Was the great dagger or wood knife invented or first made at Pistoia?

Monsieur de la Noue informs us that "the Reiters (*Ritters*, German cavalry) first brought pistols into general use, which are very dangerous when properly managed." A rather Hibernian sentence as it appears at first sight, but the author means dangerous to the enemy, and not to the owner. The aforesaid Ritters gave such ascendency to the pistol as to occasion in France, and subsequently in England, the disuse of lances. Père Daniel says that the horsemen who were armed with pistols in the time of Henry II. of France, were thence called "pistoliers," a term subsequently introduced into England. The wheel-lock having been invented before the pistol, the match-lock appears never to have been applied to that weapon; at least, no example of it has been met with. Specimens of various dates from the reign of Henry VIII. were in the Meyrick Collection, including a superb pair which had belonged to Alexander de Medici, Duke of Tuscany, A.D. 1530. See Plate XV. for a selection copied from Skelton's engravings, and showing the gradual change in the form of the butt, by which the date of the weapon can be readily ascertained. Fig. 1 is a long wheel-lock pistol of the reign of Edward VI. Fig. 2, a pocket wheel-lock pistol of the reign of Mary. Fig. 3, a wheel-lock pistol of the end of her reign. Fig. 4, a wheel-lock pistol of the reign of Elizabeth. Fig. 5, a double-barrelled wheel-lock pistol of the reign of James I., dated 1612. Fig. 6, a long wheel-lock pistol of the same reign. Fig. 7, a long double-barrelled pistol of the reign of Charles I. Fig. 8, a wheel-lock pistol, *temp.* Cromwell. Fig. 9, a wheel-lock pistol of the reign of Charles II. Fig. 10, a double-barrelled revolving wheel-lock pistol of the reign of William III. Fig. 11, another of the close of his reign, the magazine only revolving.

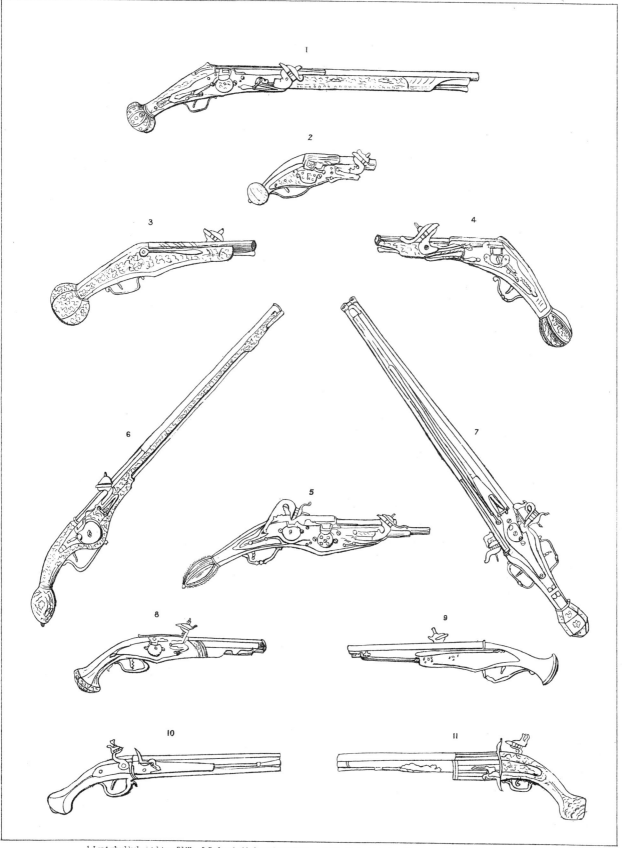

1. Long wheel-lock pistol, temp Ed. VI. 2. Pocket wheel lock pistol temp Mary. 3. Wheel-lock pistol, close of her reign. 4. Wheel-lock pistol, temp. Elizabeth.
5. Double barrelled wheel-lock pistol, temp. Jas. I. 6. Long wheel-lock pistol same reign. 7. Double barrelled long wheel-lock pistol. temp. Chas. I.
8. Wheel-lock pistol, temp. Commonwealth. 9. Wheel-lock pistol, temp. Chas. II. 10, 11, Double barrelled revolving fire-lock pistols, temp. Will. III.

PLACARD, PLACATE. A stomacher worn by both sexes from the reign of Edward IV. to that of Henry VIII. Half a yard of stuff is always allowed for the king's placard, which is ordinarily of cloth of gold or equally rich materials. Henry VIII., the day before his coronation, wore a placard embroidered with diamonds, rubies, great pearls, and other rich stones. (Hall's 'Union.') It is difficult to identify the placard in male attire: as only half a yard was allowed for the making, it must have been merely a facing to the front of the under dress; its shape, or the mode by which it was attached, not being distinguishable. The placard seems to have been superseded by the waistcoat, which is first heard of towards the close of this reign. (See WAISTCOAT.)

In armour, the placard or placate was an additional piece covering the lower portion of the breast or back plate, rising to a point in the centre, where it was attached to the breast or back by screws, or to the gorget by a strap and buckle. It was introduced about the middle of the fifteenth century. The fine effigy of Richard Beauchamp, Earl of Warwick, in the Beauchamp Chapel at Warwick, affords an early example. The Earl died in 1439; but the effigy is presumed to have been executed some ten years later. The edges are escalloped in this and many instances. The effigy of Sir John Crosby in Great St. Helen's Church, London, who died in 1475, displays three placards on the breast-plate. Three are also seen on the breast-plate of Sir Anthony Grey (1480), on his brass at St. Albans. Subjoined is an instance of four, from a MS. in the Nat. Lib., Paris.

Placate, single. From MS. copy of Boccace, *circa* 1420.

Placate of four pieces. From 'Le Miroir Historial,' MS. 1440, Nat. Lib., Paris.

Back Placate. From the same.

PLACKET. Fairholt, following Nares, Dyer, and other glossarists, says, "a woman's petticoat;" but Halliwell observes that "their quotations do not bear out this opinion," and agrees with Forby, ii. 255, who calls it "a woman's pocket;" and Grose has "PLACKET-HOLE, a pocket-hole." It is used in that sense in an epigram printed in 1665, and I can remember hearing it so applied early in the present century. (*Vide* Halliwell, 'Dict. of Archaic Words,' *in voce.*)

PLAID, PLODDAN. The chequered cloak or mantle still worn in Scotland. An English gentleman who visited Edinburgh in 1598 says, "The citizens' wives and women of the country did weare cloaks made of a coarse cloth of two or three colours in chequer work, vulgarly called 'ploddan;'" and "plaiding" is still the term for the chequered tartans in the Lowlands. The Gaelic term for the plaid is *breacan feile*—literally, "the chequered, striped, or spotted covering;" and the parti-coloured cloth woven by the Gauls and Britons was by them called *breach* and *brycan*, from *breac*, speckled or spotted. The plaid worn by the men was originally a large mantle of one piece belted round the body, and thence called "the belted plaid." (Logan's 'Hist. of the Scottish Gael.' See TARTAN and GENERAL HISTORY.)

PLASTRON-DE-FER. A breast-plate of iron introduced in the twelfth century to prevent the pressure of the hauberk upon the chest. It was sometimes worn under the gambeson, but more frequently between it and the hauberk. In a combat between Richard Cœur de Lion, then Count of Poitou, and a knight named Guillaume de Barre, they are said to have charged each other so furi-

ously that their lances pierced through their shields, hauberks, and gambesons, and were only prevented by their plastrons from transfixing their bodies. The gorget, the acton, and the haubergeon, when made of plate, were the successors of the earlier plastron. The term was also applied in France to the stuffed and quilted pectoral of leather worn by fencing-masters as late as 1742, and still exists in the French language.

PLATE. See ARMOUR.

PLEASAUNCES, PLEASAUNTES. "A kind of lawn or gauze. It is mentioned in MS. Cantab., Ff. i. 6, f. 14." (Halliwell, *in voce.*) "On every side of her stood a countesse holding a clothe of pleasaunces when she list to drink." (Hardyng, 'Suppl.' f. 70.) There appear to have been at least two sorts of this stuff; for Hall, describing the dresses of six ladies in a court masque, *temp.* Henry VIII., says, "Their faces, neckes, armes, and handes covered in fyne pleasaunce blacke : some call it *lumberdines*, which is marveylous thinne, so the same ladies seemed to be nygrost (negresses), or blackmores." This black lumberdine could not possibly have been of the same kind of pleasaunce as the cloth held by the countesses in the above quotation. It becomes, therefore, a question whether the kerchief of pleasaunce worn by "the knyght of Spayne," mentioned in the 'Paston Letters,' was so called from its material, or that it was the ordinary appellation of a scarf or kerchief bestowed by a lady on her favoured champion for the purpose therein alluded to. (See KERCHIEF OF PLEASAUNCE.)

PLUME-HOLDER. An extra piece made to fit on a helmet, and having a pipe in it to hold feathers. Annexed is an example from the Londesborough Collection.

PLUNKET. A cloth made in Wiltshire, Essex, Suffolk, and Norfolk, *temp.* Edward VI., also called *vervises, tuskins,* and *celestines.* But plunket in the fifteenth century was the name of a colour :—"PLUNKET (coloure), jacinctus" ('Prompt. Parv.') ; to which Mr. Way's note is as follows :—"'Plonkete,' or in another MS. 'blunket,' occurs in the 'Awntyks of Arthure,' and is explained by Sir F. Madden as signifying 'white stuff.'"

Plume-holder.

"Hir belte was of plonkete with birdies fulle baulde."

In Mr. Robson's edition, "blenket," st. xxix. ; possibly the white stuff called in French *blanchet.* "Ploncket : colour *blew.*" (Palsg.) "Cæsius : graye of colour or blunkette, Scyricum blunkct colour or light watchet. Venetus : lyght blewe or blunket." (Elyot.) "Couleur pers. : skie colour, a blunket or light blue." (Cotgrave.) The old gloss on Spenser's 'Shepherd's Calendar, May,' explains it as signifying grey. (See Nares and Jamieson, v. "Bloncat.") Here is a mass of contradictory information that is perfectly bewildering. A jacinth (hyacinth) is not white, nor grey, nor blue. It is a gem of the family of the garnets, and the Syrian is sometimes of a fine violet colour. This is the colour always indicated by *hyacinthus* or *jacintus* in mediæval writings ; but, apart from this, are we to consider that the cloths called "plunkets" gave their name to the colour, or that the colour, whichever it was, gave its name to the material ? Of "the long *coloured* cloths called 'plunkets,'" some are described as *celestines.* These might have been of "the lyght blewe" or "skie colour" called "blunket" by Elyot and Cotgrave. They were distinguished by broad lists ; but if not from the French *blanchet,* whence no doubt "blanket," manufactured here as early as the reign of Edward III.,* where are we to seek the derivation of the word "plunket" either as applied to a cloth or a colour ?

POINTS. See AIGUILLETTE, page 3 ; also under HERLOT and HOSE.

* According to some glossarists, blanket took its name from one Thomas Blanket, who first set up a loom at Bristol in 1340.

POKE. A pouch or pocket.

> "With that he pulled a dial from his poke."
> Shakespere, *As You Like It.*

POLE-AXE. See AXE (POLE).

POLEYN. The knee-cap of plate armour. (See GENOUILLÈRES.)

POMANDER. (*Pomme d'ambre,* French.) A ball or hollow ornament of other shape containing perfumes, worn in the pocket, or suspended by a chain round the neck, or from a girdle. They were used against infection. "I will have my pomanders of most sweet smell." ('Book of Robin Conscience.')

> "The bob of gold
> Which a pomander ball does hold,
> This to her side she does attach
> By gold crochet or French pennache."
> *Mundus Muliebris,* 1690.

POMPOM, PONG-PONG. An ornament for a lady's cap, fashionable in the reign of George II.; an artificial flower, feather, butterfly, tinsel, &c.

> "Hang a small bugle cap on as big as a crown,
> Snout it off with a flower *vulgo dict.* a pompom."
> *Receipt for Modern Dress,* 1753.

> "Who flirt and coquet with each coxcomb that comes
> To toy at your toilets and strut in your rooms,
> While you're placing a patch or adjusting pong-pong."
> *London Magazine* for May 1748.

The "ball tuft" of coloured worsted worn in front of the shakos or caps of infantry of the line is in France still called a *pompon* ("dimin. de *pompe*"). "Pomponner, v. act., orner de pompons : pomponner une coiffure." (Napoléon Landais, 'Dict. Gén.')

PONIARD. See DAGGER.

POUCH. A bag worn by countrymen at their girdle.

> "And by his syde his whynard and his pouche."
> Skelton's *Bouge of Court.*

> "One of these ware a jerkin made of buff,
> A mighty pouch of canvas at his belt."
> Thynne's *Pride and Lowliness.*

The term was also applied to the purse worn at their belt by gentlemen in the fifteenth and six-teenth centuries. It was the custom to wear a knife or dagger stuck through the straps of it. (See DAGGER.)

POULAINES. See SHOE.

POURPOINT. A close-fitting body garment, deriving its name from the needlework employed in its construction or ornamentation, and called *pourpointerie.* The military pourpoint was of leather or cloth, stuffed and quilted like the gambeson, and its name was transmitted to the civil doublet, to which it bore but little resemblance.

POWDER-FLASK or *HORN.* A case for carrying gunpowder was naturally necessitated by the invention of fire-arms. There was great variety in form and material in the early examples, as will be better shown by drawings than by descriptions. (See Plate XVI.)

POWDER (HAIR). It is difficult to fix on a precise date for the introduction or adoption of hair-powder in this country. The gold-dust that glittered in the hair of the Roman emperors—a custom imported, according to Josephus, from the East, and practised by the Jews—has nothing in common with the mixture which good sense and good taste have not yet utterly discarded, although its use is now relegated to the coachmen and footmen of a few aristocratic families, on whose heads it appears in unequal and ridiculous patches.

From the paintings in Anglo-Saxon MSS., representing persons of both sexes with blue, red, green, and orange-coloured hair, it has been suggested by Strutt, that powders of various hues were employed by those early colonists of Britain to produce those effects ; but no allusion has been discovered in any of their writings to such a practice, and I consider such representations to be simply the result of the want of skill in the painter, or rather dauber, who, childlike, used the nearest or most glaring colour at hand—scarlet and orange for red or golden hair, and blue or green for grey. It is true the Gauls used a lixivium made of chalk, which had the effect of reddening the hair—a practice, I need scarcely observe, not altogether discarded in the nineteenth century ; but the Danes and the Norsemen, who took such pride in their long fair locks, combing them carefully every day, were surely innocent of such pollution, and it is not till we reach the reign of Elizabeth in England that we become aware of the presence of hair-powder proper, though not composed of wheaten flour, as was the later description. At what exact period it was introduced, I have already said, is not decided ; but that, with other fashions, it came to us from France some time towards the middle of the sixteenth century appears most probable. That effeminate and contemptible sovereign, Henri Trois—

> " Qu'au premier abord chascun estoit en peine
> S'il voyait une roy-femme ou bien un homme-reyne "—

had " son chef tout empoudré " with " poudre de violette musquée ;" and in the reign of his successor, the popular Henri Quatre, several perfumed hair-powders were used by ladies for their perukes or false curls. The women of the lower classes, unable to purchase such costly compounds, contented themselves with the dust of rotten oak, which imparted a reddish hue to the hair, while the country girls powdered their heads with flour, little dreaming of its adoption a century later by the *beau monde*, as well as the general public throughout Europe.

It is easy to imagine the rapidity with which this fashion found its way into the court of the contemporary of both these sovereigns, and how eagerly it would be adopted by so vain a woman as Elizabeth ; but it does not appear to have been followed by the general public in this country during her reign, or that of her successor, James I., or it must have attracted the notice of the satirists and dramatists, who have not allowed any other caprice of the toilet to escape them. Stubbs is severe on the practice of dyeing the hair, but makes no mention of powder. One of the earliest notices of its use by men occurs in an epigram quoted by Mr. Fairholt from a collection entitled 'Wit's Recreations,' printed in 1640. It is headed 'On Monsieur Powder-wig :'

> " Oh, doe but marke yon crisped sir you meete,
> How like a pageant he doth walk the street ;
> See how his perfumed head is powdered o'er !
> 'Twould stink else, for it wanted salt before."

This was eight years before the execution of Charles I., but yet we see no portraits of that period with powdered hair. That it was worn by both sexes during the Commonwealth, is shown by several satirical effusions of that time. The ladies are told—

> " At the Devil's shoppe you buy
> A dresse of powdered hayre,
> On which your feathers flaunt and fly,
> But I'de wish you have a care
> Lest Lucifer's self, who is not prouder,
> Do one day dress up your haire with a powder."
> *Musarum Deliciæ,* 1655.

1.Powder horn, temp. Henry VII.- 2.Powder horn or flask, temp. Henry VIII.- 3.Powder horn or flask, temp. Philip & Mary.- 4.5.6. Temp. Elizabeth- 7. Temp. Chas I.- 8.Temp. Commonwealth.

And in 'The Impartial Monitor about following the Fashions,' published in 1656, the author (R. Younge), after lecturing the ladies, says, " It were a good deed to tell men also of mealing their heads and shoulders, for these likewise deserve the rod, since all that are discreet do but hate and scorn them for it." Yet, singularly enough, it would seem that "the discreet," by which epithet I presume the Puritans are designated, were as much given to worldly vanities as the Royalists; for in a 'Loyal Litany' of that time, the latter pray, amongst other things,

> " From a king-killing saint,
> Patch, powder, and paint,
> Libera nos Domine !"

In Massinger's play, 'The City Madam,' printed in 1659, Luke tells the merchant's wife—

> " Since your husband was knighted, as I said,
> The reverend hood cast off, your borrowed hair,
> Powdered and curled, was, by your dresser's art,
> Formed like a coronet, hanged with diamonds
> And richest orient pearls."

Still no trace of powder is discoverable in the paintings known to me of the Interregnum, or even of the Restoration period. I do not remember, in the magnificent collection of miniatures belonging to his Grace the Duke of Buccleuch, any indication of powder in the hair or wig of any personage of the seventeenth century. "The Merry Monarch's " black periwig remained unsullied by powder to the day of his death, and Louis le Grand is reported to have only yielded in his latter days to the unnatural disfigurement. Pepys is silent on the subject—the minute Pepys, who would surely have recorded the first time that either he or his wife wore powder; but though severe on false curls, and particular about periwigs, he has not a word to say about hair-powder. Nor does his rival gossip, Evelyn, mention it till after the accession of William III., when in his 'Mundus Muliebris,' 1694, he describes a lady's dressing-room as containing, amongst a host of articles for the toilet,

> " rare
> Powders for garments, some for hair."

It does not appear that William, or Mary, or Queen Anne, ever wore powder. None of their portraits, at any rate, indicate it; but no doubt can exist as to its being in fashion with the male sex at the close of the seventeenth century. "A cloud of powder beaten out of a beau's periwig," is a line in Cibber's comedy of 'Love's Last Shift,' 1695; and the fine portrait of Colley himself, in his character of Lord Foppington, at the Garrick Club, exhibits him in a powdered wig of ample proportions. Gay, in his ' Trivia,' advises the reader to pass a coxcomb

> " with caution by,
> Lest from his shoulders clouds of powder fly ;"

and during the reigns of the first two Georges, the wearing of powder became all but universal amongst the upper and middle classes of society. Grey-coloured powder was exceedingly fashionable in 1753. In the 'Receipt for Modern Dress,' published in that year, it is said to the ladies—

> " Let your powder be grey, and braid up your hair,
> Like the tail of a colt to be sold at a fair ;"

and, in a sort of answer to this attack on the fair sex, a poem appeared in the same year entitled ' Monsieur à la Mode,' in which occur the following lines :—

> " And now for to dress up my beau with a grace,
> Let a well-frizzled wig be set off from his face,
> With a bag quite in taste, from Paris just come,
> That was made and tied up by Monsieur Frisson,
> With powder quite grey—then his head is complete :
> If dressed in the fashion, no matter for wit."

The great estimation in which light grey human hair was held some years previously may account for the invention of grey hair-powder. Although I doubt the use of blue hair-powder by the Anglo-Saxons, I am aware that such a composition was known in the latter half of the eighteenth century, and was worn by the celebrated Charles James Fox when a fashionable young man about town in 1770. The tax imposed upon hair-powder by his great political rival Pitt in 1795, assisted by the change of fashion in France consequent on the Revolution, rapidly relieved us from a custom as foolish as it had become filthy. This work is limited to the reign of George II., and I am therefore spared the task of describing the heads of the ladies in the days of George III.

PRODD. A light cross-bow for shooting deer. Two beautifully-carved specimens were in the Meyrick Collection. One of them is given here from the engraving by Skelton, also some smaller

Prodd. *Temp.* Elizabeth.

Small Prodd carried on horseback for ladies to shoot deer with. *Temp.* Elizabeth.

Prodd. *Temp.* James I.

Prodd. *Temp.* William III.

Prodd combined with petronel. *Temp.* Charles I.

specimens for ladies, such as Queen Elizabeth is said to have shot with at Cowdray, and one combined with a wheel-lock petronel, *temp.* Charles I.

PUG. A short cloak worn by ladies about the middle of the last century. Lawrence White, in his poems printed in 1742, speaking of a gentleman's vest or waistcoat, says that it

> "now has grown a demi-cloke,
> To show the fashion of the joke,
> To keep the hero warm and snug
> As any lady's velvet pug."

PUKE. A colour between russet and black. (Barret.) "*Chiaro-scuro:* a dark puke colour." (Florio.) "The colour of the camell is for the most part browne or puke, yet there are heards of white ones in India." (Topsell's 'Four-footed Beasts,' 1607.)

PUMP. "A shoe with a thin sole and low heel." (Johnson.) First mentioned in the sixteenth century. "Get good strings to your beards, new ribbons to your pumps." (Shakespere, 'Midsummer Night's Dream,' act iv. sc. 2.) They were specially worn by footmen, who were consequently called "pumps:" "Poh! passion of me! footman! Why, *pumps*, I say, come back!" (Middleton, 'A Mad World, my Masters,' 1608.)

> "'What's he, approaching here in dusty pumps?'
> 'A footman, sir, to the great King of Kent.'"
> Middleton, *Mayor of Queenborough.*

PUNGE. See PURSE.

PURFLE, PURFYLL. The "hemme of a gowne" (Palsgrave); whence

PURFILED. Edged or bordered, from the French *pourfiler*, "to work upon the edge." (Tyrwhitt.) The Monk in Chaucer's 'Canterbury Tales' has—

> "His sleevis purfiled at the hand
> With gris, and that the finest of the land."

"To purfle: *pourfiler d'or;* to purfle, tinsel, or overcast with gold thread." (Cotgrave.)

PURL. In one sense, as Mr. Fairholt describes it, "a pleat or fold of a ruff or band." "I have seen him sit discontented a whole play, because one of the purls of his band was fallen out of his reach to order again." ('Amends for Ladies,' 1516.) "My lord, one of the purls of your band is without all discipline fallen out of his rank." (Massinger, 'Fatal Dowry.') But the word also signified a species of lace of gold, silver, or other metal, used for the edging of ruffs and ruffles and the trimming of various articles. It is called in French *canetille.* "Gold or silver PURLE: canetille, cannetille; set, wrought, edged with purle, canettillé; a small needlework purle, canetille, cannetille." (Cotgrave.) "PURL: Border, hem, fringe, stitch work, a *twist* of gold or silver." (Halliwell.) To *purl* or *perl* is to turn swiftly round, to curl or run in circles, to spin like a top. "It is a term still used in knitting. It means an inversion of the stitches, which gives to the work in those parts in which it is used a different appearance to the general surface. The seams of stockings, the alternate ribs, and what are called 'the clocks,' are *purled.*" (Ibid.) A narrow braid much used at the present day for bordering needlework is called "pearl edging,"—an orthographical error, but no doubt in itself a modern illustration of the "*purl* edging" of the sixteenth century.

"Of the difference between purles and true lace," Mrs. Palliser remarks, "it is difficult now to decide. The former word is of frequent occurrence among the New Year's gifts" (to Queen Elizabeth), "where we have 'sleeves covered all over with purle'" (gift of Lady Radcliffe, 1561); "and in one case the sleeves are offered unmade, 'with a piece of purle upon a paper to edge them'" (gift of Lady St. Lawrence). "It was yet an article of great value, and almost worthy of entail," she adds, "for in 1573

Elizabeth Sedgwicke of Wathrape, widow, bequeaths to her daughter Lassells, of Walbron, 'an edge of perlle for a remembrance,' desiring her to give it to one of her daughters." (Surtees' 'Wills and Inventories.')

In the Great Wardrobe accounts of Elizabeth, we meet with entries of "Flanders purle" and " Italian purle," also the following items :—"For one yard of double Flanders cut work worked with Italian purl, 33*s. 4d.* 3 yards broad needle-work lace of Italy, with the purls of similar work, at 50*s.* per yard, £8 15*s.*"

In a memorandum among the State papers of James I., of one "Misteris Jane Drumonde," who had the furnishing of his queen's "linen cloth," are the following two entries :—"Item 68 purle of fair needlework, at 20 pence the purle, £5 15*s. 4d.* Item for 6 yards of fine purle at 20*s.*, £6." One twenty pence "the purle," and the other twenty shillings "the yard." If "the purle" means "the yard," which it would appear to do by the sum total, the difference in price between "fair purl" and "fine purl" is enormous. In a roll of the reign of Charles I., A.D. 1630, the bag and comb-case "for his Majesty's barber" is described as trimmed "with silver purle and parchment lace." "Purled point raised lace" is mentioned in an inventory of the wearing apparel of Charles II. "Six cards of piece lace looped and purled" were taken out of a waggon in April 1698. ('London Gazette.') And "fine purle to set on a pinner" occurs in a lace bill about the same period. That, whatever the fabric, it was principally used for edging is clear, from notices of it as early as the reign of Henry VIII. Among the wedding dresses of Mary Neville, wife of George Clifton, 1536, is entered "a neyge (an edge) of perle, £1 4*s. 6d.* ;" and Anne Basset, daughter of Honor, Lady Lisle, writes in 1539 from a convent in France, begging earnestly for "an edge of purle" for her coif. "A perle edging" to the coif of the Duchess of Suffolk is also mentioned in 1546. But, in addition to these notices, for the collection of which we are principally indebted to the indefatigable research of Mrs. Palliser, I find in the second inventory of the apparel of Henry VIII., A.D. 1542, "On paire of hoose of crimeson satten embrauded with *pirles of Denmark gold*" (MS. Harleian, No. 1419) ; and we must not forget that Chaucer, as early as the fifteenth century, describes the leathern purse of the Wife of Bath as "perled with latoun," which Strutt has interpreted "ornamented with latoun in the shape of pearls" ('Dress and Habits,' vol. ii. pt. 5), overlooking the fact that perle or purl is a verb active, and that the purse was edged or bordered (*i.e.* perled) with the latten or latoun, a metal resembling brass, much used in the Middle Ages. I have shown that "canetillé" signified anything edged or bordered with canetille ; and *perled* or *purled* would similarly signify anything edged with purl lace, whatever might be the material, if, indeed, the word "purl" was not derived from the French *pourfil,* the edge, border, or hem itself, and, as in many analogous cases, imparted its name to the edging.

PURPLE. This colour, which is properly a mixture of crimson and blue, is frequently alluded to in French romances as combining other colours. "Pourpre gris" (grey purple) occurs in the ' Lay of Sir Launfal,' and " un vert mantel porprine" (a green purple mantle) in the 'Fabliau de Gautier d'Anpais.' Mons. le Grand conjectures that the crimson dye being, from its costliness, used only on cloths of the finest manufacture, the term crimson (or purple) came at length to signify, not the colour, but the texture of the stuff. In a note to Way and Ellis' 'Fabliaux,' this opinion is quoted with the following comment :—"Were it allowable to attribute to the weavers of the Middle Ages the art now common amongst us, of making what are usually called *shot* silks (or silks of two colours predominating interchangeably, as in the neck of the drake or pigeon), the contradictory compounds above given, white crimson, green crimson, &c., would be easily accounted for." And why not allowable ? Surely those who could make "cloth of gold of crimson, blue cloth of silver," and many other such materials, were equal to the making of shot silks or velvets of blended colours. We have the authority of Adhelm, Bishop of Sherborne, as early as the seventh century, for the proficiency of the Anglo-Saxons in such arts ; and in his poem ' De Virginitate ' he expressly says, " It is not the web of *one uniform colour* and texture that pleases the eye and appears beautiful, but one that is woven with shuttles filled with threads of purple and *various other colours,* flying from side to side," &c.

Cotton MS. Nero, D 4.

From a statue, 13th century, at St. Denis.

PURSE. See AULMONIÈRE, GIPICIÈRE, and POUCH. The term "purse" has superseded all others as a receptacle for money. Derived from the French *bourse*, it is mentioned by Chaucer, who speaks of a leathern one worn at the girdle of the Wife of Bath, which was

"Tassed (tasselled) with silk and perled with latoun."

(See PURL.) A purse of crimson satin embroidered with gold is mentioned in the inventory of the contents of the palace at Greenwich, *temp.* Henry VIII. (Harleian MS. No. 1412.)

PUSANE, PIZAINE. A gorget, collar of steel, or breast-plate. It was sometimes made of jazerant work, for in the inventory of Louis X. of France the entry occurs of "iij colaretes pizaine de jazeran d'acier." In the old romance of 'The Adventures of Arthur at the Tarnewathelan,' a knight is said to pierce his adversary "through ventaylle and pusane." In the inventory of the armory of Winchester College, taken in the fifteenth century, is an entry of "vii breast-plates *cum* iiij pusiones." These notices are all in favour of the pusane being a collar or gorget, and not a breast-plate, and therefore renders doubtful the derivation of the name from the old French word *pis*, the breast, which has been suggested as a correction of Meyrick, who considered it to imply that such defences were made or originally worn at Pisa. That the word *piceris* should occur in an account of horse armour, does not, in my opinion, affect the question, as we are left to imagine the particular article it is applied to.

There is also a passage in the romance of 'Richard Cœur de Lion' which is rather puzzling. The king, charging impetuously his antagonist,

"Bare away halfe his schelde,
His pusen therewith gan gon,
And also his brandellet bon."

That his pusane should be carried away with half his shield, by the same blow, surely indicates that it must have been an exterior defence; while the former quotation from 'King Arthur's Adventures,'

"Through ventaylle and pusane,"

implies that it was worn *under* the ventaille, which, in this case, means the piece of the mail hood which wraps round the neck and lower portion of the face, and is fastened at the side of the head by arming points. (See AVENTAILE.) If "brand*ellet*" is the diminutive of "brand," and signifies a small sword (the *estoc*, generally carried by the knight on the *right* side of his saddle), the royal lance, in displacing that *also* by the same blow, must have been wielded in a most incomprehensible fashion. Mr. Robson, in a note to 'King Arthur's Adventures,' supports his opinion that the pusane was "either a gorget or a substitute for it," by a quotation from a Scotch Act of Parliament (*anno* 1429), by which it is ordered that every one worth 20*l.* a-year, or 100*l.* in moveable goods, should be horsed and armed as "a gentill man aucht to be," and persons of less estate, having but 10*l.* a-year or 4*l.* in goods, are to have "a gorget *or pusanne*, with rerebrasares, vanbrasares, and greffes of plate, *breast plate*, and leg splents, at the lest." This is surely conclusive that the pusane was not a breast-plate, for it is to be worn with one as a gorget would be. Finally, Henry V., when raising funds for his French expedition in 1415, pawned to the Mayor and City of London "a collar called pusan or pysane d'or, worked with antelopes and set with precious stones." Whether this collar was one of gold plate to be worn as a gorget, or a gold chain or livery collar, or made of cloth of gold embroidered with antelopes and jewels, who is to decide? At all events it was a collar, and not a pectoral of any description, and the derivation of the word is still, I think, to seek.

UADRELLE. See MACE.

QUARRELL. The arrow for a crossbow, so called from the squareness of the head. Two are figured at page 21.

> "That saw an arblastere, a quarrell he let fly."
> *Robert of Brunne.*

In Drayton it is spelt "quarry," p. 29. According to Guiart, the arrow by which Richard Cœur de Lion was mortally wounded was a quarrell.

> "Ainsi fina par le quarrel
> Qu'Anglois tindront a deshonneste,
> Le Roi Richard qui d'arbaleste
> Aporte premier l'us en France *
> De son art et mal chevance."
> *Chron. Metr.* l. 2644.

It is difficult to imagine how a square-headed or four-edged arrow could pierce through armour of any description, as it appears to have done; but one sort was pyramidal, the four sides tapering to a point.

> "Quarells quayntly swappez thorowe, knyghtez
> With isgne so wcokyrly that wynche they never."
> *Morte d'Arthure*, MS. Linc.

QUELLIO. See RUFF.

QUENTISE. See COINTISE.

QUEQUER. See QUIVER.

QUERPO, CUERPO. To be in "querpo" signified being without a cloak or upper garment. "*Cuerpo* is the body, and *in cuerpo* means in body clothing." (Gifford, note to 'Fatal Dowry.') "By my cloth and rapier it fits not a gentleman of my rank to walk the streets in querpo." (Beaumont and Fletcher, 'Love's Cure,' act ii. sc. 1.)

QUERPO-HOOD. Mr. Adey Repton says it was worn by Puritans, and is mentioned in the 'Works of Ned Ward:'

> "No face of mine shall by my friends be viewed
> In Quaker's pinner or in querpo hood."
> *Archæologia*, vol. xxvii.

* A popular error in France. See under ARBALEST, p. 10.

QUEUE. See LANCE-REST and PIGTAIL.

QUILLON. A name given to the horizontal guard of a sword in the sixteenth century.

QUIVER. A case for arrows. Although Bailey derives the word from the Saxon *cocen* (*Köcher* in German), it does not seem to have been applied to the article in question before the seventeenth century, when it occurs in Cotgrave. Even as late as Queen Elizabeth, in a MS. of that date containing directions for the equipment of archers, it is simply said, "Every man one sheaf of arrowes with a case of leather defensible against the rayne." That cases for arrows were used, however, by the Anglo-Saxons is proved by their paintings (see woodcut below); and Bishop Adhelm, in his Enigma 'de Lorica,' speaks of them by their Latin name *pharetris :*

"Spicula non vereor longis exempta pharetris ;"

which has naturally been translated, "I fear not the darts taken from the long quivers." And "long quivers" they appear to be, only an inch or two of the feathered shafts projecting from them. They were appended to a belt slung over the shoulder, as we see them in figures on the Greek and Etruscan vases. They are met with again in the Bayeux Tapestry of a similar form, and worn by the Norman archers at their backs or at their girdles. (See p. 51.) In the illuminated MSS. of the twelfth, thirteenth, and fourteenth centuries, there are numberless figures of archers and crossbow-men without quivers, but in many instances bearing their arrows in their belts, like the Squire's Yeoman in the 'Canterbury Tales :'

"A shefe of peacock arwes bryght and kene
Under his belt he bare ful thriftely."

And it is not before the second year of the reign of Henry VI., 1424, that any one appears to have

Anglo-Saxon Hunter. Cotton MS. Claudius, B 4.

Lady hunting. Harl. MS. 1431.

Archer. From Hewitt, vol. iii. p. 592.

Bolt case. From Skelton.

met with the least allusion in inventories, ordinances, or other records, to cases for arrows. In that year, however, a document preserved in the convent of St. Victor at Marseilles, quoted by Meyrick,

mentions them, under the name of *caexiis*, a word I cannot find in Ducange ; and in a MS. Royal, Lib. Brit. Mus. E iv., written for King Edward IV., *circa* 1480, there are figures of crossbow-men with arrow cases of a square form, on which is distinguishable the *briquet* or fire-steel, the well-known badge of the Duke of Burgundy. (See woodcut, page 11.) Later we find the word *quequer* in one of the Robin Hood ballads (Halliwell, *in voce*) :

" To a quequer Robin went."—i. 90.

And ultimately, as I have previously stated, we find in Cotgrave, " CARQUOIS : a quiver for arrowes." A quiver or bolt-case of the end of the sixteenth or beginning of the seventeenth century was formerly in the Meyrick Collection. It was covered with embossed leather. (See woodcut, previous page.) I give also the figure of a lady hunting in the fifteenth century from Harleian MS. No. 1431, and that of an English archer from the picture of the Departure of Henry VIII. from Calais, 1544.

QUOIF. See COIF.

AIL. (*Rægel*, Ang.-Sax.) A covering. (See HEAD-RAIL under COVER-CHIEF, and NIGHT-RAIL.) A *rayle* is described as a " kercheffe" in an Act twenty-second of Edward IV.

RAMILIE. See HAT, p. 206, and PERIWIG, p. 393.

RANSEUR. A weapon similar to the partizan, but having a sharper point and lateral projections, in lieu of the curved cross at the base of the blade which distinguishes the former.

Sir S. Meyrick, in the letterpress to Skelton's 'Engraved Specimens,' Plate LXXXVII., "Spetums, partizans, and ranseurs," observes : " These weapons are so nearly possessed of the same characteristics, viz. a blade with lateral projections, that if we confine the word 'partizan' to the sense in which it was used from the middle of the sixteenth (fifteenth ?) century, it might be retained as a general name for the whole. There exists, however, for our guidance, a valuable though scarce work by Pietro

Fig. 1. Fig. 2. Fig. 3. Fig. 4.

Ranseurs, 1461-1500. From Meyrick Collection. Fig. 1. *Temp*. Edward IV. Fig. 2. *Temp*. Richard III. Figs. 3 and 4. *Temp*. Henry VII.

Monti, printed at Milan in 1509, entitled 'Exercitorum atque artis militaris collectanea,' *in which they are described with such minuteness,* as well as named, that we have not that option." After this remark, it is rather startling to find M. Demmin, under "PARTIZAN," stating that "Pietro Monti, who," in the above-named work, "has particularly wished to describe this weapon, with which the guards of Francis I. and his successors were armed, has *confounded the partizan with ranseurs and halbards,* an error which has been committed in our days in the catalogue of the celebrated Meyrick Collection at Goodrich Court, where even spontoons and langue-de-bœuf bayonets (?) have been placed in the category of partizans." If the learned antiquary has, from some inadvertence, as inaccurately represented the descriptions of Monti as he has the catalogue of the Meyrick Collection, a copy of which is now before me, I can only attribute it to one of those excusable naps in which good Homer himself is said to have indulged occasionally. (See SPETUM.)

RAPIER. A long, light sword, introduced into England from France in the sixteenth century, generally supposed to be during the reign of Elizabeth. A MS. cited by Steevens in his edition of Shakespere, vol. iii. p. 327, gives some reasons for supposing the weapon had been heard of in the time of Henry VIII. (Meyrick, 'Crit. Inq.,' vol. iii. p. 48) ; but however that may be, there is sufficient evidence to show that it was considered a novelty in her reign, and was worn by nearly all gentlemen in civil attire. Bulleine, in his 'Dialogue between Soarnesse and Chirurgi,' 1579, speaks of "the long foining rapier" as a *new* kind of instrument "to let blood withall ;" and Stowe says, *sub anno* 1578, "Shortly after the thirteenth year of Elizabeth" (that would be subsequent to 1571) "began long tucks and long rapiers, and he was held the greatest gallant that had the deepest ruffe and longest rapier. The offence to the eye of the one, and the hurt unto the life of the subject that came by the other, caused her Majesty to make proclamation against them both, and to place selected grave citizens at every gate to cut the ruffes and break the rapiers' points of all passengers that exceeded a yeard in length of their rapiers and a nayle of a yeard in depth of their ruffes." Fuller, in his 'Worthies of England,' published in 1662, speaking of sword-and-buckler fighting, remarks that "since that desperate traytor Rowland Yorke first used thrusting with rapiers, swords and bucklers are disused ;" and Darcie, in his 'Annals of Queen Elizabeth,' also names the same person (Rowland Yorke) as the first "who brought into England that wicked and pernicious fashion to fight in the fields in duels with *a rapier called 'a tucke,'* only for the thrust." This "desperate traytor" appears to have betrayed Daventer to the Spaniards in 1587, "whence," says Meyrick, "it (the rapier) might be supposed to be a Spanish weapon ; but though it is generally so accounted, its name is French, and from that people was it first received by the English." ('Crit. Inq.' *ut supra.*) On this I must observe, firstly, that Yorke must have introduced it before his treason, as he could not have done so after it, and we have evidence of its being a fashionable weapon "shortly after" 1571 ; and, secondly, though Yorke may have brought it from France, it is by no means shown to be a weapon of French origin. The French undoubtedly have the word *rapière* in their vocabulary, which the Spaniards and the Italians have not ; but it is derived, according to Napoléon Landais, from the German *Rappier,* a sword or foil, and *rappiaren* in that language is "to fence with foils." I am consequently inclined to consider that the rapier was first made in Germany—a foil, in fact, used for foining and fencing only ; an art which was then superseding the old sword-and-buckler practice, to the great grief and disgust of the writers of that period. It was taught in Queen Elizabeth's time by one Giacomo di Grassi, who set up a school in London for the purpose ; but as early as 1553 it was popular in Italy, as appears from a work entitled 'Trattato di Scientia d'arme,' by Camillo Agrippa Milanese, published, with plates, at Rome in that year. The engravings illustrate encounters with single rapier, with what was termed "a case of rapiers" (each combatant having a rapier in each hand), with rapier and dagger, and with rapier and mantle, the latter being held in the left hand to use as a shield.

Stowe says the mode of fighting with the sword and buckler was frequent in England with all men till that of the rapier and dagger took place, which began about the twentieth of Elizabeth. Sometimes a very small buckler, called a "rondelle à poing," was used in lieu of the dagger or the mantle.

The rapier became the constant companion of the gentleman. It was worn even when dancing. In 'Titus Andronicus' Demetrius says to his brother Chiron :

> " Why, boy, although our mother unadvised.
> Gave you a dancing rapier by your side."
> <div align="right">Act ii. sc. 1.</div>

The rapier had a cup-guard below the cross, the commoner sort of plain steel, but men of rank and fortune had them of silver or silver gilt, or steel perforated of most elaborate workmanship.

Nearly every collection, national or private, contains fine specimens. Those formerly in the armory at Goodrich Court have unfortunately been omitted by Skelton. Stubbs, of course, has his growl at the gallants of his day, whose rapiers and daggers were "gilt twice or thrice over the hilts with good angel gold ; others at the least are damasked, varnished, and engraven marvellous goodly ; and lest anything should be wanting to set forth their pride, the scabbards and sheaths are of velvet and the like, for leather, though it be more profitable and so seemly, will not carry such a majority or glorious showe as the other." ('Anatomie of Abuses.')

<div align="center">Hilts of Rapiers. Tower Armory.</div>

RASH. "A species of inferior silk or silk and stuff manufacture." (Nares.) It is included in a list of such materials by Taylor the Water Poet, in his ' Praise of Hempseed :'

<div align="center">" Rash, taffeta, paropa, and novato."</div>

(See page 370, under MOCHADO.)

RAY. The standard measure for the *drap de raye,* or striped cloth, according to the statute of Edward III., was twenty-seven yards in length and six quarters and a half in breadth ; and in the thirty-second year of his reign it was ordered to be made in England of the same length and breadth as that which was made at Ghent in Flanders. (Rot. Parl. *an.* 25 and 32 Edward III., Harl. MS. 7059.)

Ray or striped cloth was much worn in the thirteenth and fourteenth centuries, and, after its disuse in civil attire, was retained in official dresses. In the time of Edward II. the complaint is made that

> " now in every town
> The ray is turned overthwart that should stand down.
> They be disguised as tormentors, that comen from Clerkes' play ;"

indicating that the clothes were made with the stripes across the body instead of running down the

stuff, so that they looked like tormenters (*i.e.* executioners), who in the Mysteries or Scripture plays were usually dressed in strange and fantastic habits. (Fairholt.) Rayed or striped cloth was much. used throughout the Middle Ages. It was worn by serjeants-at-law in the fifteenth century, and was commonly given for liveries. (See GENERAL HISTORY.)

RAYNES (Cloth of). Fine linen constantly mentioned in mediæval romances, and named from Rennes in Brittany, the original place of its manufacture. It retained its reputation in England as late as the sixteenth century.

> " I have a shirte of reyns with sleeves pendent."
> *Mystery of Mary Magdalen*, 1512.

> " Your skynne that was wrapped in shirtes of raynes."
> Skelton's *Magnificence, circa* 1512.

It was used also for bed linen :

> " Cloth of raynes to sleep on softe."
> Chaucer's *Dream*, l. 265.

> " Your shetes shall be of cloths of rayne."
> *Squyer of Lowe Degree.*

RAYONNE. (French.) "An upper hood pinned in a circle like the sunbeams." This very vague explanation is given in the 'Fop's Dictionary' (1690), of the following lines in 'Mundus Muliebris :'—

> " Round which it does our ladies please
> To spread the hood called rayonnés."

REBATO, RABATO. (*Rabat,* French.) A falling band or ruff, so called from the verb *rabattre,* to put back. (Menage.) "A rebato worn and with frissoning too often." (Dekker's 'Satiromastics.')

"Rabatoes" are mentioned amongst the articles of a fashionable lady's wardrobe in the old play of 'Lingua,' 1607 ; and

> " Shadowes, rebatoes, ribbands, ruffs, cuffs, falls,"

is a line in a similar catalogue in 'Rhodon and Iris,' a dramatic pastoral, first acted at Norwich in 1631. "Rebato wires" are noticed in Heywood's play, 'A Woman killed with Kindness,' 1617, which appears to explain the following passage from Dent's 'Pathway,' quoted by Halliwell :—"I pray you, sir, what say you to these great ruffs which are borne up with supporters and *rebatoes,* and even with poste and raile." Here the inference would surely be that the rebato had transferred its name to the wires that supported the ruff. (See SUPPORTASS.)

REBEN. "A kind of fine cloth" (Halliwell, *in voce*) ; but no reference or authority. Query, *Ribban.*

RERE-BRACE. Armour for the arm above the elbow. (See BRASSART.)

RHINGRAVE. The French name for the petticoat breeches worn in the reign of Charles II.

RIBBON, RIBAND. (*Ruban,* French.) Originally signifying the bands or borders of garments. "Adorées bandes" (gilt ribands): Guillaume de Lorris, 'Roman de la Rose.'

> " Full well
> With orfraies laid every dell,
> And portraied in the ribaninges
> Of dukes' stories and of kings."
> Chaucer, *Romaunt of the Rose.*

Ribbons of that description seem to have been known as early as the time of Edward III. in England, as they are mentioned in an Act of Parliament passed in the thirty-seventh year of his reign, in conjunction with other ornaments of gold or silver prohibited to be worn by tradesmen, artificers, or "gens d'office, appellez yeomen :" " Ceinture, cottell, fermaille, anel, garter, nouches, *rubans,* cheisnes, binds, seals," &c.

It is not, however, till the sixteenth century that ribbons in the present sense are seen or heard of, and only in the seventeenth that they acquired that hold on public favour which has lasted to the present day. The profusion in which they were worn by men in the days of Charles II. and James II. is almost incredible. Every portion of their attire was trimmed with them. Evelyn, describing the dress of a fop of his time, says : "It was a fine silken thing which I espied walking th' other day through Westminster Hall, that had as much ribbon about him as would have plundered six shops and set up twenty country pedlars. All his body was drest like a May-pole or a Tom o' Bedlam's cap. A fregat newly rigg'd kept not half such a clatter in a storme as this puppet's streamers did when the wind was in his shrouds ; the motion was wonderful to behold, and the well-chosen colours were red, orange, and blew, of well-gum'd satin, which argued a happy fancy." ('Tyrannus, or the Mode.') Ribbon head-dresses were worn by ladies at the beginning of the eighteenth century. In a letter to the 'Spectator' it is reported that "a lady of this place had some time since a box of the newest ribbons sent down by coach. Whether it was her own malicious invention or the wantonness of a London milliner, I am not able to inform you ; but among the rest, there was one cherry-coloured ribbon, consisting of about half-a-dozen yards, made up in the figure of a small head-dress."

RIBBON OF AN ORDER OF KNIGHTHOOD. The first appearance of this decoration in its present shape occurs towards the end of the seventeenth century. The "lesser George," as the jewel which is appended to the ribbon of the Order of the Garter is called, was not worn before the thirteenth year of the reign of Henry VIII., by whom it was added to the other insignia. It hung on the breast from a chain or a silk ribbon which passed round the neck, and the colour of the ribbon in the thirty-eighth year of his reign was black. (Ashmole's 'Hist. of the Order of the Garter.') No alteration occurred until the reign of James I., when the colour of the ribbon was changed to sky-blue. The broad ribbon worn over the left shoulder and brought under the right arm, where the jewel now hangs, was introduced shortly before the publication of Ashmole's History of the Order in 1685 ; and the story goes that after the young Duke of Richmond, son of Charles II. by the Duchess of Portsmouth, was installed Knight of the Garter, he was introduced to the King by his mother with the ribbon so arranged, and his Majesty was so much pleased with the alteration that he commanded it in future to be adopted. Charles I. is, however, represented with the ribbon and jewel so worn in a picture by Vandyke. The colour of the ribbon remained sky-blue till the reign of George II., who changed it to the present deep blue in consequence of "the Pretender's" making some knights of the Order. The portrait of Philip Dormer Stanhope, Earl of Chesterfield, in the British Museum, presents us with one of the latest examples of the light-blue ribbon. He was elected in 1728.

The ribbon of the Order of St. Andrew, instituted by Queen Anne, 1703, is green, and worn over the left shoulder, as that of the Garter is, but they are never worn together, a Knight of St. Andrew returning his insignia to the Sovereign on becoming a Knight of the Garter.

The ribbon of the Order of the Bath, instituted by George I., 1725, is scarlet, and worn by the Knights Grand Crosses over the right shoulder.

RING. Rings of the Anglo-Saxon period have been frequently found, and many of much beauty, testifying to the artistic skill of the workmen in those days, are preserved in national museums and the cabinets of private gentlemen. The collection formed by the late Lord Londesborough, and of which a catalogue, compiled by the late Thomas Crofton Croker, F.S.A., was printed for private reference in 1853, is probably unequalled in Europe, containing (including some fibula and other personal ornaments) "no less than two hundred and fifty objects ; many of which possess consider-

able archæological interest," and illustrating Egyptian, Greek, Etruscan, Roman, Hebrew, British,
Gaulish, Anglo-Saxon, and mediæval German and Italian art,
together with curious specimens of Gnostic, cabalistic, and
talismanic rings. Engravings, however, give no idea of their
character. In the Middle Ages gifts of rings were common—

Enamelled and Gold Danish Ring. From Royal Museum, Copenhagen.

> " Lo ! here is a red gold ring
> With a rich stone.
> The lady looked on that ring ;
> It was a gift for a king."
> *The Lay of Sir Degrevant.*

Gold Ring. Scandinavian. From Royal Mus., Copenhagen.

Sovereigns are invested with rings at their coronations, and rings were
indicative of clerical dignity, and denoted that the wearers were wedded to the
Church. Several episcopal and two pontifical rings are in the Londesborough
Collection. In the romance of 'King Athelstan,' written in the fourteenth century,
the King says to the offending Archbishop—

Gold Ring found at New Grange, co. Meath, Ireland.

> " Lay down thy cross and staff,
> Thy myter and thy ryng I to thee gaff."

Dugdale, in his 'Origines Juridiciales,' describes a custom which existed in the fifteenth and sixteenth
centuries, of a serjeant-at-law on his appointment to present gold rings to the king, queen, the great
law officers, and the guests at his inaugural entertainment, of values proportionate to the rank of each
recipient. As late as 1736, on a call of the serjeants, the number of rings amounted to 409, and their
cost to £773. They bore mottoes, such as "Lex regis præsidium," "Vivat Rex et Lex." Posies or
poesies for rings were popular in the Middle Ages, being short sentences, single lines, or rhyming
couplets—

> " Is this a prologue ? or the poesie of a ring ?"
> *Hamlet,* act iii. sc. 2.

> " A paltry ring
> That she did give me, whose poesy was
> For all the world like cutler's poetry
> Upon a knife—' Love me and leave me not.'"
> *Merchant of Venice.*

They were generally engraved on the outside of the ring in the fourteenth and fifteenth centuries, and
in the inside in the sixteenth and seventeenth. Annexed are several examples :

Both ladies and gentlemen wore many rings in the fifteenth century. Lady Stafford, in
Bromsgrove Church, Worcestershire (1450), has some on
every finger but the last one of the right hand. (See
also the hand of John Gyniford, Benefactor of St. Albans,
holding a purse, at page 409 of this volume.)

Gimmal rings, for betrothals or marriages, were
much in favour anciently. The word is derived from
gemelli (twins). Douce notes—" Gemmell or gemow
ring—a ring with two or more links ;" and Bailey gives

Table-cut Diamond Ring found in a grave at Carne, county of Westmeath, Ireland, 1748.

"jimmers" as a local word for jointed rings. Dr. Nares says : "Gimal rings, though originally double, were by a further refinement made triple, or even more complicated, yet the name remained unchanged." So Herrick—

> " Thou sent'st to me a true-love knot ; but I
> Return a ring of *jimmals* to imply
> Thy love had one knot, mine a *triple* tye."

The form of double, triple, and even quadruple *gimmals* may be seen in Holmes' Acad. B. iii. Nos. 45 and 47, where he quotes Morgan, who, in his 'Sphere of Gentry,' speaks of triple *gimbal* rings borne as arms by the name of "Hawberke," evidently because the hauberk was formed of rings linked into each other. Gimmel or gimmal ring, in fine, was used as a general term for all such as have two hands clasped, although, perhaps, correctly speaking, it should only be applied to duplicate rings made to resemble one, and which, by turning on a pivot, can readily be disunited, and become pledges of troth and affection. (See example annexed, showing the hands clasped, the ring closed, and the ring unclosed.) Adjoined is an engraving of a gimmal ring in the collection of the late Lord Londesborough, consisting of three rings which turn on a pivot. Fig I. shows the ring with the joined hands as worn on the finger ; fig. 2, the ring when unclosed, forming three rings secured by a pivot. It is of German workmanship.

Double Gimmal Ring.

Fig. 1.

Fig. 2.
Triple Gimmal Ring.

Signet rings were frequently worn on the thumb. Falstaff declares that when young he could have crept into "an alderman's thumb ring." Here is a personal signet thumb ring found in the bed of the Severn, near Upton, and considered to be of the fifteenth century ; also a massive thumb ring having the tooth of some animal set in the bezel as a charm against evil, and the hoop set round with precious

Personal Signet Ring
worn by merchants on the thumb.

Massive Thumb Ring. Londesborough Collection.

Alderman's Thumb Ring. Londesborough
Collection.

stones, all believed to have magical properties ; likewise an alderman's thumb ring, the seal engraved with a monkey, and inside a mystic word or charm, *anam-zapta.* The last two are from the Londesborough Collection. Hall tells us—

> " Nor can good Myson wear on his left hand
> A signet ring of Bristol diamond,
> But he must cut his glove to show his pride,
> That his trim jewel might be better spy'd."
> *Satires*, 1598.

Cramp-rings, as a preservative from that complaint, and superstitiously constructed of the handles of coffins, were consecrated during the ancient ceremony of creeping to the cross previous to the Reformation. Andrew Borde (*temp*. Henry VIII.) says : " The Kings of England doth hallowe every

yeare crampe rynges, the which rynges worn on one's finger doth helpe them which hathe the crampe."

ROBE. This word, which in French is the general term for a gown, is limited, in English, to state and official garments—the coronation and parliamentary robes of the sovereign, of the peers and peeresses, the judges, &c. The vestments of the early kings of England on state occasions do not appear to have differed from their ordinary apparel, unless occasionally the materials may have been more costly. The numerous representations of royal personages to be found in this work, show that they simply consist of a long tunic and a mantle ; the latter, in the thirteenth century, lined with ermine, and occasionally having a cape of ermine covering the shoulders. Richard I. is said to have worn a dalmatic over his tunic at his coronation, " primo tunica deinde dalmatica," and such appears to have been the order of investment ; but the dalmatic being, in point of fact, a tunic or supertunic, as it is frequently called, it is not always distinguishable in the miniatures or effigies. (See DALMATIC.) Henry VI. is said to have had, in addition to the dalmatic, " a stole round his neck." (See STOLE.) No particular colour is assigned to the coronation mantle, but we hear of our kings, on certain days, sitting at dinner in their scarlet robes, which implies some distinction, and by which, I believe, is meant their parliamentary robes. The vestments of Edward the Confessor were believed to have been preserved at Westminster, and used in the coronations of our sovereigns for many years ; but those dragged out of the iron chest there by the regicide Martin in 1634, and which were sold or destroyed in 1649, could surely have no pretension to be considered of that age, whatever the crown or sceptre might have had. They consisted of

	£	s.	d.
" One crimson taffety robe, very old, valued at	0	10	0
One robe laced with gold lace, valued at	0	10	0
One liver cull^d. (coloured) silk robe, very old and worth nothing		..	
One robe of crimson taffety sarcenett, valued at . . .	0	5	0 "

These, with a pair of buskins, stockings, shoes, and gloves, altogether were estimated at twenty-nine shillings and sixpence ! It will be noticed that the four garments are all called "robes," so that we are left in the dark as to whether they were mantles, tunics, or dalmatics.

To come to records, which one would suppose might be relied upon. Mary (Tudor), daughter of Henry VIII., proceeded from Westminster Hall to the Abbey for her coronation, "in her parliament robes of crimson velvet, containing a mantle with a train, a surcoat with a kirtle furred with wombs of miniver, a riband of Venice gold, the mantle of crimson velvet powdered with ermines, with a lace of silk and gold, and buttons and tassells of the same." Such is the account of two contemporary documents in a MS., containing the official records of the coronation of Queen Mary, in the College of Arms, marked I. 7 and W. Y. The French Ambassador, Mons. de Noailles, corrects a confusion in these accounts, and says that at a certain part of the ceremony the Queen retired to a private chamber, and having taken off her mantle, returned in a corset of purple velvet, and, after being anointed, was clad in a robe of white taffeta and a mantle of purple velvet furred with ermine, and without a band—"sans rabat."

Of the robes of Queen Elizabeth we have a minute description in her "wardrobe account." Her parliamentary robes are thus entered : "Item, one mantle of crimson vellat (velvet), furred throughout with powdered armoynes (ermines), the mantle lace of silke and golde, with buttons and tassels to the same. Item, one kirtle and surcoat of the same crimson vellat, the traine and skirts furred with powdered armoyns, the rest lined with srçonest (sarcenet), with a cap of maintenance to the same, striped downright with passamaine lace of gold, with a tassel of gold to the same furred with powdered armoyns." Her coronation robes are described in the same account as follows :—" Firste, one mantle of clothe of gold, tissued with golde and silver, furred with powdered armoyns, with a mantle lace of silke and golde, with buttons and tassels to the same. Item, one kirtle of the same tissue, the traine and skirts furred with powdered armoyns, the rest lined with sarcenet, with a pair of bodies and sleaves to the same." After the ceremony, it appears she changed her apparel a second

time for the banquet in Westminster Hall, her robes being those of "estate," and consisting of a rich mantle and surcoat of purple velvet furred with ermine. (Frag. MS. Coll. Arms, W. Y. f. 198.)

The Surcoat or Supertunic.

The Mantle.

The Dalmatic.

Stole or Armill.

Coronation Robes of James II. From Sandford.

Colobium Sindonis.

The robes of a king would necessarily differ, in some respects, from those of a queen; but they equally consisted, after the sixteenth century, of three distinct sets of apparel:—1. The parliament

robes, which the king put on in the Palace of Westminster before he proceeded to the Abbey, viz., a surcoat and mantle of crimson velvet furred with ermine, and bordered with rich gold lace. 2. The coronation robes, viz., the colobium sindonis (see COLOBIUM), of fine white cambric or lawn, and which, in the seventeenth century, was profusely trimmed about the neck, armholes, and round the bottom, with the finest point lace ;* the supertunic or surcoat of rich cloth of gold, lined with crimson taffeta, with a belt of the same stuff lined with white tabby, and furnished with a gold buckle, runner, and tab, to which hangers were affixed for the sword ; the dalmatic, which at the coronation of James II. was of purple brocaded tissue, shot with gold thread, enriched with gold and silver trails and large flowers of gold, frosted and edged with purple or mazarine blue, the lining of rich crimson taffeta, and the fastening a broad gold clasp ; the stole of cloth of tissue, the same as the supertunic, lined with crimson sarcenet, about an ell in length and three inches in breadth, with two double ribbons at each end to tie it above and below the elbows (see STOLE) ; and finally, the mantle of cloth of gold brocaded and furred with ermine. (See engravings on previous page.) 3. The robes of estate, in which the sovereign returned to Westminster Hall to the banquet, and which were of purple velvet furred with ermine, as before described.

No important alteration appears to have been made during the eighteenth century. It does not appear that there was any distinctive habit for the peers of England previous to the latter part of the fifteenth century. In all representations of them during the Middle Ages, whether standing beside the throne or in parliament, they are apparelled in the dress of noblemen of the period. In Selden's 'Titles of Honor,' printed in 1614, we have prints of a baron, a viscount, an earl, a marquess, a duke, and a prince, in their creation robes, and subjoin engravings of them illustrating their appearance in the reign of James I.

Baron.

Viscount.

* The lace used for trimming that of Charles II. cost 18*s.* the yard. Mrs. Palliser has printed the maker's bill :—
" To William Briers for making the colobium sindonis of fine lawn, laced with fine Flanders lace, 33*s.* 4*d.* To Valentine Stucky for 14 yards and a half of very fine Flanders lace for the same, at 18*s.* per yard, 12*l.* 6*s.* 6*d.*" (Accounts of the Earl of Sandwich, 28th of April, 1661.)

Earl.

Marquess.

Duke.

Prince.

Augustin Vincent, in one of his MSS. in the College of Arms, marked No. 151, written some eight or ten years later than the publication of Selden's book, has drawn and coloured the same figures

with additional illustrations, and appended to them some useful information. In the first place, we learn that the baron and the viscount are represented in their parliamentary robes, which at that time consisted of a kirtle, and mantle, and hood of scarlet cloth, furred with miniver, the mantle of the baron having, on the right shoulder, two bars of miniver with borders of gold lace, and that of the viscount two and a half. A coloured diagram of the mantle and hood are added to the figures, and a back view of a peer in his robes also illustrates the following description of his investiture :—

"First a baron of the Parliament is invested in a kirtall of scarlet girt to his middle, thereupon he putteth his hood, such a one as is here depicted, and over all his mantle ; and the mantle being on, the end of the hood is pulled out behind the neck and hangeth over the mantell as in the viscount's " (p. 256). Here are copies of the illustrations.

Diagram of Mantle.

Hood, front view.

Hood, back view.

Back view of a Peer.

The earl, marquess, duke, and prince, are represented as in Selden, in their coronation robes, which differ from their parliamentary robes by being of velvet, and having capes or tippets of ermine in lieu of bars of miniver. These robes, worn, as it will be observed, over their ordinary dress, consist of a surcoat and mantle. The parliamentary mantles of the baron and the viscount open on the right side, and have their distinguishing bars of fur on the right shoulder only. The mantles of all the others open in front, and have capes of fur covering both shoulders. This is described as "doubling." "The mantle of the

marquesse is doubled ermine, as is the earl's also ; but the earle's *is but four* and the marquess's *is of five*. The doubling of the viscount is to be understood to be but of miniver or plain white fur, so is the baron's—the baron's of two, the viscount's of *three* doublings." Thus Selden ; but Vincent a few years later says :

> " A viscount *two barres and halfe,*
> An earle *three barres,*
> A marquess *three and halfe,*
> A duke *four barres.*"

Selden is generally so accurate that it becomes a question whether any alteration took place after 1614. Vincent's notes were made between that date and 1626 ; and as he was present at the coronation of Charles I. in 1625, it is not improbable some new order might have been issued at that period. Carter, in his 'Analysis of Honor,' printed in 1655, copies the figures of Selden, and repeats his description *verbatim ;* but that it must have been written at a much earlier date is evident from his observations respecting the King and Constitution, which render it a matter of surprise that such a book could be published during the rule of Cromwell. Carter was, however, a mere compiler, and of no authority, and Vincent not only wrote from personal knowledge in his official capacity, but the distinctions so precisely described by him are those observed in the present day, which is conclusive as to their authenticity. Vincent also records that "William, Lord Berkely, was created Viscount Berkely in a surcoat of scarlet, the pinells (?) of yᵉ sleeve bound with a riband of gold, a mantell of the same with 2 *barres and a halfe* miniver, with a little hood rouled about his neck furred of the same, and between every barre a riband of gold ; and in this forme," he asserts, " were all viscounts created to the time of Queen Mary : then they began to have robes of crimson velvet and a cap of estate." Now, William, Lord Berkeley, was created Viscount Berkeley 21st of April, 1482 ; and therefore, if Vincent had authority for that statement, two bars and a half of miniver distinguished the mantle of a viscount in the last years of the reign of Edward IV. In the same curious MS.—which, it is important to observe, is a collection of precedents for the guidance of the officers of arms in all ceremonies in which it was their duty to take part—we are told that "Anthony Browne, created Viscount Montacute 2nd Sept., 1st and 2nd of Philip and Mary, was the first viscount that had a mantle of crimson velvet furred with miniver thinn powdered, without any barres or hood, but onely a little (what ?) at the topp." From this confused account I infer that the crimson velvet mantle was a creation robe, distinct from the parliamentary robe, which was of scarlet cloth, particularly as he is described as wearing " a jacket of cloth of silver," and not the kirtle or surcoat of scarlet cloth which was worn with the latter mantle. This opinion is strengthened by a further note in the same MS., informing us that " in the time of Queen Elizabeth the viscounts first had a surcote of crimson velvet," thereby completing their creation or coronation robes ; but the fact of the peers having two distinct sets of vestments is not alluded to, and we are consequently in the dark as regards the time when a regulation to that effect was made, though such little incidental scraps of intelligence as we occasionally meet with all seem to point to the sixteenth century. The earliest positive mention of such a distinction I am aware of occurs in the order of procession at the creation of Henry, Prince of Wales, in 1610, where I read, " The peers and officers of State *in their parliament robes.*" The same uncertainty exists respecting the robes of peers above the rank of a viscount. They are represented by Selden and Vincent in the mantles with which they were invested by the Sovereign at their creation, and under-garments, indifferently called kirtles, surcoats, or gowns, confined at the waist by girdles of silk ; and in these robes we subsequently see them in the processions of James II. and his successors from Westminster Hall to the Abbey, for their coronations. In the time of Queen Elizabeth and James I. the mantles were of purple velvet. Walter Devereux, Viscount Hereford, was created Earl of Essex by Queen Elizabeth in 1572, and is described in an account of the ceremony as " having on an under-gowne of purple silk, and covered with a robe of estate and a velvet mantle of the same cullor." By " a robe of estate " must be meant the kirtle or surcoat, as there could not have been one mantle worn over the other, or " and " may have been a clerical error, and we should read " or." Nevertheless, the colour of the whole habit is distinctly said to be purple, and in the MS. the robes of

the earl, marquess, and duke are so painted; yet Anne Bullen, on her being created Marchioness of Pembroke by Henry VIII. at Windsor, Sept. 1, 1532, was invested by the King with a mantle of crimson velvet, the colour of those worn by the peers of the present century at coronations. There is, however, sufficient testimony, both written and pictorial, that in the time of James, and possibly of

Charles I., the earls, marquesses, and dukes were invested with robes of purple velvet, the mantles having capes or tippets of ermine, the degrees being marked by rows of the black tails in lieu of bars of miniver on the right shoulder, a fashion which may be traced to France in the fifteenth century. (See GENERAL HISTORY.) The graceful surcoat became an unpicturesque waistcoat in the seventeenth century, and eventually discarded altogether, and peers wore their scarlet robes, as now, over their ordinary attire in Parliament, and on special occasions their robes of purple or crimson velvet over Court dress or uniform.

Our information respecting the official costume of the Bench and the Bar is abundant; but, unfortunately, the descriptions are not so clear as they are copious. The seal of Robert Grimbald, a justice of the time of Henry II., represents him in a long tunic and mantle, with a round cap on his head, and a sword in each hand;* but whether we are to consider this to be an official dress, as it differs in no particular point from that of a person of distinction of the twelfth century, may be a question. The earliest notice of the robes of the judges discovered by Dugdale, occurs in a Close roll of the 20th Edward I., A.D. 1292, where the Keeper of the

A Peeress in her coronation robes. *Temp.* James II.

Great Wardrobe is ordered to deliver unto William Scot and the rest of his fellow-justices of his bench, to John de Stonore and those with him of the Common Pleas, and Richard Sainford and other the Barons of the Exchequer, viz., "To each of them, for their summer vestments for the present year, half a short cloth, and one piece of '*fine linnen silk;*' and for the winter season, another half of a cloth colour *curt*, with a hood, and three pieces of fur of white budge; and for the feast of the Nativity of our Lord, half a cloth of colour curt, with a hood and thirty-two bellies of miniver, another fur with seven tires (rows) of miniver, and two *furs of silk*." ('Origines Juridiciales.')

From the seal of Robert Grimbald.

Herein is no description of the colour of these robes, for "cloth of colour curt" means "cloth of one colour *short*," in distinction to "cloth of colour long," subsequently mentioned. "Fine linen silk" and "furs of silk" are also expressions requiring elucidation. Similar directions were issued in the reign of Edward III., when the colour of the robes is expressly mentioned, and some of my readers may be surprised to hear that it was green. These robes were, however, not those for the judges, but delivered to them upon their being made knights, as it appears by subsequent entries.† Unfortunately, we derive but little assistance from sculpture or painting at this period.

The effigy of Sir Richard de Willoughby, Chief Justice of the King's Bench in the eleventh

* The swords of Justice and Mercy, the latter being indicated by the broken blade.

† The day before his coronation Henry IV. made forty-six knights, and gave to each of them a long coat of a green colour, with straight sleeves furred with miniver.

COURT OF KING'S BENCH, TEMP. HENRY VITH

year of the reign of Edward III., represents him in the ordinary costume of his day ; and that of Sir William Gascoigne, Chief Justice of the King's Bench, *temp*. Henry IV., in Harwood Church, Yorkshire, though a valuable authority for the

shape of the dress, affords us no indication of colour. The plate in Meyrick's 'Ancient Costume in England' has been coloured from the figure of a judge seated on the bench, in an illuminated MS. ('La Bible historial,' in the Royal Library, Brit. Mus., marked 15 D 3), the costume in which shows its date to be early fifteenth century. The mantle is red, lined with white and grey fur, the surcoat or supertunic blue, but no dependence can be placed on the colouring, which does not accord with the official descriptions, any more than does the form of the robes with that of those on the effigy.

For the time of Henry VI., however, we possess ample and undoubted authority in four illu-

Effigy of Sir Wm. Gascoigne.

Sir John Spelman. From Narburgh Church, Norfolk.

minations of that period, exhibited to the Society of Antiquaries by Mr. Corner, 6th December, 1860, and of which coloured copies have been published by the Society, in the thirty-ninth volume of the 'Archæologia.' These most interesting miniatures represent the interiors of the Court of King's Bench, the Court of Common Pleas, the Court of Chancery, and the Court of the Exchequer, with the judges, the counsel, the officers of each court, the plaintiffs, the defendants, prisoners, &c., all carefully drawn, and evidently accurately painted.

In the Court of Chancery are two judges in scarlet robes trimmed with white fur, one uncovered and tonsured, the other wearing a sort of brown fur cap (see HURE); the white fur lining of their hoods stands up like a collar about their necks. Four other persons are seated, two on each side of the judges, wearing robes of the same form, but "mustard-colour," three of whom are tonsured. Mr. Corner suggests that they are Masters in Chancery, who occupied that position down to the time of Lord Brougham.

In the Court of King's Bench are five judges, all in scarlet gowns and mantles, and wearing white coifs. Their hoods appear to belong to the gown, the white fur which lines them being visible at the edge of the tippet, from the opening of the mantle on the right shoulder.

In the Court of Common Pleas are seven judges, all in scarlet, with coifs as the former.

In the Court of Exchequer the chief baron is seated, wearing a scarlet gown and mantle, and a scarlet chaperon of the form worn at that date, having two persons on each side of him in mustard-coloured robes of the same form, two of whom wear chaperons of the same colour, and the other two in caps, and holding their chaperons in their hands. Mr. Corner suggests that they are the other Barons of the Exchequer; but I doubt it, as the robes issued to them appear to have been always similar in colour to those of the chief.

In the first volume of the 'Vetusta Testamenta,' a work published by the Society of Antiquaries for many years, but now discontinued, is an engraving from a curious painted table formerly kept in the King's Exchequer, and which recorded the standard of weights and measures as fixed in the

twelfth year of the reign of Henry VII. The character of the robes is similar to those in the painting previously mentioned.

Lord Chief Baron of the Court of Exchequer.
Temp. Henry VI.

Barons of the Court of Exchequer. *Temp.* Henry VII.

John Haugh, Justice-at-Law. From window
of Long Melford Church, Suffolk.
Temp. Edward IV.

In Swarkeston Church, Derbyshire, is the effigy of Richard Harpur, "one of the justices of the common bench, at Westmynster," in the time of Mary; and the engraving of the 'Court of Wards

Effigy of Richard Harpur, Swarkeston Church, Derbyshire.

and Liveries,' also published in the first volume of the 'Vetusta' before mentioned, is an undeniable authority for legal costume in the reign of Elizabeth.

The regulations for the apparel of the judges in the reign of Charles I. are printed in Dugdale's 'Originales,' from an order issued in 1635.

"The judges in term time are to sit at Westminster in their black or violet gowns, whither (whichever) they will, and a hood of the same colour put over their heads, and their mantles above all, the end of their hood hanging over behind, wearing their velvet caps and coiffes of lawn, and cornered caps. The facings of their gowns, hoods, and mantles is with changeable taffata, which they must begin to wear upon Ascension Day, being the last Thursday in Easter Term, and continue those robes untill the Feast of Simon and Jude; and upon Simon and Jude's day, the judges begin to wear their robes faced with white miniver, and so continue that facing till Ascension Day again. Upon all holy days which fall in the term, and on hall days, the judges sit in scarlet faced with taffata, when taffata facing is to be worn, and with furs or miniver when furs and miniver are to be worn.

When the judges go to Paul's to the sermon in term, or any other church, they ought to go in scarlet gowns, the two Lord Chief Justices and Chief Baron in their velvet and satin tippets, and the other judges in taffata tippets, and then the scarlet *casting hood* is worn on the right side above the tippet, and the hood is to be pinned abroad towards the left shoulder."

By "casting hood," I presume, is meant the hood of the fifteenth century, with its long tail or liripipe, also called a tippet, though I question the propriety of the latter phrase (see TIPPET), the turban-like portion of which was *cast* over the shoulder, the tail hanging down in front, or being tucked into the girdle, or brought across the breast "towards the left shoulder," as depicted in a charter of the Leathersellers Company, time of James I. (See woodcut

From Charter of Leathersellers Company.
Temp. James I.

The King's Solicitor. Coronation of Charles II.

annexed, also pp. 295, 296, under HOOD.)

On circuit they are instructed to go to church in their scarlet gowns, hoods, and mantles, and sit

Chief Justice of King's Bench. *Temp.* Charles II. Serjeant-at-Law. *Temp.* Charles II. Serjeant-at-Law. *Temp.* James II.

in their caps ; and in the afternoon in scarlet gown, tippet, and scarlet hood, and sit in their *cornered* caps. "The judge at Nisi Prius may, if he will, sit only in his scarlet robe, with tippet and casting hood ; or if it be cold, he may sit in his gowne with hood and mantle." (*Ibid.*)

Minute as are these directions, it would be difficult for an artist to paint a judge of any of the above periods in his robes with accuracy, unassisted by contemporary pictorial illustration. Our authorities, however, multiply during the seventeenth century. The coronation processions of Charles II., by Hollar ; of James II., by Sandford ; of William III., and the first two Georges, afford us authorities for the state costume of all the high official personages in the kingdom, and from them we select a few of the most important for the illustration of this portion of our article. (See woodcuts on preceding page.)

The official costume of the Serjeant-at-Law is frequently alluded to by writers of the Middle Ages, but the same difficulties as perplex us in so many other instances—the capricious usage of terms, the vagueness of the descriptions, and the absence of pictorial illustration — prevent our obtaining an accurate knowledge of it. A probable representation of a Serjeant-at-Law of the time of Edward I. has been given at page 102.

Lord Chief Justice Fortescue, in his book 'De Legum Angliæ Laudibus,' says that "a serjeant-at-law is clothed in a priest-like robe, with a furred cape about his shoulders, and thereupon a hood with two labels, such as doctors of the laws wear in certain universities with their coif ; but being made a justice, instead of his hood he must wear a cloak closed upon his right shoulder, all the other ornaments of a serjeant still remaining, save that his vesture shall not be particoloured, as a serjeant's may, and his cape furred with miniver, whereas the serjeant's cape is even furred with white lamb-skin." This work was written in the reign of Henry VI., though not printed before that of Henry VIII. ; it contains, therefore, the earliest detailed description of legal costume at present

known to us : but the author of 'Piers Ploughman,' in his 'Vision,' nearly a century previously, has given us glimpses of it :—

> " Then came an hundred in houves of silk,
> Sergeaunts as hem seemed
> That served at the barre."

He also asks :

> " Shal no sergeaunt for his service weare no silk houve,
> Nor peleore on his cloke for pledynge att the barre ?"

And Chaucer, in his 'Canterbury Tales,' describes the Serjeant, who was one of the pilgrims, as clad in a " medley cote,

> " Girt with a ceint of silke with barres small."

In the valuable contemporary MS. in the possession of the Earl of Ellesmere, this personage is represented in a scarlet gown parted with blue, with small bars or stripes of red ; his hood is white, and furred ; and he wears the coif (houve), which is not mentioned by Chaucer.

We now come to the four paintings of the Courts of Law in the reign of Henry VI., which have already furnished us with such interesting representations of the judges. In these curious pictures there are several serjeants apparently "pledynge att the barre," and others in consultation with their

Serjeant-at-Law. *Temp.* Henry VI. clients. All of them are attired in party-coloured gowns, some blue and green, the blue portion rayed or striped with white or pale yellow, hoods and tippets or capes of the same and lined with white fur, of which the edge alone is seen ; others in blue and mustard-colour, rayed diagonally with double stripes of black, and one in murrey and green. Each wears the white coif, but in no instance is there an indication of " the two labels "

mentioned by Sir John Fortescue, nor of the furred cloak we hear about in Piers Ploughman's 'Vision.'

A little more information is derivable from an account of the mode of making a serjeant in 1635 "He comes in a black robe, his ancient clerk bearing after him a scarlet hood with a coif upon it. The Lord Chief Justice puts on the coif (*i.e.* he puts it on the head of the serjeant), and ties it under his (the serjeant's) chin. Then he (the serjeant) puts off his black, and puts on his party-coloured robe of black and murrey, and hood of the same, with the tabard (?) hanging down behind, and all that year he goes in his party-coloured robe, and his men in party-coloured coats, unless upon a Sunday or holyday, and then in violet with the scarlet hood. At all times when the judges sit in scarlet, all the serjeants, as well he of the first year as the others, are to wear a violet robe, and a violet hood close over his neck, with the tongue hanging back and down behind." (Dugdale, 'Orig. Juridiciales.') To this account Dugdale adds, "The robes they now use (1671) do still somewhat resemble those of the fashions of either bench, and are of three different colours, viz. murrey and black furred with white, and scarlet; but the robe which they usually wear at their creation only is of two colours, murrey and mouse-colour, whereunto they have a hood suitable, as also a coif of white silk or linen." There is an account of the time of Elizabeth of a creation of serjeants-at-law similar to the above, which I omit here, as I shall have occasion to notice it under TABARD; but it ends with the information that "when they (the new serjeants) come home they go to their chambers and put on *their browne, blewe, and skarlet hoode* over both their shoulders behind about their necks, and go to dinner." I confess that the slovenly English, and the confusion of terms in these descriptions, render them, to me, inexplicable. Beyond the fact that at some time between the reigns of Henry VI. and James I. a change took place in the colours of the serjeants' gowns and hoods, that green and mustard-colour had been discarded, and rayed cloth no longer considered to "betoken prudence and temperance" (Speech of Lord Chief Justice Wray, 19th Eliz.), I can come to no conclusion satisfactory to myself, and consequently have none to suggest to my readers.

Black coifs appear worn over the white ones in the reign of Elizabeth, and only black in that of Charles II. The coif is now absurdly represented by a round black patch on the top of the wig.

In the procession of Queen Anne to her coronation, the habits of the following legal personages are thus described:—

"Six Clerks in Chancery in gowns of black flowered satin, with black silk loops and tufts.

"Masters in Chancery in rich gowns (no colour or material mentioned).

"The Queen's younger Serjeants-at-law in scarlet gowns and caps in their hands.

"Solicitor and Attorney General in black velvet gowns.

"Barons of the Exchequer and Justices of both benches in judges' robes of scarlet, with caps in their hands.

"The Lord Chief Baron and the Lord Chief Justices in scarlet robes.

"The Master of the Rolls in a rich gown." (MS. Coll. of Arms, I. 2.)

The epigram of the witty Master of the Rolls, Sir Joseph Jekyll, proves the existence of a purple robe in the reign of George II.:

> "The serjeants are a grateful race,
> Their robes and speeches show it;
> Their purple robes do come from Tyre,
> Their arguments go to it."

The late Lord Chief Baron Pollock, in answer to a question put to him by Dr. Dimond respecting the black gowns of the gentlemen of the long robe at the present day, replied that the Bar went into mourning on the death of Queen Anne, and never came out again.

Academical gowns, not properly robes, will be described in notices of professional costume in the GENERAL HISTORY.

ROCHET, ROCKET. (*Rochette,* French.) This word is considered to be the diminutive of the Anglo-Saxon *Roc,* which signified a loose upper garment. It was originally a secular habit, and

principally worn by females. It was assumed by the clergy in the Middle Ages, and is now only known as an ecclesiastical vestment.

Chaucer, in his translation of the 'Roman de la Rose,' says :

> " There is no clothe sytteth bette
> On damoselle than doth rokette ;
> A woman wel more fetyse is
> In rokette than in cote, I wis.
>
> " The white rokette riddeled faire
> Betokeneth that full debonaire,
> And sweet was she that it y-beare.
>
>
>
> For use so well will love be sette
> Under ragges as rich rotchette."

The word in the original, however, is *Surquayne*, which appears to have been a similar garment, if not identical with it. The term, notwithstanding, occurs in a French poem older than Chaucer's translation :

> " Meint bone roket bien ridée—maint blank."
> MS. Harl. 913.

which answers to

> " The white rokette riddeled faire "

of Chaucer above.

It was not always of white linen, for in the reign of Henry VII. the poet Skelton describes Eleanor Rumming, the ale-wife,

> " In her furr'd flocket
> And gray russet rocket."

The same writer, reprehending the clergy of his time for their pride and immorality, says of the bishops that

> " They ride with gold all trapped,
> In purpull and pall belapped,
> Some hatted and some cappy'd,
> Richly and warmly wrapped,
> God wotte to their grete paynes,
> In rochettes of fine reynes (cloth of Rennes),
> Whyte as Mary's milk,
> And tabards of fyne sylk," &c.

Palsgrave has " ROCHET, a surplys, rochet." Randle Holmes calls it " a cloak without a cape " !
In a MS. Royal Lib. Brit. Mus. No. 12 B 1, fol. 12, it is described as " superior vestis mulierum ; anglicè, 'a rochet.' " In Devonshire a little blue cloth cloak is so called. (*Vide* Halliwell *in voce.*)

ROGERIAN. " A nickname for a false scalp." (Fairholt.)

> " The spiteful wind, to mock the headless man,
> Tosses apace his pitch'd rogerian,
> And strait it to a deeper ditch hath blown :
> There must my younker fetch his waxen crown."
> Hall's *Satires*, 1598.

ROLL. " The heare (hair) of a woman that is laied over her forhede. Gentylwomen did lately call them their rolles." (Elyote, 'Dict.' 1548.

> " Coyfes, gorgets, fringes, *rowles*, fillets, and hair-laces."
> *Rhodon and Iris*, 1631.

RONDACHE. A shield or target more or less circular carried by a foot-soldier in the seventeenth century, having an aperture for sight, and a slit at the side, through which he could thrust his sword without exposing his arm. The engraving annexed is copied from Skelton. The original was in the Meyrick Collection, and measured two feet by one and a half.

Rondache.

ROQUELAURE. "A short abridgement or compendium of a cloak, which is dedicated to the Duke of Roquelaure." ('A Treatise on the Modes,' 1715.)

ROSE. Ornaments in the form of roses, composed of ribbons, lace —both thread and gold—and even jewels, were worn in the reigns of Elizabeth and James I. on the shoes, the garters, and hatbands of the gallants, who went to the greatest expense in their fabrication. They are constantly alluded to by the dramatists and censors of that period:

"With two provençal roses on my razed shoes."
Hamlet, act iii. sc. 2.

"Garters and roses fourscore pounds a paire."
Rowland, *Knave of Harts,* 1615.

"Roses worth a family."
Massinger, *City Madam.*

"My heart was at my mouth
Till I had viewed his shoes well; for those roses
Were big enough to hide a cloven foot."
Ben Jonson, *The Devil is an Ass.*

Effigy in Great Malvern Church,
Worcestershire.

Peacham in his 'Truth of our Times,' 1638, says: "Shoe strings that goe under the name of roses from thirty shillings to three, four, and five pounds the pair. Yea, a gallant of the time not long since paid thirty pounds for a pair;" and a portrait of Sir Thomas Urchard, as late as 1646, represents him in a pair formed of rich lace and jewels. They were worn as late as the time of the Commonwealth. (See page 199, under GARTER.) Rose hatbands are mentioned in Rowland's 'Knave of Harts,' 1615. It was also the fashion in the reign of Elizabeth for gentlemen to wear a real rose in one of their ears. (*Vide* 'King John,' act i. sc. 1; and Burton's 'Anatomy of Melancholy.')

ROUNDEL. A small circular shield used in the thirteenth and fourteenth centuries. An effigy of the former date, at Great Malvern, Worcestershire, engraved by Stothard, furnishes an early example (see woodcut). We give also one from a fresco painting formerly in the Painted Chamber at Westminster.

ROUND-ROBINS. See RUFF.

ROWEL. See SPUR.

Roundel. From fresco in Painted
Chamber, Westminster.

RUFF. This remarkable feature in the costume of both sexes, during the reigns of Elizabeth and James I., is so familiar to the sight of the

veriest schoolboy, and will be found in so many of the woodcuts in this work, that the mere mention of it might seem sufficient in this place. At the same time it has occupied so important a position in the notices of costume by contemporary writers, that a goodly volume might almost be filled by the quotations and illustrations required for an exhaustive history of it. I must endeavour to condense within reasonable limits the mass of material that lies before me in the pages of the chroniclers, the satirists, and the dramatists of the sixteenth and seventeenth centuries.

A small frill or narrow ruff is visible above the collars of the men and the partlets of the ladies as early as the reign of Henry VIII., such as at a later period Randle Holme describes by the name of "round robins :" but it is not till the middle of the reign of Queen Elizabeth that the ruff assumed those extraordinary proportions to which it is indebted for its notoriety. The diatribe of Stubbs respecting it has been repeatedly printed, but yet cannot be omitted here. Writing in 1583,* he says, "They have great and monstrous ruffs made either of cambric, holland, lawn, or of some other fine cloth, whereof some be a quarter of a yard deep, some more, and very few less : they stand a full quarter of a yard and more from their necks, hanging over the shoulder-points instead of a pantise ; but if it happen that a shower of rain catch them before they get harbour, then their great ruffs strike sail, and down they fall like dishclouts fluttering in the wind or like windmill sails. There is a certain liquid matter which they call starch, wherein the devil hath learned them to wash and dye their ruffs, which being dry will then stand stiff and inflexible about their necks. There is also a certain device

Supertasse.

made of wires, crested for the purpose, and whipped over either with gold, thread, silver, or silk, and this is called a supertasse or underpropper (see woodcut). This is applied round their necks under the ruff upon the outside of the band, to bear up the whole frame and body of the ruff from falling or hanging down. Almost none is without them ; for every one, how mean or simple soever they be otherwise, will have of them three or four a-piece for failing ; and as though cambrick, holland, lawne, and the finest cloth that can be got anywhere for money, were not good enough, they had them wrought all over with silk work, and peradventure laced with gold and silver or other costly lace. And," he adds, "they have now newly found out a more monstrous kind of ruff, of twelve, yea sixteen lengths apiece, set three or four times double, and it is of some fitly called 'three steps and an half to the gallows.'" The edition Strutt has quoted is the *fourth*, that of 1595, and the expression "they have now newly found" would lead us to infer that the introduction of this "more monstrous kind of ruff" had been a recent occurrence. The Infanta Isabella Clara Eugenia, who married in 1599 Albert Archduke of Austria, is painted in one of these monstrous ruffs (see p. 435).

Hall, in his Satires, printed 1598, describing a gallant "all trapped in his *new found* bravery," specially mentions

"His linen collar *labyrinthian* set,
Whose *thousand double turnings* never met."

And to "walk in treble ruffs like a merchant," occurs in Dekker's comedy 'If this is not a good Play, the Devil's in it,' 1612.

Stubbs's indignation against the ruffs worn by the ladies equals that he expresses against those of the gentlemen. "The women," he says, "use great ruffs or neckerchers of holland, lawne, cambric, and such cloth as the greatest thread shall not be so big as the least hair that is, and lest they should fall down they are smeared and starched with starch ; after that dried with great diligence, stroaked, patted, and rubbed very nicely ; and so applied to their goodly necks and, withal, underpropped with supertasses, as I told you before, the stately arches of Pride. They have also three or four orders or degrees of minor ruffs, placed *gradatim* one beneath another, and all under the master-devil ruff. The

* His work was first published anonymously in that year, and a third edition, "newly revised, recognised, and augmented by the author, Philip Stubs," was published in 1585. A fourth, which was the one quoted by Strutt, appeared in 1595.

skirts then of these great ruffs are long and wide, every way pleated and crested full curiously. Then, last of all, they are either clogged with gold, silver, or silk lace of stately price, wrought all over with needlework, speckled and sparkled here and there with the sun, the moon, the stars, and many other antiques strange to behold. Some are wrought with open work down to the midst of the ruff; and further, some with close work, some with purled lace and other gewgaws, so clogged, so purlaced that the ruff is the least part of itself. Sometimes they are pinned up to their ears, and sometimes they are suffered to hang over the shoulders, like flags or windmill sails fluttering in the air." ('Anatomy of Abuses,' 1595.) "Queen Elizabeth," says Mrs. Palliser, "wore her ruff higher and stiffer than any one in Europe, save the Queen of Navarre," and gives as a reason for it that she had "a yellow throat," and was anxious to conceal it, therefore she wore " chin ruffs." This was, however, in her latter days, for the entry proving this is dated in the last year but two of her reign : " Eidem pro 2 sutes de lez chinn ruffs edged in arg., 16*s*." (Eliz. 42-43, anno 1600-1601.) The price also shows that, though edged with silver, they could not have been of any importance either in point of size or material. She is represented with a small ruff close under her chin in her portrait by Zucchero (see p. 246). In the last broad piece that was struck of her—the die of which, it is supposed, was broken by her command, the likeness being too truthful for a woman who wished to pass for a Venus at seventy—she is represented with a very small frill close round her throat, a return in fact to the fashion of the ruffs worn on their first introduction. (See early portrait of Queen Elizabeth, p. 79.)

The Infanta Isabella Clara Eugenia, Archduchess of Austria.

Of her great ruffs several examples will be found in this work ; but to whatever extent it might please Her Majesty to extend the dimensions of her own ruffs, she sternly restricted those of her subjects, by not only prohibiting by statute their being worn beyond a certain size, but actually placing grave citizens at every gate of the City to cut all such as exceeded the prescribed length.

Neither law nor censure, nor what is still more powerful, ridicule, could control the ruff, which continued to be worn in one fashion or another during the reigns of James I. and Charles I., survived the Rebellion, and disappeared in the days of Charles II. A few extracts will suffice to verify this.

In 'The Dumb Knight,' 1608, Lollia observes to Collaquintida, "You have a pretty ruff," and asks, "how deep is it?" to which the latter replies, "Nay, this is but shallow; marry, I have a ruff is a quarter deep, measured by the yard." Dekker, in his 'Gull's Horne Booke,' 1609, speaks of "Your treble, quadruple, Dædalian ruffes." John King, bishop of London, called by James I. "the

Robert de Vere, Earl of Oxford.

Sir William Russell. 1590.

James I. in a quadruple ruff.

John Clinch, Chief Justice of the Common Pleas. 1584.

Sir Edward Coke, Chief Justice of the King's Bench. 1613.

king of preachers," who died in 1621, inveighed in one of his sermons against "Fashion, which has brought in deep ruffs and shallow ruffs, thick ruffs and thin ruffs, double ruffs and no ruffs;" but it is noteworthy that the bishops, who first denounced the ruff themselves, held to the fashion long after it had been set aside by all other professions. Mrs. Turner, the inventor of the yellow starch, with which it was for many years the rage in England to tinge the lace of ruffs, rebatoes, bands, and collars of all descriptions, was executed at Tyburn for the murder of Overbury in 1615, wearing "a cobweb lawn ruff of that color." (Howel's Letters, 1618.) But the belief that this incident would be

"the funeral" of the fashion proved erroneous; for five years afterwards, we find the Dean of West-minster ordering that no lady or gentleman wearing yellow ruffs should be admitted into any pew in his church; "but finding this 'ill taken,' and the king 'moved in it,' he ate his own words, and declared it all a mistake." ('Hist. of Lace,' State Papers, vol. cxiii.) "150 yards of fyne bone lace" were required "for six extraordinary ruffs, provided against his Majesty's marriage," at nine shillings

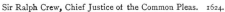

Sir Ralph Crew, Chief Justice of the Common Pleas. 1624. Sir Robert Heath, Chief Justice of the King's Bench. 1643.

per yard ('Extraordinary Expenses,' 1622–1626),—a quantity which the "quadruple" ruff, in which his Majesty is depicted in one of his portraits, will thoroughly account for. "Double as his double ruff" occurs in 'The Rape of Lucrece,' 1638; and little ruffs were worn by citizens' wives at that period:

> "O miracle! out of
> Your little ruff, Dorcas, and in the fashion!"
>
> Jasper Mayne, *City Match*, 1639.

And in the same play:

> "See now that you have not your city ruff on, Mistress Sue."

Hollar in 1640 gave to the world his 'Ornatus Muliebris Anglicanus,' in which we have the Lady Mayoress represented in a large ruff (see p. 227). Taylor the Water Poet writes at this period:

> "Now up aloft I mount unto the ruffe,
> Which unto foolish mortals pride doth puffe,
> Yet ruffe's antiquity is here but small,
> Within these eighty years not one at all."

The long hair and periwigs of the time of Charles II. rendered ruffs an impossibility.

I have given above a few specimens of the most remarkable from undoubted portraits, calling attention to the gradual increase of size in the ruff as exemplified in the engravings by Hollar of those "most potent, grave, and reverend signors," the judges.

RUFF-CUFFS. See

RUFFLE. Small frills called "hand-ruffs" or "ruff-cuffs" are mentioned in the Wardrobe Accounts of the reign of Henry VIII., when the first notice of them is found. "One payer of sleeves, passed over the arme, with gold and silver quilted with black silk, and ruffed at the hand with strawberry leaves and flowers of gold, embroidered with black silk" (MS. Harleian Lib. No. 1419); and "a ruffe of a sleeve" occurs in the same MS. It is not, however, until the

latter part of the reign of Charles II., when the lace cravat had established itself in public favour, that the ruff, discarded from the necks of all but the judges and the physicians, descended to the wrists of the gentlemen and to the elbows of the ladies, under the name of "ruffles." An advertisement in the 'London Gazette' for June 14–17, 1677, mentions, amongst "other laced linen" found in a ditch, "one pair of laced *ruffels;*" and in the Gazette for July 20, 1682, "a pair of Point de Venise ruffles," and "two pair of Point d'Espagne ruffles," are advertised as lost in "a portmanteau full of women's clothes." Double ruffles became the rage in the reign of William and Mary (see Engageants), and "weeping ruffles," as they were called, were worn by gentlemen in the time of Queen Anne and George I., of such extraordinary length that they assisted sharpers to cheat at cards, and Jacobites to pass treasonable notes to one another, the hands being hidden by them to the tips of the fingers. "His hands must be covered with fine Brussels lace," is the direction in 'Monsieur à la Mode,' in 1753.

> "Let the ruffle grace his hand;
> Ruffle, pride of Gallic land."
> *The Beau,* 1755.

Treble ruffles are mentioned by Mrs. Palliser as attached to the cuffs of ladies' morning dresses in the reign of George II., and

> "Frizzle your elbows with ruffles sixteen"

is a line in the 'Receipt for Modern Dress,' 1753.

RUG. A coarse woollen stuff used in the sixteenth century for the garments of the poorer classes. "Dame Niggardise, his wife, in a sage rugge kirtle." (Pierce Pennilesse, 1592.) "Like a subsister" (a poor begging prisoner) "in a gown of rug rent on the left shoulder." (Chettle, 'Kind Harts Dream,' 1592.) "Manchester rugs," otherwise named "Manchester freezes," are mentioned in an Act of the 6th of Edward VI., 1553. (Ruffhead, vol. ii. p. 427.)

RUSSELLS. "In the first year of Philip and Mary (A.D. 1554), it was represented to the Parliament, that of late years, *russells,* called *russel satins* and *satins reverses,* had been made abroad of the wools bred in the county of Norfolk, and being brought into this kingdom were purchased and worn, to the great detriment of the wool manufactures at Norwich." (Strutt, 'Dress and Habits,' vol ii. part v., and Ruffhead, vol. iii. p. 458.) Mr. Fairholt says "it was something like baize, but with knots over the surface, and was also termed *Brighton nup,*" but he has not given us his authority.

RUSSET. "*Russetum,* pannus vilior rusei vel rufei coloris." (Ducange, *in voce.*) A coarse cloth of a reddish brown or grey colour. "The clothiers, under a statute enacted by King John, were commanded to make all their dyed clothes, especially russet, of one breadth, namely, two ells within the lists." (Strutt, 'Dress and Habits,' vol. ii. part iv.) Henry de Knyghton, *temp.* Edward III., speaking of the Lollards, attributes to that sect the introduction of russet clothing, "prima introductione hujus sectæ nefandæ vestibus de russeto usebantur." Russet clothes in the sixteenth century are indicative of country folk. (Hall's 'Satires,' 1598.) Peacham, speaking of countrymen in 1658, says, "Most of them wear russet, and have their shoes well nailed." "Grey russet" is mentioned also in Delany's 'Pleasant Historie of Thomas of Reading,' as "the ordinary garb of country folks;" and when Simon's wife, in the same tale, complains that "the London oyster wives and the very kitchen stuffe cryers do exceed us in their Sunday attire," her husband tells her, "We are country folks, and must keepe ourselves in good compasse gray russet, and good hempspun cloth doth best become us." In a ballad between a courtier and a clown, in D'Urfey's 'Collection,' the latter says:

> "Your clothes are made of silk and sattin,
> And ours are made of good sheep's grey."

S., Collar of. See COLLAR.

SABATONS. Shoes or boots. Sabatons of crimson tissue cloth of gold were provided by Piers Courteys, the king's wardrober, for the coronation of Richard III.

SABATYNES. "Wide coverings for the shoes, made of several bands of steel." (Meyrick, 'Crit. Inq.,' vol. ii. p. 157.)

"First ye muste set on sabatynes and tye them upon the shoe with small poyntis that wille breke." (Directions how "To arme a Man," MS. Lansdowne Coll., Brit. Mus. No. 285, *temp.* Edward IV.)

. *SABLE, SABELLINE.* The skin of an animal of the weasel or marten kind (*Mustela Zibelliana*), found in Siberia, Kamschatka, and the northern parts of America. The fur, of a deep glossy brown, black at the ends, is much esteemed and highly prized at this day; and during the Middle Ages the wearing of it was limited to the nobility and certain officers of the royal household. As late as the third of Edward IV. no person below the estate of a lord was permitted to wear any furs of sables, under the forfeiture of ten pounds. (Ruffhead, vol. ix.)

> "Oh, an' these twa babes were mine,
> They should wear the silk and the sabelline."
> > *The Cruel Mother*, Kinloch's Ballads.

Sable is also the heraldic term for *black*.

SABRE. See SWORD.

SACK. (*Saque*, French.) A gown introduced from France into England in the reign of Charles II. Pepys records his wife's first appearance in one: "2nd of March, 166⅞.—My wife this day put on first her French gown called a *sac*, which becomes her very well." Sacks continued to be worn for upwards of a hundred years. We find them in high fashion in 1753, when in a satirical poem entitled 'A Receipt for Modern Dress,'

> "Let your gown be a sack, blue, yellow, or green,"

is one of the writer's special recommendations; and in a poem entitled 'Advice to a Painter,' a lover desires him, when he paints "the charmer of his heart," that he will,

> "Flowing loosely down her back,
> Draw with art the graceful sack;
> Ornament it well with gimping,
> Flounces, furbelows, and crimping."
> > *London Magazine,* 1755.

In 1763 the Countess Dowager of Effingham was robbed of the robes she had worn at the coronation of George III., with many other valuable dresses, amongst which are enumerated "a brown satin sack richly brocaded with silver, a new satin sack and petticoat, white satin ground brocaded with yellow, a scarlet unwatered tabby sack and petticoat, a white tissue flowered sack and petticoat, a white and silver sack, and a blue and gold Turkey silk sack and petticoat." Another lady, name unmentioned, who was equally unfortunate, at the same period lost "a brocaded lustrous sack, with a ruby-coloured ground and white tobine stripes, trimmed with floss; a black satin sack flowered with red and white flowers, trimmed with white floss, and a pink and white striped tobine sack and petticoat trimmed with white floss." (Malcolm's 'Manners and Customs,' vol. v. pp. 347, 348.) The sack is called a "genteel undress" in the 'Lady's Magazine' for 1770, in which is a portrait of a favourite actress, Miss Catley, so attired in the character of Rosetta in 'Love in a Village;' and "Sacques, a beautiful new palish blue or a kind of dark blue satin," are described as fashionable in the March number of the same serial for 1774, and they remained so till nearly the end of the last century. The sack appeared again in our drawing-rooms very recently, and as a quaint but graceful costume which could not be worn by everyone is not unlikely to be frequently resuscitated.

Sacque, front and back view. From a print *circa* 1720. Sacque. From a painting by Watteau.

SAFEGUARD. "An outward petticoat still worn by the wives of farmers, &c., who ride on horseback to market" (Steevens). "Called so because it guards the other clothes from spoiling" (Minsheu).

"On with your cloak and safeguard."
. *Ram Alley*, act i. sc. 1.

In the 'Merry Devil of Edmonton,' 1617, a stage direction is for travellers to enter, among them "gentlewomen in cloaks and safeguards."

SALADE, SALETT. (*Celada*, Ital.; *Schale*, "a shell," Germ.) A headpiece that succeeded the bascinet in the fifteenth century. The earliest mention of it is in Chaucer's 'Dreme:'

"Ne horse, ne male, trusse, ne baggage,
Salade, ne spere, gard brace, ne page."
line 1555.

But it does not appear in painting or sculpture, as far as I can ascertain, before the reign of Henry VI. It is also alluded to as late as the time of Shakespere, who, in 'The Second Part of King Henry VI.,' has made Jack Cade pun upon the word : "Wherefore on a brick wall have I climbed into this garden, to see if I can eat grass or pick a sallet another while, which is not amiss to cool a man's stomach this hot weather. And I think this word sallet was born to do me good ; for many a time, but for a sallet my brainpan had been cleft with a brown bill ; and many a time when I have been dry and bravely marching, it hath served me instead of a quart pot to drink in" (act iv. sc. 10). As the salade had been abandoned for a hundred years previous to the writing of this play, the mention of it is either an exceptional instance of Shakespere's attention to correct costume, or the name of the ancient headpiece had been transferred, as we have so frequently had occasion to remark, to some other and not always similar object. Some fifty years earlier there is also mention made of the salade, and the means by which it was secured upon the head. In an old interlude entitled 'Thersytes,' quoted by Fairholt,—who attributes its composition to the latter years of Henry VIII., when the wearing of the salade might possibly have been within the recollection of the writer, as it appears amongst other head-pieces of the Emperor Maximilian, who died in 1519, in the thirty-third plate of the splendid work produced by his order, though not published in his lifetime, known as the 'Eherenpforte' (Triumphal Arch), the designs for which are said to have been made by Albert Dürer,—we read :

"I wolde have a sallet to wear on my head,
Which under my chin with a thong red
Buckled shall be."

The principal characteristic of the salade was the projection behind. It was sometimes covered with velvet, and often decorated with painting and gilding. Specimens of each fashion are in the National Armoury. Some salades had movable vizors (see fig. 2) ; others an ocularium, or transverse slit for sight cut in the steel itself (see fig. 5). With these exceptions there is no variety very remarkable in their form during the ninety or hundred years they were in use throughout Europe.

Salades, 15th century.

Our engravings, all from originals in the dispersed Meyrick Collection, depict—1. An open salade of the times of Henry VI. and Edward IV.,—the colour was russet, with brass studs ; 2. Salade of bright steel, with movable vizor of the same date ; 3. The same with the vizor raised ; 4. Front view,

vizor closed ; 5. Salade with ocularium, used until the commencement of the sixteenth century ; 6. Front view of the same ; 7 and 8. Side and front views of an archer's salade with comb, latest form approaching that of the morion. The specimen is Italian, having the arms of Lucca engraved on it, and may be dated *circa* 1540. "Saletts with vyzors and bevers" are entered in an inventory of armour taken in the first year of Edward VI. (MS. Society of Antiquaries), and Meyrick speaks of a "salade with grates," mentioned in old inventories ; but no examples of either have been met with.

SAMARE or *SEMMAR* is described by Randle Holme as a sort of jacket worn by ladies in his time. "It has," he says, "a loose body and four side laps or skirts, which extend to the knee ; the sleeves short cut to the elbow, turned up and faced." The word appears to me a corruption of the Italian *zimara* (see CHIMERE), applied to some garment of the seventeenth century, which neither the text of Holme nor his illustration of it enables me to identify. .

SAMITE. (*Samy, samis,* French ; *sametum, scyamitum, samitis, xamitum,* and *examitum,* Med. Latin.) A stuff composed sometimes wholly of silk (*pannus holosericus*), but frequently interwoven with gold and silver, and in general embroidered in the most costly manner. This material was chiefly dedicated to sacred uses, and constituted many of the rich official habits of the clergy. It was not, however, confined to the Church ; the Norman monarchs, the nobility, and ladies of high rank made use of it on particular occasions, when more than ordinary display of pomp was required. (Strutt, 'Dress and Habits,' vol. ii. pt. 4.)
 Mirth, in the 'Roman de la Rose,' is described as clothed

> "D'un samy pourtrait à oyscaulx,
> Qui estoit tout à or bateu
> Tres richement ;"

which is thus translated by Chaucer :

> "In a samette with byrdes wrought,
> And with gold beaten most fetously,
> His body was clad full richely."

In the same poem we have

> "D'un samy qui est tout doré" (l. 875),

rendered by Chaucer "an overgylt samyte." Samite was of various colours. Joinville, in his Life of St. Louis, speaks of robes of black samite: "robes de samit noir." In the romance of 'Launcelot du Lac,' we read of white samite : "Cote et mantil d'un blanc samis" (MS. Royal, 20 D iv.) ; and the sacred standard of the kings of France, called the *oriflamme,* was made of red samite : "L'oriflambe qui estoit d'un vermeil samit" ('Chron. de St. Denis,' *sub ann.* 1328).

SANDAL. The Anglo-Saxons are said to have adopted the sandal from the Romans, or the Romanised Britons : but, if so, its use appears to have been limited to religious persons. In that precious MS. known as 'the Durham Book,' or 'Book of St. Cuthbert,' believed to have been written as early as the seventh century, for Eadfreid, afterwards Bishop of Lindisfarne, who died in 721, and which is preserved most carefully in the Cottonian Library, British Museum, the four Evangelists are depicted wearing sandals of the form herewith engraved.

Sandal. From 'the Durham Book.'

 There is no appearance of sandals in the figures of Anglo-Saxons, male or female, nor are they seen on the feet of persons of any class during the Middle Ages, except those of the monastic orders, or occasionally pilgrims, as alluded to in Ophelia's song in 'Hamlet' :

"How should I your truelove know
From any other man?
By his cockle hat and staff,
And by his sandal shoon."

In "the particulars" ordered to be provided for the coronation of Mary, queen of William III., are
"a pair of sandals of crimson satin, garnished the same as the
King's;" and Sandford, in his 'Coronation of James II.,' has given
us a representation of those made for that ceremony, one of which
is engraved for this work.

SANGUINE. A blood-red colour.

"In sanguine and in perse he clad was all."
Prologue to Canterbury Tales.

Sandal. From Sandford's 'Coronation of
James II.'

SARCENET. (*Saracen-net.*) A thin silk, first used in the thirteenth century, the name being
derived from its Saracenic or Oriental origin. The robe of Largesse or Liberality, in the 'Roman de
la Rose,' is described as being

"bonne et belle,
D'une couleur toute nouvelle,
D'un pourpre sarraxinesche."

Other copies read—

"Largesse out robe toute fresche,
D'un pourpre sarraxinesche;"

which Chaucer translates—

"Largesse had on a robe freshe,
Of riche purpure *sarlynische.*"

a word hardly recognizable, and probably a clerical error.

SARCIATUS, SARCILIS, SARZIL. A coarse woollen cloth, appropriated principally to
the habits of the lowest classes, and to such of those especially who subsisted on charity. (Strutt,
part iv. ch. I.)
"Petrus Franco det duobus pauperibus tunicas singulis annis—et utraque tunica sit de duobus
alnis de *sarzil* quæ currunt in foro Montisbrusonis." ('Hist. Eccles. Lugdun.' p. 321.)

SASH. Girdles of silk which would now, it is probable, be called sashes, occur as early as the
fourteenth century; but it is not till the sixteenth that they appear in costume under that name, or
more frequently under that of scarf (see SCARF). One of the earliest allusions to it occurs in Hall's
'Union of Honour, Vit. Henry VIII.,' where he speaks of "mantles of crimosyn satten, worn baudericke
or *sash* wise, so that the other garments might make a more splendid appearance." "Baudericke
(baldric) wise" means over the shoulders (see BALDRIC), as the sashes of the officers of our army
now, by a recent regulation, wear theirs, which they formerly wore round their waists. They were
much worn by civilians as well as military men in the seventeenth century, and by naval officers at the
beginning of the last century (see figure of English Admiral, 1703, at p. 116 *ante*). After the reign
of Queen Anne, the only male persons wearing sashes appear to have been soldiers and running
footmen. The dress of the latter, in 1730, is thus described :—"They wear fine Holland drawers
and waistcoats, thread stockings, a blue silk sash fringed with silver, a velvet cap with a great tassel,
nd carry a porter's staff with a large silver handle." Sashes do not seem to have been worn by
ladies previously to the second half of the last century, for Bailey, as late as 1736, has "SASH, a sort
of girdle *for tying night gowns*, &c., also an ornament worn by military officers."

SATIN. (*Satinus, sattinus, satinius,* Latin.) This well-known material is mentioned as early as the thirteenth century in Europe, at which period it appears to have been used chiefly if not solely for ecclesiastical vestments, and manufactured in Persia : "x Augusti : Casula de satino Persico quæ constit xviii florins." ('Necrolog. Parthenonis S. Petro de Cassis.') Its high price during the Middle Ages prevented its being worn by any but noble or wealthy persons. By an Act of the 22nd of Edward IV., no one under the degree of an esquire or a gentleman was allowed to wear damask or satin in their doublets. The penalty for infringing this order was forty shillings (Ruffhead, vol. ix. pp. 93, 98). By Henry VIII. the wearing of satin gowns or doublets was prohibited to all persons whose income was under a hundred marks per annum. Satin of Bruges is mentioned in an account of the revels at Court in the reign of the latter monarch, and doublets of purple, crimson, and yellow satin are described in the inventories of his apparel. (MS. Harleian, 1419.)

The use of satin in the dresses of the gentry, in the times of Elizabeth and James I., led to its application as a generic term to persons of fashion. Thus Dekker, in his 'Gull's Hornbook,' 1609, speaking of the tavern, says—"Though you find much *satin* there, yet you shall likewise find many citizens' sons." (Fairholt, 'Cost. in England.')

SAVIARDE. "A kind of jacket worn towards the end of the seventeenth century." (Halliwell.) From the name it was probably introduced into England from Savoy. An anonymous writer, quoted by Strutt, calls it a short kind of gown with four side laps of different coloured silks, and with short open sleeves. This description is almost identical with that of *samare* by Holme. (See SAMARE.)

SAY. (*Saie,* French ; *sagum, saga,* Latin.) "A delicate serge or woollen cloth." (Halliwell.) "Saye, clothe serge." (Palsgrave.) "Quodam delicato panno qui vulgo saie vocatur." (Hugo de S. Victore, 'De Claustro animæ,' liber ii. : Ducange, *in voce* SAGUM.)

> "Both hood and gown of green and yellow saye."
>> *Promos and Cassandra,* part ii. 1578.

(See SERGE.)

SCABBARD. See SHEATH.

SCAPULARY. (*Scapulare, capularis,* Latin.) A monastic garment, with a cowl or hood to it, from the Latin *scapula,* the back or blade bone of the shoulder. "Vestis scapulas tantum tegunt." (Ducange, *in voce.*) The monks of the order of St. Benedict were specially enjoined to wear the scapulary when at work in the fields, or in any other labour : "Propter opera tantum constituit S. Benedictus alteram cucullum quæ dicitur scapulare." (Sigebertus Gemblac, p. 130, edit. Basil, 1565.) M. Viollet-le-Duc says it was confounded with the "cagoul" (*cucullus*), from which it differs in width and length ; and Fosbroke (in his plate of monastic orders, 'Encyclop. of Ant.' vol. ii. p. 259) certainly represents the scapulary in the form of the cagoul—whether on good authority or not, I cannot pretend to say, as he quotes none ; but the *cucullus* of the Romans, from which the word is derived, was a garment very different from either the cagoul or coule (whence *cowl*), or the scapulary. It was more like the capa of the Normans ; a short shoulder cloak with a hood to it, which could be separated and worn by itself (see GENERAL HISTORY). From this circumstance, I take it, *cucullus* became a name for the monk's cowl only, as well as for more than one garment with a hood. Nay, it was even applied to the chasuble, which had not a hood : "Cucullum nos esse dicimus quam alto nomine casulam vocamus." Ducange has dedicated columns to this subject, under SCAPULARE and CUCULLUS, and to him I must refer the reader who desires to go deeper than it is necessary for me to do in these pages. I have pointed out the error, if an error it be, of Fosbroke, and append his representation of the scapulary with that of the cagoul which is given by M. Viollet-le-Duc, with

this observation, that if the former be not the scapulary, we have no name that I am aware of in the English language for what the French call the "cagoul." (See GENERAL HISTORY.)

Monk in Scapulary. From Fosbroke.

Cagoul. From Viollet-le-Duc.

Piers Ploughman, in his 'Vision,' alludes to this vestment by the other Latin form of the name *capularis:*

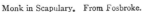

> "They shapen their chapolaries
> And *stretchet them broad*,
> And launceth high their heumes
> With babe lying in sheetes.
> They ben sewed with white silk
> And seams full quaint;
> Ystogen with stitches
> That stareth as silver."

The description is very confused, but the second line rather favours the view of Fosbroke.

SCARF. Scarfs are mentioned as early as the reign of Queen Elizabeth amongst the articles of a fashionable lady's attire. "Then," says that inveterate growler, Philip Stubbs, "must they have their silk scarfs cast about their faces and fluttering in the wind, with great tassels at every end, either of gold, silver, or silk, which, they say, they wear to keep them from sun-burning." They are named again in the dramatic pastoral 'Rhodon and Iris,' 1631: "Scarfes, feathers, fans, maskes, muffes, laces, cauls." They were in high fashion with ladies a hundred years afterwards. "A black silk furbelowed scarf" was advertised as stolen in 'The Post Boy,' November 15, 1709. In an advertisement quoted by Malcolm, dated March 1731, mention is made of "a long velvet scarf, lined with a shot silk of pink and blue." ('Manners and Customs,' vol. v. p. 325.) Examples may be seen in our engraving from the frontispiece of a book, 'The School of Venus, or the Ladies' Miscellany,' 1739. Like those of Elizabeth's time, they have tassels at the ends. Scarfs, in fact, have never been long out of fashion with the fair sex. Scarfs were much worn by knights and military officers in

the sixteenth and seventeenth centuries, and under the name of sashes are still distinguishing marks of rank in the army. Before the establishment of uniforms the scarf was also a sign of company.

From frontispiece to 'School of Venus,' 1739.

From a print *circa* 1740.

Portrait of Sir Thomas Mewtys. *Temp*. Charles I.

Officer of Pikemen. *Temp*. James I.

The cointise attached to the crest of the heaume of a knight of the thirteenth century was called a scarf, but not by contemporary writers. (See pp. 20, 122, 246, and GENERAL HISTORY.)

SCAVILONES. Long drawers worn under the hose by men in Queen Elizabeth's time. Henry Nailer, the champion of Thomas Paramor in a trial by combat, respecting his right to certain landed property, "when he came through London was apparelled in a doublet and galliegascoine breeches, all of crimson satin, cut and raised; and when he entered the lists, he put off his nether stocks, and so was bare-footed and bare-legged, saving his *silk scavilones* reaching to the ankles." (Holinshed, 'Chronicle,' *sub anno* 1571.) The word does not appear to have been met with elsewhere.

SCEPTRE. The sceptres of our early sovereigns differ each from the other according to the representations of them in contemporary illuminations. Until we arrive at the sixteenth century no two are alike. As we cannot place any reliance on the majority of them, and they do not correspond with the representations on the coins, a few cuts of the most remarkable will sufficiently illustrate this article, in addition to the examples incidentally occurring throughout these volumes.

Figs. 1, 2, 3, from MSS. of the 13th century; 4, ivory sceptre of Louis XII. (XIII. ?) of France, in Lord Londesborough's Collection; 5 and 6, details of the same; 7, 8, 9, 10, and 11, from Sandford's account of the coronation of James II.

SEAX. See DAGGER.

SEINT. (*Ceint, ceinture,* French.) A girdle.

" Girt with a seint of silk with barres small."
Prologue to Canterbury Tales.

"A seint she weared barred all of silk."
The Miller's Tale.

In a copy of 'Le Livre des nobles Femmes,' written in the fourteenth century (Royal MS. 20 C 5, Brit. Mus.), men and women are depicted wearing a thick roll of some soft material, pre-

sumably silk, which can neither be called a girdle nor a sash, encircling their hips after the fashion of the military belt of the knight, or the jewelled girdle of the lady of that period. It appears as inconvenient as it is unbecoming; but as it is some sort of seint, I give two examples of it here, not knowing where else to place them.

From Royal MS. 20 C 5, British Museum. 14th century.

SEMI-COPE. Chaucer, describing the dress of the Friar in the 'Canterbury Tales,' says:

"Of double worsted was his semi-cope,"

which Tyrwhitt explains as being "a half or short cloak."

SENDALL. See CENDAL.

SEQUANIE, SOSQUENIE, SUCKENEY. (*Surquanye,* French.) This is one of those unidentified garments that are stumbling-blocks in the path of glossarists.
The French poet asserts that

"nulle robe n'est si belle
A dame ni à demoiselle,*
Femme et plus cointe et mignotte
En surquanye que en cotte."
Roman de la Rose, l. 1213.

Which Chaucer translates:

"There is no clothe sytteth bette
On damosel than doth rokette;
A woman wel more fetyse is
In rokette than in cote, I wis."

The author of the glossary to the French 'Roman,' printed at Paris in 1736, tells us it was "ancien habillement de femme qui pendoit jusqu'aux hanches," and "*peut-être*" was like a mantle, and "*on dit*" that it was made of linen or lawn. M. Viollet-le-Duc classes it amongst the surcoats, and describes it as being without sleeves, closely fitting the bust, "quelleque peu

* Another MS. reads, "Que surquanie à demoiselle."

décolletées," and with ample skirts. M. Quicherat partly follows him, but says nothing of the absence of sleeves, adding, however, that it was worn without a girdle, that the name was imported from Languedoc, and that it was the earliest form of the word "*souquenille*," which, as I pointed out in my 'History of British Costume,' forty years ago, is French for a coachman's or groom's frock. After all, without pictorial illustration, how much wiser are we from these suggestions? for, unsupported by contemporary authority, they are nothing more, and partly contradicted by one so nearly a contemporary as Chaucer, who writes at a time when the surquanie must have been in the recollection of many, even if not still worn. He distinctly calls it a *rokette* (rochet), which was a garment that *had* sleeves, did not "dessiner le buste," and descended only to the knee,—the view taken of it by the old glossarist, whose report that it was made of linen appears to have been founded upon the line immediately following the above passage :

> "La surquanie qui fut *blanche*
> La signifoit doulce et franche ;"

but the garment mentioned by Guillaume de Lorris was more probably of white silk or samite, as in another old poem, quoted by M. Viollet-le-Duc ('Le livre dou veoir dit'), Agnes de Navarre is described as

> "Vestu d'une souquenie,
> Toute pareille et bien taillée,
> *Fourrée d'une blanche hermine ;*"

which no linen garment was ever known to be. And, as regards the word *blanche*, there is an application of it in this same poem in the lines immediately following the above :

> "Mais la douce courtoise et franche
> Vestu d'une cote *blanche*,
> *D'une escarlate riche et belle*
> Qui fu, je croi, faite à Bruxelle."

Now, a *white* "cote," of a rich and beautiful *scarlet* colour, is a rather incomprehensible description ; but the word *blanc*, f. *blanche* is derived, according to Landais, from the German *blanck*, = Fr. *luisant éclatant*, and may have been used by the author, Guillaume de Machau, in the sense of shining or dazzling, as a bright scarlet might fairly be called. One thing, however, is clear from his account, viz. that Agnes de Navarre wore a surquanie furred or lined with ermine, over a rich and beautiful scarlet *cote*, and his lines are illustrated by M. Viollet-le-Duc by the figure of a lady copied from an illuminated MS. in the National Library at Paris, 'La Cité des Dames,' by Christine de Pisan, and of the time of Chaucer. The dress is one commonly met with in paintings *circa* 1400, and of which several varieties will be found under SURCOAT. It *may* be the surquanie, but, if so, it neither resembles the rochet nor the bliaus ; and we are also met by the declaration of the poet, that a woman looks better in a surquanie *than* in a *cote*, implying they were not in his time worn together. I give an engraving of it in justice to M. Viollet-le-Duc, but cannot guarantee the identity.

Costume of a Lady *circa* 1400.

SERGE, SARGE. A coarse woollen cloth known as early as the twelfth century, a finer quality being called "say." It was much used during the Middle Ages for all portions of attire by the poorer classes, and in the piece for the decoration of houses :

> "By ordinance through the city large,
> Hanging with cloth of gold and not of sarge."
> Chaucer, *The Knight's Tale.*

A silken stuff called "sergedusoy" was used in the last century for coats by the commonalty, being a degree above cloth.

SERPENTINE. See MATCHLOCK.

SETTEE. "A double pinner." ('Ladies' Dictionary,' 1694.)

> "The settee coupé place aright."
> Evelyn, *Mundus Muliebris, or Voyage to Marryland.*

SHADOW. This word occurs frequently in descriptions of dress of the seventeenth century.

> "Shadowes, rebatoes, ribbands, ruffs, cuffs, falls."
> *Rhodon and Iris,* 1631.

Cotgrave *in voce* CORNETTE says, "A fashion of shadow or bonegrace used in old times, and at this day by some old women;" but we have as yet no satisfactory definition of the latter article of attire. (See BONGRACE and HOOD, also GENERAL HISTORY.)

SHAG. A sort of stuff like plush. In 1703 a youth who was missing is described in an advertisement as wearing "red shag breeches striped with black stripes." (Malcolm's 'Manners and Customs,' vol. v.)

SHALLOON. A woollen stuff originally manufactured at Châlons in France, whence it was first imported, and of which its name is a corruption.

SHAMEW, CHAMMER. In the tenth of Henry VIII. Hall speaks of chammer as "a new fashion garment," which he describes as "in effect a goune, cut in the middle;" but it is repeatedly mentioned two years previously in a wardrobe inventory of the eighth of the above reign, in which, amongst other entries, occurs: "A chammer of black satin, with three borders of black velvet and furred with sables; a chammer of black tylsent, with a high collar, welted with cloth of silver and lined with purple satin." Twelve yards of cloth of gold were allowed to make a chammer for the king. In one entry it is called a "cote or shamewe." (MSS. Harleian, Nos. 1419, 2284.)

SHANKS. A common kind of fur from the legs of animals, but principally from those of sheep. "Schanke of Bouge (Budge): fourrure de cuissettes." (Palsgrave.)

"Also at the goyng up of Master Chancellor to the Lollar's Tower we have good proofe that there laye on the stockes a gowne eyther of murrey or crymosyn ingrayn, furred with shankes." (Hall, 'Vit. Henry VIII.' f. 51.)

SHEAF. See ARROW.

SHEATH or *SCABBARD* of a sword, dagger, or knife.
The sheath of a British dagger found in Wiltshire was of wood lined with cloth. The British

swords do not appear to have had scabbards. The Saxon and Norman sheaths were generally of wood covered with leather, sometimes mounted in bronze. In the British Museum there is the blade of an Anglo-Saxon sword, found in a grave at Battle-edge, co. Oxon, which retains the chape and locket of bronze, the wood and leather of the scabbard having entirely perished. A scabbard entirely of bronze, and containing the blade of an iron sword, was found at Flasby, in Yorkshire. Several bronze sheaths of daggers are in the British Museum. M. Demmin has engraved a sword in its sheath of the ninth century, from an illustration in the Bible of Charles le Chauve (840–817), in the Louvre. The sheath is ornamented with a diamond or lozenge pattern. One of this description was found in a Danish barrow in Derbyshire. Another similarly decorated is represented in a MS. in the Royal Library, British Museum, marked 20 A 10, which was written at the beginning of the fourteenth century. In the thirteenth century the metal chapes and lockets of the scabbards are more or less ornamental, the

Sheath of the sword of Edward the Black Prince.

designs generally architectural. The sheath of the sword of Edward the Black Prince still hangs over his tomb at Canterbury. Oliver Cromwell is accused of stealing the sword. It is covered with crimson velvet, and resembles the one represented in his effigy. (See woodcut above.) Chaucer's Sir Thopas is described by the poet as having

"His swordes shethe of ivory;"

but whether we are to look upon this as a flight of fancy, or that sheaths of ivory were actually worn, can only be determined by the discovery of one, or the incidental mention of such in some contemporary inventory. It is probable that ivory might have been used

Sword and Dagger Sheaths of the 15th century.

Dagger Sheath of steel. *Temp.* Henry VIII.

Dagger Sheath of copper. *Temp.* Elizabeth.

for the decoration of scabbards to an extent that would justify such an expression in poetry. In Mr. Roach Smith's museum were some fine specimens of scabbards of the fifteenth century, found in an old rubbish pit in London. They were of cuir-bouilly, and stamped with various patterns. Mr. Fairholt had them engraved for his 'Costume in England,' with two dagger sheaths of about the same date found with them. (See woodcuts above.)

Two superb examples of sheaths of metal of the sixteenth century have been engraved by Skelton from the originals in the Meyrick Collection: one of steel, of the form characteristic of the reign of Henry VIII.; the other of copper, which had most probably been gilt, and representing in three compartments the story of the Prodigal Son, the figures, of course, in the costume of the time in which it was executed, viz. the early part of the reign of Queen Elizabeth. (See woodcuts above.) At page 89 we have already given the chapes of a sword and a dagger sheath of the time of Henry VIII., designed, as we are informed in Mr. Shaw's work, by no less an artist than Holbein. The lockets were equally beautiful.

SHIELD. (*Scilt, Schild*, German.) We are fortunately in possession of abundant material for the illustration of this article, as, in addition to paintings and sculptures, original specimens have been preserved for us with scarcely a break from the Britons of the time of Julius Cæsar to the period when the shield was definitively abandoned in European warfare. Of ancient British shields, the metal coatings of three were in the Meyrick Collection, and there are two in the British Museum. Of

Bronze coating of an ancient British Shield, in the Meyrick Collection, found at Rhydygorse in Cardiganshire.

Bronze Shield found in the river Isis. Now in the British Museum.

Interior of the same.

Romano-British Shield of bronze. Meyrick Collection.

Another. In the British Museum.

the former, two are circular and ornamented with concentric circles, between which are raised as many little knobs as the space will admit. They are two feet in diameter, with a hollow boss in the centre to admit the hand, as they were held at arm's length in action. The internal portion of the shield was wicker, of basket work (*bascawd*), and probably also some strengthening of leather. They were called Tarians, or clashers, from their sonorous quality, from whence it is presumed our words targe

and target, used to designate a circular shield. One smaller than these was found in the river Isis in 1836, and is now in the British Museum. Sir Samuel Meyrick remarks, on comparing it with the Highland target, "We shall find that, though the Roman mode of putting it on the arm has been adopted by these mountaineers, the boss rendered useless is still retained, and the little knobs imitated with brass nails."

The third shield in the Meyrick Collection was a most interesting specimen of the sort fabricated by the Britons after they had been induced to imitate the Roman fashions. It is modelled upon the *scutum*, and was called in consequence *ysgwyd*, pronounced *esgooyd*. It appears to have been originally gilt, a practice continued for a long time by the descendants of the Britons, and, besides a long raised ornament, having a boss in the centre and a circular plate at each end, enriched by the common red cornelian of the country, had originally the rudely-formed figure of some animal, probably in the same metal, affixed to it by pins across the centre. The discovery was not made until after the death of Sir Samuel Meyrick, and is due to Mr. Franks, of the British Museum, who traced it by the minute holes through which the pins that secured the figure on the surface had passed. It was found in the bed of the Witham, county Lincoln. Another shield of the same character is in the British Museum.

Of the Anglo-Saxon and Danish shields we have only the iron bosses to exhibit in this country. Fragments of iron rims of shields have been found in graves here, but none complete; but delineations of them abound in MSS. of those periods. The body of the shield was made of wood, that of the lime or linden tree being preferred. In the poem of 'Beowulf,' Wiglaf is said to have seized his shield, "the yellow linden wood;" and in the poem of 'Judith' we are told—

> "The warriors marched
> The chieftains to the war,
> Protected with targets,
> With arched linden shields."

The wood was covered with leather, and the rim bound with iron, which, as well as the boss, was sometimes gilt. Mr. Hewitt mentions the fact of an example being found at Linton Heath, Cambridgeshire, in which the leather covering seemed to have been stretched over the iron rims, as well as all over the surface of the shield. ('Archæologia,' vol. i. p. 98.) The use of sheepskins for this purpose was forbidden by a law of Æthelstan, under a penalty of thirty shillings.

The Anglo-Saxon shields were of two forms, circular and oval, both convex, and painted usually white, with red or blue borders and circles, but no crosses upon them previous to the eleventh century,—a fact which bears out the conjecture of Sperlingius, who quotes a MS. of that date describing an expedition of King Olave the Saint, to show that the introduction of the sacred symbol as an ornamentation of armour was due, at least in the North, to that holy and royal personage. The Danish shields were also of two sorts, circular and lunated, the former convex, the latter flat, rising in the centre of the inner curve after the fashion of the Phrygian or Amazonian *pelta*. Strutt has engraved one in his 'Horda Angel Kynan,' from an Anglo-Saxon MS., Cotton. Tiberius, c. 6. The late Sir Frederick Madden, who collected all the known authorities on the subject in an interesting paper printed in the twenty-fourth volume of the 'Archæologia,' observes—"That the Scythians pursued the Cimmerians into Asia Minor six or seven hundred years before Christ, is asserted by Herodotus and Strabo; and the tribes that afterwards migrated with Odin towards the Baltic, might have adopted from their consanguinity the Phrygian shield as well as the Phrygian cap and ringed tunic. In the Royal Museum at Copenhagen is an ancient group of figures, cut out of the tooth of the walrus, in which appears a king on horseback, holding a crescent-shaped shield." We cannot, therefore, be perfectly certain that the expression "moony shields," which occurs in the 'Lodbroka Quida,' means orbicular. From the laws of Gula, *circa* 960, we learn that the Danish shields were generally painted red, every possessor of property of the value of six marks, besides his clothes, being required to furnish himself with a red shield of two boards in thickness; and Giraldus de Bari, who was an eye-witness of the transactions of the Northmen in Ireland in the reign of Henry I.,

says, "The Irish carry red shields in imitation of the Danes. Warriors of distinction ornamented them with gilding and various colours." In Sæmund's poetical edda mention is made of a red shield with a golden border; and the encomiast of Queen Emma, in describing Canute's armament, speaks of the glittering effulgence of the shields suspended on the sides of the ships (Encom. Emmæ apud Du Chesne, p. 168). Sir F. Madden, in his paper above mentioned, tells us that "the white shield was the distinction of the ancient Cimbri," and also that "the Goths of all descriptions seem to have worn them originally white, and ornamented them by degrees with gold and colours." In the Poetical Edda, Yunnar, one of the Reguli of Germany, is made to say, "My helmet and white shield come from the Hall of Kiars," a Gaulish chief who lived in the sixth century. ('Archæo-logia,' vol. xxiv.) Subjoined are examples of Danish shields in the Museum at Copenhagen. The

Danish Shields in the Museum at Copenhagen.

shields of the Normans at the period of their invasion of England, 1066, were kite-shaped, and are supposed to have been assumed by them in imitation of the Sicilians, as fifty years before the battle of Hastings, Melo, the chief of Bari, furnished them with arms, and some twenty-five years afterwards they conquered Apulia. (Meyrick, 'Crit. Inq.,' vol. i.) A comparison of the shields in the Bayeux Tapestry with those seen upon Sicilian bronzes, leaves very little doubt of the accuracy of the suggestion. (See wood-cut annexed.)

These shields, besides the leathern straps called *enarmes*, through which the arm passed, had a long strap attached to them, forming a loop, which went round the neck, affording it additional as well as independent support, and enabling the wearer to use both hands with the greater facility. This extra strap was called the *guige :* and Wace, the Norman poet, re-marks upon the advantage this contrivance gave his country-men over the English, who, he says, did not know how to joust (tilt) or to carry arms on horseback. "When they wished to strike with their battle-axe, they were forced to hold it with both hands ; to strike strong and at the same time to cover themselves, was what they could not do." ('Roman de Rou.')

The Norman shields were ornamented with rude figures of dragons, griffins, and serpents, as well as by crosses, an-nulets, and other fantastic devices, but no regular heraldic

Sicilian Bronzes, and examples of Shields, from Bayeux Tapestry.

bearing. The reader will also observe a griffin on one of the Sicilian bronzes, but, as might be expected,

COSTUME OF A NOBLEMAN OF THE TWELFTH CENTURY.
From an Enamelled Tablet, formerly in the Cathedral of Mans.

Maclure & Macdonald. Lith™ London.

in better drawing. The boss, although useless for its original purpose, is in some instances retained, notwithstanding the painted devices on the shield, even after the appearance in the twelfth century of armorial insignia. (See the chromolithograph of a nobleman of that date, issued with Part V. of this

Shield of Edward the Black Prince, Canterbury.

Shield of Prince Edward, now lost.

work.) At that period also the shield, from being flat, was more or less bent round so as to be almost in some examples semi-cylindrical. It gradually became shorter, assuming a heart-shape, and, being made straight at the top, it arrived at the well-known form to which English antiquaries have given the name of "heater," not only as may be seen in numberless sepulchral effigies and paintings of the

Shield of John of Gaunt.

Shield of John of Gaunt. From Sandford.

thirteenth, fourteenth, and fifteenth centuries, but of which two most interesting original examples have by good fortune been preserved for us in the shields of those mirrors of chivalry, Edward the Black Prince and King Henry V. Respecting Prince Edward's shield, Bolton in his 'Elements of

Armories,' 1610, writes as follows : " The sayd victorious Prince's tombe is in the goodly cathedral church erected to the honor of Christ in Canterburie. There (beside his quilted coat armour, with halfe sleeves, tabard fashion, and his triangular shield, both of them painted with the royal arms as of our king's, and differenced with silver labels) hangs this kind of pavis or target, curiously (for those times) embost and painted." Above are given engravings of both shields. One remains : what has become of the other ?

In the fifteenth century several changes took place in the fashion of the knightly shield, the heater shape still, however, holding its own to the end of it. Two special varieties must be noticed.

German Shield, 15th century. Meyrick Collection.

Shield of Henry V. From Bedford Missal.

Shield. *Temp*. Henry V. and Henry VI.

The first, a square shield, with one or more of the corners rounded, slightly curved in the centre, and having on the right side, either at the top or just below it, an opening called, in French, " La bouche de la lance." This sort of shield is first seen about 1400. A German example was in the armoury at Goodrich Court. It was covered with gilt leather, and ornamented with scroll-work.

Sandford, in his 'Genealogical History,' has given an engraving of the shield of John of Gaunt, duke of Lancaster, as it appeared suspended over his tomb in old St. Paul's ; but Bolton has another representation of it in his 'Elements of Armories,' which I consider more faithful. (See both, p. 455.) The other variety is an oblong shield, of which a portion of the upper and lower parts are bent forward.

Carter, in his 'Ancient Architecture,' has given an engraving of a piece of carving on an old oak chest, at that time in York Cathedral, representing Henry V. in the character of St. George, and wearing the shield above described ; and in an illumination in the celebrated MS. known as the Bedford Missal, he is depicted as being armed by his esquires, and having a shield, slightly altered from the heater shape, and bearing the arms of France as altered by Charles VI., who reduced the fleurs-de-lys " sans nombre " to three, suspended by its *guige* beside him ; but a much more interesting example is preserved in Westminster Abbey, where, over the tomb of the heroic king, hangs his

Inside of Shield of Henry V., preserved in Westminster Abbey.

Norman Shield, from Bayeux Tapestry. 2. From a chess-man of the 12th Century. 3. Shield of Hehe, Comte de Maine. 4. From Seal of Gilbert de Clare, Earl of Pembroke, Temp. Stephen. From 1st Seal of Richard I. 6 Seal of William de Fortibus, Earl of Abermarle, Temp. Stephen. 7. Shield of Henry III, Westminster Abbey. 8. German Shield, Temp. Henry IV. From Add. Mss. Brit. Mus. No 12,228, Temp. Edward. III. 10. From copy of Froissart, 15th Century. 11. Ditto. 12 & 13, Pavises, 15th Century.

own shield,—sadly dilapidated, it is true, but the interior portion of which still retains distinct traces of its ornamentation, which was originally blue velvet embroidered with gold fleurs-de-lys, and in the centre an escarboucle within a frame of scroll-work. (See woodcut on the last page, from a photograph recently taken by permission of the dean and chapter.)

During the latter part of the fifteenth century the shield was rounded at bottom, and in the sixteenth gradually fell into disuse. Superbly embossed targets were borne by sovereigns and great personages, for pageantry more than defence; and a shield, properly so termed, was not to be seen amongst the English forces in the seventeenth. Bucklers, rondelles, targets, and rondaches were plentiful; but the lance and shield of the knight were rendered useless by the introduction of and improvement in fire-arms.

The reader is referred to Plate XVII. for the shapes of shields from the twelfth to the sixteenth centuries, as well as to the many examples to be found under various articles in these pages.

SHIFT. See SMOCK.

SHIRT. That linen shirts were worn by the Anglo-Saxons as early as the eighth century Mr. Strutt assures us that there is sufficient authority to prove, but unfortunately he does not cite any in support of his assertion; but in the tenth century we may fairly infer that linen shirts were worn by at least the wealthier classes, as the wearing of a woollen shirt was enjoined by the Canons as a very severe penance. The same observation may apply to the Normans, as, in every instance where a labouring man is represented without an upper garment, he is naked from the waist upwards. In the fourteenth century we have the direct evidence of Chaucer to the fact of the existence of this undermost garment, as he clothes his Knight in

"A breach and eke a sherte."
Rhyme of Sir Thopas.

which, we are told, was "of cloth of lake, fine and clere." (See LAKE.) In his 'Canterbury Tales' also, the Parson asks, "Where than the gay robes, the soft sheets, the smal sherts?"—"small" meaning probably, as Mr. Strutt suggests, "thin or delicately fine." And thenceforth the mention of it is frequent, and its ornamentation as constantly alluded to. Shirts of silk are spoken of in some of the metrical romances. Childe Waters "did on his sherte of silke." ('Reliques of Ancient Poetry,' vol. iii. p. 61); and in 'Ly Beaus desconus' we read—

"They cast on hym a sherte of silke."
MS. Cotton. Caligula, A 2.

But the material was generally of linen manufactured at Rennes in Brittany, or in the Low Countries, the former being called cloth of Reynes and the latter Holland cloth.

"I have a shert of Reynes with sleeves pendaunt."
Mystery of Mary Magdalen, 1512.

"Your skynne that was wrapped in shertes of Reynes."
Skelton's *Morality of Magnificence.*

In the fifteenth and sixteenth centuries the doublets were cut lower in the neck, made open in the bosom, and the sleeves nearly disjointed at the elbows, in order to show the fineness and whiteness of the shirts (see p. 171), the collars and fronts of which were embroidered with black or blue silk, or gold and silver thread—

"Come near with your shirtes bordered and dyspayled
In forme of surplois."
Barclay's *Ship of Fools*, 1509.

(See the illustrations to the article DOUBLET in this volume, and the figure of Henry Earl of Surrey at p. 107.)

In an inventory of apparel belonging to Henry VIII., which I have so often previousl (MS. Harl. No. 1419), there are entries of "borders of golde for shertes," "shirtes wrou black silke," and "shirtes trimmed with black and white silk ;" and in the twenty-fourth yea king's reign an Act of Parliament was passed prohibiting every person under the dignity of to wear "pinched" (that is, plaited) "shirts," or "plain shirts garnished with silk, gold, or sil the time of Elizabeth we are told by Stubbs, "that the shirts which all in a manner do we the nobility or gentry only did wear them it were more tolerable—are either of cambric, lawn, or the finest cloth that can be got and these shirts sometimes it happeneth are throughout with needlework of silk and such like, and curiously stitched with open seams, a other knackes besides ; insomuch as I have heard of shirts that have cost, some ten shillir twenty, some forty, some five pounds, some twenty nobles, and, which is horrible to hear, s pounds a piece ; yea, the meanest shirt that commonly is worn of any doth cost a crown o at the least."

"Towards the end of James I.'s reign," Mrs. Palliser observes, "a singular custom c fashion, brought in by the Puritan ladies, that of representing religious subjects, both in lace and embroidery—a fashion hitherto confined to church vestments." In the 'Custom of the (a play by Beaumont and Fletcher, the lines occur—

> " Sure you should not be
> Without a neat historical shirt."

The shirt played a conspicuous part in the male costume in the reign of Charles I] sleeves being shown from far above the elbow, and the front between the doublet and the breeches. (See pp. 109, 115, 174.) From the end of the seventeenth century there is particular to record of it.

SHOE. The shoes worn by the Belgic Britons were made, according to Meyrick ('Co Orig. Inhab. of the British Islands,' fol., 1821), "of raw cowhide, that had the hair turned (

and coming up to the ankles." The British name for t *Esgidiav*, derived, according to the same authority, fro: " protection from hurt." They were similar to the *brog* of or the shoes of the Scotch as late as the reign of Edward Froissart relates that in their midnight retreat before th forces in 1327 they left behind them ten thousand pai worn-out shoes made of undressed leather, with the hair or have been dug up in England made of one piece of leather, slit in several places, through which a thong pass being drawn tight, fastened them round the foot like "Shoes so constructed," Mr. Fairholt remarks, "were wo the last few years in Ireland ;" and he has engraved two s

Shoes from the originals in the Royal Irish Academy.

from the originals in the Royal Irish Academy, which we here reproduce.

The Romanized Britons, we are told, adopted the dress of their masters as well as their and their language (Tacitus in 'Vit. Agric.') ; and, no doubt, in addition to sandals, the chiefs and nobles wore shoes of that costly character of which the Romans were so fond. A splendid example was discovered in 1802 upon opening a Roman cemetery at Southfleet, Kent. A pair of shoes, made of purple leather, ornamented with hexagons elaborately worked in gold, were found in a stone sarcophagus between two glass vessels con- taining burnt bones. But for the unmistakable character of the

Romano-British (?) Shoe

burial-place, the pattern of the shoes would have induced me to attribute them to a later da woodcut above.)

Of the Anglo-Saxon shoes, we possess innumerable pictorial representations. Ordinarily they have one slit straight down over the instep, and fastened by a thong put above it ; but there are instances of their being slit in many places, giving them the appearance of sandals. In all examples, however, they come up as high as the ankle, and are very difficult occasionally to be distinguished from buskins or half-boots. The terms "slype-sceo" and "*un*hege-sceo" clearly show, however, that the Anglo-Saxons themselves distinguished the shoes which did not reach higher than the ankle from those which mounted above it. The shoes of the commonalty are always painted black ; but those of sovereigns, nobles, and ecclesiastical dignitaries are generally represented of gold stuff with lattice-pattern embroidery. Nearly the same observations will apply to the Anglo-Normans of the eleventh, twelfth, and thirteenth centuries. (See SOTULARES.)

On arriving at the reign of Edward III. we find constantly representations of undoubted shoes, ornamented also by embroidery in gold and colours of the most tasteful description. (See woodcuts subjoined from Arundel MS. No. 83, *circa* 1339, and the wall-paintings formerly existing in St. Stephen's Chapel, at Westminster.)

Shoes. From wall-paintings, St. Stephen's Chapel, Westminster.

The lattice and other patterns observable on these shoes illustrate Chaucer's line describing the dress of the priest Absolon, who had

" Paules windowes carven on his shoes."

The four examples from St. Stephen's Chapel exhibit the pointed toes which from the time of Rufus to that of Henry VII. were constantly in form more or less extravagant, exciting the ridicule of the poets and historians, and the censure of the clergy. Ordericus Vitalis speaks of them in the twelfth century, and says they were invented by some one who was deformed in the foot. Shoes with points made like scorpions' tails were called " pigaciæ," a term also applied at a later period to a pointed sleeve ; and a courtier named Robert stuffed the points of his shoes with tow, causing them to curl round like a ram's horn—a fashion which obtained for the inventor the name of " Cornadu."

Shoe of Edward III. From his effigy.

Pattern of the ornament of the Shoes of William of Hatfield. From his effigy.

From effigy of Lady Marmion.

The shoes of Lora, wife of Robert de Marmion, whose effigy has already supplied us with some valuable illustrations, have pointed toes of a peculiar and very ungraceful form.

In the reign of Richard II. the greatest extravagance in dress was indulged in by all classes, and the length of the toes of the boots, shoes, and every description of *chaussure*, which had been moderate in the reign of his grandfather, now increased to such an extent that they embarrassed the wearers in walking, and the points were fastened up to the knees by cords or small chains.

The author of the 'Eulogium,' a work of this date, quoted by Camden, says, "Their shoes and pattens are snouted and picked (piked) more than a finger long, crooking upwards, which they call *crackowes*, resembling Devil's claws, and fastened to the knees with chains of gold and silver." These *crackowes* were named after the city of Cracow, and, no doubt, were amongst the fashions imported from Poland, which had been incorporated with the kingdom of Bohemia by John, the grandfather of Richard's queen, Anne. The "*snout*" of one of these *crackowes* is here engraved from an original one lately in the possession of Mr. C. Roach Smith. It was six inches long, and stuffed with moss. Reduced during the reigns of Henry IV. and his son to moderate dimensions, they started out again with redoubled vigour in that of Henry VI., and became, under the name of *poulaines*, the subject of prohibitory statutes in the reign of Edward IV., at the close of which they disappeared,—let us hope, for ever. Fashion, however, as usual, rushed into the opposite extreme, and in the sixteenth century the shoes became as absurdly wide at the toe as they had previously been taper; and, from the remarkable shortness of the upper portion, afforded scarcely any protection to the feet, the toes being barely covered by the slashed leather, velvet, or other material of which the shoe was composed.

Toe of a crackow.
C. R. Smith's Collection.

Shoes from the time of Henry VIII. to James I.

After this period the shoes began to assume some resemblance to their present form, or rather to that of the modern slipper, the upper leather covering the whole of the instep.

Pumps are first mentioned in the time of Elizabeth (see page 407), but are not included by Stubbs in his account of shoes, unless he calls them *pisnetts*, which appear to have been a name for them. Of course, he must have his growl at the shoes, as well as at every other article of attire. "The men," he complains, "have corked shoes, pisnetts, and fine pantoffles, which bear them up two inches or more from the ground, whereof some be made of white leather, some of black, and some of red; some of black velvet, some of white, some of green—razed, carved, cut, and stitched all over with silk, and laid on with gold, silver, and such like." He attacks the ladies in almost the same words :— "They have corked shoes, *pins*nets, pantoffles, and slippers, some of black velvet, some of white, some of green, and some of yellow; some of Spanish leather, and some of English; stitched with silk, and embroidered with gold and silver all over the foot, with other gewgaws innumerable."

Shoes. *Temp.* Charles II.

The corked shoes he speaks of were common in England, and are frequently alluded to in the next century by the dramatists of the reigns of James I. and Charles I. A corked shoe of the time of Elizabeth, found in the Thames, was copied by Mr. Fairholt. "The upper leather was slashed and pounced in a lozenge pattern; between that and the sole was a pad of cork rising considerably toward the heel." ('Cost. in England.') They are mentioned by Stephen Gosson in his 'Pleasant Quippes,' 1592, so often quoted.

In Sharpman's comedy called 'The Fleire,' printed 1615, a lady inquires "why the citizens weare all corkes in their shooes?" and is told, "'Tis, Madam, to keep up the customs of the citie, only to be light heeled." In a play called 'Willy Beguiled,' printed 1623, a country girl says, "I came trip, trip, trip over the Market Hill, holding up my petticoats to the calves of my legs, to show my fine coloured stockings, and how trimly I could foot it in a new pair of corked shoes I had bought."

Shoes with two straps or latchets, another advance towards the form of our present shoes, are first seen about the close of the reign of Elizabeth, and necessarily brought in with them shoe-strings, by which they were fastened over the instep.

Pisnetts, Pinsnets, or *Pinsons*, as the word is indifferently written, will be separately considered under SLIPPER, where I shall also have a few words more to say concerning Pantoffle, of which I have already spoken under PANTOBLES, p. 386.

By a poem of the time of the Commonwealth, entitled 'The Way to woo a Zealous Lady,' we learn that the shoes of the Puritans had pointed toes, and those of the Cavaliers square toes, for the gentleman informs us that, amongst other objections to his dress, the lady observed,

"My Spanish shoes were cut too broad at toe."

Leaving his "pure mistress for a space," he changed all his apparel, and on his return he says—

"My shoes were sharp at toe."

The shoes in the reigns of Charles II. and James II. are distinguished by high heels and long toes, tapering to a point, but cut square at the end, the upper leather not only covering the instep entirely, but ascending some few inches up the shin. In a song in Durfey's 'Wit and Mirth,' entitled "The Young Maid's Portion," the lady speaks of her "laced shoes of Spanish leather." Malcolm says, "Spanish leather shoes laced with gold were common" about this period. In the 'Ladies' Dictionary,' 1699, a fashionable gentleman is described as sitting "with one leg on a chair in a resting posture, though, indeed, it is only to show you that he has new Picards à la mode de France.; that is, new shoes of the French fashion."

The man of fashion in 1720 wore his shoes square at the toes with diminutive diamond buckles, a monstrous flap on the instep, and high heels. (Malcolm, 'Manners and Customs,' vol. v.) "Red heels to his shoes" is one of the directions for making a beau in 1727.

"At every step he dreads the wall to lose,
And risks, to save a coach, his red-heeled shoes."
Gay's *Trivia*.

"Let him wear the wide made shoes,
Buckling just above the toes."
"Female Advice to a Painter," *London Mag.*, August 1755.

Hogarth affords us many examples of the shoes worn in the reign of George II., and varieties of shoes of all dates are also to be found incidentally throughout these volumes.

1 2 3 4 5

1, 2, and 3. Shoes *temp*. William III. 4 and 5. *Temp*. George I.

SHOE-BUCKLE. See BUCKLE.

SHOE-ROSES. Shoe-ties, so called from the bunch of ribbons in form of a rose attached to them. (See ROSE and SHOE-TIE.)

SHOE-TIE. Shoe-ties of ribbon succeeded the shoe-roses of the seventeenth century, and were generally worn by both sexes in the reign of Charles II., about the same time that the shoe-buckle appeared, with which they were occasionally associated; but shoe-strings of some description are mentioned as early as the reign of James I. "Tye my shoe strings with a new knot," occurs in the play of 'Lingua,' 1607, and "green shoe-strings" are spoken of in 'Woman's a Weathercock,' 1612. Also, in Dekker's play of 'Match Me in London,' 1631, we read of "rich spangled Morrisco shoe-strings." To "wear a farm in shoe-strings edged with gold," is one of the extravagances reprobated by Taylor the Water Poet.

Lady Fanshawe, describing the dress of her husband when ambassador from Charles II. at the Court of Madrid, says, "His shoes black, with scarlet shoe-strings and garters." ('Memoirs.')

Shoe-ties of ribbon were worn by ladies as well as gentlemen in the reign of Charles I., as they may be seen in paintings and prints of the period.

The lines in Hudibras, also,

"Madam, I do as is my duty,
Honour the shadow of your shoe-tie,"

testify not only to the fact, but to the peculiar fashion, as the large stiff bows and ends projected on each side, and consequently cast a shadow.

The humbler classes, whether in town or country, must have used strings of some material to secure the latchet of the new form of shoe introduced early in the seventeenth century. Thomas Durfey informs us that the favourite colours for the ladies' shoe-ties were red, green, or blue, but that most depended on the colour of the ribbons with which their dresses were trimmed so profusely. Shoe-strings were displaced by buckles during the first half of the eighteenth century, and became general again upon their abandonment (except for Court dress) towards the end of it. For illustrations of this article, the reader is referred to SHOE, and the numerous engravings of general costume throughout the work.

SHOULDER-KNOT. A knot of ribbon or lace first worn by men of fashion in Charles II.'s time. They were sometimes enriched by jewels. Anne of Austria presented the Duke of Buckingham, during his stay at the French court, with a shoulder-knot having twelve diamond pendants attached to it.

Shoulder-knots of ribbons of the family colours were afterwards worn by servants. Dr. John Harris, subsequently Bishop of Llandaff, in his 'Treatise on the Modes, or a Farewell to French Kickshaws,' published in 1715, speaking of the folly of copying the French fashions, says, "Let us,

Henry V. From Bedford Missal.

therefore, allow them the reputation of the shoulder-knot." It disappeared shortly after that date from the shoulders of gentlemen, but adheres to the shoulders of domestics to this day. (See AIGUILLETTE.)

SHOULDER SHIELD. A *pièce de renfort*, called by the French *manteau d'armes*, used for tilting in the sixteenth century. One belonging to a suit formerly the property of William V., Duke of Bavaria, was in the Meyrick Collection. It was ornamented by ridges of steel intersecting each other lozengewise, indicating, it may be, the arms of Bavaria, though the pattern is not uncommon. Two, superbly engraved, are in the Londesborough Collection. (See woodcuts below.)

A very early example appears in the Bedford Missal, where Henry V. is represented being armed by his esquires. In the centre of the shield is a large boss. It has been mistaken by some writers for a tilting shield, but it is clearly a piece of armour which wraps round the left shoulder, and is the prototype of the *grand garde* and the shoulder shield.

Shoulder Shield. Meyrick Collection.

Shoulder Shield. Londesborough Collection.

Manteau d'Armes. Londesborough Collection.

SICLATOUN. See CYCLAS.

SINDON. (Hebrew.) Fine linen cloth. "Sindon, pro specie panni (byssus tenuis)." (Ducange, *in voce.*) "Item unam capellam de sindone nigri vel casulam tunicam," &c. (Arestum, 9 Maii, 1320 ; Ibid.) (See ROBE, "Colobium sindonis.")

SKEIN. The dagger or war knife of the ancient Irish, derived, according to some authorities, from the Icelandic *skeina,* to wound. They were used by them as late as the seventeenth century, and well known in England by the many allusions to them by the dramatists and other writers of that period.

> "Against the light foot Irish have I served,
> And in my skin have token of their skeins."
> *Soliman and Persida,* 1599.

> "I hoped your great experience and your years
> Would have proved patience rather to your soul,
> Than with this frantic and untamed passion
> To whet their skeins."
> *Merry Devil of Edmonton,* 1617.

SLAMMERKIN. See TROLLOPEE.

SLEEVE. It may appear singular to the uninitiated that a separate article should have to be written on sleeves, when so much has been said about coats and gowns, of which they form an important portion ; but many sleeves in the Middle Ages did not form a portion of the dress, but were separate articles themselves, and worn with this or that garment according to the fancy of the owners. The change of fashion in the shape of even the permanent sleeves was so constant that the character of them more clearly indicates the different dates than perhaps any other portion of costume.

The tunics of the Britons, the Saxons, and the Danes exhibit no remarkable variety. The sleeves of the under-tunic or the kirtle are moderately tight, and reach to the wrist, and those of the super-tunic loose and wide ; but shortly after the settlement of the Normans in this country the most extraordinary and extravagant fashions of sleeves present themselves in rapid succession.

Cotton. MS. Nero, C 4.

Psalter, 12th cent. Doucean Collection, Bod. Lib.

Imprimis, in the reigns of Rufus and his brother Henry I. a rage appears to have existed for the elongation of every portion of attire, and the sleeves especially display, to an extraordinary extent, the prevalent fashion. A caricaturist of that day has represented the Father of Evil in the

dress of a fashionable lady; and on comparing it with other contemporary drawings, which are not intended for caricatures, the portrait can scarcely be considered exaggerated. (See woodcut on the last page.) Not only the sleeves, but every portion of the dress is tied up in knots to prevent its trailing on the ground. The tunics of the men have also sleeves that extend far over the hand.

Another absurd and hideously-shaped sleeve seems to have been worn by women at the same time, and survived it. It was something like a boat, and has evidently been the origin of the heraldic *maunch*, which the French very appropriately term "un maunch mal tallié."

Heraldic Maunch:
Arms of Hastings .
Temp. Henry III.

As if the force of folly could no further go, the thirteenth century is guiltless of any monstrosity so far as sleeves are concerned; but fashion seems to have acted on the principle inculcated by the French phrase, "Reculer pour mieux sauter," and we are led to conclude, from a line in a song of the time of Edward II., that the Protean deity had indulged in some extravagance at that period which has escaped pictorial representation, as we are told—

"Because Pride hath *sleeves*, the land is without *alms*;"

a pun sufficiently bad to make the fortune of a modern burlesque. The illuminations of that date do not, however, throw any light on the observation. It may be, nevertheless, an allusion to an eccentric fashion, of which numerous examples are to be found in the following reign; and the question arises whether it had made its appearance earlier than has been generally supposed, or whether Mr. Thomas Wright, to whom we are indebted for its publication, has antedated the composition of the song. The cote-hardie worn by both sexes in the reign of Edward III. is frequently depicted with short sleeves, from which depend long strips of some material generally of a white colour, but occasionally of cloth of gold or other costly material, and the edges of which were cut in the shape of leaves or other devices, contrary to the statute in that case made and provided. (See DAGGES.)

Male Costume *temp*. Edward III. From Royal MS. 19 D 2.

These unmeaning appendages are not alluded to by contemporary writers as far as my research has extended, or that apparently of other English antiquaries, who give them no special name. M. Viollet-le-Duc does not enlighten us on the point, speaking of them only as *bandes;* but M. Quicherat describes

Female Costume *temp*. Edward III.
From Royal MS. 19 D 2.

Ladies Fighting. *Temp.* Richard II. From a copy
of the 'Roman de la Rose,' Doucean Collection,
Bod. Lib.

them as " deux lanières d'étoffe dites *coudières* " (page 232), and, therefore, I presume he has been fortunate enough to find that term applied to them in some document of authority, but what or where he does not mention.

These *coudières* seem to have suggested the hanging sleeves subsequently so popular.

The reign of Richard II. is remarkable for the enormously long and wide sleeves of the houpelands and other outer garments ; the under dress of both sexes, tunic or kirtle, having tight sleeves reaching to the wrist, and some covering a portion of the hand, with buttons set close together from the wrist to the elbow. At the same time other fashions of sleeves existed. A pointed sleeve, called *pigache*, as the pointed shoes of the twelfth century had been, was worn by ladies towards the end of his reign. In a MS. entitled ' Aventures arrivées à Reimes en 1396, à une fille nommée Ermine,' we read, " Car voudrait bien que les femmes à qu'il parle de leur habit eussent vendu leurs surcos et leurs manches *à pigache* et donné l'argent en leur maison." (Ducange, *in voce* PIGACIA.)

Occleve, the poet, is severe upon sleeves in the reign of Henry IV., during which the fashions of the previous reign appear to have been little varied, and the sumptuary laws against excess of apparel as little regarded. In a poem entitled ' Pride and Waste Clothing of Lordes Men which is azens (against) their Estate,' he says :

> " But this methinketh an abusion,
> To see one walk in a robe of scarlet
> Twelve yards wide, with pendent sleeves down
> On the ground, and the furrur therein set,
> Amounting unto twenty pounds or bett (better) ;
> And if he for it paid, hath he no good
> Left him wherewith to buy himself a hood.
> * * * * * *
> " What is a lord without his men ?
> I put case that his foes him assail
> Suddenly in the street, what help shall he,
> Whose sleeves encumbrous so side trail,*
> Be to his lord ?—he may not him avail.
> In such a case he is but a woman.
> He may not stand him instead of a man.
> His arms two have right enough to do,
> And somewhat more, his sleeves up to hold.
> * * * * * *
> " Now have these lords little need of brooms
> To sweep away the filth out of the street,
> Since side sleeves of penniless grooms
> Will up it lick, be it dry or wet."

Every illumination of this date testifies to the truth of this description. (*Vide* engraving next page, and pp. 116, 273, 303.)

An Act passed in the fourth year of this sovereign's reign forbade any man, not being a banneret or person of high estate, to wear large hanging sleeves, open or closed, excepting only " gens d'armes, quand ils sont armez,"—an odd exception at first sight, but which will be understood by referring to the figure of the armed knight with *dagged* sleeves, p. 165. (See also under SURCOAT.)

The long trailing sleeves, with or without the prohibited dagged edges, continued to be worn by both sexes throughout the greater part of the fifteenth century (see figure of Henry V. from the Arundel MS., at p. 165, and the male and female costumes illustrating GOWN, pp. 217, 221, 222) ;

* It is singular that Mr. Fairholt should have quoted this very poem to prove that " *side* " signified " *wide*," and, moreover, have observed that " the word is still used with that signification in Northumberland." A glance at our mutual friend Halliwell's (Phillipps') Dictionary would have convinced him that " *side* " means " *long, trailing*," in Northumberland. Though used for " wide," or rather " ample," in some cases, in this instance the expression " trail," I think, is decisive.

but many new and fantastic shapes are depicted in the MSS. of the reigns of Henry VI. and

Edward IV. The anonymous writer of a Life of Richard II. (a monk of Evesham) speaks of gowns with deep wide sleeves, commonly called *pokys*, shaped like a bagpipe: "Maxime togatorum cum profundis et latis manicis vocatis vulgariter *pokys* ad modum *bagpipe* formatus;" they are also, he says, rightly termed "devil's receptacles"—"receptacula dæmoniorum recte dici"—for whatever could be stolen was put into them. Some were so long and wide that they reached to the feet, others to the knees, and were full of cuts. As the servants were bringing up pottage or sauces their sleeves would dip into them, and have the first taste, &c. (Vita Ric. II. p. 172.) Of sleeves shaped like a bagpipe, however, we have no pictorial example earlier than the reign of Henry VI.; and as the MS. could not have been written much anterior to that period, it is possible the author is describing dresses of his own time which he might imagine were of the same fashion some

Long Sleeves. *Temp.* Henry IV. and Henry V.

twenty years previously. The subjoined engravings are, at all events, taken from the earliest known representations of the pokys or bag-shaped sleeve, distinct from the long sleeves that dipped into the dishes, of which we have already given specimens.

Fashions of Sleeves. *Temp.* Henry VI.
Fig. 1, from Royal MS. 15 E 4; figs. 2 and 3, from Harleian MS. 2270.

It will be observed that the sleeves of the under-garments are in every instance tight-fitting and reach to the wrists.

Ladies appear in gowns with long tight sleeves, with cuffs of fur or other material, in the reign of Edward IV. (see GOWN), and the sleeves of the men are occasionally open at the elbow, to show the shirt. The shoulders are also heightened and widened by stuffing,—a practice denounced by the chroniclers, and prohibited to yeomen and persons of all lower degrees by the statute of the third of that king's reign. (See MAHOITRES.)

Many fantastic fashions of sleeves are met with during the later years of the fifteenth century: long loose sleeves, with openings at the inner portion of the joints of the arms, which enabled the wearers to draw their arms through them at pleasure; hanging sleeves from shoulder to elbow, successors to the *coudières* of the previous century, and sleeves composed of two, three, or more pieces united by points, through which the shirt sleeve is seen at every opening; and, lastly, slashed and

puffed sleeves in every variety. Specimens of nearly all these have already been given in this work, and many more must naturally occur in its progress. I shall, therefore, limit the examples here to a few of the most characteristic of the different periods.

Fashions of Sleeves. *Temp.* Edward IV.
Fig. 1, from Harleian MS. 1766; fig. 2, Royal MS. 19 C 14; fig. 3, Royal MS. 14 E 4; figs. 4 and 5, Royal MS. 15 D 2; fig. 6, Cotton. MS. Nero D 4.

The sleeves of the garments of both sexes were generally, in the sixteenth century, separate articles, taken from or added to the body of the dress at pleasure, by means of points or buttons. Amongst the Harleian MSS. is an inventory of apparel left in the wardrobe of Henry VIII., at the time of his decease in 1547. Therein are entries of "a pair of truncke sleeves of green velvet, richly embroidered with flowers of damaske gold pirl of Morisco work, with knops of Venice gold cordian raised, either sleeve having six small buttons of gold, and in every button a pearl, and the branches of the flowers set with pearles;" "a pair of sleeves ruffed at the hand, with strawberry leaves and flowers of golde embroidered with black silke." In other accounts we find "three pair of purple satin sleeves for women;" "one pair of linen sleeves paned with gold over the arm, quilted with black silk, and wrought with flowers between the panes and at the hands;" "one pair of sleeves of purple gold tissue damask wire, each sleeve tied with aglets of gold;" "one pair of crimson satin sleeves, four buttons of gold being set on each sleeve, and in every button nine pearls" (see pp. 224, 225).

In the reign of Elizabeth, Stubbs says of the ladies' gowns that "some be of the new fashion and some of the olde; some with sleeves hanging down to the skirts, trailing on the ground, and cast over their shoulders like cowtails; some have sleeves much shorter, cut up the arm, drawn out with sundry colours, and pointed with silk ribands, and very gallantly tied with love-knotts, for so they call them" (see p. 366). Both tight and loose sleeves reaching to the wrists, the latter of what has been called the *gigot* form, and slashed by way of pattern, appear in this reign and that of James I. (see p. 226). "A pair of silken foresleeves to a sattin breast-plate is garment good enough." ('The Dumb Knight,' 1608.)

Flat hanging sleeves issuing from beneath the rolls or tabs upon the shoulders are of this period, and large loose sleeves, slashed up the front to show the lining, were the principal novelties of the reign of Charles I. and the early portion of that of Charles II. (see p. 4), towards the end of which the coat was introduced, at first with sleeves not reaching to the elbow, but gradually extending to the wrist, after which the cuffs alone become their distinctive feature. (See CLOAK, COAT, DOUBLET.)

SLING. This primitive weapon was in use in our armies till the end of the fourteenth century, when cross-bows were used for stones instead. Slings were of two sorts : the cord or hand sling, and the staff sling. The former is seen in the hands of the Anglo-Saxons, one end of the cord being secured round the fingers, and the other end furnished with a tassel let loose when casting the stone (see woodcut below).

The staff sling is mentioned in the romance of ' Richard Cœur de Lion,' a work of the thirteenth century—

"Staff slynges that smyte well ;"

and they are pictured in several MSS. of that period.

Cotton. MS. Claudius, B 4, Anglo-Saxon.

MS. Bennet College, Cambridge, C v. 16.

Royal MS. 14 B 4. *Temp.* Henry III.

In Museum at
Boulogne.

Mr. Fairholt says, "In the museum at Boulogne is a curious sling. The balls for holding in the hand are of pink worsted, the thongs of leather, stamped in ridges coloured red and yellow. The leathern receptacle for the stone contains an iron spring, shown in our cut, turned out at bottom in the way it appears after propelling the stone" (see copy of cut above). Mr. Fairholt adds, "It is probably of the latest form."

SLIPPER. Under SHOE I have mentioned that the Anglo-Saxons had the word "slype-sceo" in their vocabulary. It is, however, remarkable that no representation of any sort of shoe that would justify the name has been found amongst their numerous illuminations. All the shoes depicted reach up to the ankles, and the majority have a long opening down the centre of the upper leather. Nor have I, in any mediæval paintings, met with an example of what we should, in these days, call a slipper. There is ocular proof, nevertheless, that the Gauls, under the Roman dominion, had slippers, for some have been found in Gaulish interments in France, and engraved for M. Quicherat (see GENERAL HISTORY) ; and as, Cæsar tells us, the Britons were "like unto the Gauls," they were most probably shod in a similar manner. It is not till the sixteenth century that we find the slippers constantly mentioned. Shakespere makes Jaques, in ' As You Like It,' speak of "the lean and slippered pantaloon ;" and Hubert, in ' King John,' describes the disturbed Blacksmith as

"Standing on slippers (which his nimble haste
Had falsely thrust upon contrary feet)."
 Act iv. sc. 2,

But what is more instructive is the description in Delany's ' Pleasant History of Thomas of Reading,' of a man who wore a high pair of shoes, "over the which he drew on a great pair of lined slippers," as the distinction is here complete. That the pantables or pantoffles were also slippers, the word *pantouffles*, which is still the term for them in the French language, is surely sufficient evidence ; but Stubbs speaks of fine pantoffles, which bear the wearers up "two inches or more from the ground,"

and says, "Yet notwithstanding I see not to what good use the pantoffles serve, except it be to wear in a private house, or in a man's chamber, to keep him warm : but to go abroad in them as they are now used is altogether a let or hindrance to a man than otherwise ; for shall he not be faine to knock or spurn at every wall, stone, or post, to keep them on his feet ?" (This is decisive, as showing they had only upper leathers.) "How can they be easy," he asks, "when a man cannot go steadfastly in them without slipping and sliding, at every pace ready to fall down ? Again, how should they be easy, whereas the heel hangeth an inch or two over *the slipper* from the ground" (here he calls it plainly a slipper) ; "insomuch, that I have known divers men's legs swell with the same ? And handsome how should they be, when they go flap, flap, up and down in the dirt, casting up the mire to the knees of the wearer ?" From this elaborate description I think we may fairly conclude that the pantoffle was a slipper into which the foot was thrust without a back piece ; that it had a sole (of cork ?) about two inches thick, and a heel, the position of which (hanging *over* the slipper) it is difficult to imagine.

Pisnett is rendered by Randle Holme a pump or slipper ; and *Pinsons*, which is another form of the word, is described in the Nominale MS. as thin-soled shoes, "Calceolus, pinsons." Palsgrave has "Pynson, shoe, caffignon ;" and Halliwell observes, that in the copy of Palsgrave, in the Cambridge Public Library, "or socke" is written in a contemporary hand, which seems corroborated by Elyot, who renders "saacatees, one that weareth startups or pinsons" (ed. 1559). Now startups were a sort of half boot or high shoe, as will be shown under that word ; and I am inclined therefore to think that pinsons or pisnetts were not slippers or pumps in the time of Elizabeth, whatever they might have been in that of Randle Holme.

SLIVER, SLIVING. See SLOP.

SLOP. This word presents us, I think, with the most remarkable instance of the capricious appropriation of terms to which I have had to call the reader's attention in the course of this Dictionary. Mr. Fairholt has "SLOPS, the wide Dutch breeches *mentioned by Chaucer,* and again introduced during the reign of Elizabeth."

I can scarcely account for this oversight. Chaucer's words are : "Upon that other side, to speak of that horrible disordinate scantiness of clothing as be these *cut slops or hanselines,* that through their shortness and the wrapping of their hose, which are departed of two colours—white and red, white and blue, white and black, or black and red—make the wearer seem as though the fire of St. Anthony, or other such mischance, had cankered and consumed one-half of their bodies." What allusion is there to be found in this passage to "Dutch breeches," and where in Chaucer's time are "breeches" to be met with, except in the shape of drawers, to which alone the term was applied previous to the sixteenth century ? The "slop" above mentioned is a body-garment, a *hanseline,* a jacket or cassock, "cut" so short that it exposed the tight-fitting parti-coloured hose to an extent deservedly incurring the reprobation of the clergy. That slops were not breeches as late as the reign of Henry VII., is evident from the ordinances issued by his mother, Margaret Countess of Richmond, for "the reformation of apparell for great estates of women in the tyme of mourninge," wherein the Queen's gentlewomen are directed to wear "sloppes," which are explained to mean mourning cassocks "for ladies and gentlewomen, not open before." In the first year of Henry VIII., also, according to Hall, upon Shrove Sunday, after a goodly "banket" in the Parliament Chamber at Westminster, a masque was presented in which, amongst many other fancifully attired personages (the King being one), there entered six ladies, two of whom were in garments of "crymosyne and purpull, made like *long slops,* embroidered and fretted with golde after the antique fascion ; and over the slop was a shorte garment of cloth of golde, scant to the knee, fascioned like a tabard," &c. But though they were not breeches, it appears there were shoes of some description called "slops" in the fifteenth century ; for in the wardrobe accounts of the reign of Edward IV., amongst the payments to the King's shoemaker, Mr. Fairholt found an entry of "a pair of slops of black leather, at 18*d.* a pair," besides others of russet, tawny, and red Spanish leather. It is not till the sixteenth century that we find the word "slopp" unceremoniously transferred to the nether garments ; wherefore I cannot pretend to determine.

In the History of John Winchcomb or Whitcomb, the famous clothier, commonly called Jack of Newbury, *temp*. Henry VIII., he is described as presenting himself to that sovereign "dressed in a plain russet coat, a pair of white kersie *slopps or breeches*, without welt or guard" (*i.e.* lace or border), "and stockings of the same piece, sewed to his sloppes."

Howe, also, the continuator of Stow's 'Annals,' informs us that many years prior to the reign of Queen Mary (and therefore as early at least as the time of Henry VIII.), the apprentices in London usually wore breeches and stockings made of white broadcloth; "that is, *round slopps or breeches*, and their stockings sewed up close thereto, as they were all but of one piece."

Tarlton, the famous clown of the latter days of Elizabeth, was known by "his great clownish slop;" and that here a nether garment is alluded to is clear from the lines that follow—

> "But now th' are gull'd, for present fashion sayes
> Dicke Tarlton's part gentlemen's breeches playes:
> In every street where any gallant goes,
> The swaggering slop is Tarlton's clownish hose."
>
> Rowland, *Letting of Humour's Blood in the Head vaine*, Epigram 31.

And, to make "assurance doubly sure," Wright, in his 'Passions of the Minde,' 1601, says: "Sometimes I have seen Tarlton play the clowne and use no other breeches than such sloppes or slivings as now many gentlemen weare; they are almost capable of a bushell of wheate; and if they be of sackcloth, they would serve to carry mawlt to the mill." The great Dutch slop Mr. Fairholt speaks of, he states himself, is mentioned in Middleton's 'Roaring Girl,' printed in 1612—

> "Three pounds in gold these slops contain;"

and allusions to them are frequent in other plays and works of that period.

Thus we find the word "slop" to have been applied at various times to three distinct articles of apparel—a jacket or cassock, a shoe, and a pair of breeches. But we have not done yet; for hear Palsgrave: "Sloppe, a night gowne, *robe de nuit*." At the same time he has also: "Payre of sloppe-hoses, *braiettes à marinier;*" while Halliwell defines slop "a smock frock," "any outer garment made of linen," "a summer boot or buskin much worn in the sixteenth century," and, in the Lancashire dialect, "a pocket." He also informs us that in Lincolnshire *sliver* signifies "a short slop worn by bankers or navigators. It was formerly called a *sliving*. The *sliving* was exceedingly capacious and wide." Wright, as we have seen above, speaks of "such sloppes or slivings" as being breeches worn by many gentlemen in 1601; and the breeches retained possession of the title of "slopp" from that period, as Bailey, in 1736, gives "SLOPS (from *slabbe*, Dutch), a sort of wide-kneed breeches worn by seamen."

I have dwelt longer on this subject than my readers may think necessary, but the principal use of this work is to prevent the mistakes into which painters, sculptors, actors, or authors may fall who are not aware that the appellation of an article of apparel at one period is so often transferred to one distinctly different at another, and in the course of centuries may have been used to designate half-a-dozen various objects.

Slops, we have seen, have been "everything by turns," and certainly "nothing long," in one sense of the latter word; and the name is now most appropriately assigned to slop-sellers, who are dealers in *all sorts* of old clothes.

SLUR-BOW. Mentioned in 1504; its peculiarity (merely conjectured by Meyrick) consisting in the action of the tricker.

SMOCK. The Anglo-Saxon word for a woman's undermost garment. It is mentioned under the Norman name of *chemise*, from the Latin *camisia*, in many of the early romances, and generally described as being made of the finest linen (see CHAISEL); but we hear no further particulars about it before the latter half of the thirteenth century, when it had become the fashion to ornament them

with embroidery in gold or coloured silk. The Carpenter's Wife in the 'Canterbury Tales' is thus described :

> " White was her smocke, embrouded all before
> And eke behynde on her colore about,
> Of cole-black sylke within and eke without."
>
> *The Miller's Tale.*

In the ballad of 'Lord Thomas and Fair Annet' the lady says to her maidens :

> " Dress me to my smock ;
> The one-half is of Holland fine,
> The other of needlework."

The practice of embroidering the smock lasted far into the seventeenth century. An Irish smock (that is, probably one made of Irish linen) wrought with gold and silk is mentioned in the inventory of the secret wardrobe of King Henry VIII., taken after his decease, 31st of October, fourth of Edward VI., which, as Mr. Strutt suggests, probably belonged to one of his queens ; and in another wardrobe, said to have been in the old Jewel House at Westminster, was " a waste smock wrought with silver." (Harleian MS. No. 1419.)

Startling as it may appear to our modern ideas, smocks are amongst " the New Year's gifts " to Queen Elizabeth from gentlemen as well as ladies.

Sir Gawan Carew presented her with " a smock of cameryke wrought with black work, and edged with bone lace of gold ; " and Sir Philip Sidney, in 1577–1578, made her a similar donation, which was most graciously received.

" The Lady Marquis of Worcester " gave her the following year " a smock of cameryke wrought with tawny silk and black, the ruffs and collar edged with a bone lace of silver." (New Year's gifts, 1578–1579.)

Mrs. Bury Palliser says : " We have ourselves seen a smock said to have been transmitted as an heirloom in one family from generation to generation. It is of linen cloth embroidered in red silk, with her " (Queen Elizabeth's) " favourite pattern of oak-leaves and butterflies." ('History of Lace,' p. 282.) By the kind permission of the lady and her publisher we are enabled to place a copy of this curious relic before our readers.

In Charles II.'s time, John Evelyn, in his catalogue of a lady's wardrobe, includes—

> " Twice twelve day-smocks of Holland fine,
> With cambric sleeves, rich point to joyn.
> * * * * * *
> Twelve more for night, all Flanders laced,
> Or else she'll think herself disgraced."
>
> *Mundus Muliebris, or Voyage to Marryland.*

Pattern of embroidery of Queen Elizabeth's smock.

SNAPHAUNCE. A fire-arm invented, according to Meyrick, by a set of Dutch marauders called *snap hans*, or poultry stealers. The light of the match betrayed them, and they could not afford the expensive wheel-lock ; they therefore substituted a flint for the pyrite, and an upright movable furrowed piece of steel in lieu of the wheel ; the cover of the pan being pushed back, the piece of steel was brought to stand over it, and the spark elicited as at present.

M. Demmin ignores this derivation, and says : " *The snaphaunce gun (Schnapphahn* in German) derives its name from a pecking fowl, and dates from the sixteenth century." He supports his opinion by the following statement : " The arquebus or musquet with the '*chenappan*'—a name corrupted from the German *Schnapphahn*, a cock-pecking—indicates the time of its invention, which was

the latter half of the sixteenth century, for mention is made of moneys paid in 1588 by the chamber-lain of Norwich to a gunsmith, Henry Radoe, who changed the wheel-lock of a pistol to 'a snaphaunce. The name of 'chenappan' was soon given in France to robbers who used this new weapon ; and the Spanish bandits of the Pyrenees, who were enrolled under Louis XIII., were also called 'chenappan ;' as were also the Barbets of the Alps, the last remnants of the unhappy Vaudois, who were forced by religious intolerance to become marauders and bandits." ('Weapons of War,' London, 1870.) M. Demmin, who is indebted for his principal fact to the first volume of the 'Norfolk Archæology,' page 16, quoted by Mr. Hewitt, may be right as regards the derivation of the name of *chenappan;* but there is nothing in his account that cannot be reconciled with Meyrick's, whose rendering of the word *Schnapphahn* is, I venture to submit, more correct than his own. Subjoined is a snaphaunce musket from the Meyrick Collection.

<center>Snaphaunce Musket.</center>

SNOOD. A ribbon confining the hair of an unmarried female in Scotland.

SOCK. (poceap, Anglo-Saxon.) Mr. Strutt says, " The *pedules* or *socks* were a part of the ancient dress appropriated to the feet, as the name itself indicates ; and they are frequently mentioned by the writers of the ninth and tenth centuries. It has been thought that the *pedules* were probably that part of the stocking which receives the feet, and not distinct from them, and a quotation from an old author is given in Ducange, to support this opinion ; but in proof of the contrary, a variety of authorities might be produced. Let one suffice : the *pedules* and the stockings are clearly men-tioned as two distinct parts of the dress in the ancient Carthusian Statutes (' 2 paria caligarum et 3 paria pedulum ')." I have nothing to add to or dispute in the above observations of the laborious and conscientious antiquary, to whom we are all so deeply indebted. For illustration of this article, see STOCKING.

SOLITAIRE. (French.) A black ribbon attached to the bag of the wig, and worn loosely round the neck by gentlemen in the eighteenth century, after the fashion of the French Court in the reign of Louis XV.

<center>" Now quite a Frenchman in his garb and air,

His neck yoked down with bag and solitaire."

The Modern Fine Gentleman, 1746.</center>

<center>Solitaire. From a

print of the period.</center>

<center>" A black solitaire his neck to adorn,

Like those of Versailles by the courtiers there worn."

" Monsieur à-la-Mode," *Lond. Mag.* 1753.</center>

SOLLERETS. (French.) The articulated steel shoes of the armour of plate, worn from the fourteenth to the sixteenth century, and taking the form of the ordinary shoe, according to the fashion of the day. Some, like a shoe, were independent of the jambs ; others formed a portion of them. Fine examples of the long-toed sollerets are to be seen in the armoury at the Tower, the Londesborough Collection (now at the Alexandra Palace), and in that of Mr. James of Aylesbury.

I have the pleasure of adding an engraving of one of the latest specimens of the long-toed solleret, forming a portion of the jamb, that has yet been discovered, and moreover of an historical interest, surpassing any of its date. There is every reason to believe that it is a portion of the suit which, at one time complete, was preserved in the Abbey of Tewkesbury, and is traditionally asserted

to have belonged to Edward Prince of Wales, son of Henry VI., and who was stabbed by Richard Duke of Gloucester, afterwards Richard III., in the field at Tewkesbury. That it is of that date, there can be no doubt ; that it was made for a youth is undeniable, and, apart from all historical

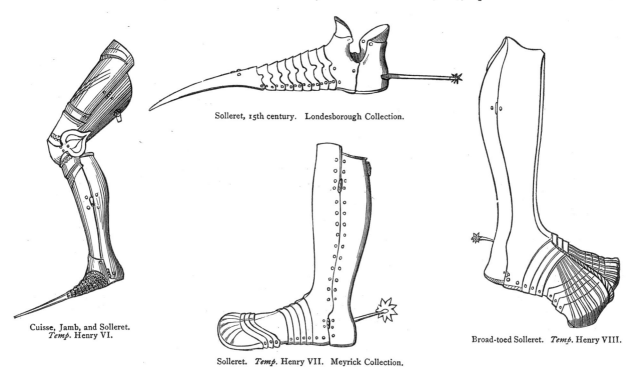

Solleret, 15th century. Londesborough Collection.

Cuisse, Jamb, and Solleret.
Temp. Henry VI.

Solleret. *Temp.* Henry VII. Meyrick Collection.

Broad-toed Solleret. *Temp.* Henry VIII.

associations, it is, from its exquisite workmanship, probably unrivalled. The articulations of the plates, with escalloped edges on the instep, allowing a freedom of movement to the foot equal to that permitted by a stocking, are specimens of mediæval art deserving the attention of all persons interested in the progress of science.

SORTI, SORTIE. "A little knot of small ribbon. It appears between the bonnet and the pinner." ('Ladies' Dictionary,' 1694.) A description all but identical is given in 'Mundus Mulie-bris,' 1690. It is rather startling to hear of a lady's *bonnet* in the reign of the Third William ; but as the word occurs in both works, it cannot be an error of the press or the pen, and I presume it is the French term for cap (*bonnet*) which the authors have adopted, as such an affectation is characteristic of the period.

SPAGNOLET. "A gown with narrow sleeves, and lead in them to keep them down, *à la Spagnole.*" ('Ladies' Dictionary,' 1694.)

SPANGLES. Spangles are first mentioned in England towards the end of the fifteenth century, and under the name of *pailles* and *pailliettes* some years earlier in France. (*Vide* 'Roman du Petit Jehan de Saintré.') In the third year of King Henry VIII., in a grand masque at Greenwich, entitled 'La Forteresse dangereuse,' Hall tells us that the King, accompanied by five knights, entered the hall apparelled in coats "the one halfe of russett satyn spangled with spangles of pure gold, the other halfe of riche cloth of golde." ('Union, Vit. Hen. VIII.') They were much used in Elizabeth's time, to increase the effect of personal decorations of every description. We have already heard of "spangled garters worth a copyhold," *temp.* James I. ; and they have continued ever since to add to the glitter of embroidery, the ornamentation of fans, &c. &c.

SPANNER. The instrument used to screw up the wheel-lock fire-arms ; also applied to the touch-boxes used for priming powder. (See TOUCH-BOX.)

Spanner. Meyrick Collection.

SPARTH. (Anglo-Saxon.) Apparently a battle-axe.

> "And an axe in his other, huge and unmete,
> A spetor (spiteful) sparthe to expouse in spelle quo so my'zt."
> *Sir Gawayne and the Green Knyzt.*

> "Some sayd he lookyd grim, as he would fight ;
> He hath a sparth of twenty pound weight."
> Chaucer, *The Knight's Tale.*

SPATTERDASHES. Bailey, in 1736, says, " a sort of light boot without soles." Fairholt, quoting no authority and giving no example, says, " coverings for the legs used by soldiers, which fastened at the side like gaiters, but were secured more tightly to the leg by straps and bands under the knee." In Cumberland, gaiters are still called *spats* (Halliwell *in voce*), and some protections for the legs to which no special name can be safely applied may be found in mediæval delineations, partaking of the character of " boots without soles " or " gaiters," fastened at the sides. The word " gaiter," from the French *guêtre*, does not appear in the English language before the middle of the last century, and therefore has not been included in this Dictionary. Boyer, edit. 1764, has, " Spatterdashes (or, as they are called in the West, Spatter*plashes*), *espèce de bottines.*"

M. Viollet-le-Duc presents us with several examples of these leggings, which were laced, buttoned, or fastened by hooks and eyes up the sides, under the name of HEUSE, whence our *hose*, which the French called *chausses.* They will be considered in the GENERAL HISTORY.

SPEAR. (*Speer*, German.) One of the most ancient of offensive weapons. The earliest were of two kinds : the longer used by the cavalry, or by the foot to repel their advances ; the shorter, for close combat, or to be hurled as a javelin. The latter, about six feet in length, has been frequently found in graves. The spear-heads of the Belgic Britons, after they had acquired the art of metallurgy from their Phœnician visitors, were, like their sword and axe blades, of bronze, or at least a mixture of copper and tin generally so called. The name of the weapon, according to Meyrick, was *gwaew-fon* or *wayw-fon.* It varied in length and shape, and was nailed in a slit in the shaft, which was usually of ash. ('Cost. of the Orig. Inhabitants of the British Islands,' folio, p. 8.) The spears of the Anglo-Saxons were headed with iron and occasionally barbed. Their name for this weapon was *æsc*, being that of the wood of which its shaft was made, and which, like the British, was commonly ash. In Cædmon's paraphrase of the Gospels, a soldier is called *æscberend*, " spear-bearer." *Esc-plega* is used in the fragmentary 'History of Judith,' for " the play of spears," a poetical term for a battle ; and in the poem of 'Beowulf' we meet with *eald æsc wiga*, " old spear warrior." The Normans latinized the name for the spear, which in their own language was *lance*, into *fraxineæ*, from the same circumstance. The Teutonic word *speer* was used by the early English writers of the fourteenth century :

> "Raying of speryis and helmes bokelyng,"
> (Chaucer, *The Knight's Tale*,)

and is frequently used indifferently for lance. Strictly speaking, however, the lance was the special weapon of the knight, and the spear that of the foot-soldier. In 'Sir Percival of Galles,' a romance of

the fifteenth century, mention is made of a "lyttille Scotte's spere," and of one of the characters in it we are told that

> "He wolde schote with his spere
> Beastes·anol other gere;"

which would be, of course, by casting it at them like a javelin. Subjoined are a variety of spear-heads, from the tenth to the sixteenth century.

Figs. 1 to 3, British; 4 to 8, Anglo-Saxon and Norman; 9 and 10, 15th century; 11 and 12, 16th century.

SPEAR, BOAR or *HUNTING.* No difference appears to have existed in early days between the spears used for war and those employed in hunting; but in the fifteenth and sixteenth centuries the latter were furnished with a cross bar to prevent the head entering too deeply into the animal, and the broad blade was elaborately engraved and occasionally gilt.

Anglo-Saxon. Cotton. MS. Tiberius, B v. 9th century.

MS. 14th century, Doucean Collection.

Boar Spears. 16th century. Meyrick Collection.

SPETUM. A variety of the partizan, differing from it and the ranseur only in the curving downward of the lateral blades. I have noticed under RANSEUR the singular observations of M. Demmin on the work of Pietro di Monti and the 'Catalogue of the Meyrick Collection.' Any one who will take the trouble to compare the woodcuts illustrating the three weapons above named in this work, will see at a glance that no such confusion as M. Demmin speaks of exists in Sir Samuel's description of them, and for which he declares himself indebted to the Italian contemporary author.

Spetums. Meyrick Collection.
1, *temp.* Richard III.; 2 and 3, *temp.* Henry VII.; 4, *temp.* Henry VIII.

SPLINTS. Armour composed of overlapping plates working on rivets, and thereby allowing free action to the limbs or body. They are mentioned as early as the reign of Edward III. In an inventory of arms and armour taken at Holy Island, in 1362, an entry occurs of " iiij paier of splentes ;" and in the old romance of ' Richard Cœur de Lyon,' written in the fourteenth century, we are told

"He was armed in splentes of steel :"

a description which Sir Samuel Meyrick, who quotes it (' Critical Inquiry,' vol. ii. p. 33) as remarkable, being perhaps the earliest mention of splints, appears to have overlooked the much greater importance of. "Splints," he observes, " were those overlapping pieces which defended the inner part of the arm, and were introduced in Henry VIII.'s time. Probably, however, in this case, the whole armour is described." Certainly, such is the natural inference, and therefore it would be most interesting to ascertain whether or not a suit of splints was known in the reign of Edward III. similar to those worn in the sixteenth and seventeenth centuries, examples of which were in the Meyrick Collection. Mr. Hewitt, who has also quoted the above-named romance, adds a passage from another of about the same date, ' Guy of Warwick,' which tells us the hauberk of the Giant Colbrand was formed of

"thick splints of steel,
Thick, y-joined strong and well.
 * * * *

Hosen he had also well y-wrought,
Other than splintes was it nought ;"

and from the examples he alludes to evidently considers that the armour here spoken of is of the jazerant description, or rather of what he terms "the strips and studs," of which he gives so many examples, both foreign and English. (See, for the latter, woodcut of brassarts from effigy of Schweinfurth, 1369, at p. 53 *ante*.) As this, however, is only conjectural, I limit my illustrations to the representation of armour of splints, recognized as such in the sixteenth and seventeenth centuries.

Breast and Back. 1558. Meyrick Collection.

Breast and Back. 1640. Ibid.

SPONTOON. "A weapon probably of Italian origin, much like a partizan" (Meyrick, 'Glossary to Crit. Inq.'), but distinguished from it by the absence of small curved projections at the base of the blade. Its name appears to have been derived from that of a weapon of the sword kind, mentioned in a document quoted by Meyrick, of so early a date as 1328 : "Lanceam, scutum et spatam, sive *spontonem* et cultellum," &c. The spontoon appears in the reign of Henry VIII., and was used as late as the last century by officers in the British infantry, who indicated by its motions certain com-

mands and evolutions : when pointed forward, the regiment advanced ; when pointed backward, it retreated ; and when planted, it halted. Several specimens of the reign of George II. are to be seen in the Tower armoury.

Spontoons. Tower of London.

SPORAN. The pouch worn by the Scotch Highlanders, and at present a distinguishing feature of their national costume, but its first adoption in the peculiar and ornamental form now worn is of very recent date. That of Simon Frazer, Lord Lovat, executed in 1746, is said by Mr. Logan ('History of the Gael') to have been smaller and less decorated. Some such appendage to the girdle is of very early occurrence in the costume of most nations, but the tasselled sporan is more like the pouch of a North American Indian than the European gipicierre or aulmonière of the Middle Ages, and its position in front is an additional peculiarity.

SPRIGHT. A small arrow entirely of wood, discharged from a musquet. "Sprights, a sort of short arrows (formerly used for sea-fight) without any other heads than wood sharpened, which were discharged out of musquets, and would pierce through the sides of ships where a bullet would not." (Blount, 'Glossographia,' p. 606.) Sir Richard Hawkins, in 1593, testifies to the accuracy of this startling assertion : "General Michaell Angell demanded for what purpose served the little short arrowes which we had in our shippe, and those in so great quantitie. I satisfied them that they were for our muskets. They are not as yet in use amongst the Spaniards, yet of singular effect and execution, as our enemies confessed : for the upper worke of their shippes being musket proofe, in all places they passed through both sides with facilitie and wrought extraordinary disasters." ('Voyage to the South Sea.') As "musket arrows" they are constantly mentioned in inventories and other documents of the sixteenth century, and appear to have been fired out of "gonnes" and demi-culverines. (See Hewitt, vol. iii. p. 684.)

SPUR. (*Spuran*, Ang.-Sax.) Spurs were first of the spear kind, called "pryck spur," whence the mediæval term "pricking" for spurring :—

"A gentle knight was pricking o'er the plain."
Spenser, *Faery Queen.*

These had simply a single goad, with or without a neck, the latter being the earliest form, the neck being added by the Franks and Saxons. (See Plate XVIII., fig. 1.) The rowel is first seen on the great seals of Henry III., but it did not become common before the reign of his son and successor, Edward I., and varieties of the goad spur continued in use to the middle of the fourteenth century, examples of both rowel and goad occurring on the brass of Sir Hugh Hastings, at Elsing, Norfolk, 1347. The spur of the latter half of the fourteenth century and the commencement of the succeeding one was of the rowel kind, the points varying in number from six to twelve, the shanks coming under the ankle, the neck short and inclined downwards. (See Plate XVIII., fig. 3.) In the reign of Henry V. the necks were straight and very long. (See Plate XVIII., figs. 4 and 5.) In the reign of Edward IV. the rowels had spikes between two and three inches in length, the neck curving upwards. (Plate XVIII., fig. 6.) One about this date, in the museum of C. Roach Smith, Esq., is seven inches and a half long from the heel to the tip of the rowel. The reason appears to have been the fashion of barding the horses, which rendered it difficult to touch them with a short-necked spur. The fashion changed in the time of Henry VII., and the thin spiked rowel was displaced by other forms, which will be better understood by reference to the woodcuts appended, and the accompanying plate of spurs, containing

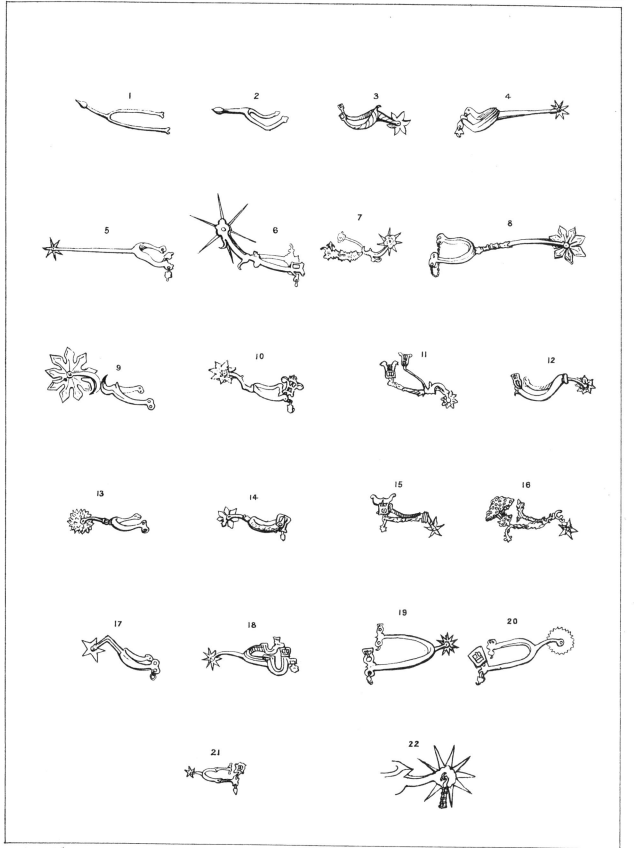

1. Frankish Spur, 10th Century.- 2. Norman spur.- 3. Temp. Henry V.- 4.5. Temp. Henry VI.- 6. Temp. Ed. IV.- 7. Temp. Richard III.- 8.9. Temp. Henry VII.- 10.11. Temp. Henry VIII. 12. Temp. Ed. VI.- 13. Temp. Elizabeth.- 14. Temp. Jas. I.- 15.16. Temp. Chas. I.- 17. Temp. Cromwell.- 18. Temp. Chas. II.- 19. A gambado spur, temp. Jas II.- 20. A gambado spur, temp William III.- 21 Temp. George I. (All from Meyrick Collection) 22. A jingling spur, temp. Elizabeth. (Londesborough Collection)

specimens to the reign of George I. The spurs of knights were gilt, those of esquires silvered. In Elizabeth's time it was the fashion to have mottoes engraved on the shanks. Mr. Fairholt engraves

Spur, *temp.* Edward IV. Museum of Mr. C. R. Smith.

Spur, *temp.* Elizabeth.

one of that period, having upon it the motto, "A true knight am I; anger me and try." Another fancy was to increase the natural clank of the spur by attaching metal ornaments, called "gingles."

> "I had spurs of my own before, but they were not *ginglers*."
> > Ben Jonson, *Every Man in his Humour.*

(See Plate XVIII., fig. 22, from Lord Londesborough's Collection.)

Ripon, in Yorkshire, was celebrated for its manufacture of spurs in the seventeenth century :

> "Why, there's an angel, if my spurs
> Be not right Rippon."
> > Ben Jonson, *Staple of News*, act i. sc. 2.

> "Whip me with wire, headed with rowels of
> Sharp Rippon spurs."
> > Davenant, *The Wits*, 1666.

STAMEL, STAMMELL. "A kind of fine worsted." (Halliwell, *in voce.*)

> "Some stamel weaver, or some butcher's son,
> That scrubbed slate with a sleeveless gown."
> > *The Return from Parnassus*, 1606, p. 248.

"Shee makes request for a gowne of the newe fashion stuffe for a petticote of the finest stammell, or for a hat of the newest fashion." ('The Arraignment of lewd, idle, forward, and unconstant Women,' 1628.)

> "But long they had not danced till this young maid,
> In a fresh stammell petticote array'd,
> With velure sleeves and bodies tied with points."
> > *Times Curtaine drawne*, 1621.

Stamel appears to have been generally dyed red :

> "And in a chamber close beside
> Two hundred maidens did abide
> In petticoats of stammel red."
> > *History of John of Whitcomb.*

"A red stamell petticoat and a broad straw hat" are said to be the dress of a country haymaker in Delany's 'Pleasant History of Thomas of Reading.'

Mr. Payne Collier, in his reprint of 'Friar Bacon and Friar Bungay,' written in 1594, says in a note to the following passage,—

> "The bonny damsel filled us drink,
> That seemed so stately in her stammel red,"—

"Stammel is sometimes used for a red colour, and sometimes for a species of cloth; in this instance it meant the latter, as the colour of the stammel is noted by the adjective." Certainly in this instance, as in those above quoted; but where is an instance of stammel being used to signify any colour?

Save that being generally red, a "stammel petticoat" or "stammel breeches" ('Little French Lawyer') sufficiently indicates the colour of the stuff, if no other is mentioned. The countryman in the comedy of 'The Triumphant Widow,' 1677, promises his sweetheart "a brave stamell petticoat, guarded with black velvet." Here, no doubt, is meant a red petticoat with black borders, so constantly met with in paintings of that date; but the word is not used for red in the sense Mr. Collier suggests, nor can I find any mention of it that supports his opinion. Mr. Fairholt conjectures that stamel may be a corruption of

STAMIN, "a worsted cloth of a coarse kind, manufactured in Norfolk in the sixteenth century," and I am strongly inclined to agree with him, though Mr. Strutt has apparently not suspected it. At least he does not allude to such a circumstance in his notice of the latter stuff, which he briefly describes as cloth "mentioned in the twenty-fifth year of the reign of Henry VIII., made at several places in Norfolk, especially Norwich, Yarmouth, and Lynn." ('Dress and Habits,' vol. ii. part v.)

Beside *Stamel* and *Stamin,* another name occurs in much earlier documents, which appears to indicate a similar, if not an identical manufacture. Strutt includes, amongst the materials for clothing known in the thirteenth century, a stuff called

STANIUM or *STAMFORTIS,* "for *stamen forte*" (such are his words), and adds,—"which, I presume, was a strong sort of cloth, and of a superior quality, we find ranked with the brunetta and the camelot ('Bruneta etiam, vel nigra vel etiam *stanio forte* vel cameletto'—Stat. Raymundi, an. 1233). A tunic of this stuff was estimated at fifteen shillings ('Pro tunicâ de *Stamforti* xv. solidi'—Comput. apud D. Brussel, tom. ii. p. 156). It was occasionally red and green, but those colours were forbidden to the clergy." ('Dress and Habits,' part iv., chap. I.)

It is at least probable that the cloths manufactured in Norfolk in the sixteenth century were of the same description as the *Stanium* of the thirteenth, or received their names from it in consequence of some resemblance either in texture or colour.

STAR. The star as a decoration is comparatively of modern date. The star of the Order of the Garter is, I believe, the most ancient, and dates back only to the time of Charles I., who caused

Star of the Garter. Star of the Thistle.

the badge of the order to be surrounded by rays. The star of the Order of St. Andrew, or the Thistle, appears in the reign of Queen Anne, and that of the Bath owes its origin to George I.

An Order of the Star is said to have been founded by John II., king of France, in 1351 ; but I have met with no reliable representation of its insignia. The stars of other orders of knighthood will be noticed in the GENERAL HISTORY.

STARTUP. A high shoe, or half boot, worn in the sixteenth century by country folks, sometimes called "*bagging shoes.*" "A country shoe, a startop, a high shooe." ('Junius Nomenclator,' *in voce* PERO.) "The soccus of the ancients is also rendered in the old dictionaries 'a kind of bagging shoe, or manner of startups, that men and women did use in times past ; a socke.'" (Fairholt, 'Cost. in England.') Thynne, in his 'Debate between Pride and Lowliness,' describes those worn by a countryman most minutely :—

Star of the Order of the Bath.

> "A payre of startups had he on his feete,
> That laced were up to the small of the legge ;
> Homelie they were, and easier than meete,
> And in their soles full many a wooden pegge."

The words "easier than meete" explain the epithet of "bagging" applied to the shoes, and the express statement that they were laced "up to the small of the legge" leaves no doubt as to their height, and reminds us of those of Chaucer's Carpenter's Wife, which were "laced high up on her leggs ;" but Tarleton, the celebrated droll, whom I have spoken of under SLOP, and who, in his assumption of the character of a countryman,

> "in pleasaunt wise
> The counterfet expreste
> Of clowne with cote of russet hew,
> And startups with the reste,"

is depicted in the Harleian MS. 3385, whence the above lines, in shoes which have no appearance of being laced, and the tops of which are hidden by loose trowsers reaching to the ankles, so that we cannot ascertain how high they ascended the leg. We are thus deprived of a contemporary illustration.

Cotgrave explains *guestres* (whence our *gaiters*) as "startups, high shoes, or gamasches for country folks." The runners (*currors*) or foot-messengers of the heralds were in the fifteenth century "called 'Knights Caligates of Arms,' because they wear startups to the middle leg." (Gerrard Leigh's 'Accedens of Armory,' 1652, translated from the Latin of Upton, 'De Studio Militari.')

STAYS. The injurious practice of tight lacing, "a custom fertile in disease and death," appears to have been introduced by the Normans as early as the twelfth century (see page 463) ; and the romances of the Middle Ages teem with allusions to, and laudations of, the wasp-like waists of the dames and demoiselles of the period.

> "Their kirtles were of Inde sendell,
> Y-laced, small, jolyf, and well."
> *Lay of Syr Launfal, circa* 1300.

The French version is still stronger : "Laciée moult estreitement,"—very tightly laced. The Lady Triamore, in the same romance, is described as

> "clad in purple pall,
> With gentyll body and middle small."

Chaucer, describing the Carpenter's Wife, says her body was "gentyll and small as a weasel;" and the depraved taste extended to Scotland. Dunbar, in 'The Thistle and the Rose,' describing some beautiful women, observes—

> "Their middles were as small as wands."

And to make their middles as small as possible has been ever since an unfortunate mania with the generality of the fair sex, to the detriment of their health and the distortion of their forms. In the fifteenth century we first hear of "a pair of bodies;" but it is not till the sixteenth that we meet with "the whalebone prison," as it was happily designated by John Bulwer at a subsequent period.

Stephen Gosson, in his 'Pleasant Quippes,' which I have frequently referred to, thus attacks the bodice of the time of Elizabeth:

> "Those privie coats by art made strong,
> With bones, with paste, and such like ware,
> Whereby their backs and sides grow long;
> And now they harnest gallants are.
> Were they for use against the foe,
> Our dames for Amazons might go;
> But seeing they do only stay
> The course that Nature doth intend,
> And mothers often by them slay
> Their daughters young and work their end,
> What else are they but armour stout,
> Wherein like gyants Jove they flout?"

Bulwer, whom I have mentioned above, says: "Another foolish affectation there is in young virgins, though grown big enough to be wiser; but they are led blindfold by a custom to a fashion

Stays or Bodices, *temp.* 1700.

pernicious beyond imagination, who, thinking a slender waist a great beauty, strive all they possibly can by straight lacing themselves to attain unto a wand-like smallness of waist, never thinking them-

selves fine enough till they can span the waist. By which deadly artifice, while they ignorantly affect an angust or narrow breast, and to that end by strong compulsion shut up their waists in a whalebone prison, they open a door to consumptions." ('Artificial Changeling,' printed 1653.)

Malcolm, writing on the fashions of the first half of the eighteenth century, says : "The ladies' boddice or stays were sometimes made of silk, with black straps to fasten with buckles, set with stones or false jewels," and records the loss of some "cherry-coloured stays trimmed with blue and silver," with other articles advertised in 'The Post Boy,' Nov. 15, 1709. ('Manners and Customs,' vol. v.) "I pair of black stays" is entered in the 'Account of my Cousin Archer's cloths,' dated Nov. 21, 1707. A writer in 'The Weekly Register,' June 10, 1731, says, "The stay is a part of modern dress that I have an invincible aversion to, as giving a stiffness to the whole frame, which is void of all grace and an enemy to beauty ; but as I would not offend the ladies by absolutely condemning what they are so fond of, I will recall my censure and only observe, that even this female armour is changing mode continually, and favours or distresses the enemy according to the humour of the wearer."

The stays that retained their original character of "a *pair* of boddies," are seen in an old print, undated, but clearly about the year 1700, which represents the front and back view of a young woman, whose stays are composed of two pieces laced together before and behind ; and "a pair of stays" they continued to be called, notwithstanding their subsequent incorporation. The monstrous "whalebone prisons" of the time of George II., are delineated in several of Hogarth's most instructive engravings.

STEINKERK. See CRAVAT.

STIRRUP-HOSE. See STOCKING.

STOCK. In its present sense a stiff neckcloth buckled at the back of the neck, the successor of the cravat. Formerly, it signified a sword of some description, from the Ital. *stocco.* In Nash's 'Return from Parnassus,' it is spoken of incidentally, and Nash is himself described in it as "a fellow that carried the deadly stock in his pen ;" and, thirdly, it was used for the stockings.

STOCK-BUCKLE. The buckle which fastened the stock or cravat behind, of plain gold, silver, or steel, and sometimes of diamonds or other precious stones.

> "The stock, with buckle made of plate,
> Has put the cravat out of date."
> Whyte's *Poems,* 1742.

STOCKINGS. Tooke derives this word from the Anglo-Saxon *prican,* "to stick," and says, "It is corruptly written for *stocken, i.e. stock* with the addition of the participial termination *en,* because it was stuck or made with sticking-pins, now called knitting-needles ;" but does he find any coverings

Anglo-Saxon.

Anglo-Norman.

for the legs called *stockings* in Anglo-Saxon? That they possessed such articles of clothing is abundantly testified (see woodcut above); but the name for them was *hose* (see HOSE, p. 302). The Normans termed them *chausses*, as we have also stated under that heading at page 95. But they very early used the Saxon name for the long hose with feet to them that they wore for five or six centuries. Men of both nations are represented as wearing short stockings and socks in addition to the long hose, sometimes with and sometimes without shoes. In the latter case, I presume, they were of leather,—the *skin-hose* of the Anglo-Saxons. With respect to the ladies, we find that as early as the time of Chaucer they had adopted the Saxon term *hose*, as well as the men. Of the Wife of Bath, he tells us—

> " Hire hosen weren of fine skarlet redde,
> Ful straite y-teyed."

From Royal MS. 2 B vii.

We have indubitable proof of the form afforded us by an illumination in a MS. of the fourteenth century (Royal, 2 B vii.), in which a lady of the time of Edward II. is represented in the act of putting them on. That they were of cloth in the thirteenth century we gather from an order of Henry III. for three pair for his sister Isabella, which were to be embroidered with gold. The hose of the humbler classes was made of blanket:

> " She hobbles as she goes
> With her blanket hose."—Skelton.

It is not till the sixteenth century that the familiar name of *stocking* presents itself to us, and then it occurs as the term used for " stocking of hose;" that is, adding continuations to the trunk hose or breeches of that period, which said continuations received the name of the " nether-stocks," the breeches in turn being distinguished by that of " upper stocks."

In an inventory taken in the eighth year of Henry VIII., are entries of " a yarde and a quarter grene velvete for stockes to a payr of hose for the kyng's grace," and of the same quantity of " purpul saten to cover the stocks of a payr of hose of purpul cloth of gold tissewe for the kynge."

" It is generally understood," observes Mr. Strutt, " that stockings of silk were an article of dress unknown in this country before the middle of the sixteenth century; and a pair of long Spanish silk hose at that period was considered as a donation worthy of the acceptance of a monarch, and accordingly was presented to King Edward VI. by Sir Thomas Gresham. This record, though it be indisputable in itself, does not by any means prove that silk stockings were not used in England prior to the reign of that prince; notwithstanding it seems to have been considered in that light by Howe, the continuator of Stow's ' Chronicle,' who at the same time assures us that Henry VIII. never wore any hose, but such as were made of cloth." I have remarked in my edition of Strutt, " that there is probably a confusion here of the ancient hose with the modern stocking" (' Dress and Habits,' vol. ii. p. 149, edit. 1842). The quotations he adduces in proof of his opinion are by no means convincing. " One pair of short hose of black silk and gold woven together," having been found amongst other articles appropriated to women, may possibly have belonged, as he suggests, to one of Henry's queens; but " one pair of hose of purple silk and Venice gold, woven like unto a caul and lined with blue silver sarsenet, edged with a passemain of purple silk and gold wrought at Milan," was clearly a pair of " upper stocks;" and in any case the material, consisting of silk and gold mixed, would indicate a fabric that could not fairly be called silk, such as the Spanish stockings were made of, and which thenceforth became familiarized to us in England. " Six pair of black silk hose knit," is an entry more favourable to Mr. Strutt's conclusions. " ' In the third year of the reign of Elizabeth ' (we are told by the same chronicler) ' Mistress Montague, the Queen's silk woman, presented to her Majesty a pair of black silk knit stockings, which pleased her so well that she would never wear any cloth hose

afterwards.' These stockings were made in England; and for that reason, as well as for the delicacy of the article itself, the Queen was desirous of encouraging this new species of manufacture by her own example." (Strutt, 'Dress and Habits,' *ut supra.*) The "black silk hose knit," previously mentioned, were no doubt of foreign manufacture; and if "nether stocks" or stockings, we must read "unmade" in lieu of "unknown" in England, which might probably be the author's meaning.

"In 1564 William Rider, then apprentice to Thomas Burdett, at the Bridge foot opposite to the church of St. Magnus, seeing a pair of knit worsted stockings at an Italian merchant's brought from Mantua, borrowed them, and, having made a pair like unto them, presented the same to the Earl of Pembroke, which was the first pair of worsted stockings known to be knit in this country." (Howe *ut supra.*) Nineteen years afterwards stockings of silk, worsted, and other materials, were common in England. Stubbs, the first edition of whose 'Anatomie of Abuses' was published in 1583, says, "Then have they nether stocks or stockings, not of cloth though never so fine, for that is thought too bare, but of Jarnsey, worsted, cruel, silk, thread, and such like, or else at least of the finest yarn that can be got, and so curiously knit with open seams down the leg, with quirkes and clocks about the ankles, and sometimes haply interlaced with gold or silver threads, as is wonderful to behold; and to such impudent insolency and shameful outrage it is now grown that every one almost, though otherwise very poor, having scarcely forty shillings of wages by the year, will not stick to have two or three pair of these silk nether-stocks, or else of the finest yarn that can be got, though the price of them be a royal, or twenty shil-

Stockings, *temp.* Elizabeth. From Queen Elizabeth's procession.

lings, or more, as commonly it is; for how can they be less, whenas the very knitting of them is worth a noble or a royal, and some much more? The time hath been when one might have clothed all his body well from top to toe for less than a pair of these nether-socks will cost." Of the women he says, in similar words, "Their stockings in like manner are either of silk, Jarnsey, worsted, cruel, or at least of fine yarn thread or cloth as is possible to be had; yea, they are not ashamed to wear hose of all kinds of changeable colours, as green, red, white, russet, tawny, and else what not. These thin delicate hosen must be cunningly knit and curiously indented in every point with quirks, clocks, open seams, and everything else accordingly."

At the close of the sixteenth century, William Lee, Master of Arts and Fellow of St. John's, Cambridge, invented a stocking frame. Tradition attributes this invention to a pique he had taken against a woman with whom he was in love, but who did not return his passion. She got her livelihood by knitting stockings, and, with the base view of depreciating the poor girl's employment, he is said to have constructed this frame, at which he first worked himself and then taught his brother and some other relations. The stocking knitters becoming generally alarmed used every means in their power to bring his invention into disrepute, and apparently succeeded, for he left England and settled at Rouen in Normandy, where he was at first much patronised; but the murder of Henri Quatre and the subsequent troubles brought him to ruin, and he died at Paris of a broken heart, an end well deserved for the cruel and mean revenge he had taken on a woman he professed to love. (Stow, *sub an.* 1599.) In 1611 we read, "Good parts without the habiliments of gallantry are no more set by in these days than a good leg in a woollen stocking." (Robert Taylor, 'The Hog hath lost his Pearl.')

In 1658 the fashion of wearing large stirrup-hose or stockings two yards wide at the top, with points through several eyelet-holes by which they were made fast to the petticoat breeches, was brought to Chester from France by one William Ravenscraft. (Randle Holme.) Long and short

kersey stockings are reckoned amongst the exports in the Book of Rates, 12th Charles II., and in it there are entries of stockings of leather, of silk, of woollen and of worsted for men and children ; Irish stockings and the lower end of stockings, which, Mr. Strutt observes, are probably what are now called socks ; and, amongst the imports, hose of *crewel*, called Mantua hose, and stockings of *wadmol.* In the reign of William III. gentlemen wore their stockings pulled over the knee and half-way up the thigh, a fashion continued in the reigns of Anne and George I. Blue and scarlet silk stockings with gold or silver clocks were very fashionable in the reign of George II.

STOLE. An embroidered band or scarf, forming a portion of the ecclesiastical vestments of a priest, and also of the coronation robes of a sovereign prince.

> " Forth cometh the Priest with stole about his neck."
> Chaucer, *Canterbury Tales.*

The ends of the stole are visible beneath the dalmatic in nearly all representations of clerical personages. (See pp. 93 and 94 *ante.*)

The stole has also been long employed in the investiture of kings. Walsingham, in his account of the coronation of Richard II., mentions that the king was invested first with the tunic of St. Edward and then with the dalmatic, " projecta circa collum ejus *stolâ.*" Henry IV. is described as having been arrayed at the time of his coronation as a bishop that should sing mass, with a dalmatic like a tunic and a stole about his neck. (MS. W. Y., College of Arms.) The investing with a white stole, " in modum crucis in pectore," is particularly mentioned in several foreign ceremonials. Goldastus in the ' Constitutiones Imperiales,' speaking of Maximilian, king of the Romans, says, " induebatur cum sandalis et stola alba in modum crucis in pectore."

Royal personage, *temp.* Edward I. From a MS. formerly in the library of H.R.H. the Duke of Sussex.

On opening the tomb of Edward I. in Westminster Abbey, A.D. 1774, his corpse was discovered arrayed in a dalmatic or tunic of red silk damask and a mantle of crimson satin, fastened on the shoulder with a gilt buckle or clasp decorated with imitative gems and pearls. The sceptre was in his hand, and a stole was *crossed over his breast,* of rich white tissue studded with gilt quatrefoils in filigree work, and embroidered with pearls in the shape of what are called " true lovers' knots." In a fine MS. of that period, formerly in the library of H.R.H. the late Duke of Sussex, several figures in regal costume have a stole crossed on their breasts, splendidly embroidered. (See engraving of one annexed.)

The regal stole, from some inexplicable circumstance, obtained, as early as the reign of Henry VII., the name of *armil*, whereby

Stole of Thomas à Becket.

it has been subsequently confounded with the bracelets (*armillas*) which form a portion of the regal ornaments.

In the ' Little Devyse of the Coronation of Henrie VII.,' we read as follows : ' And it is, to wit, that armyll is made in manner of a stole, woven with golde, and set with stones, to be put by the cardinal about the king's neck, and comyng from bothe shulders to his bothe elbowes, where thei shall be fastened by the Abbot of Westminster with lace of silke to every side the elbowe, in two places, that is to say, above the elbowes and beneth."

Mr. Taylor, in his 'Glory of Regality,' has ventilated the subject as far as possible, and pointed out that the form of delivery in the ceremonial, which is now "Receive this armil," is in the 'Liber Regalis' (*temp.* Richard II.), and in other ancient authorities, expressed in the plural number, "Accipe *armillas*," and that by *armil* cannot be meant the "*curtal weed*" armilausa mentioned by Camden as a sort of cloak worn in 1372, as that was not "made after the manner of a stole," the form of which well-known ecclesiastical vestment has never undergone any alteration. An engraving of "the armilla," as it is called, but more correctly the stole, has been given at page 421, from the print in Sandford's 'Coronation of James II.' In the preceding page is given an engraving of the stole of Thomas à Becket, preserved, with other of his vestments, in the Cathedral of Sens.

The long tunic worn by women in the old Roman days was called *stola*. The transference of the name to so dissimilar an article of costume is a useful caution against hasty conclusions from merely verbal evidence. (See GENERAL HISTORY.)

STOMACHER. The stomacher is first mentioned towards the end of the fifteenth century, at which time it was worn by both sexes.

In the 'Boke of Curtasye,' a MS. of that date, the chamberlain is commanded to provide, against his master's uprising, "a clene sherte and breche, a pettycotte, a doublette, a long cotte, a stomacher, hys socks and hys schone;" and in the 'Boke of Karvyng,' another MS. of the same period, a like personage is told: "Warme your soverayne his pettycotte, his doublett, and his stomacher," &c.

Mr. Strutt says that it was the same article as the placard, by which name it was generally called when it belonged to the men; but the above quotations do not support that opinion as far as the latter part of it is concerned. The placard was, however, a stomacher of some kind, though, as I have observed in my notice of it (page 401), its shape in civil costume is, from its position, not ascertainable. The stomacher I take to have been a distinct article of apparel, however similar its purpose, as it is named in company with the placard in inventories of that period. Half a yard of stuff was the allowance for a stomacher for the Queen and other ladies of the household. (MS. Harleian, 2284.) There was one in the wardrobe at Westminster, of purple gold raised with silver tissue and damask wire, and another of crimson satin, embroidered all over with flat gold damask pirles, and lined with sarcenet. (MS. Harleian, 1419.) In the same inventory is an entry of "six double stomachers," probably meaning lined. In the fifteenth century the doublet and the bodice were laced over the stomacher; but after it was discarded by the male sex, and had become the sole property of the ladies, it assumed a more prominent position, and by persons of rank and wealth was richly ornamented and covered with jewels. In a poem printed in 1755, entitled 'Advice to a Painter,' the lover describes the dress in which he would have the "charmer of his heart" portrayed; and, amongst other instructions, says —

> "Let her breast look rich and bold
> In a stomacher of gold.
> Let it keep her bosom warm,
> Amply stretch'd from arm to arm,
> Whimsically travell'd o'er,
> Here a knot and there a flow'r."
>
> *London Magazine* for July 1753.

And in another, entitled 'A-la-mode,' a lady is told—

> "Let your stomacher reach from shoulder to shoulder,
> And your breast will appear much fairer and bolder."
>
> *Universal Magazine* for 1754.

STONE BOW. A small crossbow for propelling pebbles, used by boys to kill birds with. In the Scottish version of the 'Romance of Alexander,' a child is described

> "With a stone bow in hand all bent,
> Wherewith he birds and magpies slew."

SUBTALARES, SOTULARES. A kind of shoe or ankle-boot, from "*Sub-talaris*, quia sub-talo est," *i.e.*, beneath the ankle, or from "*subtel*, pro *subtal*, carnem pedes," the hollow of the foot. (*Vide* Ducange *in voce*.) It would be hazardous to speak authoritatively respecting the form of these articles, after studying carefully the host of quotations collected by Ducange and the definitions of the various glossarists. From some it would seem that there was a loose or easy slipper so called, from others a warm shoe for winter wear, "setting close about the ankles," to use the description of Strutt. The word occurs in a document of the time of King John : "Unum par sotularium fretas de orfrasio." (De Jocal. recipiendis, Pat. Roll 9, John, A.D. 1108.) Their being embroidered with gold indicates no special purpose for which they were used, and there is nothing in the entry to enlighten us as to their shape. I have therefore not included them amongst boots, shoes, or buskins. In the 'Forma Coronationis,' ascribed to the time of Richard II., it is directed, " Princeps coronandus tantummodo caligis *sine sotularibus* calcietur," which Mr. Taylor explains as without "soles or sandals ;" and Richard II. is described as proceeding to his coronation "caligis tantummodo calciatus," in conformity with the rule, which appears to have been observed as late as the reign of Richard III., who, with his Queen Anne, according to Grafton, " came down out of the White Hall into the Great Hall at Westminster, and went directly to the Kinges Benche, and from thence the King and Queene, goyng upon raye cloth barefooted (*i. e.*, without soles or sandals), went unto St. Edward's shrine." ('Glory of Regality,' p. 271.)

SUDARIUM. See ORARIUM.

SULTANE. A gown trimmed with buttons and loops. ('Mundus Muliebris,' 1690.)

SUPERTOTUS. Literally, *surtout*, or *over-all.* A cloak or mantle, with sleeves and hood, covering the whole person, and worn by travellers or others in cold or bad weather. Mr. Strutt

Saxon woman in Supertotus. Cotton. MS. Claudius, B iv.　　　Figure of man in Supertotus. From Sloane MS. 2435, 15th century.

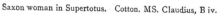

considers it identical with the balandrana, an opinion in which he is borne out by the statutes of the order of St. Benedict, 1226. (See BALANDRANA.) I cannot accept, however, the figure he points

out in his 72nd Plate as an example of it. He should rather, I think, have indicated one on his 69th Plate, from a MS. of the fifteenth century in the Sloanian Collect. Brit. Mus. No. 2435, containing rules for the preservation of health, in French, and representing Winter. (See woodcut in preceding page.)

SUPERTUNIC. As its name imports, a garment worn over the tunic; not necessarily a tunic itself, but generally so. Mr. Fairholt says, "an upper tunic *or gown*," and the latter being worn over a tunic might, as I have intimated, be termed a supertunic; but I do not conceive it was ever so called, and I have scrupulously endeavoured throughout this work to avoid the confusion which must occur from applying, without the most positive authority, the name identified with one article of apparel to another. While, therefore, I agree with Mr. Strutt that the supertotus and the balandrana were one and the same garment, I hesitate to adopt his opinion that the supertunic was identical with the surcoat, although I admit that "both these names are evidently applicable" to either.

Women in Supertunics. 14th century.

The distinction I draw is this: the supertunic was a loose dress worn by the Saxons and Normans of both sexes over another *tunic*. It had sometimes long and ample sleeves: "Magnum super-tunicale rotundum cum magnis et latis manicis" (Robertus de Sorbonâ, 'in Sermonibus de Conscientiâ'); and the same author describes another without sleeves, "sine manicis," those of the under-tunic passing through the arm-holes of the upper. The surcoat (*surcote*) is the Norman name for a similar garment worn by women over the *cote*, a close-fitting dress which superseded the tunic in the thirteenth century, and by men over the hauberk or *cotte de maille* at the same period. That the "new" garment, as Mr. Strutt himself calls the surcoat, continued for some time to be spoken of by the Latin writers of that day by the name of the old one, there can be little doubt, though "super-vestimentum" is also employed by them more correctly to designate the surcoat, and in the fourteenth century *surcotium*. (See SURCOAT.)

SUPPORTASSE. A frame of wire made to support the great ruff worn in the reign of Elizabeth. (See woodcut, fortunately copied by Mr. Fairholt from a Dutch engraving of that date—a most valuable illustration, as it may possibly be unique—under RUFF, p. 434.)

SURCOAT. (*Surcote,* French ; *surcotium,* Inf. Lat.) A garment worn by both sexes in the thirteenth and fourteenth centuries, and by the men in military as well as civil attire. It resembled in many respects the supertunic, and has been considered by some writers as identical with it (see SUPERTUNIC). It might with equal propriety be called a bliaus (see BLIAUS), which was a very similar vestment. I have endeavoured, however, to show that it had a distinctive character, in my notice of supertunic, and have little more to say on that point. Exterior garments, with or without sleeves, are seen in great variety in the fourteenth, and a very peculiar one—for which no special name can be found, but which M. Viollet-le-Duc has elected to designate a supertunic—makes its appearance in the reign of Edward III., and continues in fashion amongst noble ladies to the middle at least of the fifteenth century. In my 'History of British Costume,' I distinguished that remarkable habit by the name of the sideless garment, the arm-holes being made so wide that the body of the dress is reduced to a few inches in breadth both in front and at the back, and so deep that they show the girdle which encircles the *cote* or kirtle below the hips. If this be not a surcoat, I am unable to find any appellation which specially appertains to it. (See woodcuts subjoined.)·

The borders of the dress in the reigns of Richard II. and Henry IV. were trimmed with the richest furs, and the front of the body faced with them, a row of jewels or gold buttons descending

Ladies in Surcoats. 14th century.

from the neck to below the waist ; and the effect produced by this arrangement gives the dress, in many examples, the appearance of a jacket. In some instances the skirts of the exterior garment are so long that they have to be gathered up and carried over the arm ; in others they barely cover the feet, and have an opening up the side, bordered with ermine or other fur.

The surcoats worn by the nobles and knights in the fourteenth and fifteenth centuries, in civil attire, are of infinite variety : some long, some short ; some with sleeves, some without ; many that render it a task of no inconsiderable difficulty to classify, as they might easily be confounded with the gown, the bliaus, the heuke, the tabard, the coat-hardy, and other exterior garments which have their special distinctions and appellations. The military surcoat is clear of all such confusion. It appears first in the twelfth century, descending in folds to the knee, or a little below it. It is without sleeves, and is open in front to the girdlestead.

King John is the first English sovereign represented wearing a surcoat over his hauberk (see woodcut from his great seal). It was usually made of silk of one uniform colour, occasionally richly embroidered, and sometimes altogether of cloth of gold or silver. It has been conjectured that

the custom originated with the Crusaders, for the purpose of distinguishing the many different leaders serving under the Cross, as well as of veiling the iron armour, so apt to heat excessively when exposed to the rays of a Syrian sun. The date of its first appearance in Europe, and the circumstance of the knights of St. John and of the Temple being so attired in their sepulchral effigies, are certainly facts in favour of the supposition.

The surcoat is said by a contemporary authority to have been worn to defend the armour from the wet:

> " Gay gownes of grene
> To hould thayre armur clene,
> And were hitte fro the wete."
> *The Avowynge of King Arthur.*

Great Seal of King John.

But there is nothing in this assertion which renders the former proposition inadmissible. On the contrary, it adds to the probability, by proving that one purpose of the surcoat *was* to protect the armour from the weather. Rain would injure it in this climate. Heat and sand render such a veil equally necessary on the

Effigies in the Temple Church, London, illustrating the various forms of the Military Surcoat in the 12th and 13th centuries.

plains of Syria. It might as well be contended that a cloak or overcoat could not be worn in these days to keep out the cold because it was proof against a shower.

Are we to consider that *all* surcoats were green, on the faith of this single authority ? At the date of its composition heraldic decoration had contributed to give distinction as well as splendour to the knightly surcoat, the length of which greatly varied during the thirteenth century, and sleeves were added to it in the reign of Edward I. (See, under ARMOUR, effigy of Brian FitzAlan of Bedale, p. 16.) The use of armorial bearings is exemplified by the fate of the Earl of Gloucester at the battle of Bannockburn, who would not have been killed had he not neglected to put on his "toga propria armatura," by which he would have been recognized ; and the danger of the extreme length of the surcoat, by the death of Lord Chandos in Spain (43rd Edward III.), who slipped while pursuing his enemy. Having on a long surcoat, his legs became entangled in it, and he fell and received a mortal wound as he endeavoured to rise again.

The inconvenience, setting aside the peril, of long surcoats must have been previously experienced by knights fighting on foot, and probably led to the curtailment of them in front in more than one fashion, and subsequently to the introduction of the jupon ; immediately preceding which it lost its fulness, and was cut up the sides, the edges of which were laced together. (See woodcut annexed, from effigy of Sir John de Lyons, in Warkworth Church, co. Northampton, *circa* 1346.)

Sir John D'Aubernoun, Stoke Dabernon Church, Surrey.

Sir John de Lyons, Warkworth Church, 1346.

The surcoat ceases to be worn as a military garment with the reign of Edward III., one of the latest instances being that which associates it with that of the death of Lord Chandos in 1373.

SURPLICE, SURPLOIS. A white linen vestment still worn by officiating Protestant clergymen and choristers, as well as in the Church of Rome, wherein it was appropriated to regular canons in the thirteenth century, who wore it over the rochet, its form at that period being that of a shirt with large sleeves. Durandus, 'Rationale Divin. Offic.,' liber iii., derives the name from the Latin *superpellicium*, which he says was given to it because originally it was worn over tunics made of the skins of beasts; that its whiteness signified purity, chastity, and innocence, and therefore it

was frequently put on before all the other sacred vestments, such as the chasuble and the cope, or the aumuse (how it could be put on *after* the first, or even the second, I do not comprehend) ; that its amplitude typified charity, and therefore it covered the profane and ordinary garments, such as the cassock, the tunic, or the coat ; and lastly, that as it was made in the form of a cross, it represented the Passion of our Lord, which any cassock, tunic, or coat, having straight sleeves, would, I submit, equally do. Such was the rage for symbolism in the Middle Ages.

The Rev. Herbert Haines more simply describes it as "an enlargement of the albe, without apparels or girdle. It had very deep sleeves, was frequently *plaited*" (which suggests to me a more natural derivation of the name), "and was not open in front as in modern times. In brasses it generally reaches to the ankles, but in early examples covers the feet. The name surplice, derived from its being placed over the *pelliceum*, or fur tunic, worn chiefly in the Northern countries" (the French sur*plis* does not appear to have awakened his attention), "is first met with in England in the eleventh century ; but a similar white vestment was worn by all orders of ecclesiastics, under different names, at all times." ('Manual of Monumental Brasses,' part i. p. lxxv.)

Chaucer's Clerk (Clericus) wore over his sky-blue kirtle

> "a gay surplice,
> As white as is the blossom in the ryse."
> *The Miller's Tale.*

Rowley, in his comedy 'A Match at Midnight,' 1633, makes one of his characters observe to another, "It has turned his stomach for all the world like a Puritan's at the sight of a surplice ;" and Bishop Corbet, in his song 'The Distracted Puritan,' makes his hero exclaim—

> "Boldly I preach ; hate a cross, hate a surplice,
> Mitres, copes, and rochets."
> Percy, *Reliques.*

And a page might be filled with quotations showing the strong aversion of the Nonconformists to this article of clerical costume.

It is unnecessary to engrave an example of so familiar an object.

SWORD. (*Schwerde*, Germ.) This well-known weapon, having been from the earliest historical times manufactured and wielded in all nations of whom any records have been handed down to us, requires more pictorial than verbal illustration. The swords of the Belgic Britons were of bronze and leaf-shaped, like those which are found in so many parts of Europe, Asia, and Africa. For their introduction into these islands all testimony concurs in pointing to the Phœnicians. Specimens are to be found in most collections of note, private or public. The British Museum, the Tower of London, and the Royal Irish Academy, Dublin, may specially be

Ancient British Sword of bronze.

mentioned. The hilts of these swords were usually of horn, which gave rise to the proverb : "A gavas y carn gavas y llavyn"—"He who has the horn has the blade." (Meyrick.)

The Saxon swords were of two sorts, each of iron, and about three feet in length : the first straight, double-edged, and very sharp, without any crosspiece or other kind of guard ; the second with a crosspiece, and sometimes a foliated pommel. The hilts of these swords appear to have been generally of wood cased with bone, horn, or leather, and, in some instances, of the precious metals. In the 'Poetical Edda,' Gunnar, a German Regulus, boasts that he has "filled seven chests with swords ; each of them has a hilt of gold." The hilt of the sword of Charlemagne is said by Eginhart to have been of gold, and the warriors who manned the galley given by Godwin to Hardiknute bore swords with

Anglo-Saxon Swords.

hilts of the same costly material. "A silver-hilted sword which Woolfricke made" is mentioned in the will of Prince Athelstan, dated 1015, and pages might be filled with quotations from German, Frankish, Norwegian, Saxon, and Danish writers to the same effect.

The swords of the Normans differed in no important respect from those of their *consanguinei.* Many original specimens are in existence, and the seals of our early Norman kings and their great nobles afford us ample information as to the shape of their hilts, which are furnished with a cross-piece, either straight or curving towards the blade (see QUILLON), the pommels being round, lozenge-shaped, square, or foliated. The sepulchral effigies of the twelfth and the three succeeding centuries afford us abundant examples of the swords of those periods. The subjoined engravings are from original specimens, formerly in the Meyrick Collection.

1 2 3 4 5 6

1. *Temp.* Henry VI.
4. Engraved by Albert Dürer, 1495.
2. *Temp.* Edward IV.
5. *Temp.* Henry VIII.
3. Commencement of reign of Henry VII.
6. Sabre of Venetian Estradiot. 16th century.

The blades of the swords of the latter half of the fifteenth century tapered to a very fine point, and had a ridge down the centre. In the reign of Henry VII. the upper portion of the blade was frequently engraved and gilt.

The sixteenth century introduced to us the rapier and the sabre. Both weapons were known in Europe in 1570. The former has been noticed under its special heading at p. 414. The latter, a cut-and-thrust sword, was of Eastern origin, and appears to have travelled through Greece and Venice into France and Germany. (See fig. 6, above.)

For further information I must refer the reader to the accompanying plate, as well as to the

1. Temp. Henry VI.- 2 Temp. Edward IV.- 3 & 4. Temp. Henry VII.- 5,6,7,8 & 9. Temp. Henry VIII.- 10 to 16 Temp. Queen Elizabeth.-17. Sword of Wolfgang Wilhelm, Count Palatine of the Rhine 1614.
(All from the Meyrick Collection)

numerous engravings of armed personages throughout these volumes, and to the articles ESTOC, FALCHION, RAPIER, and TUCK.

SWORD (TWO-HANDED). The "Zweihander," or two-handed sword, is said by M. Demmin to be the real espadon, and no earlier than the fifteenth century. It was the ordinary weapon of the foot-soldier in Switzerland, whence it was introduced into England in the reign of Edward IV. One of that date was in the Meyrick Collection, and is engraved here from the copy by Skelton, with five others of the respective reigns of Richard III., Henry VII., and Henry VIII. The latter monarch displayed great ability in the management of this weapon. Hall records an instance occurring at Greenwich at the Feast of Pentecost, in the second year of his reign, when the King, with two others, challenged all comers "to fight every of them xii. strokes with two-handed swordes," and displayed "his hardy prowes and great strength" to the delight of his lieges. (Chron. p. 515.)

In Joachim Meyer's work on 'Fencing,' published at Strasburg in 1570, the wielder is depicted grasping the hilt close to the cross-guard with one hand, the pommel with the other.

"Come with thy two-hand sword."
Shakespere, *Romeo and Juliet.*

Some of these two-handed swords had wavy blades (see woodcut, next page). Mr. Hewitt gives them the name of *flamberg*, which M. Demmin warns us not to mistake for the flamberg or flame-sword of

Temp. Edward IV. *Temp.* Richard III. *Temp.* Henry VII.

the Swiss, which he distinguishes from that "used with both hands." The name is, however, only applied to the blade, which, if it has wavy edges, would be a flamberg, whatever its length or other peculiarities. There were two-handed swords of state of huge proportions, intended solely for processional purposes. Two are in the Tower, and there was one in the Meyrick Collection. Of this description, I imagine, was the "greate twoe-handed sworde, garnyshed with sylver and guylte, presented to King Henry VIII. by the Pope," which is entered in 'The Inventory of the Regalia of James I. in the

secrete jewel-house within the Tower of London,' quoted by Mr. Hewitt, vol. iii. p. 652. What has become of this (for more than one reason) very interesting relic ?

Two-handed Swords. 16th century.

Teeth, original size.

Sword-breaker.

SWORD-BREAKER. A weapon of the dagger form, with a pointed blade of considerable breadth and thickness, furnished with a row of barbed teeth, the barbs of which admit the sword of the adversary, but prevent its withdrawal, and a rapid twist snaps it in two. I give an example from the Meyrick Collection, with two of the teeth size of the original, from Skelton's 'Engraved Specimens.'

SWYN FEATHER. In 'A Treatise of War,' written in 1649, MS. Harl. 6008, quoted by Grose in his 'Military Antiquities,' vol. i. p. 111, it is recommended that " each dragoonier should carry at his girdle two swyn feathers, or foot pallisados, of 4½ feet length, headed with sharp forks and iron heads of 6 inches length, and a sharp iron foot to stick in the ground, for their defence against horse." Turner ('Pallas Armata,' 1671) gives a more particular account of it. He says, " I think I may in this place reckon the Swedish feather among the defensive arms, tho' it doth

participate of both defence and offence. It is a stake five or six feet long, and about four finger thick, with a piece of sharp iron nailed to every (each) end of it. By the one it is made fast in the ground, in such a manner that the other end lyeth out, so that it may meet with the breast of a horse, whereby a body of musketeers is defended as with a palisado."

Subjoined is a swyn-feather, with its case, formerly in the Meyrick Collection. The swyn-feather was combined with the musket-rest in the reign of Charles II. It was concealed in the staff of the rest, and protruded when touched by a spring. The term swyn-feather was sometimes applied to the bayonet which succeeded it, and has been from a misapprehension of the word *swyn* or *sweyne* called a "hog's bristle," but, from the above contemporary descriptions, "swyn" clearly meant "Swedish."

Swyn-feather and case.

Swyn-feathers combined with musket-rests. *Temp.* Charles II.

SYRCA. The Anglo-Saxon name for a coat of mail:

"They shook their syrcas,
The garments of battle."—Beowulf.

Also a shirt.

Robert of Brunne, describing the escape of Isaac, "Emperor of Cyprus" (as he styled himself), from the forces of Richard Cœur de Lion in 1199, says he saved his life by flying "bare in his *serke* and breke." *Sark* is still used in Scotland. "Weel done, cutty sark." (Burns's 'Tam O'Shanter.')

ABARD. "A jacquet or sleeveless coat worn in time past by noblemen in the warres, but now only by heraults, and is called their coat of armes in servyse." (Spight's Glossary, 1597.) The definition is not to be disputed, and there is little to be added to it in 1876 with any degree of authority, and yet it is provoking to think how much more information is desirable on the subject, and might be obtainable could we identify the dresses which the painters of the Middle Ages have so liberally bequeathed to us, with the names we find in the pages of the very volumes they have illustrated. The tabard was an article of apparel sufficiently familiar to the public in the days of Richard II. to be selected for the sign of an inn in the Borough, whence Chaucer in fancy leads his immortal Canterbury pilgrims ; but assuredly the tabard which he tells us was worn by the poor ploughman, bore little resemblance to that worn by a nobleman " in the war," or a herald " in service." Moreover, the military tabard is not seen before the reign of Henry VI., and I have not met with that of a herald previous to the fifteenth century. M. Viollet-le-Duc has, with his customary courage, included both these tabards in his notice of HAQUETON, and unmistakably represented them in their accepted form. We have heard of " heralds in heukes " (see p. 289), and that puzzling garment appears in one of its many shapes to have approached that of the tabard of the knight and the coat of the herald, but in none that have been given to the haqueton can I discern the slightest resemblance. M. Quicherat simply testifies to the appearance of the name in the thirteenth century, and that it had assumed the form of the dalmatic in the fourteenth.

Ducange has " TABARDUM, TABARDUS. Tunica seu sagum militare ; Angli tabard. (Boxhornius in 'Lexico Cambro Britannico.') TABAR. *Tunica longo, chlamys, toga ;* Hispani *tavardo* dicunt ; Itali, *tabarro ;*" and amongst other authorities cites the following :—"Permittimus autem (prælatis) quod possint habere mantellis rotundos, sive *tabarda* longitudinis moderatæ." (Concilium Badense, anno 1279, cap. 2.) " Fratres sacerdotes dicti Hospitales tunica, supertunica, tabardo et capucio nigri coloris utantur." (Statuta Hospitalis S. Juliani, Matth. Paris, p. 164.) " Icellui Chabace osta et devesti son tabart *ou* mantel." (Lit. Remiss., ann. 1389.)

To nearly the close of the fourteenth century there is evidence, therefore, that the name of tabard was applied to a long tunic, a cloak or mantle, and, as far as we can learn from such verbal description, to nothing approaching the peculiar garment which has been recognized as a tabard from the middle of the fifteenth century to the present day. As late as the reign of Henry VII. we find Skelton reproaching the clergy for wearing " tabards of fine silk," but discover nothing in representations of clerical personages at all resembling a tabard, unless it may be the scapulary. Henry VI. is

The Lady of the Tournament Delivering the Prize

(From a copy of the "Traité des Tournois" of King Rene, in the National Library at Paris)

Date about 1450

the first English sovereign who is represented on his great seal in a tabard, embroidered with the arms of France and England quarterly, and annexed is an engraving of his own tabard, which was formerly suspended, together with his helmet, sword, and gauntlets, over his tomb, now destroyed, in St. George's Chapel, Windsor. A drawing made in the time of Henry VIII., which I discovered amongst a miscellaneous collection of papers in a volume of the Add. MSS. Brit. Mus., has preserved for us an authentic representation of that interesting relic. After that period the examples are frequent of knights so attired (see third figure on page 18, under ARMOUR), and the heralds and pursuivants depicted in the numerous illuminations of that period are invariably represented in their tabards

Tabard of King Henry VI.

of arms, which can scarcely be called sleeveless, as the distinction between the pursuivant and the

Pursuivant of Arms. 15th century.

herald in those days, and at least to the time of Elizabeth, was that the former wore his tabard with the "maunches (sleeves) of his coat on his breast and back;" and, on his promotion to the dignity of herald, the eldest herald, at the command of his sovereign, "turned the coat of arms, setting the maunches thereof on the arms of the said pursuivant." (Legh's 'Accedens of Armory,' 1562, translated from Upton, 'De Studio Militari,' a writer of the time of Henry IV.) Adjoined is a representation of a pursuivant of the fifteenth century; and in the chromolithograph issued with our Ninth Part will be seen a herald and two pursuivants of the Duke of Brittany, from King René's 'Traité des Tournois,' in which the above distinctions are strictly observed.

The "sleeves" of these tabards, however, are only loose flaps hanging over the arms, but not enclosing them, like those of the French *mandille* of the sixteenth century, which resembles the tabard in almost every particular (see MANDELION, and figure of "Laquais, from Montfaucon," page 354). The tabards of the heralds of some foreign sovereigns were and are without sleeves of any description. (See GENERAL HISTORY.) The military tabard is not seen after the accession of Henry VII.

TABBY. (*Tabis*, Fr.; *tabi, tabino*, Ital.) "A kind of coarse silk taffety watered." (Bailey.) But Malcolm tells us of "a pair of silver tabby boddices, embroidered with silk and gold," that were lost with other articles in 1685. ('Mann. and Cust.,' vol. ii. p. 335.) Tabbying is explained by Bailey as "the passing of a sort of silk or stuff under the calendar to make a representation of waves on it."

TACES or *TASSETS.* (*Tassettes*, Fr.) Horizontal steel bands or hoops forming a skirt to the

Brass of John Leventhorpe. 1433.

Brass of Roger Elmbrygge, Esq. 1435.

Taces with Tassets attached. 1525.

Long Tassets. 1530.

breastplate, first seen in the reign of Henry V. (See figure of Sir Robert Suckling, p. 18.) In the reign of Henry VI. they are reduced in number to three or four, and have *tuiles* attached to them by straps and buckles. Subsequently, in the reign of Henry VII., they had occasionally added to them four or five overlapping plates working on Almaine rivets in lieu of the tuiles. This alteration was followed by the dismissal of the hoops altogether and in the introduction of long separate tassets, made to cover the whole thigh from the waist to the knee, where they terminated sometimes in knee-caps more or less ornamental. In the reign of Elizabeth they were made in two parts to accommodate the bombasted breeches then in fashion, and were worn till armour of every description was abolished below the waist.

TAFFETA, TAFFETY. (*Taffetas*, Fr.; *taffeta*, Ital.) A silk known in England as early as the fourteenth century, and probably manufactured in Brittany, where it was called *taftas*. "TAFFATA, TAFFATIN. Pannus sericus quem vulgo taffetas dicimus (armorici *taftas*, unde nomen)." (Ducange *in voce*.) It was used for the linings of rich mantles: "Unum mantellum . . . de Camoca duplici cum alba taffatin." ('Mon. Ang.' vol. iii. part 2, p. 86.) "Unum mantellum Comitis Cantia de panno blodio laneo duplicatum cum viride taffata." (Ibid.) It was much used in the sixteenth century for various articles of dress. Gowns and petticoats of taffeta are enumerated by Stubbs amongst the fashionable garments of the ladies in Queen Elizabeth's time, and some gowns he describes as having "capes reaching down to the middle of their backs, faced with velvet or fine taffata and fringed about very bravely." In 'Eastward Hoe,' a comedy printed in 1605, mention is made of "a buffen gown with tuftaffetie cape," and "two pages in tafatye sarcenet" are spoken of in the play of 'Lingua,' 1607. Cotgrave gives us the names of various sorts of taffety known in his time: "Taffetas chenille stript (striped?), taffata, taffetas à gros grain, silk gogeram (grogram), taffetas mouschété, taffe-taffata, taffetas velouté, the same."

TAKEL, TACLE. This word is used by Guiart under the year 1298—

> "Mes hauberjons et cervelières,
> Ganteles, tacles et gorgières,
> Qui entre les cops retentissent
> Les armes de mort garantissent."
> * * * *
> "Tacles, hauberjons et cointises." (Sub ann. 1301.)
> * * * *
> "Targes fendent, tacles resonnent." (Sub ann. 1302.)

The glossarists are by no means of accord in their explanations of the term as here introduced. Lacombe and Roquefort consider it a shield or buckler, and the phrase "tacles *resonnent*" following that of "targes fendent" is certainly suggestive of such a definition. Ducange is also of their opinion, inasmuch as he takes the word to be a synonym for talvas, a large shield borne by the Normans. (See TALVAS.) Meyrick, with whom Way appears to have agreed, conjectures from the context in the first two quotations, that it signifies literally "tackle, appurtenances of armour," and suggests that it particularly applies to "the movable pieces which connect the shoulder-plate with the gorget, and those which came from the back plate over the shoulders to the breast." But Guiart wrote in the reign of Henry III., when such armour was unknown, and how Mr. Way could have overlooked this singular inadvertence of Sir Samuel Meyrick is even more extraordinary than the mistake itself, which I can only account for by supposing he meant his suggestion to apply only to the sense in which the word was used in the reign of Henry VI., when, he says, it occurs amongst the habiliments provided for a joust of peace.

Takel had, however, a signification in the fourteenth century which is clear enough. It was the name for an arrow, and is used by Chaucer in his translation of the 'Roman de la Rose,' in speaking of the arrow of the God of Love; also in the Prologue to his 'Canterbury Tales' he writes:—

> "Wel could he dress his takell yemanly."

In 'A Lytel Geste of Robyn Hood' also we read—

> "When they had theyr bowes bent,
> Their takles feathered free,
> Seven score of wyght young men
> Stode by Robin's knee."

TALVAS. (*Talavacius, talochia, talebart,* Inf. Lat.) A large shield, something resembling the pavois invented in France. Ordericus Vitalis, in lib. viii., speaking of Robert de Belesme, says, "Robertus autem qui pro duritiâ jure talavacius vocabatur," &c. ; and Rolandus Patavinus, in his 'Chron. Tarvis.' lib. viii., c. 10, says, "Circa et pedites cum talavaciis statuit super turrim et portam." We read also in the 'Roman de Vacca'—

> "As talwaz se sont et couvrir et moller."

"In quâ fuerint decem homines armati *tavolaciis vel scutis,* lanceis vel lancionibus." ('Stat. Patav.' lib. iii.) The Tavolacini were the police soldiers of Italy, who were armed with lances and shields. In letters-remissory of the fourteenth century this shield is repeatedly spoken of as a "boucler ou taloche," "un taloche de fer," &c. (*Vide* Ducange *in voce,* and Way's Glossary to Meyrick's 'Crit. Inq.') We have no authority for its particular shape.

TAPUL. This word occurs in Hall's description of armour made for a tournament in the reign of Henry IV. A tournament of his own invention apparently, for no record has been preserved of it, and the armour he describes is not of that time, but of his own ; yet, though as imaginary as the tournament, the terms he uses are those familiar to him, and can be depended upon as authority for illustrating the armour of the reign of Henry VIII. The passage is as follows :—

"One company had the plackard, the rest, the port, the burley, the tasses, the lamboys, the back-pece, the *tapull* and the border of the curace all gylte." To the word "tapull" Sir Samuel Meyrick appended a foot-note (vol. ii. p. 214) to this effect : "Perhaps the projecting edges perpendicularly along the cuirass, from the French *taper,* 'to strike,' for it was the custom to gild that to correspond with the border of the cuirass." Acting on this conjecture, he thenceforth applied the name of tapul to the ridge which distinguishes the breastplate of the sixteenth century, and has been followed by nearly all English antiquaries and adopted by the critical M. Demmin. I see no reason to doubt its accuracy, which has been tacitly admitted by Mr. Way. (See BREASTPLATE.)

TARGE or *TARGET.* A shield or buckler, called by the French *targe,* by the English *target,* by the Arabs *tarka,* by the Germans *Tarisch,* and by the Bohemians *tarts,* all which are derived from the Celtic *tarian.* Some, however, have supposed the derivation to be from the Latin *terga,* and have adduced as a proof the following passage from Virgil, 'Æn.' lib. ix. :—

> "Quam nec duo taurea terga
> Nec duplici squamâ lorica fidelis et auro
> Sustinuit."

But the Latin word itself was of the same Celtic origin. The targe was sometimes emblazoned. Thus, in the 'Monasticon Anglicanum,' vol. iii. p. 16, we read : "Cum targis de armis Regum Angliæ et Hispaniæ." It was usual to line the targets with velvet of different colours as early as the reign of Henry II., for, in Fantôme's 'Chronicle of the War between the English and the Scots between the years 1173 and 1174,' it is said, —

> "Quil verrard maint gunfamm e maint cheval de pris,
> Mainte targe dubblé blanc e vermeil et bis."

Chaucer describes the Wife of Bath wearing a hat

"As broad as is a bokeler or a targe."

The difference between the buckler and the target consisted in the former being held in the hand, and the latter worn on the arm like the roundel, for which it seems to have been merely another name (see ROUNDEL); for Meyrick cites an instance of the circular plates for the protection of the armpits, called "roundels," being mentioned in an inventory, dated 1379, as *targeta*. (Glossary *ut supra*.)

The early targets were of various sizes, some very large. Matthew Paris says: "Oppositis corporibus suis propriis et *amplis clypeis* qui targiæ appellantur" (sub anno 1240); and William Guiart speaks of

"Les grants targes au col asisses."

In the sixteenth century some targets were oval-shaped, like the rondache. Sutcliffe in his 'Practice of Arms,' 1593, tells us: "Of the targettiers, those in the first rankes have targets of proofe, the rest light targets. These should be made of wood, either hooped or barred with yron, *in form ovall*, three foote and a halfe in length, and two foote and a halfe in breadth." We have seen that the targets in the thirteenth and fourteenth centuries were painted with armorial bearings and various ornamental devices, but the targets of metal in the sixteenth century were magnificently engraved and embossed; not merely those displayed in ceremonies or processions, but such as were used in actual warfare. Amongst the spoils captured at the siege of Ostend, in 1601, was a target "wherein was enammelled in gold the Seven Worthies, worth seven or eight hundred guilders." ('Commentaries of Sir Francis Vere,' p. 174.) In the Meyrick Collection were the undoubted targets of Francis I. and the Emperor Charles V., now, alas! lost to this country for ever. They have been carefully engraved by Skelton, whose work is of the greatest value to artists, as it contains faithful representations, drawn to scale, of all the principal treasures in that matchless collection, of which we have been so unfortunately deprived. Our engraving of the former is from one reduced to the scale of one inch and a half to a foot.

Highland Target. 16th century.

Target of Francis I. A.D. 1526.

Sir S. Meyrick has called attention to the application of the term "targe" to a dagger or small sword. In a letter-remissory dated 1451, it is stated, "Le suppliant tira une targe ou dague qu'il avoit et en frapa icellui Seguin;" and Monstrelet says: "Les autres gens avoient targes et semitarges qui sont espées de Turquie." ('Crit. Inq.,' vol. ii. p. 116.) The explanation "which are Turkish swords" may refer only to the *semitarges* (scimitars), but it is curious to find a sword described as a *semitarge*, whether we consider "targes" in the same passage to be included in the explanation or not.

TARS, CLOTH OF. (*Tarsicus, Tartarinus,* Lat. ; *Tarsien,* Fr.) "Species panni ex Tartariâ advecti, vel operis Tartarici." (Ducange, *in voce* Tartarinus.)

> "His cote armure was cloth of Tars."
> Chaucer, *The Knight's Tale.*

Glossarists are by no means unanimous respecting the derivation of this word. Roquefort agrees with Ducange : "Tartaire, sorte d'étoffe de Tartarie" ('Glossaire de la langue Romane') ; and Warton inclines also to that opinion. "Tars," he says, "does not mean Tarsus in Cilicia (what assurance has he of that fact ?), but is rather an abbreviation for Tartarin, or Tartarium."

> "On every trumpet hangs a broad banner
> Of fine Tartarium full richly bete."
> Ibid. *The Flower and the Leaf.*

Skinner derives it from Tortona in the Milanese, and cites stat. iv. of Henry VIII., cap. 6. ('History of English Poetry,' i. 364.) I confess I have a strong feeling in favour of Tarsus, the capital of Cilicia, in Asia Minor, once the rival of the great mercantile cities, Athens, Antioch, and Alexandria ; for it was from that part of the world that the most costly stuffs of mixed silk and gold were imported into England in the Middle Ages. Halliwell has "TARS. Tharsia, a country adjoining Cathay," which, as Cathay is China, means of course Tartary ; but he quotes no authority, and merely describes cloth of Tars as "a species of silken stuff formerly much esteemed." He does not, however, confound Tars with Tartarin, and there, I think, he is right. (See TIRETAINE.)

TARTAN. This word, so entirely associated with our popular ideas of the national costume of Scotland, is derived by Mr. Logan ('Hist. of the Gael,' 2 vols., 8vo, London) from the Gaelic *tarstin* or *tarsuin,* "across ;" but the true Gaelic term for the Highland plaid or mantle is *breacan-feile,* literally the chequered, striped, or spotted covering. *Tarsa, tarsin,* and *tarsua,* are all used for "across," "athwart," "over," "through," "past," and would apply to the crossing of the threads in the weaving of any sort of cloth. With the exception of *tarsnan,* which signifies "a cross-beam," the root *tars* or *tart,* in all its combinations, expresses things which *cross so minutely* as to deceive the sense, as the spokes of a wheel in motion, light shining through glass, &c., and not to such strongly-marked chequers as distinguish the Highland plaid. That variegated pattern has also a Gaelic name of its own, *Cath-dath,* commonly translated "war colour," but ingeniously rendered by a friend of Mr. Logan "the strife of colours,"—an etymology which has certainly the high merit of being as probable as it is poetical and characteristic. The epithet is exactly such as a Highland senachie would have applied to the splendid breacan of his chieftain. The word "tartan," therefore, whatever may have been its original, I believe to have been the name of the material itself, and not of the pattern it might be worked in, as it was sometimes of one colour only. In a wardrobe account of the reign of James III. of Scotland, A.D. 1471, an entry occurs of "an elne and an halfe of blue tartane to lyne his gowne of cloth of gold," and another of "halve an elne of doble tartane to lyne collars to her Lady the Quene." (Logan's 'Hist. of the Gael ;' Heron's 'Hist. of Scotland ;' 'The Ilbreachta of Tigheirnanas, or Law of Colours ;' 'Hist. of British Costume,' &c. See also TIRETAINE.)

TASSEL. (*Tasselle, tasseau,* French ; *tassellus, tacella, tassella,* Lat.) This word, familiar in its present sense of an ornamental termination or pendant to the cords of mantles and various other articles of costume and furniture, as early as the fourteenth century, was at the same time applied to the square or diamond-shaped plates, clasps, or fibula that were attached to the upper portion of the mantle, and through which the cords passed which secured it on the shoulders, and was probably derived from the Latin *tassa, patera,* as *tassee* is defined in Halliwell to be "a clasp or fibula."

(See MANTLE and cut annexed.) It also signified a fringe, *fimbria,* and was possibly used in that sense by Chaucer: "Tassed with silk and perled with latoun."

Tasseau from Effigy of William of Hatfield. York Cathedral.

TASSETS. See TACES.

TAUNTONS. A broad cloth, so named from Taunton in Somersetshire, its place of manufacture. It is mentioned in an ordinance of the third year of the reign of James I., 1605. (Ruffhead.)

THRUM. "The extremity of a weaver's warp, often about nine inches long, which cannot be woven." (Halliwell.) Caps and hats knitted with this material were called thrum. "Silk thrummed hats are mentioned *temp.* Elizabeth." (Fairholt.)

> "And there's her thrum'd hat and her muffler too."
> Shakespere, *Merry Wives of Windsor,* act iv. sc. 2.

> "A thrumbe hat had she of red."
> *Cobbler of Canterbury,* 1608.

"The sailor's thrum" is mentioned in the ballad on Caps printed by Durfey in his 'Pills to purge Melancholy:'

> "The saylors with their thrums doe stand
> On higher place than all the land."

TIFFANY. "A sort of thin silk or fine gauze." (Bailey.) Mentioned in the 'Pastoral of Rhodon and Iris,' 1631: "Thin tiffanies, cobweb lawn and fardingals."

TINSELL. See TYLSENT.

TIPPET. A term applied in the Middle Ages to three different articles of apparel: 1, a pendent streamer from the arm (see SLEEVE); 2, the long tail of the hood or chaperon of the fifteenth century (see HOOD), also called "liripipe;" 3, the cape of the hood, or a distinct covering for the shoulders. Chaucer's lines, cited by Fairholt under this head,

> "On holydayes before her he wold go
> With his typet bound about his head,"
> (*Reeve's Tale,*)

may apply to two of the articles mentioned above, for the cape was bound about the head by the long tail or tippet, in various fantastic shapes. Hall speaks of "mantles like tippets" in his 'Union of Honour.' A "sable tippet" is entered in a list of articles of a lady's dress in 1717, where it is priced at £15. ('Book of Costume,' p. 152.) Bailey, who derives the word from the Saxon *toppet,* says, "A fur neckerchief, &c. (!), for women, also a Doctor of Divinity's scarf."

'The Weekly Register' of July 10, 1731, in "A General Review of Female Fashions, addressed to the Ladies," observes, " I have no objection to make to the tippet. It may be made an elegant and beautiful ornament; in winter the sable is wonderfully graceful, and a fine help to the complexion. In summer the colours and the composition are to be adapted with judgment, neither dull without fancy, nor gaudy without beauty. I have seen too many of the last, but as I believe them to be the first trial of a child's games in such performances, I only give this hint for their amendment."

TIRETAINE. (*Tiretanni,* Latin.) A fine woollen cloth, much used for ladies' dresses in the thirteenth century, and generally of a scarlet colour, whence probably its name, the *teint* or colour of Tyre, scarlet being a term indifferently used for purple by early writers, and including "all the gradations of colours formed by a mixture of blue and red from indigo to crimson." (*Vide* 'Illustrations of Northern Antiquities,' 4th edit., 1814, p. 36.)

"Robbes faites par grand devises
De beaux draps, de soies et de laine,
De scarlate de tiretaine."
Roman de la Rose.

TISSUE. (*Tissu*, French.) A fine-woven fabric of silk, gold, or silver. The frequent mention of it throughout these volumes, in descriptions of costume from the thirteenth century, renders any further notice here unnecessary.

TOP-KNOT. A bow of ribbon forming part of the head-dress of a lady in the reign of William and Mary.

"There's many short women that couldn't be matched
Until the top-knots came in fashion."
The Vindication of Top-knots and Commodes, 1691.

TORQUES. Wreathed ornaments of gold and other metals for the neck (so named from the Latin *torquere*, to twist), worn by the Celtic and barbaric nations of antiquity, and adopted from them by the Belgic Britons. The mode of wearing them will be best understood by the annexed engraving

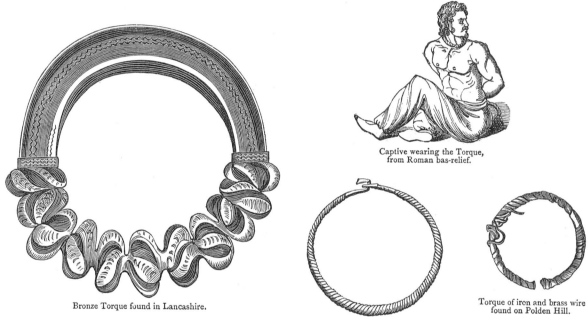

Captive wearing the Torque,
from Roman bas-relief.

Bronze Torque found in Lancashire.

Bronze Torque found on the Quantock Hills.

Torque of iron and brass wire
found on Polden Hill.

of "a barbarian," from a Roman bas-relief. A torque of a remarkable form, inasmuch as that it was not twisted, was found at Rochdale, in Lancashire, in 1831, and is engraved and described in the 'Gentleman's Magazine' for June 1843; for, although the word *torque* or *dorch* is strictly applicable only to the twisted or, as Mr. Birch describes them, the funicular examples, varieties have been found of the plain collar with bulbous terminations.

"Scheffer bestows eight chapters on the torque in his very learned and ingenious treatise 'De Antiquorum Torquibus Syntagma.' He maintains that three species of ornaments were included under the generic name of torque; viz.: 1. The torques proper, called 'canella cum fibulis,' composed of rings and hooks, linked together like a chain; 2. The circulus, formed of rods of gold laid together like cords, and twisted into a wreath; and 3. The monile, a plain, broad collar of gold, which fitted close to the neck." (Meyrick, 'Cost. of the Orig. Inhab. of the British Islands,' folio, 1821, p. 14, note.) I hesitate to include the third class amongst the veritable torques, and prefer the definition of Mr. Birch, who has almost exhausted the subject in his papers published in the second and third volumes of the 'Archæological Journal.' (See GENERAL HISTORY.)

The term torques is equally applicable to the girdles of twisted iron wire worn around their

waists as well as round their necks by the Mæatæ and Caledonians as late as the time of the Emperor Severus.

TOUCH-BOX or *PRIMER*. A receptacle for the fine gunpowder used for priming, resembling the powder-flask, but smaller. "For xi English musquets, at xxvij's a-piece, with the rest, fflask,

Touch-box of embossed leather. *Temp*. Elizabeth.

Embossed gold Touch-box. *Temp*. Elizabeth.

Touch-box and Spanner combined, of steel engraved and gilt. *Temp*. Elizabeth.

Steel Touch-box. *Temp*. Charles II.

Touch-box of ebony inlaid with ivory. *Temp*. Elizabeth.

and touch-boxes, £xiiii, xviis. Item, for vii calyvers, w^th flasks and touche-boxes, at viiis. vid. a pece." ('Norfolk Archæology,' vol. i. p. 11.) In the Meyrick Collection were three beautiful specimens of the time of Elizabeth : one of ebony, inlaid with ivory, with strongly-gilt ornaments ; another of gold, on which was a combat beautifully embossed ; and the third of embossed leather. There was also a fourth of steel, of the time of Charles II. These are engraved by Skelton, and have been copied for this work. (See woodcuts on preceding page.)

Fairholt, following Halliwell, describes the touch-box as "a receptacle for lighted tinder carried by soldiers who used matchlocks, the match being lighted at it ;" but the quotations accompanying this statement do not by any means support it, and the form of the boxes herewith engraved clearly shows their purpose, and could not be intended to hold tinder. Its German name also is "Zünd-pulverflasche." (Demmin.)

TOWER. See COMMODE.

TROLLOPÉE. A loose morning gown worn by ladies about the year 1756 ; also called a slammerkin. Both these words have furnished nicknames for a slovenly, slatternly person.

TROWSERS, TROSSERS, TRUIS. These familiar articles of apparel are of Oriental origin, and, from the earliest period of which we have reliable information, distinguished the "barbarians" from the Greeks and the Romans. On the columns and arches of the Roman Emperors the Gauls are invariably so attired. The Britons are described by Tacitus as being "near and like the Gauls," who are expressly said by Diodorus Siculus to have worn close trowsers, which they called "*braccæ*" (lib. v. cap. 30), because they were ordinarily made of the chequered cloth called *breach* and *brycan*, from which said *braccæ* we derive the word *breeches*. (See BREECHES.) They appear to have been abandoned in Britain during the domination of the Romans, but were still worn in Ireland and Scotland, where they were known by the name of *truis* and *triubas*. The *heuse* of the Saxons and the *chausses* of the Normans succeeded them in England ; but they occasionally appear in the illuminated MSS. of the twelfth century (*vide* woodcuts annexed), if, indeed, they were not one and

Gaul. From the Antonine Column.

Figure of Job in a Latin MS., Royal C vi. 12th century.

Cotton. MS. Nero, C iv. 12th century.

the same originally, and only compressed by the gartering exhibited in the illuminated copies of those periods. It is not, however, till the reign of Henry VIII., in England, that the word *trouses* appears in wardrobe accounts ; but, whether derived from the old word *truis*, or from the verb *to*

truss, i.e. to tuck up or fasten the hose by points to the doublet, I will not undertake to decide. In Ben Jonson's 'Staple of Newes,' Peniboy, junior, "walks in his gowne, waiscoate, and trouses," expecting his tailor ; which appears to justify Gifford's definition, that they were "close drawers, over which the hose or slops were drawn." (*Vide* Halliwell *in voce*.) Randle Holme, however, applies the term to the hose themselves, assuring us that, in the second year of the reign of Henry VIII., the wearing of *trowses*, or breeches fitting close to the limbs, was first introduced (revived, he should have said) ; and, though not a contemporary witness, his evidence must not be hastily rejected. He is supported by Dekker, who, in his 'Gull's Horn Book,' 1609, speaks of "the Italian's *close* strosser," another form of the word. The general fashion of trowsers in England dates from a period within my own recollection, but on the Continent, as well as in Ireland and Scotland, they may boast an antiquity only inferior to that of their Oriental prototypes. (See GENERAL HISTORY.)

TUCK, TOCK. (*Estoc*, French.) A rapier, or other kind of small sword. "One of you rub over my old tucke with a few ashes ; 'tis grown odious with toasting cheese." (Beaumont and Fletcher, 'Cupid's Revenge.')

" Then I pressed the nearest with my dagger, and the farthest with my tuck." (Earl of Ossory, 'Guzman,' 1693.)

The term is also applied to a blade concealed in a tube, which springs out when required, as does a modern sword-stick.

Cotgrave has, "Tucke, a little rapier. *Verdun.*" Its French name would lead us to imply that Verdun was celebrated for the manufacture of this particular weapon. In an inventory of the reign of Edward VI. is an entry of two "three-edged tockes, with vellet scabbards." (Meyrick, ' Crit. Inq.' vol. iii. p. 10.)

TUCKER. "A slip of linen or lace, pinned along the top of women's stays or gowns, about the neck." (Bailey.) Also called "a pinner" by Randle Holme : "A pinner, or tucker, is a narrow piece of cloth, plain or laced, which compasseth the top of a woman's gown, about the neck part." ('Academy of Armorie,' 1683.) "To be in best bib and tucker," is a familiar phrase at the present day. (See MODESTY-BIT.)

TUFT MOCKADO. A stuff made to imitate velvet or

TUFT TAFFATY. (Halliwell.) See MOCHADO and TAFFETA.

TUILES, TUILLETTES. (French.) Steel plates to protect the thighs, appended by straps and buckles to the lowest of the taces. They are first seen very small in effigies in England in the early part of the reign of Henry VI. The brasses of Roger Elmbrygge, Esq., Beddington Church,

1458. 1495. 1585.

Surrey, 1435, and John Leventhorpe, Esq., Sawbridgeworth Church, Hertfordshire, 1433, afford early examples. (See page 499.) Later they increased in length, reaching almost to the knees, and

partook of the character of the armour, being fluted, ribbed, escalloped, &c. They disappeared at the close of the fifteenth century, and were replaced by a shorter description of almost their original form.

TULY, TEWLY. The name of a silk or thread made in the sixteenth century. "A skein of tewly silk" is mentioned in Skelton's 'Garland of Lawrell.' The Rev. Alexander Dyce, in a note to the passage, quotes directions for to make "bokeram tuly, or tuly thread," from a MS. in the Sloanian Collection, Brit. Mus. No. 73, by which it would appear that it was of "a manner of red colour, as it were of crop madder :"—"probably," remarks Mr. Fairholt, "of the sprouts or tops of madder, which would give a less intense red." ('Cost. in England.')

TUNIC. (*Tunica*, Latin.) The name of a body garment, which, of various lengths, materials, and fashions, has existed from the time of the Romans to the present day, when the appellation is specially appropriated to the coat of the soldier. It was adopted by the clerical writers of the Middle Ages to describe the *pais* or *cotta* of the ancient Briton, the *roc* of the Anglo-Saxon, and the *cote* of the Norman. Its history extends far beyond the time of the colonization of these islands, and, with the exception of the cloak or mantle, it was in one form or another the earliest article of apparel in the world. Its illustration will consequently be found in these volumes, under all the designations it

Cotton. MS. Nero, C iv. 12th cent. From a MS. in the Nat. Lib., Paris. 13th cent.

has received since the first known record of its existence,—the *calasiris* of the Egyptians, described by Herodotus ('Euterpe,' xxxvii.). (See Introduction to GENERAL HISTORY.)

TYLSENT, TILSON, TINSELL. "*Tinsell-Brocatel*, a thin cloth of gold or silver." (Cotgrave.) A material frequently mentioned in the descriptions of dresses in the reign of Henry VIII. "A chammer of black tylsent, with a high collar welted with cloth of silver and lined with purple satin." (Wardrobe Inventory, 8th of Henry VIII. MS. Harl. 2284.) "Fifteen yards of russet tylsent, to line a double mantle, with sleeves of black cloth of gold upon bawdkin." "Sixteen yards and a half of purple satin for the lining of a mantle of purple tylsent made in the Spanish fashion." (MS. Harl., *ut supra.*)

"A doblet of white tylsent cut upon cloth of gold, embraudered with hose to the same, and clasps and auglettes of golde, delivered to the Duke of Buckingham." (Ibid.)

The following items are extracted from a curious list of 'Garments for Players, an. vii. Henry VIII.' (1516), printed by Mr. J. P. Collier, in his 'History of English Dramatic Poetry,' vol. i. pp. 80, 81 :—

"A long garment of cloth of golde and *tynsell*, for the Prophete on Palme Sunday."

"Itm a capp of *grene tynsell* to the same."

"Itm ii garments and an halfe of *grene tinsell.*"

"Itm ii coots, *crimsen vellwett and tinsell paned.*"

"Itm a coot of crimson velvet and *tilson satten.*"

MBER, UMBRERE, UMBRIL. The peak or shade (*ombre*, French) in front of head-piece, occasionally movable like the vizor, to which it was sometimes attached. It is mentioned as early as the reign of Henry VI. In an inventory taken in Holy Island, A.D. 1437, the first entry is, " v. galee cum v. umbrills et iiii ventills." It would seem to have been occasionally used to designate the whole face-guard :

> " And for to see him with syghte
> He put his umbrere on highte,
> To behold how he was dyghte."
>
> *Romance of Sir Percival of Galles.*

UMBO. The central projection or boss of a shield, target, or buckler. Many have been found in Anglo-Saxon interments, and numerous examples are figured in Douglas's 'Nenia Britannica,' and

Bosses of Anglo-Saxon Shields.

1 and 2, from Fairford ; 3, Mr. Rolfe's Collection ; 4, Wilbraham Cemetery ; 5, Meyrick Collection ; 6, Ozingell Cemetery ; 7 and 8, C. R. Smith's Collection.

other works. Our engravings are from originals discovered in England, and preserved in the British Museum and various private collections.

Across the hollow of the boss was nailed or riveted a bar of wood or iron, by which the shield was held out at arm's length by the warrior's hand when in conflict, or carried peacefully at his side. Some of the convex form had a spike in the centre, the conical-shaped terminating generally in a flat button. The boss, in various forms, appears on the early Anglo-Norman kite-shaped shield, although borne on the arm, instead of being held in the hand, and was continued in bucklers and targets as long as such defences were in use, which in Scotland was at least as late as the battle of Culloden. (See SHIELD, BUCKLER, and TARGET.)

UNCIN, ONCIN. (*Uncinus,* Latin.) " A staff with a hooked iron head, somewhat like one horn of a pickaxe, whose use was very serviceable for striking through the apertures of the mascles." (Meyrick, ' Crit. Inq.' vol. i. p. 19.) A pick in fact (see woodcut, p. 364).

> "Restitit uncino maculis hærente plicatis."
>
> Guil. le Breton.

" Hinc oncin appellatus nostris Baculus recurvus." (Ducange.) Halliwell has " Unce, a claw."

UNIBER. Apparently the same as umber. "In all editions of Stow's 'Survey' it is *uniber;* in all those of the ' Annals,' it is *umber.*" (Meyrick, ' Crit. Inq.' vol. ii. p. 122, note.)

UNIFORM. Uniform in the British army dates from the commencement of the last century. As armour was gradually abandoned, uniformity in clothing became more and more necessary ; and by the time it was completely discarded, every regiment in the service had its regular uniform, the colour being generally scarlet, and the different corps distinguished from each other by the colour of their lace and facings.

The uniform of the Navy barely comes within the limits prescribed for this work. Its origin is attributed to the accidental meeting, in 1748, of George II. and the Duchess of Bedford on horseback. Her Grace was attired in a riding habit of blue, faced with white, and the king was so pleased with the effect that a question having been just raised as to the propriety of deciding upon some general dress for the Royal Navy, he immediately commanded the adoption of those colours,—a regulation which appears never to have been gazetted, nor does it exist in the records of the Admiralty, although it is referred to in a subsequent order in 1757. (*Vide* ' Journal of the British Archæological Association.')

The dresses, accoutrements, and arms of the various branches of our national forces, naval and military, will be found described under separate heads in the Dictionary, or in due chronological order in the GENERAL HISTORY.

UPPER STOCKS. (*Haute de chausses*, French.) See STOCKINGS.

AIR. A fur ranking with ermine and sable, amongst the most highly-prized of the many used for the lining or trimming of mantles, gowns, and other articles of apparel in the Middle Ages.

It is said to have been the skin of a species of squirrel (some say weasel), grey on the back and white on the throat and belly. Its name, however, is generally admitted to have been derived from the variety of its colours, and not from the animal itself, which leaves it open to the question whether it was not a mixture of furs, and not solely that of one animal : for instance, the white of the ermine, the menu-vair, with the bluish-grey of the weasel; the "gris and gros" of which we read so constantly. Nothing conclusive has been advanced by any writer I have been fortunate enough to meet with, either respecting vair or minever, the latter being considered the pure white fur ("minever pure") with which the robes of the Peers and Judges are trimmed; by others the ermine with minute spots of black in it ("minutus varius") in lieu of the complete tails; and by a third glossarist, "the fur of the ermine mixed with that of the small weasel,"—the identical arrangement, I am inclined to believe, which constituted vair. According to Guillaume le Breton, the skins of which it was composed were imported from Hungary ; but the white stoat is called to this day a *minifer* in Norfolk. Vair gives its name to a charge in heraldry, wherein it is depicted, like a series of heater-shaped shields, alternately white and blue (argent and azure), and such is its general appearance on the mantles or tippets of noble personages in illuminations or enamels. (See pages 357 and 358, and the chromo-lithograph issued with Part V., representing a Norman nobleman, from an enamelled tablet in the museum at Mans: see also 'Notes to Way and Ellis's Fabliaux ;' Ducange and Halliwell ; Sandford, 'Coronation of James II.;' Strutt, 'Dress and Habits,' part iv.)

VAMBRACE, VANTBRACE. (*Avant bras,* French.) Armour for the fore-arm (see BRASSART). A graceful curve was given to the upper half of the vambrace for the right arm in the fifteenth century, to defend the inner part of the elbow-joint. (See woodcut annexed.)

Vambrace for right arm, 1490. Meyrick Collection.

Another, from
'The Triumph of Maximilian.'

VAMPLATE. A circular plate that protected the hand on a lance. (See LANCE.)

VANDYKE. Mr. Fairholt says, "A cut edge to garments, like a zigzag or a chevron. They were a revival of a fashion occasionally depicted in Vandyke's portraits, and from which they were named." ('Cost. in England,' Glossary.) The vandyke was a sort of frill or neckerchief, so called from its edging, in fashion towards the close of the reign of George II.

> "Circling round her ivory neck,
> Frizzle out the smart vandike,
> Like the ruff that heretofore
> Good Queen Bess's maidens wore."
>> *Advice to a Painter,* 1755.

> "A vandyke in frize your neck must adorn."
>> *A la Mode,* 1754.

> "Your neck and your shoulders both naked should be,
> Was it not for vandyke blown with chevaux de frize."
>> *Beaux receipt for a Lady's dress,* 1753.

VARDINGALE, VERDINGALE. See FARTHINGALE.

VEIL. (*Voile,* French.) One of the most ancient articles of female attire; the couvre-chef of the Anglo-Saxon ladies, and transmitted by them to the conventual costume, but retaining, nevertheless, its place in the wardrobe of the fair sex to the present day.

VELVET, VELLET. (*Villuse, velours,* French; *villosa,* Latin.) Velvet, under one or other of the foregoing names, is mentioned by writers of the early portion of the thirteenth century. "Quemdam pannum villosum qui Gallis villuse dicitur." (Matt. Paris, in 'Vita Abbatum.') M. Quicherat informs us that the word in its different forms of *velluse, velloux, voluel,* originally signified a material of which napkins, and occasionally some garments, were made; amongst others, the mantles of the Knight-Templars: and that, "dans leur superbe," they availed themselves of this circumstance, and considered they were authorized to wear velvet. ('Histoire du Costume en France,' p. 180) Notwithstanding the estimation in which this new manufacture must have been held in the fourteenth century, we hear little of it either in prose or poetry during the reigns of the first three Edwards; silk, satin, damask, cloth of gold, every rich stuff being alluded to save velvet. It is not mentioned in the sumptuary laws of Edward III., and appears for the first time in an Act of the fourth of Henry IV., A.D. 1403, in which it is ordered, that "no man not being a banneret, or person of higher estate, shall wear any cloth of gold, of crimson, of velvet, or motley velvet," excepting only "gens d'armes quant ils seunt armez," who were permitted to dress themselves according to their pleasure. After that period the mention of velvet is of frequent occurrence, and during the sixteenth and seventeenth centuries it was worn to a considerable extent by persons of condition of both sexes, and has continued in high estimation to the present day.

VENTAIL. See AVENTAILE. The word is applied to protections for the face as late as the reign of Henry VI. See quotation from an inventory dated 1433, under UMBER.

VEST. This term was first specially applied to a body garment adopted by Charles II. in 1666. Its introduction is noted to the very day by our inestimable friend Pepys. Under the date of October 8, in the above year, he writes: "The King hath yesterday in council declared his resolution of setting a fashion for clothes which he will never alter. It will be a vest, I know not well how, but it is to teach the nobility thrift, and will do good." On the 14th of the same month, he tells us: "This day the King begins to put on his vest being a long cassocke close to the body, of black cloth and pinked with white silk under it and a coat over it, and the legs ruffled with black riband like

a pigeon's leg ; and upon the whole I wish the King may keep it, for it is a very fine and handsome garment."

On the 17th, we hear that "the Court is all full of vests, only my Lord St. Alban's not pinked but plain black, and they say the King says the pinking upon white makes them look too much like magpies, and therefore hath bespoke one of plain velvett."

Only five weeks later, November 22, Mr. Batelier brings him "the news how the King of France hath, in defiance of the King of England, caused all his footmen to be put into vests, and that the noblemen of France will do the like, which, if true," he declares, "is the greatest indignity ever done by one prince to another."

Evelyn in his 'Diary' adds to our information on this subject some interesting particulars, differing slightly in date from Pepys, who names the 14th of October as the day on which the King first wore his vest. "1666, October 18th—To Court, it being the first time his Majesty put himself solemnly into the Eastern fashion of vest after the Persian mode, with girdle and straps, and shoe-strings and garters into bouckles, of which some were set with precious stones, resolving never to alter it ; and to leave the French mode, which had hitherto obtained to our great expence and reproch. Upon which divers courtiers and gentlemen gave his Majesty gold by way of wager, that he would not persist in this resolution."

On the 30th he says : "To London, to our office ; and now I had on the vest and surcoat or tunic, as 'twas called, after his Majesty had brought the whole Court to it. It was a comely and manly habit, too good to hold, it being impossible for us in good earnest to leave the Monsieures

Henry Bennet, Earl of Arlington.

vanities long." From the latter sentence it would appear that even by the end of the month the fashion was changing, and that the insult of the King of France in November was a little too late to have affected Charles's resolution.

Randle Holme, some years afterwards, describes the vest as "a wide garment reaching to the knees, open before and turned up with a facing or lining, the sleeves turned up at the elbows." His descriptions are very confused, and not to be implicitly relied on. As a coat was worn over the vest the sleeves of the latter could scarcely be turned up at the elbow. (See woodcut from portrait of Henry Bennet, Earl of Arlington, who, I believe, is painted in the short-lived fashion aforesaid. The sleeves of the *coat* are "turned up at the elbows.")

I am not aware of another representation of the vest of 1666, which bequeathed its name to the waistcoat.

VIRETON. An arrow or quarrel for a cross-bow ; so called because it spun round in its flight, the feathers being curved to produce that effect. It is mentioned as early as 1345. In a deed of that date quoted by Meyrick, we read of "xx caissiæ viretonorum in quarum quâlibet ad minus sint D Viretoni ;" and in a charter dated 1377, "Dedit balistas, viratonos, pavesia." ('Crit. Inquiry,' vol. ii. p. 107.)

A Vireton.

VITTÆ. See INFULA.

VIZARD. A mask. The term is properly applied to such masks as were worn on the stage or in masquerades for the purpose of disguisement, in distinction to those worn by ladies in the sixteenth and seventeenth centuries, though used by Dryden in the latter sense in his prologue to 'Almanzor and Almahide.'

"So as when vizard-mask appears in pit."

In the time of Edward III., masks for "disguisings" were called *visours*. In 1348, that king kept his Christmas at Guildford Castle, on which occasion there were ordered, amongst other things, for the "ludi domini Regis," "forty-two visours of various similitudes ; that is, fourteen of the faces of women, fourteen of the faces of men with beards, fourteen of the heads of angels, made with silver," &c.

VIZOR. The movable face-guard of a helmet. It first appears with the bascinet towards the middle of the fourteenth century ; and the brass of Sir Hugh Hastings at Elsing, co. Norfolk, 1347, affords an early example in the figure of Ralph Lord Stafford, which occupies a niche in the architectural border (see woodcut annexed). In the reign of Richard II., two forms are visible—one obtuse, the other peaked ; in some examples so sharply as to resemble the beak of a bird.

Vizored Bascinet of Ralph Lord Stafford. From the Hastings brass.

Vizored Bascinet, *temp.* Henry IV. In Meyrick Collection.

Head of Robert Chamberlayne.

This fashion lasted, with slight variations, to the end of the reign of Henry V., at which period it is occasionally called by the name of its predecessor, *ventail:* " ii basnetts cum ventells, ii basnetts

sine ventells. 1 antiquum basenet cum le ventell." (Inventory taken at Holy Island, A.D. 1416.) (See woodcuts: 1, of a vizored bascinet, formerly in the Meyrick Collection, *temp.* Henry IV.; and 2, from the figure of Robert Chamberlayne, Esquire, to Henry V., 1417, in the Register Book of the Abbey of St. Albans, Brit. Mus. Subjoined is an engraving of a bascinet with obtuse vizor, exhibited by Mr. S. Pratt at a meeting of the British Archæological Association, 20th November, 1852. For later examples, see HELMET, p. 285.)

Vizor of the same. Front view.

Vizored Bascinet with camail attached. 14th century.

VOLANTE-PIECE. An extra defence for the face used in tilting armour, introduced in the reign of Henry VII. Meyrick remarks that the salient angle of this piece was so sharp that, without the lance was furnished with a coronal, it was impossible to strike it ; and as it was accounted the highest honour to hit the forehead, it was often covenanted that it should not be used when the lance had not a coronal. (*Vide* letter-press to Plate V. of Skelton's 'Engraved Specimens,' from which we have taken our example.)

Volante-piece.

VOLUPERE. (*Envelopper?* French.) A head-dress worn by both sexes, but of what precise description has yet to be ascertained. The earliest mention I find of it is in an 'Account of John Marreys, the King's tailor,' 18th and 19th of Edward III., 1344–45, wherein are entered voluperes for the king's head, two of which were worked with pearls and red silk ribbons. ('Archæologia,' vol. xxxi. p. 142.) The name also occurs in Chaucer's description of the dress of the Carpenter's young wife in the 'Miller's Tale,' and he only tells us that the tapes of her white volupere were embroidered with black silk. In my edition of Strutt's 'Dress and Habits,' I mentioned in a foot-note to this passage (vol. ii. p. 170), that in the contemporary copy of Chaucer at Bridgewater House, the Carpenter's Wife is depicted wearing beneath a broad black hat a reticulated head-dress, which is white, with blue lacing ; also that I considered the word "tapes" to apply to laces that form the net or chequer work of the head-dress. The figure is too minute to admit of any indication of embroidery upon the laces, and they may have been carelessly painted blue instead of black : but the head-dress is of the kind so

often seen in paintings and sculptures of that day, and it would be highly interesting could we identify its having borne the name of volupere. (See HEAD-DRESS.)

That she wore with it a broad fillet of silk increases the probability. Halliwell calls it a cap or kerchief, and Fairholt says " it is also used for a night-cap ;" but neither refers to any authority, nor notices the voluperes of King Edward III.

VOULGE, BOULGE, BOUGE. There appears to be great diversity of opinion respecting this weapon. Père Daniel says it was " une espèce d'épieu " (spear or halbard), something like a boar-spear, as long as a halbard, with a large pointed blade ; " but the blade of the voulge was to have a cutting edge, and be broad in the middle :" also that it was the same as the guisarme, as those who carried voulges are called in a MS. ordinance or memorandum of the time of Louis XI. of France, "guisarmiers." The words of the memorandum are as follow :—"Item luy semble que ceux qui porteroient voulges les devroient avoir moyennement larges qu'ils eussent ung peu de ventre. Et aussi qu'ils fussent tranchans et bon estoc. Et que lesdits *guisarmiers* ayent salade a viziers, gantelets et grant dagues, sans espées." The description is not very clear, but sufficiently so to show that it was not much like the guisarme, or at least what is generally considered the guisarme. M. Demmin claims a high antiquity for the voulge in Switzerland, and says it was also much sought after in

France during the fifteenth century, at which time there existed a regiment of infantry called VOULGIERS, who were armed with this broad-bladed and long-hafted weapon, of which he gives three examples :—1. A Swiss voulge, about 16 inches in length, found on the battle-field of Morgarten (1319), *Arsenal of Lucerne.* 2. Swiss voulge, with hook, fourteenth century. 3. Swiss voulge, fourteenth century, *Arsenal of Zurich.* If these be really voulges, which I have no authority to assert or deny, they certainly bear no resemblance to a boar-spear, a guisarme, or the weapons in the Meyrick Collection which he considered voulges, and of which I have given an example under "LANGUE DE BŒUF,"—another name, ac-

Voulge. Tower of London.

Weapons termed Voulges by M. Demmin.

cording to Meyrick, for the voulge of the fifteenth century ; and in that case what are we to call that remarkably-shaped weapon, unlike any halbard, battle-axe, or partizan ? Mr. Hewitt ignores it altogether. M. Demmin comments on "Langue de bœuf swords" and "Langue de bœuf daggers," the latter being what are also termed "anlaces ;" but all this nomenclature is unsupported by any conclusive evidence, and must be received with respectful reservation. Above is given an engraving from a voulge in the national collection, Tower of London.

VOYDERS, VUIDERS, WAYDERS. This word occurs in a romance of the early part of the fifteenth century, called ' Clariodes,' and which contains a mass of allusions to costume and armour that deserves the special study of the antiquary interested in those particular branches of archæology.

"Sabatyns, greves, cusses (cuisses) with voyders."

And again—

"And on his armes, rynged not to (too) wyde,
There were voyders fretted in the mayle,
With cordes round and of fresh entayle."

Meyrick, followed by Fairholt, defines voyders or vuiders to be the same as guiders, *i.e.* straps to draw together the open parts of the armour ; but there is an entry in an inventory of articles delivered

out of the armoury at the Tower of London, 33rd of Henry VI., A.D. 1455, which is not so easily reconciled with that definition. " It'm viij haberg'ons, some of Meylen (Milan) and some of Westewale (Westphalia), of the which v of Meylen were delyv'ed to the College of Eyton, and other iii broken *to make slewys of woyders and ye's.*" Sir Samuel, in a foot-note to this passage, says, " Sleeves of vuiders, that is, with openings through which appeared the mail," and adds that " ye's " is a contraction signifying " these:" but granting so much, what sense can be made of " these " at the end of the sentence ? What are we to understand by " to make sleeves of vuiders and these "? Besides which, these habergeons were either of mail or of plate, and in either case, if broken up to make vuiders, they would themselves, according to the above interpretation, form the sleeves with openings through which the mail was to appear ! Under correction, I take *ye's* to be a contraction for eyes (*yeux*, French), frequently written *yes* in ancient documents (see Halliwell *in voce*) ; and as they must have been of metal as well as the vuiders, and probably *rings*, they might be used together for closing various parts of the armour, as hooks and eyes are still employed for similar purposes. There is no evidence to prove that vuiders or guiders were straps of leather. Amongst the habiliments for a joust of peace *temp.* Edward IV., we find an entry of " a paire of plates and thritty (thirty) gyders," but no indication of the material they were made of. I merely throw out these suggestions in the absence of all acceptable explanation ; Mr. Way, in his commentary on the subject in vol. iv. of the Journal of the Institute, having failed in affording one.

ADMOLL, WADMAL. "A very thick coarse kind of woollen cloth." (Halliwell.) Manufactured in England *temp*. Charles II. (Strutt, 'Dress and Habits,' vol. ii. part v.)

WAFTERS. Swords having the flat part of the blade placed in the usual direction of the edge, blunted for exercise, *temp*. Henry VI., so named from wafting the wind at every blow. (Meyrick, 'Crit. Inq.' vol. ii. 119.) "Furst viij swerdes, and a long blade of a swerde made in wafters, some greater and some smaller, for to leerne the king to play in his tendre age." (Inventory of goods delivered out of the Tower, 33rd Henry VI., 1455.)

WAISTCOAT. This now familiar name is first met with in inventories of the reign of Henry VIII. It was worn under the doublet and had sleeves, and, being made of rich materials, must have been occasionally visible in consequence of the slashing of the upper garment, a fashion carried to a great extent at that period. In an inventory made in the 33rd of Henry VIII. (1542), there are entries of one " waistcoat of cloth of silver, quilted with black silk, and stuffed out with fine camerike" (cambric), and of another " of white satin, the sleeves embroidered with Venice silver." The Earl of Essex, the favourite and victim of Queen Elizabeth, at the time of his execution, " put off his doublet, and he was in a scarlet waiscoat" (Stow, 'Annals,' p. 794) ; and Sir Thomas Wyatt, on ascending the scaffold, " put off his gowne, untrussed his points, and plucked off his doublet and his waiscoat" (Ibid. p. 622). Howe, the continuator of Stow, speaking of times previous to the reign of Elizabeth, says—"Then no workman knew how to make a waistcote wrought worth five pounds, nor no lord in the land wore any of that value, altho' at this day " (*circa* 1625) "many milleners' shops are stored with rich and curious embroydered waistcotes, of the full value of tenne pound a-piece, yea, twenty pound, and some forty pound." A waistcoat was also worn by women in the reign of Henry VIII. In the inventory above quoted, we find "two wastecotes for women, being of clothe of silver, embroidered, both of them having sleeves."

We hear nothing more of the waistcoat until nearly the end of the reign of Charles II., when, in an inventory of apparel provided for that monarch in 1679, occurs the entry of a complete suit of one material under the modern designation of "coat, waistcoat, and breeches." The name also reappears in this reign in the catalogue of a lady's wardrobe.

"Two point waistcoats for the morn,"

are enumerated in the list of articles indispensable to a lady's toilette by John Evelyn in the pleasant *jeu d'esprit* I have so frequently quoted, entitled 'Mundus Muliebris,' or, as it is sometimes called, 'A Voyage to Marryland ;' and as late as 1707, *temp*. Queen Anne, "j wascoate" is mentioned in the 'Account of my Cousin (Mrs.) Archer's clothes,' to which I have also been much indebted. I believe,

however, that this waistcoat was a portion of the lady's riding suit, as she also possessed a gold-laced cloth coat, and we find Addison about the same date describing a fair equestrian attired in "a coat and waistcoat of blue camlet, trimmed and embroidered with silver." From the days of James II., however, the waistcoat retained its position undisturbed as an integral portion of male apparel, varying only in length or material. At first they were as long as the coat (see woodcut, p. 110), and continued so during the reigns of William III., Queen Anne, and George I. (see woodcuts, p. 118); but shortened by "the bucks and bloods" of the time of George II. Respecting the materials, in 1687 Mr. Richard Hoare, who by mention of the sign of the Golden Bottle was evidently a member of the famous family of that name in Fleet Street, possessed a waistcoat and breeches of cloth of silver. In 1697 Spanish drugget coats and waistcoats lined with Persian silk were fashionable; the buttons and button-holes silver-frosted, the waistcoat trimmed with silver orris lace and silver buttons. Fringed waistcoats were in fashion in 1714. A Mr. John Osheal was robbed of a fine cinnamon cloth suit with plate buttons, the waistcoat fringed with a silk fringe of the same colour. "Waistcoats of gold stuffe, or rich flowered silks of a large pattern with a white ground," were worn by the noblemen and gentlemen at court on the birthday of King George II. in 1735. (Malcolm's 'Manners and Customs,' vols. ii. and v.)

WALKING-STICKS, in the general sense of the word, distinguished from the staff of the traveller, the bourdon of the pilgrim, or the crutch of age, appear in the hands of gallants of the fifteenth century; but canes are first heard of in the reign of Henry VIII., and were probably introduced to Europe after the discovery of America. "A cane garnished with golde, havinge a perfume in the toppe, under that a diall, with a pair of twitchers and a pair of compasses of golde, and a foot-rule of golde, a knife and a file, the haft of golde, with a whetstone tipped with golde," is entered in a MS. inventory of the contents of the Royal Palace at Greenwich, *temp.* Henry VIII. (Harl. MS. 1412.) Also "a cane garnished with sylver and gilte, with astronomie upon it." These curious canes were probably gifts to Henry or his father, and not intended to walk with; for in the same inventory we find walking-sticks distinguished from them, "Six walkyng staves, one covered with silke and

golde;" and walking-sticks of various lengths and sizes, with gold, silver, ivory, or horse heads, are seen and mentioned during the sixteenth and seventeenth centuries. In Charles II.'s time the French walking-stick, with a ribbon and tassels to hold it when passed over the wrist, was fashionable, and continued so to the reign of George II. "The nice conduct of the clouded cane," was the test of the beau in the days of Anne and George I. In the following reign an ugly and grotesque walking-stick justly excited the censure and the ridicule of the public press. The 'Universal Spectator' in 1730 observes, "The wearing of swords at the court end of the town is by many polite young gentlemen laid aside, and instead thereof they carry large oak sticks with great heads and ugly faces carved thereon." In the 'London Evening Post,' December 1738, a writer under the name of Miss Townley expresses her surprise and disgust at the dress of the men in the boxes of the Haymarket Theatre, some of whom "wore scanty frocks, little shabby hats put on one side, and clubs in their hands." The 'London Chronicle,' in 1762, acknowledges that "walking-sticks are now almost reduced to an useful size."

15th cent. 17th cent. 1730.

WAMBAIS. See GAMBESON.

WATCHET. One of the many names for blue. "Pale blue." (Halliwell.)

> "The saphire stone is of a watchet bleue."
> Barnfield's *Affectionate Shepherd*, 1594.

The kirtle of the Parish Clerk in the 'Canterbury Tales' is described by Chaucer to have been of "light waget," which, if watchet was a pale blue, must have been a very light blue indeed. Cotgrave makes it the same as *pers* in French, which he translates "Watchet, blunket (plunket), skie blue." (See PERS and PLUNKET.)

WELSH-HOOK. Glossarists are undecided about this weapon, which is mentioned by dramatists of the sixteenth century. "And swore the Devil his liegeman upon the cross of a Welsh-hook." (Shakespere, 'Henry IV.' Part I. act ii. sc. 4.) "Enter with Welsh-hooks, Rice ap Howell, &c." (Marlowe, 'Edward II.') A variety, perhaps, if not the same as the Welsh bill. Two thousand Welsh bills were ordered by Richard III. (August 17, 1483) to be made five days before the battle of Bosworth. The woodman's bill is still called a bill-hook, and by "the cross" might be meant the lateral projections above the socket of the blade. (See BILL, *temp.* Henry VII., p. 42.)

WHINYARD. A Scottish name for a poignard, of which word it appears to be a corruption. Queen Mary Stuart, describing Rizzio's murder to her ambassador in France, writes, "At the entry of our chamber they gave him fifty-six strokes with whinyards and swords." Knox also says that "they despatched him with whinyards *or* daggers." (Keith, pp. 331, 429. Glossary to Meyrick's 'Crit. Inq.')

WHISK. A name given to the gorget or neckerchief worn by women, *temp.* Charles II. :—"A cambric whisk with Flanders lace about a quarter of a yard broad and a lace turning up about an inch broad, with a stock in the neck, and a strap hanging down before, was lost between the new Palace and Whitehall. Reward 30*s.*" ('Mercurius Publicus,' May 8, 1662.) "Lost, a tiffany whisk, with a great lace down and a little one up, large flowers, with a rail for the head and peak." ('The Newes,' June 20, 1664.)

Randle Holme says, "A woman's neck whisk is used both plain and laced, and is called of most a gorget or falling whisk, because it falleth about the shoulders."

WIG. See PERIWIG.

WIMPLE. (*Guimple,* French.) The covering for the head and chin worn by the Anglo-Norman women, first mentioned in the reign of John, 1199–1216, and retained in the conventual costume.

> "Wering a veil instead of wimple,
> As nonnes don in their abbey."
> Chaucer, *Romaunt of the Rose.*

It appears to have been sometimes but another name for the veil or kerchief, *peplum* being rendered "wimple" in a MS. vocabulary of the thirteenth century (Doucean Coll. Bod. Lib. Oxford), though distinguished from it by Chaucer in the above quotation; the lines in the original French being—

> "Elle eut ung voille en lieu de gimple,
> Ainsi comme nonnain d'abbaye."
> *Roman de la Rose,* l. 3645.

That they were worn together is clear, however, from other passages in the same poem, viz.—

> "Aultre fois luy met une gimple
> Et par dessus ung cueuvrechief
> Qui cueuvre le gimple et le chief,
> Mais ne cueuvre pas le visaige."—(l. 21,870.)

And separately, as the Wife of Bath in the 'Canterbury Tales' is said to have been

> "Gwimpled well, and on hir hede an *hat.*"

The wimple was made of fine white silk or linen. King John, in the second year of his reign, orders four good and white wimples for his queen: "Quatuor wimpliarum albarum et bonarum." (Rot. lib. viii. Nov. 1200.) It was bound on the forehead by a golden or jewelled fillet amongst the wealthy, by a plain silken one amongst the humbler classes. Wimples and fillets of silk were forbidden to the nuns, who wore them, as now, of plain linen.

WIN-BREDE, WAGNE-PAGNE. (*Gagne-pain*, French.) Originally a name given to a sword. "A wyn-brede to be put in the knythes handes." (Harleian MS., 6149, fol. 46.) Later the term was applied to a musket, as the weapon by which the soldier won or gained his bread.

WINGS. "Welts or pieces set over the place on the top of the shoulders where the body and sleeves are set together." (Randle Holme.) These projections on the shoulders of the doublets of the men, and also of the women,—who, Stubbs tells us, had them, "like the men, buttoned up to the breast, and made with wings, welts, and pinions on the shoulder-points,"—are seen in numerous representations of the costume of the sixteenth and seventeenth centuries. In Ulpian Fulwell's interlude, 'Like will to like, quoth the Devil to the Collier,' printed in 1568, Nichol Newfangle, the Vice, says—

> "I learned to make gowns with long sleeves and wings."

WIRE-HAT. Mr. Hewitt considers this to be the English name for the *coif de mailles*, but adduces no evidence in support of his opinion. The word occurs frequently in inventories and wills of the fifteenth century; but nothing in the context in any instance I have met with which enables me to arrive at any conclusion:—"Item lego j wyrehatt." "Item j wyre-hatt harnest with sylver." ('York Wills,' pp. 343, 419.) "It'm a wyre hatt garnysshed yᵉ bordour serkyll." (Tower Inventory, 33rd Henry VI., A.D. 1455.)

I do not remember having seen *coif* rendered "hat" by any English writer; *coif* or *quoif* is an English word of Norman origin, and an article of apparel very distinct from a hat at any period. I can only accord Mr. Hewitt the benefit of the doubt.

WORCESTERS. Cloth so named from the city in which it was originally manufactured. Long worcesters and short worcesters are mentioned in the fourth year of the reign of Edward VI., A.D. 1553. (Ruffhead, vol. ii. pp. 429–441.)

WORSTED. A woollen cloth, so called from its being first manufactured at Worstead, in Norfolk, about the reign of Henry I.

AINTURE. (*Ceinture*, Fr.) A belt or girdle. The word occurs in this form in a letter-remissory dated 1397 : " Le suppliant print une xainture de cuir garnie de six clos d'argent."

YSGWYD. See SHIELD.

YSGYN. The British name for the skin of any wild beast, but more particularly the bear. (Meyrick, ' Orig. Inhab.')

ZAGAYE. A lance used by the Stradiots or Estradiots, *temp.* Henry VII., mercenary troops in the Venetian and French armies. M. Guillaume de Bellay, in his work on ' Military Discipline,' includes them amongst the weapons of the light cavalry in the service of Francis I., and says the zagaye, "which they call arzegaye," should have a shaft ten or twelve feet long, and pointed at both ends with iron. (See LANCEGAYE.)

ZATAYN. Satin. " Et ad faciendū unū doubleti de zatayn." (Wardrobe Account, Edward III.) The original name for this material, derived from the Chinese seaport town of Zaitun, famous in the fourteenth century for the manufacture of silken fabrics of all descriptions, which received the general appellation of *Zaituniah* from that circumstance. ('Travels of Ibn Batuta,' *circa* 1347. *Vide* Col. Yule's edit. of Marco Polo, vol. ii. p. 220, note.)

ZIBELLINE. See SABLE.

APPENDIX.

BESAGNES. In my notice of this word (p. 41), I referred the reader to HARNESS (p. 253), under which head I suggested that "besagnes" might have been a clerical error, and that we should probably read "besag*ue*s, the military pick, or some other knightly weapon, and not any portion of armour ;" adding that "another occurrence of the word" (which had only been met with in the passage quoted from Rous's 'History of the Earl of Warwick'), "would solve the mystery." I have since accidentally lighted on another occurrence of it, in the 'Romance of Clariodes,' a MS. of the fifteenth century. In a long and minute description of the armour of certain knights the author says :—

> "Wambras with wings and rerebras thereto,
> And *thereon sette were besagnys*."

This disposes of my suggestion as well as of the conjecture of Sir Samuel Meyrick, that they were small circular plates which covered the pins on which the vizor turned. It is clear from the above lines that the "besagnes," whatever may have been their form, were pieces of armour affixed to the rerebrace (*pièces de renfort*, as the French call extra protections worn for the joust or tournament), and not connected with the vizor. It is to be regretted that Meyrick should have overlooked or forgotten this mention of besagnes in the long extract from the Romance which he has himself printed in his 'Critical Inquiry' (vol. ii. p. 78), as it would have caused him to reconsider the subject, and probably have enabled him to identify the articles alluded to. At present we are still in the dark as to their shape or position, and can only presume they were some sort of garde-bras of which we do not recognize any representation or which may be known to us by another name.

CAPHA. "A gown of purple *capha* damask" is mentioned in a wardrobe account of the reign of Henry VIII. ; and at p. 219, under the article GOWN, I have expressed myself at a loss to explain "*capha* damask." Capha is rendered by Ducange "*matta storea*, gall nutte," *i.e.*, "Tissu de paille ou de jonc," which could never apply to damask. It is more probably the name of a place where the stuff was manufactured. Caffa or Kaffa in the Crimea was a port of some consequence in the seventeenth century.

DEVICE—referred to under BADGE, but inadvertently omitted. The device differed from the badge in being a temporary assumption on some particular occasion, while the latter was a family distinction, as hereditary as a coat-of-arms. In the sixteenth century the assumption of devices in jousts of peace was carried to a ridiculous height. King Henry VIII., in 1522, appeared in a joust given for the entertainment of the envoys of the Emperor, and entered the lists on a courser barded in cloth of silver of Denmark embroidered with letters *L* in gold, and under the letters a man's heart wounded and a great roll of gold, on which was written in black letters the words "*mon navera*." "Put together," says the chronicler, "it is *elle mon cœur a navera*, 'she hath wounded my heart.'" (Hall, p. 630.)

The object of the badge was publicity and identification; it was a "cognoissance," a "sign of company," and to it properly belonged the "cri de guerre" motto, *mot*, or word of the family. The device, on the contrary, with its accompanying legend, was assumed for the very opposite purpose of mystification, or at least of covertly alluding to the immediate motive or sentiment of the bearer. Both the badge and the device are occasionally called "a *rebus*," but the term is more strictly applicable to the latter, as it was in fact a pictured riddle or "painted metaphor," as Dallaway calls it, and its legend was emphatically described by the French "l'âme du devise"— the soul or spirit of the device.

FAUCHART. The observations on M. Viollet-le-Duc's description of this weapon, to which I alluded at p. 184, are simply these. Firstly, whilst admitting that the fauchart (or falx) was originally nothing more than a scythe-blade set upright on the top of a staff, not one of his illustrations represents such a weapon. Secondly, that he assumes the original weapon was superseded by one of the same name specially fashioned for war, though he acknowledges that it is difficult to establish the date at which this alteration took place; but where is the authority for the assumption that such an alteration ever took place? He cites none; I know of none. The difference between the primitive weapon and its successor, he says, consisted in the former having its cutting edge on the concave or inner side of the blade, and the latter on the convex or outer side. This special military fauchart, he

tells us, appeared in France and Italy in the thirteenth century, and he illustrates this information by an engraving of a weapon which has no *outside* edge (see cut annexed), which, he says, was also called a voulge, and is now known as a bill-hook (*serpe*). (See VOULGE and LANGUE DE BŒUF.) Another change in the fauchart is stated to have taken place in the fourteenth century, when it was called in France a "couteau de brèche," and was specially used for storming a fortress or for boarding a vessel, and this statement M. Viollet-le-Duc illustrates by engravings of early glaives and a bill of the fifteenth century (see BILL and GLAIVE). After all this assertion, unsupported by any evidence or indeed other opinion, except one hazarded by Sir Samuel Meyrick, that the fauchart bore some resemblance to a bill, M. Viollet-le-Duc concludes by stating that it is not easy to ascertain the exact distinctions between the voulge, the fauchart, the guisarme, and the *couteau de brèche*, and, in fact, that "ces noms semblent avoir été donnés à des armes analogues sinon identiques." That it is

A Fauchart, 13th century, according to M. Viollet-le-Duc.

not *easy* to ascertain the exact distinctions I am too fully aware, but I protest against the difficulty being made an excuse for confounding utterly dissimilar objects, and for pronouncing *ex cathedra*, without a grain of authority, a judgment on a disputable question.

GREY. There is a reference under BADGER (p. 28) to this word, which is in fact but another name for that animal whose fur was in much request during the Middle Ages. In the reign of Henry IV. it was ordered by statute that no clergyman under the degree of a canon residentiary "shall wear any furs of pure miniver of *grey* or of biche;" and garments furred with *grey, christe-grey*, miniver, or biche, were prohibited to apprentices to the law, clerks in Chancery or of the Exchequer, &c., and the wives of esquires if not ennobled.

ROBE. Under this heading I have to correct a curious error, partly perhaps typographical, in Dugdale's 'Origines Juridiciales,' which mystified and misled me at p. 426. On referring to the

Close Roll of the *20th of Edward I.*, quoted by him as containing the earliest notice of the robes of the Judges, no such order could be found, and, after some trouble kindly taken for me at the Record Office, it was discovered that the quotation was from the 20th of Edward *III.*, altering the regnal year from 1292 to 1347, and, moreover, that the words "fine linen silk" and "furs of silk," which I had reserved for explanation, were such mistranslations of the abbreviated Latin as one should hesitate to lay to the charge of Dugdale. The word rendered "fine linen silk" is *sindon*, "unam peciam sindon," a Hebrew term for a very fine species of linen (see SINDON), and it is just possible that Dugdale may have written "*or* silk," as the question has been mooted, and the omission of the conjunction is an error of the press. The other mistake is undoubtedly the author's, as he has repeated it more than once in his subsequent extracts. The words in the roll are "duabz fururis de Bissh," "two furs of *biche*," the skin of the female deer (see BICHE); and the latter has been misread BYSSUS, a textile fabric, which has been occasionally called silk (see BYSSINE). The misprint of Edward I. for Edward III. is a serious error, as it antedates the "*earliest* notice" of the robes of the Judges fifty-five years, and dependence upon it might lead to much unintentional misrepresentation and erroneous conclusion, as well as entail considerable trouble and loss of time to students who, as in my case, may desire to consult the original record. Had I not fortunately been perplexed by the strange terms "fine linen silk" and "furs of silk," I own I should never have questioned the more important statement affecting the date of the first official record of English judicial costume.